EXPLORATIONS
THE VISUAL ARTS
SINCE 1945

EXPLORATIONS
THE VISUAL ARTS SINCE 1945

KATHERINE HOFFMAN

IconEditions

An Imprint of HarperCollins*Publishers*

For Those I Love

EXPLORATIONS: THE VISUAL ARTS SINCE 1945. Copyright © 1991 by Katherine Hoffman. All rights reserved. Printed in the United States of America. No part of this book may be used or reproduced in any manner whatsoever without written permission except in the case of brief quotations embodied in critical articles and reviews. For information address HarperCollins Publishers, 10 East 53rd Street, New York, NY 10022.

FIRST EDITION

Designed by Alma Orenstein

Library of Congress Cataloging-in-Publication Data

Hoffman, Katherine, 1947–
 Explorations : the visual arts since 1945 / Katherine
Hoffman. —
 1st ed.
 p. cm.
 Includes bibliographical references and index.
 ISBN 0-06-433331-0 / ISBN 0-06-430200-8 (pbk.)
 1. Art, Modern—20th century—Themes, motives. I. Title.
 N6490.H635 1990 89-26986
 709′.045—dc20

91 92 93 94 95 CC/MPC 10 9 8 7 6 5 4 3 2 1

91 92 93 94 95 CC/MPC 10 9 8 7 6 5 4 3 2 1 (pbk.)

CONTENTS

List of Illustrations **vii**
Acknowledgments **xiv**
Preface **xv**

I. Toward New Routes: 1945–1960 **1**

Painting, 1945–1960 **5**
Printmaking, 1945–1960 **53**
Photography, 1945–1960 **59**
Sculpture, 1945–1960 **69**
Architecture, 1945–1960 **87**
Multimedia and Intermedia,
 1945–1960 **97**

II. Upheavals: The 1960s **103**

Painting and Beyond, 1960s **107**
Printmaking, 1960s **141**
Photography, 1960s **147**
Sculpture, 1960s **157**
Architecture, 1960s **182**
Multimedia and Intermedia, 1960s **192**

III. Individuals and Eclecticism:
 The 1970s **203**

Painting, 1970s **207**
Printmaking, 1970s **227**

Photography, 1970s **231**
Sculpture, 1970s **243**
Architecture, 1970s **258**
Multimedia and Intermedia, 1970s **269**

IV. Searching for Heroes: The 1980s **281**

Painting, 1980s **287**
Printmaking, 1980s **321**
Photography, 1980s **325**
Sculpture, 1980s **337**
Architecture, 1980s **357**
Multimedia and Intermedia, 1980s **365**

Looking Backward and Forward **375**
Selected Bibliography: Books
 and Exhibition Catalogs **377**
Index **390**

Color plates follow page 208.

I think that what we're really seeking is an experience of being alive, so that our life experiences on the purely physical plane will have resonances within our innermost being and reality, so that we actually feel the rapture of being alive.

. . . to see through the fragments of time to the full power of original being—that is a function of art.

Joseph Campbell
The Power of Myth

LIST OF ILLUSTRATIONS

I. Toward New Routes: 1945–1960

1.1. Francis Bacon, *Head Surrounded by Sides of Beef*, 1954. Oil on canvas, 129.9 × 122 cm. Copyright © 1990 The Art Institute of Chicago, Harriott A. Fox Fund, 1956.1201. All rights reserved.

1.2. Alex Colville, *Horse and Train*, 1954. Glazed tempera on Masonite, 41.2 × 54.2 cm. The Art Gallery of Hamilton (Ontario), Gift of Dominion Foundries and Steel Ltd (Dofasco, Inc.), 1957. Copyright © Vis Art Copyright, Inc. Photograph: Paul Sparrow, Multi-Media Techniques, Ontario.

1.3. Fernand Léger, *The Great Parade*, 1954. Oil on canvas, 117¾ × 157½". Solomon R. Guggenheim Museum, New York. Photograph Robert E. Mates.

1.4. Balthus, *Golden Days* (Les Beaux Jours), 1944–49. Oil on canvas, 148 × 200 cm. Hirshhorn Museum and Sculpture Garden, Smithsonian Institution, Washington, D.C.

1.5. Hans Hofmann, *Blue Rhythm*, 1950. Oil on canvas, 122 × 91 cm. Copyright © The Art Institute of Chicago, Gift of the Society for Contemporary American Art, 1952.2000. All rights reserved.

1.6. Jackson Pollock, *Autumn Rhythm*, 1957. Oil on canvas, 105 × 207". The Metropolitan Museum of Art, New York, George A. Hearn Fund, 1957 (57.92).

1.7. Lee Krasner, *Cornucopia*, 1958. Oil on canvas, 90½ × 70". Robert Miller Gallery, New York.

1.8. Willem de Kooning, *Woman and Bicycle*, 1952–53, 76½ × 49" Whitney Museum of American Art, New York.

1.9. Franz Kline, *The Bridge*, 1955. Oil on canvas, 80 × 52¾". Munson-Williams-Proctor Institute, Utica, N.Y.

1.10. Philip Guston, *The Room*, 1954–55. Oil on canvas, 71⅞ × 60". Los Angeles County Museum of Art, Museum Purchase, Contemporary Art Council Fund. Copyright © 1990 Museum Associates. All rights reserved.

1.11. Barnett Newman, *Covenant*, 1949. Oil on canvas, 47¾ × 59⅝". Hirshhorn Museum and Sculpture Garden, Smithsonian Institution, Washington, D.C., Gift of Joseph H. Hirshhorn, 1972.

1.12. Clyfford Still, *1954*, 1954. Oil on canvas, 113½ × 156". Albright-Knox Art Gallery, Buffalo, Gift of Seymour H. Knox, 1957.

1.13. Mark Rothko, *Four Darks in Red*, 1958, 102 × 116". Whitney Museum of American Art, New York.

1.14. Adolph Gottlieb, *Circular*, 1960. Oil on canvas, 90 × 72". New York University Art Collection, New York, Grey Art Gallery and Study Center, Gift of the artist, 1966.28. Photograph: Geoffrey Clements.

1.15. Robert Motherwell, *Elegy to the Spanish Republic, XXXIV*, 1953–54. Oil on canvas, 80 × 100". Albright-Knox Art Gallery, Buffalo, Gift of Seymour H. Knox.

1.16. Robert Motherwell, *The Red and Black #53*, 1987. Collage on Whatman paper, 32 × 25". M. Knoedler & Co., Inc., New York. Photograph: Ken Cohen.

1.17. Joan Mitchell, *Hemlock*, 1956. Oil on canvas, 91 × 80". Whitney Museum of American Art, New York.

1.18. Sam Francis, *Shining Back*, 1958, 79⅜ × 53⅛". Solomon R. Guggenheim Museum, New York.

1.19. Larry Rivers, *Washington Crossing the Delaware*, 1953, 83⅝ × 111⅝". The Museum of Modern Art, New York.

1.20. Helen Frankenthaler, *Mountains and Sea*, 1952, 86⅞ × 117¼". Collection the artist.

1.21. Kenneth Noland, *Spread*, 1958, 117 × 117". New York University Art Collection, New York.

1.22. Morris Louis, *Alpha*, 1960, 105½ × 145½". Albright-Knox Art Gallery, Buffalo.

1.23. Ad Reinhardt, *Red Painting*, 1952. Oil on canvas, 6'6" × 12'. The Metropolitan Museum of Art, New York, Arthur Hoppock Hearn Fund, 1968.

1.24. Ellsworth Kelly, *Green White*, 1959, 46 × 60". Private collection.

1.25. Robert Rauschenberg, *Canyon*, 1959. Combine painting 81¾ × 70 × 24". Collection Mr. and Mrs. Michael Sonnabend, New York.

1.26. Jasper Johns, *Flag*, 1955. Encaustic, oil, and collage on fabric, 42¼ × 60⅝". The Museum of Modern Art, New York, Gift of Philip Johnson.

1.27. Frank Stella, *The Marriage of Reason and Squalor*, 1959, 90¾ × 132¾". The Museum of Modern Art, New York.

1.28. Wolfgang Wols, *Oiseau (Bird)*, 1949. Oil on canvas, 36¼ × 25³⁄₅". Courtesy of The Menil Collection,

Houston. Photograph: Maurice Miller.

1.29. Jean Dubuffet, *Triumph and Glory,* December 1950. Oil on canvas, 51 × 38½″. Solomon R. Guggenheim Museum, New York. Photograph: Robert E. Mates.

1.30. Alberto Burri, *Composition,* 1953. Oil, gold, and glue on canvas and burlap, 34 × 39⅜″. Solomon R. Guggenheim Museum, New York. Photograph: Robert E. Mates.

1.31. Karel Appel, *Personnage,* 1961. Oil on canvas, 77 × 51″. Michelle Rosenfeld, Inc., Fine Arts.

1.32. Wifredo Lam, *Zambezia, Zambezia,* 1950. Oil on canvas, 49 × 42½″. Solomon R. Guggenheim Museum, New York, Gift of Joseph Cantor. Photograph: Robert E. Mates.

1.33. Rufino Tamayo, *Woman in Grey,* 1959. Oil on canvas, 76¾ × 57″. Solomon R. Guggenheim Museum, New York. Photograph: Robert E. Mates.

1.34. Lucio Fontana, *Spatial Concept,* 1957. Pen and ink on paper mounted on canvas with punctures and scrapes, 55″ × 6′6⅜″. The Museum of Modern Art, New York, Gift of Morton G. Neumann.

1.35. Gabor Peterdi, *Germination,* 1952. Aquatint, etching, and engraving, printed in black with offset color, plate: 19¾ × 23¹³⁄₁₆″. The Museum of Modern Art, New York, Gift of Mr. and Mrs. Walter Bareiss.

1.36. Yozo Hamaguchi, *Asparagus and Lemon,* 1957. Mezzotint, printed in black, composition: 11½ × 17⅜″. The Museum of Modern Art, New York, Gift of Heinz Berggruen.

1.37. M. C. Escher, *Other World,* 1947. Wood, engraving, printed in color, composition: 12⁷⁄₁₆ × 10¼″. The Museum of Modern Art, New York, Purchase.

1.38. Leonard Baskin, *Torment,* 1958. Woodcut, printed in black, block: 31 × 23⁵⁄₁₆″. The Museum of Modern Art, New York, Gift of the artist.

1.39. Robert Rauschenberg, *Accident,* 1963. Lithograph, edition of 29, 41¼ × 29½″. Courtesy Universal Limited Art Editions, West Islip, N.Y.

1.40. Ansel Adams, *Moon and Half Dome, Yosemite National Park, California,* 1960.

1.41. Harry Callahan, *Weed Against the Sky,* Detroit, 1948. Copyright © Harry Callahan. Courtesy Pace/MacGill Gallery, New York.

1.42. Minor White, *Ritual Branch,* 1958. Photograph: International Museum of Photography at George Eastman House, Rochester. Gelatin silver print, 9⅜ × 9⅛″. Reproduction courtesy The Art Museum, Princeton University, Princeton, N.J., The Minor White Archive. Copyright © 1982 The Trustees of Princeton University.

1.43. Aaron Siskind, *Chicago 10 or 16,* 1965. Silver print, image: 13⁷⁄₁₆ × 10⁷⁄₁₆″. Museum of Art, Rhode Island School of Design, Providence, Gift of Robert B. Menschel. Photograph: Cathy Carver.

1.44. Lotte Jacobi, *Photogenic,* date unknown. Gelatin silver print. Addison Gallery of American Art, Phillips Academy, Andover, Mass.

1.45. Frederick Sommer, *Circumnavigation of the Blood,* 1950. Gelatin silver print, 10.3 × 14.3 cm. Copyright © Frederick Sommer.

1.46. Robert Frank, *Trolley, New Orleans* (from *The Americans*). Silver gelatin print. Copyright © 1990 The Art Institute of Chicago, Restricted gift of Photo Gallery.

1.47. Lisette Model, *Singers at Sammy's Bar, New York,* c. 1950. Gelatin silver print, 15¾ × 19¾″. Addison Gallery of American Art, Phillips Academy, Andover, Mass., Gift of anonymous donor.

1.48. Pablo Picasso, *Baboon and Young,* Vallauris, 1951. Bronze (cast 1955), after found objects, 21 × 13¼ × 20¾″. The Museum of Modern Art, New York, Mrs. Simon Guggenheim Fund.

1.49. Alberto Giacometti, *City Square,* 1948. Bronze, 8½ × 25⅜ × 17¼″. The Museum of Modern Art, New York, Purchase.

1.50. Germaine Richier, *The Batman,* 1956. Bronze, 34″ high. Wadsworth Atheneum, Hartford, Gift of Mrs. Frederick W. Hilles. Copyright © Wadsworth Atheneum.

1.51. Henry Moore, *King and Queen,* 1952–53. Bronze, 63½ × 59 × 37½″. Hirshhorn Museum and Sculpture Garden, Smithsonian Institution, Washington, D.C., Gift of Joseph H. Hirshhorn, 1966.

1.52. Barbara Hepworth, *Sea Form (Porthmeor),* 1958. Bronze, 30½ × 44⅛ × 12¾″. Hirshhorn Museum and Sculpture Garden, Smithsonian Institution, Washington, D.C., Gift of Joseph H. Hirshhorn, 1966.

1.53. Eduardo Paolozzi, *Japanese War God,* 1958. Bronze, 64½ × 23 × 12″. Albright-Knox Art Galley, Buffalo, Gift of Seymour H. Knox, 1960.

1.54. Giacomo Manzù, *Young Girl on a Chair,* 1955. Bronze, 45 × 23¾ × 43¼″. Hirshhorn Museum and Sculpture Garden, Smithsonian Institution, Washington, D.C., Gift of Joseph H. Hirshhorn, 1966.

1.55. Alexander Calder, *Black Widow,* 1959. Painted sheet steel, 7′8″ × 14′3″ × 7′5″. The Museum of Modern Art, New York, Mrs. Simon Guggenheim Fund.

1.56. Isamu Noguchi, *Kouros,* 1944–45. The Metropolitan Museum of Art, New York.

1.57. Isamu Noguchi, *Portal,* 1976. Thirty-six feet high, fabricated of standard industrial 4-foot-diameter hollow steel pipe. Cuyahoga Justice Center, Cleveland.

1.58. Joseph Cornell, *The Hotel Eden,* 1945. Assemblage with music box, 38.3 × 39.7 × 12.1 cm. National Gallery of Canada, Ottawa.

1.59. Louise Nevelson, *Sky Cathedral,* 1958. Wood construction painted black, 11′3½″ × 10′¼″ × 18″. The Museum of Modern Art, New York, Gift of Mr. and Mrs. Ben Mildwoff.

1.60. Louise Bourgeois, *The Blind Leading the Blind,* c. 1947. Painted wood, 67⅛ × 64⅜ × 16¼″. Robert Miller Gallery, New York. Becon Collection Ltd.

1.61. David Smith, *Hudson River Landscape,* 1951, 49½ × 75 × 16¾″. Whitney Museum of American Art, New York.

1.62. David Smith, *Cubi XII,* 1963. Stainless steel, 109⅝ × 49¼ × 32¼″. Hirshhorn Museum and Sculpture Garden, Smithsonian Institution, Washington, D.C.

1.63. Mark di Suvero, *Hankchampion,* 1960. Whitney Museum of American Art, New York.

1.64. Richard Stankiewicz, *Our Lady of All Protections,* 1958, 51 × 31 × 32″. Albright-Knox Art Gallery, Buffalo.

1.65. John Chamberlain, *Nutcracker,* 1958, 50 × 50 × 30″. Courtesy Allan Stone Gallery, New York.

1.66. Peter Voulkos, *Little Big Horn,* 1959. Stoneware, poly-

chrome and underglazed, 62 × 40 × 40″. The Oakland Museum Art Department, Gift of the Art Guild of The Oakland Museum Association. Photograph: M. Lee Fatherree.

1.67. Mies van der Rohe, Crown Hall, Illinois Institute of Technology, Chicago, 1950–56.

1.68. Philip Johnson, Glass House, New Canaan, Conn., 1945–49.

1.69. Mies van der Rohe and Philip Johnson, Seagram Building, New York, 1954–58.

1.70. Eero Saarinen, TWA Terminal, Kennedy Airport, New York, 1956–62.

1.71. Frank Lloyd Wright, Solomon R. Guggenheim Museum, New York, 1943–45, 1956–59.

1.72. Louis I. Kahn, Alfred Newton Richards Medical Research Laboratories, University of Pennsylvania, Philadelphia, 1957–61. Photograph: John Ebstel.

1.73. R. Buckminster Fuller, U.S. Pavilion, Expo '67, Montreal, 1967.

1.74. Jørn Utzon, Sydney Opera House, off Bennalong Point, Sydney, 1956–73.

1.75. Le Corbusier, chapel at Ronchamp, France, 1950–54.

1.76. Oscar Niemeyer, Presidential Palace, Brasília, 1958.

1.77. Pier Luigi Nervi, *Palazzetto dello Sport,* Rome, 1958.

1.78. Allan Kaprow, Happening, Southampton, N.Y., 1966. Photograph: Burton Berinsky.

II. Upheavals: The 1960s

2.1. Andy Warhol, *Campbell's Soup Can with Can Opener,* 1962. Synthetic polymer paint on canvas, 6′ × 52″. Collection Windsor, Inc. Copyright © 1988 The Museum of Modern Art, New York.

2.2. Andy Warhol, *Self-Portrait,* 1966. Six Canvases, each 22⅝″ × 22⅝″. Sidney and Harriet Janis.

2.3. Roy Lichtenstein, *Drowning Girl,* 1963, 67⅝ × 66¾″. The Museum of Modern Art, New York.

2.4. James Rosenquist, *Nomad,* 1963. Oil on canvas, plastic paint, wood, 84 × 210″. Albright-Knox Art Gallery, Buffalo, Gift of Seymour H. Knox.

2.5. Tom Wesselmann, *Bathtub Collage #3,* 1963. Oil on canvas and collage, 7′ × 8′10″ × 24″. Museum Ludwig, Cologne. Courtesy Sidney Janis Gallery, New York.

2.6. Jim Dine, *Tie,* 1962, 25¾ × 19½″. Ileana and Michael Sonnabend.

2.7. Ed Ruscha, *Flash, L.A. Times,* 1963. Mead Corporation.

2.8. Ronald Kitaj, *Walter Lippmann,* 1966. Oil on canvas, 72 × 84″. Albright-Knox Art Gallery, Buffalo, Gift of Seymour H. Knox, 1967.

2.9. David Hockney, *A Bigger Splash,* 1967. Tate Gallery, London/Art Resource, New York, T 03254.

2.10. Gérard Deschamps, *Tango-Bolero,* 1961. Fabric, 20 × 24 × 4″. Courtesy Zabriskie Gallery, New York.

2.11. Romare Bearden, *The Street,* 1964. Collage on board. Exhibited at The Museum of Modern Art, New York, 1971.

2.12. Alex Katz, *Ives Field II,* 1964. Weatherspoon Art Gallery.

2.13. Philip Pearlstein, *Female Model in Robe Seated on Platform Rocker,* 1973. Oil on canvas, 72 × 60″. Courtesy of the San Antonio Museum Association.

2.14. William Bailey, *"N" (Female Nude),* c. 1965. Oil on canvas, 48″ × 72″. Whitney Museum of American Art, New York, Gift of Mrs. Louis Sosland 76.39.

2.15. Neil Welliver, study for *Pond Pass,* 1969, 48 × 48″. Collection the artist, courtesy Marlborough Gallery, New York.

2.16. Janet Fish, *Black Vase with Daffodils,* 1980. Oil on canvas, 66 × 50″. Robert Miller Gallery, New York. Photograph: eeva-inkeri.

2.17. Audrey Flack, *Chanel,* 1974. Acrylic on canvas, 56 × 82″. Courtesy Louis K. Meisel Gallery, New York.

2.18. Richard Estes, *Woolworth's,* 1974. Oil on canvas. San Antonio Museum of Art.

2.19. Chuck Close, *Frank,* 1969. Acrylic on canvas, 9 × 7′. The Minneapolis Institute of Arts.

2.20. Alice Neel, *Andy Warhol.* Whitney Museum of American Art, New York, Gift of Timothy Collins.

2.21. Kenneth Noland, *Bend Sinister,* 1964. Synthetic polymer on canvas, 92½ × 162½″. Hirshhorn Museum and Sculpture Garden, Smithsonian Institution, Washington, D.C., Gift of Joseph H. Hirshhorn, 1966.

2.22. Bridget Riley, *Current,* 1964, 58⅜ × 58⅞″. The Museum of Modern Art, New York.

2.23. Frank Stella, *Agbatana I,* 1968, 120 × 180″. Whitney Museum of American Art, New York.

2.24. Richard Diebenkorn, *Ocean Park No. 27,* 1970. The Brooklyn Museum.

2.25. Agnes Martin, *The Tree,* 1964, 72 × 72″. The Museum of Modern Art, New York.

2.26. Sol LeWitt, *Wall Drawing,* 1970. Pencil in four colors, 6 × 6′. John Weber Gallery, New York. Photograph: Walter Russell.

2.27. Joseph Kosuth, *One and Three Chairs,* 1965. The Museum of Modern Art, New York.

2.28. Jasper Johns, working proof for *Ale Cans,* 1964. Lithograph, printed in black with paint additons, composition: 14¹/₁₆ × 10¹⁵/₁₆″. The Museum of Modern Art, New York, Gift of the artist in honor of Tatyana Grosman.

2.29. Robert Rauschenberg, *Sky Garden,* 1969. Six color lithographs/silkscreen, 89 × 42″. Copyright © Gemini G.E.L., Los Angeles, 1969.

2.30. Andy Warhol, *Marilyn Monroe,* 1962. Acrylic and silkscreen on canvas, 81 × 66¾″. Leo Castelli Gallery, New York. Photograph: Eric Pollitzer.

2.31. Garry Winogrand, *Hard Hat Rally, New York,* 1969. Gelatin silver print. Courtesy Fraenkel Gallery, San Francisco, and the Estate of Garry Winogrand.

2.32. Lee Friedlander, *Newark, N.J.,* 1962. Courtesy the artist.

2.33. Bruce Davidson, *East 100th Street,* 1966–68. Copyright © Bruce Davidson, Magnum Photos.

2.34. Duane Michals, *Things Are Queer,* detail, 1973.

2.35. Ralph Gibson, image from *The Somnambulist,* 1968. Copyright © Ralph Gibson. Courtesy the artist.

2.36. Jerry Uelsmann, *Small Woods Where I Met Myself.* Copyright © 1967. Courtesy the artist.

2.37. Claes Oldenburg, *Giant Hamburger,* 1962. Art Gallery of Ontario.

2.38. Red Grooms, *Loft on 26th Street,* 1965–66, 28¼ × 65¼ × 28½″. Hirshhorn Museum and Sculpture Garden, Smithsonian Institution, Washington, D.C.

2.39. George Segal, *Bus Riders,* 1964. Hirshhorn Museum

and Sculpture Garden, Smithsonian Institution, Washington, D.C.

2.40. Duane Hanson, *Security Guard,* 1975. Collection Palevsky.

2.41. Edward Kienholz, *The Wait,* 1964–65, 80 × 148 × 78″. Whitney Museum of American Art, New York.

2.42. Richard Artschwager, *Hair Boxes,* 1969. Rubberized hair, various dimensions. Leo Castelli Gallery, New York. Photograph: Rudolph Burckhardt.

2.43. Carl Andre, *Lead Piece (144 Lead Plates 12 × 12 × ⅜″),* 1969. Overall ⅜ × 144⅞ × 145½″. The Museum of Modern Art, New York.

2.44. Donald Judd, *Untitled,* 1968.

2.45. Robert Morris, *Untitled (L-Beams),* 1965–67. Gray fiberglass.

2.46. Robert Morris, *Untitled,* 1967–68. Felt.

2.47. Sol LeWitt, *Untitled Cube,* 1968, 15½ × 15½ × 15½″. Whitney Museum of American Art, New York.

2.48. Dan Flavin, *Untitled (to the "innovator" of Wheeling Peachblow),* 1968, 96½ × 96¼ × 5¾″. The Museum of Modern Art, New York.

2.49. Barnett Newman, *The Broken Obelisk,* 1963–67. Corten steel, 25′5″ × 10′6″. Rothko Chapel, Houston. Photograph: Don Getsug/*Time* magazine.

2.50. Robert Smithson, *Spiral Jetty,* April 1970. Coil 1,500′ long, approximately 15′ wide. Great Salt Lake, Utah.

2.51. Walter De Maria, *The Lightning Field,* 1971–77. New Mexico. U.S.A. Dia Art Foundation.

2.52. Christo, *Running Fence,* 1972–76. Sonoma and Marin counties, California. Height 18′, length 24 miles. Photograph: Jeanne-Claude, courtesy Christo.

2.53. Anthony Caro, *Rainfall,* 1964, 48 × 99 × 52″. Hirshhorn Museum and Sculpture Garden, Smithsonian Institution, Washington, D.C.

2.54. George Sugarman, *Concord,* 1974. Polychromed aluminum, 96 × 90 × 60″. Robert Miller Gallery, New York.

2.55. Eva Hesse, *Sans II,* 1968. Fiberglass, 38 × 86 × 6″. Whitney Museum of American Art, New York, Purchase with funds from Dr. and Mrs. Lester J. Honig and the Albert A. List Family.

2.56. Eduardo Chillida, *Comb of the Wind,* 1977. Donostia Bay, San Sebastián. Photograph: F. Català-Roca.

2.57. Magdalena Abakanowicz, *Backs* (group of 80 figures: life size and larger; all similar in general shape, but each different in size and expression), 1976–80. Burlap and resin. Courtesy Marlborough Gallery, New York.

2.58. Skidmore, Owings & Merrill, Lever House, New York, 1951–52.

2.59. Skidmore, Owings & Merrill, John Hancock Center, Chicago, 1965–70. Photograph: Hedrich-Blessing; Skidmore, Owings & Merrill.

2.60. Hans Scharoun, Berlin Philharmonie, 1956–63.

2.61. James Stirling, building for the History Faculty, Cambridge University. Photograph: Ezra Stoller. Copyright © Esto.

2.62. Isozaki, Iwata Girls' High School, Iwata, Japan, 1963–64.

2.63. Kenzo Tange, Yamanashi Press and Radio Center, Kofu, Japan, 1967.

2.64. Paolo Soleri, Arcosanti (near Scottsdale, Ariz.), 1970 on.

2.65. Moshe Safdie, David Barott, and Boulva, Habitat,

2.66. Expo '67, Montreal, 1964–67.

2.66. Robert Venturi, Venturi house, Chestnut Hill, Philadelphia, 1962.

2.67. Venturi & Rauch, Cope & Lippincott, associated architects, Guild House, Philadelphia, 1960–65.

2.68. Kenneth Knowlton, computer-processed photograph, consisting of 112 × 45 cells.

2.69. Barron Krody, *Search,* 1969. Photograph: Mike Campbell.

2.70. Bruce Nauman, *Holograms (Making Faces),* 1968. Photographic image on glass, 8 × 10″. Leo Castelli Gallery, New York. Photograph: Frank J. Thomas.

2.71. Joseph Beuys, *I Like America and America Likes Me,* 1974.

III. Individuals and Eclecticism: The 1970s

3.1. Brice Marden, *Grove Group III,* 1973–80. Oil and wax on canvas, 72 × 108″. The Pace Gallery, New York.

3.2. Miriam Schapiro, *Pandora's Box, 1973.* Acrylic spray collage, two panels of 68 × 28″ Collection Zora's, California. Photograph: Frank J. Thomas.

3.3. Joyce Kozloff, *Tent-Roof-Floor-Carpet/Zemmour,* 1975. Diptych, acrylic on canvas, 6½ × 8′6½″ × 4′. Collection Dr. Peretz; Collection Morganelli, Heumann and Associates.

3.4. Valerie Jaudon, *Jackson,* 1976. Oil on canvas, 72 × 72″. Holly Solomon Gallery, New York.

3.5. Robert Kushner, *Slavic Dancers,* 1978. Acrylic on cotton, 119 × 240″. Holly Solomon Gallery, New York.

3.6. Lucas Samaras, *Reconstruction #52,* 1979. Sewn fabrics, 79½ × 87″. The Pace Gallery, New York.

3.7. Philip Guston, *Feet on Rug,* 1978. Oil on canvas, 80 × 104″. David McKee Gallery, New York.

3.8. Susan Rothenberg, *Nonmobilizer,* 1974. Acrylic on canvas, 66 × 75¾″. Willard Gallery, New York. Photograph: Eric Pollitzer.

3.9. Nicholas Africano, *The Cruel Discussion,* 1977. Acrylic, wax, and oil on canvas, 73 × 90″. Holly Solomon Gallery, New York.

3.10. Neil Jenney, *Cat and Dog,* 1970. Acrylic on canvas, 58 × 117″ (including frame). Private collection, New York.

3.11. Jennifer Bartlett, *Rhapsody,* 1975–76. Baked enamel and silkscreen grid on 16-gauge steel, enamel overall, 7′6″ × 153′9″; 988 plates of 12 × 12″. Paula Cooper Gallery, New York. Photograph: Geoffrey Clements.

3.12. Pat Steir, from the *Brueghel* series, 1983–84. Oil on canvas, 84 panels, each 27 × 22″. Courtesy Michael Klein, Inc.

3.13. Frank Stella, *Shāma,* 1979. Mixed media on aluminum, 78 × 125 × 34⅝″. M. Knoedler & Co., Inc., New York.

3.14. Sam Gilliam, *Autumn Surf,* 1973. Polypropylene, 150 yards; interior space, 30 × 60′. San Francisco Museum of Modern Art. Photograph: Paul Hoffman.

3.15. Helen Frankenthaler, *Savage Breeze,* 1974. Woodcut from 8 lauan mahogany plywood blocks, hand cut by the artist; printed in white, lime green, mauve, yellow, dark green, and orange on 2 laminated sheets of 31½ × 27″ Nepalese handmade paper. Published in 1974 by Universal Limited Art Editions, West Islip, N.Y.

3.16. Jim Dine, *Six Hearts,* 1970. Lithograph offset from 6

zinc plates; printed in 6 colors on sheet of 30 × 22″ Crisbrook Waterleaf paper with collage, spray painting, and hand painting in tempera by the artist after editioning. Published by Petersburg Press, London.

3.17. Robert Mapplethorpe, *Ajitto, Right,* 1980. Gelatin silver print, 16 × 20″. Robert Miller Gallery, New York.

3.18. John Baldessari, *Concerning Diachronic/Synchronic Time: Above/On/Under (with Mermaid),* 1976. Six parts, each 9⅝ × 13⅞″.

3.19. Bernhard and Hilla Becher, *Winding Towers,* 1976–82. Courtesy Sonnabend Gallery. Photograph: Zindman/Fremont.

3.20. Sandy Skoglund, *Revenge of the Goldfish,* 1981. Installation, Castelli Graphics, New York.

3.21. Joel-Peter Witkin, *The Wife of Cain,* 1981, New Mexico. Copyright © Joel-Peter Witkin. Courtesy Pace/MacGill Gallery, New York, and Fraenkel Gallery, San Francisco.

3.22. Cindy Sherman, *Untitled Film Still,* 1979, 10 × 8″. Metro Pictures, New York.

3.23. Joel Meyerowitz, *Porch, Provincetown,* 1977. Color print. Courtesy of the artist.

3.24. Alice Aycock, *Maze,* 1972. Gibney Farm, New Kingston, Pa.

3.25. Mary Miss, *Sunken Pool,* 1974. Connecticut.

3.26. Charles Simonds, *Dwelling,* 1976. Earth, sticks, and stones on roof of P.S. 1, Long Island City, N.Y. Courtesy P.S. 1.

3.27. Beverly Pepper, *Perazim II,* 1975, 8 × 18 × 8′. Courtesy André Emmerich Gallery, New York.

3.28. Robert Stackhouse, *Running Animals/Reindeer Way,* 1976. Max Hutchinson Gallery, New York.

3.29. Jon Borofsky, installation, 1980. Paula Cooper Gallery, New York.

3.30. Judy Pfaff, *Kabuki (Formula Atlantic),* detail, February 12–May 3, 1981. Installation, "Directions 1981," Hirshhorn Museum and Sculpture Garden, Smithsonian Institution, Washington, D.C.

3.31. Nancy Graves, *Fenced,* 9/1985. Bronze and steel with polyurethane paint, 98 × 32½ × 62″. Collection Mr. and Mrs. Roy S. O'Connor. Courtesy M. Knoedler & Co., Inc., New York. Photograph: Ken Cohen.

3.32. Tony Cragg, *Black and White Stack,* 1980. Mixed materials. Courtesy Lisson Gallery, London.

3.33. Robert Arneson, *California Artist,* 1982. Stoneware with glazes, 68¼ × 27½ × 20¼″. San Francisco Museum of Modern Art, Gift of the Modern Art Council. Photograph: Don Myer.

3.34. Jackie Winsor, *Four Corners,* 1972. Wood, hemp, 27 × 48 × 48″. Allen Memorial Art Museum, Oberlin College. Courtesy Paula Cooper Gallery, New York.

3.35. Judy Chicago, *The Dinner Party,* 1979.

3.36. Hugh Stubbins and Associates, Citicorp Center, New York, 1973–78.

3.37. I. M. Pei & Partners, East Building, addition to the National Gallery, Washington, D.C., 1968–78.

3.38. Renzo Piano and Richard Rogers, Centre National d'Art et de Culture Georges Pompidou, Paris.

3.39. John Burgee Architects, American Telephone and Telegraph Corporate Headquarters (two views), New York, 1978–83. Photograph (skyline view): Richard Payne.

3.40. Charles Moore, Piazza d'Italia, New Orleans, 1975–80.

3.41. Michael Graves, Public Services Building, Portland, Oregon, 1978–82. Official city of Portland, Oregon, photograph.

3.42. Richard Meier, Douglas House, Harbor Springs, Mich., 1971–73. Copyright © 1974 Ezra Stoller, Esto Photographics, Inc.

3.43. Ricardo Bofill, Spaces of Abraxas, Marne-la-Vallée, France, 1978–82. Courtesy Ricardo Bofill/Taller de Arquitectura, Barcelona. Photograph courtesy Max Protetch Gallery, New York.

3.44. Hans Hollein, Austrian Travel Bureau, Vienna.

3.45. Arata Isozaki, Fujimi Country Club, near Oita, 1972–74.

3.46. Maples-Jones Associates, SITE Projects, Inc., Indeterminate Facade Showroom, Almeda-Genoa Shopping Center, Houston, 1975.

3.47. Vito Acconci, *Trademarks,* 1970. Activity. Photograph courtesy Sonnabend Gallery, New York.

3.48. Gilbert and George, *The Singing Sculpture,* 1971. Performance. Courtesy Sonnabend Gallery, New York.

3.49. Laurie Anderson, *Duets on Ice* (two views), 1975. Courtesy Institute of Contemporary Art, University of Pennsylvania, Philadelphia.

3.50. Ed Emshwiller, *Sunstone,* 1979.

3.51. Richard Voss, *Fractal Planetrise.* Richard F. Voss/IBM Research.

IV. Searching for Heroes: The 1980s

4.1. Georg Baselitz, *The Brücke Choir* (Brückechor), 1983. Oil on canvas, 109 × 175½″. Emily and Jerry Spiegel Collection. Courtesy Mary Boone Gallery, New York. Photograph: Zindman/Fremont.

4.2. A. R. Penck, *Am Fluss (Hypothèse 3),* 1982. Dispersion on canvas, 102⅜ × 137½″. Private collection. Courtesy Sonnabend Gallery, New York.

4.3. Anselm Kiefer, *Osiris und Isis,* 1985–87. Diptych, mixed media on canvas, 150 × 220¼ × 6½″. San Francisco Museum of Modern Art, purchased through a gift of Jean Skin, by exchange, the Mrs. Paul L. Wattis Fund and the Doris and Donald Fisher Fund. Photograph: Ben Blackwell.

4.4. Francesco Clemente, *The Fourteen Stations, No. VII,* 1981–82. Oil on canvas, 78 × 90″. Gagosian Gallery, New York.

4.5. Sandro Chia, *The Idleness of Sisyphus,* 1981. Oil on canvas in two parts, overall 10′2″ × 12′8¼″. The Museum of Modern Art, New York, acquired through the Carter Burden, Barbara Jakobson, and Saidie A. May Funds and purchase.

4.6. Enzo Cucchi, *Vitebsk-Harar,* 1984. Oil and polyurethane on canvas, 141 × 187¾″. Courtesy Sperone Westwater Gallery, New York. Photograph: Dorothy Zeidman.

4.7. Julian Schnabel, *King of the Wood,* 1984. Oil and bondo with plates and bronze casting of spruce roots, 10 × 19½″. Courtesy The Pace Gallery, New York. Photograph: Phillips/Schwab.

4.8. Robert Longo, *All You Zombies (Truth Before God),* 1986. Cast bronze, mechanized steel pedestal; aluminum; acrylic, charcoal, and graphite on canvas, 167½

× 195 × 177½″. Metro Pictures, New York. Photograph: Bill Jacobson Studio.

4.9. Eric Fischl, *Bad Boy*, 1981. Oil on canvas, 66 × 96″. Saatchi Collection, London. Courtesy Mary Boone Gallery, New York. Photograph: Zindman/Fremont.

4.10. Leon Golub, *Interrogation II*, 1980–81. Acrylic on canvas, 304.8 × 426.7 cm. Copyright © 1990 The Art Institute of Chicago, Gift of the Society for Contemporary Art, 1983.264. All Rights Reserved.

4.11. David Salle, *Intact Feeling*, 1984. Acrylic, oil on canvas, wood, 120 × 84″. Private collection. Courtesy Mary Boone Gallery, New York. Photograph: Zindman/Fremont.

4.12. Keith Haring, one-man show, December 1983–January 1984, installation view. Tony Shafrazi Gallery, New York. Photograph: Ivan Dalla Tana.

4.13. Kenny Scharf, *When the Worlds Collide*, 1984. Oil and enamel spray paint on canvas, 10′2″ × 17′5″. Tony Shafrazi Gallery, New York. Photograph: Ivan Dalla Tana.

4.14. Jean-Michel Basquiat, *Untitled*, 1981. Acrylic and oil stick on wood, 6′ × 4′. Courtesy Annina Nosei Gallery. Photograph: D. James Dee.

4.15. Jasper Johns, *Summer*, 1985. Encaustic on canvas, 75 × 50″. Copyright © Jasper Johns/VAGA, New York, 1990. Photograph: Copyright © Dorothy Zeidman.

4.16. Komar and Melamid, *Evening at Bayonne*, 1988. Three panels: oil on canvas, black house paint, and brass leaf, 25 × 73⅞″. Private collection. Courtesy Ronald Feldman Fine Arts, Inc., New York. Photograph: D. James Dee.

4.17. Masami Teraoka, *Geisha and Fox, AIDS* series, 1988. Watercolor on BFK Rives, 14¾ × 25″.

4.18. Ross Bleckner, *Always Saying Goodbye*, 1987. Oil on linen, 48 × 40″. Collection Jewel Garlick, New York. Courtesy Mary Boone Gallery, New York. Photograph: Zindman/Fremont.

4.19. Tim Rollins and K.O.S. (Kids of Survival), *Amerika X*, 1986–88. Watercolor, charcoal, and bistre on book pages on linen, 60 × 175″. South Bronx. Courtesy Jay Gorney Modern Art, New York. Photograph: Ken Schles.

4.20. Meyer Vaisman, *In the Vicinity of History*, 1988. Process inks and acrylic on canvas, 96 × 172½ × 8½″. Sonnabend Gallery, New York.

4.21. Elizabeth Murray, *Cracked Question*, November 1987. Oil on 6 canvases, 13′5½″ × 16′2″ × 1′11½″. Courtesy Paula Cooper Gallery, New York. Photograph: Geoffrey Clements.

4.22. Peter Halley, *Red Cell*, 1988. Acrylic, Day-Glo acrylic, Roll-A-Tex on canvas, 82 × 128″. Collection Carroll Janis, Conrad Janis. Courtesy Sonnabend Gallery, New York.

4.23. April Gornik, *Flood at Twilight*, 1990. Oil on linen, 68 × 84″. Edward Thorp Gallery, New York. Photograph: Dorothy Zeidman.

4.24. Paul Sierra, *Three Days and Three Nights*, 1985. Oil on canvas, 44 × 60″. Collection the artist. Courtesy Robert Berman.

4.25. Eric Bulatov, *Sky-Sea*, 1984. Oil on canvas, 79 × 79″. Photograph courtesy Phyllis Kind Gallery, New York.

4.26. Frank Stella, *Pergusa Three*, from the *Circuits* series, 1982. Woodcut relief print, 60 × 48″. Walker Art Center, Minneapolis/Tyler Graphics Archive. Copyright © Frank Stella/Tyler Graphics Ltd, 1983.

4.27. Sherrie Levine, *Untitled (After Walker Evans: 2)*, 1981. Photograph, 8 × 10″. The Menil Collection, Houston. Courtesy Mary Boone Gallery, New York.

4.28. Richard Prince, *Tell Me Everything*, 1986. Ektacolor print, 86 × 48″. Courtesy Barbara Gladstone Gallery, New York.

4.29. Barbara Kruger, *You Are Not Yourself*, 1983, 72 × 48″. Courtesy Mary Boone Gallery, New York.

4.30. James Welling, *Untitled*, 1980. Silver print, 4½ × 3½″. Jay Gorney Modern Art, New York.

4.31. Starn Twins, *Double Mona Lisa with Self-Portrait*, 1985–88, 107 × 160″. Courtesy Stux Gallery, New York.

4.32. Nicholas Nixon, *Tom Moran and His Mother, Catherine*, August 1987. Gelatin silver print, 8 × 10″, no. 1 in a series of 12. Courtesy Zabriskie Gallery, New York. Copy photograph: D. James Dee.

4.33. John Coplans, *Self-Portrait (Side Torso Bent with Large Upper Arm)*, 1985. Galerie Lelong, New York. Copyright © John Coplans, 1985.

4.34. Nancy Burson, *Untitled*, 1988, 24 × 20″.

4.35. Thomas Ruff, *Portrait*, 1988, 82¾ × 65″. Courtesy Museum of Fine Arts, Boston, Ernest Wadsworth Longfellow Fund.

4.36. Martin Puryear, *The Spell*, 1985. Pine, cedar, and steel, 56 × 84 × 65″. Photograph courtesy Donald Young Gallery, Chicago.

4.37. Joel Shapiro, *Untitled*, 1984. Bronze. The Saint Louis Art Museum, Gift of Mr. and Mrs. Barney A. Ebsworth.

4.38. Bryan Hunt, *Prodigal Son, Barcelona* series, 1985. Cast bronze on limestone base, 89 × 26⅝ × 23½″, edition of 4. Blum Helman Gallery, Inc., New York.

4.39. Rodney Alan Greenblat, *The Guardian*, 1984. Acrylic and mixed media, 26 × 20 × 9″. Gracie Mansion Gallery, New York.

4.40. Harold Tovish, *Region of Ice*, 1984. Mixed media, 34 × 79 × 60″.

4.41. Haim Steinbach, *Generic Black and White #2*, 1987, 26¾ × 74 × 12¾″. Jay Gorney Modern Art, New York.

4.42. Jeff Koons, *Michael Jackson and Bubbles*, 1988. Porcelain, 42 × 70½ × 32½″, edition of 3. Sonnabend Gallery, New York.

4.43. Richard Serra, *Tilted Arc*, 1981, New York. Cor-Ten steel, 12′ × 120′ × 2½′. Copyright © Richard Serra/VAGA, New York, 1990.

4.44. Vietnam Veterans Memorial, Washington, D.C., 1980–82. Designed by Maya Ying Lin.

4.45. Susana Solano, *Fa El 8*, 1989. Iron and marble, 48½ × 94¾ × 40½″. Courtesy Donald Young Gallery, Chicago. Photograph: Michael Tropea.

4.46. Gilberto Zorio, *Stella (per purificare le parole)*, 1980. Terra cotta, metal, 440 cm. square. Sonnabend Gallery, New York. Photograph: Alan Zindman.

4.47. Frank Gehry, Norton House, Venice, Calif., 1983. Photograph: Copyright © Tim Street-Porter/Esto.

4.48. Peter Eisenman, Wexner Center for the Visual Arts, Ohio University, 1989. Photograph: Copyright © Jeff Goldberg/Esto.

4.49. Norman Foster and Associates, Hong Kong and Shanghai Bank, 1979–84.

4.50. I. M. Pei, addition to the Louvre, Paris, 1989. Photograph: Serge Sautereau.

4.51. Skidmore, Owings & Merrill, Haj Terminal, Jidda, Saudi Arabia.

4.52 Kenneth Knowlton, *Charlie Chaplin*, 1983.

4.53. Joseph Nechvatal, *The Informed Man*, 1986. Computer/robotic assisted acrylic on canvas, 82 × 116″. Collection The Dannheiser Foundation. Courtesy

Brooke Alexander, New York. Photograph: Ivan Dalla Tana.

4.54. Jennifer Holzer, "Laments," March 2, 1989–Winter 1990, installation at Dia Art Foundation, New York. Photograph: Bill Jacobson Studio.

4.55. John Sanborn, *Luminaire*, 1986.

4.56. Teri Yarbrow, from *Atomic Dreams*, 1987.

4.57. Max Almy, from *Perfect Leader*, 1983.

COLOR PLATES

Plate 1. Mark Rothko, *Orange and Yellow*, 1956. Oil on canvas, 91 × 71″. Albright-Knox Art Gallery, Buffalo, New York, Gift of Seymour H. Knox, 1956.

Plate 2. Morris Louis, *Point of Tranquillity*, 1959–60. Magna on canvas, 101¾ × 135¾″. Hirshhorn Museum and Sculpture Garden, Smithsonian Institution, Washington, D.C., Gift of Joseph H. Hirshhorn, 1966.

Plate 3. Karel Appel, *Personnage*, 1961. Oil on canvas, 77 × 51″. Michelle Rosenfeld, Inc., Fine Arts, New Jersey.

Plate 4. Janet I. Fish, *Raspberries and Goldfish*, 1981. Oil on canvas, 72 × 64″. The Metropolitan Museum of Art, New York, Purchase, The Cape Branch Foundation and Lila Acheson Wallace Gifts, 1983.

Plate 5. Frank Stella, *Shāma (#10, 5.5x)*, 1979. Mixed media on aluminum, metal tubing, and wire mesh,

6′6″ × 10′5″ × 34⅝″. (Indian Bird Series.) Collection Diane and Steven Jacobsen, Courtesy of M. Knoedler & Co., Inc., New York.

Plate 6. Jim Dine, *Fourteen Color Woodcut Bathrobe*, 1982. Woodcut from two 65½-×-35½″ plywood blocks, printed once in 13 colors from sawn block and once in black, Paper 76 × 42 Rives BFK, Edition: 75, plus 15 AP, 4 PP. Printed by Garner Tullis, Experimental Printmaking Workshop, San Francisco. Published by Pace (193–120).

Plate 7. William Eggleston, *Memphis Tennessee*, 1972.

Plate 8. Nancy Graves, *Acordia*, 1982. Bronze with polychrome patina, 92¼ × 48 × 23½″. Private Collection, Courtesy of M. Knoedler & Co., Inc., New York.

Plate 9. Michael Graves, The Portland Building, Portland, Oregon. Photograph: Pascahll/Taylor.

ACKNOWLEDGMENTS

ACKNOWLEDGMENTS are sometimes difficult in a book of this sort, which contains such varied materials from sources as diverse as spontaneous conversations with friends and colleagues, questions and comments from students over the years, and formal primary and secondary sources from a variety of libraries. Instead of giving a long list of specific thank-yous, I'd like to particularly thank the staff members of the Bradford College and Andover public libraries, as well as staff members of various museums and galleries from which illustrations and other sources were obtained. To friends and family members, who encouraged and helped me during the process of writing the book, thank you. And to my children, Kristen, Geoffrey, and Ashley, a special thanks and continuing apology for the time I had to take from you to finish this project. May your own creative and artistic spirits continue to thrive and inspire those around you. Finally, a thank-you to my editor, Cass Canfield, Jr., for his enthusiasm and support for this book.

PREFACE

SINCE World War II experiments and changes in the visual arts have been many and varied. As J. Robert Oppenheimer wrote, "One thing that is new is the prevalence of newness, the changing scale and scope of change itself, so that the world alters as we walk in it, so that the years of man's life measure not small growth, or rearrangement or moderation of what he learned in childhood, but a great upheaval."[1] Since 1945 the power of the artist and art work has had increasing significance on both the individual viewer and culture at large. This book seeks to chronicle and elucidate some of the vast changes in the visual arts since 1945, with the premise that, as citizens of the twentieth century, it is important for us to attempt to understand the art of our times, in order to be equipped to deal with questions and issues of art and culture in the future. The story of the visual arts since 1945 is a complex one—a tapestry woven of artists, art works, critics, scholars, the general public, and the marketplace. Included here are samples of all of these threads and the interaction of these strands. The numerous and varied quotations are here in order that the actual voices of the artists, critics, and others be more clearly heard and understood. The division of the book into chronological and media divisions is not meant to set up hard-edge boundaries and boxes but is simply one possible method of organization. Indeed the evolution of the visual arts since 1945 has been toward increasing openness of form and content, and toward a breaking down of boundaries between traditional media of the visual arts and between the visual arts and other art forms. And of course, artists may be at work both before and after the time in which they are presented here. In a book of this type and length, it is impossible to include all of what has happened since 1945 and impossible to discuss in depth any one artist's development. Those artists and works selected to appear here are intended to be representative examples of larger trends and issues. The cast of characters is meant to provide a balance of male and female artists on an international level, as well as representative samples of significant work from areas mentioned less frequently than the United States and Europe. Since the center of "the art world" until recent years was seen as New York, beginning with the rise of the Abstract Expressionist, many of the artists here, selected for discussion, are from the United States.

In the last few years much of the publicity involving the visual arts has revolved about money and economics. For some, art has become simply an investment and/or a commodity. There have been record market prices,

such as Jasper Johns's *False Start* selling for $17 million, a record for a living artist, and Andy Warhol's *Marilyn (20 Times)* selling for $3.9 million, a Pop art record. But beyond the marketplace and the form, there is a spirit inherent in works of art of significance—a spirit that may be alien and unfamiliar, that may provoke questions of a deep contemplation, that may provide a space of inner repose. It is this changing and evolving spirit, inherent in a variety of visual arts experiments created in the years since 1945, that this book seeks to at least partially illuminate. For in the end, beyond the text, there must be a private dialogue between the art work and the viewer, which may remain unspoken.

The roles artists have assumed since 1945 have been diverse, from iconoclast of traditional art forms, materials, and methods to political and social critic, celebrity, and aesthete. There have been thrusts toward "art for art's sake," as well as thrusts toward a complete integration of art and life.

There are no set boundaries and rules anymore for making or judging a work of art, which makes the task of understanding the diversity of work done in the visual arts since 1945 all the more difficult. This volume intends to make clear the importance of the visual arts since 1945 in their reflection of, and challenge to, our times, pointing to multiple levels of meaning and multiple realities in our complex world. For as the Spanish artist Antoni Tàpies noted, "The artist will always be part of life and change. His task, in my view, is not purely receptive. He is not, as some say, a simple reflection of his time. I am more inclined to believe that the role of the artist can be an active one and that with others he has it in his hands to modify our concept of reality."[2] And further, Mark Rothko wrote, "Today, the artist is no longer constrained by the limitation that all man's experience is expressed by his outward appearance. Freed from the need of describing a particular person [or object or event], the possibilities are endless."[3] It is hoped that this book may stand as testament for the potential, and creative spirit, of these "endless possibilities," and as inspiration for future artistic and critical inquiry, and experimentation.

KATHERINE HOFFMAN
Andover, Massachusetts, Spring 1989

NOTES: PREFACE

1. J. Robert Oppenheimer, cited in Richard Marshall, ed., *Great Events of the Twentieth Century* (Pleasantville, N.Y.: Reader's Digest Association, 1977), cover.
2. Antoni Tàpies, cited in Roland Penrose, *Tàpies* (New York: Rizzoli, 1979), reprinted in Dore Ashton, ed., *Twentieth Century Artists on Art* (New York: Pantheon Books, 1985), p. 182.
3. Mark Rothko, cited in Dore Ashton, *About Rothko* (New York: Oxford University Press, 1983), reprinted in Dore Ashton, ed., *Twentieth Century Artists on Art*, p. 247.

I

TOWARD NEW ROUTES:
1945–1960

THE YEAR WAS 1945, a year that was rocked by physical and metaphysical explosions. It was the beginning of experiments, changes, and explosions that were to have a far-reaching effect on all spheres of a global society. On April 30, 1945, Hitler committed suicide. On May 8 the Allied forces jubilantly celebrated VE Day, ending World War II in Europe. The Allied Control Commission divided Germany into four zones, and Berlin was occupied by three powers. On August 6, 1945, the United States dropped an atomic bomb on Hiroshima. On August 9 a second bomb was dropped, on Nagasaki. With the surrender of Japan came the end of World War II, on August 14. In the same year Franklin Delano Roosevelt died, Mussolini was killed, and De Gaulle was elected president of the French provisional government. The Independent Republic of Vietnam was formed, with Ho Chi Minh as president.

Like the political world, the art world, too, was to embark on a journey of turbulent and tumultuous changes, which would be both harbinger and reflector of changes in the world at large. As the postwar years unfolded, the very nature of art and the role of the artist were to be questioned and reformulated in ways that would shake traditional perceptions and illusions.

The late forties and the fifties were a time of transition. Despite the end of World War II, political conflicts continued to disturb balances of power. Politically, the fifties began and ended with turmoil, with the outbreak of the Korean War in 1950 and with a revolution in Cuba and the rise to power of Fidel Castro in 1959. In between, events such as the death of Stalin and the emergence of Nikita Khrushchev, the fall of Dien Bien Phu in Vietnam, the "Red Scare" and McCarthy trials in the United States, the execution of Julius and Ethel Rosenberg, the declaration of school segregation as unconstitutional, the launching of Sputnik I by the U.S.S.R. and the beginning of outer space exploration, were to alter traditional views and perceptions. The threat of atomic and nuclear war loomed further as the first hydrogen bomb was exploded in 1952. Bomb shelters were built in suburban backyards. There seemed to be marks of continuing political change from the late forties onward. In 1948 Gandhi was assassinated, the same year that the Marshall Plan was approved by the U.S. Congress for U.S. aid to Europe. In 1949 the communist People's Republic in China was proclaimed under Mao Zedong. East and West Germany were established as separate republics that same year. The Algerian War began in 1954. In 1956 the Suez Canal crisis occurred and Soviet troops invaded Hungary to quickly crush rebellion against So-

viet domination. The European Common Market was established in 1957.

In the sciences there were a number of important discoveries and explorations. The xerography process was discovered in 1946. That same year Admiral R. E. Byrd led an expedition to the South Pole, and a pilotless rocket missile was constructed by Fairley Aviation Company. In 1947 Bell Labs invented the transistor. Mount Everest was climbed for the first time in 1953 by Edmund Hillary and Tenzing Norgay. In 1954 Jonas Salk's polio vaccine was used in a mass immunization of Pittsburgh school children. In 1958 NASA, the National Aeronautics and Space Administration, was formed in the United States. The spirit of exploration was firmly established.

In literature works such as J. D. Salinger's *Catcher in the Rye*, Allen Ginsberg's *Howl*, Jack Kerouac's *On the Road* explored the adolescent, the individual traveler; and Ginsberg and Kerouac marked the beginning of the "beat" generation. Samuel Beckett wrote *Waiting for Godot*; Arthur Miller wrote *Death of a Salesman* and *The Crucible*; Ernest Hemingway wrote *Old Man and the Sea*; Vladimir Nabokov wrote *Lolita*, Simone de Beauvoir wrote *The Second Sex*; and Paul Tillich wrote *The Courage to Be*. In music the German composer Karlheinz Stockhausen experimented with electronic sounds and developed a system of notation for them. John Cage wrote his well-known *4′3″* in 1952. Rock 'n' roll and Elvis Presley blared as American youth found their own music. Filmmakers sought a new independence, as François Truffaut made his *Four Hundred Blows*, Godard, *Breathless*, and Fellini, *La Strada*.

Some have looked back on the fifties as an uncreative and unidealistic period, where, particularly in the United States, conformity reigned. One often conjures up images of carbon-copy suburbs, of *Leave It to Beaver* and *Father Knows Best* families, of TV dinners (by 1954 29 million U.S. homes had television), and poodle skirts. But in the arts there was a sense of a growing distance between the artist and the larger mainstream of society. It was a time that marked the beginnings of aesthetic revolutions everywhere. Those beginnings will be traced in the following pages.

PAINTING, 1945–1960

DURING World War II and the decade following, the themes of war and its refuse were echoed in the works of a number of artists. Artists who had come of age and prominence in the earlier part of the century—such as Max Ernst, Picasso, Max Beckmann, and Ben Shahn—made powerful works showing the anguish and impact of the war years that could not be easily erased or forgotten. Other artists, who were at later stages in their careers, continued ideas and forms of earlier work.

Picasso, who had spent the war years in France, completed his *Charnel House* in 1945, which, like his masterful 1934 *Guernica*, was painted entirely in blacks, grays, and whites and communicated the anguish of war through the disarray and entanglement of body parts and features. Max Ernst, using his technique of decalcomania, enabling him to build up a rich surface, responded to the devastation of war in his *Europe after the Rain*, 1941–42, where an apocalyptic landscape appears in a charred and mysterious jungle. Jacob Lawrence, a black artist, painted *War Series, No. 6*, 1947, where the strong, stark, flattened form of a woman bending over a dreaded large "white letter" documents the burden of human grief. Ben Shahn's *Liberation*, 1945, although clearly depicting the rubble of glutted war zones, casts a ray of hope for the future as three young children swing playfully through the picture plane in a classic triangle of tradition and order.

A number of artists dealt with the crucifixion image as symbol of desolation and defeat. About 1945 Francis Bacon, the Irish-born British artist, made a series of evocative and unorthodox studies on the theme of the crucifixion, climaxing in his *Magdalene*, 1945–46. The complementary blue and orange tones in the piece accentuate the grief of the wailing, bent over figure, whose head is like that of a tortured animal. Bacon was influenced by old masters as diverse as Giotto and Van Gogh in creating his powerful, figurative expressionist pieces, which have continued to develop themes seen in the crucifix series—the monstrous, the deformed, violence, and victimization. Bacon is also noted for a series of studies of a pope, after Velázquez's *Portrait of Pope Innocent X* in the Doria Gallery in Rome. The figure of the pope is usually shown in some type of trapped situation with his mouth open in a scream or shout. The disturbing juxtaposition of an ecclesiastical figure between two bloody sides of beef in his *Head Surrounded by Sides of Beef (Study after Velázquez)* [1.1] suggests a world turned upside down, as the blood reds and regal purples vie with each other on the picture plane. It seems no mistake that the dark "negative space" above the pope's head is in

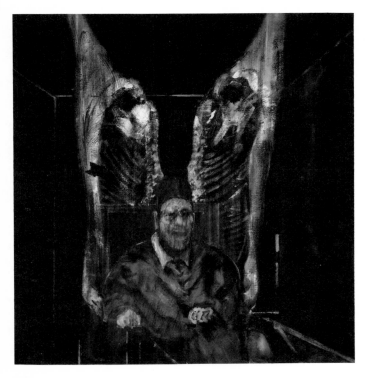

1.1. Francis Bacon, *Head Surrounded by Sides of Beef*, 1954. The Art Institute of Chicago.

the shape of a chalice and pushes and pulls with the sides of beef.

In 1946 the English painter Graham Sutherland was commissioned to paint a crucifixion for the Church of St. Matthew in Northampton. Sutherland looked to Grünewald's sixteenth-century Isenheim altarpiece for inspiration and created his own expressionistic agony in his large frontal (ninety-by-ninety-six-inch) image of *Christ on the Cross.*

Similar in subject but different in style from Bacon and Sutherland was the work Henri Matisse created in his *Stations of the Cross,* 1948–51, for the Dominican Chapel of the Rosary in Venice. Gone were the lush colors and patterns of the young Matisse—replaced instead by a black and white linear asceticism, inherent in the glazed ceramic tiles painted with black outlines.

Interpretations of the figure were, in general, few in the immediate postwar years, as artists began to search for new content and form to deal with a world turned upside down by the ravages of war and changes in cultures. In an art world that increasingly emphasized abstraction, there were, however, some exceptions. One was the work of Andrew Wyeth. His 1948 *Christina's World,* showing a young polio victim crawling toward her old New England farmhouse through an expansive field of browning grasses, may be seen as a symbol of the postwar individual groping for but unable to reach easily a firm base or past. The odd angles of the painting, along with Wyeth's painstaking and immaculate tempera techniques, which illustrate every detail and blade of grass, increase the impact of the piece.

Another artist grappling with figurative elements in a realistic mode was Alex Colville of Canada. Colville, unlike Wyeth, was influenced by Surrealism, jolting the viewer with unexpected juxtapositions of images and angles. In

many of his works there is an apprehension of disaster, as in his *Horse and Train* of 1954 [1.2]. The painting was based on two lines from a poem, "Dedication to Mary Campbell" by the South African writer Roy Campbell, whom Colville had met during Campbell's lecture tour in Canada. The poem and the painting pit the human and emotional, represented in the wildness and naturalness of the horse, against the inhuman, the mechanical, massive force. Although there is a sense of impending doom in the piece, the dark horse or individual appears undisturbed by the oncoming train. The unknown looms before the horse and the viewer as well, since there is no single reading of the painting. The narrative suggested in the paint-

ing may be played out in a variety of ways, and therein lies much of its power, this suspension between imagination and reality, for the setting is "real," at Aulac just outside of Sackville, where the elevated track crosses the Tantramar marshes. It was reported that Colville stood beside the track one night as the train approached in order to capture the scene in his mind.

Combining realistic figurative elements and abstraction, Fernand Léger, in the same year that Colville painted *Horse and Train,* painted what some consider his final masterpiece, *The Great Parade* [1.3], a year before his death. For this piece, Léger did scores of preliminary and preparatory drawings, watercolors, gouaches,

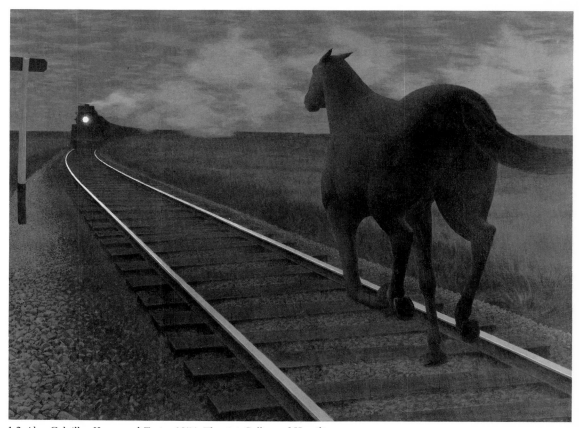

1.2. Alex Colville, *Horse and Train,* 1954. The Art Gallery of Hamilton.

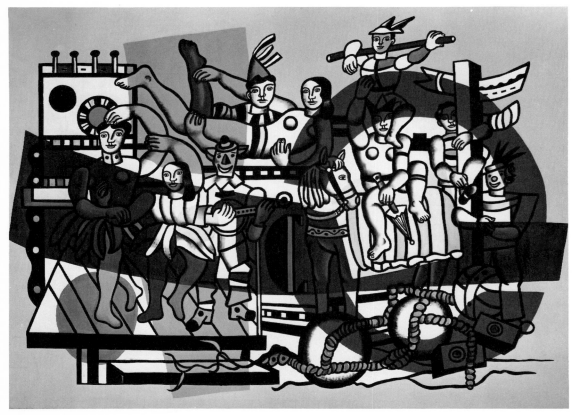

1.3. Fernand Léger, *The Great Parade*, 1954. Solomon R. Guggenheim Museum, New York.

and canvases, and included a number of themes and forms that had appeared in earlier cycles such as *The Divers, The Cyclists, The Constructors,* and *The Country Outing.* The figures are at once real and abstract and are enhanced by the broad, flat color areas of three primary and two secondary hues that are in contrast to the black lines of the figures. The centrally placed *C* refers to "cirque" as the main subject of the painting. This is a parade and a world of harmony, unlike the disturbing stillnesses of a Colville or Wyeth. One may ask whether this is the view of an artist in his later years at one with his work and his world or an escape from the actual characters of an everyday world.

The figurative work of Balthus, who after his discharge from the French army settled in Switzerland, combined a classical calm inherent in his figures and composition with a sense of anxiety and decadence. Balthus, or Balthus Klossowski de Rola, as he was named, had been enthusiastically encouraged as a young man by the poet Rainer Maria Rilke. As a young artist he had also copied frescoes by Piero della Francesca. Balthus's enigmatic and dreamlike situations, such as his *Golden Days (Les Beaux Jours)* [1.4], struck at the confused anxieties of a postwar Europe.

The first major new art movement to emerge after World War II was American Abstract Expressionism, which for some was the

first major new movement to begin in the United States. As artists searched for new heroes in a changing world, they began a journey inward to explore new content, processes, and new materials. The "traditional" abstraction of the early part of the century, they thought, was too cold, and American Scene painting was too localized and provincial. The large, vibrant, and active forms and techniques of what was to be called Abstract Expressionism seemed more relevant. The story of Abstract Expressionism is a complex intertwining of personalities—artists and critics—formal experiments, and philosophical and aesthetic journeys into a raw and unexplored interior. The artists included Jackson Pollock, Lee Krasner, Willem and Elaine de Kooning, Mark Rothko,

Clyfford Still, Barnett Newman, Adolph Gottlieb, William Baziotes, Hans Hofmann, and Robert Motherwell.

The roots of Abstract Expressionism may be traced back partly to the Surrealists. During the war a number of major Surrealist artists and writers—including André Breton, founder of the movement, Max Ernst, Salvador Dali, Masson, Tanguy, and Matta—had come to the United States. The Surrealist practice of automatism, whereby imagery developed out of a type of stream of consciousness and doodling, became an important technique for artists such as Pollock, de Kooning, Motherwell, Baziotes, and Gorky. Arshile Gorky, born in Armenia but brought to the United States as a child, was probably the only one of the future Abstract

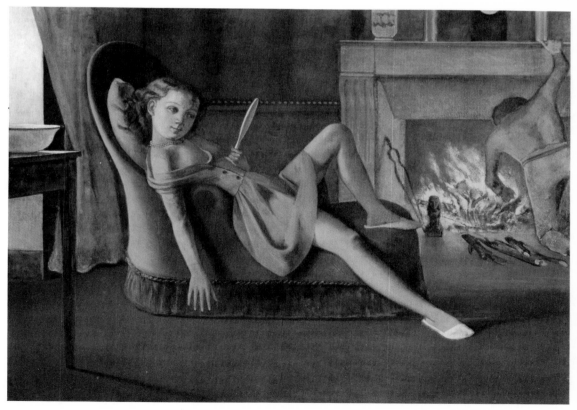

1.4. Balthus, *Golden Days (Les Beaux Jours)*, 1944–49. Hirshhorn Museum and Sculpture Garden, Washington, D.C.

WPA

Expressionists to become closely associated with the Surrealists. The center of Surrealism in New York was Peggy Guggenheim's Art of This Century Gallery on West Fifty-seventh Street. Guggenheim's avid interest in modern art had been influenced by Herbert Read and Marcel Duchamp. She had bought a large collection in Paris and managed to get her collection to America as the Germans prepared to advance into France. Shortly after Pearl Harbor she married Max Ernst, and she formally opened her gallery in October 1942, with a room for Surrealism and one for abstract art. Her interests expanded to include American art and her important "Exhibition of Collage" and 1943 "Spring Salon" included works by Pollock, Baziotes, and Motherwell. At her assistant Howard Putzel's urging, Peggy decided to represent Mark Rothko and also signed a contract with Pollock, paying him $150 a month against any future commissions. Pollock was thus able to leave his custodian's job at Peggy's uncle's Museum of Non-objective Paintings (later the Guggenheim Museum). Pollock had his first one-man show with Peggy Guggenheim in 1943 and became a central attraction at the gallery. Upon seeing Pollock's 1945 show at Art of This Century Clement Greenberg called him "the strongest painter of his generation and perhaps the greatest one to appear since Miró."[1] Guggenheim gave four Americans their first one-man shows at Art of This Century: Baziotes, Hofmann, and Motherwell in 1944, and Clyfford Still in 1946. When World War II ended, a number of European artists went home. Guggenheim closed her gallery in 1947 and moved to Venice. (Max Ernst had run off with a young artist, Dorothea Tanning.)

The roots of Abstract Expressionism also lay in the Depression years. One of Franklin Roosevelt's efforts to counter the Depression was the Works Progress Administration's Federal Art Project, which created jobs and provided materials for artists. Many of the future Abstract Expressionists were employed by the project, including Gorky, Pollock, de Kooning, Rothko, Baziotes, Gottlieb, Philip Guston, and James Brooks. More important than the content of their work, which tended to be realistic at the time, was the spirit of community and solidarity that grew as these artists found and came to know each other. Following the WPA days many of the New York artists kept in touch with each other, meeting to view each other's work and to have long discussions about art, among other topics.

One gathering place was Hans Hofmann's studio and school on West Eighth Street. Hofmann, an artist and teacher who had settled in New York in 1932, had been in Paris between 1904 and 1914 before establishing a successful school in Munich. He was exposed to the major early twentieth-century art movements such as Fauvism, Cubism, and German Expressionism, and was influenced particularly by the work of Kandinsky. After devoting a number of years to drawing, Hofmann experimented with pouring and dribbling paint and with allowing uncorrected, brusque brushstrokes to remain on the canvas. Some of Hofmann's best-known abstractions were those begun in 1946, which included vibrantly colored, aggressively brushstroked, open areas, such as his *Blue Rhythm* of 1950 [1.5]. None of the major Abstract Expressionists formally studied with Hofmann, but they often dropped by his studio to hear his spontaneous lectures.

Also important in fostering solidarity among the artists was The Club. De Kooning, Kline, the sculptor Philip Pavia, and several others had met regularly at the Waldorf Cafeteria in the evenings, escaping from their cold-water studios. As more artists joined them, money was collected to rent a loft at 39 East Eighth Street. Activities expanded beyond informal discussions of topics such as Blake's transcendentalism, Albert Pinkham Ryder, Nietzsche, Kirkegaard, Sartre, and Camus, to more formal panel discussions, guest lecturers, and Sunday night gatherings with dancing and music. As de

1.5. Hans Hofmann, *Blue Rhythm*, 1950. The Art Institute of Chicago.

Kooning, one of the frequent visitors to The Club, or The Eighth Street Club, as it was sometimes called, commented, "Painting is a way of living, that is where the form of it lies."[2] A number of artists, particularly Pollock, also met at the Cedar Street Tavern on University Place, about a block away. The Cedar was a somewhat dingy neighborhood bar, but a place of intellectual security for the artists and a place where credit was often extended by the bartender if an artist was broke. Upon the invasion of a television set, the artists requested its removal to allow their conversations to continue uninterrupted.

What then came out of the cockroach-filled lofts, cold-water studios, and late evening discussions at various locales? A generation of painters who were to be called the heroic generation of Abstract Expressionists, the New York School, or "Action Painters" (Action Painting was coined by the critic Harold Rosenberg in 1951). There was not a formal program or clear-cut idea of what painting was to be; but there was a sense that traditional modes of visual expression were worn out and that new routes must be explored. It was a generation of pioneers, of risk takers, who rejected existing realist and geometric tendencies and were attracted to Surrealist content and the technique of automatism. The new routes were to involve journeys inward to the mind, inner mythologies, to the felt experience. As Robert Motherwell stated, "The need is for felt experience—intense, immediate, direct, subtle, unified,

warm, vivid, rhythmic."[3]

Many painters began to focus on the act of painting itself, on large gestures, on applying paint spontaneously, as Pollock became noted for in his large-scale drip paintings. Gradually the energies of the pivotal dark, smoke-filled rooms began to spread to a wider world. In 1943 the public stage had been somewhat set by a letter to Edwin Alden Jewell, *New York Times* art critic, signed by Mark Rothko and Adolph Gottlieb, who were enraged at a review of their paintings in the annual Federation of Modern Painters and Sculptors Show, in particular Rothko's *Syrian Bell* and Gottlieb's *Rape of Persephone.* Barnett Newman also assisted in the initial formulation of the letter. The letter may be seen as a type of aesthetic and moral creed.

No possible set of notes can explain our paintings. Their explanation must come out of a consummated experience between picture and onlooker. The point at issue, it seems to us, is not an "explanation" of the paintings, but whether the intrinsic ideas carried within the frames of these pictures have significance. We feel that our pictures demonstrate our aesthetic beliefs, some of which we, therefore, list:

1. To us art is an adventure into an unknown world, which can be explored only by those willing to take the risks.

2. This world of the imagination is fancy-free and violently opposed to common sense.

3. It is our function as artists to make the spectator see the world our way—not his way.

4. We favor the simple expression of the complex thought. We are for the large shape because it has the impact of the unequivocal. We wish to reassert the picture plane. We are for flat forms because they destroy illusion and reveal truth.

5. It is a widely accepted notion among painters that it does not matter what one paints as long as it is well painted. This is the essence of academicism. There is no such thing as good painting about nothing. We assert that the subject is crucial and only that subject matter is valid which is tragic and timeless. That is why we profess spiritual kinship with primitive and archaic art. Consequently, if our work embodies these beliefs it must insult anyone who is spiritually attuned to interior decoration; pictures for the home; pictures for over the mantel; pictures of the American scene; social pictures; purity in art; prizewinning potboilers; the National Academy, the Whitney Academy, the Corn Belt Academy; buckeyes; trite tripe, and so forth.[4]

Referring to themselves as Mythmakers, Rothko and Gottlieb made verbal and visual statements on the importance of myth and turned away from the Surrealists' illustration of dreams.

It is not enough to illustrate dreams. While modern art got its first impetus through discovering the forms of primitive art, we feel that its true significance lies not merely in formal arrangement, but in the spiritual meaning underlying all archaic works. . . . That these demonic and brutal images fascinate us today is not because they are exotic, nor do they make us nostalgic for a past which seems enchanting because of its remoteness. On the contrary, it is this immediacy of their images that draws us irresistibly to the fancies and superstitions, the fables of savages and the strange beliefs that were so vividly articulated by primitive man.[5]

Rothko wrote that his turning to myths, as in *Baptismal Scene,* was

because they are the eternal symbols upon which we must fall back to express basic psychological ideas. They are the symbols of man's primitive fears and motivations, no matter in which land or what time, changing only in detail but never in substance, be they Greek, Aztec, Icelandic or Egyptian. And our modern psychology finds them persisting still in our dreams, our vernacular and our art, for all the changes in the outward conditions of life.[6]

Entering the world of myth and embracing a wide range of feelings and experiences, including violence and brute force, were also ways to deal with the brutalities of World War II.

Pollock too saw himself as a mythmaker as is indicated to some extent in titles of some of

his early works, *Male and Female, Guardians of the Secret, Totem Lesson,* and *She-Wolf.* William Baziotes, Theodoros Stamos, and Hans Hofmann also dealt with mythic figures in the mid- and late forties. Ultimately the desire to create a "modern" mythic art led to abstraction. For as Rothko stated, "Our presentation of these myths, however, must be on our own terms, which are at once more primitive and more modern than the myths themselves—more primitive because we seek the primeval and atavistic roots of the idea rather than their graceful classical versions: more modern than the myths themselves because we must redescribe their implications through our own experience."[7]

These artists' public assertions appeared more strongly by 1947 with the publication of *Possibilities* by Robert Motherwell and Harold Rosenberg. The periodical contained statements by Pollock, Baziotes, Rothko, and David Smith, among others. There was no second issue. In 1948 when the Boston Institute of Modern Art changed its name to the Institute of Contemporary Art because it was felt the term "modern art" communicated little, a number of the New York School artists staged a well-publicized protest meeting at the Museum of Modern Art. In 1950 eighteen artists and ten sculptors sent a letter to the Metropolitan Museum of Art, which was planning an exhibit of current art, and accused the museum of being "notoriously hostile to advanced art."[8] The letter appeared on the front page of the *New York Times,* and shortly thereafter the exhibit "American Painting Today—1950" opened at the Metropolitan. *Life* magazine ran a photograph of eighteen artists, the "Irascibles." Although a number of the artists believed that their experimental and subjective works could benefit society at large, as the work challenged what was felt to be the stagnation and degeneration of the late forties and early fifties, the general public did not look to its artists for any real social authority. The most

enthusiastic supporters of the New York School, aside from the artists themselves, were artists in other fields, such as John Cage, Virgil Thompson, and Edgard Varèse in music; Merce Cunningham, Erik Hawkins, and Midi Garth in dance; Frank O'Hara, John Ashbery, and Barbara Guest in literature; and Charles Olson, Robert Creeley, and Joel Oppenheimer (associated with Black Mountain College) in poetry. A number of collaborations by artists in different fields also occurred.

The critics Harold Rosenberg and Clement Greenberg also supported the artists in their writings and theories. Tom Wolfe somewhat cynically asserts that perhaps the critics influenced the artists, rather than vice versa.

> Ah, the music was playing! And Clement Greenberg was the composer! Other artists were picking up on his theories and Rosenberg's, sometimes by reading them in the journals—*Partisan Review, The Nation, Horizon,* but more often in conversation. With The Club going down on Eighth Street, the artists of bohemia were now meeting all the time, everyday and talking up a storm.... But this Abstract Expressionism... was an abstraction of an abstraction.... But somehow the ethereal little dears are inapprehensible without words. In short the new order of things in the art world was: first you get the Word, and then you see.[9]

Wolfe also implied that Greenberg used Pollock to establish his own theories and reputation. "But Greenberg did something more than discover Pollock or establish him. He used Pollock's certified success to put over flatness as the theory—the theoretical breakthrough of Einstein-scale authority—of the entire new wave of the Tenth Street cénacle des cénacles."[10]

What then was this powerful work and the cast of characters that created such a revolution in the visual arts? Perhaps the most legendary figure is Jackson Pollock, whom many view as the quintessential Abstract Expressionist. Stories revolving around the persona of Pollock,

with his Wyoming roots, his alcoholism, his male chauvinism, his tragic end in a car accident in 1956, have often gone hand in hand with his large-scale, aggressive drip paintings. There was, nevertheless, a voice that echoed those of his generation in the midst of an intensive quest of new forms and processes and contact in the world of art and the world of the creative subconscious. Brian O'Doherty writes of the myth that has come to surround Pollock and his work:

> The fusion of certain American (noble savage and frontiersman) and modern (artist-outcast) legends makes Pollock's myth a classic text within which can be read the tragicomedies of ambition, both personal and cultural, the habits of modernism and the hazards of art, and the dialogue between public expectation and inspired surprise. Like most powerful myths it received its energies from the fact that it was necessary to help accomplish certain aims and having done so, presides over its own history in a way that conceals profound contradictions.[11]

Pollock was not simply a crude Westerner or noble savage making art in epic proportions. He was aware of a variety of traditions in art and was trained academically in art. He was an admirer of Picasso, Miró, Albert Pinkham Ryder, El Greco, and American Indian art. By age seventeen Pollock had come to New York and studied at the Art Students League from 1930 to 1932 with Thomas Hart Benton, known for his American Scene painting. Pollock recalled, "My work with Benton was important as something against which to react very strongly, later on; in this, it was better to have worked with him than with a less resistant personality who could have provided a much less strong opposition."[12] One can see the influence of Benton in a number of his 1930 paintings in his use of rhythmic contours. Around 1938 Pollock's interests turned from Benton to Orozco, Rivera, and Siqueiros. In 1936 he had worked at Siqueiros's workshop in New York and had watched Rivera and Orozco paint. Pollock's in-

terest in mythology may have been further stimulated by an article by John Graham, "Primitive Art and Picasso," which appeared in the *Magazine of Art* in April 1937.

> Primitive races and primitive genius have readier access to their unconscious mind than so-called civilized people. It should be understood that the unconscious mind is the creative factor and the source and the storehouse of power and of all knowledge, past and future. . . . Two formative factors apply to primitive art: First, the degree of freedom of access to one's unconscious mind in regard to observed phenomena, and second, an understanding of the possibilities of the plain operating space. The first allows an imaginary journey into the primordial past for the purpose of bringing out some relevant information, the second permits a persistent and spontaneous exercise of design and composition as opposed to the deliberate which is valueless. These capacities allow the artist, in the first place, to operate . . . [with] the most elemental components of form. In this process . . . superfluous components . . . are dispensed with.[13]

In the work Pollock completed from 1942 to 1947 there were frequent references to mythic imagery. By 1947 Pollock eliminated recognizable allusions from his work and concentrated on the rhythmic, ritualistic gestures that were a part of his experimental pouring and spraying of paint on his epic-sized canvases. Pollock described the importance of his experimental working process.

> My painting does not come from the easel. I hardly ever stretch my canvas before painting. I prefer to tack the unstretched canvas to the hard wall or the floor. I need the resistance of a hard surface. On the floor I am more at ease. I feel nearer, more a part of the painting, since this way I can walk around it, work from the four sides and literally be *in* the painting. This is akin to the method of the Indian sand painters of the West.
>
> I continue to get further away from the usual painter's tools such as easel, palette, brushes, etc. I prefer sticks, trowels, knives and dripping fluid paint or heavy impasto with sand, broken glass and other foreign matter added.

When I am *in* my painting, I'm not aware of what I'm doing. It is only after a sort of "get acquainted" period that I see what I have been about. I have no fears about making changes, destroying the image, etc., because the painting has a life of its own. I try to let it come through. It is only when I lose contact with the painting that the result is a mess. Otherwise there is pure harmony, an easy give and take, and the painting comes out well.[14]

The importance of nature is sometimes underestimated in Pollock's work but is nevertheless present, as indicated in some of his titles, *Autumn Rhythm* [1.6], *Lavender Mist, Ocean Greyness.* In some instances Pollock in his assumptions of heroicism was seeking to become nature. At one point he responded to Hans Hofmann, "I am nature."[15] Pollock's giant overall paintings executed between 1947 and 1950 are those that formalist critics such as Clement Greenberg so highly praised and theorized upon. Another painting of this period, Pollock's *One: Number 31, 1950,* evokes broad, expansive qualities of light and haze with its converging lines and shimmering spots of blue, pink,

and silver. Pollock's paintings of this period may be linked historically to Monet's late paintings and to future stain paintings. Pollock's line has a sense of urgency and power that few had caught before him. His work was spontaneous but not purely accidental. Frank O'Hara has commented on Pollock's ability to use line to create at once illusion and material immediacy: "There has never been enough said about Pollock's draftsmanship, that amazing ability to quicken a line by thinning it, to slow by flooding, to elaborate that simplest of elements, the line—to change, to reinvigorate, to extend, to build up an embarrassment of riches—in the mass of drawing alone."[16]

In 1951–52 Pollock limited his palette to black and in 1953 abandoned his "drip" technique. In 1950 he had resumed drinking and did fewer paintings in his last years. On the night of August 11, 1956, at forty-four, Pollock, a victim of his own drunk driving, was killed instantly as his car struck a clump of trees. Yet despite this premature end, Pollock had at least, as his fellow artist Willem de Kooning once said, broken the ice.[17]

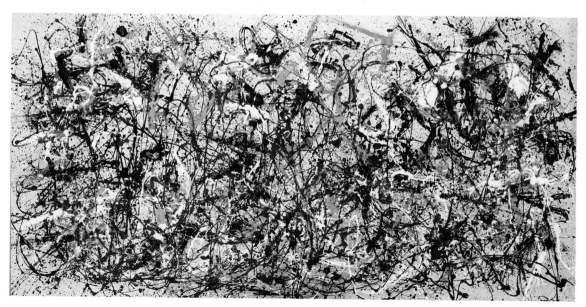

1.6. Jackson Pollock, *Autumn Rhythm,* 1957. The Metropolitan Museum of Art, New York.

Lee Krasner, Pollock's wife, also worked in the Abstract Expressionist manner and is often given short shrift and overshadowed by Pollock's more flamboyant life and work. But Krasner's paintings, drawings, and collages also reflect a courageous experimentalism. As the child of Russian Jewish immigrants, Krasner grew up in Brooklyn, speaking four languages and determined at an early age to become an artist. Studying at Cooper Union and the National Academy of Design, she found these too restrictive and turned to exhibitions of Picasso and Matisse at the Museum of Modern Art. As a number of other artists of the Abstract Expressionist generation, she was employed by the WPA to paint murals during the Depression. She also joined the politically active Artists Union and American Abstract Artists, a group promoting nonrepresentational art. Through the latter she met Piet Mondrian, who encouraged her to experiment further with abstraction. She also studied with Hans Hofmann from 1938 to 1940. Hofmann once said of one of her works, "This is so good, you would not know it was done by a woman."[18]

She met Pollock in 1942 when they both appeared in a group show. After marrying Pollock in 1945, Krasner continued to do her own work but was also devoted to promoting Pollock's career. From 1946 to 1949 she developed her "Little Image" paintings, where she merged geometric and organic tendencies with calligraphic forms on thickly painted abstract canvases. Her fifties paintings such as *Cornucopia* [1.7] with its lovely spontaneity and swirling forms evokes memories of Matisse as well as the expressive qualities of Krasner's "heroic" generation. In the mid-fifties and later in the late seventies Krasner also created large collages by destroying or cutting up old drawings and paintings and reusing them, as is well illustrated in her seventy-two-inch-square *Past Continuous* of 1976, now in the Guggenheim collection. In her first set of collages she even used some of Pollock's rejected pieces. Until her death in 1984 Krasner continued to keep aspects of the Abstract Expressionist aesthetic alive. She maintained, "To say that Abstract Expressionism is dead has more to do with public relations than with art."[19] "I am never free of the past. I have made it clear that I believe the past is part of the present, which becomes the future."[20]

Sharing the leadership of this new American avant-garde with Pollock was Willem de Kooning. Stowing away on a ship, the young de Kooning arrived in the United States in 1923 from the Netherlands. It was not until the forties that de Kooning came to be well known, as his style evolved into a combination of Cubism, Expressionism, and Surrealist automatism. His painting *Excavation,* 1950, was first seen at the 1950 Venice Biennale and it won first prize at the Chicago Art Institute Annual in 1951. The title of the painting implies what it is about—an excavation or archaeological dig into fragments of the body and urbanization. The overall gestural qualities of the work draw the viewer into a tangled yet coherent web of evocative but often rootless forms. "Indeed, de Kooning's pictures more than anything else, are metaphors for his own and modern man's existential condition, capturing the anxious, rootless, and violent reality of a swiftly paced urban life. De Kooning characterized the modern American metropolis as a 'no-environment,' remarking that its flux is totally alien to the stable milieu of the Renaissance in which everything had a fixed place."[21]

De Kooning's recurring subject has been the female figure. These monumental females were first shown in 1953. The women in his art are both seductive and odious. They have been likened to goddesses, tramps, and temptresses. Many of the paintings show a deep-seated tension, resulting from an ongoing dialectic of creating and destroying, in broad, violent gestures. As Brian O'Doherty writes,

The Women are compromising pictures, since they are as much an attempt to destroy an icon as preserve one. . . . Cubism is as much the "sub-

1.7. Lee Krasner, *Cornucopia*, 1958.
Robert Miller Gallery, New York.

ject" of the Women as the biological mythologies her presence has invited. . . . The Women are an attack on the history, thus reluctantly admitting its existence. As abstractions they are mythic, but the myth is the darker side of the American dream. . . . One of the constant insecurities of these Women is their situation. Where are they?[22]

De Kooning's *Woman and Bicycle* [1.8], 1952–53, continues in the tradition of Picasso, but its radical gesture, sometimes violent strokes, and frontal format suggest an immense sense of freedom in portraying an image of both traditional and popular culture. In his later female images de Kooning introduced elements of lyri-

cism and comedy. De Kooning's late work, into the seventies and eighties, although continuing his active expressionism, is more mellow in color and gesture.

De Kooning's wife, Elaine, also became noted for her work as an artist. An administrator at the Leonardo da Vinci School in New York introduced her to de Kooning in 1938. Five years later they were married. In the early fifties Elaine made stylized paintings inspired by news photographs of athletes. She also wrote a number of critical articles for *Artnews*, supporting artists such as Arshile Gorky and David Smith. She also did a series of vigorous paintings based on bullfights she had seen in Mexico. She, too, continued a form of expressionism in

her late years. Her paintings of the late eighties were based on imagery found in the ancient European caves such as those at Lascaux. She died in 1989 from cancer.

The gestural style that inspired critic Harold Rosenberg to use the term "action painting" was even more emphatically employed by Franz Kline (1910–1962), who grew up in the coal country around Wilkes Barre, Pennsylvania, an area that would later be reflected in

his art work. Before settling in New York's Greenwich Village in 1939, he had studied in London and Boston. Around 1950 he began to be influenced by de Kooning's work, departing from his earlier figurative works, which had reflected urban New York or his rural Pennsylvania. He also eliminated color from his work, creating works of monumental, spare black and white gestures. Although they often alluded to specific locales or objects such as *The Bridge*

1.8 *(opposite).* Willem de Kooning, *Woman and Bicycle,* 1952–53. Whitney Museum of American Art, New York.

1.9. Franz Kline, *The Bridge,* 1955. Munson-Williams-Proctor Institute, Utica, N.Y.

[1.9] of 1955, his works were for him "painting experiences. I don't decide in advance that I'm going to paint a definite experience, but in the art of painting, it becomes a genuine experience for me."[23] Some have tried to relate Kline's work to large Oriental ideograms. Kline has countered, "People sometimes think I take a white canvas and paint a black sign on it, but this is not true. I paint the white as well as the black, and the white is just as important."[24]

The power and diversity of the new gestural painting was further seen in the works of artists such as Bradley Walker Tomlin, James Brooks,

Al Held, and Philip Guston. Held's paintings, such as *Taxi Cab I* (cover), were beautifully colored, richly textured, and gave the gestures a structure. Guston's paintings were more tentative and ephemeral. Guston used a probing and searching brushstroke, at times weighty, at times spare. His 1954–55 *Room* [1.10] suggests mysterious space and melancholy, with layers of both calm and disquiet. Although Guston changed his subject matter in the seventies and eighties to figurative work with imagery suggestive of still life and cartoon figures such as Krazy Kat, his strong brushwork and glowing

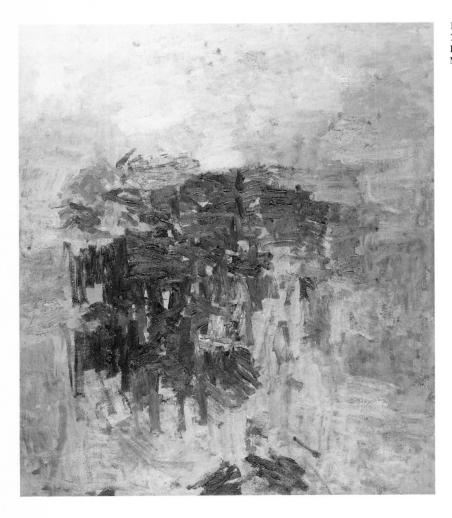

1.10. Philip Guston, *The Room,* 1954–55. Los Angeles County Museum of Art.

1.11. Barnett Newman, *Covenant*, 1949. Hirshhorn Museum and Sculpture Garden, Washington, D.C.

pigments continued in a sense of search and psychic exploration.

By 1949 it became apparent that there were two main tracks of Abstract Expressionism—gesture painting and color field painting. The strong emotive qualities of the gesture painters' expressive brushwork gave way to large, intense color fields that were broad and more refined. The large-scale, unified, single-image fields of many of these paintings enveloped the viewer, who was invited into a world of color accusation and changing perceptual dynamics intended to create a sense of spiritual awe. The critic Robert Rosenblum referred to some of these works as evincing the "abstract sublime" and traced it back to nineteenth-century landscape painting in his 1975 book *Modern Painting and the Northern Romantic Tradition*.

Probably the best known of these artists were Mark Rothko, Clyfford Still, and Barnett Newman. These artists searched for transcendental truths, for an art, in Newman's terms, of "pure idea," a sublime that had grown out of the myth-inspired semi-abstractions of the early and middle forties. Newman had also looked to the art of the Northwest Coast Indians as he attempted to fuse the modern and the primitive. A turning point came for him in 1948 with *Onement I,* with its strong vertical, thickly painted center stripe and undefined background with undulating color densities. In that same year Newman declared in an article titled "The Sublime Is Now":

The question that now arises is how, if we are living in a time without a legend or mythos that can be called sublime, if we refuse to admit any exaltation in pure relations, if we refuse to live in the abstract, how can we be creating a sublime art? We are reasserting man's natural desire for the exalted, for a concern with our relationships

1.12. Clyfford Still, *1954*, 1954. Albright-Knox Art Gallery, Buffalo.

to the absolute antiquated legend. . . . We are freeing ourselves of the impediments of memory, association, nostalgia, legend, myth, or what have you, that have been the devices of Western European painting. Instead of making *cathedrals* out of Christ, man, or "life," we are making them out of ourselves, out of our own feelings. The image we produce is the self-evident one of revelation, real and concrete, that can be understood by anyone who will look at it without the nostalgic glasses of history.[25]

Newman's very titles, such as *Abraham, Covenant,* and his *Stations of the Cross* series, suggest immediately a spiritual quest. In his 1949 *Covenant* [1.11] the large color field calls for a multilevel dialogue with the viewer, a communing rather than a quick reaction. In con-

trast to the personal emotive surfaces of gestural painters, the color fields of Newman are deeply quiet and reserved, going beyond the self to his private vision of the sublime.

Clyfford Still's color abstractions are usually composed of jagged contours of vertical colored areas. One sometimes feels the presence of isolated figures standing in an open, vast, unknown landscape upon viewing a piece such as Still's *1954* [1.12].

Still himself wrote of the notion of exploring unknown terrain. "It was a journey that one must make, walking straight and alone. . . . Until one had crossed the darkened and wasted valleys and come at last into clean air and could stand on a high and limitless plain. Imagination, no longer fettered by the laws of fear, became

as one with Vision. And the Act, intrinsic and absolute, was its meaning and the bearer of its passion."[26]

Perhaps the best known of the color field painters is Mark Rothko (d. 1970), whose life and work stands as an important case study in the history of modern American art. Born in 1903 in Dvinsk, Russia, as Marcus Rothkovich, Rothko came to the United States at age ten as part of the influx of about two million Russian Jewish refugees escaping to America between 1881 and 1914. Educated first in Portland, Oregon, then for two years at Yale University, and intermittently at the Art Students League in New York during the twenties, Rothko began as a figurative painter. He obtained his citizenship papers in 1938 and eliminated the last syllable of his surname in the early forties. Moving toward a freer visual expression, he arrived by 1947 at the magnificent large-scale luminescent color fields for which he is best known [1.13]. The glowing colors, ranging from somber darks to brilliant lights, are capable of imparting a transcendent spirituality. His 1956 *Orange and Yellow* (Plate 1) with its exquisite balance of color and surface texture is but one example of Rothko's great ability to transform color and form to what may be called a secular form of sacred art. In his later years Rothko devoted time to large ensembles of paintings such as those at the Tate Gallery (originally designed for the Seagram Building in New York), the murals at Harvard University, and the Houston Chapel.

1.13. Mark Rothko, *Four Darks in Red*, 1958. Whitney Museum of American Art, New York.

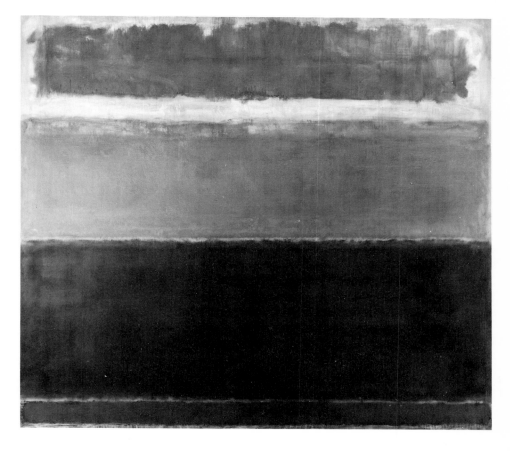

The Harvard murals represent an example of the difficulties involved in institutional maintenance of art works, especially works made with materials never submitted to the trials of light and aging. In 1964 five large Rothko panels were installed on the tenth floor of Harvard's Holyoke Center. Within four years, though, the lithol red (later withdrawn from the market due to its difficult properties) that Rothko had used in combination with a more stable ultramarine blue to create a purplish-crimson background had begun to fade to a denim blue, particularly in areas receiving direct sunlight. Rothko apparently was not notified of the fading, and decisions as to what to do were delayed. Eventually the paintings were ruined. In 1979 the paintings were removed from Holyoke Center and transferred to the Fogg Museum, where they were taken off the stretchers and placed in storage. Finally in 1988 the Arthur M. Sackler Museum at Harvard mounted the exhibition "Mark Rothko's *Harvard Murals*" in what was described as "the university's attempt to 'clean up its act' regarding its priceless legacy," for "even in a tragically damaged state, the epic-scaled paintings still are deeply moving and powerful works of art."[27]

Rothko's large-scale installation at the Houston Chapel, completed in 1966 for the de Menils, has survived better the tests of time. The fourteen pieces, one of which represented Salvation, another, Damnation, in configurations of browns, blacks, and purples, consumed Rothko. He wrote to the de Menils on New Year's day in 1966, "The magnitude on every level of experience and meaning of the task in which you have involved me, exceeds all my preconceptions. And it is teaching me to extend myself beyond what I thought was possible for me. For this, I thank you."[28]

On a cold February day in 1970, Rothko's assistant Oliver Steindecker found him lying in a pool of blood. The *New York Times* ran the story the next day on the front page:

Mark Rothko, a pioneer of Abstract Expressionist painting who was widely regarded as one of the greatest artists of his generation, was found yesterday, his wrists [sic] slashed, in his studio at 157th East 69th St. He was 66 years old. The chief Medical Examiner's office listed the death as a suicide. Mr. Rothko had suffered a heart attack last year and friends said he had been despondent in recent months.[29]

Beyond Rothko's violent death, which left many questions among his friends and family, was the controversy surrounding Rothko's estate of eight hundred paintings, which his executors, shortly after Rothko's death, turned over to the Marlborough Gallery for far less than they were worth. Rothko's wife, Mell, and two children, Kate and Christopher, were left nothing. Outraged, Kate filed suit against the executors and Marlborough. "The legal battle became the longest, most complicated, and costliest in the history of art."[30] Following a four-year lawsuit and eight-month trial, Kate Rothko won, and criminal convictions were handed down against the original trustees of the Rothko Foundation and Marlborough Gallery. A new Mark Rothko foundation was formed for the purpose of appropriately distributing paintings and drawings to various museum collections and allowing for the pursuit of research and conservation related to Rothko's life and work. Mark Rothko's life, work, and death stand as a poignant example of the complex and powerful forces of interaction between the artist, galleries and museums, and society at large in the contemporary world.

Like Rothko, Adolph Gottlieb (1903–1974) had pursued mythological content in his early work, developing a system of pictographs within an abstract grid as he appeared to probe the human mind. He later abridged his imagery in a series of "Imaginary Landscapes." His *Circular*, 1960 [1.14], brings forth an imagery he was to use frequently. The image is at once universal and specific, controlled and uncontrolled, as Gottlieb probes into the forces of

1.14. Adolph Gottlieb, *Circular*, 1960.
New York University Art Collection,
New York.

rationality and irrationality.

The youngest of the original Abstract Expressionist movement was Robert Motherwell (b. 1915), who has made important visual and verbal statements related to Abstract Expressionism. Trained in both philosophy and art history, as well as being involved in studio art, Motherwell wrote a good deal and served as editor and director of The Documents of Modern Art series. Some of Motherwell's best-known paintings are his *Elegies to the Spanish Republic* [1.15], a lengthy series that, begun in 1949, lasted over thirty years. It ended only after the death of Franco and the restoration of a parliamentary democracy in Spain. Motherwell said of the *Elegies, "The Spanish Elegies* are not political but my private insistence that a terrible death happened that should not be forgotten. . . . The pictures are also general metaphors of the contrast between life and death, and their interrelation."[31] The biomorphic and void shapes of the *Elegies*, although funereal in color and concept, are pregnant with a life of their own, thereby contributing to a powerful but lyrical ambiguity that makes the pieces so arresting. His canvases can be related to both the color field and gestural painters of his generation, as well as to works of Matisse, Picasso, and Miró. Unlike most of the other Abstract Expressionists, Motherwell worked frequently in collage. Although painting and collage have been parallel activities for Motherwell, he sees them as distinct. For him "collages are a modern substitute

for still-life. . . . My painting deals in large sim-
plifications for the most part. Collage in con-
trast is a way to work with autobiographical
material—which one wants sometimes. . . . I do
feel more joyful with collage, less austere. A
form of play which painting, in general, is not,
for me, at least."[32] Motherwell has continued
and refined the elegant lyricism in his paint-
ings, collages, and collage prints of the seven-
ties and eighties, as is seen in a piece such as
The Red and Black # 53, 1987 [1.16].

Motherwell's words of 1955 still seem to
have relevance for his life and work as it has
continued to the present. "Through pictures
our passions touch. Pictures are vehicles of pas-
sion, of all kinds and orders, not pretty luxuries
like sports cars. In our society, the capacity to
give and to receive passion is limited. For this
reason, the act of painting is a deep human
necessity, not the production of a hand-made
commodity."[33]

A second generation of Abstract Expression-
ists included Grace Hartigan (b. 1922), Joan
Mitchell (b. 1926), and Sam Francis (b. 1923).
Hartigan, a New Jersey–born artist, supported
herself and her son by doing mechanical draft-
ing in an airplane factory when her husband
was drafted for World War II. Moving to New
York, Hartigan was inspired by the works of
Pollock and de Kooning and began to paint
large-scale works herself.

Born into a wealthy family in Chicago, Joan
Mitchell began painting as a child and received
her B.F.A. from Smith College and M.F.A. from
the Art Institute of Chicago. During 1948–49
she worked in France on a Fulbright Fellow-
ship. Returning to New York, she had her first
one-person exhibition in 1951. She moved to
Paris in 1955. Mitchell was particularly inspired
by de Kooning and Kline. Her work, in many
instances, although as aggressive as theirs, was
more lyrical and linear. She described her work

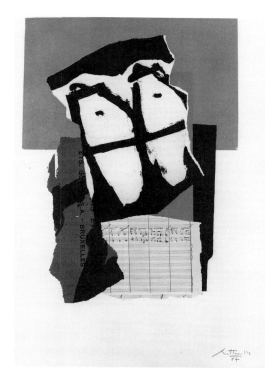

as not "autobiographical or emotionally expressive" as some other Abstract Expressionists' work, but as that which "comes from and is about landscape, not about me."[34] She claims that many of her works, such as *Hemlock,* 1956 [1.17], have been inspired by the light and the landscape near her home in Vétheuil, where Claude Monet once lived.

Sam Francis, a young San Francisco artist enrolled at the University of California at Berkeley, found himself inspired by the work of Clyfford Still and Mark Rothko. In the mid-fifties Francis painted abstract, brilliantly colored cellular units with washes of pigment (he painted the canvas white first). In the late fifties he began to favor more varied splatters and splashes of color and emphasized the white areas in the work, which gradually came to dominate later pieces. The emphasis on the white field came following trips to Japan in 1957 and 1958, where Francis was influenced

1.15 *(opposite).* Robert Motherwell, *Elegy to the Spanish Republic, XXXIV,* 1953–54. Albright-Knox Art Gallery, Buffalo.

1.16 *(above).* Robert Motherwell, *The Red and Black #53,* 1987. M. Knoedler & Co., Inc., New York.

1.17 *(right).* Joan Mitchell, *Hemlock,* 1956. Whitney Museum of American Art, New York.

by Oriental calligraphy. The sense of infinity suggested by the white in *The Whiteness of the Whale* and *Shining Back* [1.18], with their floating areas of abstract color, creates a universe that is both corporeal and ethereal.

Also of a second generation, using gestural elements but in figurative contexts, were artists such as Larry Rivers, Lester Johnson, Philip Pearlstein, Leon Golub, and West Coast artist Richard Diebenkorn, in their early work. Rivers (b. 1923) attempted a somewhat satirical and parodic combination of academicism and modernism in his *Washington Crossing the Delaware* of 1953 [1.19], based on the popular academic painting by Emanuel Leutze. In his intent to shock, he said,

1.18. Sam Francis, *Shining Back*, 1958. Solomon R. Guggenheim Museum, New York.

I was energetic and ego-maniacal and what is even more important, cocky and angry enough at the time to want to do something no one in the New York art world doubted was disgusting, dead, and absurd, rearrange the elements, and throw it at them with great confusion. Nothing could be dopier than a painting dedicated to a national cliché. . . .

In relation to the immediate situation in New York . . . [it] was another toilet seat—not for the general public as it was in the Dada show, but for the painters.[35]

The combination of the heroic gestures of the Abstract Expressionists and the heroic figure of George Washington, the "classic" hero, produced a strange tension and perhaps angst for the viewer. Where was Rivers going and what was he doing? This painting was to determine Rivers's style for a number of years.

As the fifties progressed, the Abstract Expressionist began to be shown more widely and became more established. As art scholarship has emerged, particularly concerning the first generation of this "movement," there have been various opinions advanced concerning its significance, usually depending on the generation of critics examining it. In the fifties Harold Rosenberg's "action painting" theory focused on the individual anguish of the artist brought forth on the canvas. In the fifties another theory espoused by John McCoubrey in his *American Tradition in Painting* spoke of an American tradition and a search for an American identity through the "new" art. In the late fifties and early sixties the "New Criticism and Formalism" of Clement Greenberg praised the formalist innovations of the Abstract Expressionists, which were to be viewed in an international context. Since the seventies a variety of critical views has emerged representing various intellectual and cultural contexts, from Marxist and feminist to anthropological and interdisciplinary methodologies of criticism.

Further research has also been done concerning the meeting of Eastern and Western

1.19. Larry Rivers, *Washington Crossing the Delaware*, 1953. The Museum of Modern Art, New York.

thought during the period, as suggested in David Clarke's *Influence of Oriental Thought on Post-War American Painting and Sculpture.* The role played by specific texts and writers as scholars, such as Fenellosa, Coomaraswamy, Watts, John Cage, the *I Ching,* and the *Tao Te Ching,* is being further examined, as well as Oriental concepts of the process and function of art. The "overall" or "network" nature of some artists' work, such as Pollock's, is being considered in relationship to a sense of continuum in an Oriental worldview and an abandonment of heavy, solid forms. The Oriental concept of the void relating to fullness, not nothingness, and the use of empty space by artists such as Sam Francis to suggest infinite, unbounded space is only one example of the intertwining of Eastern and Western thought.

It is also interesting to note that in Japan during this period, some of the paintings being done were akin to some of the Abstract Expressionists' work, although in general the works were of quieter, more lyrical sensibilities. The works of Tukuoka Shinsen and Fukuda Heihachirō are examples. Tukuoka Shinsen's subtle color gradations in painted paper pieces such as *Stream,* 1954, or *Red Pines,* 1956, are similar to some of Rothko's work but are more firmly grounded in nature imagery. Trees and stream are evident, but cropped and abstracted, as the artist goes beyond nature to enter "yūgen," a world of profound mystery and calm beyond the surface of the trees and stream. Heihachirō's *Virgin Snow,* 1948, is a painted silk portrait of six stepping stones shaded in various hues on snow-white softness, employing some of the color field sensibilities in a gentle manner.

Because both the Abstract Expressionists and their work have had such a major impact on postwar art, and may be seen as having significant links to earlier art of this century, it is important to continue to try to understand the development and the power of the works as well as the criticism that has come to surround it, to try to better understand the "triumph of American painting"[36] on a variety of levels.

Fusing the spontaneous and expressive techniques of the Abstract Expressionists, particularly those of Jackson Pollock, and her own new technique, which came to be called "stain painting," Helen Frankenthaler began to emerge as a major figure in American painting with her 1952 painting *Mountains and Sea*

[1.20]. "I put in the charcoal lines gesture first, because I wanted to draw in with color and shape the totally abstract memory of the landscape. I spilled on the drawing in paint from the coffee cans. The charcoal lines were original guideposts that eventually became unnecessary."[37]

This work was an important innovation and change from Frankenthaler's earlier work. The daughter of a New York Supreme Court justice, Frankenthaler had had a private school education in New York and at Bennington College, where she had studied with the Cubist painter Paul Feeley. She was also a student of Hans Hofmann and was married to Robert Motherwell from 1958 to 1971. Frankenthaler's work

1.20. Helen Frankenthaler, *Mountains and Sea*, 1952. Collection the artist.

in a variety of media—drawing, printmaking, and painting—has continued to evoke powerful energies as she manipulates and choreographs spaces, shapes, and colors into creative textural movements that dance before the viewer's eyes.

Frankenthaler's stain technique was to have an influence on other painters such as Kenneth Noland and Morris Louis. Some applied the term "color field" to expansive color paintings of Louis, Noland, and a group of painters based in Washington, D.C., as well as New York–based Frankenthaler and Jules Olitski. The critic Michael Fried, an admirer of Clement Greenberg, helped to carry forth verbally what he felt was the significance of the stain techniques. Kenneth Noland described it this way:

> The thing is color, the thing in painting is to find a way to get color down, to float it without bogging the painting down in Surrealism, Cubism, or systems of structure. . . . In the best color painting, structure is nowhere evident, or nowhere self-declaring.
> No graphs; no systems; no modules. No shaped canvases. Above all, no *thingness*, no *objectness*. The thing is to get surface sliced into the air as if by a razor. It's all color and surface. That's all.[38]

Born in Asheville, North Carolina, Noland had first studied at Black Mountain College in North Carolina with Josef Albers and Ilya Bolotowsky. Black Mountain was a unique interdisciplinary community of creative minds and spirits, where artists such as Robert Rauschenberg, Merce Cunningham, and John Cage were as well. Noland later studied with Ossip Zadkine in Paris from 1948 to 1949. His involvement in stain painting was triggered by his visit with Morris Louis to New York, where he saw Helen Frankenthaler's painting *Mountains and Sea*. Noland had his first New York show in 1957, exhibiting thinly painted or stained gestural canvases. In 1959 he presented his "target" paintings, consisting of concentric bands

of color separated by white, as in his 1958 *Spread* [1.21]. The circular forms allude to both the universal and the particular as the eye is forced to probe deeply into the outer area. Noland later moved from his gestural staining to the use of hard-edged stripes in his circular, chevron, and horizontal series. Major recognition came to Noland when he was chosen to represent the United States at the Venice Biennale in 1964.

Morris Louis's large open-stained abstractions appear more spontaneous than Noland's work. Louis's first New York show, as Noland's, was in 1957, and a one-man show of his large-scale stain paintings was in 1959. Louis was forty-two when he began the stain paintings for which he was to become well known, but continued for only eight years more, until his death in 1962 at age fifty. Upon seeing Frankenthaler's work, Louis realized the potential for using color as a major pictorial element and began to pour paint onto the canvas. His first major stain paintings, the *Veils*, consisted of waves of transparent paint poured down the canvas, creating a diaphanous surface of softly modulated colors. There was no heavy impasto or surface building, simply sheer color, presented in fluid forms. From 1955 to 1957 Louis returned to painting in a more traditional Abstract Expressionist manner, but returned to the *Veils* in 1958, painting them in large, simpler configurations. The blue-green tonality of his *Tet*, 1958, suggests a poetic, lyrical sensibility, while a piece such as his black *Dalet Tet*, 1958–60, suggests an atmosphere of mystery and wonder. In 1960 Louis stopped making his *Veils* and explored new ways of working with color in later series such as his *Florals*, *Columns*, *Unfurleds*, and *Stripes*. In his *Unfurleds* Louis emptied the center of the canvas. It was a revolutionary move. "Never before in Western art had so large an unpainted area possessed such authority. With the staining technique Louis was able to suppress any textural differences between painted and unpainted

areas of the canvas, and in the *Unfurleds,* he made the white canvas as important as the colored portions, using the dazzling light of the canvas to balance the two banks of color."[39] *Alpha* [1.22] is another example of Louis's brilliant sense of color. No one is quite sure how these paintings were made, but it appears likely that he may have folded a canvas over a scaffolding propped against the wall and manipulated the canvas and/or scaffolding. He had the paint specially made for the work. Louis once said, "Paintings should produce a delicious pain in the eye—make the viewer gasp—knock him down and seduce him."[40] His large-scale dramatic experiments with color in his last eight years of painting often do just that (Plate 2).

Associated with the stain painters, particularly for his work from 1960 to 1964, was Jules Olitski. Olitski was born in Snovsk, Russia, in 1922 but moved to the United States in 1923. Like Noland he had studied with Ossip Zadkine, from 1949 to 1951. He did not exhibit his stain paintings until 1960. His biomorphic forms in pieces such as *First Pull* and *Cleopatra Flesh* show color as an immediate and vibrant subject matter. In 1965 Olitski began to use spray guns to build up the paint surface and later used gel to create a very tactile surface. In 1966 he was chosen to represent the United States at the Venice Biennale, and in 1969 he was the first living artist to be given a one-person show at the Metropolitan Museum in New York.

Challenging the spirit of the Abstract Expressionists during the forties and fifties were a number of artists who continued with experiments begun earlier in the century, or forged new styles and ideas. One was Stuart Davis, whose vibrant geometric abstractions repre-

1.21. Kenneth Noland, *Spread,* 1958. New York University Art Collection, New York.

1.22 *(opposite).* Morris Louis, *Alpha,* 1960. Albright-Knox Art Gallery, Buffalo.

sent an important link between Cubism and Pop art. His 1952 *Rapt at Rappaport's* with its brilliant greens, reds, and blues pulsates with the movement of a jazz piece. The letters and numbers, used in a structural fashion, add yet another dimension to the piece. The billboard-like life of the painting with its clear-cut forms and colors stands far from many of the gestural painters.

One of the most outspoken artists questioning Abstract Expressionism was Ad Reinhardt, whose writings and visual art works stood in opposition to the gestural works of the Abstract Expressionists and those influenced by them. His highly reductive monochromatic canvases, such as *Red Painting* [1.23], 1952, and particularly his later all "black" ones cried out for a purity of art without remnants of the artist's personality and society. In the mid-forties Reinhardt found himself influenced by Mondrian's writings and paintings and professed his belief in visual abstraction as a means to reach a social

and political utopia. In the fifties, though, he renounced his political utopianism in art and called for "art-as-art," rejecting any political uses of it. The first version of his art-as-art dogma appeared in a magazine, *It Is,* in 1958 in the form of aphorisms. He was to reiterate his ideas later in the following statement:

> The one thing to say about art is that it is one thing. Art is art-as-art and everything else is everything else. Art-as-art is nothing but art. Art is not what is not art. . . . The one standard in art is oneness and fineness, rightness and purity, abstractness and evanescence. The one thing to say about the best art is the breathlessness, lifelessness, deathlessness, contentlessness, formlessness, sparelessness, and timelessness. This is always the end of art.[41]

Reinhardt chose to deny all meaning in his work, feeling that it thus remained pure and untainted by outsiders' interpretations. Some of Reinhardt's theories had an Eastern tenor to them, and it is not surprising that he taught

1.23. Ad Reinhardt, *Red Painting*, 1952. The Metropolitan Museum of Art, New York.

1.24 *(opposite)*. Ellsworth Kelly, *Green White*, 1959. Private collection.

Oriental art at Brooklyn and Hunter colleges in New York. As a student he had studied art history at Columbia University and the Institute of Fine Arts of New York University. He was also a political activist, sympathetic to leftist causes. His purist and reductive work—his writings and paintings—were to influence subsequent minimalist and conceptual artists.

A number of other artists, such as Ellsworth Kelly, Leon Polk Smith, Alexander Liberman, and Agnes Martin (most exhibiting at the Betty Parsons Gallery in New York), had also experimented in the fifties with what came to be called "Hard-Edge" painting. The term was first coined by California critic Jules Langsner in 1959 and further used by Lawrence Alloway in 1960–61, as he wrote, "forms are few in hard-edge and the surface immaculate. . . . The whole picture becomes the unit; forms extend the length of the painting or are restricted to two or three tones. The result of this sparseness

is that the spatial effect of figures on a field is avoided."[42] A piece such as Kelly's *Green White*, 1959 [1.24], shows his concern with a strong clarity of form and the effect of color. Kelly became a leader of the Hard-Edge painters and by the sixties his work had become more symmetrical and devoted to flat overall color. He also experimented with shaped canvases in the seventies, and it is often difficult to differentiate his paintings from sculptural reliefs.

As the fifties progressed, other responses and opponents to Abstract Expressionism's gestural emphases and influences emerged more strongly. By the mid-fifties Clement Greenberg had announced at The Club that gesture painting had become "timid, handsome, second generation . . . in a bad way."[43] A review by John Ferren implied the work was no longer avant-garde, that it was a "parochial show." "From my chair I see a general consolidation. What

new frontiers there are, are implicit develop-
ment rather than surprises. . . . This year there
is not the intensity of experiment and the some-
times outrageous personal gesture of other
times. There is instead the intensity of the fin-
ished picture."[44] In 1958 Alfred Barr, head of
the Museum of Modern Art, challenged an au-
dience as he asked about the state of rebellion
in the art world, implying the possibility of Ab-
stract Expressionism becoming an academic
movement.

One of the strongest attacks on the second
generation came from the artist Allan Kaprow,
who was to become noted for his involvement
with Happenings and Environments (see dis-
cussion under Multimedia and Intermedia). His
1958 comment was devastating: "The 'Act of
Painting,' the new space, the personal mark
that builds its own form and meaning, the end-
less tangle, the great scale, the new materials,
etc. are by now clichés of college art depart-
ments. The innovations are accepted. They are
becoming part of text books."[45]

In 1960 William Rubin wrote of the "poor
quality of contemporary Abstract Expressionist
or de Kooning style painting," "rendered deco-
rative by painters who have converted it into a
formula and given it 'professional' finish and
polish. This happens only after a style has
passed its period of vitality, when the metaphor
becomes the cliche."[46] Thus both artists and
critics pointed to the demise of Abstract Ex-
pressionism as a rebellious spirit of the avant-
garde. It seems ironic that as the art work be-
came more accepted and established as a
movement (perhaps exemplified by the Metro-
politan Museum of Art's purchase of Jackson
Pollock's *Autumn Rhythm* for $30,000 in
1957), the art world's response became more
critical.

The door was thus open to the experiments
of younger artists in different modes of aes-
thetic expression. The young Robert Rauschen-
berg and Jasper Johns brought objects, both ac-
tual and rendered, back into painting, working
in the gap between art and life. Rauschenberg's

comments became axioms for many young art-
ists: "Painting relates to both art and life. Nei-
ther can be made (I try to act in that gap be-
tween the two)."[47] or "Any incentive to paint is
as good as any other. . . . A pair of socks is no less
suitable to make a painting with than wood,
nails, turpentine, oil and fabric. . . . There is no
poor subject. Painting relates to both art and
life."[48]

In the mid-fifties the young native Texan
Robert Rauschenberg shocked the art world by
transforming the free brushstrokes of a de
Kooning to canvases loaded with rags, frag-
ments of comic strips, decals, and discarded
remnants, as well as paint. His work was to have
a profound impact on several generations. He
has been called a "protean genius" by art histo-
rian Robert Rosenblum, who has further noted
that "every artist after 1960 who challenged
the restrictions of painting and sculpture and
believed that all of life was open to art, is in-
debted to Rauschenberg—forever."[49]

Born Milton Rauschenberg in 1925 in Port
Arthur, Texas, a somewhat shabby oil refinery
town, Rauschenberg had little contact with art
except the holy cards hung in his home as a
young boy. Following a public school education
in Port Arthur, he enrolled at the University of
Texas at Austin, in pharmacy, but lasted only a
short while, for he refused to dissect a live frog
in an anatomy class. He then entered the U.S.
Navy and served as a mental health nurse in
various California hospitals during the war.
During a break Rauschenberg visited the Hunt-
ington Library in San Marino and saw his first
"real" painting: Sir Joshua Reynolds's *Portrait
of Mrs. Siddons as the Tragic Muse* and Thomas
Gainsborough's *The Blue Boy.* He decided he
wanted to paint, and one night in his navy bar-
racks locked himself in the bathroom, to avoid
ridicule, to paint his first piece, a portrait of a
Navy friend.

When the war was over, Rauschenberg stud-
ied at Kansas City Art Institute under the G.I.
Bill, then briefly at the Académie Julian in Paris
(until 1953), but knew no French. He did meet

his future wife, Susan Weil, there. Upon their return to the U.S. he enrolled at Black Mountain College with Josef Albers, the Bauhaus veteran noted for his color abstractions, in particular his *Homage to a Square* series. Albers disliked Rauschenberg's work. But perhaps more important than being in Albers's class was the creative atmosphere and fellow artists that Rauschenberg found at Black Mountain. The composer John Cage and the dancer-choreographer Merce Cunningham were particularly influential. Indeed, when Rauschenberg moved to New York in 1949, he joined the group of dancers and musicians surrounding Cage, Cunningham, and Morton Feldman and felt more at home with these artists than painters at the time.

Rauschenberg had little money for his supplies and found himself collecting "junk": cardboard cartons, old postcards, a stuffed bird, a broken umbrella, which were incorporated in his "combines" of the fifties, such as *Rebus* or *Canyon,* 1959 [1.25]. These were particularly influenced by the work of the German Dadaist Kurt Schwitters, whose work he had seen at the Museum of Modern Art, and Marcel Duchamp. Rauschenberg shocked the world around him with his 1959 *Bed,* where he substituted a pillow, sheet, and patchwork quilt for the canvas and hung them on the wall. Leo Steinberg commented on his innovations:

> What he invented above all was, I think . . . a pictorial surface that let the world in again. Not the world of the renaissance man who looked for his weather clues out of the window but the world of men who turn knobs to hear a taped message, "precipitation probability ten percent tonight," electronically transmitted from some windowless booth. Rauschenberg's picture plane is for the consciousness immersed in the brain of the city.[50]

Rauschenberg in those days was a precursor of both Pop art and the appropriationist aesthetic of Post-Modernism. He also incorporated techniques of reproduction such as silk screening and transfer drawings into his work. The critic Douglas Crimp has commented on Rauschenberg's part in a post-modern aesthetic.

> The fiction of the creating subject gives way to the frank confiscation, quotation, excerptation, accumulation and repetition of already images. Notions of originality, authenticity, and presence, essential to the ordered discourse of the museum are undermined. Rauschenberg steals the *Rokeby Venus* and screens her onto the surface of *Crocus,* which also contains pictures of mosquitoes and a truck, as well as a reduplicated Cupid with a mirror. She appears again, twice in *Transom,* now in the company of a helicopter and repeated images of water towers on Manhattan rooftops.[51]

Rauschenberg and Jasper Johns had met in 1954, and in 1955 Rauschenberg, now divorced, moved into a loft in the same building as Johns. The two "enfants terribles" supported themselves in those days by doing window displays for Tiffany and Bonwit Teller stores. Rauschenberg's audience in the fifties consisted mainly of younger artists such as James Rosenquist, Robert Morris, Claus Oldenberg, and Jean Tinguely. Rauschenberg spoke of those days: "We were relieved of the responsibility the Abstract Expressionists had. They had fought the battle of showing there was such a thing as American art, we didn't have that problem. We were undistracted by things we couldn't imagine, like art collectors and taxes. There was a very strong sense of just getting up and doing something."[52] Some have placed Rauschenberg in complete opposition to the Abstract Expressionists, particularly because of the story of his erasing a de Kooning pencil drawing, which in fact de Kooning had given him for that purpose. However, Rauschenberg did use the "gestures" of the Abstract Expressionists but in a depersonalized and objective manner, in the splattered, bold strokes of many of his works.

Although Rauschenberg and Johns were good friends, their work was quite different. The more carefully modulated encaustic sur-

1.25. Robert Rauschenberg,
Canyon, 1959. Collection
Mr. and Mrs. Michael
Sonnabend.

faces of Johns's early work—his flags, targets, and maps—were often filled with paradox, asking the viewers to rethink what they were looking at. For example, was the flag a flag or a painting of the flag? Why would the word *red* be written over a yellow area? Problems in perception have been major concerns for Johns.

Like Rauschenberg, Johns was also from the South. Born in Augusta, Georgia, in 1930, Johns went to live with his grandparents in Allendale,

South Carolina, since his parents separated soon after he was born. As a child he moved around South Carolina living with various relatives, finally finishing high school in Sumter while living with his mother and stepfather. Even as a child he wanted to be an artist, and saw his grandmother working as an artist. He attended the University of South Carolina in Columbia briefly. He also served in the army, and there are rumors that he painted a mural

that was considered unsuitable in a Fort Jackson building. When Johns became famous, Fort Jackson officials realized what they had, only too late, as the building was razed to the ground. After his army discharge he went to New York to continue college but quit after the first day and worked in a bookstore while painting sporadically. In 1954 he destroyed everything he had done up to that point and recalls, "I decided to do only what I meant to do, and not what other people did. When I could observe what others did, I tried to remove that from my work. My work became a constant negation of impulses."[53]

In 1955 Johns and Rauschenberg were living in the same building. Johns, then only twenty-five, was experimenting with flag imagery, based on a dream he had had in 1954 and also did his first target painting. Johns began his flag paintings as the United States was about to emerge from the horror of the McCarthy era. In 1954 the American public could watch the army-McCarthy hearings on television, and patriotism was a volatile issue. Johns's flags in their various transformations, in grays, whites, oranges, and greens, in sculptmetal, in pencil, in painting, in two and three dimensions, were not tools of public propaganda as one might think but icons that question. While the image was presented in an affirmative fashion, its power and significance is presented in ambiguity and question.

Through Rauschenberg Johns met John Cage, and through Cage he met Merce Cunningham. Cage and Cunningham were to become important figures in Johns's life and work, as they were for Rauschenberg. The years 1956–57 were the first time Johns used objects attached to the painted surface and then painted over the objects as if they were a part of the original surface. In 1956 Johns also did the first of his alphabets. By then he was painting full time, working as a window dresser only when he had to. Two of his paintings, *Flag on Orange Field* and the small *White Flag*,

were shown in Bonwit Teller's windows in 1957–58, thereby emphasizing the object-ness of his paintings. The first public display of his work in a museum or gallery (with the exception of one of his paintings appearing in a Rauschenberg painting in 1956) was in 1957, when his *Green Target* (1955) was included in a group show at the Jewish Museum, following the suggestion of Allan Kaprow. There Leo Castelli, who was to become one of New York's chief gallery owners and dealers, saw the piece. In March 1957 Castelli went to Pearl Street to invite Rauschenberg to show in his new gallery and asked Rauschenberg about seeing Johns's work as well. Castelli recalls that first visit: "I walked into the studio, and there was this attractive, very shy young man, and all these paintings. It was astonishing, a complete body of work. It was the most incredible thing I've ever seen in my life."[54] Castelli exhibited Johns's *Flag*, 1955 [1.26], in a group show in 1957, and a year later gave Johns his first one-man show, where Johns showed his targets, his numbers and alphabets, and received critical acclaim. Despite this recognition, Johns two years later changed his work. His 1959 painting *False Start*, with its explosive colors and stenciled, mislabeled colors (*gray* is painted in red letters on a patch of yellow, for instance), again questioned traditional modes of perception and ways of viewing color as only a visual sensation. (In 1988 *False Start* sold at auction for $17 million dollars.) In 1959 Johns also met Marcel Duchamp, who like Johns was interested in interplays between thought and language, and visual and verbal perceptions.

In his use of commonplace imagery, in his creating new forms of representation, and in establishing the significance of the painting as object, not simply representation of an object, Johns provided a key link from Dada to Pop art.

The young Frank Stella was influenced by Johns, particularly by his repetition of motifs. Stella, like Johns and Rauschenberg, began to question and move beyond gesture painting.

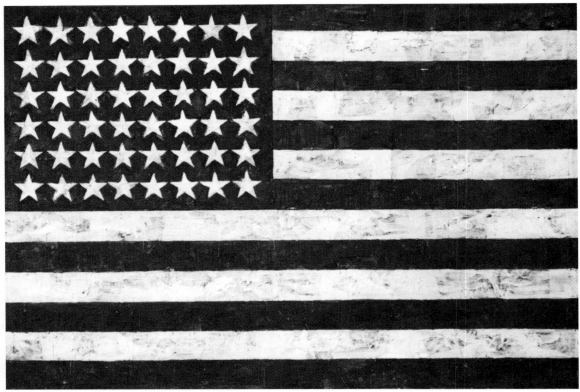

1.26. Jasper Johns, *Flag*, 1955. The Museum of Modern Art, New York.

He was to state:

> I think I had been bodily affected by . . . the romance of Abstract Expressionism, . . . particularly as it filtered out to places like Princeton and around the country, which was the idea of the artist as a terrifically sensitive, ever-changing, even ambitious person—particularly, as described in magazines like *Artnews* and *Arts* which I read religiously. It began to be kind of obvious . . . and terrible and you began to see through it. . . . I began to feel strongly about finding a way that wasn't so wrapped up in the hullabaloo, . . . something that was stable in a sense, something that wasn't constantly a record of your sensitivity, a record of flux.[55]

Stella's visual response was his series of Black paintings, whose intellectual rigor appeared as a strong alternative to the emotions of the Action painters. The rigor of Stella's academic training at Andover Academy and Princeton University was to some extent reflected in the rigor of this early work. Executed between 1958 and 1960, the paintings consisted of symmetrical patterns of stripes, painted in black enamel with a housepainter's brush and were intended to remove illusionistic space from the painting and concentrate on the painting as pure and as an object. As Stella himself said, "My painting is based on the fact that only what can be seen there is there. It really is an object. . . . If the painting were lean enough, accurate enough or right enough, you would just be able to look at it. All I want anyone to get out of my paintings, and all I ever get out of them, is the fact that you can see the whole idea without any confusion. . . . What you

see is what you see."[56] The Black paintings' titles were often taken from blues songs, night clubs, Nazi rhetoric, such as *Arbeit macht frei*, 1958 (slogan for concentration camps); or other "dark" subjects, such as *The Marriage of Reason and Squalor*, 1959 [1.27]. Some of Stella's "purist" aesthetics may be seen as forerunners of the Minimalist movement of the sixties.

With both Abstract Expressionism and the responses it inspired, in opposition and influence, the decade of the fifties saw American painting come to international attention. Such was clearly in evidence by 1958 when a large exhibition called "The New American Painting," organized by the International Council of the Museum of Modern Art, toured eight European countries. American painting had truly come of age under its own origins and auspices.

While the leading movement of the fifties was Abstract Expressionism in the United States, other experiments were taking place in Europe. In the first decade after World War II geometric abstraction with clean-cut forms similar to the type of abstract art favored by artists in the Abstraction-Création group of the 1930s came back, particularly in France, Scandinavia, and Switzerland. In 1947 a group of artists favoring mathematical and geometric tendencies founded the Salon des Réalités Nouvelles. Austerity and discipline appealing to the mind, not the senses, were evident in many of the artists' works. The work was seen as a logical conclusion to earlier Cubist explorations.

A piece such as Auguste Herbin's *Laughter* of 1959 with its clearly delineated colors and forms recalls some of the geometry of the De Stijl painters as well as the Cubists. In Switzerland a leader of a concrete art group in Zurich was Max Bill, who had been a pupil of Josef Albers at the Bauhaus. Others in the group included Camille Graeser, Verena Loewensberg, Richard P. Lohse, and Gottfried Honegger. In his work Bill often used arithmetical or algebraic progressions, with the square as the basic modulus, as seen in his *Two Color Groups with Dark Square Excentrum* of 1956.

But much of the postwar School of Paris abstract painting consisted of a turn toward the more lyrical and personal with fluid forms and colors. The lyrical artists of the School of Paris, often called Lyrical Abstractionists, such as Roger Bissière, Alfred Manessier, Jean Bazaine, Maria Elena Vieira de Silva, Gustave Singier, and Pierre Tal Coat, drew little distinction between representational and nonrepresentational elements in their work. As one sees in Manessier's 1957 *Nocturne*, the painting may be seen as both abstract and representational in its musical and nighttime allusions and connotations. The work in general tended to be "loose" and more improvisatory than the earlier geometric abstraction, although some artists retained a cubist structure in their works. One group of abstract artists, and Henri Valensi in particular, called themselves Musicalists, as they explored the potentialities of the musical score, translated into visual terms. By 1957 the Salon des Réalités Nouvelles realized the dangers of its somewhat narrow aesthetic concerns and changed its name to Réalités Nouvelles–Nouvelles Réalités, to reflect a broader understanding and spirit of abstraction. Other School of Paris approaches included the more calligraphic styles of Hans Hartung, Pierre Soulages, the Chinese artist Zao-Wou-Kij and the richly textured surfaces, often with bold patches of color, of Jean-Paul Riopelle or Nicholaes de Staël. Riopelle was actually of Canadian origin, but in later years he settled in France while still exhibiting in Canada. He and Paul Emile Borduas had founded a group, "Les Automatistes," stressing automatism in 1940 in Montreal. Riopelle was married to American Abstract Expressionist Joan Mitchell. Although the School of Paris work took place independently of the Abstract Expressionist work in the United States, it had some affinities with the American gesture painters, particularly in its search for an intuitive, individual expression. But the School of Paris painting tended to be less radical, much smaller in scale, and more in the French tradition of "La belle peinture."

1.27. Frank Stella, *The Marriage of Reason and Squalor*, 1959. The Museum of Modern Art, New York.

Some of the School of Paris painters, such as Mathieu, Da Silva, Riopelle, Hartung, and Soulages, have also been linked with Tachism or L'Art Informel.

Tachisme (Tachism) was sponsored to a large extent by three "lone wolf" artists, Wolfgang Schultze (Wols), a student of Paul Klee's living in Paris in the late forties, Jean Fautrier, and Camille Bryen. The term *Tachisme* was coined by the critic Michel Tapié to describe paintings containing splotches of color *(taches)*, which appeared to have been applied by chance or whimsy. There were no preconceptions of what was to be. Tapié also used the term *un art autre* or "another art" to describe

this very free, undisciplined art. The splotches of color were said to be ways of dissolving form. The paintings were not projections or expressions of the artist's inner emotions but were to be a state of mind. The work also pointed sometimes to traces of the existence of other beings—animals, objects, people—which were seen as "spots" in the artist's consciousness. In Wols's *Bird* [1.28] he was not necessarily interested in the symbolic or personal significance of birds but in their presence and imprint on the artist and his world, and the subsequent freedom of the artist to express such. According to one critic, Wols's "sole reason for eliminating the image of things—actually it would be more

accurate to say he tried to prevent elements from coming together into rational, comprehensible structures—was to reproduce with the greatest possible immediacy the way alienating external elements can oppress one's consciousness."[57]

Another artist associated with Tachism was Jean Dubuffet. Dubuffet combined figurative and expressionist tendencies in his collecting of *Art Brut* or "crude art" of mental patients, prisoners, and others outside the social mainstream; and used rubbish scraps, among other objects, in his painting, seeking to have society rethink its priorities and values. Beginning about 1945 Dubuffet attempted to break out of traditional modes of painting where colors

1.28. Wolfgang Wols, *Oiseau (Bird)*, 1949. The Menil Collection, Houston.

were brilliant and forms easily understood, as he worked on a thick ground consisting of sand, soot, earth, fixatives, and even chicken droppings into which pigment was mixed. Figures were scratched into the ground, creating a mysterious and primordial experience for the viewer. A particular inspiration for Dubuffet was the book *Bildnerei der Geistes Kranken* by Hans Prinzhorn, containing art of the insane, children's art, and the work of Paul Klee, who had also used children's and psychopathic art as sources.

His 1946 exhibit in Paris, entitled "Mirobolus Macadam et Cie" caused much controversy as it upset the traditional elegance of much of French painting. Dubuffet spoke of his intentions:

> Many people having made up their minds to run me down, have imagined that I take pleasure in showing sordid things. What a misconception. . . . I do my best to rehabilitate objects regarded as unpleasing (do not, I beg of you deny these objects all hope), and my work always stems from an attitude of celebration (of incantation). But a clear-sighted celebration, once all the smoke and camouflage is away. One must be honest. No veils! No shams! Naked, all things first reduced to their worst . . .
>
> And now what happens with art? Art has been considered since the Greeks, to have as its goal the creation of beautiful lines and beautiful color harmonies. If one abolishes this notion, what becomes of art? . . . Art addresses itself to the mind, and not to the eyes. It has always been considered in this way by primitive peoples, and they are right. Art is a language, instrument of knowledge, instrument of communication.[58]

Dubuffet often worked in themes or series, such as his *Corps de Dames,* where, for instance, *Triumph and Glory* [1.29] affronted traditional ideas of female beauty; his landscapes and landscape tables of the early and mid-fifties; and his series of doors, begun in 1957. By the mid-sixties Dubuffet had changed his style to a different palette, of red, blue-black

1.29. Jean Dubuffet,
Triumph and Glory,
December 1950. Solomon
R. Guggenheim Museum,
New York.

and purple, and whites, and depicted doodle-like, organic amoeba forms, which appeared trapped in a giant jigsaw puzzle or maze, as in his *Nunc Stans* of 1965. These "figures" were often translated into sculptural forms on a large environmental scale, such as his 1972 *Group of Four Trees.* But it is probably for his revolutionary ideas and works of the late forties and fifties

that Dubuffet is best remembered.

In general, Tachism may be seen as a form of Expressionism that can be traced back to the German *Die Brücke* artists. Some of the richly textured surfaces of the Tachist paintings inspired Spanish painters such as Antoni Tàpies, who built up his surfaces like old walls or ruins, and Italian artist Alberto Burri, who used odd

materials such as sacking in his paintings. Tà-
pies wrote of his search for new forms:

> Outworn forms cannot contribute to contempo-
> rary ideas. If the forms are incapable of wound-
> ing the society that receives them, of irritating it,
> of slanting it toward a meditation . . . if they are
> not a revulsion, then they are not a genuine work
> of art. . . . The viewer has to feel obliged to make
> an examination of conscience and to readjust his
> former conceptions. The artist has to make him
> understand that his world was too narrow, has to
> open up new perspectives to him.[59]

Burri was a doctor by training and only began
painting as a prisoner of war in the United
States. Some of his works have a marked sense
of violence and brutality in them. They also
have an affinity with Schwitters's collages. In
the mid-fifties he burned designs on thin wood
panels as part of his pieces. His *Composition,*

1953 [1.30], illustrates his ability to portray a
brutal elegance that evokes both irrationality
and order.

The urge toward Expressionist forms sur-
faced also in the Netherlands, where, in 1948,
Karel Appel, Cornelis Corneille, and Georges
Constant formed the Experimental Group,
which opposed De Stijl and academic painting.
Following contact with similar groups in
Copenhagen and Brussels, this became the in-
ternational Expressionist group called CoBra,
so named because most of the artists came from
the Low Countries (CO = Copenhagen, BR =
Brussels, A = Amsterdam). Officially begun in
Paris in 1948, the group as a group lasted until
1951, although some of the artists continued
painting in the CoBra style for a number of
years thereafter. These artists, who included
the Danish Asger Jorn, the Belgian Pierre Ale-
chinsky, as well as Appel, Constant, and Cor-

1.30. Alberto Burri,
Composition, 1953.
Solomon R.
Guggenheim
Museum, New York.

neille, turned to sources such as children's art, primitive art, and graffiti. They emphasized social and political freedoms and a freedom they felt to be inherent in abstract expressive forms. They relied in particular on the gestural brushstroke. Writing in 1949, Constant spoke for the group:

> For those of us whose artistic, sexual, social, and other desires are far-sighted, experiment is a necessary tool for the knowledge of our ambitions—their sources, goals, possibilities, and limitations. . . . It is impossible to know a desire other than by satisfying it and the satisfaction of our basic desire is revolution. Therefore, any real creative activity—that is, cultural activity, in the twentieth century—must have its roots in revolution. Revolution alone will enable us to make known our desires, even those of 1949. The revolution submits to no definition! Dialectical materialism has taught us that conscience depends upon social circumstances, and when those prevent us from being satisfied, our needs impel us to discover our *desires.* This results in experiment, or the release of knowledge.[60]

In comparison to Dubuffet and Lautrier in France, CoBra's work in general tended to be more frenzied and violent. Karel Appel's *Personnage,* 1961 [1.31], shows an electrifying combination of color and linear concerns (Plate 3).

Through friendship with Asger Jorn, the artist Wifredo Lam was also somewhat linked with the CoBra group. Born in Cuba of a mixed Chinese, black, and Spanish background, Lam had experienced the problems in Cuba that eventually led to the revolution which he supported. But he left Havana for Spain in 1923 and went to Paris in 1938, where he met the Surrealists and Picasso, who became his friend. Lam shared a studio with Jorn in the late forties and was included in the large CoBra exhibition of 1951. In the late fifties he established a studio in Italy, where he worked until the late seventies, although he retained a formal residence in Paris. Lam combined expressionistic tenden-

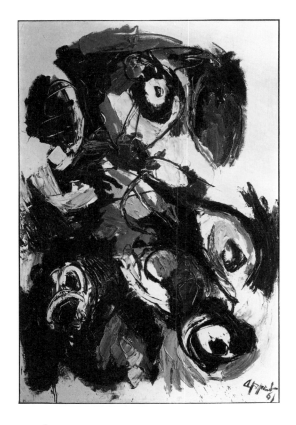

cies with motifs of Afro and Cuban life, which influenced both European and American art. In his 1950 *Zambezia, Zambezia* [1.32] one sees the influence of the Surrealists and Picasso. But this woman is also a woman/beast from a world of primitive mythology, an image that is both real and fantastic. Lam has written of his work, "My pictures are a reflection, an intimate confession of my existence. They have a deep relation with the 'interior' and with the movement of my childhood. . . . I decided that my painting would never be the equivalent of that pseudo-Cuban music for nightclubs. I refused to paint cha-cha-cha. I wanted with all my heart to paint the drama of my country, but by thoroughly expressing the Negro spirit, the beauty of the plastic art of the blacks."[61] In 1960 Lam married the young Swedish artist Lou Laurin thereby extending his influence to Scandinavia.

During the fifties and sixties he was sometimes associated with artists in the Situationists (see discussion under Multi- and Intermedia, 1945–1960) and the group Phases.

Expressionistic form and content were also seen in the work of other Latin and South American artists, some of whom were to have an influence on both European and American artists. Roberto Matta Echaurren, or Matta, as he was called, came to Paris in 1933 from his native Chile and became closely associated with the Surrealists. His "psychological morphologies," as he called them, influenced a number of American artists while he was in New York from 1938 to 1948.

> When I started painting, it was through a necessity, of trying to find an expression which I call morphology, of the functioning of one's thinking, or one's feeling. I tried to use, not my personal psychic morphology, but a social morphology. Using the totemic images involved in a situation which was more historical; the torture chambers and so on. I tried to pass from the intimate imagery, forms of vertebrae, and unknown animals, very little known flowers to cultural expressions, totemic things, civilizations.[62]

Matta's paintings have embraced a variety of themes, including pre-Columbian, colonial, and Catholic heritage, and political conflicts. In 1941 he spent time with Robert Motherwell exploring Incan and Mayan monuments and cultures in Mexico. In the late forties and the fifties, though, he broke with the Surrealists and Abstract Expressionists, feeling they were too limited, and turned toward creating a cos-

1.31 *(opposite)*. Karel Appel, *Personnage*, 1961. Michelle Rosenfeld, Inc., Fine Arts.

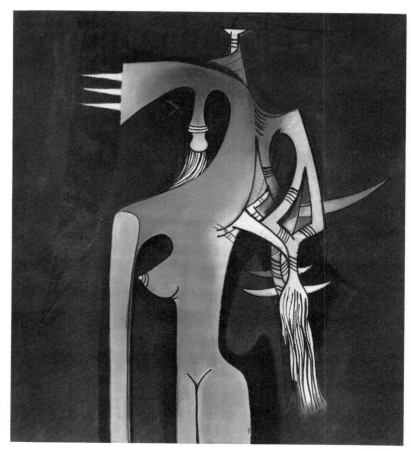

1.32. Wifredo Lam, *Zambezia, Zambezia*, 1950. Solomon R. Guggenheim Museum, New York.

mic plan that would unite art and science. In *A Grave Situation,* 1946, for example, transparent planes converge and conflict as machine-like forces push and pull and are manipulated by futuristic beings. Yet the crucifixlike imagery catapults the viewer into spiritual and ritualistic realms, as Matta seeks to unmask humanity's identities. As he remarked, "Through art we want to put away the mask, to show our own face and make a better system of human relations."[63]

Also associated with the Surrealists and fantastic imagery was the Mexican Frida Kahlo. Although she died in 1954, the compelling images she created, of physical and psychic pain of her own and her country's anguish, continue to have enormous impact on those who view them. Her 1945 *Moses* is one example that combines historical and personal imagery of pain, conflict, and myth. Kahlo's life was one filled with the physical pain, resulting from an accident at age fifteen that crushed her pelvis and spine, undergoing thirty-five operations, and the turbulence of her relationship and marriage with the noted Mexican muralist painter Diego Rivera. Many of her works also dealt with the several painful miscarriages she experienced. Her works, usually portraits, and often self-portraits, combined folk elements of her native Mexico and traditional Christian symbolism. Noted also for her colorful dress and her collection of Mexican folk art, she associated with a number of important artistic and political figures of her time—including Leon Trotsky, Nelson Rockefeller, André Breton, Isamu Noguchi, and Clare Booth Luce.

Associated with the Mexican muralist movement but moving beyond, to tenets of Modernism, during this era was another Mexican, Rufino Tamayo. By 1938 Tamayo was spending winters in New York and summers in Mexico City. In New York through exhibitions and personal contacts Tamayo came into contact with the work of Picasso, Matisse, and knew personally Marcel Duchamp, Stuart Davis, Yasuo

Kuniyoshi, and Joan Miró. Some of Tamayo's most powerful work was done between 1946 and 1956, in paintings that depicted monstrous images of the human figure such as *Woman Reaching for the Moon* of 1946 or *Cosmic Terror* of 1954. He spoke of the time as a "tragic moment when man is assaulted by machines," and his fear that "technology will reduce men and women to robots and calculating machines, if it even lets them live at all."[64] In 1957 Tamayo moved to Paris, where he stayed for seven years. His figures became flatter and less violent. In *Woman in Grey,* 1959 [1.33], one sees the influence of both Picasso and primitive artisans, such as the ancient art of the Cyclades, as a woman's body becomes a musical instrument and totem figure. In his work the ordinary is transformed into a mythic fantasy. In this work one also finds the strong blue that appeared frequently in traditional Mexican households.

In Italy artists such as Emilio Vedova employed the aesthetic of the American Abstract Expressionists, while artists such as Lucio Fontana and Piero Manzoni extended the realm of painting in different ways. Vedova and Fontana had in the early forties been a part of a partly expressionist, partly neo-realist Corrente group that had formed in 1940 in opposition to the Novecento realism fostered by the Fascist regime. The group included Vedova, Renato Birolli, Renato Guttso, Ennio Morlotti, Giuseppe Santomaso, Giacomo Manzù, and Afro and Giuseppe Capogrossi.

Following the war there was a regrouping into the New Front of the Arts as small groups took various approaches to a new art. A Realist Manifesto of 1946 emphatically declared "painting . . . is an act of participation in the totality of human reality in a particular time and place."[65] The "Forma" group in Rome, including Carla Accardi and Piero Dorazio, spoke of the compatibility of formalism and Marxism. In the "Origine" group Capogrossi and Alberto Burri pointed to the importance of a social con-

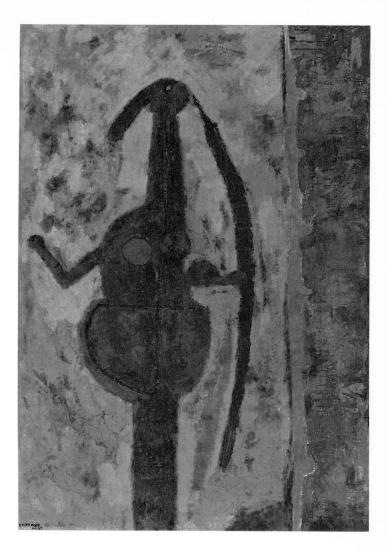

1.33. Rufino Tamayo, *Woman in Grey,*
1959. Solomon R. Guggenheim Museum,
New York.

cern in art through collaborations with architecture and industrial design.

Lucio Fontana, who had returned from Argentina, where he had written his *Manifesto Bianco,* declared, "Today, the human spirit tends to exist in a transcendental reality and go beyond particulars to discover Unity and the Universal through an act of the spirit now entirely free of the constrictions of matter."[66] In the 1950s he painted *Spatial Concepts* [1.34], which were monochrome canvases with perforated holes. The pierced surfaces (and the gesture of perforation was important) appeared in Milan at the same time Pollock began to experi-

ment with pouring pigments onto the canvas. With his perforations Fontana raised questions about the portrayal of space and shadow in traditional modes.

Another small group, the Nuclears, followed the spacialists, emphasizing the significance of exploring an atomic universe. By 1957 the Nuclears and Piero Manzoni, who was close to Fontana, the German ZERO group (see discussion in Multimedia and Intermedia, 1945–1960), as well as Yves Klein (see page 100) issued a "Manifesto Against Style" to "affirm that the essence of the work of art is in its existence 'as a modifying presence in a world that by now

1.34. Lucio Fontana, *Spatial Concept*, 1957. The Museum of Modern Art, New York.

has a need for presences rather than representations.'"[67] Manzoni eliminated color and figural allusions from his work to produce an "achrome" that was to exist as an object without space or color references. He made eleven identical pictures in white. Italian artists thus entered the international art scene after the war with a variety of themes and experiments.

In Great Britain immediately following the war artists such as Jack Smith, whose work was almost Social Realist, reflected the difficulties of postwar recoveries. Many British artists prior to the mid-fifties looked to Paris for new developments. Initially little was known in Europe about the Abstract Expressionists due to few periodicals and international exhibitions. After two exhibitions of American Abstract Expressionists in London in 1956 and 1959, however, a number of younger artists visited the United States or were influenced by the work. Some

artists, such as Jack Smith, became distinguished abstract painters. Two British painters whose works were widely shown abroad during the late forties and early fifties were Francis Bacon and Ben Nicholson. Bacon's powerful expressionist pieces often evoked pain and anxiety. Nicholson's work, which influenced a number of other British artists, consisted mainly of geometric abstractions that were Constructivist-based.

But perhaps more important in Great Britain at this time were the intimations of Pop art that emerged by the mid-fifties. The work of Richard Lindner may be seen as precursor to the world of Pop art, while Richard Hamilton, Peter Blake, and Eduardo Paolozzi may be seen as the pioneers of the first generation of British Pop art, which appeared in the mid-fifties independently of American Pop art. Richard Hamilton's collage *Just What Is It That*

Makes Today's Homes So Different, So Appealing?, 1956, is usually considered to be the first Pop "painting." The piece showed two pin-up figures, male and female, in a mechanized environment of mass culture. A vacuum cleaner, tape recorder, and television were accompanied by a Music Hall program, sentimental comic strip, and can of ham, among other things. The piece appeared in a 1956 exhibit entitled "This Is Tomorrow" at the Whitechapel Gallery in London. In the catalog for the exhibit, Hamilton wrote, "We reject the notion that tomorrow can be expressed through the formal presentation of rigid formal concepts. Tomorrow can only extend the range of the present body of visual experience. What is needed is not a definition of meaningful imagery but the development of our perceptive potentialities to accept and utilize the continual enrichment of visual material."[68] "Tomorrow" was to bring a decade fraught with changes in the arts and all aspects of society, which would make the fifties seem quiet in comparison.

NOTES: PAINTING, 1945–1960

1. Clement Greenberg, *The Nation*, April 7, 1945 (n.p.).
2. Willem de Kooning, "What Abstract Art Means to Me," *Museum of Modern Art Bulletin* 18, 3 (Spring 1951) (n.p.).
3. Robert Motherwell, quoted in Brown, Hunter, Jacobus, Rosenblum, and Sokol, *American Art* (New York: Harry N. Abrams and Prentice-Hall, 1979), p. 477.
4. Adolph Gottlieb and Mark Rothko, letter to *New York Times,* quoted in Edward Alden Jewell, " 'Globalism' Pops into View," *New York Times*, Sunday, June 13, 1943.
5. Adolph Gottlieb and Mark Rothko, *The Portrait and the Modern Artist.*
6. Rothko, mimeographed script of a broadcast on "Art New York," H. Stix, director, WNYC, New York, Oct. 13, 1943, p. 4.
7. Ibid.
8. Letter to Roland L. Redmond, Metropolitan Museum of Art, 1950. Quoted in Calvin Tomkins, *Off the Wall: Robert Rauschenberg and the Art World of Our Time* (New York: Penguin Books, 1980), p. 48.
9. Tom Wolfe, *The Painted Word* (New York: Farrar, Straus and Giroux, 1975), pp. 59, 62.
10. Ibid., p. 58.
11. Brian O'Doherty, *American Masters: The Voice and the Myth in Modern Art* (New York: E. P. Dutton, 1982), p. 97.
12. Jackson Pollock, "Jackson Pollock," *Arts and Architecture* 61, 2 (February 1944): 14 (answers to a questionnaire).
13. John D. Graham, "Primitive Art and Picasso," *Magazine of Art* 30, 4 (April 1937): 236–37.
14. Jackson Pollock, "My Painting," *Possibilities* (Winter 1947–48), cited in Ellen Johnson, ed., *American Artists on Art, from 1940 to 1980* (New York:
Harper & Row, 1982), p. 4.
15. Jackson Pollock, quoted in O'Doherty, *American Masters*, p. 123.
16. Frank O'Hara, quoted in Elizabeth Frank, *Pollock* (New York: Abbeville Press, 1983), p. 71.
17. Quoted in Frank, *Pollock*, p. 105.
18. Quoted in Mark Stevens, "The American Masters," *Newsweek*, January 2, 1984, p. 67.
19. Quoted in Ellen Landau, "Lee Krasner's Past Continuous," *Artnews*, February 1984, p. 76.
20. Quoted in Nancy Heller, *Women Artists: An Illustrated History* (New York: Abbeville Press, 1987), p. 163.
21. Irving Sandler, *The Triumph of American Painting: A History of Abstract Expressionism* (New York: Harper & Row, 1976), p. 131.
22. Brian O'Doherty, *American Masters*, pp. 160–63.
23. Franz Kline, quoted in Katherine Kuh, *The Artist's Voice: Talk with Seventeen Artists* (New York and Evanston: Harper & Row, 1962), p. 144.
24. Franz Kline, quoted in Brown, Hunter, et al., *American Art*, p. 490.
25. Barnett Newman, "The Sublime Is Now," *The Tiger's Eye*, no. 6, December 1948, p. 51.
26. Clyfford Still, letter to Gordon Smith, January 1, 1959, in catalog of an exhibition "Paintings by Clyfford Still," Albright-Knox Art Gallery, Buffalo, N.Y., November 5–December 13, 1959, n.p.
27. Charles Giuliano, "The Tragic Legacy of Mark Rothko," *Art New England*, October 1988, p. 3.
28. Quoted in Lee Seldes, *The Legacy of Mark Rothko* (New York: Holt, Rinehart and Winston, 1978), p. 64.
29. Ibid., p. 2.
30. Ibid., book jacket.
31. Robert Motherwell, a conversation at lunch, Smith College, Northampton, Mass., November 1962.
32. Robert Motherwell, in *An Exhibition of the Work of*

Robert Motherwell (Northampton, Mass.: Smith College Museum of Art, 1963), p. 8.

33. Robert Motherwell, statement in *The New Decade*, New York, Whitney Museum, 1955.

34. Joan Mitchell, *The Subject Is Women*, National Museum of Women in the Arts (New York: Universe Books), n.p.

35. Larry Rivers, "A Discussion of the Works of Larry Rivers," *Artnews*, March 1961, p. 54.

36. To use Irving Sandler's phrase. In *The Triumph of American Painting* Sandler chronicles in particular the development of Abstract Expressionism from 1949 to 1952.

37. Helen Frankenthaler, quoted in "The Achievement of Helen Frankenthaler," *Art International*, September 20, 1967, p. 36.

38. Kenneth Noland, quoted in Philip Leider, "The Thing in Painting Is Color," *New York Times*, August 25, 1968.

39. Katherine Klapper, *Morris Louis, Major Themes and Variations* (Washington, D.C.: National Gallery of Art, n.d.), pp. 1–2.

40. Ibid., p. 1.

41. Ad Reinhardt, "Art as Art," *Art International*, December 1962, n.p.

42. Lawrence Alloway, quoted in H. H. Arnason, *History of Modern Art: Painting, Sculpture, Architecture* (New York and Englewood Cliffs, N.J.: Harry N. Abrams and Prentice-Hall, 1986), p. 493.

43. Club panel, "The Role of the Critic in Contemporary Art," May 25, 1956, John Ferren (moderator), Robert Goldwater, Clement Greenberg, Thomas Hess, and Stuart Preston. Quoted in Irving Sandler, *The New York School* (New York: Harper & Row, 1978), p. 279 (notes taken by Sandler).

44. John Ferren, "Stable State of Mind," *Artnews*, May 1955, pp. 22–23, 62–64.

45. Allan Kaprow, "The Legacy of Jackson Pollock," *Artnews*, October 1958, p. 26.

46. William Rubin, "Young American Painters," *Art International* 4, 1 (1960): 24–31.

47. Quoted in William Seitz, *The Art of Assemblage* (New York: Museum of Modern Art, 1961), p. 116.

48. Quoted in George M. Cohen, *A History of American Art* (New York: Dell, 1971), pp. 240–41.

49. Quoted in "The Most Living Artist," *Time*, November 29, 1976, p. 54 (no byline).

50. Leo Steinberg, *Other Criteria: Confrontations with Twentieth Century Art* (New York: Oxford University Press, 1972), p. 90.

51. Douglas Crimp, "On the Museum's Ruins," in Hal Foster, ed., *The Anti-Aesthetic: Essays on Postmodern Culture* (Port Townsend, Wash.: Bay Press, 1983), p. 53.

52. Quoted in "The Most Living Artist," p. 61.

53. Quoted in Michael Crighton, *Jasper Johns* (New York: Harry N. Abrams, 1978), p. 27.

54. Quoted in ibid., p. 36.

55. Quoted in William Rubin, *Frank Stella*, exhibition catalog (New York: Museum of Modern Art, 1970), p. 13.

56. Quoted in Bruce Glaser, interviewer, and Lucy R. Lippard, "Questions to Stella and Judd," *Artnews*, September 1966, pp. 58–59.

57. Maurice Besset, *The Universe History of Art and Architecture* (New York: Universe Books, 1976), p. 162.

58. Quoted in Dore Ashton, ed., *Twentieth Century Artists on Art* (New York: Pantheon Books, 1985), pp. 122–23.

59. Cited in Alexander Cirici, *Tàpies: Testimony of Silence* (New York: Tudor, 1972).

60. George Constant, *Cobra* (Amsterdam), no. 4 (1949), p. 304. Translated by Lucy Lippard.

61. Wifredo Lam, quoted in Ashton, ed., *Twentieth Century Artists on Art*, pp. 117–18.

62. Matta, quoted in ibid., p. 117.

63. Quoted in *Matta*, exhibition catalog (La Jolla, Calif.: Tasende Gallery, 1980), p. 13.

64. In Emily Genauer, *Rufino Tamayo* (New York: Harry N. Abrams, 1974), pp. 22–23.

65. Cited in Henry Martin, "The Italian Art Scene," *Artnews*, March 1981, p. 72.

66. Quoted in ibid., p. 73.

67. Henry Martin, ibid., p. 73.

68. Cited in Eddie Wolfram, *History of Collage* (New York: Macmillan Co., 1975), p. 159.

PRINTMAKING, 1945-1960

THE postwar period brought radical changes in the medium of printmaking as it grew to stand as an independent entity rather than a mere adjunct to the other work of two- and three-dimensional artists. Artists began to work directly on the plate or stone rather than translating a preliminary drawing to the print medium. Although it was not until about 1960 that prints began to have a major presence in the art world, important experimentation in this ancient medium had been occurring since 1945. "Perhaps never before have so many major painters and sculptors created prints," wrote Elaine L. Johnson, associate curator of drawings and prints at the Museum of Modern Art about this period. "To the artists printmaking offers challenges in method, material, and often scale, enabling them to expand their creative expressions and make them available. The ready availability of prints in turn benefits many members of the public, giving them the opportunity to extend their knowledge of developments in modern art and acquire original works of art at modest cost."[1]

One of the most important and influential printmakers in the United States and Europe was the British engraver Stanley William Hayter. During the twenties he had established an experimental graphics workshop called Atelier 17 in Paris. Hayter and his fellow printmakers revived the art of engraving by combining it experimentally with etching and introducing outside elements to create new and stimulating textures. Hayter's workshop profoundly influenced artists such as Picasso, Chagall, and Miró. In 1940, fleeing the Nazis, Hayter moved Atelier 17 to New York at the New School for Social Research. Hayter's group experimented with color printing, relief whites, printing in plaster, and techniques of soft-ground etching, to name a few. Hayter had also developed a system of automatic drawing to capture some of the Surrealist spirit, by randomly moving the plate around as he moved his burin.

In 1944 Jackson Pollock walked into Hayter's studio and for the next year created a series of plates and trial proofs, exploring context and form similar to his paintings and drawings of the time, combining Hayter's techniques with his personal imagery. The plates he had engraved in 1944-45 were packed away when he moved to a small Long Island farmhouse with his new wife, Lee Krasner, in 1945. It was not until 1967 that these plates were discovered in a warehouse, and new editions of fifty were printed of the seven plates (eight engraved sides).

William Baziotes, Mark Rothko, and Robert Motherwell also printed at Hayter's studio, although Motherwell learned more about etching at the studio of Kurt Seligman, an émigré Surrealist artist. Atelier 17 in the forties be-

came a meeting place for European artists flee-
ing Europe and a school for young printmakers.
A few prints were made there by artists such as
André Masson, Yves Tanguay, Jacques Lip-
chitz, Max Ernst, Marc Chagall, Joan Miró, Sal-
vador Dali, Matta, and Alexander Calder. In
1950 Hayter returned to Paris. In 1951 in Paris
a large collaborative project involving artists
and poets was begun. In 1960 it was finally com-
pleted as an album by one of the poets, Morris
Weisenthal, and contained the first prints of
Franz Kline and Willem de Kooning.

Among those attracted to this printmaking
haven were Gabor Peterdi and Mauricio La-
sansky. Peterdi, painter and printmaker, origi-
nally from Hungary, had wandered through
Europe to Paris, attracted by the Surrealists. He
was influenced by his work with Hayter and
after the forties greatly affected two genera-
tions of students. His *Germination,* 1952 [1.35],
an aquatint, etching, and engraving, stands as a
symbol and metaphor for the burgeoning of
new forms and techniques. While teaching at
Yale University, Lasansky had developed his

intaglio technique in Argentina and worked
with Hayter in New York. In 1945 he went to
the University of Iowa to establish a teaching
intaglio workshop, where he urged students to
rebel against the old academic forms and ex-
periment with new forms. His workshop in-
spired students who left there to start new
ones, and facilities for printmaking began to
emerge in a number of universities.

Some of the most audacious experiments in
intaglio in the fifties were done by two French
artists, Pierre Courtin and Pierre Soulages,
both of whom created highly textured surfaces.
Courtin's work was literally three dimensional,
with raised surfaces like bas reliefs cast in lami-
nated paper. His *Chant G,* 1953, illustrates his
belief that engraving was a tactile art, not a
visual one. Working in France as well was the
Japanese-born Yozo Hamaguchi, who became a
master of the mezzotint. The stillness and emp-
tiness of his sparse still lifes, such as *Asparagus
and Lemon,* 1957 [1.36], are quite Zenlike. His
velvety surfaces are alluring and mysterious.

In Germany Rolf Nesch continued his ex-

1.35. Gabor Peterdi,
Germination, 1952. The
Museum of Modern Art, New
York.

1.36 *(opposite).* Yozo
Hamaguchi, *Asparagus and
Lemon,* 1957. The Museum of
Modern Art, New York.

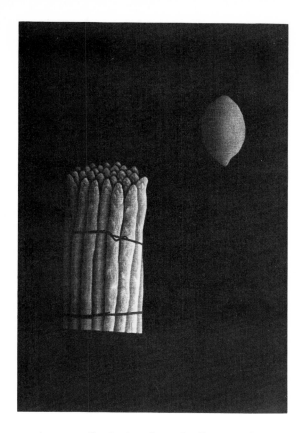

periments of printing from "collages" of metal and junk materials on metal plates. During the fifties his work was widely exhibited and may be seen as a forerunner to interests in "junk" assemblage. In the Netherlands the unusual etchings of Anton Heyboer, who had been left for dead in a Nazi work camp at age nineteen, were done on roofing zinc. Done in a primitive and expressionistic manner, the work contained statements, numbers, and occasional figures. Some appeared in maplike configurations that seemed like schemas to make sense of Heyboer's confused world, as seen in *The System with Figure*, 1957.

The development of centers of printmaking spawned the birth of a variety of "institutions" to show the emerging work. The Brooklyn Museum's annual National Print Exhibition, an open exhibition, began in 1947. Regular regional and international exhibitions devoted themselves to prints, such as the Northwest Printmakers Society, the Philadelphia Print Club, and international biennials of prints in Cincinnati (begun in 1950), Ljubljana (1955), and Tokyo (1957).

In Europe the ancient art of the woodcut, which had been used so forcefully by the German Expressionists, was used by a number of CoBra artists, along with lithography and etching. The Dutch printmaker Maurits Cornelius Escher became noted for his wood engravings, which were so enigmatic yet often mathematically based. His use of multiple perspectives and disjunctive spatial imagery throws the viewer into new and strange worlds, as in his 1947 *Other World* [1.37]. There, human-headed birds "guard" the entry/exit from the classical architectural realm to a world of lunar craters. The drug-oriented subculture of the sixties was particularly attracted to Escher's work.

In Japan Munakata Shikō continued his vigorous work in woodcutting. Unlike traditional Japanese woodcuts, his were often frenzied and intense. His boundless energy was an inspiration for a new revival of Japanese prints. He worked solely with the woodcut until the end of his life in 1977, despite his contemporaries' preference for more fashionable mixed media prints.

The art of the woodcut and relief printing was influenced by an interest in German art in America, and in particular by the arrival of Max Beckmann in America in 1947. The 1950 Brooklyn Museum exhibit "American Woodcut: 1670–1950" included a few contemporary artists, such as Antonio Frasconi from Uruguay, who had begun to make woodcuts there in 1944, Adja Yunkers (who had arrived from Stockholm after the war), and Josef Albers.

Among those influential in the teaching of woodcut was Louis Schanker, who experimented with building up his surfaces with vibrant forms and colors. (Hayter intensely disliked the medium of woodcut, referring to such printmakers as "woodpeckers.")[2] Adolph Gottlieb worked with Schanker in 1944–45. Among Schanker's students were Leonard Baskin and

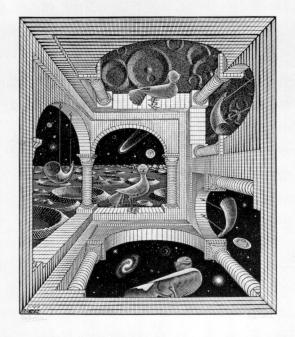

1.37. M. C. Escher, *Other World*, 1947. The Museum of Modern Art, New York.

1.38 *(below).* Leonard Baskin, *Torment*, 1958. The Museum of Modern Art, New York.

Carol Summers. In many of his prints of the fifties, Baskin responded to injustices and conflicts of the postwar years in his large expressionist woodcuts. Works such as *Man of Peace*, 1952, responded to the Korean conflict. His 1958 *Torment* [1.38] illustrates both a personal and universal sense of anguish and despair, as he skillfully calls the grains of the wood to cry forth.

Carol Summers's *Chinese Landscape* is an example of an Oriental influence that became significant at the time. During this period,

the freshest new influence seems to have come from Japan, but not necessarily only from the famous Ukiyo-e prints. The Japanese people were seen in their own country for the first time by considerable numbers of impressionable young Americans—soldiers on duty in Japan with the Army of the Occupation—and their daily lives and surroundings were discovered to contain elements that could be applied Stateside. Reverence for natural objects, beautifully mutilated or otherwise transformed by nature, was a novel idea to the Americans, who thereafter be-

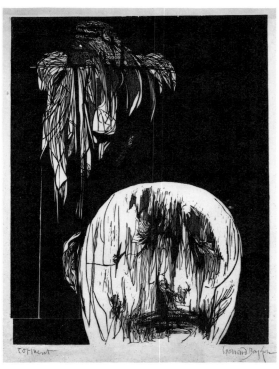

came fascinated by driftwood and weathered rocks. Calligraphy, especially when executed in a heavy inked, free manner, was also fresh and intriguing.[3]

Lithography remained an important printmaking technique in Europe following the end of World War II, particularly in France, which had well-established commercial houses. Jean Dubuffet found the medium of lithography particularly well suited to his crude and often childlike techniques, which resulted in multiple textures and fanciful forms. He experimented directly on the lithographic stone with different chemical reactions and even used fire. He delighted in some of his effects created by technical accidents. His *Work and Play* of 1953 shows his typical playful figures, which are the only parts deliberately sketched. The subtle color harmonies of grays, pinks, and tawny browns in combination with the rich textures of the surface illustrate the extent of his imagination and originality for the time. Alberto Giacometti used the technique of lithography to create a master image, and produced editions of prints similar to his drawings, as is seen in his 1952 *Bust*, portraying Giacometti's brother Diego, his frequent model. Other European artists using figurative and expressionistic qualities in their work, such as Francis Bacon, Graham Sutherland, Henry Moore, Antonio Saura, and the Polish Maryan, used lithography to recapitulate their painting and drawing concerns.

Lithography in the United States did not really flourish experimentally until the late fifties, with the founding of Universal Limited Art Editions (ULAE) by Tatyana Grossman in her cottage in West Islip, Long Island, in 1957. After her artist husband Maurice's heart attack, which made it difficult for him to continue painting and teaching, Grossman needed to support her husband and herself. Originally from Siberia and educated at the Dresden Academy of Arts and Crafts, Grossman had little business or art experience. But with courage, a second-hand lithography press, some

lithographic stones found in the garden, and support from artist friends and students, a printmaking workshop was born that would influence the course of lithography. Larry Rivers was the first artist to work at ULAE. Among his projects was a collaboration with the poet Frank O'Hara, which resulted in their *Stones,* 1957–59, containing both visual imagery and text.

Grossman provided an atmosphere that inspired artists to truly experiment with the medium of printmaking. She often personally delivered small lithographic stones to artists' studios, hoping to entice them to work with her. In 1960 Jasper Johns at thirty made his first lithographs with Grossman, of his target and number images. Rauschenberg began making lithographs at ULAE in 1962 when he explored John Cage's theories of chance. His well-known *Accident,* 1963 [1.39], for which he won the international print competition in 1963, was made following the cracking of the large lithography stone during proofing. Rauschenberg took the broken bits of stone, added them to the composition and printed with the cracked stone.

De Kooning made his first lithograph, a large calligraphic, movement-filled piece, *Untitled,* 1960, at the workshop of Nathan Oliveira and George Miyasake at the University of California in Berkeley, dipping a floor mop into tusche and swabbing the stone in an utterly untraditional fashion, thereby transferring the gestures of "action" painting to the stone.

The appearance of a print by such a famous artist, at a moment when his drawings and paintings had a wide and appreciative audience, had no precedent. From an economic point of view . . . de Kooning's lithographs presented an astonishing situation: within two years they were selling at the same level as Picasso's colorful linoleum cuts. . . . De Kooning's prints, therefore, may be seen as forecasting the burgeoning impact on the art market of works by American painters in the print mediums.[4]

1.39. Robert Rauschenberg, *Accident*, 1963. Courtesy Universal Limited Art Editions, West Islip, N.Y.

In general, though, printmaking was not a major medium for the Abstract Expressionists.

The founding of Grossman's workshop closely coincided with the founding of the Pratt Graphic Art Center in 1956, pushing for artists to work directly on stones and plates rather than having work reproduced by a master craftsman. And in 1960 June Wayne, a Chicago painter who had worked with Lynton Kistler in lithography on the West Coast, founded the Tarmarind Lithography Workshop in Los Angeles with the support of the Ford Foundation

for a decade. Her workshop too was to lead to significant changes in approaches to printmaking. One of the goals of Tarmarind was to resurrect the art of lithography and introduce the art to mature artists.

Serigraphy as a medium for artists came into use by the fifties. Silk-screening, or serigraphy, was originally considered a rapid and cheap way of reproducing commercial images. It was not until 1932 that the first American artistic screenprints were recognized in the work of Guy Maccoy, who was inspired by the colored stencils of French artists then exhibiting in New York. During the Depression in the United States a WPA silk-screen project under the sponsorship of artist and printmaker Anthony Velonis brought silk-screening to the attention of serious artists for the first time. Carl Zigrosser, then curator of the Philadelphia Museum of Fine Arts, began to use the term *serigraph* (Latin *seri*, meaning silk, Greek *graphos*, to write) to differentiate creative processes from commercial endeavors. In 1940 a National Serigraph Society was formed in the United States, and by the fifties artists such as Ben Shahn, Ruth Gikow, Harry Sternberg, Velonis, and Marcel Duchamp in the United States were readily using silk screen. The most successful serigraphs were "hard-edge" pieces where the artist used sharply delineated planes of flat color—edge next to edge. During the fifties a number of American silk-screen artists went to Europe, where an exchange of concepts and methods of screenprinting provided the basis for a full-scale blooming of silk screening in the sixties.

NOTES: PRINTMAKING, 1945–1960

1. Elaine L. Johnson, *Contemporary Painters and Sculptors as Printmakers* (New York: Museum of Modern Art, 1966), pp. 5, 9.
2. Quoted by Sue Fuller, "Symposium on American Prints, 1913–1963," Museum of Modern Art, New York, December 3, 1974 (unpublished transcript of the proceedings).
3. Riva Castleman, *American Impressions: Prints Since Pollock* (New York: Alfred A. Knopf, 1985), p. 19.
4. Ibid., p. 73.

PHOTOGRAPHY, 1945–1960

DISCUSSION of postwar photography as an art form in America perhaps really begins in 1940 with the establishment of a permanent department of photography at the Museum of Modern Art under the directorship of Beaumont Newhall, a young art historian. The founding of the department followed Newhall's curating an important exhibition, "Photography 1839–1937," probably the first "modern" survey of photography, at the museum in 1936. Significant, too, was the museum's first one-person exhibition, *American Photographs*, by Walker Evans, in 1941. Evans's spare but eloquent imagery was to influence documentary as well as formalist and poetic photography in the decades following. Newhall's pioneering support of the art of photography led to exhibitions of photography by leading art museums in Europe and America and the inclusion of photography courses in art schools and universities. In 1949 George Eastman House was founded, also contributing to the advance of photography. By 1950 both black and white and color images had captured much of the globe, particularly due to the popularity of picture magazines, which in particular advanced the documentary photographic image.

As World War II ended a variety of trends in photography including "straight," documentary, and formalist, existed and were to be fur-

ther explored and sometimes combined in the fifties. The tradition of straight photography, established by major early twentieth-century photographers such as Alfred Stieglitz, Paul Strand, Edward Weston, and Ansel Adams, was continued. Alfred Stieglitz's death in 1946 marked the end of an influential photographer and impresario/gallery dealer, capable of inspiring and supporting both artists and clients. Yet Stieglitz was to illumine future horizons in photography.

As a young man Ansel Adams had met Stieglitz, and their continuing relationship through correspondence and personal contact was to foster American East–West Coast cultural exchange. Both Stieglitz and Adams were committed to the artistic "equivalent," that art was an equivalent of the artist's most profound experience in life. Both, for much of their careers, were committed to straight photography, where the final image was visualized in advance, and exact images of great detail and rich texture, often interpreting humanity and its environment, were printed with great precision. Stieglitz gave Adams a one-man show in 1936, and Adams dedicated his *Portfolio One* to Stieglitz. For Adams, Stieglitz was somewhat of a father confessor, although some of Adams's images done prior to meeting Stieglitz indicate their similar aesthetic concerns. In many ways

they were soulmates. Some of Adams's letters to Stieglitz indicate the profound influence of the older man on the young Adams. "My visit with you provoked a sort of revolution in my point of view—perhaps the word simplification would be better. . . . If you have not given me the awareness of anything but a standard, I would be eternally grateful. It is up to me and to others that have so greatly benefited through your influence to pass the message."[1]

Adams continued for much of his career the aesthetic established by the short-lived West Coast group "f/64" begun in 1932, which included Adams, Edward Weston, Willard Van-Dyke, Imogen Cunningham, and Consuelo Kanage. The group promoted the achievement of great depth of field and overall sharpness, particularly through using a large-format camera, small lens aperture (whence the name of the group), and printing by contact rather than enlarging. As an environmentalist, Adams devoted much of his life to photographing and preserving sweeping mountain, valley, and desert vistas, particularly in the Rockies and Sierra Nevadas. Although Adams had been trained as a pianist, he was lured to photography as a teenager by the gift of a Brownie camera, and a visit to Yosemite. Although drawn to the sublime of the dramatic American vistas he captured in film, he also did a number of powerful portraits, such as that of Georgia O'Keeffe and Orville Cox, and Edward Weston (1945). In the forties Adams invented the Zone System, a system of exposure and development that allowed the photographer to control the tones of black and white prints. Adams became both a teacher and promoter of photography. Between 1948 and 1956 he published four photography books. He also published a book of photographs, *Born Free and Equal,* that included some he had taken of the thousands of Japanese-Americans interned in the Manzanar Relocation Center in California during the war. In 1949 he was named a consultant to the Polaroid Corporation and worked with Edwin Land on the Polaroid Land process, which had been invented by Land in 1947. The process, which allowed the photographer to process a high-quality picture a few moments after shooting, without spending time in the dark room, opened up a great new territory for photographic exploration.

Adams was director of the Sierra Club from 1936 to 1970. He fought outspoken battles against those trying to develop Big Sur in California and led a drive to remove U.S. Interior Secretary James G. Watt from office in the early eighties. Although he stopped taking photographs for public consumption in 1965, he continued to update his books and promote photography and conservation. In 1979 he was featured on the cover of *Time,* the first photographer to be featured there. At his death in 1984, at age eighty-four, he left a legacy of dramatic, precisely composed and articulated images, in particular his powerful landscapes, which spoke so well of what is perhaps America's most original and greatest natural resource—her land. Among his best-known photographs are *Moonrise over Hernandez,* taken in fifteen seconds when he stopped his car one day in 1941 in New Mexico, and his *Moon and Half Dome, Yosemite National Park, California,* 1960 [1.40]. A work such as *Half Dome* shows his reverence for his subject matter and his meticulous sensitivity to composition and tonal areas. His ability to render light in complex and beautiful ways separated him from many other landscape photographers. His work, although traditional in subject matter, was approached with a modern eye, an eye that attempted continually to remind the viewer that there may be a paradise "out there," and, if existing nowhere else, it was permanently recorded in his alluring black and white images. Adams wrote of his experiences in Yosemite in an introduction to his *Portfolio 3.* "Who can define the moods of the wild places, the meaning of nature in domains beyond those of material use? Here are worlds of experience beyond the world of the aggressive man, beyond history, and beyond science. The

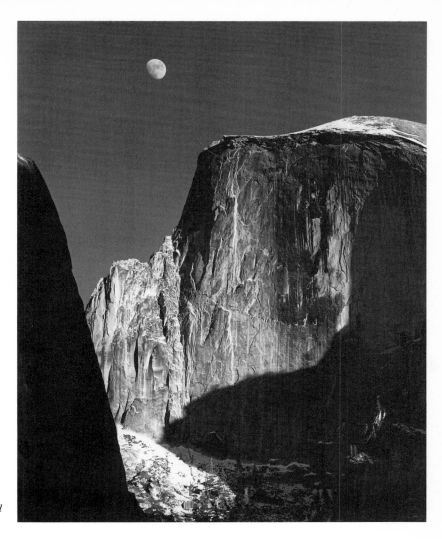

1.40. Ansel Adams, *Moon and Half Dome, Yosemite National Park, California*, 1960.

moods and qualities of nature and the revelations of great art are equally different to define; we can grasp them only in the depths of our perceptive spirit."[2]

The legacy of the straight image was to be used in other ways, as seen in the work of Harry Callahan, Minor White, and Aaron Siskind. Callahan, as illustrated in his *Weed Against the Sky*, Detroit, of 1948 [1.41], explored new depths of imagery by "revealing the subject in a new way to intensify it."[3] This piece, with its simplicity of image, bears suggestions of Oriental and inner worlds. Callahan's poignant images of his wife, Eleanor, and his urban landscapes, particularly of Chicago, also point to the inner significance of the subject. Callahan was the first photographer to represent the United States in photography at the Venice Biennale in 1978.

These photographers were associated with the Institute of Design in Chicago, where some of the most interesting experiments in photography were done during the forties and fifties. There László Moholy-Nagy and Gyorgy Kepes, both exiles from the Dessau Bauhaus and innovators in photographic techniques, held positions. With the influence of the Bauhaus figures and continuing advances in scientific photography, photographers such as Callahan, Siskind, and White were able to combine Bauhaus ideas

and Stieglitz's ideas of "equivalents," where the subject is only the starting point, leading to feelings and metaphorical experiences unconnected with the initial subject. Minor White explored the "equivalent" in his photographs, teaching, and writing:

> To get from the tangible to the intangible (which mature artists in any medium claim as part of their task) a paradox of some kind has frequently been helpful. For the photographer to free himself of the tyranny of the visual facts upon which he is utterly dependent, a paradox is the only possible tool. And the talisman paradox for unique photography is to work "the mirror with a memory" as if it were a mirage, and the camera a metamorphosing machine and the photograph as if it were a metaphor. . . . Once freed of the tyranny of surfaces and textures, substance and form [the photographer] can use the same to pursue poetic truth.[4]

The photograph was to be transformed into a new experience. As editor and publisher of *Aperture,* a quarterly magazine devoted to photography begun in 1952, White frequently published visual and verbal statements alluding to his statement above. As indicated in its inaugural statement signed by Minor White, Dorothea Lange, Beaumont and Nancy Newhall, Dody Warren, Ernest Louie, Melton Ferris, and Barbara Morgan, *Aperture* was "intended to be a mature journal in which photographers can talk straight to each other, discuss the problems that face photography as profession and art, comment on what goes on, descry the new potentials . . ."[5] The impact of White's energy and creativity was noted by Gerry Badger:

> Its [*Aperture*'s] energy sprang from Minor White, an intense, charismatic, almost demented individual who bore the twin crosses of Roman Catholicism and homosexuality, the one willingly, the other perhaps not. Spirit, however, could never quite vanquish flesh, which made his quest for the spirit even more desperate. Ultimately such a personal quest had to be made alone. It would seem significant that when he died in 1976, the Minor White "school" appeared to die with him, almost overnight, with few remnants or rites of passage.[6]

White's *Ritual Branch* of 1958 [1.42] exemplifies well his quest for spiritual metamorphosis.

Aaron Siskind emphasized linear elements and sharp edges of his often ambiguous images. He had initially been concerned with social documentary work as part of his role in the Photo-League in New York in the late thirties. But he turned to more formal concerns following the summer of 1944 that he spent making a series of still lifes of ropes, fishheads, and other discarded objects in the small fishing village of Gloucester, Massachusetts. As he stated:

> For the first time in my life subject matter, as such, ceased to be of primary importance. Instead, I found myself involved in the relationships of these objects, so much so that these pictures turned out to be deeply moving and personal experiences. . . . Our province is this small bit of space, and only by operating within that limited space, endlessly exploring the relationships within it—can we contribute our special meanings that come out of man's varied life. Otherwise our photographs will be vague. They will lack impact, or they will deteriorate into just genres as so many documentary shots do.[7]

Siskind became friends with painters of the New York School, such as Franz Kline, and joined in the often heated discussions of a num-

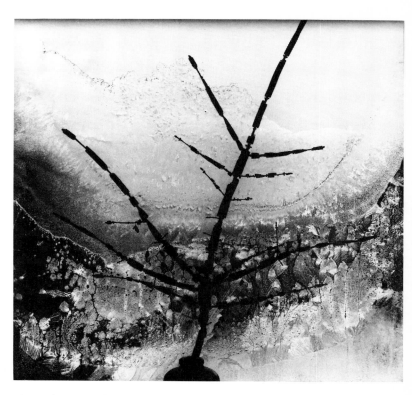

1.41 *(opposite)*. Harry Callahan, *Weed Against the Sky*, Detroit, 1948. Courtesy Pace/MacGill Gallery, New York.

1.42. Minor White, *Ritual Branch*, 1958. International Museum of Photography at George Eastman House, Rochester.

ber of artists at the Cedar Bar. The influence of some of the large gestural strokes of the painters is seen in some of his works, such as *Chicago 25*, 1957, or his later *Chicago 10 or 16*, 1965 [1.43].

In postwar Europe, in attempts to revitalize the spirit of photographic experiments at the Bauhaus that had been shunned by the Hitler regime, a German physician, Otto Steinert, renounced medicine for photography and began with some friends to reexamine photography's potentials. As with some American photographers such as Minor White, there was an interest in exploring notions of metamorphosis and inner realities. Using the name "fotoform," Steinert and his circle exhibited their work first in Milan and then at an international photographic trade show, "Photokina," in 1950 in Cologne. The great success of the show inspired Steinert to organize a large international exhibition in 1951 at the City Art School in Saarbrucken, where he was director. The show, entitled "Subjektive Fotografie," was accompa-

nied by a book containing a large number of photographs and three essays discussing new ideas about photographic aesthetics by Steinert and the art historians J. A. Schmoll, called Eisenwerth, and Franz Roh. (Roh had written the book *Foto-Auge*, which accompanied an important 1929 Film and Foto exhibition in Stuttgart.) Included in the 1951 exhibition were some photographs of the former Bauhaus artists, Moholy-Nagy, Herbert Bayer, and Man Ray. Two subsequent exhibitions were held in 1954 and 1958. Steinert also organized several exhibitions in the Folkwangmuseum at the Folkwangschule in Essen, where he was director of the department of photography. His own work alternated between purely formalistic concerns in montage and photogram techniques, and straight, stark landscapes and portraits.

In England Bill Brandt, one of Britain's best-known photographers, explored inner realities creating optic distortions through the use of a wide-angle lens and a small aperture, as seen in

1.43. Aaron Siskind, *Chicago 10 or 16*, 1965. Museum of Art, Rhode Island School of Design, Providence.

his 1953 *Nude, East Sussex Coast.* In the twenties Brandt had been influenced by Man Ray and associated with the Surrealists, while in the thirties he had turned to social documentation, showing contrasts among social classes in his photographs.

Beyond the camera, some photographers also turned to cameraless imagery. The photogram, a technique involving the exposure to light of objects placed on photographic paper and subsequent development of the paper, alone and in combination with other experimental techniques attracted a number of photographers. The technique was actually an early nineteenth-century discovery that had been particularly revived and renewed by Bauhaus photographers. In the United States Carlotta Corpron, Nathan Lerner, and Lotte Jacobi experimented with free-form procedures.

Lotte Jacobi's lovely lyrical abstractions, which she called "photogenics" [1.44], were among the results of these experiments. The photogenics were named by Leo Katz, painter, master teacher, and printmaker who had been persuaded by Jacobi to give a course on cameraless photography in 1946 to counter the boredom of her then-ill husband, Erich Reiss, who had distinguished himself as a publisher in Germany. In the course Jacobi went beyond the photogram technique "to move light around" by playing with glass, cellophane, and cut paper. For her "the experience was a marvel. With the photogenics, I felt young again."[8] Jacobi had left Germany in 1935 for New York, leaving much of her work behind. Following her husband's death in 1951, Jacobi continued her photogenics work as well as her portraits of well-known figures, particularly those in the arts, for which she had become known earlier. Her portraits of Albert Einstein, Minor White, Paul Caponigro, Peter Lorre, Marc Chagall, Alfred Stieglitz, Robert Frost, and Thomas Mann are windows looking into the inner psyches of other creative figures. She also exhibited the work of other artists, including painters, sculptors, and printmakers, in her New York studio on Fifty-second Street and studied printmaking further with Leo Katz at Atelier 17. Following her husband's death in 1951, she moved to Deering, New Hampshire, in the summer of 1955 with her son John and his wife, Beatrice. She continued to make photographs and take courses, and her work has been shown internationally. Otto Steinert and Albert Renger-Patzsch, among her first supporters, continued to include her in international exhibitions.

Barbara Morgan also experimented with photograms and other techniques of light drawing and montage. Europeans such as Herbert Franke in Austria, Peter Keetman in Germany, and Jaroslav Rajzik in Czechoslovakia used oscilloscopes and prisms to produce geometric abstractions similar to earlier Russian Constructivist work.

Other approaches to cameraless imagery

1.44. Lotte Jacobi, *Photogenic*, date unknown. Addison Gallery of American Art, Andover, Mass.

during the fifties included experiments on glass plates that produced nonobjective patterns that were printed on monochromatic silver, and color dye-transfer materials—a modernization of *cliché verre*. The American Henry Holmes Smith produced some works with affinities to Abstract Expressionist painting of the era. Fredrick Sommer also experimented with glass and cellophane in the fifties, painting on or smoking the glass to create nonobjective shapes. Sommer, versatile and enigmatic, who had been called architect, painter, composer, philosopher as well as photographer, also created montages, assemblages, and straight photographs. Some of his work has been connected with Surrealism, but his work often goes beyond the Surrealist aesthetic into deeper, uncharted territory, as is seen in his *Circumnavigation of the Blood*, 1950 [1.45]. As Minor White wrote in 1956, "Frederick Sommer makes no concessions to the casual observer. . . . Consequently a superficial glance at his pictures reveals as much as a locked trunk of its contents."[9] Sommer himself later stated, "You have to learn to take chances, you have to learn to appreciate juxtapositions, a set of things, a constellation of things in a way that you just happen to meet. You have to be flexible enough to see the possibilities."[10]

French photographer Jean Dieuzaide created sensitive textural abstractions by using pitch, while Jean Pierre Sudre used chemical salts on glass in a random fashion, a technique he called "crystallography."

During the fifties formal and metaphorical experiments in photography were concurrent with documentary work and responses to society and culture. Photojournalism flourished under the auspices of picture magazines like *Life* and *Look*. War and destruction had been chronicled, but so too were remote places and cultures, everyday life, and scientific microphotographs. The photojournalist Andreas Feininger's *Self Portrait* is perhaps exemplary of the piercing eye of many of the photojournalists. The need for photographs for photo essays led to the establishment of picture agencies and photographers' collaboratives. One of the best-known collaboratives, Magnum, was founded by Robert Capa, Cartier-Bresson, George Rodger, and Chim (David Seymour) in 1947.

1.45. Frederick Sommer, *Circumnavigation of the Blood*, 1950. Collection the artist.

Indeed, in a fifties America documentary photography following in the traditions of Jacob Riis and Lewis Hine was favored over formalist experiments. Photography critics Bruce Downes, editor of *Popular Photography,* and Jacob Deschin, critic for the *New York Times,* tended to champion documentary work. And Willard Morgan and Edward Steichen, who succeeded Beaumont Newhall at the Museum of Modern Art, also favored the documentary approach. One of the most popular and important exhibitions of the fifties was "The Family of Man" show organized by Steichen at the Museum of Modern Art. One of the first blockbuster shows of 508 photographs by 273 photographers from sixty-eight countries, the show traveled to forty-one countries in various versions and was seen by approximately nine million people. The show was intended to show the oneness and interconnectedness of men and women throughout the world in its common rituals of birth, love, work, death, peace, justice, and so forth. But there was criticism at the time as well as in retrospect for its editorial superficialities. One writer asserted:

> The human experience is universalized, and thereby trivialized, into a series of simplistic and woolly minded—though undoubtedly liberal—platitudes. The real complexities of life, rooted in the social order, are overlooked.
>
> *The Family of Man* presented a rag-bag of certified, archetypal notions in a form easily digested by a mass audience, whose presiding values it both summarized and confirms. . . . *The Family of Man* was, in short, the embodiment of fifties photo-journalistic values, their zenith. It was also the last great fling of this mode, a mode that was becoming less relevant both to photographers, and, though more gradually, to the communications industry.[11]

"The Family of Man" exhibit and book also illustrated to some extent the conflict inherent in

magazine photography—between editorial request and selection on one side and the ideas of individual photographers on the other. W. Eugene Smith in light of such conflicts resigned from *Life* magazine twice and was often in debate with his editors.

During the same year of "The Family of Man" exhibition, a Swiss fashion photographer turned photojournalist, Robert Frank, was roaming the United States on a photographic journey, capturing various facets of an American postwar society under the auspices of a Guggenheim Fellowship. Frank had first come to the United States in 1947 and became particularly friendly with Walker Evans. The result of his ten thousand miles of travel was a book, *The Americans,* published in France in 1958 and in the United States in 1959. Frank's images were often irreverent, exposing the glut of a consumer society and subtle racial attitudes that perhaps only an outsider could have so captured in the fifties. In *Trolley, New Orleans*

[1.46] from the book one sees Frank's abilities to capture complex psychological and social issues without resorting to verbal rhetoric. The windows of the trolley become structural boxes on the continuum of a grid, whose structure separates the people on the trolley literally and figuratively. There is no contact between the figures in the images or with the world outside the trolley, except for blank stares. The trolley and its windows become a metaphor for entrapment, of alienated figures of the "social landscape" (a termed coined by photographer Nathan Lyons in the sixties). Some of the images in the book were blurred or unevenly framed, reflecting Frank's rebellion against established print techniques. Many Americans did not want to deal with Frank's style or content, and he was widely criticized. Frank's America was similar to Jack Kerouac's America in *On the Road,* an invisible America at the side of the road.

Frank's work, more than the work of a Sis-

1.46. Robert Frank, *Trolley, New Orleans* (from *The Americans*). The Art Institute of Chicago.

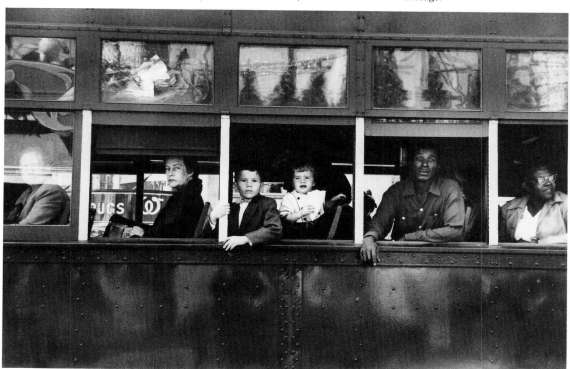

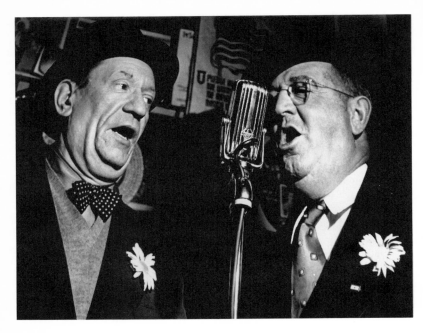

1.47. Lisette Model, *Singers at Sammy's Bar, New York,* c. 1950. Addison Gallery of American Art, Andover, Mass.

kind, White, or Callahan, was to have a profound effect on photographers of his own, as well as subsequent, generations. William Klein in the fifties photographed New York in raw and harsh scenes. His book *Life Is Good and Good for You in New York Trance Witness Reveals* shook many in the photographic world in 1956. Others who commented later on culture in similar terms were Gary Winogrand, Les Krims, Lee Friedlander, and Danny Lyon (see discussions in later sections on photography).

Another European working in the United States from the fifties on was Lisette Model, initially known for her eerie images of bench sitters on Monte Carlo. Upon coming to the United States, some of her work was done for *Harper's Bazaar.* Her work of the forties and fifties is blunt and forces confrontation of the subject and viewer, as evidenced in her *Singers at Sammy's Bar, New York* of c. 1950 [1.47]. Model also became noted as a teacher. One of her most prominent students was Diane Arbus (see page 151).

Looking back over the fifties, the two publications *Aperture* and *The Americans* serve as significant examples of two major tracks of photography during that era. White and his colleagues had initiated new ways of approaching form and interpretation, while Frank initiated new responses to the social landscape.

NOTES: PHOTOGRAPHY, 1945–1960

1. Ansel Adams to Alfred Stieglitz, March 15, 1936, April 18, 1938, Beinecke Library, Yale University.
2. Adams, *Portfolio 3,* first published in hardcover by New York Graphics, Boston, 1977.
3. Harry Callahan quoted in John Szarkowski, ed., *Callahan* (New York and Millerton, N.Y.: Museum of Modern Art and Aperture, 1976), p. 14.
4. Minor White quoted in *Art in America* 46, 1 (1958): 52–55.
5. Quoted in Peter Turner, ed., *American Images: Photography 1945–1980* (New York and London: Viking Press and Barbican Gallery, 1985), p. 14.
6. Gerry Badger, "From Humanism to Formalism: Thoughts on Post-War American Photography," in ibid., p. 14.
7. Quoted in Carl Chiarenza, *Aaron Siskind: Pleasures and Terrors* (Boston: New York Graphic Society, 1982), p. 14.
8. Lotte Jacobi quoted in Kelly Wise, ed., *Lotte Jacobi* (Danbury, N.H.: Addison House, 1978), p. 12.
9. Quoted in Turner, ed., *American Images,* p. 51.
10. Ibid.
11. Badger, "From Humanism to Formalism," p. 13.

SCULPTURE, 1945–60

Much sculptural work in the years imme-
diately following World War II con-
tinued or revived early twentieth-century
Modernist forms, as works by artists whose ca-
reers had been interrupted by the war flow-
ered. Among the older masters who continued
their work were Picasso, Jean Arp, Jacob Ep-
stein, and Naum Gabo. Picasso's 1951 *Baboon
with Young* [1.48], which employs two cars to
form the mother baboon's head and jug to form

1.48. Pablo Picasso,
Baboon and Young,
1951. The Museum of
Modern Art, New York.

her body, shows Picasso's continuing inventive-
ness and marvelous imagination and presages
later, more brutal "junk sculpture." A deviation
from his earlier Dadaist orientation, Arp's
smooth stone carvings of organic and figurative
forms, such as his 1958 *Torso Sheaf*, gave new
impetus to his career. In 1954 he was awarded
the major prize for sculpture at the Venice
Biennale.

Two of the older masters who dominated
postwar sculpture were Henry Moore and Al-
berto Giacometti, whose work exerted influ-
ence for several generations. Giacometti was
obsessed with the condition and essence of hu-
manity, and his work often reflects the despair
of Existentialism (Giacometti was friends with
Jean-Paul Sartre). His lonely figures often stand
untouched by and unconnected with their
world. The tall, elongated figures for which he
became known, with no distinct or refined de-
tails but rather a textural roughness, may be
seen as monuments to the plight of modern
humanity. His 1948 *City Square* [1.49] ex-
presses the subtle anxieties of anonymity and
alienation of the modern age. Important in the
piece, beyond the figures, is the void and emp-
tiness of the square—man, alone and alienated.
Although he drew his subject matter from the
people around him—his mother, his brothers,
in particular his brother Diego, the objects in

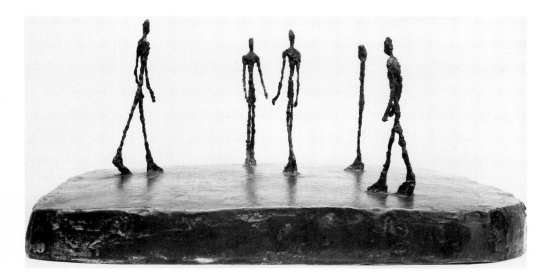

his studio—his figures were both specific and universal. "I'd like to make a head that would be the head of everyone," he said, "but which, with only slight modification, could become any particular person."[1] Born in the small, rocky Swiss village of Borgonovo and inspired by his father, Giovanni Giacometti, a Post-Impressionist painter, Alberto had copied reproductions of old master paintings as a young boy. His first sculpture was of his brother Diego. He studied painting and drawing at the Ecole des Beaux-Arts and sculpture at the Ecole des Arts-et-Métiers in Geneva. In the late twenties he was associated with the Surrealists but broke away from them. From 1935 to 1940 he worked with a model all day but later turned to his memory. During the war, after spending months in a Paris hospital following a 1938 car accident, Giacometti worked on tiny figurative sculptural pieces, paring them down to their essence, small enough to fit in matchboxes. In 1947 Pierre Matisse persuaded Giacometti to send his sculptures to be exhibited in New York. Giacometti also exhibited in Paris after the war but was continually dissatisfied with his work, always searching for a perfected image to match his vision, in sculpture as well as in painting and printmaking. Upon viewing his works

displayed in a Geneva gallery in 1963, three years before his death, Giacometti commented, so typically, of himself, "All this is only sketches. I do as much as possible with the same model, but I'll never finish. Every day I find something new. The closer you approach, the more there is to see; the more there is to see, the more you know, the more mysteries there are."[2] Exhibits of Giacometti's work in the forties were to inspire some of the Abstract Expressionists.

Capturing some of the same angst as Giacometti, but in a more turbulent fashion, was the work of Germaine Richier. Her figures became enmeshed in tangles of bat wings, spiders' webs, and rotted leaves, as one sees in her 1956 *Batman* [1.50]. Here there was no escape from the tangled web, only a sense of entrapment and transformation of the human figure. As a girl growing up on a farm in Southern France, Richier had become interested in the metamorphosis of insects, and transferred this interest to her sculpture. In the fifties Richier also experimented with different materials as she added paint and broken glass to her work. She also collaborated for a short time with Hans Hartung and Maria Elena Viera da Silva.

Approaching the figure in a more refined fashion than Giacometti or Richier, yet experi-

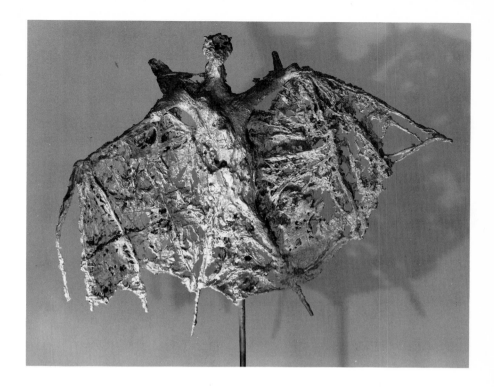

1.49 *(opposite)*. Alberto Giacometti, *City Square*, 1948. The Museum of Modern Art, New York.

1.50. Germaine Richier, *The Batman*, 1956. Wadsworth Atheneum, Hartford.

menting with combinations of surrealism and abstraction, was the English Henry Moore. Son of a coal miner, Moore had studied at the Royal College of Art until 1925. He was influenced by a variety of sources he found in British and European museums, from Pre-Columbian, pre-classical, and African to the Surrealists in the thirties. During the war he became an official War Artist, saving him from the front, and became known for his *Shelter Drawings,* of figures in London's underground air-raid shelters, which were to inspire later sculptures of family groupings and draped figures. It was not until after the war that Moore's work began to have international influence. In 1946 a retrospective of his work was held at the Museum of Modern Art in New York. In 1948 he received the International Prize for Sculpture at the Venice Biennale, and in 1953 he was awarded the International Sculpture Prize at the São Paulo Biennale. In the early fifties Moore experimented with large, angular, bonelike figures, as his 1952–53 *King and Queen* [1.51], where the faces are masklike yet regal. He became partic-

ularly noted for his reclining figures. Some of these reflect his formal concerns with positive and negative spaces and shapes, such as his *Interior Exterior Figure,* 1951. Others are concerned more with the states of humanity, such as the death and destruction inherent in his *Falling Warrior* of 1956–57. Many of his reclining figures also suggest landscapes, alluding to parallels between body and land forms. In 1957 Moore was commissioned to do a large-scale piece for the UNESCO building in Paris—a seventeen-foot-long travertine marble reclining figure, classical but also modern. Early on, Moore spoke of some of his concerns in sculpture:

Appreciation of sculpture depends upon the ability to respond to form in three dimensions. That is perhaps why sculpture has been described as the most difficult of all arts; certainly it is more difficult than the arts which involve appreciation of flat forms, shape in only two dimensions. Many more people are "form-blind" than color blind....

This is what the sculptor must do—He must

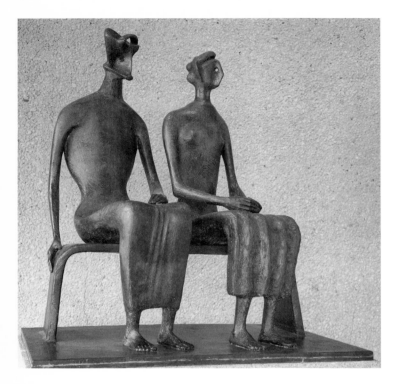

1.51. Henry Moore, *King and Queen*, 1952–53. Hirshhorn Museum and Sculpture Garden, Washington, D.C.

strive continually to think of, and use, form in its full spatial completeness. . . . The first hole made through a piece of stone is a revelation. . . . The hole connects one side to the other, making it immediately more three dimensional. . . .

Each particular carving I make takes on in my mind a human, or occasionally animal character and personality, and this personality controls its designs and formal qualities, and makes me satisfied or dissatisfied with the work as it develops. . . . My sculpture is becoming less representational . . . and so what some would call more abstract; but only because I believe that in this way I can present the human psychological content of my work with the greatest directness and intensity.[3]

Similar in some ways to Moore's sensibilities was the work of another British sculptor, Barbara Hepworth. Hepworth was more influenced by Constructivism, however, particularly following her second marriage, to the

English painter Ben Nicholson, also influenced by the earlier Constructivist esthetic. During the war Hepworth had moved from London to St. Ives with her young family, which included triplets. The coastal landscape nearby was to influence her later work. Her work in the early fifties focused particularly on series of figurative groups in white marble, somewhat reminiscent of ancient Cycladic art forms. She later switched to larger-scale biomorphic and organic sculptures, often containing open "voids," such as her *Sea Form (Porthmeor)*, 1958 [1.52], which suggests the expansiveness of the sea and the forms of its creatures and plant life. After 1960 she was awarded a number of large-scale commissions, and one of her most famous pieces is the *Single Form* (memorial to Dag Hammarskjöld) at United Nations Plaza in New York, created in 1962–63 following Hammarskjöld's death in 1961. In 1965 Hepworth was named Dame Commander of the Order of the

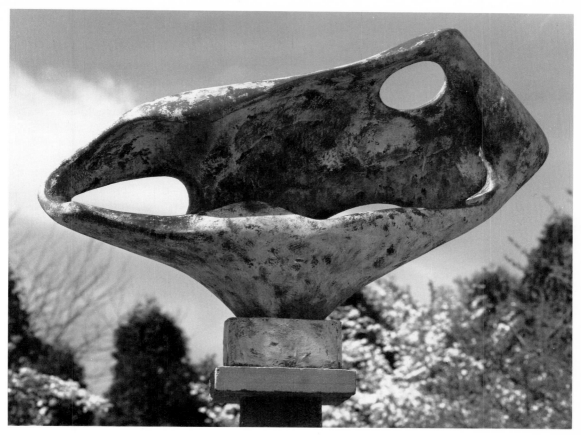

1.52. Barbara Hepworth, *Sea Form (Porthmeor)*, 1958. Hirshhorn Museum and Sculpture Garden, Washington, D.C.

British Empire. She died tragically ten years later in 1975 when a fire destroyed her studio.

In Britain in the late forties and fifties, a new generation of sculptors besides Henry Moore also came to dominate the British art scene, although some of their work was not to have the far-reaching impact of Moore or Hepworth. These sculptors, who included Kenneth Armitage, Lynn Chadwick, Reg Butler, Eduardo Paolozzi, and Bernard Meadows, were perhaps first noticed internationally at the 1952 Venice Biennale. Trained as an architect, Butler came to sculpture late, beginning in 1944. He invented and patented a new way of casting bronze and became well known when he won the international *Unknown Political Prisoner* competition (to commemorate the fate of unknown political prisoners) in 1953. Continuing

the expressive figurative traditions of Bacon and Sutherland in three dimensions were pieces such as his large *Girl*, 1954–56. Butler's style changed radically in the sixties when he created a series of bronze twisted nudes, painted with simulated flesh and hair materials, that were similar to but more expressive than the works of the American Superrealist sculptor John de Andrea.

Chadwick also began as an architect, made mobiles for a short period, and turned to figurative imagery by the fifties. He was well known for his winged figures, such as *Winged Figure*, 1955, which combines the worlds of a Greek Winged Victory and some of Henry Moore's figures to explore new territories of both grace and awkwardness. His later *Winged Figures* of the sixties became more monumen-

tal and spare, using geometric forms that pushed toward Minimalism.

Perhaps more innovative than Butler and Chadwick was Eduardo Paolozzi. His early work was influenced by Dada and Surrealist artists, and to some extent Jean Dubuffet's "Art Brut." By the fifties Paolozzi had begun to use small machine parts and other found objects imprinted in plaster and finally cast in bronze as he explored relations between technology and art. His *Japanese War God* of 1958 [1.53], which includes fragments of clocks, locks, and cats, speaks to his growing concern for the

death and destruction of humanity through the uncontrolled uses of technology. Increasingly interested in machine forms, Paolozzi created polished aluminum pieces in the sixties, some of which looked like actual machines. Paolozzi was also one of the founders of the Independent Group, meeting at the Institute of Contemporary Arts in London from 1952 onward, which was to become a preliminary voice in the development of British Pop Art.

In Italy two leading figurative sculptors following the war were Giacomo Manzù and Marino Marini, who had achieved acclaim prior to the war. Manzù's work drew upon European influences such as Donatello, Etruscan art, Medardo Rosso, and Edgar Degas, which make much of his work very traditional. Yet there was a vitality given to everyday objects and situations without reference to symbolism that asked the viewer to review the everyday world, as in his 1955 *Young Girl on a Chair* [1.54]. Manzù also did a number of images of Catholic cardinals, but did not always concentrate on the sense of religious mystery that might surround such figures. In some instances the formal volumes of the figure and his robes seem more important. He was close to Pope Pius XII, though, and in 1952 was commissioned to make a new set of bronze doors for St. Peter's Cathedral in Rome.

Unlike Manzù, Marini captured the public's attention through his horses and riders, such as *Horse and Rider* of 1952–53. Before and during the war Marini's riders were seen on the horse. After the war he began to experiment with abstractions of horse and rider, eventually portraying an unseated rider in an abstracted, expressive form. By the early seventies he was portraying aspects of a riding horse in abstraction, as illustrated in *Ideal Stone Composition*, 1971. Marini and Manzù, although basically conservative in their work, provided footstones for Italian sculptors to emerge from the long Fascist period.

In Mexico German-born Mathias Goeritz

1.53 *(opposite)*. Eduardo Paolozzi,
Japanese War God, 1958.
Albright-Knox Art Gallery, Buffalo.

1.54. Giacomo Manzù, *Young Girl on
a Chair,* 1955. Hirshhorn Museum
and Sculpture Garden, Washington,
D.C.

emerged by 1949 as a leading Constructivist sculptor. His large architectural-environmental abstract pieces eluded traditional ideas of sculpture in both scale and content. In 1952 his experimental museum, called The Echo, had large rooms filled with huge geometric structures through which the viewer could walk. More spectacular was his collaboration with Luis Barragan and Mario Pani on *The Square of the Five Towers,* 1957–58, designed as an approach to Satellite City, a new residential section seven miles north of Mexico City. The five painted concrete triangular forms—three white; one yellow; one orange—were designed to soar from 120 to 185 feet into the open air. Works such as these undoubtedly influenced later European and American large-scale site sculptures.

Sculpture in America, like painting, also brought new innovations in form and content in the fifties, perhaps more so than European work, which recalled, in part, prewar efforts. However, the work of individual sculptors, rather than a consolidated school or movement, appears to stand out. One sculptor, who had like a number of Europeans come of age artistically before World War II, was Alexander Calder. A native of Philadelphia, Calder was born into a family of artists—his father and grandfather were both sculptors. He initially studied engineering, but also studied illustration, and turned to art in 1922. He went to Paris in 1926 and attracted attention with his moving wire *Circus.* His first mobiles, so named by Marcel Duchamp (Hans Arp later called the standing pieces "stabiles") were shown at the Galerie Vignon in 1932. Beginning in the late forties he was particularly interested in working in monumental forms, and completed a number of commissions in the ensuing decades, including his 1952 *Acoustical Ceiling,* at Aula Magna, University City, Caracas, Venezuela; his giant *Mo-*

bile executed in 1957 at New York's Kennedy Airport; his 1959 *Black Widow* [1.55] at the Museum of Modern Art in New York; and *La Grande Vitesse,* an imposing and expansive fifty-five-foot-high red stabile at Calder Plaza, Vandenberg Center, in Grand Rapids, Michigan. One of his last pieces before his death in 1976 was a magnificent mobile that was executed and finally finished under the direction of Pierre Matisse for the new wing of the National Gallery in Washington, D.C., designed by I. M. Pei. The mobile stands as a monument to Calder's ingenuity and his contribution to kinetic sculpture.

Like Calder, the Japanese-American sculptor Isamu Noguchi after the war continued to work prodigiously. Born in Los Angeles in 1904 of a Japanese father and an American mother, he spent his childhood in Japan and was to combine brilliantly Eastern and Western forms and concepts in much of his sculptural work. When he first attempted to study sculpture with Gutzon Borglum (later known for his Mount Rushmore portraits of four American presidents), he was told he was not good enough to be an artist. Noguchi tried medical school, but soon returned to sculpture, studying at the Leonardo da Vinci School in New York. In 1927 he received a Guggenheim Fellowship and was able to study in Paris for two years under Brancusi's guidance. Returning to New York in 1929, he made a living by making portrait busts but returned in 1930 to Paris and then traveled to Beijing, where he studied brush drawing and calligraphy for eight months. Subsequently, he lived in Japan for six months, working with clay and studying gardens. During the thirties his art reflected social concerns, such as his sculpture of a lynched man and his seventy-two-foot polychrome cement mural in Mexico City depicting aspects of Mexican history. He also made stage sets for Martha Graham and continued to collaborate with her until his death in 1988. In 1938 he received his first large commission to represent the freedom of the press for the entrance to the Associated Press building in Rockefeller Center in New York. During World War II Noguchi, as a Japanese American, asked to spend six months at a relocation center in Arizona. In the mid-forties he worked on a series of marble pieces that were carved and constructed. His smoothly refined *Kouros,* 1944–45 [1.56], recalls the Greek tradition, as well as Arp and Brancusi, but shows Noguchi's own vision of spatial intricacies. Returning to Japan once again in 1949, he began to realize the significance and potential of stone and its collaborative relationships with other elements

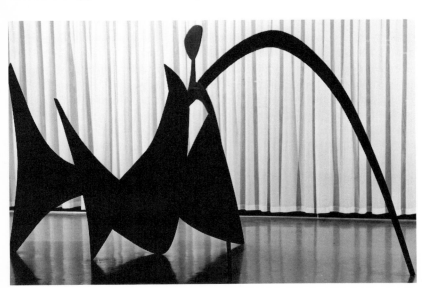

1.55 *(left).* Alexander Calder, *Black Widow,* 1959. The Museum of Modern Art, New York.

1.56 *(opposite, top).* Isamu Noguchi, *Kouros,* 1944–45. The Metropolitan Museum of Art, New York.

1.57 *(opposite, bottom).* Isamu Noguchi, *Portal,* 1976. Cuyahoga Justice Center, Cleveland.

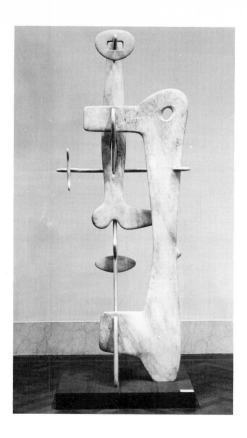

Cleveland [1.57]; and his 1984 *Bolt of Light-ning* (conceived almost fifty years earlier), a 102-foot-tall stainless steel sculpture designed as a memorial to Benjamin Franklin, installed near the Benjamin Franklin Bridge in Philadelphia. In 1985 Noguchi designed and financed his own garden museum, which opened in an old factory building in Long Island City in Queens; and in 1986 he was selected to represent the U.S. at the Venice Biennale, for which he created a 10½-foot-tall marble *Slide Mantra.* Noguchi's vision was unique, not one to be put in a stylistic box. But his combining of Eastern and Western thought and conceptions of space in his sculpture spoke of deep-seated rhythms of nature and the contemplation of ritual.

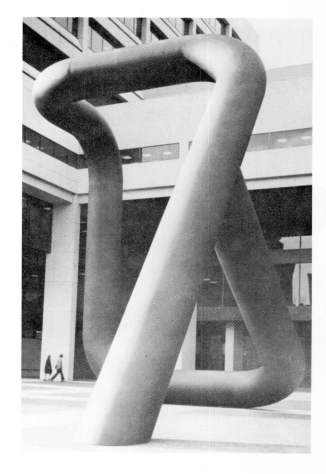

in the environment. "Stone is the fundament of the earth, of the universe," he said. "It is not old or new but a primordial element. Stone is the primary medium, and nature is where it is, and nature is where we have to go to experience life."[4]

During the fifties he became involved in creating full environments—gardens, playgrounds, outdoor environments. One of his best-known works dates from the fifties, *The Fountain of Peace,* for the UNESCO building in Paris, a commission secured under the recommendation of the architect Marcel Breuer. Noguchi selected the stones in Japan. Other large-scale projects later included the Sunken Gardens at the Beinecke Library at Yale University, 1960–64, and the New York Chase Manhattan Bank, 1961–64, the 1968 *Red Cube,* balanced on its tip in southern Manhattan; the 1976 *Portal* at the Cuyahoga Justice Center in

Another unclassifiable figure was Joseph Cornell, whose private and magical boxes made a unique contribution to American art. Cornell spent his early years selling textile samples and did not begin his career in art until he was thirty, in 1932. Some of his early work was influenced by Max Ernst, but it was his friendship with Marcel Duchamp that served as a catalyst for much of his work. The juxtaposition of disparate objects in his boxes partakes of both a dream and everyday world. The boxes were never very big. The largest recorded dimensions are approximately twenty-four by eighteen by six inches, and he often employed a gridlike structure and repetition of related shapes and forms. There is a sense of intimacy yet newness and mystery inherent in many of the boxes, as seen in his *Hotel Eden* [1.58].

Like Cornell, Louise Nevelson created new worlds with found objects in her large assemblages, which often appeared to be private dreamscapes. Her work was indebted to Cubism and Constructivism. The mural scale of her work, analogous to the large scale that dominated much of Abstract Expressionist painting in the fifties, was an important contribution. It is interesting to note that Nevelson had worked as an assistant to the Mexican muralist Diego Rivera in the early thirties. Like the Abstract Expressionist, she too removed the figure from her work to express a private and subjective world, but her work was a more structured and defined expression, as one sees the gridlike format she often used. Nevelson had also visited

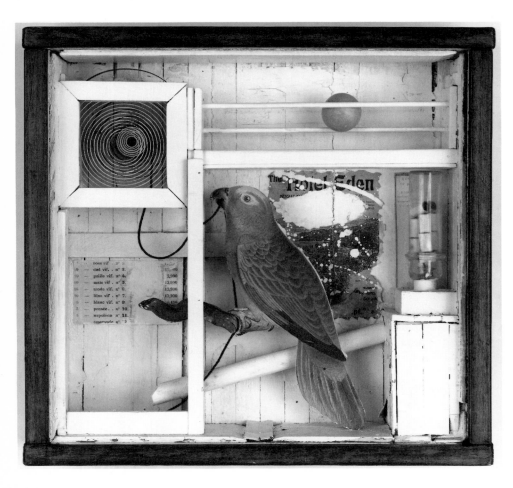

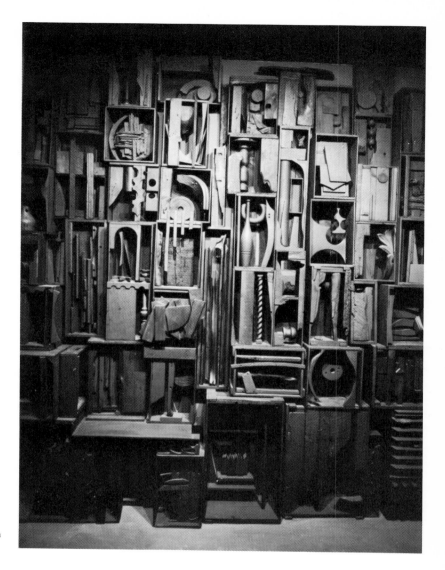

1.58 *(opposite)*. Joseph Cornell, *The Hotel Eden*, 1945. National Gallery of Canada, Ottawa.

1.59. Louise Nevelson, *Sky Cathedral*, 1958. The Museum of Modern Art, New York.

the ancient art and architecture of Mexico and Central America in the early fifties, where she was inspired by the integration of art and mythology and of sculptural form and architectural scale. Her exhibition at Grand Central Moderns in 1955 was titled "Ancient Games and Ancient Places."

Out of her small New York East Thirtieth Street house emerged some new and unforgettable forms that were a far cry from traditional figurative sculpture. Impressive were the inherent sense of drama and theatricality in some of the works, particularly when she turned an entire gallery into a total environment. Her 1958 *Sky Cathedral* [1.59], with its mysterious shadows and forms, is like a stage set, drawing the viewer into its complex shapes. The struggle of stereotype male and female qualities also appears in some of her works. Concerning enclosing her sculpture in boxes, she wrote in 1956:

I wanted to be more secretive about the work and I began working in the enclosures. . . .

There's something more private about it for me and it gives me a better sense of security. I feel that my works are definitely feminine. . . . A man simply couldn't use the means, of say, fingerwork to produce my small pieces. They are like needle-work. . . . My work is delicate; it may look strong, but it is delicate. . . . My whole life is in it, and my whole life is feminine. . . . Women through the ages could have had physical strength and mental creativity and still have been feminine. The fact that these things have been suppressed is the fault of society.[5]

From an early age Nevelson had proven herself to be an independent female. Born in 1899 in Russia of a Russian Jewish family, her family moved to Rockland, Maine, by 1905, and she declared early that she wanted to be a professional sculptor. Living in a small rural town that was anti-Semitic in many ways, Nevelson was anxious to leave. In 1920 she married Charles Nevelson and moved to New York, which was a collage of inspiration for her, as she studied art, acting, and dance. The birth of her son, Myron, and her ever-stronger devotion to art contributed to conflicting roles as mother, wife, and artist and to the dissolution of her marriage by 1931. Fleeing to Europe, Nevelson sought out Hans Hofmann, who encouraged her to look closely at Cubism. Returning to New York, she enrolled at the Art Students League. Her early pieces were of bronze and terra-cotta, but by the fifties she was particularly involved with wood, attracted to its immediacy and its alive qualities. Beginning in the mid-sixties, she also experimented with sculpture made of clear Plexiglas, aluminum, Formica, and Cor-Ten steel. Until her death in 1987, Nevelson in her late years was often seen as the doyenne of sculpture. Despite her intimidating persona, with her paisley scarves and triple-layered eyelashes, she did not see herself as "the strong woman." Personal and private revelations were more important—"When people say that I'm a strong woman, it offends me to no end, because I don't want to be a strong woman. All

I want is to reveal what I understand about the world to myself. And that is my whole search. I want it to be revealed to me. For that I work; for that I will work more."[6]

Another artist who began to make sculpture in the late forties, and who also worked with wood, was Louise Bourgeois. Bourgeois, a native Parisian, had moved to the United States in 1938 when she married art historian Robert Goldwater. She exhibited in shows with Pollock and de Kooning and knew Breton and Miró, who had come to New York as refugees. She was also friends with Le Corbusier and Amadée Ozenfant. A number of her early works had to do with concepts of freedom and resistance. In her piece *The Blind Leading the Blind*, c. 1947 [1.60], consisting of seven pairs of black and seven pairs of red wooden posts united by a horizontal lintel, the black pairs appear ready to break away. She later turned to using other materials that could be poured, modeled, and assembled. In the sixties and seventies she also used plaster and latex to explore male and female themes. Her 1969 plaster and latex sculpture *Little Girl*, showing a doll-size, scaly genital form hanging from a meat hook, is filled with both irony and a foreboding violence.

Also working in wood in some of his sculptural projects was the visionary architect and sculptor Frederick Kiesler, a Romanian-born designer who came to the United States in 1926. Although his work was never well known during his life, he was friends with many avant-garde artists, such as Léger, Duchamp, Mondrian, Van der Rohe, Schoenberg, Varèse, Warhol, Cage, Johns, Rothko, de Kooning, Reinhardt, and Martha Graham. Kiesler felt there was little distinction between sculpture and architecture, and he was among the first to create walk-in sculptural environments, such as his *Galaxies*. In his 1951 *Galaxy* there is an eerie tension created between the wooden, thorned, bonelike forms and the void of the empty space. His designs for structures, such as his plan for an *Endless House* of 1958–59, aban-

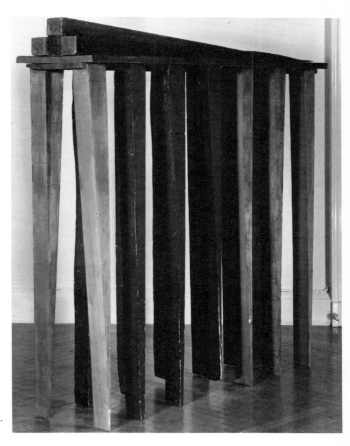

1.60. Louise Bourgeois, *The Blind Leading the Blind*, c. 1947. Robert Miller Gallery, New York. Becon Collection Ltd.

doned traditional rectangular forms for egg-shaped configurations of freely flowing spaces. The house, which was never built, was to be made from reinforced concrete and wire mesh, and included pools, floors of sand and grass, and terra-cotta tile. The materials Kiesler chose in some ways anticipated the work of Frank Gehry several decades later, although Kiesler's work tended to be more organic and contained softer forms. Kiesler's first major structure that was actually built was his Shrine of the Book in Jerusalem, completed in 1965, just a few months before Kiesler's death at age seventy-five.

As is perhaps evident, it was not artists such as Calder, Noguchi, Kiesler, Cornell, Bourgeois,

and Nevelson who captured the most critical approval during the late forties and the fifties. Instead, many critics sought work more easily identifiable with Abstract Expressionism and looked to the fluid metal constructions that appeared to be adapted from Surrealist tendencies. Seymour Lipton, Herbert Ferber, Theodore Roszak, Reuben Nakian, David Hare, and Ibram Lassaw were among those whose work was sought after once Abstract Expressionism had reached its peak. Yet much of their work did not have the vibrance or heroic qualities that made the paintings so powerful. It was really only later with pieces done by the painters, such as de Kooning's figurative bronzes or Barnett Newman's three-dimensional "zips," such

as *Here*, 1950, or his Houston Chapel *Broken Obelisk* [2.49], or work by younger sculptors like Mark di Suvero and John Chamberlain, that some of the expansive Abstract Expressionist sensibilities were more fully realized in three dimensions.

Ibram Lassaw began making abstract sculptures in the thirties and was one of the first American sculptors to use welding. He was a founding member of the American Abstract Artists group in 1936. Lassaw, born in Egypt in 1913, had moved with his Russian émigré parents to New York in 1921 and was quickly attracted to modernist experiments. His works of the fifties were often delicate explorations of space through the use of irregular and like units. Besides being influenced by the Abstract Expressionists, Lassaw was also influenced by sources as diverse as Mondrian, scientific explorations of outer space (one 1954 work was called *The Planets*), and Eastern philosophy. His 1952 *Kwannon* is an ode to the Buddhist goddess of compassion and pity, Kuan Yin.

Of all the sculptors in America during this period, it is perhaps David Smith who was to have the greatest impact on American and European sculpture, with his use of welded junk forms to create new totalities and totems. Born in Decatur, Indiana, Smith showed an interest in art as a teenager and later learned welding techniques while working at an automobile plant. During the war years he worked as a machinist and welder in the American Locomotive Company plant in Schenectady, New York. Settling full time in Bolton Landing, New York, in 1944 and building a studio he called Terminal Iron Works, Smith made a number of open-form linear structures, often based on landscape forms, such as his *Hudson River Landscape* of 1951 [1.61]. His maturity as an artist began with his *Agricola* series, made from abandoned farm tools he had collected around Bolton Landing, and continued to explode with inventiveness through work such as the *Sentinel, Voltri,* and *Cubi* [1.62] series until his untimely death in 1965, when his pickup

1.61. David Smith, *Hudson River Landscape*, 1951. Whitney Museum of American Art, New York.

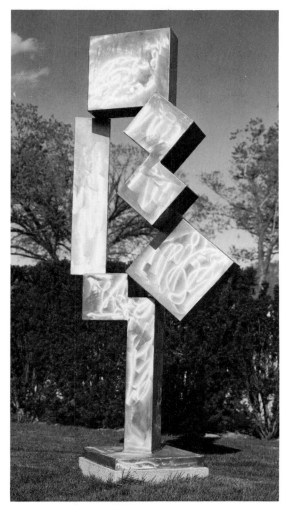

1.62. David Smith, *CUBI XII*, 1963. Hirshhorn Museum and Sculpture Garden, Washington, D.C.

seven sculptures in a month, using scraps from five deserted steel mills near the Italian town of Voltri. Much of Smith's work was meant to be seen outside, and he placed much of it on his land in Bolton. At times his property appeared much like a garden of ten-foot metal blooms, as the painted pieces thrust forth from the ground or as the polished stainless steel of some took on the color of the sky. Beside the power and strength of Smith's work was sometimes hidden a more personal and human side. Some of his pieces contain stenciled letters, parts of his two daughters' names. Other pieces allude to the human form, in an almost lyrical, drawing quality. The complexity and power of his work were indicated in a moving statement by his good friend Robert Motherwell upon his death. "Oh, David," Motherwell wrote, "you were as delicate as Vivaldi and as strong as a mack truck."[7]

Smith's own words echo his deep belief in the power and revolutionary spirit of his art:

I believe that my time is the most important in the world. That the art of my time is the most important art. . . . Art is not divorced from life. It is dialectic. It is ever changing and in revolt to the past. Prior to this the direction of art was dictated by minds other than the artist for exploitation and commercial use. That freedom of man's mind to celebrate his own feeling by a work of art parallels his social revolt from bondage. I believe that art is yet to be born and that freedom and equality are yet to be born.[8]

truck spun off a country road near his studio in Bolton Landing. Smith's work, like Smith himself, was larger than life in spirit and in form. Of large stature and great strength, Smith would often arrange the pieces to be welded by foot, with his heavy work shoes, not by hand or drawing. He often worked quickly, with jazz-like improvisation. For his *Voltri* series, when he was invited to make a sculpture for the Spoleto Festival in Italy, he completed twenty-

Smith was married to artist Dorothy Dehner for twenty-three years, during which time she devoted most of her energies to running their farm, while doing some painting and writing poetry. After their divorce she began to make and exhibit large sculptures of cast bronze, carved wood, and Cor-Ten steel. Often abstract and mysterious, some of the pieces recall African tribal sculpture.

A direct heir of Smith's bold spirit was Mark di Suvero, whose large cantilevered wooden beam pieces reflect Smith as well as Construc-

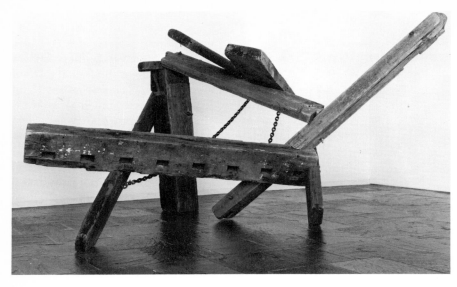

1.63 *(left).* Mark di Suvero, *Hankchampion,* 1960. Whitney Museum of American Art, New York.

1.64 *(below).* Richard Stankiewicz, *Our Lady of All Protections,* 1958. Albright-Knox Art Gallery, Buffalo.

tivism in their careful use of geometry. The works were also heirs of Abstract Expressionism, in particular Kline and de Kooning. Di Suvero (b. 1933) would often add "junk"—chairs, buckets, ladders, and so on—to his pieces. He once commented, "My sculpture is painting in three dimensions."[9] Many of his pieces, such as *Hankchampion* [1.63], 1960, were made from salvaged building materials and were raw and brutal, yet formally they were beautifully controlled.

Two other sculptors experimenting with industrial scraps and assemblage techniques were younger artists, Richard Stankiewicz and John Chamberlain. Stankiewicz had first produced sculptures while serving in the navy during World War II. Thereafter he had studied with Hans Hofmann and then with Fernand Léger and Ossip Zadkine in Paris. Stankiewicz's work did not have the strength and power of Smith's, but tended to be more humorous and witty, as seen in *Our Lady of All Protections* [1.64].

Chamberlain's work was more powerful and more complex. Like Smith, he was from Indiana, and he had studied at Black Mountain College from 1955 to 1956, coming into contact with America's avant-garde of the time. Chamberlain's use of wrecked automobile parts,

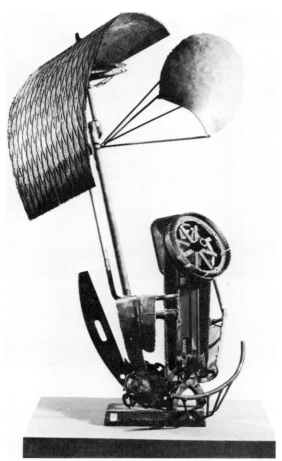

crushed, compressed, and welded to create a spontaneous abstract overall "gesture," reflected the heritage of the Abstract Expressionists. As seen in his 1958 *Nutcracker* [1.65], perhaps more important than a comment on civilization's mechanical refuse of destruction were the formal relations established through shapes, shadows, interaction of ready-made colors, and positive and negative spaces.

By the mid-fifties assemblage techniques had begun to be taken seriously in New York, as artists used a Dada inheritance to forge new territories. Moving past welding techniques, Robert Rauschenberg further challenged the traditional materials of sculpture in his 1959 *Monogram*. Here Rauschenberg placed a stuffed angora goat with an old rubber tire around it on a painting containing Abstract Expressionist brushstrokes. The traditional wall painting had become a rug, as Rauschenberg

1.65. John Chamberlain, *Nutcracker*, 1958. Courtesy Allan Stone Gallery, New York.

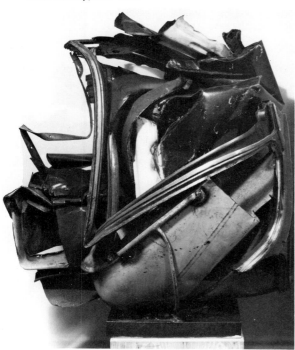

also challenged accepted notions of what a painting was.

H. C. Westermann also experimented with assemblage in a witty and surrealist fashion. His 1958 *Memorial to the Idea of a Man If He Was an Idea* employs vernacular and cartoon elements in a figurative box assemblage that opens to show a headless baseball player and a hanging trapeze artist in a mass of Pepsi bottle caps. The "head" of the large assemblage resembled the Chicago water tower where the artist was living at the time.

Peter Voulkos, the California ceramicist, took some of the spontaneous gestural qualities of Abstract Expressionists and assemblage concepts to challenge long-set utilitarian approaches to clay. In the mid-fifties Voulkos began to punch holes in his ceramic plates, making them no longer traditional utilitarian pieces. By the late fifties he was making massive, voluminous sculptures, which were perhaps some of the largest self-contained ceramic works done in the postwar period. During 1958 and 1959 he produced sixteen enormous sculptures. In 1959 his *Black Bulerias* won the Rodin Prize at the first Paris Biennale. Pieces from these years include his 1959 *Little Big Horn* [1.66] and *Gallas Rock*, commissioned in 1959, an eight-foot-high sculpture of about one hundred elements.

The concept of assemblage and its many variations was somewhat sanctified by 1961 when curator William Seitz mounted a large exhibition, "The Art of Assemblage," which included European and American sculptors, at the Museum of Modern Art. As he wrote in the accompanying catalog:

> The current wave of assemblage owes at least as much to Abstract Expressionism (with its Dada and Surrealist components) as it does to Dada directly, but it is nevertheless quite differently oriented: it makes a change from a subjective, fluidly abstract art toward a revised association with the environment. The method of juxtaposition is an appropriate vehicle for feelings of dis-

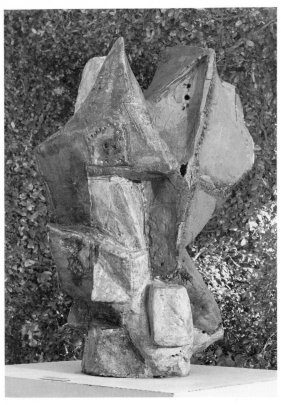

1.66. Peter Voulkos, *Little Big Horn*, 1959. The Oakland Museum Art Department.

enchantment with the slick international idiom that loosely articulated abstraction has tended to become, and the social values that this situation reflects. . . .

Yet the need of certain artists to defy and obliterate accepted categories, to fabricate aggressive objects, to present subjects tabooed by accepted standards, to undermine the striving for permanency by using soiled, valueless, and fragile materials, and even to present ordinary objects for examination unaltered—these manifestations are signs of vitality. . . .

And it must be recognized with approval and pleasure, that in addition to enriching and adulterating the themes and forms of painting and sculpture, makers of assembled art have wrought a truly magical transformation: from banality and ugliness, dispersion and waste, tawdriness and commercials, they have created challenging, meaningful, and often beautiful objects, ordered by principles inseparable from this century.[10]

The buds of assemblage techniques of the fifties were to blossom more openly and radically in the sixties. But artists such as Cornell, Nevelson, Smith, Di Suvero, and Rauschenberg, as diverse as their work was, had laid the foundation for future experimentation.

NOTES: SCULPTURE, 1945–1960

1. Quoted in Israel Shenker, "A Driven Artistic Lifetime of Jousting with the Void," *Smithsonian*, September 1988, p. 114.
2. Ibid.
3. Henry Moore, "The Sculptor Speaks," *The Listener* (London) 18, August 18, 1937, p. 449.
4. Quoted in Michael Brenson, "Isamu Noguchi, the Sculptor, Dies at 84," *New York Times*, December 31, 1988, p. 9.
5. Cited in Wendy Slatkin, *Women Artists in History, from Antiquity to the Twentieth Century* (Englewood Cliffs, N.J.: Prentice-Hall, 1985), pp. 152–53.
6. Cited in Robert Hughes, "Sculpture's Queen Bee," *Time*, January 12, 1981, p. 71.
7. Cited in Robert Hughes, "Iron Was His Name," *Time*, January 31, 1983, p. 71.
8. Quoted in Cleve Gray, ed., *David Smith by David Smith* (New York, 1968), excerpts cited in Ellen H. Johnson, ed., *American Artists on Art, from 1940 to 1980* (New York: Harper & Row, 1982), p. 38.
9. Quoted in Calvin Tomkins, *The Bride and the Bachelors: The Heretical Courtship in Modern Art* (New York: Viking Press, 1965), p. 137.
10. William Seitz, *The Art of Assemblage* (New York: Museum of Modern Art, 1961), pp. 87, 92.

ARCHITECTURE, 1945–1960

THE monumentality of some of the sculptural work done in the postwar years pointed to the sculptural forms in architecture that emerged as architecture and sculpture grew to have closer relationships and affinities. After the war the language of the International Style, with its window walls, formal geometric forms, its cantilevers, lack of ornamentation, use of ferro-concrete, open, continuous interior spaces, and flat roofs still prevailed for some architects. The adages "less is more" and "form follows function" still had some relevance and meaning, and postwar architects built on this language. Bauhaus émigré Mies van der Rohe's buildings at the Illinois Institute of Technology [1.67] and his 1946 house for Edith Farnsworth were glass boxes, constructions reduced to essential forms, forms that could be said to have some similarities to what was to become Minimal sculpture in the sixties. Mies van der Rohe felt "structure was spiritual," and in his "abstract" building forms pushed toward the spiri-

1.67. Mies van der Rohe, Crown Hall, Illinois Institute of Technology, Chicago, 1950–56.

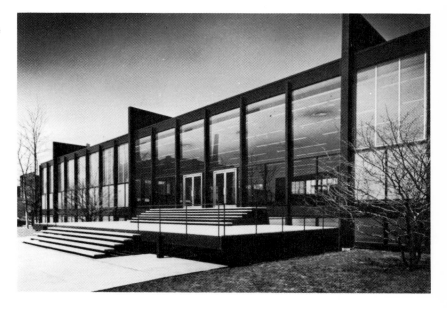

tual, much as Mondrian had in his paintings that emphasized verticals and horizontals, pure primary colors, and black and white. Philip Johnson emulated the master Mies van der Rohe in the Glass House [1.68] he built for himself in 1945–49 in New Canaan, Connecticut. Such spaces allowed little individual idiosyncrasy and no true relationship with nature. The glass, though letting a view of the outside in, served as a cool barrier to the world outside.

Mies van der Rohe became known for his "skyscraper style" of tall glass rectangular boxes in the decade between his Promontory apartments in Chicago and the Seagram Building, 1954–58, which he designed in collaboration with Philip Johnson [1.69]. Mies van der Rohe's use of the I-beam facade in his buildings was seen as a daring innovation in the late forties. The use of the I-beams to dress up the glass emphasized the verticality of the commercial cathedrals, and the glass skins of the buildings glistened with the radiance of medieval stained glass. The Seagram Building is a Late Modernist triumph, luxurious with its solid bronze and tinted glass, rising thirty-eight stories and 520 feet. The tower is set on a "base" or plaza, which allows the public to tread its pink granite pavement, and holds twin pools with fountains,

small groves of beech trees, and precinct walls of serpentine marble. The building is classical and modern, as it stands like a glass column, heroic in stature. It is interesting to compare the spiritual aesthetics of a building such as this and Barnett Newman's sculpture *Here,* one a public search for a universal aesthetic, the other a private search. Many have criticized these glass buildings for their cold and impersonal qualities and their neglect of the need for urban sociability. Yet the pristine forms offer a clarity and precision to both urban and rural landscapes.

As the forties came to an end, there was a growing dissatisfaction with the Miesian style and increased interest in adding decorative interpretation to the building and moving away from the glass skin. There was a search for more "human" qualities to be seen or felt in a building. As Matthew Nowicki, a well-respected architect and teacher from China, who came to the United States in 1947, commented,

We must face the dangers of the crystallizing style not negating its existence but trying to enrich its scope by opening new roads for investigation and future refinements. "Form follows function" may no longer satisfy ambitions aroused

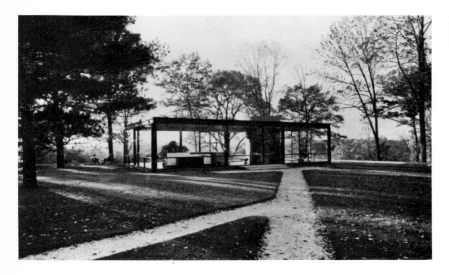

1.68. Philip Johnson, Glass House, New Canaan, Conn., 1945–49.

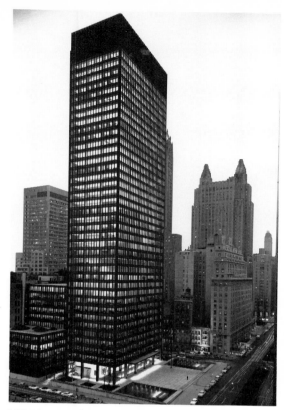

1.69. Mies van der Rohe and Philip Johnson, Seagram Building, New York, 1954–58.

when form becomes judged for its universal values, but sensitivity to the minute exigencies of life remains the source of creative invention leading through the elimination of "exactitudes" to the more important and more general truth which equals beauty.[1]

Among the most restless architects during these years was Eero Saarinen. Saarinen had begun working with his architect father, Eliel Saarinen, originally from Finland. Unlike Johnson, who studied at Harvard under Walter Gropius and Marcel Breuer representing the Bauhaus aesthetic, Saarinen had studied more traditional modes of construction at Yale in the thirties. Saarinen tended to be interested more in pictorial effects than the colder formalism of Johnson and Mies van der Rohe. Saarinen's Jefferson Memorial Arch, begun in 1948 in St. Louis, shows his early attempt to fuse sculpture

and architecture. The stainless steel arch soars 630 feet between the city of St. Louis and the Mississippi River. Elevators carry visitors to the top of the pure geometric form that serves as a gateway to the West.

Saarinen's rebellion against Miesian design came to fruition in his design for the TWA terminal at the John F. Kennedy airport in New York, 1956–62 [1.70], which stands in the midst of other terminals at the airport, many of which are pseudo-Miesian in style. The building, with its soaring sculptural forms, like the wings of a bird, stands as a monument to flight. The influence of the German Expressionist architect Erich Mendelsohn is felt in this daring concrete work.

Emphasis on organic form was also found in Frank Lloyd Wright's Guggenheim Museum, 1943–59 [1.71]. At the end of the war Frank Lloyd Wright was nearly seventy as he worked on this major project, which was intended to be in harmony with the collection of "nonobjective art" it was to show and house. The museum, with its concrete spiral, similar to a shell, contains themes that appeared in Wright's earlier work—the organic and curved forms, the use of cantilevers, and the open, communal interior space. Wright himself wrote of his intention in designing the building, which he referred to as "My Pantheon":

Here for the first time architecture appears plastic, one floor flowing into another (more like sculpture) instead of the usual superimposition of stratified layers cutting and butting into each other by way of post and beam construction.

The whole building cast in concrete, is more like an egg shell—in form a great simplicity. . . . The light concrete flesh is rendered strong enough everywhere to do its work by embedded filaments of steel, either separate or in mesh. The structural calculations are thus those of the cantilever and continuity rather than the post and beam. The net result of such construction is a greater repose, the atmosphere of the quiet unbroken wave: no meeting of the eye with abrupt changes in form.[2]

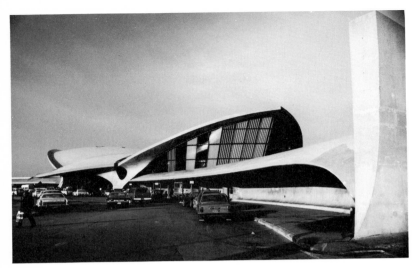

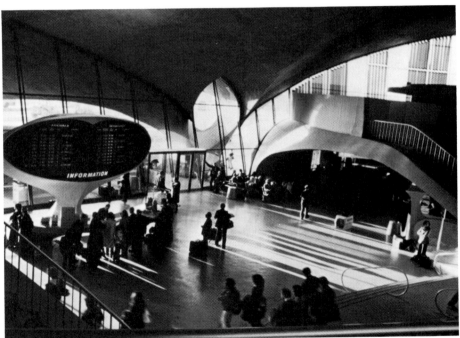

1.70. Eero Saarinen, TWA Terminal, Kennedy Airport, New York, 1956–62 (exterior and interior).

Wright died in 1959 at the age of ninety-two before the museum was completely finished.

The museum has been criticized for its anti-urban qualities, for its appearance being more like a parking garage than a museum, for its monumentality taking away from the art on its walls. But for all the criticism, its curved forms and giant oculus window are a pleasure to in-teract with, and the building remains a monu-ment to modern art.

Transforming Miesian design in a different manner was Louis Kahn, who had been trained at the University of Pennsylvania in the twen-ties in the Beaux Arts tradition. At the onset of each new architectural project and problem, he was said to pose the question, "What form

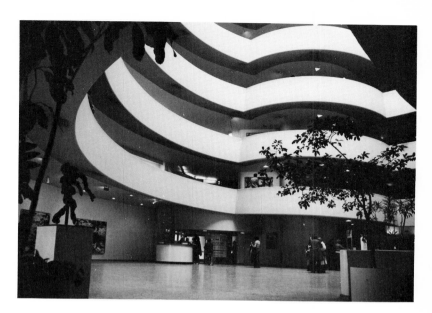

1.71. Frank Lloyd Wright, Solomon R. Guggenheim Museum, New York, 1943–45, 1956–59 (exterior and interior).

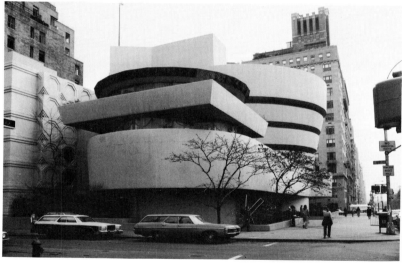

does the space want to become?" Important in the early fifties for him was his stay at the American Academy in Rome and his travels to Greece and Egypt. He sought not to copy the ancients but to prove the underlying principles and concepts of classical architecture and make them universal in the modern world. His architectural vision also contained social aspects, for he "believed there to be archetypal patterns of social relationship, that it was the business of architecture to uncover and celebrate.

A good plan would be one which found the central meaning, as it were, of the institution housed."[3]

Kahn's Richards Medical Research Building at the University of Pennsylvania in Philadelphia, 1957–61 [1.72], was an influential building, uniting form and function in monumental and tactile, strong masses. The towers house stairwells and utilities, and the center contains research laboratories. The towers of concrete, brick, and glass emphasize verticality and

strength, somewhat akin to the Roman ruins and the towers of the medieval towns he had admired in Italy. Later works of Kahn, such as the Jonas Salk Institute for Biological Studies in La Jolla, California, 1959–65, and his design for the parliament building in Dacca, Bangladesh, 1963, show his continuing ability to bring meaning to monumental and massive forms in relationship to the institution served, not relying on a bare or spare functionalism or formalism. Kahn's notion of the role of architecture may be seen in his own words:

> If I were to define architecture in a word, I would say that architecture is a thoughtful making of spaces. It is not filling prescriptions as clients want them filled. It is not fitting uses into dimensioned areas. . . . It is a creating of spaces that evoke a feeling of use. Spaces which form themselves into a harmony good for the use to which the building is to be put. . . .
> I believe that the architect's first act is to take the program that comes to him and change it. Not to satisfy it but to put it into the realm of architecture, which is to put it into the realm of space.[4]

Perhaps one of the most innovative structures to be successfully completed in the fifties

was Buckminster Fuller's development of the geodesic dome, a term Fuller took from a navigator's geometry of curved surfaces used to plot circular routes. With no formal training as architect or engineer, Fuller is perhaps best described as an inventor and philosopher of ideas. His design for a Dymaxion House in 1927 with its labor-saving devices and octagonal living room had been a radical break with single-family homes. His geodesic dome was developed initially as a Ford Motor Company commission for a dome 93 feet in diameter. Fuller's use of tetrahedral shapes, with light-weight metal and cable construction, allowed for inexpensive and quick construction to span large interior spaces. One of the largest such domes was erected to house a repair facility for the Union Tank Car Company in Baton Rouge, Louisiana, in 1958–59. The dome, 384 feet in diameter, looked like a bright yellow welded honeycomb supported by a blue pipe skeleton. Fuller constructed other well-known domes in the Climatron of the St. Louis Botanical Gardens; an office building for Savogran Company in Norwood, Massachusetts, in 1957; and at Expo '67 in Montreal [1.73].

In general, American postwar architecture of the fifties, despite innovative individual ar-

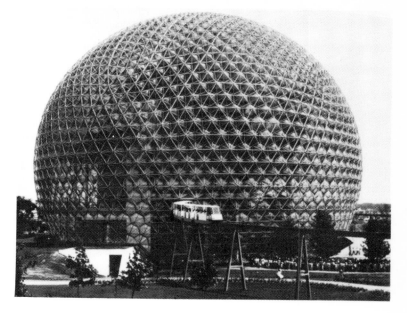

1.72 *(opposite).* Louis I. Kahn, Alfred Newton Richards Medical Research Laboratories, University of Pennsylvania, Philadelphia, 1957–61.

1.73 *(right).* R. Buckminster Fuller, U.S. Pavilion, Expo '67, Montreal, 1967.

1.74 *(below).* Jørn Utzon, Sydney Opera House, off Bennalong Point, Sydney, 1956–73.

chitects and buildings, did not have the heroic and grand stance that painting came to have.

Beyond the United States there was also a growing dissatisfaction with the Miesian style. In Australia the concrete parabloid shapes of the Sydney Opera House, 1956–73, designed by Danish architect Jørn Utzon [1.74], were a daring and dramatic change from both classical and International Style influences. The build-

ing, which stands on a promontory above the harbor, so influenced the population that it has become a symbol of the city, much as the Eiffel Tower is associated with Paris. The rhythmic, sail-like forms befit their placement near the water and suggest the flow of music and water. Utzon saw the Opera House as a type of medieval church, with constant interplays of light and movement. "If you think of a Gothic church

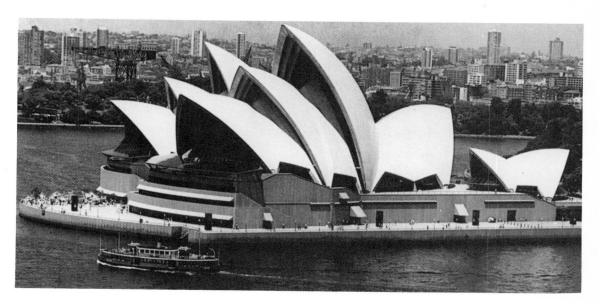

you are closer to what I have been aiming at. . . . Looking at a Gothic church, you never get tired, you will never be finished with it. . . . This interplay of light and movement . . . makes it a living thing."[5]

An actual church that embodied experiments in style and use of materials was Le Corbusier's chapel Notre-Dame-du-Haut, 1950–54 [1.75], perched high on a hill in Ronchamp in the rural slopes of eastern France. Le Corbusier, noted for his early modernist forms of buildings, such as the Villa Savoye of 1929–31, in his later years turned to more expressive and "brutal" forms. Some of his work and that of other architects is referred to as Brutalism, so-called because of roughly finished forms and the use of *beton brut*, or raw concrete. His com-

mission to plan the new capital of the Punjab at Chandigarh and to design the major administrative buildings such as the Secretariat, the Assembly, and the High Court, which were completed, gave him the opportunity to experiment with both the raw concrete and sculptural forms. The tendency toward sculptural intensity became even stronger in his pilgrimage church at Ronchamp, in great contrast to his more austere and rationalistic early structures. His imagination seemed to run free, and he wrote of his inspiration in working on the design. "I have not experienced the miracle of faith but I have often known the miracle of inexpressible space, the apotheosis of plastic emotion."[6] The massive, soaring concrete roof atop thick, curvilinear walls that are sprayed

1.75. Le Corbusier, Chapel at Ronchamp, France, 1950–54.

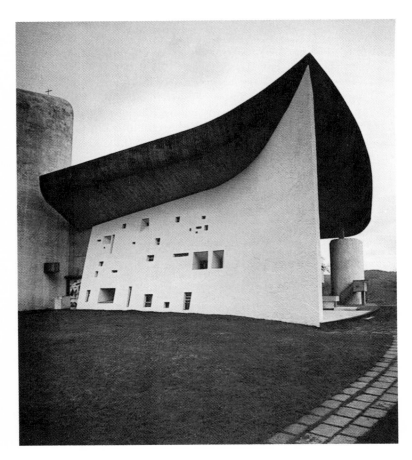

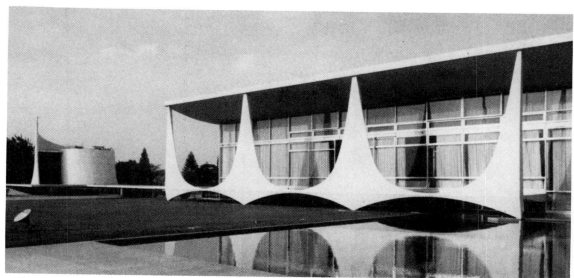

1.76. Oscar Niemeyer, Presidential Palace, Brasília, 1958.

with rough white concrete appears like the prow of a ship, an image that is prevalent in the history of Christianity. The randomly sized and placed windows provide for the interplay of varying shadows and light in the interior, with its cavelike quality and floor that slopes toward the altar. When the church was completed in 1955 many were shocked and critical, calling it irrational and mannerist. Yet the spectator upon arriving at Ronchamp cannot be passive. This "sculpture" in the round provokes immediate involvement.

Le Corbusier served as consultant in South America with a group of Brazilian architects headed by Lucio Costa and Oscar Niemeyer for the Ministry of Education and Health in Rio de Janeiro. The influence of Le Corbusier on Niemeyer is seen in Niemeyer's designs for Brasilia, which was to become the answer to dreams of an inland capital for Brazilians. In particular, the Presidential Palace, with its glass core, large, shading concrete slab roof, and series of diamond-shaped concrete exterior supports, carries intimations of Le Corbusier to a new design sense—less brutal and more elegant than the Le Corbusian Chandigarh or

Ronchamp. The palace became the symbol of a new city [1.76].

Le Corbusier's influence was also felt in Japan in the unfinished concrete surfaces of Kenzo Tange's Kagawa Prefectural Offices at Takamatsu, 1955–58. Tange had been a student of Le Corbusier's, but unlike Le Corbusier, Tange's proportions and interlocking verticals and horizontals of the post and lintel structure give the building a more delicate look. Tange, in keeping with some Japanese traditions, sensitively combined man-made and natural materials, using rough natural boulders with his concrete surfaces. He even used a boulder for the base of the information desk in the main hall. Tange's tendency toward expressionistic monumental forms was seen more clearly in his later Olympic Stadium in 1963 in Tokyo, with its powerful curves and flowing forms.

In Italy one also saw a resurgence of architectural activity in the years after the war, perhaps in partial response to the edicts of Fascism and its war-torn state. A group of architects known as Studio Architetti BBPR (Gianluigi Banfi, Lodovico Belgioioso, Enrico Peressuti, Ernesto Rogers) began to revitalize

1.77. Pier Luigi Nervi, Palazzetto dello Sport, Rome, 1958.

Italian architecture. Their massive Torre Velasca, 1954–58, a steel and concrete office tower in Milan, has been considered one of the first skyscrapers on the continent of Europe. Its allusions to medieval fortress towers were criticized at the time, but today, in the postmodern era, their historicism is accepted.

The Italian architect and engineer Pier Luigi Nervi continued in the late fifties the experiments he had begun between the wars using reinforced concrete spans. His Palazzetto dello Sport [1.77], created for the Olympic Games in Rome, is jewel-like in its combination of ancient and modern forms, with its low domelike vault with layers of flexible steel mesh and wire sprayed with concrete, braced by Y-shaped buttresses. The spacious interior

and the decorative weblike ceiling of the dome exudes a taut energy and suggests an expansiveness crucial to athletic events. In this and his earlier aircraft hangars, he proved it was possible to oppose the International Style boxes and span huge interior spaces with beautifully articulated curved and concrete forms.

In general, architecture in the late forties and fifties must be seen as more than a continuation of or reaction to a Miesian aesthetic or the International Style. For in this reaction and extension of forms and materials there were some important innovations, many of which brought architecture and sculpture closer together and set the stage for further experiments in the sixties.

NOTES: ARCHITECTURE, 1945–1960

1. Matthew Nowicki, "Origins and Trends in Modern Architecture," *The Magazine of Art*, November 1951, p. 279. Nowicki died in 1950 in an airplane crash on his way home from a trip to India, where he had begun work with Albert Mayer on the town planning of the new capital of East Punjab.
2. Quoted in Solomon R. Guggenheim Museum brochure (published by the museum, New York, 1960).
3. William J. R. Curtis, *Modern Architecture Since 1900*, 2d ed. (Englewood Cliffs, N.J.: Prentice-Hall, 1987), p. 313.
4. Quoted in J. Rowan, "Wanting to Be," *Progressive Architecture*, April 1961, pp. 130–49.
5. Jørn Utzon, "The Sydney Opera House," *Zodiac 14*, Milan, 1965, p. 49.
6. Le Corbusier, *The Modulor* (Cambridge, Mass.: Harvard University Press, 1954), p. 32.

MULTIMEDIA AND INTERMEDIA, 1945-1960

Post–World War II art has been marked increasingly by interdisciplinary and multidisciplinary tendencies, as traditional boundaries between painting and sculpture, between the visual arts and other art forms, have been transgressed. As Allan Kaprow suggested in his influential 1958 article "The Legacy of Jackson Pollock," "The young artist of today need no longer say 'I am a painter,' or 'a poet,' or 'a dancer.' He is simply an 'artist.' All of life will be open to him. He will discover out of ordinary things the meaning of ordinariness. He will not try to make them extraordinary. Only their real meaning will be stated. But out of nothing he will devise the extraordinary."[1] Under the influence of Allan Kaprow the term "Happening" evolved in the late fifties to describe what Kaprow called "collages in action," where elements of theater were amalgamated with the visual arts. Kaprow described the Happening as an event that simply happened. "Though the best of them [Happenings] have a decided impact—that is one feels 'here is something important'—they appear to go nowhere and do not make any particular literary point. In contrast to the arts of the past, they have no structural beginning, middle or end. Their form is open-ended and fluid. . . . They exist for a single performance, or only a few more, and are gone forever, while new ones take their place."[2]

The flavor of some of these early Happenings was captured in Kaprow's own words.

> Everybody is crowded into a downtown loft, milling about, like at an opening. It's hot. There are lots of big cartons sitting all over the place. One by one they start to move, sliding and careening drunkenly in every direction, lunging into people and one another, accompanied by loud breathing sounds over four loudspeakers. Now it's winter and cold and it's dark, and all around little blue lights go on and off at their own speed, while three large brown gunny-sack constructions drag an enormous pile of ice and stones over bumps, losing most of it, and blankets keep falling over everything from the ceiling. A hundred iron barrels and gallon wine jugs hanging on ropes swing back and forth, crashing like church bells, spewing glass all over. Suddenly, mushy shapes pop up from the floor and painters slash at curtains dripping with action. A wall of trees tied with colored rags advances on the crowd, scattering everybody else. Coughing, you breathe in noxious fumes, of the smell of hospitals and lemon juice. A nude girl runs after the racing pool of searchlight, throwing spinach greens into it. Slides and movies, projected over walls and people, depict hamburgers: big ones, huge ones, red ones, skinny ones, flat ones, etc. You come in as a spectator and maybe you discover you're caught in it after all, as you push things around like so much furniture.[3]

Although these Happenings contained theatrical and dramatic elements, they were to be

distinguished from traditional theater, according to Kaprow, in the lack of plot, the lack of separation between the audience and artists/performers, the rawness of the outdoor or loft settings, and the tendency to use nonverbal and nonsequential material. Participants in a Happening were given tasks; they did not "play roles." Time, action and interaction, and immediacy became important dimensions of the work, as art and life became closely intertwined.

Antecedents for these Happenings can be traced back to early Dada and Futurist events, such as the German Dada artist Kurt Schwitters's Merz theater proposal, and to the later influence of composer John Cage. In 1952 Cage sponsored what some call the first American Happening at Black Mountain College, where he taught. Robert Rauschenberg and dancer Merce Cunningham participated in this event. Kaprow studied with Cage at the New School for Social Research in New York from 1956 to 1958. Cage urged his students to look at Dada works, to look at Buddhism, and to look at the theater of Artaud, which called for "a total theater," where the audience took part. Other artists influenced by Kaprow included George Brecht, Al Hansen, Jim Dine, Red Grooms, Claes Oldenburg, and Robert Whitman. Important too for the evolution of the Happening was the "action" and spontaneity of Abstract Expressionism and the emergence of "junk" assemblage. Kaprow's work itself had evolved from paintings to assemblage to creating "Environments" to sponsoring and participating in Happenings. In 1958 he exhibited his first "Environment"—a transformation of a given space. Kaprow transformed an entire gallery by creating aisles whose walls were covered with strips of plastic and cloth that were painted with splotches of bright paint and adorned with tinfoil, crumpled cellophane, and Christmas tree lights. Viewers interacted with each other and became part of the "piece." In 1959 Kaprow did his first full Happening, *18 Happenings in 6 Parts*, at the Reuben Gallery, which along

with the Judson Gallery became noted for sponsoring Happenings. In this piece an audience was moved through three rooms at the sound of a bell and participated with live painting, music, poetry, and slides simultaneously. Kaprow's Happenings continued into the 1960s [1.78].

Analogous to American Happenings were the events of a group of Japanese artists that in 1952 had formed an association called the Gutai (a word meaning gestalt or configuration) or Concrete Group. The Gutai performed "actions" that allowed them to escape from what they felt were the limitations of traditional painting and sculpture and the constrictions of Japanese social traditions. In a 1955 piece, *Making a Work with His Own Body*, Kazuo Shiraga used himself as paint. The group, founded and sponsored by artist and entrepreneur Jiro Yoshihara, actually staged some Happenings in Japan prior to the appearance of such in the United States.

In France in 1957 a group of European artists and poets emerged from the CoBra and Lettrist movements to form the Situationniste Internationale (SI), whose goal was to transform art into a cultural critique. "Their methods included 'experiments in behavior' aimed at altering conduct through the creation of 'situations' leading to the construction of authentic collective environments and personal experiences,"[4] aimed ultimately at changing political and social conditions or what they called the "spectacle" of the "dominant culture." SI published theoretical texts in the *Internationale Situationniste*. SI was involved in creating events, situations—or happenings—but unlike the Americans, stressed their engagement in political conditions. What started, though, as an artistic avant-garde became by the late sixties a radical political, revolutionary group. During the sixties it allied itself with such causes as the political agitation in Algeria, the civil rights movement in America, and in 1968 joined the "Enragés" on the Occupation Committee of the Sorbonne in Paris.

1.78. Allan Kaprow, Happening, Southampton, N.Y., 1966.

In 1955, reacting in a different direction were the artists who were part of an important kinetic art exhibit, "Le Movement," at the Galerie Denise René in Paris. These artists were concerned with motion in a work, both retinal and actual movement within the piece. One of the most influential artists to emerge from the exhibit was the Swiss-born Jean Tinguely, noted for his junk sculpture and use of motors within them. He often employed a combination of humor and irony as he programmed his pieces to paint, make sounds, and sometimes destroy themselves. He wrote of the role of the machine in his art and of his ideas of an all-encompassing art:

All machines are art, even old, abandoned, rusty machines for sifting stones . . . so: art is the distortion of an endurable reality. I correct the vision of reality that strikes me in the every-day world. Art is correction, modification of a situation, art is communication, connection . . . only . . . well? Art is social, self-sufficient, and total. (Does Rüdlinger [curator of the Basel Art Museum] agree?) Techniques: the materials of the modern work of art: whiskey-aluminum-nuts-sausage-salad-petrol-sugus [soft candy]-complexes-money-screws-pastries-engines.[5]

One of Tinguely's best-known pieces, his 1960 *Homage to New York*, was designed to make music and create paintings, and included a bathtub and a piano. It struck strongly at notions of permanence and stability, introducing a subtle sarcasm into the Museum of Modern Art courtyard on a cold March day, when the piece self-destructed as Tinguely intended. Tinguely has continued to use motorized parts into the eighties to raise formal and conceptual questions that probably would not have been possible with traditional materials and methods. His 1981 *Cenodoxus Isenheim Altarpiece*, where he reinterpreted *Cenodoxus*, a Baroque play, and Matthias Grünewald's Isenheim altarpiece, was a motorized openwork triptych relief, asking the viewer to face death in a more direct and more savage manner than the sixteenth-century piece could ever do. The mechanized assemblage of parts, which included a skull, a large blue wooden wheel, a bouquet of feathers, and red and yellow rusty bars, was a provocative collision and confrontation of sacred and profane, of high and low culture.

Another artist working in Paris with kinetic movement and "new" materials was the Hungarian-born Nicolas Schöffer. Unlike Tin-

guely's, Schöffer's work was more programmed and employed cybernetic elements as he pushed toward the integration of art and science. In the mid-fifties he constructed what he called "Luminodynamic Spectacles" in open urban spaces and parks. These were "audio-visual" towers that responded with light and sound to people passing by and changing weather patterns. In 1961 he built a *Cybernetic Tower* in Liège, Belgium. One hundred fifty feet high, the tower was made of Plexiglas and aluminum that radiated color and light as well as music through an electronic "brain."

Paris of the late fifties saw the emergence of the eccentric yet forceful artist and friend of Jean Tinguely, Yves Klein, whose impact was to continue into the next decades, although his career as an artist was relatively brief—from approximately 1954 to his death at age thirty-four due to a heart attack. Born in Nice in 1928, Klein was the son of two "lyrical abstractionists" and was more interested in becoming the best judo master in France than in being any type of artist, although in 1948 he had "signed" the sky above Nice and called it his first work of art. He studied judo in Japan for fifteen months to obtain his black belt, fourth degree. He was outraged upon his return to France to find that the French Federation of Judo refused to recognize his credentials and banned him from their competitions. His ambition changed to becoming a great painter. In 1955 he submitted a solid orange canvas to the Salon des Réalités Novelles, which quickly rejected it, but Klein continued his monochromes briefly in his IKB (International Klein Blue) pieces, which were all identical blue panels of the same dimensions. For him color was an autonomous element, and painting was a vehicle to show such. For him blue was synonymous with the notion of a sense of freedom associated with the sky and space. "Through color," Klein said, "I experience a feeling of complete identification with space. I am truly free."[6] This dazzling ultramarine blue was also used by Klein in sponge pieces painted with the blue and at-

tached to bases of the wall. He became particularly well known as a kind of enfant terrible for a show entitled "Vide" (the Void) at the Iris Clert Gallery in Paris. There were no paintings, simply the walls of the gallery he had painted white. The facade of the gallery and the sidewalk were painted blue. Elaborately dressed soldiers were stationed at the entrance to the gallery and blue cocktails were served. Many thought the show was a joke, but in truth Klein may be seen as a pioneer in the creation of environments and in the origins of conceptual art. Three thousand people came to that 1958 opening at Iris Clert and later Klein sold what he called "immaterial zones of pictorial sensibility," signed receipts for which he was paid in gold, half of which he threw into the Seine. Such transactions were carried out in a ceremonial manner that Klein, as showman and performer, thrived on.

Klein's bare walls were followed by his *Anthropometrics* of 1960, where nude models covered with blue paint were rolled on canvases to make an imprint; his *Cosmogonies*, where he experimented with the results of rain spattering onto wet blue canvases; and his fire paintings, where actual flames penetrated asbestos with red, yellow, and blue pigments.

Klein was also obsessed with levitation and had studied Rosicrucian mystical doctrines. On November 27, 1960, an imitation of the Paris weekly *Dimanche* showed Klein in a business suit hurling himself from what appeared to be the second story of an apartment house as he tried to move beyond art and penetrate space. The caption read, "The painter of space hurls himself into the void." In truth Klein had jumped into a tarpaulin, held by his judo colleagues, who were removed in the darkroom from the "documentary" photograph. Klein later published a second photo of the "event," different from the first, thereby calling attention to his trickery. Klein's fraudulent leap is best seen in the evolution and context of his ideas and experiments to go beyond art, not as a public statement about physically harming

himself or a suicide attempt.

Like Klein, the Greek artist Takis was interested in space travel and actually attempted to "launch" a friend by suspending him in a magnetic field. Takis dealt with intangible forces. One of his pieces involved the spectator's throwing nails against a magnetized plate which automatically arranged them in a pattern of order and symmetry. The role of the artist as unique creator was slowly being eroded.

Like Takis and Klein, the Italian-born Piero Manzoni in his brief career (he died at age thirty in 1963) contributed to a demystification of the artist and art object. Manzoni was influenced by Klein. In 1957, after seeing Klein's blue monochromes, he produced his *Achromatics*, eleven identical pictures in white. In 1959 he made a series of pneumatic sculptures—balloons that expanded and contracted in compressed air, and for which the buyer could also purchase Manzoni's breath.

In 1960 Manzoni made 150 hard-boiled eggs with his fingerprint on them. Manzoni commented that the public could swallow a whole exhibit in seventy minutes. Some critics have commented on the eggs' affinity to magic, life and fertility, and the fingerprint as a symbolic laying on of hands. He later sold his thumbprints.

In 1961 he produced ninety containers of Artist's Shit *(merda d'artista),* each one ounce, hermetically sealed, and signed by Manzoni. In the same year he signed his name to the bodies of girls and men whom he exhibited. In 1961 he also made his first *Magic Base* upon which whatever stood, person or object, would be considered a work of art as long as he, she, or it was there. Manzoni himself was the first to stand on the base and be photographed as a living work of art. Among his last pieces were his *Bread Works,* where round rolls covered with plaster were set out on a panel in a grid pattern. It is unclear whether Manzoni may have pointed to symbolic significances of bread as the basis of religious and communal rituals, or whether he was interested in the "objectness" of the bread and its common everyday qualities made formal in the plaster. Like Marcel Duchamp, both Klein and Manzoni forced the viewer, before the full blooming of Conceptual art, to rethink notions concerning the nature of art and its materials.

In Italy Lucio Fontana was close to some of the ideas of both Manzoni and Klein. In 1946, then living in Argentina, Fontana wrote in his *White Manifesto,* "We are abandoning the use of known forms in art and we are initiating the development of an art based on the unity of time and space. . . . Color (the element of space), sound (the element of time) and motion (that develops in time and space) are the fundamental forms of the new art."[7] In 1949 Fontana created his first spatial environment in Milan at the Naviglio Gallery, where a completely black room was lit by black wooden lamps. Another Italian, Bruno Munari, pronounced in his 1952 *Manifesto del Maccinismo,* "No more oil colors, but jet flames, chemical reactions, rust, thermal changes."[8] In 1949 he had made "travel sculpture" of wire mesh parts that could be mailed and reconstructed elsewhere. He later made "unreadable books" that could be taken apart and put together according to the whims of the reader.

A climate conducive to experimentation in Europe in the fifties led to the establishment of new groups of artists. One of the most significant was Group ZERO, founded in Düsseldorf, Germany, by Otto Piene and Heinz Mack in 1957 (later to be joined by Gunther Uecker in 1961). The name ZERO referred to new beginnings and was derived from the moment of blast-off in a space rocket countdown. The group was devoted to the use of recent technologies such as light-projected "paintings." Somewhat impatient with the gallery and museum systems, Piene and Mack had a series of "Night Exhibitions" in their lofts in 1958 and 1959. Each "exhibit" lasted only an evening, and pieces such as Piene's *Light Ballets,* with light projected through moving perforated

stencil screens and accompanied by electronic piano sounds, were more like performances. Piene was particularly interested in the sky as a space for his work and organized a number of "Sky Events" in the late sixties and early seventies. Piene eventually came to the United States and became noted for his work as artist and teacher at the Center for Advanced Visual Studies at the Massachusetts Institute of Technology in Cambridge. His beliefs in creating expansive environments beyond "the object" that would alter the perceptions of the many, not the few, have influenced several generations of artists. As he has stated,

> The artist catering to the tastes and expectations of the chosen few is a pitiable creature. Artists' obligations lie elsewhere. . . . The artist planner is needed. He can make a playground out of a heap of bent cans, he can make a park out of a desert, he can make a paradise out of a wasteland, if he accepts the challenge to do so. . . . Elements and technology are the means that permit the revival of large-scale artistic activities. Wind may be considered the new siccative, while fire is the new gel. Technology permits the artist to talk to many, design for the many, and execute plans for many. It's time now to do more than project: it's time to act.[9]

A rival group to ZERO was the Group de Recherche d'Art Visuel (GRAV) founded in Paris in 1960 and disbanded eight years later. The group, which included Julio Le Parc, Horacio Garcia-Rossi, François Morellet, and

Yvaral (Vasarely's son), was dedicated to active spectator participation as a principle of the art work. The group stressed anonymity of individuals and emphasis on the group's work. In 1961 an exhibit they sponsored in Zagreb, Yugoslavia, stressed light, motion, and sound with which the spectator could interact, in defiance of the heavy pigments of the Tachists. Other small groups formed quickly, such as Gruppo T in Milan, Gruppo N in Padua, Equippo 57 in Spain, and the Dvizdjene Group in Moscow. Collectively this proliferation of groups was referred to as "The New Tendency," or Nouvelle Tendence. Although this "group" phenomenon had dwindled by the mid-sixties, their demonstrations in new media and emphasis on spectator involvement in a work were most influential. More European museums and galleries began to hold technologically oriented exhibits by the late fifties and early sixties. Of particular import was a retrospective exhibit of kinetic art from Naum Gabo held at the Stedelijk in Eindhoven, Holland, in 1961.

The fifties, then, were far more than the stereotyped images in the United States, of silence and conformity, where the tidy lawns and split-levels of quiet suburbia were the accepted aesthetic or "antiseptic" norm. In both the United States and the war-torn countries of Europe and Japan, there was an artistic and creative spirit that sought change. Experiments with new materials and forms in the arts were to lead the way to the more explosive sixties.

NOTES: MULTIMEDIA AND INTERMEDIA, 1945–1960

1. Allan Kaprow, "The Legacy of Jackson Pollock," *Artnews,* October 1958, cited in Ellen Johnson, *American Artists on Art, 1940–1980,* pp. 57–58.
2. Allan Kaprow, " 'Happenings' in the New York Art Scene," *Artnews,* May 1961, pp. 36–39+.
3. Ibid.
4. Kristine Stiles, "Sticks and Stones, The Destruction in Art Symposium," *Arts Magazine,* January 1989, p. 54.
5. Jean Tinguely, "Modern Art: Playing . . ." (extract from *National Zeitung, Basel,* October 13, 1967), reprinted in Dore Aston, ed., *Twentieth-Century Artists on Art* (New York: Pantheon Books, 1985), p. 186.
6. Quoted in Peter Selz, *Art in Our Times, A Pictorial History, 1890–1980* (New York: Harcourt Brace Jovanovich and Harry N. Abrams, 1981), p. 420.
7. Quoted in Douglas Davis, *Art and the Future* (New York: Praeger Publishers, 1973), p. 52.
8. Ibid.
9. Otto Piene, *More Sky* (Cambridge, Mass.: MIT Press, 1970), pp. 4–5.

II

UPHEAVALS:
THE 1960S

THE SIXTIES was a decade of tremendous upheaval and tumultuous change, evident in many facets of society throughout the world. There was great violence and there were miraculous achievements. The decade began with headlines in 1960 such as U-2 reconnaissance jet with pilot Gary Powers is shot down over Russia; South African police kill 92 blacks during demonstration at Sharpeville; Khrushchev at UN pounds shoe in anger; blacks sit in at Greensboro, North Carolina, lunch counter; Kennedy wins narrow victory.

The youthful John F. Kennedy, the first Catholic to be elected to the United States presidency, brought with him the spirit and vision of a "new frontier." He established the Peace Corps, for which approximately ten thousand volunteered in its first three months. He proposed civil rights legislation, cut taxes, and pushed space exploration. But he faltered during the disastrous Bay of Pigs invasion in 1961. A year later nuclear war threatened during the Cuban missile crisis. But in general, Kennedy and his family brought a sense of hope and style to the White House. The Kennedys became an American royalty.

All that quickly changed, however, on a clear November day in 1963 in Dallas when Lee Harvey Oswald raised his gun and assassinated Kennedy, and along with him the dreams of many. It was a tragic day that few who lived then can forget. It was a bitter omen of what was yet to come in the decade.

In the same year that Kennedy was shot, Martin Luther King gave his famous speech, highlighted by the well-known words "I have a dream that one day this nation will rise up and live out the true meaning of its creed . . . that all men are created equal." Yet the words, so strong that day, were hollow echoes five years later when King himself was tragically assassinated. As if one assassination were not enough in 1968, Robert F. Kennedy, who was running for president, was also assassinated.

Following King's death, protest riots broke out, and the more militant Black Panthers emerged. Kennedy's successor, Lyndon Johnson, called for "the Great Society," and a "war on poverty." But the Great Society became secondary to the issue of the Vietnam War, which left lasting scars on America, so torn over its validity.

American culture of the sixties was heightened by a new activist spirit. There were civil rights activists. Eldridge Cleaver wrote *Soul on Ice.* Feminism was reborn. The National Organization for Women was founded in 1966, led by women such as Betty Friedan, who wrote *The Feminine Mystique* in 1963, and Gloria

Steinem. Rebellious youths became part of the Free Speech Movement and were "hippies" and "flower children." They marched to the 1968 Chicago Democratic convention to protest the Vietnam War, only to be beaten down by Mayor Daley's police, all seen on national television. The music of the Beatles and groups such as Jefferson Airplane were inspiration. The rock festivals at Woodstock and Altamont were like giant Happenings. But the spirit of Altamont was subdued by the bloody violence that followed. American youth and students were not the only ones to rebel. French, German, and Mexican students clashed with established forces in the late sixties.

And beyond Vietnam there was turmoil elsewhere. In 1965 there was the Indian-Pakistani War. In the same year Mao Tse-tung announced his Cultural Revolution in China, against all established power. The Red Guards struck at any attempts to revive the old culture of China. In the Mideast a third war broke out between Israel and its Arab neighbors in 1967. Although the war was won by Israel in six days, there were marks of continuing problems in the area. The year 1967 also brought a military coup in Greece and the killing of the revolutionary leader Che Guevara by Bolivian troops. In 1968 Prague Spring ended with the Russian invasion of Czechoslovakia.

Space exploration was firmly established when the Russians put the first man in space in 1961. In the same year Alan Shepard was the first American to fly in space. In 1962 U.S. astronaut John Glenn orbited the earth three times. And in 1969 Neil Armstrong and Edwin Aldrin landed on the moon and walked, leaving behind their plaque that read, "We came in peace for all mankind." Scientific discoveries also brought the first heart transplant and the beginnings of the computer age.

The literature of the decade was a mixture of reflections of tension and anxiety about the times as well as visions for a different world. James Baldwin wrote *Another Country.* Ken Kesey wrote *One Flew over the Cuckoo's Nest.* Peter Weiss wrote *Marat Sade.* Aleksandr Solzhenitsyn wrote *The Cancer Ward.* Marshall McLuhan, whose prophecies of a "global village" were to ring true, wrote *Understanding Media: The Extensions of Man.*

The movies *Bonnie and Clyde* and *Easy Rider* captured a bravado spirit of the decade. Stanley Kubrick envisioned new and different worlds in *Dr. Strangelove* and *2001: A Space Odyssey.*

The radical politics and violence of the world at large did not permeate the art world of the sixties as much as one might think. But the rate and amount of change, as art movements tumbled one after the other, from Pop to Op to Hard Edge to Minimal, and so forth, was indicative of the vast changes going on in the rest of society. With the arrival of Andy Warhol, artists became celebrities and art an industry that more and more people talked about.

PAINTING AND BEYOND, 1960S

THE Abstract Expressionists continued to work in the sixties. Rothko worked on the ecumenical Rothko Chapel in Houston. Barnett Newman worked on his *Stations of the Cross* series from 1958 to 1966. The Color Field painters or Post-Painterly Abstractionists, as they were sometimes called, such as Helen Frankenthaler and Sam Francis, opened their canvases to large, airy designs and brilliant colors. Morris Louis did his *Unfurleds*. Robert Rauschenberg made even more complex paintings often using silk-screen transfers that reflected the fragmentation of both "high" and "low" culture. Jasper Johns experimented further with numbers and letters.

But it was Pop art and the arrival of Andy Warhol in the early sixties that were to have a major impact on the art world. (The term "Pop" art was originally coined by Lawrence Alloway in 1958 to describe the English equivalent in works such as those of Richard Hamilton.) American Pop art, which elevated the everyday object to the realm of art, was a rebellion against Abstract Expressionism. Gone were the emotions, gestures, and intimations of myth and inward journeys inherent in the powerful brushstrokes and color areas of some of the Abstract Expressionists. There was an interest in the everyday object, particularly mass-produced objects and subjects from commer-

cial art, the machine, and figuration. Roots of American Pop art can be seen in the early work of Stuart Davis, in the influence of Marcel Duchamp and his rebellious spirit, Kurt Schwitters's use of "junk" and everyday objects, Fernand Léger's machinelike Cubism, and in the work of Johns, Rauschenberg, and Rivers.

The first group exhibit to show "Pop" tendencies was the "New Realists" show at the Sidney Janis Gallery in 1962. Exhibits following quickly thereafter that further promoted the Pop mentality were Lawrence Alloway's "Six Painters and the Object" in 1963 at the Guggenheim Museum and "The Popular Image" exhibit at the Washington Gallery of Modern Art, also in 1963. In November of 1963 Gene Swenson interviewed eight Pop artists for *Artnews,* asking "What is Pop Art?" Excerpts from those conversations throw further light on the significance of Pop art for a number of artists and their approach to it.[1] Robert Indiana responded:

> Pop is everything art hasn't been for the last two decades. It is basically a U-turn to a representational visual communication. . . . It is an abrupt return to Father after an abstract fifteen year exploration of the womb. Pop is a reenlistment in the world. It is Shuck the Bomb. It is the American Dream, optimistic, generous and naive. . . . Pure Pop culls its techniques from all the present day communicative processes.

Roy Lichtenstein replied:

> ... the use of commercial subject matter in paint-
> ing, I suppose. . . . Everybody has called Pop art
> "American Painting," but it's actually industrial
> painting. America was hit by industrialism and
> capitalism harder and sooner and its values seem
> more askew. . . . I think the meaning of my work
> is that it's industrial, it's what all the world will
> soon become. Europe will be the same way, soon,
> so it won't be American, it will be universal.

And Andy Warhol stated,

> Everybody looks alike and acts alike, and we're
> getting more and more that way. I think every-
> body should be a machine. I think everybody
> should like everybody. . . . I think it would be
> great if more people took up silkscreens so that
> no one would know whether my picture was
> mine or somebody else's.

A couple of years later Swenson accepted
the challenge of Warhol's comments that he
wanted to be a machine when Swenson wrote,

> Art criticism has generally refused to say that an
> object can be equated with a meaningful or aes-
> thetic feeling, particularly if the object has a
> brand name. Yet, in a way, abstract art tries to be
> an object which we can equate with the private
> feelings of an artist. Andy Warhol presents ob-
> jects we can equate with the public feelings of an
> artist. Many people are disturbed by . . . the trend
> towards de-personalization in the arts, . . . they
> fear the implications of a technological society.
> . . . A great deal that is good and valuable about
> our lives is that which is public and shared with
> the community. It is the most common clichés,
> the most common stock responses which we
> must deal with first if we are to come to some
> understanding of the new possibilities available
> to us in this brave and not altogether hopeless
> new world.[2]

The art historian Robert Rosenblum later
stressed the technique as well as content in
talking about the nature of Pop art.

> Pop Art . . . must have something to do not only
> with what is painted but also with the way it is
> painted; otherwise Manet's ale bottles, Van
> Gogh's flags and Balla's automobiles would qual-
> ify as Pop Art. The authentic Pop artist offers a
> coincidence of style and subject, that is, he repre-
> sents mass-produced images and objects by using
> a style which is also based upon the visual vocabu-
> lary of mass production.[3]

Thus commercial art conventions were raised
to the status of "high" art.

Unlike the Abstract Expressionists, there
was no group camaraderie or "community" of
artists who spent a lot of time with each other.
The Pop artists were not initially friendly with
each other and their work emerged indepen-
dently, responding to a "spirit" of the times, a
spirit of the influence of mass media—televi-
sion, comic strips, movies, billboards, and the
like. As Henry Geldzahler wrote in 1963, Pop
art was "inevitable":

> The popular press, especially and most typically
> *Life Magazine,* the movie close-up, black and
> white, technicolor and widescreen, the billboard
> extravaganzas, and finally the introduction,
> through television, of this blatant appeal to our
> eye in the home—all this had made available to
> our society, and thus to the artist, an imagery so
> pervasive, persistent, and compulsive that it had
> to be noticed. . . . The artist is looking around
> again and painting what he sees. . . . We live in
> an urban society, ceaselessly exposed to mass
> media. . . . Pop art is immediately contemporary.
> . . . It is an expression of contemporary sensibility
> aware of contemporary environment.[4]

Through the Pop artists the imagery of mass
media appeared as a new American icon, but
one of coolness and little warmth.

Artists usually associated with Pop art on
the American East Coast include Andy War-
hol, Roy Lichtenstein, James Rosenquist, Tom
Wesselmann, Claes Oldenburg (see discussion
under Sculpture, 1960s), Robert Indiana, and
Jim Dine. Of those, it is Andy Warhol whose

own image has become an "icon," who often stands as a symbol of the Pop art movement. His name now conjures up images of entrepreneur, huckster, and collector as well as artist.

Born in Pennsylvania coal country in Forest City in 1925, Andrew Warhola, as he was originally named, was the son of a coal miner who died in 1942. For years he was purposely vague about the date and place of his birth. Brought up as a Roman Catholic and of Eastern European descent, he understood early the power of icons. During summer vacations he gained frequent exposure to rows of commercial goods as he worked in a five-and-dime store and sold peaches. He moved to New York in 1949 after graduating from the painting program at Carnegie Institute of Technology. While at Carnegie Tech he also worked as a window decorator in a Pittsburgh department store. In New York he became commercially successful illustrating shoes for I. Miller, stationery for Bergdorf Goodman, television weather charts for CBS, and Christmas cards for Tiffany. But Warhol wanted more than commercial success and began painting again. He was particularly influenced by the work of Johns and Rauschenberg, who had stepped beyond Abstract Expressionism. One of Warhol's early paintings, *Del Monte Peach Halves*, 1961, although, with its dripped elements, still very painterly, points the way to the famous soup can paintings that he began in 1962. In the early sixties he also began painting pictures of money. The idea of painting money is said to have originated in a conversation between Warhol and Murial Latow, the director of a failing gallery.

"All right," Murial said. "Now, tell me, Andy, what do you love more than anything else?"

"I don't know," Andy said. "What?"

"Money," Murial said. "Why don't you paint money?"[5]

Warhol's soup can paintings [2.1] were actually first shown in Los Angeles at the Ferus Gallery. A neighboring gallery, in protest and criticism, set up a display of soup cans, selling for twenty-nine cents each. Warhol's paintings were selling for $100 each.

By the end of 1962 Warhol had adopted the use of the silk-screen process on canvas to reproduce his iconography of Coke bottles, movie stars, dollar bills, the electric chair, and so on. The use of the silk-screen procedure allowed him to produce works based on the reproduction of magazine and newspaper imagery. He wrote in 1962, "I adore America and these are some comments on it. My image is a statement of the symbols of harsh, impersonal products and brash materialistic objects on which America is built today. It is a projection of everything

2.1. Andy Warhol, *Campbell's Soup Can with Can Opener*, 1962. The Museum of Modern Art, New York.

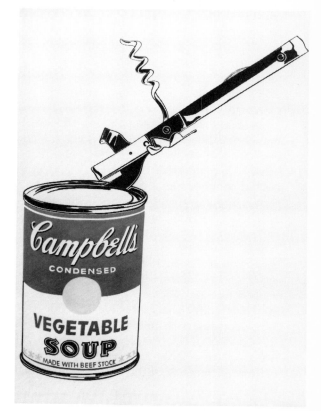

that sustains us."[6] Warhol's multi-image paintings, be they soup cans, disasters, or celebrities, show no emotion. They are flat, deadpan, repetitive, and play off the notion of a distanced television image. Death and disaster became commodities too in pieces such as *Ambulance Disaster*, 1963, or *Lavender Disaster*. The latter depicts fifteen electric chairs in pretty cosmetic colors.

Warhol's portraits of celebrities (a number of these were done in the seventies) such as Liza Minnelli, Marilyn Monroe, Mick Jagger, Philip Johnson, Jackie Kennedy, and Leo Castelli, and even his own self-portraits, have immortalized the figures as images of wealth, power, and stardom in the age of Pop. One does not see individual portraits of the lower classes. Barbara Rose commented about his commissioned portraits, "Someday [they] will appear as grotesque as Goya's paintings of the Spanish court. Like Goya, Warhol is a reporter, not a judge, for it was not obvious to Goya's contemporaries they were deformed either."[7]

Warhol's persona and life-style were as famous as his paintings. With his Warhol Enterprises, his Factory (his studio), he gathered people about him as he became a star. In his early years of fame he was noted for "his wildean life, with its parties and hints of perversity, his fondness for the fib and the put-on, his 'underground' movies with their nudity and unexpected couplings, in a period when social and sexual mores were in disarray."[8] He was also associated early in his career with vanguard rock groups such as the Velvet Underground.

His brashness was somewhat tempered, though, one day in 1968 when Valerie Sonas, who had once played a bit part in a Warhol film, walked into the Factory and shot him. Given only a fifty-fifty chance to live, Warhol had a long convalescence. But during that time he started his monthly newspaper, *Interview*. He was to go on to publish several books, such as *POPism*, a memoir of the sixties, *Exposures*, a book of celebrity pictures with Warhol's candid camera, and *The Philosophy of Andy Warhol*.

In the last years of his life Warhol turned to a kind of gestural expressionism, which he had once fought against, in his abstract oxidation paintings that were made by urinating on canvas covered with bronze or copper paint. Had he decided to make a more personal appearance in these late paintings, in contrast to his earlier machinelike aesthetic of depersonalization? His unexpected death in 1987 following surgery left a similar aura that had surrounded much of his life. His 1986 *Self-Portraits* were his last exposures for the world and combined past and present for Warhol [2.2].

Color him red and Warhol's in hell. Overprint with raspberry ripples and he's at the soda fountain. Add combat browns and greens and he melts into the jungle, Warhol, the *Contra*, Warhol the Clown, Warhol the man on black, his chin grounded on the bottom of each canvas, is one and the same Warhol throughout, lending himself for purposes of exploitation. This is where the cookie crumpled.[9]

During his life, Warhol had amassed an art collection of thousands of pieces, from kitsch to fine art of various periods to classic antiques. An auction was held following his death to raise money to give away a required yearly 5 percent of the assets of the new Andy Warhol Foundation for the Visual Arts which was the primary beneficiary of Warhol's will. The auction was an event Warhol would have loved: $25.3 million was made from a collection that included chalkware dogs and Puss 'n' Boots cookie jars. There was a slick ninety-five-dollar catalog, parties, and previews. Warhol's statement that "Good Business is the best art" had come true.

Beyond the hype, part of Warhol's achievement lay in his ability to transform and create images that originated in sources accessible to everyone and that were not locked in the myths of Abstract Expressionism. As one critic wrote,

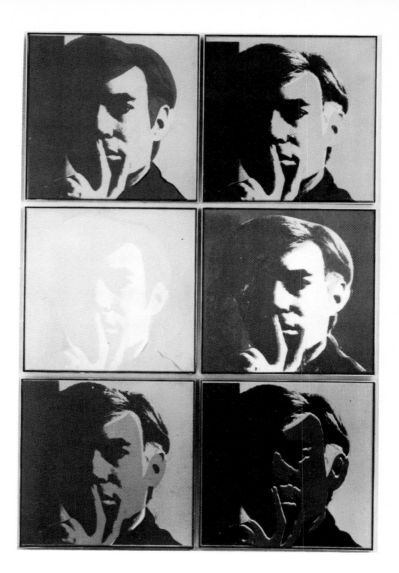

2.2. Andy Warhol, *Self-Portrait,* 1966.
Sidney and Harriet Janis.

Part of Warhol's achievement was to legitimatize his love of secular, profane subjects by attaching them to traditional religious values. For those who love popular culture, love stars, need the American mainstream, his purity, self-effacement and belief in a transcendent present hold out the promise of salvation. Warhol argues that self-effacement and sensual excess, purity and trash, can exist together.[10]

If Warhol was shocking initially with his soup cans, so too was Roy Lichtenstein with his transformation of comic strips as he united "high" and "low" art. As he enlarged and al-tered the comic strip to a monumental paint-ing, Lichtenstein was able to create a sense of drama without sentiment and emotion [2.3]. As he commented, "One of the things a cartoon does is express violent emotion . . . in a com-pletely mechanical and removed style."[11] Lich-tenstein later took his comic-strip style and made "art about art" in his transfiguration of artists such as Picasso, Braques, Monet, and Ma-tisse.

James Rosenquist took his experience as a billboard painter to create ambitious paintings of fragments of everyday American life—a car,

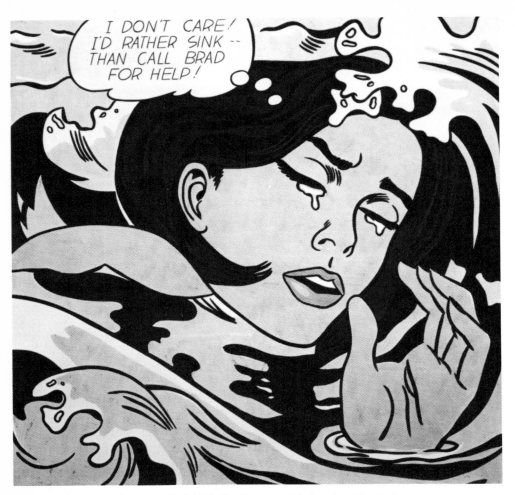

2.3. Roy Lichtenstein, *Drowning Girl*, 1963. The Museum of Modern Art, New York.

a picnic table, spaghetti. Unlike Warhol's and Lichtenstein's, Rosenquist's work was more formally routed in the aesthetics of Cubist collage. For him there was a freedom in the use and juxtaposition of his fragments. "The images are like no-images," said Rosenquist. "There is a freedom there. If it were abstract, people might make it into something. If you paint Franco-American spaghetti, they won't make a crucifixion out of it, and also who could be nostalgic about canned spaghetti? They'll bring their reactions but, probably, they won't have as many irrelevant ones."[12] In his 1963 *Nomad* [2.4] he juxtaposed advertising media with im-

ages of the open road that the film *Easy Rider* was to exalt. Yet there is a coolness and detachment as well as irony in the arrangement of the images. The lithe ballet shoes and soggy spaghetti, the open sky, and front of a soapbox become one.

Rosenquist did not usually deal with political themes, but his piece *F-111* of 1965 was named after a warplane and was a comment on the Vietnam War. Eighty-six feet in length and ten feet high, the painting covered the four walls of a room in the Castelli Gallery, where the piece was first shown. Scenes of destruction are combined with images of routine American

life in the sixties. A smiling blond-haired little girl is juxtaposed near a bomber and clouds of destruction. The sale of the painting at the time, allegedly for sixty thousand dollars, was reported on the front page of the *New York Times* because of its price and political commentary. Following *F-111*, Rosenquist experimented with mixed media and constructions such as his *Tumbleweed*, 1963–66, made of neon, sticks of wood, and chromium barbed wire.

Tom Wesselmann also employed a billboard aesthetic in some of his pieces, among them his series of *Still Lifes*, large pieces consisting of images of food cut from subway posters and advertisements. He is perhaps best noted for his *Great American Nude* series that he began

in 1961, which grew out of an early student interest in cartoon illustration. He had studied cartooning at the Cincinnati Art Academy and later transferred to the Cooper Union in New York in the late fifties. In his *Bathtub Collage #3*, 1963 [2.5], one sees Wesselmann's ability to deal with close-up cropped imagery. The woman is and is not a sex symbol, for in his cool, hard-edged treatment of the subject there is little sensuality. Beginning in 1963 Wesselmann made a number of paintings into environments as he added real furniture to the paintings, and in one work the breast of a live woman appeared from the ceiling.

More abstract than Rosenquist or Wesselmann was the work of Robert Indiana. Like Stuart Davis, Indiana was concerned with the

2.4. James Rosenquist, *Nomad*, 1963. Albright-Knox Art Gallery, Buffalo.

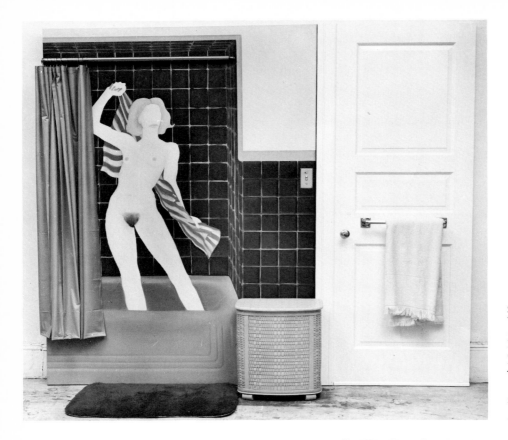

2.5 *(left)*. Tom Wesselmann, *Bathtub Collage #3*, 1963. Museum Ludwig, Cologne. Courtesy Sidney Janis Gallery, New York.

2.6 *(below)*. Jim Dine, *Tie*, 1962. Ileana and Michael Sonnabend.

use of letters and numbers in his pieces and like the American Precisionists used clean, clear-cut forms. Some of his works, such as his *Southern States* series, offer an indictment of American society, unlike much of Pop imagery. Many of his works, such as *American Dream I*, 1961, look like road signs, using stenciled lettering. Here one is forced to question the nature of the American dream—was it take all?

More loosely associated with Pop art were the more expressive works of Jim Dine. His imagery, which included his bathrobe, his neckties [2.6], tools, his palette, his color charts, and hearts, was more personal and less detached than some of the other Pop artists. In some pieces he employed actual objects, as in *Five Feet of Colorful Tools*, 1962. Unlike some who talked about the use of objects to bridge the gap between art and life, Dine's belief was "there's art and there's life. I think life comes to art but

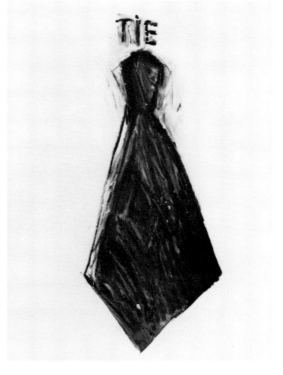

if the object is used, then people say the object is used to bridge that gap—it's crazy. The object is used to make art, just like paint is used to make art."[13] For Dine the immediacy and "presentness" of the object was important, not the object itself but the way it was used in his paintings. Sometimes there were elements of parody in the work. Max Kozloff wrote that Dine "outwits our cherished illusion of the non-representational and is an inspired middleman between the simulated and the recreated, re-selling them at his pleasure; he is, if you will, the mad jobber of art."[14]

Dine's roots actually lay in Abstract Expressionism, and he particularly admired Motherwell and de Kooning. Arriving in New York in the early sixties from Ohio, Dine was attracted to the work of Allan Kaprow, then teaching at Rutgers University. Dine participated in a number of early Happenings along with Claes Oldenburg, Robert Whitman, and Red Grooms. By 1966 Dine was established as a major contributor to Pop art as he became more and more involved with the use and depiction of objects. But the New York art world was beginning to feel like a pressure cooker for him, and from 1966 to 1969 he stopped painting completely. He and his family moved to London for five years, and he began to look at the work of some of the old masters in both Paris and London. It was only through the medium of printmaking, which freed him from the pressures of making paintings, that he was able to reestablish his creativity.

Some West Coast artists such as Mel Ramos, Edward Ruscha, Joe Goode, Wayne Thiebaud, and Billy Al Bengston were also associated with Pop art. The influence of Hollywood, the large supermarkets, and the variety of California subcultures, such as the hot-rod world, contributed to Pop imagery. Thiebaud became noted for his painted displays of baked goods, such as his *Pie Counter*, while Ramos became known for his pin-up "calendar" nudes, often depicted in conjunction with aspects of American advertis-

ing, such as his *Val Veeta*, where a young nude woman seated on a box of Velveeta cheese is not so much an erotic or sensual statement as a satiric comment on commercial imagery.

Ruscha, who was from Nebraska, arriving in Los Angeles in the late fifties, painted empty filling stations that were not only comments on conformity in America but also well-articulated hard-edge studies in color and shape, as evidenced in his *Standard Station, Amarillo,* 1963. One is reminded of Precisionist paintings earlier in the century. Ruscha sometimes focused solely on the words in his paintings, as they became dominant signs, both literally and figuratively, in the "landscape" of Ruscha's paintings. In his 1963 *Flash, L.A. Times* [2.7], the boldface bright yellow letters on an electric green field shriek at the viewer and immortalize part of the California culture.

In England Pop artists who had developed independently of the Americans, such as Richard Hamilton, Richard Smith, Eduardo Pao-

2.7. Ed Ruscha, *Flash, L.A. Times,* 1963. Mead Corporation.

lozzi, Robyn Denny, and Peter Blake, continued to work, but more abstractly. The Independent Group, which had been formed earlier, was sociologically oriented. Other Pop-oriented artists turned more toward the environment—that is, the colors, lights, and forms of mass media rather than human images. Richard Smith, for example, did a series of variations on a cigarette package motif, as seen in his 1962 *Soft Pack.*

Influential in the development of English Pop art was the American-born R. B. Kitaj, who was studying at the Royal College of Art in London under the G.I. Bill. He was born Ronald Brooks but took the name of his mother's second husband, Dr. Walter Kitaj, a Viennese Jew. In the sixties Kitaj was often inspired by images from photographic materials and methods of photomechanical reproduction, as well as filmmaking. He did paintings of everyday scenes and personalities of modern history such as Walter Lippmann [2.8]. Here, as in other paintings of the time, he used broad, flat areas of color with a linear emphasis. The fragmentation of the composition and breakup of space harks back to some Cubist structures. Unlike many of the Pop artists, though, Kitaj's personal interests were not so much with popular cul-

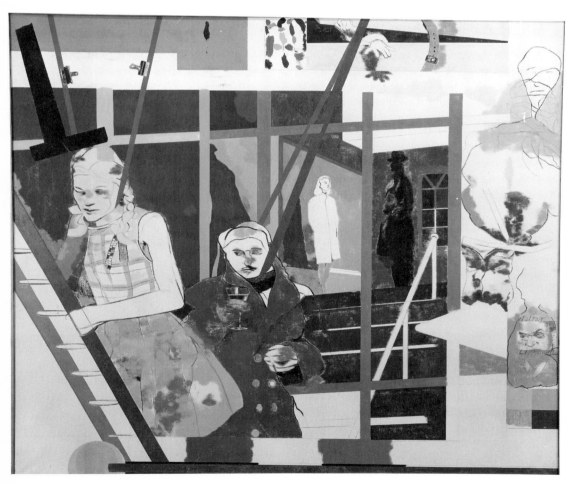

ture as with literacy and theoretical sources. He loved Kafka, Joyce, Eliot, and Pound, and was very much influenced by the German-born critic Walter Benjamin. He surrounded himself with books, and has stated, "For me, books are what trees are for the landscape painter."[15] In his later works Kitaj's work became more expressionistic, less flat, and even more brilliantly colored, as he explored his Jewish roots in his 1980s paintings. A number of these paintings reflected his concerns with the plight of the Jews during the Holocaust. Kitaj has continued to work in London since his student days.

Kitaj's fellow student at the Royal College of Art was David Hockney. Hockney, with his charming personality, his blond hair, and granny glasses, was somewhat a celebrity figure himself as he emerged during the early sixties. Hockney drew his imagery not from comic strips or ads but from his friends and places he visited, as seen in his *Portrait of Nick Wilder,* 1966. On a 1961 visit to New York he did a series of etchings entitled *A Rake's Progress.*

Hockney traveled extensively—to Germany, Italy, Egypt, New York, and Los Angeles. Attracted to the Southern California light and life-style, Hockney made his home base there, keeping a studio in London. In southern California he developed the iconography he is most noted for—the palm trees, bungalows, sprinklered lawns, and most of all the swimming pool. His *A Bigger Splash* [2.9], 1967, shows his use of cool, flat colors. Here the blues of the sky and water are juxtaposed next to the warmer tones of yellow, tan, and orange-red to create an eerie emptiness, where the only sound is the splash in an environment of stillness and flatness. Later Hockney took his fasci-

2.8 *(opposite).* Ronald Kitaj, *Walter Lippmann,* 1966. Albright-Knox Art Gallery, Buffalo.

2.9. David Hockney, *A Bigger Splash,* 1967. Tate Gallery, London.

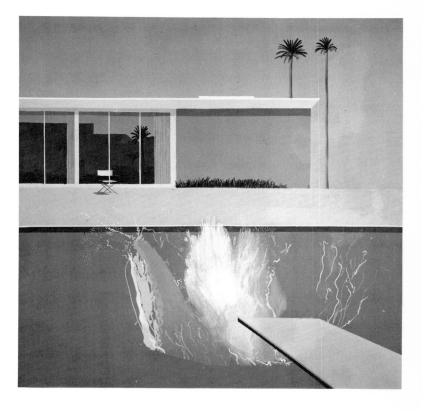

nation with pools further as he actually painted the bottoms of pools to simulate light and movement.

Hockney has worked in various media and formats, including painting, etching, drawing, stage designs, posters, and photography. His work often contains a Matisse-like brilliance of color and flattened forms, as well as Dada playfulness.

In the early sixties Hockney used the camera for preliminary studies for his paintings. In his monumental photocollages of the eighties, often using the Polaroid camera, Hockney explored space and time relationships that are rooted in the investigations of Picasso and Braque in their Analytic Cubism. In a piece such as *The Brooklyn Bridge, Nov. 28, 1982,* Hockney follows the movement of his eye over time and shatters traditions of smooth-edged, four-sided formats in photography.

Hockney's work is filled with both clarity and wit, mirrored even in his dress. (He often wears mismatched polka dots and stripes and two different colored socks.) He has been called by Maurice Tuchman, senior curator of twentieth-century art at the Los Angeles County Museum of Art, "perhaps the most popular serious artist in the world today."[16] Although Hockney is not usually directly associated with the American Pop artists, he shows similar sensibilities in his attempts to close the gap between art and life and his attention to everyday culture.

Although there was no "hard core" Pop art on the continent of Europe, as in the United States, there was work going on in Europe that had some analogies to Pop art. On October 27, 1966, a new group, called the Nouveaux Réalistes, was founded by Pierre Restany and Yves Klein. The original group included Arman Fernandez, François Dufrêne, Raymond Hains, Martial Raysse, Daniel Spoerri, Jean Tinguely, and Jacques de la Villeglé. It later included César Baldaccini, Christo, Gérard Deschamps, Mimmo Rotella, and Niki de Saint-Phalle. The

solidarity of the group faded after Klein's death in 1962, but the artists in the group continued to have influence into the sixties. A manifesto was written in Milan, and the group showed at Restany's Gallery J in Paris and in an important exhibit in the United States at the Sidney Janis Gallery in New York in 1962. The exhibit included British and American Pop artists, representatives of the French Nouveau Réalisme, as well as related new works from Italy and Sweden. Restany stated in the catalog for that show:

> In Europe, as well as in the United States, we are finding new directions in nature, for contemporary nature is mechanical, industrial and flooded with advertisements. . . . The reality of everyday life has now become the factory and the city. Born under the twin signs of standardization and efficiency, extroversion is the rule of the new world.[17]

A further comment by Restany, that "the new realism registers the sociological reality without any controversial intention,"[18] illustrated the group's desire to create impersonal statements without the taint of either Abstract Expressionism or Social Realism—an intent similar to the American Pop artists. The "New Realism" meant "putting your feet back on the ground. That was the real question. The war had traumatized us, we considered abstract art an art of evasion which had no interest in presenting this world. . . . The fact of dreaming was, quite simply, the fact of existing. There was no difference between dream and reality."[19]

Unlike the American Pop artists, the European group would rarely consider transposing large-scale single images, such as a soup can or comic strip frame, onto the canvas. The work of the Nouveaux Réalistes was quite varied but may be divided into four major categories: painting, décollage, assemblages (a number of these artists were shown in the Museum of Modern Art's 1961 "The Art of Assemblage" exhibit), and "Action Spectacle." Décollage in-

volved "un-collaging" or tearing away materials to reveal underlayers and structures. The décollagistes, such as Rotella and Dufrênes, illegally scraped layers of posters and advertisements from public places and transformed them into new works, as seen in Dufrênes's *La Demi-soeur de l'inconnue*, 1961, which consists of torn posters on canvas. Gérard Deschamps's *Tango-Bolero* [2.10], made from beautifully colored and patterned fabrics and scarves, is both painterly and sculptural, as the fragmented forms of everyday objects create a new unified whole. "The New Realists rarely let the chosen object speak for itself, but invest it with a soupçon of mystery and elegance by fragmentation, juxtaposition, or slight alteration. It is not the directness, the banality, the refreshing anonymity of urban reality that appeals to them, but the hitherto unrecognized strangeness latent in every common object, old or new."[20]

Fusing American and English Pop with New Realism was the Haitian-born Hervé Télémaque, who often took Disney cartoons as a source of inspiration. Télémaque had lived in New York from 1957 to 1960 and moved to

2.10. Gérard Deschamps, *Tango-Bolero*, 1961. Courtesy Zabriskie Gallery, New York.

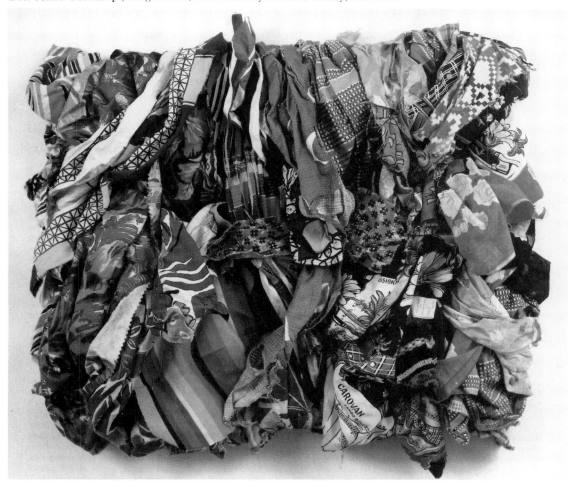

Paris in 1961. His works often had a violent edge to them, with his juxtaposition of fragmented images from contemporary society and use of large areas of black canvas, as seen in *Piège,* 1964.

The Spanish artist Juan Genovés used the photographic imagery common to the Pop artists to create commentaries on war, destruction, and political repression in the sixties and seventies. Such commentary, with the notable exception of Rosenquist's *F-111,* was unusual for Pop artists. The horror of political repression and victimization of the unknowing is seen in a piece such as *Sobre la Represión Politica,* where the "victims" are "surrounded" in an empty and endless planar surface.

Of the same generation as the European New Realists was the Colombian painter Fernando Botero, known for his obese figures and portrayal of bourgeois Colombian society— middle-class businessmen, their families, politicians, military figures, lovers, prostitutes. The directness of his statements and the impersonality of his social types has some affinities with the New Realists. In 1960 Botero moved to New York and found a greater freedom to develop his imagery. He now maintains residences in New York, Paris, Colombia, and Italy.

The Brazilian artist Antonio Henrique Amaral married Pop art and political statement as he used the image of the banana to symbolize Brazil. One of his early uses of the banana shows it linking the Brazilian and American flags to suggest American economic dominance over Brazil. The motto of the Brazilian flag, "Order and Progresso," became a pun "Prog-(Esso)." The Pop use of the banana led to Amaral's use of photorealist techniques in his paintings of the seventies.

A German urban response to the dreams of Surrealism and the personal, emotional gestures of Abstract Expressionism was "Quibb art." H. P. Alvermann and Winfred Gaul stated in the First Quibb Manifesto, written in Düsseldorf in 1963, "Quibb art is no German version

of Pop Art, New Vulgarism, Junk culture, Nouveau Réalisme or Neo-Dada. . . . We do not work with cardboard knives. We work with a butcher's knife. Our art is no excursion to Disneyland. . . . Surrealism constructed its monsters. We find them on the street. We do not want to shock, the things shock us."[21] These artists and others influenced by the group often used photo collage and montage, and their work was often that of protest. John Anthony Thwaites commented on the nonexistence of a hard-core Pop art in Germany, "Pop art proper exists in Germany only in the world of its epigones. Quite possibly, Pierre Restany is right: Pop is a product of the megalopolis, and since the loss of Berlin, Germany has no super-cities to inspire it."[22]

Returning to the United States, the art of Romare Bearden dealt with the streets and everyday life of a black America in a manner distinct from the Pop artists yet asserting, like them, the importance of the everyday environment. Best known for his collages, Bearden's art is an art of life, drawing upon experiences from urban New York and the rural South. Bearden was born in Charlotte, North Carolina, and grew up in Harlem. Growing up, he played baseball, wrote songs, and studied jazz and literature, as well as art. He started out making cubist paintings. In the thirties his work became more figurative when he studied with Georges Grosz at the Art Students League in New York. His exhibitions began in 1940 and by the early 1960s Bearden was one of only two black artists to show work regularly in New York galleries. The other was Jacob Lawrence. In 1963 Bearden was a founder of the Spiral Group, dedicated to the furthering of the role of the black artist in society at large. The word *spiral* was chosen by one of the members, Hale Woodruff, to designate the concept of the black artist's movement upward and outward. It was with the Spiral Group that Bearden began to concentrate seriously on collage, feeling it was a medium that all artists could take part in.

Bearden's collages, with their kaleidoscopic qualities, speak to the viewer with compassion. His work speaks not only of black culture and its traditions and imagery but also of human and universal qualities of men and women. Such is seen in, for example, *The Street* [2.11], 1964, and *Interior* of 1969. In an interview he once stated:

> I wasn't an abstract expressionist or a pop artist. . . . I believe that it was because I had something unique to say about the life that I know best. I took an art form that was different. What I had to say took a little different form than most of the paintings around; I used the collage. Especially in some of the earlier collages that I did, I chose some of the photographic materials for a certain reason, I wanted to give an immediacy, like a documentary movie.[23]

It was not until 1971 that Bearden's work was fully acknowledged, when a retrospective exhibition, "The Prevalence of Ritual," was held at the Museum of Modern Art. With that exhibition came an increasing visibility for other Afro-American artists. Bearden's *Odysseus* series from the seventies symbolizes well Bearden's own search to reclaim his past and articulates its significance for the contemporary world.

The vibrance of lives lived in Bearden's collages stand in contrast to the cooler figures of what came to be called New Perceptual Realism[24] and Photo-Realism, which frequently drew upon photographic resources and commercial advertising. This new realist tendency was identified as early as 1963 by Sidney Tillim, who wrote in *Arts Magazine,* "In a spirit analogous to pop art, the most literate realism concentrates . . . on the factual presence . . . of the object that is simply *there*—returned, re-

2.11. Romare Bearden, *The Street,* 1964.

gained. . . . The expression is primarily on the *restitution* of the object rather than the emotional evocation *through* the object . . . for the moment, then a new realism would be anti-expressionist, anti-rhetorical."[25]

The flat, planar colors of Alex Katz's paintings emphasize the stiffness of his figures, in *Ives Field* 11, 1964 [2.12]. Often Katz portrayed his figures, usually his friends, family, or personalities of the art world, close-up from the shoulder up, almost like billboard images, as suggested in *Vincent with Hood*. Although the pictorial language is simplified, there is a complex coolness and sense of distancing, with no sentimentality and emotion.

Philip Pearlstein, although more illusionistic than Katz, was also associated with this new Realism, with his powerful nude figures, often cropped and painted at odd angles. In his *Female Model in Robe Seated on Platform Rocker* [2.13], 1973, Pearlstein uses classical elements—the pose, the mirror—but the portrayal of the figure is harsh, anti-idealistic. In little of Pearlstein's work is there a sense of a warmth of life, psychological or social, beyond the surface of the figure and the painting. Pearlstein has commented on his work:

I have made a contribution to humanism in 20th century painting—I rescued the human figure from its tormented, agonized condition, given it by the expressionist artists, and the cubist dissectors and distorters of the figure, and at the other extreme I have rescued it from the pornographers, and their easy exploitation of the figure for its sexual implications. I have presented the figure for itself, allowed in its own dignity as a form among other forms in nature.[26]

Other artists associated with the New Perceptual Realism were Jack Beal, Alfred Leslie, Neil Welliver, and William Bailey. The eerie, theatrical lighting of Leslie's large frontal figurative images forces the viewer into a direct and close confrontation with the figure. In contrast, the stillness of William Bailey's nudes and still lifes has a distancing effect. In Bailey's *"N" (Female Nude)* [2.14], c. 1965, there is a suggestion of another mysterious world, well structured and serene, mirrored in the articulate composition of the piece. In a world of tumultuous events, stillness was shocking at the time.

Neil Welliver and Fairfield Porter created landscape images that were both realistic and abstract, as they explored color, shape, and shadow in pieces such as *Pond Pass* [2.15],

2.12. Alex Katz, *Ives Field II*, 1964. Weatherspoon Art Gallery.

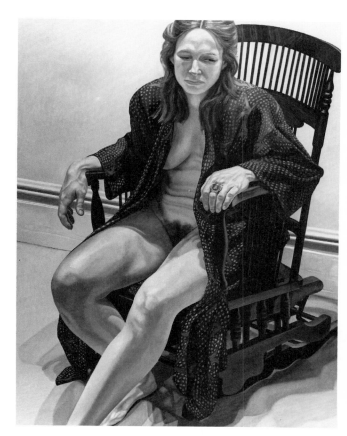

2.13. Philip Pearlstein, *Female Model in Robe Seated on Platform Rocker,* 1973. Courtesy of the San Antonio Museum Association.

2.14. William Bailey, *"N" (Female Nude),* c. 1965. Whitney Museum of American Art, New York.

1969, and *The Garden Road*, 1962. Porter's landscapes, portraits, and still lifes tend to be more intimate and luminous than Welliver's more expansive pieces. It is interesting to note that Porter, as well as artists such as Bailey and Pearlstein, were influenced in their early days by the Abstract Expressionists. Porter's first one-man exhibition was due to de Kooning's advocacy. Also turning from the Abstract Expressionist style, as well as her Bauhaus-inspired training at Yale, was Janet Fish, who by the mid-sixties had stated her preference for a

painterly realism. Her dazzling still lifes, particularly of glass objects [2.16], are brilliant portrayals of the interactions of light, shape, and color. Ordinary glassware is transformed into luminescent jewels (Plate 4).

Realism in the sixties was not easily accepted then, or in subsequent decades, by those who cried out for the new, for the rebellious. William Bailey, for example, was accepted by an established gallery but never given a show. It was not until the late sixties that Bailey and others began to build a reputa-

2.15. Neil Welliver, study for *Pond Pass*, 1969. Collection the artist, courtesy Marlborough Gallery, New York.

2.16. Janet Fish, *Black Vase with Daffodils*, 1980. Robert Miller Gallery, New York.

tion among a small group of collectors and acquaintances. The difficulties some of these realist painters faced were described by Mark Stevens:

> The temper of the twentieth century has also discouraged realism. There is little faith today in fixed meanings or stable perspectives; philosophers and structuralist critics have left even the simplest works and images tangled in ambiguity. Arriving at a steady image of man himself has been no easier. . . . In our era pop artists have kept their distance through irony, jokes, and commercially derived imagery, for example, while the photorealists imposed the filter of photography between themselves and the world.[27]

Those artists who did turn to the use of the camera in Photo-Realism, where camera images were projected onto the canvas, were per-

haps more readily accepted, for the camera provided a mechanical filter between the artist and his world, and between the viewer and subject. There was a "safe" distance and literalness established with no commitment or comment. As Chuck Close commented, "The camera is objective. When it records a face it can't make any hierarchical decisions about a nose being more important than a cheek. The camera is not aware of what it is looking at. It just gets it all down. I want to deal with the image it has recorded which is . . . two dimensional and loaded with surface detail."[28] Indeed, Photo-Realism was a "simulacrum," not of life but of a photographic image of life.

Artists using photo-realist techniques included Chuck Close, Richard Estes, Audrey Flack, Robert Bechtle, Richard McLean, the British-born Malcolm Morley, and Don Eddy. Audrey Flack was among the first to create a genuine photo-realist painting. A native New Yorker, Flack had decided at age five to become an artist. Studying at the Cooper Union and Yale, she had first worked in an abstract expressionist style but turned to realism. In the early sixties her work focused on social and political themes, such as the civil rights movement and the assassination of President Kennedy. By the late sixties she had begun to use slides of "still-life" arrangements, projected on the canvas to paint. Like a number of other artists, she turned to using an airbrush, which provided a smoother surface. Despite the mechanical process of her work, Flack often chose personal objects to create her large *vanitas* canvases, such as her *Chanel*, 1974 [2.17], where the seventeenth-century genre becomes contemporary. The alluring colors and shapes of the fruit, the makeup, the draperies, and so on in their complex spatial arrangement are compelling. The inclusion of objects such as the calendar, the clock, and the hourglass add a fourth dimension of time to the piece.

Different from the luscious objects in Flack's pieces were the more delicate, reflec-

2.17. Audrey Flack, *Chanel*, 1974. Courtesy Louis K. Meisel Gallery, New York.

tive surfaces of Richard Estes's paintings. Estes often chose store windows, such as *Woolworth's*, 1974 [2.18], to create multiple layers of reflection and refraction.

Chuck Close chose to enlarge the human head in his giant frontal portraits. Initially working with black and white, Close did not use color until 1970. For him it was not the subjects of his paintings that were important but rather the situations and decisions that resulted from the photographic processes [2.19]. In an interview for *Art in America*, he stated:

> I was never happy inventing interesting shapes and interesting color combinations because all I could think of was how other people had done it. . . . Now there is no invention at all; I simply accept the subject matter. I accept the situation. There is still invention. It's a different kind of invention. It's "how to do it," and I find that, as a kind of invention, much more interesting. I do think approaching a painting that way—with any

kind of self-imposed discipline—ultimately affects the subject matter. That's what sustains me. I'm not concerned with painting people or with making humanist paintings.[29]

That these artists were so attracted to photographic processes emphasizes the impact again of the media, as was seen with some of the Pop artists. The media was beginning to dictate what was real and not real. As Richard Estes responded in an interview, "It [the media] has to affect the way you see things. Your whole life affects what you do. Even if you don't watch T.V. you are affected by it. We see things photographically. We accept the photograph as real. But, maybe if you showed a photograph to someone in a primitive society who had never seen a photograph, he might not recognize what it was."[30]

Quite different from the Photo-Realists in her approach to the figure and realism was Alice Neel. Her expressionistic portraits re-

2.18. Richard Estes, *Woolworth's,* 1974. San Antonio
Museum of Art.

2.19. Chuck Close, *Frank,* 1969. The Minneapolis
Institute of Arts.

ceived little credence during the Abstract Expressionistic era, yet they provided penetrating views of her family members, fellow artists, and neighbors. Neel was from a wealthy Philadelphia family but rejected her background when she married a Cuban student after studying at Moore College of Art. Her life seemed to be filled with tragedy: her first child died of diphtheria, and she was abandoned by her husband. She went to New York after being released from the hospital following a nervous breakdown. Her somber and often expressionistic pieces of the forties and fifties were not recognized at the time. It was not until the sixties and onward, when there was renewed interest in the figure, that her portraits of people such as Bella Abzug, Ed Koch, and Red Grooms received recognition. Sometimes referred to as a "collector of souls," Neel often probed deeply into the psyches of her subjects in her penetrating portraits. Her portrait of Andy Warhol [2.20] shows us something besides the glitz that often surrounded Warhol. Neel was perhaps not fully recognized until 1975, when the Whitney Museum held an exhibition devoted to her work. In 1976 Neel was elected to the National Institute of Arts and Letters.

Abroad, the work of the British artist Lucian Freud, a native of Berlin and friend of Francis Bacon, also penetrated beyond surface details in his moving, expressive portraits. The grandson of the psychoanalyst Sigmund Freud, Lucian Freud has been a figure of myth and mystery. He has kept himself from the public, giving his telephone number to no one, and does not have his name or number on his front door. He has been both severely criticized and highly praised. One critic for *Le Monde* described his "painting flesh like badly carved ham." Yet Robert Hughes, art critic for *Time,* called him "the greatest living realist painter," while John Russell of the *New York Times* called him "the *only* living realist painter . . . as a witness to human nature in the second half of our century has had no equal, whether

2.20. Alice Neel, *Andy Warhol.* Whitney Museum of American Art, New York.

in Britain or elsewhere."[31] There is a disturbing sense of anxiety about many of his pieces, which are usually painted from models in his studio. "What do I ask of a painting?" Freud says, "I ask it to astonish, disturb, seduce, convince."[32] Freud's portraits have continued to be provocative over several decades. In the early seventies he began a series of powerful portraits of his mother, Lucie Brasch. The series continued into the eighties.

Other figurative painters in Britain besides Francis Bacon and Freud included Michael Andrews, Frank Auerback, and the Australian Sidney Nolan, who moved to England in 1955. Nolan often painted scenes from the early pioneering history of Australia and was among the

first to give Australian art a sense of identity.

Other artists noted for their realistic work during the sixties were Paris-trained Avigdor Arikha from Israel, Antonio López-Garcia from Spain, and Claudio Bravo, the Chilean painter residing in Tangiers. Bravo's work is trompe l'oeil. His pristine *Blue Package,* 1968, is ready to be opened.

Along with Pop art and various approaches to Realism, abstract art also developed in a variety of formats during the sixties. Hard-Edge painting begun during the fifties by artists such as Ellsworth Kelly and Ad Reinhardt flourished further in the work of artists such as Kenneth Noland [2.21] and Al Held. In many of the Hard-Edge pieces there was no foreground or background, no figures, but a sense of a total unity. There was little or no play with optical illusions.

In 1965 an exhibition entitled "The Responsive Eye" opened at the Museum of Modern Art. The show was an international survey of what was called "optical" art. William Seitz, the curator, included both European Constructivist and related work, and American approaches to abstraction. The term *optical* art had been first used in 1964 to describe that abstract art, usually of Constructivist roots, which dealt with optical elements such as color interaction, after-images, moiré patterns, and perceptual movement, often treated systematically. Its sculptural analogue was kinetic sculpture, which physically moved. Important to the movement's beginnings were Josef Albers in his *Homage to the Square* series, begun in 1949, and Victor Vasarely with his shifting planes of both black and white and color, whose vibrations often bewildered the viewer. In 1955 Vasarely had issued his *Yellow Manifesto,* where he had called for the abandonment of traditional easel painting for what he called "kinetic plastics." The unique work of art created by an individual artist was to be replaced by a more social art made by an artist involved with

2.21. Kenneth Noland, *Bend Sinister,* 1964. Hirshhorn Museum and Sculpture Garden, Washington, D.C.

industrial techniques for a mass audience.

Although "The Responsive Eye" exhibition was criticized by some for its curatorial choices, a number of artists' works now particularly associated with Op art received international recognition as a result of the show. One was the English artist Bridget Riley. After World War II Riley had studied at the conservative Goldsmiths College of Art in London and then in 1952 at the Royal College of Art. She then supported herself as a commercial artist and teacher. Her interest in contemporary art was sparked by seeing an exhibit of the Abstract Expressionists. She had studied the pointillist

paintings and their optical mix, and in 1960 began making the optical paintings for which she is best known. The undulating lines of her black and white paintings based on the shimmer of moiré patterns, such as *Current* [2.22], created disturbing optical reactions in the eyes of the viewer. Other artists working with similar "Op" effects included the American Richard Anuskiewicz, a student of Josef Albers; Michael Kidner, Larry Poons, and the Israeli-born Yaacov Agam (Jacob Gibstein). Larry Poons created large canvases of pulsating dots; Kidner experimented with moiré effects; Anuskiewicz used explosive color with straight lines and per-

2.22. Bridget Riley, *Current*, 1964. The Museum of Modern Art, New York.

2.23. Frank Stella, *Agbatana I*, 1968. Whitney Museum of American Art, New York.

spective techniques; while Agam made painted reliefs that could be viewed in a variety of perspectives.

Abstraction was explored in another vein through color interactions and the creation of shaped canvases. In 1960 Frank Stella gained recognition with his "stripe" paintings that were shown at the Museum of Modern Art's "Sixteen Americans" show. The paintings were large notched pieces with the stripes following the configurations of the notch. In 1967 Stella turned to brilliantly colored protractor shapes, as in *Agbatana I*, 1968 [2.23]. These may have resulted from his comparative study of Hiberno-Saxon illuminations and Pollock's poured paintings while at Princeton. In the seventies Stella moved onward to even bolder and more dynamic shaped and colored pieces, often using lacquer and oil colors on aluminum,

such as his *Untitled Metal Maquette*, 1977. The boundaries between painting and sculpture were diminishing.

Other artists experimenting with shaped canvases included the British Richard Smith, with his rough, jagged-edged canvases, and Charles Hinman who went beyond the flat shaped canvas to curvilinear and organic shapes that forcefully protruded from the wall.

The same year Stella began his protractor series, Richard Diebenkorn began his majestic *Ocean Park* [2.24] series in California, combining classical architectural "lines" and structure with expansive and light-filled color planes. The series followed his relocation to Santa Monica and phases of abstract expressionist and figurative painting. In these works one sees the passion of the Color Field painters tempered to a serene but heroic statement in his evocation

2.24. Richard Diebenkorn, *Ocean Park No. 27*, 1970. The Brooklyn Museum.

of the California landscape.

Another approach to abstraction was seen in the work of Cy Twombly, who after World War II worked mainly out of Rome. Twombly, a poet as well as a painter, became known for his chalk-board-like canvases of slate-gray grounds and white "grafitti" marks combined with words and numbers. His marks were reminiscent of the earlier gesture painters, but differed in their brevity, litheness, and more lyrical qualities. Although his "chalk" marks are not necessarily meant to be read, there are at times implied relationships between visual and verbal languages inherent in his work. His *Untitled*, 1969, creates a tension as one wants to "read" the numbers and letters but at the same time becomes visually absorbed in the ambiguities of the floating forms.

A concern with simple, basic forms and shapes and the revival of constructivist tendencies in the sixties led to Primary Structure or Minimal or ABC art. Emphasis was on reducing a visual statement to its essential and elemental shapes and forms. Usually there were strong geometric and industrial-like forms and intense, unmodulated, flat colors. Some paintings were based on mathematical or other systems.

Agnes Martin transformed haunting memories of the New Mexican landscape that she brought to New York to classical, refined grid paintings. She used the grid to define structure and to suggest open, continuous forms, which were both precise and elusive. Her use of monochromatic colors created veiled but radiant lights. Her grids varied in size and emphasis of color or line. "My formats are square, but the

grids are not absolutely square," explained Martin, "they are rectangles a little bit off the square, making a sort of contradiction, a dissonance, though I didn't set out to do it that way. When I cover the square surface with rectangles, it lightens the weight of the square, destroys its power."[33] Her paintings both observe and transform images of nature, as suggested in her 1964 *Tree* [2.25], and in some of her poetry. She wrote of one of her poems, "This poem, like the paintings, is not really about nature. It is not what is seen. It is what is known forever in the mind."[34] Martin deals with what is known more than what is seen, with memories and ideas. Her delicate work of nuances was both rooted in the past, being reminiscent of early American quilt designs and Indian textiles, and connected to the future, anticipating later experiments with the grid format.

Also influenced by the Southwest was Georgia O'Keeffe, who had moved to New Mexico, following the death of her husband, Alfred Stieglitz, in 1946. Although O'Keeffe is not usually directly associated with the Minimalists, some of her patio paintings have a direct affinity with a Minimalist aesthetic. In a piece such as *White Patio with Red Door*, 1960 (forty-eight by eighty-four inches), the large white plane, the twelve small rectangles, or stepping stones, and the "red door" suggest a spare and mystical beauty of reductive geometric forms. She diverged from a number of Minimalists, however, in her continuing attachment for "the object," in this case, the patio from which the piece has been abstracted. The twelve small rectangles are and are not stepping stones. This ambiguity contributes to the mystery of the painting. The expansive space of this as well as other later patio paintings was to dominate most of O'Keeffe's work in the sixties. Following a trip around the world by air in 1959 and a trip down the Colorado River in

2.25. Agnes Martin, *The Tree*, 1964. The Museum of Modern Art, New York.

1961, O'Keeffe also experimented with more organic, free-flowing, simplified forms in her series of paintings based on configurations of a river from an aerial perspective. O'Keeffe also completed a series of four paintings, *Sky Above the Clouds*, whose stylized geometric forms became "equivalents" for O'Keeffe's response to her flying experiences. The fourth *Sky Above the Clouds* was the largest canvas O'Keeffe had ever painted—eight by twenty-four feet.

Pushing monochromatic experiments further than Agnes Martin had was Robert Ryman, who in 1967 exhibited ten square paintings of equal size, each composed of all white brushstrokes on steel sheets. Ryman was concerned not with the subject but the process of pure painting. "There is never a question of what to paint, but only how to paint. The how of painting has always been the image—the end product."[35] In 1968 Ryman applied white polymer paint to twelve squares of classico paper put together to form a grid. Smaller geometric units were reflected in whites and shadows. In later works he made large wall-sized pieces. Ryman's white paintings convey a lyrical magic.

The younger Brice Marden, who had recently graduated from the Yale School of Art, developed rich but spare color surfaces using a mixture of beeswax and oil pigments. He has continued to refine his work. Some of his work of strong vertical and horizontal panels alludes to the post and lintel system of classical buildings based on the mathematical proportions of the Golden section. Often there is a sense of mystery about the work, which is based on geometric relationships (i.e., the size of the panels within a piece) and movement from dark to light or vice versa.

In the mid-sixties Dorothea Rockburne began using mathematical set theory as the basis for her work. She had studied painting at Black Mountain College in the late fifties, but found that she "didn't want to do painting that involved stretcher bars and canvas because the stretcher bars never seemed to have a function other than to represent external elements in a way you weren't supposed to see."[36] Initially Rockburne used paper, grease, oil, graphite, and chipboard to create oil-soaked geometric rectangles that interacted with each other. In the seventies she moved to using folded paper and ink or pencil, as well as gesso on sized linen to make her *Golden Section* paintings. In a piece such as *Neighborhood* of 1973 there is both a powerful simplicity yet a complexity in the intersecting lines and shapes. The tension of polarities in Rockburne's work—the simple/complex, primitive/sophisticated, ordered/unordered, balanced/unbalanced—points to the layers of richness possible in the work and illustrate that not all Minimal works were simply reduced geometric forms, as some took them at surface value.

Following the 1966 "Primary Structures" exhibition at the Jewish Museum, the Minimal work of Sol LeWitt commanded much attention. His white baked enamel pieces based on the permutations of a cube (see later discussion of sculpture) stood out as "cool," precise structures, which were to become icons of American art. Born in 1928 in Connecticut, LeWitt had had a variety of work experiences that were to feed directly and indirectly into his modular pieces and wall drawings. Following his graduation with a B.F.A. from Syracuse University, he served in the U.S. Army in Korea and Japan from 1951 to 1952, which gave him the opportunity to study Oriental shrines, temples, and gardens. In 1953 he moved to New York and attended Cartoonists and Illustrators School, later known as the School of Visual Arts. In the mid-fifties he did production work for *Seventeen* magazine and worked with the architect I. M. Pei on a project for the Roosevelt Field Shopping Center in Long Island, New York. Working at the Museum of Modern Art's information and book sales desk from 1960 to 1965, LeWitt met artists Robert Mangold, Robert Ryman, and Dan Flavin, who were working

as guards, as well as the critic Lucy Lippard, who was working in the Museum Library at the time. (In 1976 Lippard and LeWitt founded Printed Matter, a group whose goal was to print as well as distribute artists' books.) LeWitt also met the sculptor Eva Hesse in 1960, whom he knew well until her death in 1970. In 1963 his first three-dimensional works, which showed the influence of the Bauhaus, De Stijl, and Constructivism, were shown in a group show at St. Mark's Church in New York. By 1966 he was combining modules in serial formats. He made his first wall drawing on the wall of the Paula Cooper Gallery in 1968 in an attempt to develop his premise for drawings: "lines in four directions—vertical, horizontal, and the two diagonals." At the time, LeWitt's use of the wall instead of paper as the surface for his drawing was considered revolutionary. The grid often served as the basis for the drawings [2.26], and LeWitt could devise a system of instructions for the drawings in advance. Lawrence Alloway described LeWitt's working method:

A site becomes available, not necessarily one that the artist has seen in advance. After consideration of the dimensions and physical properties of the walls, LeWitt stipulates a certain kind of mark, and a certain form of distribution of marks by a sketch and/or verbal or written account. The instructions also serve as the work's descrip-

2.26. Sol LeWitt, *Wall Drawing,* 1970. John Weber Gallery, New York.

tion after it has been done, so that the wall is bracketed verbally, both before and after execution. The process-record is abbreviated, compressed between identical accounts of conception and completion.[37]

For some drawings LeWitt actually telephoned or sent instructions for someone else to execute the drawings, thereby raising questions concerning the uniqueness and role of the individual artist. For instance, he sent the following instructions from Vancouver to the Paula Cooper Gallery in 1970: "Within a 6 foot square 500 vertical black lines, 500 horizontal yellow lines, 500 diagonal (left to right) blue lines, and 500 diagonal (right to left) red lines are drawn at random."[38] There was also the possibility of different interpretations of the instructions, thereby introducing a "performance"-collaborative component to the work, just as a conductor might interpret a musical score. In later works LeWitt expanded his "syntax" of visual elements beyond straight lines to include circles, arcs, irregular lines, and further use of color. "By establishing system as a method for himself, LeWitt had created a way of working that was almost infinitely elastic and open-ended, one idea leading to another and still another, in intuitive leaps, from suggestions inherent in the work . . . new permutations were systematically exploited to produce new variations."[39] The plan of the drawing, which was to be shown with the actual finished drawing, was for LeWitt as important as the drawing. Le-Witt's drawings firmly established the integrity of drawing as an independent medium, which could be distinct from painting and not simply "a preliminary study." Many of the Abstract Expressionist painters had considered drawing to be a "Renaissance" medium and felt it was important to paint, not draw. (Jasper Johns had also begun to draw as much as paint; Robert Rauschenberg had started incorporating more drawings into his paintings; and Claes Oldenburg had begun to exhibit his drawings by this

time.) It may be argued, though, that the Abstract Expressionists' gestural application of line may be considered a type of drawing, with paint. As Bernice Rose wrote, "Drawing in dripped black paint from one work to the next on a continuous strip of white canvas instead of a sketch pad, Pollock provides a series of drawings that rival paintings in their breadth of scale and ambition. They set the precedent for the scale of LeWitt's later wall drawings."[40] Le-Witt's Minimalist wall drawings also attacked the traditional association of drawing with academic draftsmanship, of faithful and detailed renderings of life models, casts, and the like. Further, LeWitt's wall drawings contributed to the development of large-scale site pieces, and may be seen as a public statement of LeWitt's or his draftsman's private dialogue with the wall. The drawings have also been described as ritualistic.

> The use of language as a systematic regulatory device for the work enforces a reading of Le-Witt's work as ritualistic. Ritual is "a symbolic system of acts based on arbitrary rules" just as "language is an arbitrary symbol system based on arbitrary rules." . . . The purpose of ritual is to insure that the world works. Ritual has no connection with individual emotion; it is not expressionistic, but is a formalized cultural expression.[41]

It is important to bear in mind, though, that LeWitt's plans, his *ideas,* were as significant as the visual product. LeWitt's emphasis on concepts was to lead to full-blown conceptual art works and "dematerialization" of the art object by the seventies. Indeed, LeWitt's "Paragraphs on Conceptual Art," which appeared in *Artforum* in June of 1967, has been seen as a cornerstone of the new movement.

> I will refer to the kind of art I am interested in making as conceptual art. In conceptual art the idea or concept is the most important aspect of the work . . . the idea becomes a machine that makes the art . . . what the work of art looks like isn't too important. It has to look like something

if it has physical form. No matter what form it finally may have it must begin with an idea. . . . This kind of art should be stated with the greatest economy of means.[42]

In 1969 LeWitt pushed his theories further in his "Sentences on Conceptual Art," which appeared in two publications, *0.9,* edited by Vito Acconci in New York, and in an issue of the journal *Art and Language* in England. "Ideas alone can be works of art; they are in a chain of development that may eventually find some form. All ideas need not be physical. . . . Since no form is intrinsically superior to another, the artist may use any form, from an expression of words (written or spoken) to physical reality, equally."[43]

Although conceptual art is certainly not painting or sculpture, it seems relevant to mention the early conceptual artists and their work here, as an outgrowth of Minimalist concerns such as those of LeWitt. A number of these artists were interested, like LeWitt, in the language and nature of art. One such artist was Joseph Kosuth, who by age twenty, in 1965, decided it was important to go beyond geometric shapes. He made his *One and Three Chairs* [2.27], which attempted to depict the concept of "Chairness," by exhibiting a "real" chair, a photograph of a chair, and the dictionary definition of a chair. Kosuth's piece becomes a "metasign," inviting analysis of what a chair truly is. Kosuth later used only dictionary definitions of art-related words, such as "painting," in pieces such as his *Art As Idea As Idea* of 1966. He also did a series of blown-up, photostatted definitions of water and hydrogen compounds. Rejecting formalist art, Kosuth wrote, "At its most strict and radical extreme the art I call conceptual is such because it is based on . . . the understanding of the linguistic nature of all art propositions, be they past or present, and

2.27. Joseph Kosuth, *One and Three Chairs,* 1965. The Museum of Modern Art, New York.

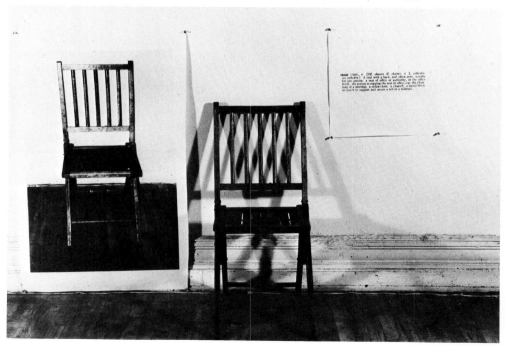

regardless of the elements used in their construction."[44] Kosuth later predicted that art would become a type of philosophical dialogue concerning the nature of art. In 1968 Kosuth met Lawrence Weiner, a native New Yorker who had moved to California, and who by 1968 abandoned paint and decided art could not exist without verbal language. His art was to consist primarily of written proposals in a notebook. Weiner introduced Kosuth to Seth Siegelaub, a young New York art dealer interested in showing conceptual art. Siegelaub was particularly interested in the work of Weiner, Kosuth, and two other former Minimal artists turned Conceptualists, Robert Barry and Douglas Huebler. Huebler's pronouncement in 1968 that "the world is full of objects, more or less interesting. I do not wish to add any more. I prefer, simply, to state the existence of things in terms of time or space,"[45] firmly stated the attitude of a number of early Conceptualists. Siegelaub organized two important exhibitions in 1968 of Conceptual work, one at Bradford College, in Bradford, Massachusetts, where Huebler taught from 1957 to 1973, and the other at Windsor College in Putney, Vermont. Several later exhibitions in New York in 1969 existed only in catalog form. One example of Huebler's work of this time is his *Location Piece, No. 14,* 1969. Huebler called for photographs to be taken from a plane over all the states between New York and Los Angeles:

> During a given 24 hour period 24 photographs will be made of an imagined point in space that is directly over each of 24 geographic locations that exist as a series of points 15 longitudinal degrees apart along the 45° Parallel North of the equator. . . . The 24 photographs, a map of the world and this statement will join altogether to constitute the form of this piece. The owner of this work will assume the responsibility for fulfilling every aspect of its physical execution.[46]

With these sentences, the work really existed only in the artist's or viewer's mind.

Conceptual art began to develop simultaneously in the United States, Canada, and Europe. In England there was the Anglo-American group called Art = Language, whose members included Terry Bainbridge, Michael Baldwin, Ian Burn, Charles Harrison, Harold Hurrell, Phillip Pilkington, Mel Ramsden, David Rushton, and Kosuth. These artists investigated relationships between art and language in their journals and later on tape, in posters, and film. The French artist Daniel Buren reduced his paintings to commercially printed vertical stripes and placed them in various environments, such as on storefronts or among billboard ads. The context of the stripes, not the stripes themselves, made the piece. In Canada there was the N.E. Thing Company. In Germany, Hanne Darboven used digits, numbers, and letters derived partly from days, weeks, and months of the calendar as her graphic vocabulary. She filled pages and pages with her notations and then filled gallery walls, creating a mysterious calligraphic environment. She spoke of her concerns with systems:

> A system became necessary: how else could I in a concentrated way find something of interest which lends itself to continuation? My systems are numerical concepts, which work in terms of progressions and/or reductions akin to musical themes with variations. . . . The most simple means of setting down my ideas and conceptions, numbers and words, are paper and pencil. I like the least pretentious and most humble means, for my ideas depend on themselves, and not upon material; it is the very nature of ideas to be non-materialistic. Many variations exist in my work. There is consistent flexibility and changeability, evidencing the relentless flux of events.[47]

In Italy there were several artists whose works of the early sixties were to lead to Conceptual art and *Arte Povera* (impoverished art). Pino Pascali and Michelangelo Pistoletto are two to consider in particular. Pascali became noted for his dynamic ideas and pieces such as mock-up dolphins leaping through gallery walls

and his giant toy tanks and anti-aircraft guns. Pistoletto was known for his "mirror" paintings on reflecting stainless steel and his works using newspapers, rags, candles, and other odds and ends. In the mirror paintings he transferred the enlargements of photographs to highly polished steel surfaces. Because of the reflective quality of the surfaces, the viewer also became an integral part of the painting. The work thus literally combined art and life and was never static, changing according to the viewer and where the work was placed. Pistoletto believed his work should be in a constant state of flux.

Artists such as Alighiero Boetti, Pierpaolo Calzolari, Eliseo Mattiacci, Giuseppe Penone, and Mario and Marisa Merz became associated with *Arte Povera*, where the power of the imagination as an extension of nature dominated, not the forms or materials of the work. Emphasis was on the presentation of energy in its pure state, not the representation of energy. The tools of this art included almost anything— neon lights, twigs, fat, the human body itself, interventions into the processes of nature. Mario Merz made collections of things organized around the Fibonacci number series. One of his pieces consisted of a large white barge covered with small white bags of talc or sand, while Giuseppe Penone covered the walls of galleries with impressions taken from every square inch of his body.

Arte Povera became more internationally oriented with the publication of the young Italian critic Germano Celant's book *Arte Povera* in 1969 by Praeger in the United States. (It had appeared earlier in Milan.) In the book Celant discussed both European and American artists (including a number of those Conceptualists mentioned earlier here) whose work he felt fit under the term *arte povera*, and concepts of de-aestheticizing and dematerializing art. The book included Process, Performance, Minimalist, Earthwork, and Conceptual artists. Harold Rosenberg, in his essay "De-aestheticization," pointed to the significance of the term.

> Art "povera" does not associate itself with the needy, but . . . asserts its alienation from the art market and its opposition to "the present order in art." In addition, poverty represents for it a kind of voluntary creative detachment from society, a refusal either to adopt the traditional role of the artist or to approve art values of any sort. In reducing the seductiveness of art to the vanishing point, it suggests the presence of a mendicant order, independent of the community and disciplined against succumbing to its "cultural goods." . . . Jan Dibbets's remark, "I'm not really interested any longer to make an object," is the typical "povera" position.[48]

It was not until 1970, though, with the exhibition "Information" mounted at the Museum of Modern Art, that concept and idea became a dominant force in the art world, as the object and formalism were temporarily shoved aside. The radical break with the traditional object may be seen as a mirror of the breaking away from traditional values and established institutions that was occurring in society at large by the late sixties.

NOTES: PAINTING AND BEYOND, 1960S

1. Gene R. Swenson ed., "What is Pop Art?" answers from eight painters, part I, *Artnews*, November 1963, pp. 40–43+.
2. Gene R. Swenson, *Collage*, no. 3–4, 1965.
3. Robert Rosenblum, "Pop Art and Non Pop Art," *Art and Literature* 5 (Summer 1964): 89.
4. Henry Geldzahler, in "A Symposium on Pop Art," *Arts Magazine*, April 1963, p. 37 (transcript of a symposium held at the Museum of Modern Art, December 1962).
5. Calvin Tomkins, "Raggedy Andy," in *Andy Warhol* (Boston: New York Graphic Society, n.d.), p. 12.
6. Andy Warhol, "New Talent USA: Prints and Drawings," *Art in America* 1 (1962): 42.
7. Quoted in Howard Smagula, *Currents: Contemporary Directions in Visual Arts* (Englewood Cliffs,

N.J.: Prentice-Hall), p. 54.

8. Paul Gardner, "Gee What's Happening to Andy Warhol?" *Artnews*, November 1980, p. 76.

9. William Feaver, "Andy, Inc.," *Artnews*, February 1989, p. 97.

10. Michael Brenson, "Looking Back at Warhol: Stars, Super-Heroes, and All," *New York Times*, February 3, 1989, p. 3.

11. Swenson, "What is Pop Art?," part I.

12. Ibid.

13. Ibid.

14. Max Kozloff, "Art," *The Nation*, January 27, 1962, commentary section.

15. Quoted in Israel Shenker, "Always against the Grain," *Artnews*, March 1986, p. 84.

16. Quoted in Colman Andrews, "The Most Popular Serious Artist in the World," *Metropolitan Home*, May 1983, p. 66.

17. Quoted in H. H. Arnason, *History of Modern Art: Painting, Sculpture, Architecture* (New York and Englewood Cliffs, N.J.: Harry N. Abrams and Prentice-Hall, 1986), p. 448.

18. Ibid.

19. Pierre Restany, quoted in Meyer and Raphael Rubinstein, "Europa Resurgent—Objects and Activities of the Nouveaux Réalistes," *Arts Magazine*, September 1988, p. 69.

20. Lucy Lippard, *Pop Art* (New York and Toronto: Oxford University Press, 1966), p. 176.

21. Ibid., p. 191.

22. Thwaites, "Germany: Prophets without Honor," *Art in America*, no. 6, December 1965, pp. 110–15.

23. Quoted in "Romare Bearden, Collagist and Painter, Dies at 75," *New York Times*, March 13, 1988, p. 36.

24. This term was used by Irving Sandler in *American Art of the 1960s* (New York: Harper & Row, 1988), chap. 8, to distinguish those artists who felt the eye was more important than the camera in perceptual practices, and to delineate more precisely the term *New Realism*, often associated with the rise of realistic figurative tendencies in the early sixties.

25. Tillim, "Month in Review," *Arts Magazine*, April 1963, p. 46.

26. Quoted in Arnason, *History of Modern Art*, p. 610.

27. Stevens, "Art Imitates Life—The Revival of Realism," *Newsweek*, June 7, 1982, p. 66.

28. Quoted in Cindy Nemser, "An Interview with Chuck Close," *Artforum*, January 1970, p. 51.

29. Excerpts from an interview by Linda Chase and Robert Feldman in "The Photo-Realists: 12 Interviews," *Art in America* (special issue), November–December 1972, pp. 78–80.

30. Ibid., p. 79.

31. Critics' citations concerning Freud are from Mariner Warner, "Lucian Freud—The Blinking Eye," *New York Times Magazine*, December 4, 1988, p. 68.

32. Ibid.

33. In *Agnes Martin*, exhibition catalog (Philadelphia: Institute of Contemporary Art, University of Pennsylvania, 1979), p. 9.

34. Ibid., p. 12.

35. Robert Ryman, *Art in Process IV*, exhibition catalog (New York: Finch College Museum of Art/Contemporary Study Wing, 1969), n.p.

36. Dorothea Rockburne, in "Dorothea Rockburne, an Interview by Marcia Tucker," in *Early Work by Five Contemporary Artists*, exhibition catalog (New York: New Museum, 1977), n.p.

37. Lawrence Alloway, "Sol LeWitt: Modules, Walls, Books," *Artforum*, April 1975, pp. 38–45.

38. Quoted in Bernice Rose, "Sol LeWitt and Drawing," in Alicia Legg, ed., *Sol LeWitt*, exhibition catalog (New York: Museum of Modern Art, 1978), p. 33.

39. Ibid.

40. Ibid., p. 38.

41. Ibid., p. 40.

42. Sol LeWitt, "Paragraphs on Conceptual Art," *Artforum*, June 1967, p. 83.

43. Sol LeWitt, "Sentences on Conceptual Art," *Art Language* (England), May 1969, pp. 11–12.

44. Joseph Kosuth, "Introductory Notes by the American Editor," *Art Language* (England) 2, February 1970, pp. 2–3.

45. Quoted in Arnason, *History of Modern Art*, p. 564.

46. Ibid.

47. Hanne Darboven, in *Art International*, April 20, 1968, p. 55.

48. Harold Rosenberg, "De-aestheticization," in *The De-definition of Art* (New York: Macmillan Co., 1972), p. 35.

PRINTMAKING, 1960S

WHILE printmaking did not have a major role in Abstract Expressionist work, it did become more influential in the sixties, particularly for Pop and Photo-Realist artists. In the early 1960s there were two significant projects that helped draw artists to the possibilities of printmaking. One was the publication of a six-volume series, titled *The International Avant-Garde* (1962–64), by Arturo Schwarz, an art dealer from Milan. The books contained small etchings and drypoints by approximately one hundred artists, mainly European, but also American. It was notable for its omission of the Abstract Expressionists. The other publication, *1¢ Life,* published in 1964, was the result of collaboration between Walasse Ting, a Chinese painter and poet, and Sam Francis, who had met Ting in Paris in 1962. Ting had asked artists to create full-page visual images to accompany his poems, and the 1964 *1¢ Life* contained for the first time powerful Pop imagery in a color print format.

Tatyana Grosman encouraged her artists to make books using original formats. Rauschenberg in 1964 created a piece that he called a "multiple" to describe an object produced in an edition, not in a mold. (The term *multiple* was first used in 1959 by a group of European artists, some associated with the Neo-Dadaist Fluxus group, for prop objects they made for performances. Rauschenberg's use of the term applied to three-dimensional work done in a print workshop.) In his two-dimensional print works, Rauschenberg began to concentrate more on his photographic images. One of Claes Oldenburg's best-known prints of the sixties was a multiple, *Tea Bag*, from *Four on Plexiglas*, 1966, a silk screen on vacuum-formed Plexiglas. This work inspired the founding of Multiples in 1965, a combination gallery and publishing house. Artists who worked with Grosman at Universal making lithographs during the sixties included Jim Dine, Helen Frankenthaler, Robert Goodnough, Jasper Johns, Robert Motherwell, Larry Rivers, James Rosenquist, Lee Bontecou, and Marisol. Jasper Johns's compelling lithograph *Ale Cans* [2.28] was made with Grosman in 1964. In the print Johns made a "portrait" of his sculpture made after two Ballantine beer caps. In the print they become enigmatic, as they float on a pedestal in blackened space. Like the sculpture, one can is open and the other is closed. The graphic lines create a web of complexity for what are normally considered simple, throwaway objects. Referred to as "Peter and Paul" by Grosman, it has been a sought-after print for the last twenty years. According to one writer in 1983, the print was valued at over $15,000. It initially sold for $175 in 1964.[1] Johns also created his

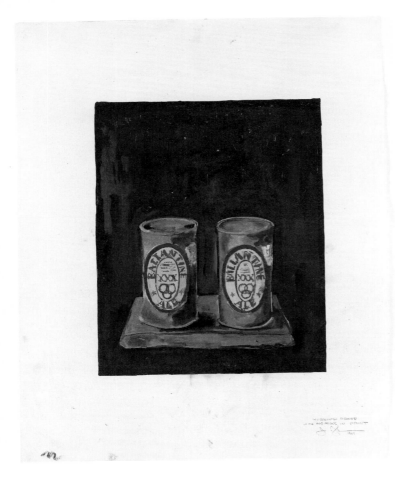

2.28. Jasper Johns, working proof for *Ale Cans*, 1964. The Museum of Modern Art, New York.

2.29 *(opposite)*. Robert Rauschenberg, *Sky Garden*, 1969. Gemini G.E.L., Los Angeles.

well-known series *0–9* of each of the digits from zero to nine with Grosman in the early sixties. Significant and unusual at the time was Johns's use of one stone that was partially ground down for each successive image, thereby creating very subtle variations and transformations in the images.

Experiments in lithography were further enhanced by the founding of several workshops. Irwin Hollander opened a workshop in New York and printed New York–based artists. Jean Milant founded Cirrus Editions in Los Angeles. Tamarind-trained printers also began to work at places such as the Nova Scotia workshop, Landfall Press in Chicago, and Graphic-studio at the University of South Florida, Tampa.

Particularly important in the mid-sixties was the founding of Gemini Ltd., a custom print shop (to become Gemini G.E.L., the publishing workshop, a few months later), by Ken Tyler in Los Angeles. Tyler, an artist and talented printmaker and student at Tamarind, had worked closely with Josef Albers at Tamarind on two lithographic suites, *Day and Night* and *Midnight and Moon.* Inspired by Albers, who became his mentor, Tyler in 1965 stated, "I decided I didn't want to become another printmaker who was a frustrated painter. If I was going to become a printmaker, I wanted to devote all my energies to it and I wanted to become the best."[2] With a five-hundred-dollar loan from his mother-in-law and some free studio space, Tyler started what was to become an

important center for lithographic work. Only six years after its founding Gemini had published 285 editions. In 1971 the Museum of Modern Art held a retrospective of Gemini's work, "Technics and Creativity," with accompanying catalogue raisonné. In 1974 Tyler opened a new studio, Tyler Graphics, in the East, near New York City, in Bedford. Tyler's personality as well as his skills attracted artists. Besides showing artists how to do things, he worked with them, often inventing new techniques. For Jasper Johns, Tyler developed a way to achieve a spectrum or rainbow effect on a large surface.

In 1970 Tyler and Johns extended techniques of relief printing by using a powerful hydraulic press to "print" on thin sheets of lead, instead of the more usual technique of squeezing dampened paper into depressions of a chemically etched plate. Johns made five unusual prints using this method in that year. *High School Days* touts a man's shoe with a mirror on the tip of the shoe. *The Critic Smiles* shows a profile of a toothbrush where there are teeth instead of bristles. *Flag* is a textured transformation of the American flag. *Light Bulb* is a bare bulb suspended from an old cord, and *Bread* is a handpainted slice of Wonder-type bread. Johns's wit and power to transform our perceptions of common objects are clear in these pieces and are enhanced by the technique he developed with Tyler.

For Robert Rauschenberg, Tyler helped produce the largest lithograph ever made at the time, *Sky Garden* [2.29], in 1969, where the composition was made up primarily of newspaper and magazine images.

Tyler worked with a variety of artists, including Oldenburg, Stella, Albers, Motherwell, Frankenthaler, Mitchell, Richard Hamilton, Roy Lichtenstein, Malcolm Morley, and David Hockney and employed a variety of techniques beyond lithography. Frank Stella began printing with Tyler in 1967. Between 1967 and 1982, when he had his first print retrospective

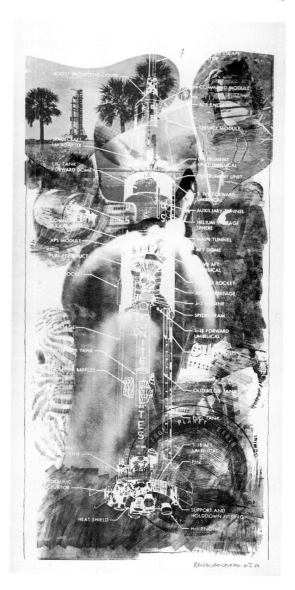

show, Stella created nearly two hundred editions in collaboration with Gemini G.E.L., Petersburg Press, and Tyler Graphics.

Printmaking was for many of the Pop artists a natural extension of their art. As Roy Lichtenstein commented, "Pop looked like printed images, . . . and putting the printed images back into print was intriguing."[3] Lichtenstein's

prints perhaps more than his paintings revealed his efforts to achieve a sense of mechanical perfection in his work. "In my paintings I can try to make things 'perfect' but I can't because I'm not that skillful," explained Lichtenstein. "The paintings, in spite of me, have a certain handmade look, but in prints you can achieve that sense of perfection."[4] During the sixties Lichtenstein frequently employed commercial printing techniques to achieve an industrial look. In 1964 he produced his first plastic silk screen, *Sandwich and Soda.*

Silk-screening was probably the most popular form of printmaking in the sixties to communicate the Pop aesthetic. Silk screen was used alone or in combination with other printing techniques, such as lithography. Ed Ruscha's silk screen prints translated the California landscape into cool but forceful compositions, as seen in his large *Standard Station* of 1966.

By 1962 Andy Warhol was almost exclusively using the silk-screen process to make his series of mechanically produced American "icons" of movie stars [2.30], Coke bottles, soup cans, dollar bills, and so on. His 1965 *Jackie III* provided a Pop alternative to traditional "heroic" portraiture of America's stars, leaders, and their families.

In the late sixties Ernest Trova's sculpture and screenprints of anonymous, machinelike figures extended the Pop aesthetic by being mechanical specimens themselves. Trova's plate from *F.M. Manscapes,* 1969, shows humans that have become machinelike as they appear to fan out like the spokes of a wheel. The hard edges, for which the silk-screen and stencil process was particularly effective, are evident here as well as in many of the Pop artists' work. One also sees the use of an Art Deco statuette form in Trova's work that became more popular in the seventies.

Employing machine imagery through photo-silk-screen techniques was Eduardo Paolozzi. In his 1964 *Conjectures to Identify* his collage-like composition of machine imagery and hard-edged areas of strident blues, magentas, yellow, and greens dominate an almost undiscernible scene of figures worshiping before a crucifix. The English printer Christopher Prater fostered and produced much of Paolozzi's print work as well as other artists such as R. B. Kitaj and Richard Hamilton. In 1963 Prater's Kelpra studio was selected by the Institute of Contemporary Arts in London to create screenprints with selected artists for commission, including Hamilton, Hockney, Paolozzi, and Bridget Riley. Prior to this, Prater had been a commercial printer with one assistant. Following the 1963 project, the studio became a major center for screenprinting and was particularly involved with developing photomechanical techniques.

On the Continent, proponents of the New Realism—Klein, Tinguely, and Arman—were not involved in printmaking in the early sixties. A number of years after Klein's death in 1962, Arman, Tinguely, and his wife, Niki de Saint-Phalle, as well as the young Bulgarian Christo did turn to some printmaking. Tinguely's prints documented and exhibited his self-destructing machines. Saint-Phalle's *Nanas* are now seen as early evidence of female consciousness raising. Christo's prints were able to articulate visually plans for his wrapped projects as well as unrealized projects. In 1959 Arman, Tinguely, and Saint-Phalle were among those who contributed to the first multiple art project, MAT (Multiplication of Transformable Art), a group of three-dimensional objects in editions.

The hard edges of Op and Minimalist art also readily translated into silk screen and other types of printing in the sixties. Some Minimal artists also found etching and lithography attractive media in which to pursue interests in process, allowing a truth to the materials used. Among the Minimal artists concerned with printmaking were Robert Ryman, Robert Mangold, Brice Marden, Sol LeWitt, Donald Judd, and Dorothea Rockburne. Ryman, Mangold, Marden, and Rockburne worked in particular

2.30. Andy Warhol,
Marilyn Monroe, 1962.
Leo Castelli Gallery,
New York.

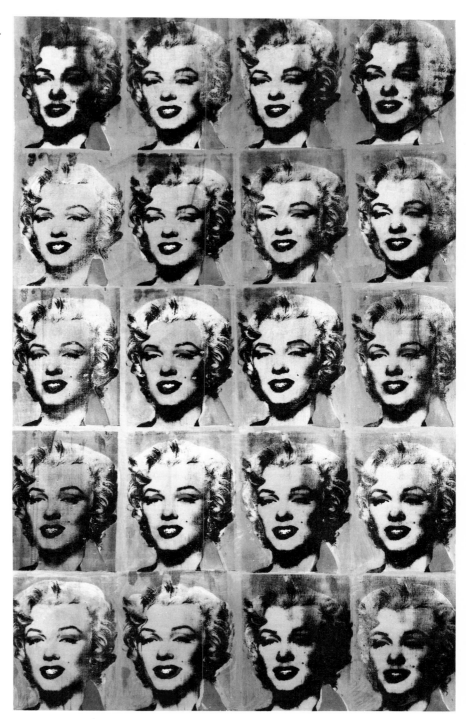

at Crown Point Press, lured by Robert Feldman, the founder of Parasol Press. Kathan Brown, the young intaglio printmaker, was able to create both subtle and pure areas of aquatint that gave the minimal statements a magical simplicity. Rockburne used folded paper techniques in her prints as she continued to employ the mathematical formulas explored in her paintings.

Of the Op artists making prints, Victor Vasarely's work was among the most prominent. His *Planetary Folklore,* 1964, with its complex colors and squares, is typical of his work. He and other members of the Denise René Gallery in Paris attracted a number of Latin American artists, who were also drawn to printmaking and works that produced optical sensations. These young Latin Americans included the Argentinean Julio LeParc, the Brazilian Almire Mavignier, and the Venezuelans Jesus Rafael Soto, and Carlos Cruz-Diez. The U.S. artist Richard Anuszkiewicz, a student of Josef Albers, illustrated William Blake's *The In-ward Eye* with his sharp lines and activated color (published in 1970). Bridget Riley's black and white screenprints had the same visually disturbing qualities as her paintings. And the Belgian Pol Bury cut photographs into concentric circles and presented them askew in printed form.

Photo-Realist artists made use of silk-screen techniques to further their graphic vocabulary of smooth, often reflective, planes and colors. Their "prints, for the most part, have been mementos of paintings, executed almost exclusively with photographic techniques and thus paradoxically regenerating the photo-generated imagery of the unique works."[5]

By the end of the sixties the proliferation of prints and printmaking had greatly accelerated. The prints not only offered the possibilities of greater access to art works for the general public but also more firmly established themselves as commodities, since they were not unique. The power of the print was to become even greater in the next decade.

NOTES: PRINTMAKING, 1960S

1. Howard Smagula, *Currents: Contemporary Directions in Visual Arts* (Englewood Cliffs, N.J.: Prentice-Hall, 1983), p. 116.
2. Quoted in Judith Goldman, "Kenneth Tyler: The Artisan as Artist," in *Tyler Graphics: The Extended Image* (New York and Minneapolis: Abbeville Press and Walker Art Center, 1987), p. 28.
3. Quoted in *Roy Lichtenstein: Graphic Work, 1970–1980,* exhibition brochure (New York: Whitney Museum of American Art, downtown branch, 1981), n.p.
4. Quoted in Ruth Fine, *Gemini G.E.L.: Art and Collaboration,* exhibition catalog (Washington, D.C., and New York: National Gallery of Art and Abbeville Press, 1984), p. 192.
5. Riva Castleman, *Prints of the Twentieth Century, A History* (New York: Museum of Modern Art, 1976), p. 202.

PHOTOGRAPHY, 1960S

As HAS been seen, boundaries between photography and other art forms, such as painting and printmaking, had begun to be transgressed by the sixties, as artists such as Rauschenberg, Warhol, and Estes used photographic images and techniques to make a variety of visual statements. Conceptual artists and Earthworks artists began to use photographs as documentation. Photography was a tool, a means to an end for some, but in general photography was still considered quite distinct from the other art forms.

Like some of the Pop artists, photographers in America turned to the everyday environment, and a "snapshot aesthetic" became prevalent among the approaches to photography. The casualness and neutrality inherent in many snapshots was attractive to a number of photographers. Some using this technique were concerned with social documentation and photographed the "social landscape" without sentimentality or emotion. The term "social landscape" was actually not formally used until 1966, when Nathan Lyons, a photographer and educator, coined the phrase in conjunction with an exhibition at George Eastman House, "Toward a Social Landscape." Of particular interest in this show was the work of Lee Friedlander, Garry Winogrand, Duane Michals, Bruce Davidson, and Danny Lyon. Nathan

Lyons was an important activist for photography as an art. During much of the sixties he was at George Eastman House (now the International Museum of Photography) in Rochester, New York, where he mounted a number of important exhibitions and developed publications. In 1962 he was one of the founders of the Society for Photographic Education. In that same year he began a series of photographs, *Notations in Passing*, which dealt with approaches to perception.

Garry Winogrand, one of the photographers Lyons championed, began as a freelance photojournalist and advertising photographer. During the sixties he became noted for his street photography, which often showed a bizarreness and complexity that the casual observer would easily overlook. His 1969 *Hard Hat Rally, New York* [2.31] is not only about a particular situation but also about the complex layering of urban life, as one sees upon scanning the crowd in the photograph. It is one of many moments frozen in time. Winogrand's once-stated intent, that he often "photographed to see how things looked when they had been photographed, can be seen to have inspired a generation."[1]

Winogrand's friend Lee Friedlander also photographed street scenes, often linking together fragments of urban existence. In an image such as *Newark, New Jersey*, 1962 [2.32],

2.31. Garry Winogrand, *Hard Hat Rally, New York*, 1969. Courtesy Fraenkel Gallery, San Francisco, and the Estate of Garry Winogrand.

one sees the disparate worlds of advertising, of a bartender, of a young boy, of store windows, and so forth juxtaposed in a poignant and coherent whole. Many of his street and streetside images, taken throughout the United States, emphasize an American vernacular—a roadside Texan café with neon star, a telephone booth next to a shiny car, parking meter, and trash basket; a roadside chapel with "God Bless America" in billboard letters mounted on its roof next to a car window and mirror. Besides photographing street scenes, Friedlander also did portraits, trees and flowers, and American monuments.

Other photographers concerned with street views and ordinary people were Todd Papageorge, Larry Fink, Joel Meyerowitz, and Mark Cohen. Their work does not pass judgment or communicate profound emotions; instead it asks the viewer to make decisions about a given image.

An interest in an American vernacular led to the use of humor and wit by photographers such as Elliot Erwitt and Burke Uzzle. A well-known advertising photographer and filmmaker, Erwitt capitalized on chance encoun-

ters and the art of juxtaposition to make his subtly humorous pieces, such as *Pasadena*, 1963.

A new naturalism or what came to be called the "new topographics" (which did not come into use as a formal term describing photographic style until 1975 with an exhibition at the International Museum of Photography) emphasized appearance, not judgment, and often portrayed elements of an industrial culture, such as tract housing, factory buildings, and land developments. The images were sharply printed with tonal accuracy, unlike Winogrand, who often distorted tonal values with a flash, used odd angles of perspective, or cropped his image in an unusual manner. The catalog for the 1975 "New Topographics" exhibition used words or phrases such as "utilitarian," "of the world," and "pure subject matter." These photographers included Robert Adams, Lewis Baltz, Frank Gohlke, Roger Mertin, Joe Deal, and Stephen Shore. Baltz's factories and industrial parks or Gohlke's grain elevators are straightforward, blunt, and often sterile, but they still transmit a message about American culture.

Beyond the new topographics there were a number of photographers who were more concerned with humanist views and/or people-oriented content, as well as with communicating some type of value system. But as one writer pointed out,

> Humanism should not be confused with emotion, as opposed to naturalism's intellect. Humanism in photography is not anti-intellectual. It cannot be. The ability, even need, of a photographer to project value judgments is not a mystical, instinctive feeling only attained by intuitive, non-rational insight. True existence of a value system can be felt, but it cannot be understood and intelligently used, by vague hopes and desires. To be productive and powerful the individual's sense of life has to be analyzed and verified conceptually. Humanism in photography is an intellectual as well as an emotional endeavor.[2]

From Roy DeCarava, Louis Faurer, Jerome Liebling, Helen Levitt, and Max Yavno came images such as a young black man hunched over a stack of Pepsi bottle cases (DeCarava's *Pepsi, New York,* 1964) or a blind man bent over a meager meal (Liebling's *Blind Home, St. Paul Minnesota,* 1963), in which it was apparent where the photographer's sympathy lay.

The volatility of social and political events in America during the sixties served as fuel for photographers of that decade. Some photographers began to probe more deeply into social issues and their documentation. Support from federal and state funds (the National Endowment for the Arts had been established in 1965) and from private foundations, such as the Guggenheim, made it possible for documentation projects made in the tradition of a Jacob Riis or Lewis Hine.

2.32. Lee Friedlander, *Newark, N. J.,* 1962. Courtesy the artist.

The civil rights movement was recorded and covered by photojournalists such as Bob Adelman, Bruce Davidson, Leonard Freed, Danny Lyon, and Mary Ellen Mark. In 1966 Bruce Davidson brought a large-format view camera, flash, and a tripod into East 100th Street [2.33], one of the "worst" blocks in New York City. There he photographed for two years images of fear, loneliness, affection, and alienation. The finished photographs were exhibited at the Museum of Modern Art, and Davidson invited his subjects to the show.

Danny Lyon, a young photographer born in 1942, documented not only the civil rights movement but also prison life and the "hippy" youth culture. His photo essay on Hell's Angels bike riders, *The Bikeriders* (1968), and his *Con-*

2.33. Bruce Davidson, *East 100th Street*, 1966–68.

versations with the Dead (1971), depicting life in Texas state prisons, were powerful and evocative visual statements.

Philip Jones Griffiths showed the hardships of the Vietnam War in his *Vietnam, Inc.* Leonard Freed, a young Israeli photographer, expressed his concern for and sympathy with the civil rights movement. As a magazine photographer, Freed hoped that his pictures could somehow serve as catalysts for social change. From 1964 onward he photographed various aspects of the civil rights movement, culminating in the publication of *Black in White America* by Grossman in 1968.

Photographers such as Davidson, Freed, Griffiths, and Lyon were examples of what came to be called the "concerned photographer," a term perhaps first formally used by Cornell Capa, founding director of the International Center of Photography, a photographer himself. Capa recalls his coming to the term following the untimely deaths of his fellow photojournalists Werner Bischof, David Seymour, and his brother Robert Capa. On a boat trip to an island off Mexico, Capa shouted to his wife, "Eureka . . . we keep talking about the tradition that Chin, Werner, Dan, and Bob represented, but we just recite the words. We have never defined what this tradition is. It is a concern for mankind that connects their work; it's not their style. The 'concerned photographer' was born right there."[3] In 1966 an International Fund for Concerned Photography was established, and in 1967 the Riverside Museum in New York mounted the "Concerned Photographer" exhibition. Capa was criticized for the term "concerned photographer" by those who felt that all good photographers were "concerned." Capa persisted, though, and mounted another exhibition, "The Concerned Photographer 2," showing the work of Marc Riboud, Roman Vishniac, Bruce Davidson, Donald McCullin, and W. Eugene Smith.

As more photographers projected concern for black communities in America, black pho-

tographers also became more recognized. Among those who became noted in photojournalism were Chester Higgins, Anthony Barboza, and Beuford Smith.

In 1968 the Metropolitan Museum mounted an unprecedented show with a substantial catalog, "Harlem on My Mind—Cultural Capital of Black America, 1900–1968." Through documentary newspaper clips and photographs by those in and outside Harlem, a sixty-eight-year history of Harlem was presented, with its strength and potential. Allon Schoener, editor of the catalog and exhibition coordinator, wrote in his foreword, "We are in the midst of a period of fundamental change. Where do we go from here? If we—both black and white—can accept the reality of Harlem as an important fact in our lives, we will have accomplished something."[4] Thomas Hoving wrote in his preface, "We have this remarkable show because the city and the country need it. We put it on because this great cultural institution is indeed a crusading force attempting to enhance the quality of life, and to support and buttress and confirm the deep and abiding importance of humanism. *Harlem on My Mind* is Humanism."[5]

Although the show was controversial, it did call attention to black culture. Many of the early photographs in the exhibit were taken by Harlem photographer James Van Der Zee, whose work had recently been rediscovered in an attic. In 1969 the James Van Der Zee Institute was founded in New York to promote photography as an art form and as a means of communication, and in particular to encourage and assist black photographers.

Different from the more sympathetic viewpoints of the "concerned photographers" yet still concerned with elements of American culture was Diane Arbus. Hers was a photography of confrontation, photographing the underside, the "darker" side, of life with her images of freaks, social misfits, and the physically deformed, asking viewers to face unpleasantness and their own "freakishness" head on. Even her images of "ordinary" subjects have a haunting, otherworldly quality.

Born in 1923, she started as a fashion photographer, but in the sixties turned to more personal imagery, wanting to photograph things nobody would see unless she photographed them. The worlds she came to photograph were very distant from the world of fashion and the comfortable, upper-middle-class Jewish world of refinement she had grown up in. "One of the things I felt I suffered from as a kid was I never felt adversity," she once said. "I was confirmed in a sense of unreality which I could only feel as unreality."[6] She spoke of her consuming interest in freaks:

> Freaks was a thing I photographed a lot. It was one of the first things I photographed and it had a terrific kind of excitement for me. I just used to adore them. I still do adore them. I don't quite mean they're my best friends but they made me feel a mixture of shame and awe. Like a person in a fairy tale who stops you and demands that you answer a riddle. Most people go through life dreading that they'll have a traumatic experience. Freaks were born with their trauma. They've already passed their test in life. They're aristocrats.[7]

In her photograph of the giant Eddie Carmel, *A Jewish Giant at Home with His Parents in the Bronx, 1970, New York,* it is the subject that is important, not the composition, as the giant, unable to stand straight in the room, looks down at his "Lilliputian" parents. The scene becomes all the more extraordinary in the ordinariness of its setting.

The freaks were only a portion of her work, yet in all of her subjects she seems to capture a darker side of human existence. Her capacity to portray the psychological depths of her subjects is seen in a piece such as *Child with Toy Hand Grenade,* 1962, where both evil and innocence spills forth in the child's demeanor. At the age of forty-eight, during the summer of 1971, Arbus tragically took her own life. Some

2.34. Duane Michals, *Things Are Queer*, detail, 1973.

have observed that her suicide was inevitable given her imagery, yet it seems important to have the work stand separately from her life, as a piercing record of the many layers of humanity.

Duane Michals also went beyond the limits of everyday life by artificially staging "dramas," which he photographed in narrative fashion. Michals came to photography by chance, when someone loaned him a camera during a trip to Russia. He was first involved in fashion and magazine work, but found the single image too limiting. Michals started with a preconceived idea or concept and took a series of photographs, sometimes using language with the visual images, to portray different realities. Among his well-known narrative sequential pieces are *The Fallen Angel*, 1968, *The Human Condition*, 1969, *Chance Meeting*, 1970, and *Things Are Queer*, 1973 [2.34]. Michals's pieces often raise questions, as well as suggesting a "story" or dreamlike situation, as in *Chance Meeting*, which consists of six photographs of two men in dark suits passing each other. In the last frame, the figure, whose back has been to the camera, turns toward the camera, looking for the now vanished second figure. One asks, Did these men know each other? If so, how? What is the meaning of chance encounters? Michals calls into play subconscious motifs and asks the viewer to focus not only on the visual narrative before him but also to consider what is not photographed, the intangible. In some works, such as *The Fallen Angel*, one sees the influence of Surrealism. As Michals commented in his book *Real Dreams*, "Everything is subject for photography, especially the difficult things in our lives: anxiety, childhood hurts, lust, nightmares. The things that cannot be seen are the most significant. They cannot be photographed, only suggested."[8]

Ralph Gibson also used elements of Surrealism in combination with documentary "street" photography to create images where dreams and reality collide and intermingle. Born in

2.35. Ralph Gibson, Image from *The Somnambulist*, 1968. Courtesy the artist.

1939, Gibson began photographing while in the navy, taking documentary photographs. Upon leaving the navy, he attended the San Francisco Art Institute, one of the first art schools in the United States to offer a degree in photography. He then worked as a darkroom assistant to Dorothea Lange, who had become well known for her powerful photographs documenting the Depression years. For many years he did freelance work for advertising agencies and corporations. During the sixties he worked for Eli Lilly Pharmaceuticals, Bantam Books, and *Look* and *Life* magazines. Yet at the same time he had been impressed by Robert Frank's book *The Americans* and its concept as a photographic essay. Believing in the importance of the book as a vehicle for photographic expression, Gibson founded Lustrum Press, devoted to fine arts photographic publishing. He, with the press, published his first book in 1968, *The Somnambulist* [2.35]. Although the book resembles *The Americans* in structure, it also contains dreamlike elements and juxtapositions of different striking images. There are people enveloped in clouds of smoke, cropped sections of bodies, a sunflower looming over a house, an image of a man's hand superimposed over sand dunes and sky. One of

2.36. Jerry Uelsmann, *Small Woods Where I Met Myself,* 1967. Courtesy the artist.

the most haunting images in the book is that of a hand reaching mysteriously through a doorway. The lighting and the shadows cast show Gibson's ability to combine formal elements with content to create striking images. In his later books, *Déja-Vu* and *Days at Sea,* one sees further his effective combination of abstract formal elements with the conceptual content. In some images in *Déja-Vu* one sees the influence of Minimal art, with Gibson's use of spare, geometric forms.

Influences of Surrealism in a much different manner were also seen in the work of Jerry N. Uelsmann and Robert Heinecken, who both used montage as a means to create new imagery. Juxtaposing several negatives, Uelsmann introduced the viewer to a world of haunting but lyrical fantasies. His work is both playful and psychologically probing, as seen in his 1967 *Small Woods Where I Met Myself* [2.36].

Heinecken's montages alluded to advertising and commercial imagery, in particular to a violent sexism. Trained as a printmaker and photographer, the California-based Heinecken sometimes combined techniques from both media. He also sometimes drew on the work and added or subtracted color.

Emphasis on formalist techniques was seen in the work of Ray Metzker, who had been a student of Callahan and Siskind. He synthesized and/or repeated forms, often emphasizing pattern and pulsation in the work, such as

his 1967 *Arches* and *Penn Center,* 1966.

The use of color in photography was slowly emerging outside commercial images during the sixties. A dye color film had actually been on the market since the development of Koda-chrome and Agfa color Neu in 1935 and Ekta-chrome in 1942. But interests in documenta-tion and straight imagery had kept most photographers in the realm of black and white. A few photographers, such as Harry Callahan and Syl Labrot, had experimented in the fifties with planes of color and surface texture. And Eliot Porter, noted naturalist photographer, used color to emphasize a delicacy and lyricism in the natural landscape. Charles Pratt trans-formed natural forms into artistic abstractions through focusing on color, texture, and shape. In a piece such as his *Maine,* 1968, the rock forms and their subtly colored and textured surfaces, as well as the "negative" spaces be-tween the rocks, become a strong abstraction. Ernst Haas used multiple images for his city scenes, such as *New York Triangle,* 1965, where the hard edges of buildings intersect to form a precisionist view of erupting skyscraper forms. (In 1952 Haas had shot a series of color views of New York for *Life* magazine's first picture story in color.)

Outside the United States in the sixties and into the seventies, the influence of Robert Frank's subjective approach to documentation was to be found in Europe, Canada, and Latin America. In Canada Lynn Cohen, Charles Gag-non, and Gabor Szilasi were among those who engaged in "street" photography to heighten viewer awareness. In Central and South Amer-ica photographers such as Panamanian Sandra Eleta, Brazilians Claudia Andujar and Maureen Bisilliat, Venezuelan Roberto Fontana, and Mexicans José Angel Rodriguez and Graciela Iturbide photographed their people and the effects of economic and social change. The Mexican photographer Manuel Alvarez Bravo, who had photographed prolifically in the thir-ties, developing a style involving elements of Surrealism and Mexican folk culture, re-emerged as an artist. During the forties and fifties he had worked as a movie cameraman and took few personal photographs. Examples of his work were well distributed and beauti-fully reprinted in a 1968 issue of *Aperture.* By 1977 Central and South American photogra-phers were more fully recognized with a hemi-spheric conference held in Mexico City reveal-ing the dynamic and diverse approaches to photography in the region.

In Great Britain photojournalists such as Bert Hardy, George Rodger, Philip Jones Grif-fiths, and Don McCullin continued the spirit of documentation. Philip Jones Griffiths also docu-mented the hardships of the Vietnam War in his book *Vietnam, Inc.* Tony Ray-Jones injected a bit of humor into his social observations, as seen in *Glyndebourne,* where an elegantly dressed upper-class couple picnic on a closely cropped lawn, adjacent to a field of cows and sheep. The black and white of the couple's at-tire is mirrored in the black and white of the cows' hides.

In southern France photography was fur-ther encouraged by the establishment of a new group, "Expression Libre" (Free Expression), in 1964. The group pushed for the introduction of photography into university programs. Some members of this group, such as Denis Brihat and Lucien Clergue, used models and preestab-lished settings for their work, while others, such as Bernard Plossu (who later moved to the United States), explored a "subjective realism" and social documentation.

In Italy photographers arose out of what one writer called a "peripheral ghetto,"[9] following an era of isolation during and after World War II. Photojournalism flourished, and a number of photojournalists, including Gianni Berengo, Franco Fontana, Mario Giacomelli, and Georgio Lotti, were inspired to shoot the Italian landscape. Their views of sloping vineyards, twisted olive trees, or winding roads were often quite romantic. An early Giacomelli photo-

graph, *Landscape No. 289*, 1958, is but one example. Franco Vaccari began to experiment with collage techniques.

American ideas concerning straight photography reached Japan when Yasuhiro Ishimoto returned to Japan in 1953 after studying in the United States at the Institute of Design. Japanese photographers, though, worked mainly for publication rather than exhibition. A number of Japanese photographers, such as Shomei Tomatsu, recorded changes in Japanese society. Tomatsu published eight photographic books. His image *Sandwich Man, Tokyo,* 1962, from his book *Nippon* shows aspects of both a modern and a traditional Japan.

Two Japanese photographers who emerged internationally were Ikko (Ikko Narahara) and Eikoh Hosoe. Ikko used "straight" images with surreal effects: in his *Two Garbage Cans* and *Indian Village, New Mexico, U.S.A.*, part of a series entitled *Where Time Has Vanished*, two metal garbage cans fly with the clouds down a deserted New Mexican street. Eikoh Hosoe made poetic and fanciful montages, such as his *Ordeal by Roses No. 29,* 1961–62. Although similar to Uelsmann's, much of Hosoe's work tends to be more somber and sometimes more complexly layered.

In general, photography began to be more widely collected and exhibited during the six-ties than ever before. All kinds of photographs—snapshots, industrial and architectural photographs, news photos, along with photographs made in the name of art—were looked at more seriously. John Szarkowski's mounting of an exhibition, "The Photographer's Eye," at the Museum of Modern Art in 1964 was to influence future methods of viewing photographs. Instead of assembling the show historically, Szarkowski used categories such as "The Detail," "The Frame," and "Time" inherent in the photographic medium. A number of subsequent exhibitions in the sixties were also organized using ahistorical and relativist approaches, which often raised questions for the viewer.

Although there appears to have been an emphasis on straight imagery, photography in the sixties had many strands, from social documentation to formalist concerns, to the use of photography in painting, printmaking, and as documentation for site and conceptual art works. But as Susan Sontag has written, "What is most interesting about photography's career . . . is that no particular style is rewarded; photography is presented as a collection of simultaneous but widely differing intentions and styles, which are not perceived as in any way contradictory."[10] These differing strands were to become more pronounced in the seventies.

NOTES: PHOTOGRAPHY, 1960S

1. Peter Turner, *American Images: Photography 1945–1980* (New York: Viking Press, 1985), p. 125.
2. Bill Jay, "The Romantic Machine: Thoughts on Humanism in Photography," in ibid., p. 15.
3. Cornell Capa, quoted in Richard Woodward, "The International Center of Photography Comes of Age," *Artnews*, February 1986, pp. 84–85.
4. Allon Schoener, *Harlem on My Mind—Cultural Capital of Black America, 1900–1968* (New York: Metropolitan Museum of Art and Random House), foreword.
5. Thomas Hoving, in ibid., preface.
6. Quoted in Howard Smagula, *Currents: Contempo-rary Directions in Visual Arts* (Englewood Cliffs, N.J.: Prentice-Hall, 1983), p. 197.
7. Diane Arbus in *Diane Arbus* (Millerton, N.Y.: Aperture, Inc., 1972), p. 3, copyright © 1972 The Estate of Diane Arbus.
8. Duane Michals, excerpt from *Real Dreams* in *Duane Michals* exhibition catalog (New York: Sidney Janis Gallery, 1976), n.p.
9. Italo Zannier, "Contemporary Italian Photography," *Venezia* 79, p. 280.
10. Susan Sontag, quoted in Bill Jay, "The Romantic Machine," p. 112.

SCULPTURE, 1960S

ROY LICHTENSTEIN, in an address to the College Art Association in 1964, stated, "Since art works cannot really be the product of blunted sensibilities, what seems at first to be brash and barbarous turns in time to daring and strength, and the concealed subtleties soon become apparent."[1] In looking back at the visual arts that emerged during the sixties, and at sculpture in particular, one finds a variety of bold and "brash" experiments that were important not only for their innovation but also for subtleties that have emerged in the years since the sixties.

Icons of popular culture surfaced in pre-Pop and Pop sculpture as well as painting in the United States. Jasper Johns created a body of cast bronze pieces that included a mounted flashlight, a light bulb, a toothbrush, and later a painted Savarin can. His hand-painted cast bronze Ballantine ale cans set on a pedestal, entitled *Painted Bronze,* 1960, were harsh commercial symbols. But they were also transformed by Johns's gestural paint strokes into mysterious objects of ambiguity, one empty, one full. Andy Warhol continued his use of mass production techniques and imagery in sculptural pieces such as *Brillo,* 1964, a series of stacked silk-screened soap pad Brillo boxes. The six boxes, stacked in a 3-2-1 configuration as if one were at a store display, was almost like a parody of traditional "serious" museum art.

Claes Oldenburg, who had been a major participant in early Happenings, was a major figure in Pop sculpture. In December 1961 and January 1962 he displayed his painted papier-mâché sculptures of oversized foods and other commodities in his storefront studio at 167 East Second Street, which he had nicknamed "The Store." There were oversized enamel painted pies, hamburgers, shirts, dresses, all for sale. The previous summer he had elucidated his ideas about art in a catalog for an exhibition, "Environments, Situations, Spaces," at the Martha Jackson Gallery that proclaimed a freedom from traditional constrictive definitions of the nature of art:

> I am for an art that is political—erotical—mystical, that does something other than sit on its ass in a museum. . . .
> I am for an art that embroils itself with the everyday crap and still comes out on top.
> I am for an art that imitates the human, that is comic, if necessary, or violent, or whatever is necessary. . . .
> I am for the art that grows in a pot, that comes down out of the skies at night, like lightning, that hides in the clouds and growls. I am for art that is flipped on and off with a switch. . . .
> I am for the art of bright blue factory columns and blinking biscuits signs. . . .
> I am for the U.S. Government Inspected Art,

Grade A art, Regular price art, Yellow Ripe art, Extra Fancy art, Ready-to-eat art, Best-for-less art, Ready-to-cook art, Fully cleaned art, Spend less art, Eat Better art, Ham art, Pork art, Chicken art, tomato art, banana art, apple art, turkey art, cake art, cookie art.[2]

By the mid-sixties Oldenburg's oversized soft-sculpture pieces—a telephone, a toilet, typewriter, fan, work shirt—had introduced elements of parody and humor into the world of sculpture [2.37]. His frequent use of vinyl, with its slick, commercial qualities, added a dimension of outrageousness to many of the pieces. It is interesting to note that Oldenburg, unlike some women artists, was not criticized for his use of "soft" materials. Oldenburg's work transformed the mundane into the extraordinary and fanciful. His work, for some, was also seen as subversive. According to Donald Kuspit,

Oldenburg is subversive in a way that the best art always is: he converts ordinary things that we are conscious of into signifiers of what we are ordinarily unconscious of, namely, the body as it exists in the unconscious, the so-called "libidinal

body." This transformation is so completely perverse, that it can be understood to indicate the return of repressed rage, even malevolent resentment of the adult world. By making rigid, solid objects soft and seemingly hollow, Oldenburg has made them infantile and libidinal; in the unconscious, the body is always the soft, fluid infant's body. . . . Oldenburg's soft sculptures invite us to touch them, even fondle them. . . . They not only have the same soft body as the infant, but seem to idealize its softness. Each object doesn't just lose its objective qualities, it regresses to the infantile state of softness. This must be the ideal state of bodiliness.[3]

By the mid-sixties Oldenburg had also made a number of proposals for monumental sculptural pieces. In 1967 he exhibited "Proposals for Monuments": *Fagends and Drainpipe Variations* at the Janis Gallery, and in the same year, *Giant Wiper* and other proposals at Chicago's Museum of Contemporary Art. Some of the first proposed monuments were *Proposed Colossal Monument for Lower East Side, N.Y.C.—Ironing Board*, 1965, and *Proposed Colossal Monument for Central Park North, N.Y.C.—Teddy Bear*, 1965. Many of the propos-

2.37. Claes Oldenburg, *Giant Hamburger*, 1962. Art Gallery of Ontario.

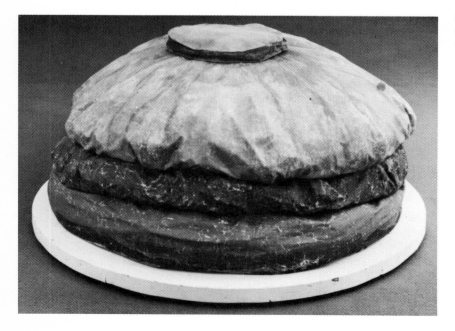

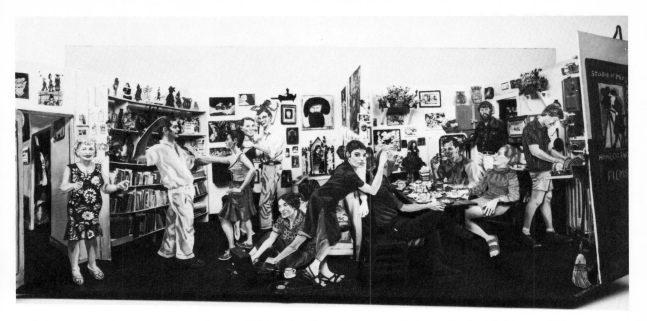

2.38. Red Grooms, *Loft on 26th Street*, 1965–66. Hirshhorn Museum and Sculpture Garden, Washington, D.C.

als contained quite lyrical drawings that suggest some of the whimsy and fantasy inherent in some of Oldenburg's work. Oldenburg's first proposal to be realized was his mighty *Lipstick Ascending on Caterpillar Tracks,* 1969, a site-specific piece in front of a classical war memorial at Yale University. The piece exuded a strange hybrid of male and female qualities as a small two-inch object associated with feminine cosmetics also became a male phallic symbol as well as a colossal lipstick rising twenty-four feet into the air. The piece also served as an antiwar monument during the Vietnam War. One critic wrote: "Lipstick-rocket-tank, it mocks the military erection and puts its pink finger on a culture that measures its virility in missiles. But it is benign, too. It has its own erotic claims. 'I wish for the best of all things,' Oldenburg has said, and the giant lipstick no less than his teddy bear or baked potato can be seen as a monumental claim for comfort and love."[4] A later monumental piece consisted of a giant clothespin, a forty-five-foot-high, ten-ton metal piece, erected opposite a classical city hall in one of Philadelphia's most historic and elegant public squares. Needless to say, the piece provoked controversy, as an object usually associated with domestic, mundane activities became an aggressive, dominant, and public object. Oldenburg's monumental projects led to the proliferation of site-specific sculptures in the next decades. During the sixties Oldenburg also designed some buildings in the shape of their names, such as M-U-S-E-U-M and P-O-L-I-C-E station, which may be seen as forerunners of architectural sculpture. In all of these large-scale works Oldenburg played with scale or what he called the "poetry of scale"[5] as his pieces interacted with and engaged both the human form and the buildings and objects in the piece's immediate environment.

The use of common objects as well as the human form—figures in their everyday environments—was seen in the work of Red Grooms and George Segal. Red Grooms, moving from the tradition of Happenings, created vibrant caricaturelike sculptural installations that incorporated details of everyday life and popular culture, as seen in his *Loft on 26th Street* [2.38], 1965–66. Here life is teeming with everydayness. In 1974 Grooms, with his wife, Mimi Gross, and a team of engineers, elec-

tricians, painters, fabric sculptors, and carpenters, began a large-scale project to re-create lower Manhattan, entitled *Ruckus Manhattan.* The piece included such disparate elements as the World Trade Center towers (thirty feet high), a graffiti-filled subway station, the Stock Exchange, prostitutes from Forty-second Street, and polluted sewers filled with alligators. Although Grooms's work sometimes appears zany and parodic, there is an underlying truth to life in the vitality of the interaction of the brightly colored forms and figures. He is not, though, a social critic. His "flagrant goofiness . . . occasionally permits an extremely sophisticated view of the world to show through. Grooms is not a social critic. . . . He doesn't comment so much as celebrate, so his affronts to good taste and high style don't read as acts of rebellion or protest."[6]

George Segal also created architectural settings with human figures, but his were of a much different sensibility than the zany Grooms figures and many of the other Pop artists, although he was included in group shows of Pop art. His plaster figures, such as those in *Bus Riders,* 1964 [2.39], exhibit a seriousness and expressiveness suggesting a spatial, often lonely, interior of the figures. In the sixties Segal's figures were created by molding plaster-soaked canvas over a model. (Originally making large expressionist paintings in the fifties, he was his own first model in 1961.) He then used the resulting shell. With this method, the features were not fully delineated and this in combination with their overall whiteness made the figures appear to be universal, "everyman." In the early seventies Segal somewhat altered his technique by making a cast of the interior of the plaster bandage of the shell, thereby achieving more detailed features on the figure, and an increased realism. He also began to color some of his figures in an overall, intense, and artificial color, as in *Blue Girl in Front of Black Door.*

Another well-known American Pop figura-

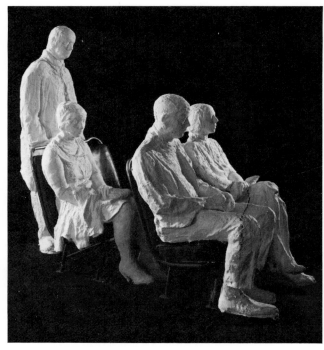

2.39. George Segal, *Bus Riders,* 1964. Hirshhorn Museum and Sculpture Garden, Washington, D.C.

tive sculptor was Marisol (Escobar). Although she was born in Paris of Venezuelan parents, Marisol moved to New York in 1950. She initially studied painting at the Art Students League and with Hans Hofmann, but quickly turned to sculpture. She had her first solo exhibit at the Leo Castelli Gallery in 1959 and became known for her carved and assembled and painted wooden sculptures, such as *Women and Dog,* 1964. Some of her work contains subtle political and social satirical elements, as we are forced to look at aspects of ourselves, our heroes, and our celebrities.

Depicting the figure in a different manner were Duane Hanson and John De Andrea, whose search for exact realistic representation was analogous to Photo-Realist painting. The term "Superrealist" was also used, particularly in relation to the sculpture. Influenced by Segal (although Segal encased the mold of the figure in his sculpture), both molded their figures from models and painted them in a trompe

l'oeil fashion. Hanson usually dressed his fig-
ures. He found his models everywhere—tour-
ists, construction workers, junkies, janitors—
and used life-sized polyester resin and
fiberglass casts. Hanson had been introduced to
polyester resins by the German artist George
Grygo while Hanson was teaching in Germany.
Until he was forty-two his work had been
mainly abstract and somewhat decorative. He
made his first figure molded in clay and then
cast in polyester resin and fiberglass. His work
has been divided into several phases: the bru-
tal, violent political pieces of 1967–69, such as
War (1967), a Vietnam protest piece; stereo-
types, such as *Security Guard,* 1975 [2.40] and,
beginning in 1971, everyday people, such as a
woman reading a letter with her poodle. In a
number of the "stereotypes," such as the *Tour-
ists* or *Supermarket Shopper,* Hanson makes
visual editorial comments.

> The shopper, well, I was interested in the de-
> scriptive elements of a person who so mindlessly
> pushes her cart around the market, isn't mindful
> of her shape, isn't mindful of her health, isn't
> mindful of her looks. And that's also tragic to me.
> That's not a put-down, but it relates to art as I see
> it. . . . And then there were the Tourists, the
> shorter man with the taller lady, short pants and
> the very garish clothes. They are people who are
> very American looking, and have made all the
> wrong choices. It's fascinating to me because it
> was a sort of aloofness in them, a sort of not caring
> what the other people around them think, and
> there's something beautiful in that. They look
> ridiculous but lovable, and now I think that's
> beautiful. Truth is beautiful, isn't it?[7]

Many have approached Hanson's figures, the
janitors, the guards, and the like, as if they were
real figures. But in truth we are confronted not
with an "other" but with bits of ourselves, un-
veiled, transformed into material forms.

John De Andrea's polyester-resin figures,
usually nudes, although extremely realistic, are
coldly classical, showing De Andrea's interest

in classical forms and his divergence from Han-
son's aesthetic.

Combining the spirit of Grooms's and
Segal's tableaux with the political and social
bite of Hanson's early work were the assem-
blages of Edward Kienholz. Kienholz's socially
conscious work of the sixties attempted to point
to the foibles and misery beneath the facade of
modern civilization. His *State Hospital* and *Il-
legal Operation* are gruesome depictions of

2.40. Duane Hanson, *Security Guard,* 1975. Collection
Palevsky.

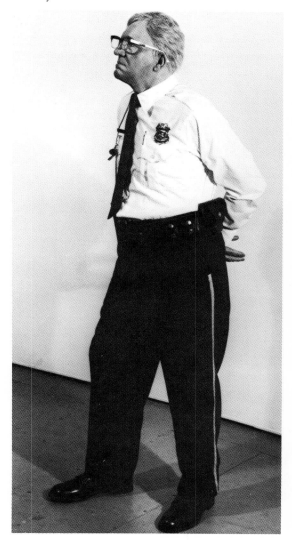

what Americans did not want to see under the shiny, glittering "surfaces" of an advancing society. Or in his poignant piece, *The Wait* [2.41], the specter of death pervades the silent tableau of a crippled old woman, who is seated with photographic memories of her youth in her necklace of faded glass jars and on the table.

Hovering between Pop art and Minimalism was the sculpture of Richard Artschwager. His formica *Table with Pink Tablecloth*, 1964, is a combination of painting and sculpture, fused in a minimal "box" with trompe l'oeil table with pink tablecloth. There is an illusion of space and fact of solidity at the same time, with the

black "space" underneath the table. In the sixties Artschwager also developed a series of rubberized hair objects [2.42] that recalled Duchampian humor, and his "blp" series. In the latter series, he combined three-dimensional physical aspects of sculpture with the flatness of painting as he applied his relief punctuation marks (small ovals) or "blps" to the surface, raising questions about perception. He also covered "blp"-shaped forms with rubberized hair material. "I wanted to make something that pays attention to the way things look on the periphery of sight, things that are blurred," he said, "so I put together those blps minus the

2.41. Edward Kienholz, *The Wait*, 1964–65. Whitney Museum of American Art, New York.

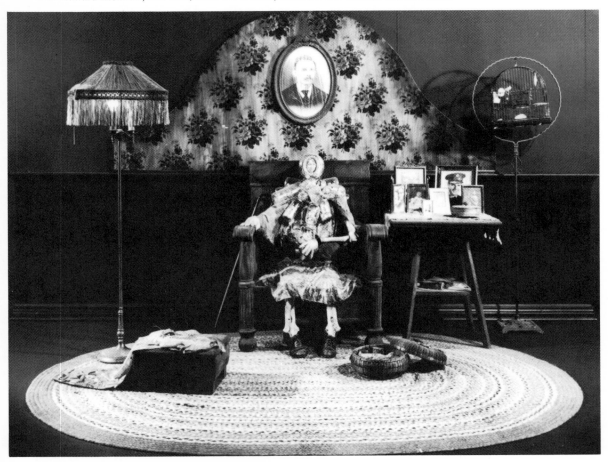

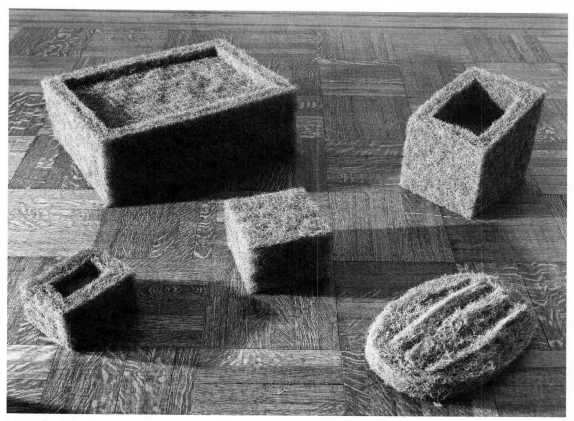

2.42. Richard Artschwager, *Hair Boxes*, 1969. Leo Castelli Gallery, New York.

element of focus." He went on to state his work shared the spirit of the times. "It was the time of the rapture of materiality," he explained, "in place of the spiritual."[8]

Like the Minimal painters, Minimal sculptors rebelled against the emotional excesses of the Abstract Expressionists and looked for inspiration to various sources, such as the Russian Constructivists, the ready-mades of Marcel Duchamp and the polemics of Ad Reinhardt. These artists advocated materiality, systems, seriality, and removal of any evidence of the artist's hand. Robert Morris wrote of the interest in a new way of looking at the interrelations between an object and the space it inhabits. "Simplicity of space does not necessarily equate with simplicity of experience. Unitary forms do not reduce relationships. They order

them. If the predominant, hieratic nature of the unitary form functions as a constant, all those particularizing relations of scale, proportion, etc. are not thereby canceled. Rather they are bound more cohesively and indivisibly together."[9] Those artists associated with Minimal sculpture include Tony Smith, Sol LeWitt, Robert Morris, Donald Judd, Dan Flavin, Carl Andre, and Anne Truitt. One of the most important exhibits heralding the significance of Minimal sculpture in the United States was entitled "Primary Structures," held at the Jewish Museum in New York in 1966. One of the pieces that attracted attention in the show was by the young Carl Andre, a native of Quincy, Massachusetts. The piece, entitled *Lever*, was a four-hundred-foot lateral progression of firebricks placed on the floor beginning at one wall

in the gallery and progressing outward. Andre commented about the piece, "All I'm doing is putting Brancusi's *Endless Column* on the ground instead of in the sky. Most sculpture is priapic with the male organ in the air. In my work, Priapus is down on the floor, the engaged position is to run along the earth."[10] Andre moved from using bricks to using standardized squares of metal—aluminum, copper, zinc, and lead (one metal per piece)—and encouraged viewers to walk on the pieces, as in *Lead Piece*, 1969 [2.43], to become more totally involved with the piece beyond visual perceptions. As he noted,

> There are a number of properties which materials have which are conveyed by walking on them: there are things like the sound of a piece of work and its sense of friction, you might say. I even believe that you can get a sense of mass, although this may be nothing but a superstition which I have. Standing in the middle of a square of lead would give you an entirely different sense than standing in the middle of a square of magnesium.[11]

Andre's use of prefabricated materials emphasized an industrial component but also gave him the freedom to develop systems and arrangements where elements could be inter-changed. The viewer could relate parts to the whole, and the whole to its parts. But the "objectness" of the piece was primary. Andre also referred to "sculpture as place" and the difficulty of inherited cultural traditions and meanings that could overwhelm him. "Because what the idea 'minimal art' really means to me is that the person has drained and rid himself of the burden that stands shadowing and eclipsing art. The duty of the artist is to rid himself of the burden."[12]

The Minimalists' emphasis on objecthood was clearly seen in the work of Donald Judd, whose clean, seemingly untouchable, gleaming objects became synonymous with Minimalism. His rows of hard identical boxes, or his harmonious arrangements of rectangular solids, such as his 1968 *Untitled* [2.44], shift perceptions of sculpture from metaphorical considerations to contemplation of the object and its relationship to its environment. In Judd's work, as in a number of Minimalists' work, European traditions of sculpture and interest in the sublime were subverted. "What Minimalism did, in effect, was to detach the sublime from the sense of tragedy to which it was attached in Abstract Expressionism. Without tragedy, without the feeling for the inevitability of failure and death, space in American art changed. It lost its

2.43. Carl Andre, *Lead Piece* (144 Lead Plates 12 × 12 × ⅜"), 1969. The Museum of Modern Art, New York.

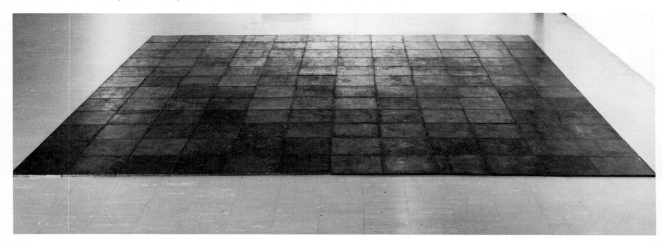

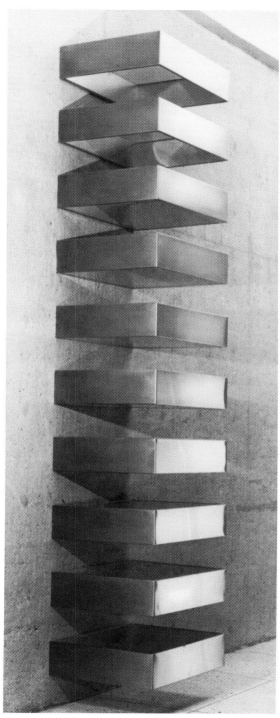

2.44. Donald Judd, *Untitled*, 1968.

weight, becoming instead free and expansive—like a blank slate, almost everything seemed possible except insecurity and doubt."[13] The significance of "an expanded field" in sculpture and its relation to Post-Modernism was articulated by the critic Rosalind Krauss in her 1978 essay "Sculpture in the Expanded Field."[14] With its beginnings in Minimalism, sculpture was later to be considered in an expanded space, not on a pedestal, and to have complex interrelationships with landscape, architecture, and "pure" space.

Donald Judd pronounced in the sixties, "I'm totally uninterested in European art, and I think it's over with."[15] He sought to promote a democratic approach to the work, heading away from any evidence of the artist or cult of the artist. Yet his work was never universally accessible and was difficult in concept and content for some. For others who accepted the Minimalist premises of the work, its shiny surfaces cried, "Look, but do not touch." Judd's work, like that of a number of Minimalist sculptors, expanded in scale and impressiveness as the decade progressed.

Both Tony Smith and Canadian-born Ronald Bladen made monumental forms that exuded heroic qualities. Smith's work, such as *Cigarette*, often included archlike forms that harked back to the heroic arches of ancient Rome. But the shape twisting back on itself gave an added tension that was different from some of the other Minimalists, who favored the cube. Bladen startles our sensations with his tipped rectilinear forms in pieces such as his 1966–67 *Untitled* and his 1966 *Black Triangle*, where the sleek, stark thirteen-foot-high triangle is tipped on end and points to the ground. Bladen described his quest for the monumental:

My involvement in sculpture outside of man's scale is an attempt to reach that area of excitement belonging to natural phenomena such as a gigantic wave poised before its fall or man-made

phenomena such as the high bridge spanning two distant points.

> The scale becomes aggressive or heroic. The esthetic a depersonalized one. . . . The drama . . . is best described as awesome or breathtaking.[16]

Robert Morris approached monumentality somewhat differently in his pieces that involved total rooms and the intersections of mass and space [2.45]. Morris moved somewhat from Minimalism in the late sixties to deal with what came to be called "process" art, where the process was as important as the product. In December 1968 he organized an exhibit at Leo Castelli's warehouse, "Nine at Leo Castelli," which included Richard Serra, Eva Hesse, Alan Saret, and Bruce Nauman, who had made sculptures of spineless materials such as rubber, string, cloth, and wire that took their shape according to gravity. Morris's own felt pieces were arranged according to the fall of gravity, whereby forms could be changeable and open-ended [2.46]. Morris's concise 1968 essay "Anti-form" in *Artforum* further articulated his ideas at the time.

In these cases considerations of gravity become as important as those of space. The focus on matter and gravity as means results in forms which were not projected in advance. Considerations of ordering are necessarily casual and imprecise and unemphasized. Random piling, loose stacking, hanging, give passing form to the material. Chance is accepted and indeterminacy is implied since replacing will result in another configuration. Disenchantment with preconceived enduring forms and orders for things is a positive assertion. It is part of the work's refusal to continue aestheticizing form by dealing with it as a prescribed end.[17]

Different from the monumental forms of Robert Morris, Tony Smith, and Ronald Bladen were the serial and open cubic pieces of Sol LeWitt [2.47] and the painted wood pieces of Anne Truitt. Truitt did not begin studying sculpture until the age of twenty-four after she had received a degree in psychology from Bryn Mawr College. Marriage to journalist James Truitt took her to Japan as well as to various locations in the United States. Her slender, dignified pieces, such as the red-painted wood *King's Heritage*, stand like icons of strength.

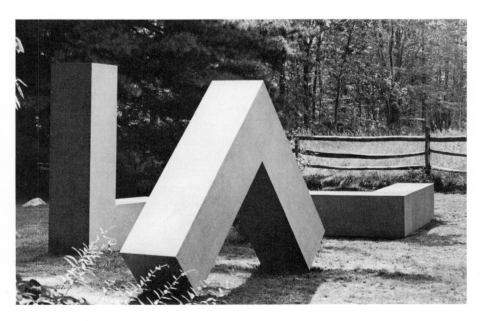

2.45. Robert Morris, *Untitled (L-Beams)*, 1965–67.

2.46. Robert Morris, *Untitled*, 1967–68.

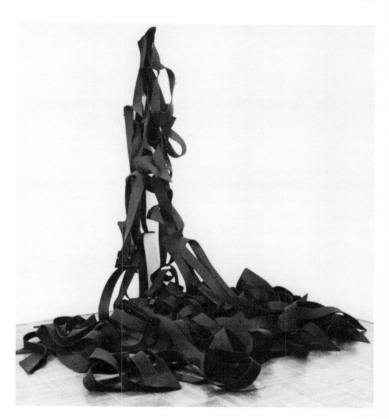

2.47. Sol LeWitt, *Untitled Cube,* 1968.
Whitney Museum of American Art, New
York.

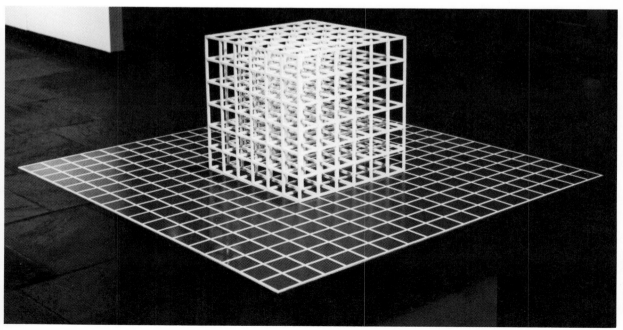

Since her first one-person show at André Emmerich Gallery in 1963, she has shown widely and published two volumes of her journals.

Dan Flavin transformed Minimalist shapes by using lights to make his forms and shapes, often incorporating portions of a given space, such as the corner of a gallery, as seen in his 1968 *Untitled (to the "innovator" of Wheeling Peachblow)* [2.48]. With a few fluorescent lights Flavin was able to transform spaces and shapes into magical entities.

The West Coast artist Larry Bell also used light in beautiful minimal glass boxes that contained delicate shiftings of light and color.

Richard Serra pushed beyond a number of the other Minimalists in his Prop pieces, where the shapes were indeed Minimalist. But there was a sense of precariousness in the propped position, quite different from the order and sta-

bility of most Minimalist pieces. Like Morris, Serra also created a number of scatter pieces. He also continued to work in Minimalist forms and has created a number of large public space pieces. During the sixties the U.S. government began spending more on public art, particularly through the General Services Administration (GSA) Art-in-Architecture program. The program stipulated that 0.05 percent of the total cost of the building be spent on art in or around the building. The National Endowment for the Arts, begun in 1965, also established an Art in Public Places program, and corporations became involved in supporting the arts. (See later discussion of Serra's *Tilted Arc,* page 347.)

Although not truly Minimalist, an important piece of the sixties, utilizing strong geometric forms, was Barnett Newman's outdoor *Broken Obelisk* [2.49], executed in Houston in 1963–

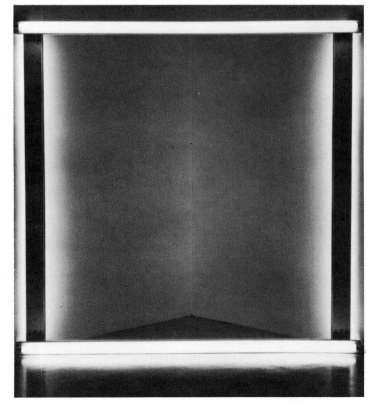

2.48. Dan Flavin, *Untitled (to the "innovator" of Wheeling Peachblow),* 1968. The Museum of Modern Art, New York.

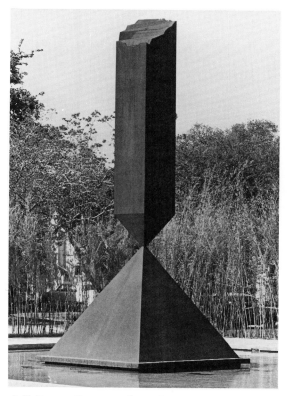

2.49. Barnett Newman, *The Broken Obelisk*, 1963–67. Rothko Chapel, Houston.

67. Newman's forms are spare and pure, like the Minimalists, until one comes to the gradated top of the otherwise pure geometric form. Newman alters our perceptions of the ancient forms by this and the inversion of the obelisk form balanced perfectly on its pyramid base. The energy and tension of this balance point is at times overwhelming.

By the end of the sixties the work of Dan Flavin, Robert Morris, and others who had begun to execute sculpture "in situ" thereby creating impermanent pieces had prompted Carl Andre to use the term "post studio sculpture." The southern California artist Robert Irwin pushed this aesthetic further in a series of large curved disks, set off the wall, whose shadows created illusions of nothingness. He also placed semitransparent textile scrims, lit from behind, in gallery spaces, luring the viewer into a hypnotic void.

The emphasis on situational sculpture and abandonment of traditional sculptural materials served as a foundation for the young artists in the late sixties who became involved in Earthworks or Land Art. A number of Earthworks artists had actually begun by making Minimal sculptures. In 1968 the Dwan Gallery in New York made public this trend in an exhibit, "Earthworks," that included the work of Carl Andre, Michael Heizer, Robert Morris, Oldenburg, Dennis Oppenheim, and Robert Smithson, among others. The solid, unitary forms of many of the Earthworks hark back to Minimalism but add an aggressiveness and harsh beauty inherent in the large land forms. Gone was the traditional museum and gallery space for some, and photographs became documentation.

Perhaps one of the best-known Earthworks artists was Robert Smithson, who died tragically in an airplane crash in 1973 while working on one of his pieces, *Amarillo Ramp*. His well-known and magnificent *Spiral Jetty* [2.50] was a coil of rocks in Great Salt Lake, fifteen hundred feet long and fifteen feet wide, constructed of black rock moved by a bulldozer. The piece has changed over time as rock crystals, earth, and red water formed by algae have adhered to the coil. The scale of the piece also changes for the viewer, depending on where he or she stands. In describing the work, Smithson referred to a

> sense of scale that resonates in the eye and the ear at the same time. Here is a reinforcement and prolongation of spirals that reverberates up and down space and time. So it is that one ceases to consider art in terms of an "object." The fluctuating resonances reject "objective criticism," because that would stifle the generative power of both visual and auditory scale. Not to say that one resorts to "subjective concepts" but rather that one apprehends what is around one's eyes and ears, no matter how unstable or fugitive. One seizes the spiral, and the spiral becomes a seizure.[18]

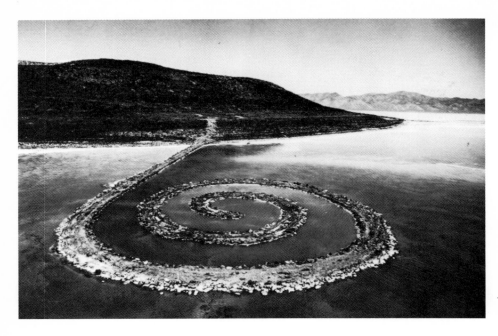

2.50. Robert Smithson, *Spiral Jetty*, April 1970. Great Salt Lake, Utah.

Upon Smithson's death, his wife, Nancy Holt, also an artist, carried on some of his concerns, as well as her own work. Her *Dark Star Park*, an urban park built between 1979 and 1984, combines huge concrete spheres set on shallow circular pools, with a large section of pipe serving as a tunnel under a curved earth ramp. The park is situated in Rosslyn, Virginia, just across the Potomac River from Washington, D.C. At the intersection of several major well traveled roads, it offers a reprieve from commercial and highway signs, with its pristine and organic curvilinear forms.

Michael Heizer used the earth in a harsher and more aggressive manner than Smithson in his giant depressions or cuts into the earth. His *Double Negative*, 1969–70, was a deep, majestic cut in the edge of a mesa near Overton, Nevada. His later *Complex One*, 1972–76, was a large mastaba-like piece in the Nevada desert with cantilevered sections of concrete that served as framing devices. Heizer claimed his sources for the piece were the Egyptian mastaba and the snake bands bordering the ball court at Chichén Itzá for the framing elements. A full day is required to see the piece in all its aspects, and one could see something quite different at different times of the year because of the change of shadows. Of the isolation of his works, Heizer said, "In the desert I can get that kind of unraped, peaceful religious space artists have always tried to put in their work."[19] Heizer, like a number of other Earthworks artists, had also turned to the distant outdoors to escape the commodity orientation of the art market. However, a number of artists using photographs as documentation and to sell a work, insisted the photographs were as important as the work itself.

Walter de Maria's approach to the use of the earth was varied and at times anxiety provoking. Following the creation of some brilliantly polished stainless steel Minimalist pieces in the mid-sixties, de Maria in 1968 filled a Munich art gallery with dirt. He also placed his own body in the landscape and had himself photographed. He created huge line drawings in the desert, such as *Mile Long Drawing*, 1968, consisting of two parallel lines of chalk, 12 feet apart. Somewhat later pieces, such as his *The Lightning Field* of the mid-seventies, possess a conceptual and neo-Dada-like quality that pro-

vokes the viewer as the nature of art is questioned. *The Lightning Field,* 1971–77, is a mile square "field" in New Mexico with four hundred stainless steel poles that can conduct lightning [2.51]. Set in a grid of sixteen by twenty-five poles, at 220-foot intervals, the poles may be seen as pinnacles of meditation or as cold industrial objects that may be dangerous when lightning strikes. It is this ambiguity that makes the piece psychologically alluring.

Another well-known Earthworks artist was Dennis Oppenheim. His pieces include *Time Pocket,* 1968, where he used a chainsaw to cut an 8-foot-wide, two-mile path into a frozen Connecticut lake, and *Directed Seeding-Canceled Crop,* 1969, where he plowed an *X* with 825-foot cross arms into a Dutch grain field.

Outside the United States, the British artist Richard Long worked in the landscape by taking extensive walks and mapping basic shapes and lines—straight lines, circles, crosses, squares, and so on. The Dutch artist Jan Dibbets approached reshaping the landscape by using a camera, shooting at various axes and angles, to make a new, composite landscape by mounting together a series of photographs.

Related to the Earth artists but introducing man-made elements into the works was the Bulgarian-born Christo Javacheff, known simply as Christo. Settling in New York in 1964 and eventually becoming an American citizen, Christo began in the mid-sixties to make proposals in the form of drawings and collages to wrap monuments, buildings, and elements in the natural landscape, thereby transforming the initial "object." In 1968 he wrapped the

2.51. Walter de Maria, *The Lightning Field,* 1971–77. New Mexico. U.S.A. Dia Art Foundation.

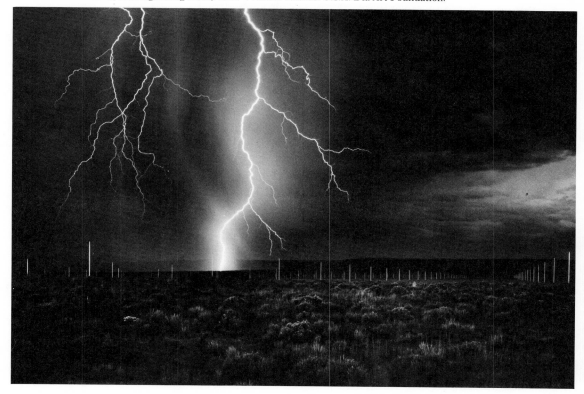

172

UPHEAVALS: THE 1960S

Kunsthalle in Bern, Switzerland, using twenty-seven thousand square feet of reinforced polyethylene tied with nylon rope. In 1969 he wrapped the Chicago Art Institute both inside and out with heavy brown tarpaulins.

His first "earth" work involved wrapping a one-and-a-half-mile-long and eighty-five-feet-high shore line of Little Bay, Australia, near Sydney. There he used one million square feet of synthetic woven fiber and thirty-five miles of orange polypropylene rope. Later pieces have included his 1971 *Valley Curtain,* in the Colorado Canyons, which was destroyed by a great gust of wind that tore the orange nylon off its cables. His famous and magnificent *Running Fence,* 1972–76 [2.52], consisted of shrouds of white nylon running twenty-four miles, eighteen feet high through California's Sonoma and Marin counties and out into the sea. It took

Christo two years of proposals, presentations, and arguments to secure the necessary permissions from the counties' residents and officials, many of whom were opposed to the piece. A force of four hundred people helped install the 2,050 steel poles and reams of nylon. For its two-week duration, the piece in its changing lights and shapes according to the wind, the time of day, and where the viewer stood was an endless visual drama, glowing and pulsating in the open air. It was a triumph of the imagination and a brief transformation of the land and perceptions of the land's inhabitants. But the "art" lay not only in the final piece but also in the total process and the power of engagement—the proposals, the provocations with officials and townspeople, in short, the implementation of change, of a different vision.

Christo has continued to use fabric in his

2.52. Christo, *Running Fence,* 1972–76. Sonoma and Marin counties, California.

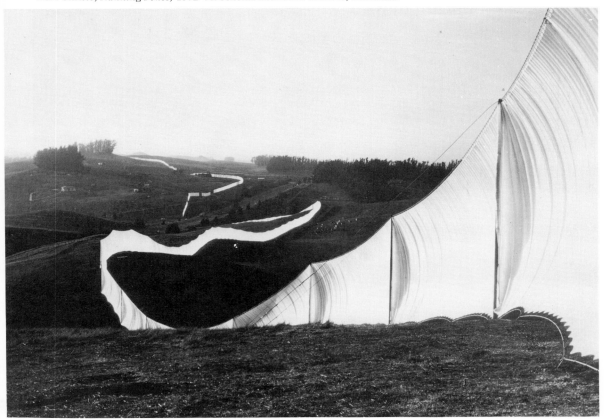

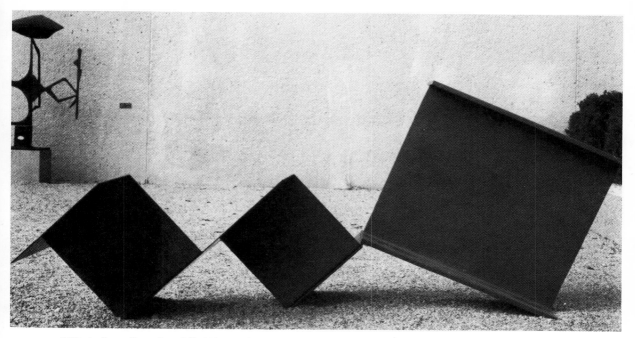

2.53. Anthony Caro, *Rainfall*, 1964. Hirshhorn Museum and Sculpture Garden, Washington, D.C.

pieces, feeling that although it is commercially produced, there are important expressive qualities inherent in fabric. Christo described fabric as "almost like an extension of our skin, and, you see that very well in the nomads, and in the tribes in the Sahara and Tibet, where they can build large structures of fabric in a short time, pitch their tents, move them away, and nothing remains."[20]

The work of Christo and a number of the Earth artists, although having origins in Minimalism, carried with it in many instances elements of the sublime and a call back to Romanticism and a search for transcendence.

Related to the Minimalists in a search for a clarity of form were those artists who were involved with construction sculpture, such as Mark di Suvero, Anthony Caro, and George Sugarman. They differed from the Minimalists, though, in their emphasis on complexity, space, and at times improvisation. In 1966 Mark di Suvero began to work more with steel beams and less with found wood timbers, and often used movable elements. There is a strong gestural quality in some of his monumental pieces, such as his *Praise for Elohm Adonai,* 1966, and his *Are Years What? (For Marianne Moore),* 1967.

Anthony Caro, British born and for a time an assistant to Henry Moore, came to the United States in 1950 and met David Smith. Although he never uprooted completely from England, he spent much time in the United States and was closely identified with the American art scene in the sixties. He taught sculpture at Bennington College in Vermont and was the only British artist invited to take part in a large survey exhibition organized by the Los Angeles County Museum of Art in 1967, "American Sculpture of the Sixties." In Caro's welded constructions, such as *Rainfall,* 1964 [2.53], there is a sense of openness, of fluidity, and even lightness, despite the heaviness of the materials. Caro wrote about his work,

> I want to make sculpture which is very corporeal, but denies its corporeality.... Much of the sculpture I'm doing is about extent, and even might

get to be about fluidity or something of this sort, and I think one has to hold it from becoming just amorphous. . . . I have been trying, I think, all the time to eliminate references, to make truly abstract sculpture. It is using these things like notes in music. But the note must not remind you too much of the world of things.[21]

Unlike Caro and di Suvero, George Sugarman used more curvilinear forms, and his work often exhibited very playful qualities. Often of varied colors and shapes, such as *Concord*, 1974 [2.54], it contained elements of formal surprise and open-endedness. During the seventies he came to be associated with the decorative movement.

A different approach to construction was seen in the work of Lee Bontecou, who on a

Fulbright Fellowship in Rome in 1957 developed a technique for welding steel frames that served as the foundation for many of her works. Combining steel with stained canvas conveyer belts that had been discarded by the laundry beneath her apartment, she created powerful reliefs. Often the works, such as *Untitled*, 1961, contained ovoid forms and were highly textured with bits of rope and other materials in addition to the canvas and welded steel. There is a sense of mystery and sometimes anxiety in the jagged and raw qualities of the pieces, which range from four to approximately twenty feet high.

In 1966 the critic Lucy Lippard noted that there had "evolved a . . . style that has a good deal in common with the primary structure

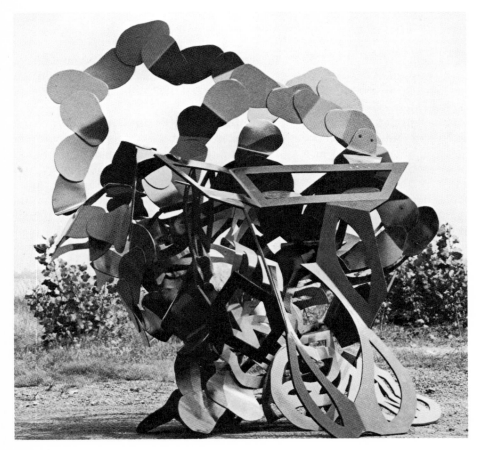

2.54. George Sugarman, *Concord*, 1974. Robert Miller Gallery, New York.

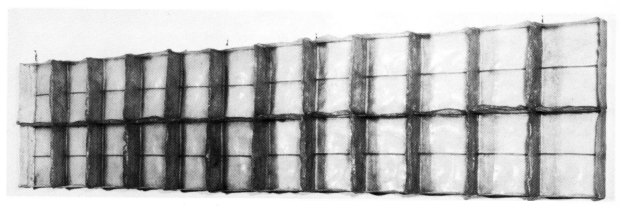

2.55. Eva Hesse, *Sans II*, 1968. Whitney Museum of American Art, New York.

[Minimalism] as well as, surprisingly, with aspects of Surrealism. [These artists] refuse to eschew . . . sensuous experience while they also refuse to sacrifice the solid formal basis demanded of the best in current non-objective art."[22] She organized a show, "Eccentric Abstraction," in that same year at the Fischbach Gallery and included artists such as Louise Bourgeois, Eva Hesse, Kenneth Price, Keith Sonnier, and H. C. Westermann. An example of this "eccentric abstraction" may be seen in the work of the young Eva Hesse. She retained Minimalism's modular and gridlike structures but added a sensuous and erotic quality through the use of unconventional materials such as rubber tubing, string dipped in fiberglass, and papier-mâché. The tension of the polarities inherent in a piece such as *Sans II* [2.55]—finite/infinite, rigid/flexible, soft/hard, inner/outer, fragile/strong—cannot be resisted. Hesse's short life and her art were monuments to her great strength and willingness to take risks. Born in Germany, Hesse and her family fled Hitler's regime and came to New York when she was three. She studied at the Pratt Institute, Cooper Union, and received a B.F.A. from Yale in 1959. But her life was filled with tragedy—her parents' divorce, her mother's suicide, her own marriage breakup, her father's death, and finally her own tragic death in 1970 from a brain tumor at age thirty-four. Her experiments in the late sixties were to

have a lasting impact on future sculpture. Of her works she wrote:

> They are tight and formal but very ethereal, sensitive fragile, see through mostly, not painting, not sculpture, it's there though. I remember I wanted to get to non art, non connotive, non anthropomorphic, non geometric, non, nothing, everything, but of another kind, vision, sort, from a total other reference point. Is it possible? I have learned anything is possible, I know that. That vision or concept will come through total risk, freedom, discipline. I will do it.[23]

Related to the "eccentric" abstractionists was the work of Lucas Samaras. Born in a small Greek town, Kastoria, in Macedonia, Samaras came to New York with his family at age eleven. Knowing little English, Samaras devoted his time to art, which his father constantly discouraged. Religious rites, icons, mosaics, liturgical implements, and so forth remained in his mind from early childhood and were revitalized on a 1967 return journey to Greece. In 1955 Samaras entered Rutgers University, where Allan Kaprow was chairman of the art department. Samaras was involved in some of Kaprow's Happenings and in theater groups at Rutgers. Much of his early visual work and his stories and poems were concerned with a search for an inner self—a personal iconography. In the early sixties Samaras made a number of boxes, reliefs, and other objects studded

with pins, razors, and other pain-giving devices, such as *Box 4 (Dante's Inferno)*. The book, usually a container for words and ideas, now became a vessel for pain, which for Samaras was related to beauty and to lost beauties. He wrote of his use of pins,

> (1) When I use them with the flat paintings they create a net pattern which breaks up the flat picture and creates a strange illusion. (2) Pins are marks, lines and dots. (3) They are relatives of nails. My father spent some time as a shoemaker. I was raised by a very religious family. The nailing on the cross. As a child I often played with pins at my Aunt's dress shop. Nailing pieces of cloth. My father spent many years in the fur business stretching and nailing furs. The pin is to an extent a part of my family. One of my earliest and strongest memories deals with seeing an Indian fakir on a bed of nails in a *World Book Encyclopedia*.[24]

In 1964 Samaras re-created his disheveled bedroom at the Green Gallery, and in 1966 constructed a mirrored room in which the artist's image and the viewer's image were repeated in myriad ways.

Lucy Lippard's "Eccentric Abstraction" exhibition prompted Robert Morris to organize his "9 in a Warehouse" show at a warehouse annex of Castelli's gallery, which marked a turn toward an interest in process. (See previous discussion of Morris's and Serra's work, pages 166–67 and 168.) Emphasis on process was seen in a somewhat different manner in the work of the German-American artist Hans Haacke and Robert Barry. In the sixties Haacke became fascinated with systems in nature and began making "weather boxes." In his *Condensation Cube*, 1963–65, Haacke used cycles of evaporation, condensation, and gravitation to create effects of change within the box. In the Plexiglas box the viewer could observe the workings and changes of time, which became a component of the piece, in process and form. Robert Barry's 1969 *Inert Gas Series*, where he released two cubic feet of helium over the

Mojave Desert to expand infinitely, also dealt with conceptual processes and the natural world.

The analogue of Op art in sculpture was kinetic construction, where motion and light were used as major physical components in a work, rather than as painted or sculpted illusions. There were many approaches to kinetics both within and outside the United States. George Rickey used long tapered strips of stainless steel that were so delicate they wavered with the slightest breeze. Len Lye, a New Zealander and experimental filmmaker as well as kinetic artist, used vibrating rods or whirling metal strips with accompanying, gripping sounds. One critic wrote that Lye's sculpture

> manages to compress so ferocious an energy that the viewer stands paralyzed, gripped by an emotion almost of terror. Lye's elements are supremely simple: hanging strips of stainless steel, six or seven feet long, are set to spinning around at very high speeds. The whiplash strain on the steel produces a series of frightening, unearthly sounds in a perfect accord with the mood of barbaric energy that seems to have been released.[25]

Lye also created groupings of delicately balanced rods that vibrated gently on their own, such as his *Grass*, where man-made elements became nature.

Pol Bury created motorized constructions in which rolling wooden balls, vibrating metal strips, and crawling steel cubes moved almost imperceptibly, as if the movement were an illusion.

Jesus Rafael Soto, of Venezuelan heritage, also used delicately balanced metal rods in constructions that oscillated at the slightest provocation. He also created entire room environments out of plastic string.

During the sixties a number of artists' manifestos emerged with theories emphasizing light and motion. In Spain there was Equipo 57, working as an anonymous team, and in Italy, Group N in Padua and Group T in Milan.

Looking at sculpture outside of the United

States during the sixties one finds affinities with American sculpture of the time, and at the same time a reliance on earlier modernist experiments as well as a push to the beyond. By the late sixties a striking difference between European and American avant-garde sculpture and extensions thereof lay in the social concerns of a number of European artists.

In England a new group of sculptors was seen emerging following an exhibition called "The New Generation" held at the Whitechapel Art Gallery in London in 1965. The show's catalog noted the influence of Anthony Caro, David Smith, and the Post-Painterly Abstractionists in America. Of the far-reaching significance of both Caro and Smith, the critic Edward Lucie Smith has commented that their work

> marked an important shift in the centre of gravity. Sculpture had throughout the post-war years taken second place to painting. Now the hierarchy was reversed. Sculpture became the point of reference, and . . . was regarded as the arena for everything truly innovative. In time this development was to be carried so far that almost every form of extreme activity would insist on describing itself as "sculpture," to the confusion of the lay public.[26]

The young British sculptors emerging in this new generation included William Tucker, Philip King, and Tim Scott. William Tucker's sixties work was both ordered and free flowing. Some of his pieces, such as *Persephone*, explored permutations of a basic shape. In *Persephone*, which looks somewhat like a large set of children's beads, there is also reference to the human form in the torsolike segments and in the upright section of the piece. Tucker also functioned as theorist, as he published a series of articles on sculpture in *Studio International*. In 1974 he wrote a book, *The Language of Sculpture*.

In France César Baldaccini, part of the Nouveaux Réalistes group, worked with automobile remains salvaged from junkyards in a manner that may be seen as a parallel to the American John Chamberlain's work. Baldaccini made "compressions," car bodies squeezed oblong into various sizes by compressing machines, and "Reliefs," wall pieces composed of automobile parts, but with color dominating form.

Niki de Saint-Phalle, also a member of the Nouveaux Réalistes, and personally involved with Tinguely, became noted for her large-scale human figures, such as her *Black Venus*, 1967, which have a garish Pop and folk sensibility about them. Born in Paris but raised in New York, Saint-Phalle returned to Paris in 1951 and joined the Nouveaux Réalistes in 1961. In 1961 she and Rauschenberg also made a piece together. In 1963 she exhibited her controversial *Hon* (the Swedish word for "she") at Stockholm's Moderna Museet. The piece was an eighty-two-foot-long, twenty-foot-high hollow sculpture of a woman lying on her back. It contained a bar, aquarium, planetarium, music rooms, and movie theater. Visitors entered through a door between the woman's legs.

An extension of sculpture into "a Nouveau Réaliste event" was at Daniel Spoerri's show in 1963 at Galerie J in Paris. Spoerri transformed the gallery into a restaurant. During phase one of the show elaborate meals with detailed menus were served to small groups of ten, with an art critic serving as head waiter each night. After eleven nights the "restaurant" closed and phase two began. Under the title "Menuspièges," Spoerri exhibited remains from each meal with assorted bits of food, plates, glasses, and silverware glued to the table and hung on the wall.

In Spain, carrying on the welding traditions of Picasso and Julio González, as well as the influence of David Smith and Anthony Caro was Eduardo Chillida, born in 1924 of Basque heritage. Originally trained as an architect, Chillida turned to sculpture in the forties. By the late fifties and early sixties he worked increasingly in monumental forms. Working with

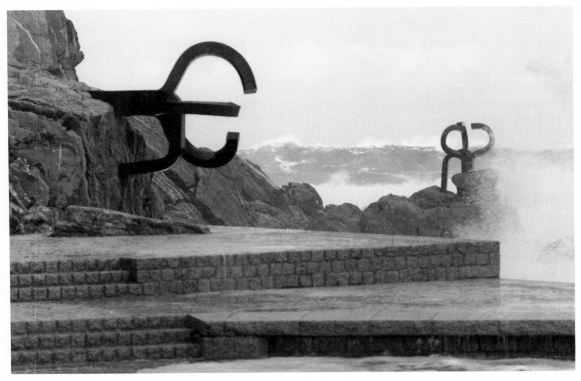

2.56. Eduardo Chillida, *Comb of the Wind*, 1977. Donostia Bay, San Sebastián.

iron, Chillida created large, majestic abstract pieces, where both space and mass are equal components. Much of his work has been like music in iron and steel—ancient and primeval forms that evoke a sense of mystery and awe. "My works are questions," he has said, "not answers."

> The way I understand art is as a question. I am concerned with the capacities and limitations of the mind, the nature of elements in space—these are all questions confronting both the philosopher and the artist. The problems are communicated and addressed in different languages, with other tools, but the ideas remain the same. . . . One approaches a work with an idea, but how it will function, exist, that is the mystery that must be discovered by the artist.[27]

Some of his works, such as his *Comb of the Wind* [2.56], on Donostia Bay, San Sebastián, in Chillida's native Basque country, are magnifi-

cent evocations of the marriage of a deep inner spirit and the forces of matter, form, and nature. He also did a *Comb of the Wind (VI)* in 1968 in front of the UNESCO building in Paris. More recent projects have included murals for the Guggenheim Museum, a memorial for the city of Guernica, and homages to particular figures, such as Bergson, Goethe, Calder, Neruda, and Gris, whose conceptions of art, life, or thought, have inspired Chillida. His 1986 *House of Goethe* in Frankfurt, with its triumphant arch and elliptical walls, was a monument to Goethe's concept of an ideal dwelling.

Exploring monumental and abstract forms in Italy were the Pomodoro brothers, Gio and Arnaldo, both working principally in bronze. Both brothers worked as goldsmiths and decorators and then turned to sculpture. Arnaldo worked principally in basic geometric forms—tall columns, large spheres, or rectan-

gular forms, in which were incised crevices and faults that look like explosive marks, which brought expressionist qualities to the otherwise smoothly polished, "perfect" forms. Arnaldo referred to Paul Klee as the inspiration for these calligraphic incisions and to Brancusi for the overall forms. The pieces may be seen as metaphors for the cracks and fissures of a complex contemporary world that make it difficult for classical, traditional concepts and forms to endure as total, untouched entities.

Gio Pomodoro's work of the same time was more organic and sensual, made from light-reflecting, large sheets of bronze. The undulating surfaces of his *Borromini Square II,* 1966, shimmering with light and shadow, is both formal and sensual.

Artists connected with the *Arte Povera* group also made an impact during this decade. Livio Marzot presented two pieces of dried cod (in an edition of thirty-three examples) as "sculpture" in a Milan gallery in 1970. Jannis Kounellis, a Greek-born inhabitant of Italy, became well known for his filling a gallery in Rome with a stableful of twelve horses. Another "sculpture" consisted of a pianist seated at a grand piano in an empty room while playing a section from Verdi's opera *Nabucco.* With such pieces Kounellis challenged the concept of what the exhibition space was and the nature of what was to be put there in the name of art. Donald Kuspit notes, "It is as though Kounellis has reduced the space to an archaeological condition, so to speak or forced its archaeological character out into the open: it is an excavated site, in which certain more or less living things are found—things once full of life and now, in their excavated condition in the art space, having about them the aura of suspended life."[28]

The native Italian Giulio Paolini, also connected with the *Arte Povera* group, made allusions to Italy's past in pieces such as *Early Dynastic,* 1971, where he exhibited a group of Tuscan columns, with a small group of columns set on large columns. Paolini saw himself as

"manipulator of language." He noted, "To put it in rather an extreme way, perhaps this great respect I have for language goes hand in hand with a certain lack of faith in it. I have never considered language as a vehicle for communicating something else, but simply as a fact in itself."[29]

During the sixties, until the economic recession in the early seventies, Italy, and in particular Milan, became a major center for art. In Rome too dealers quickly found markets for avant-garde modern art. Collections sprang up in places such as Brescia, Verona, Padua, and festivals were held in places such as Palermo, Amalfi, Nettuno, and Montepulciano. But in general, market interest tended to center around American art or other foreign art, such as the work of Joseph Beuys (see later discussion of his work, pages 199–200).

One of the most spectacular sculptural processes used during the sixties, which involved the collaboration of artist and industry, was explosive forming. The process involved shaping high-density metals under water by controlled explosion, and was used by Polish artist Piotr Kowalski in collaboration with North American Aviation in California. Kowalski's *Dynamite,* 1965, was formed by this process and highly polished by hand by the artist to create great reflective surfaces.

Also coming out of Poland, but quite different from the technological emphasis of Kowalski, was the organic fiber work of Magdalena Abakanowicz. (She also worked in bronze.) Since the sixties she has been a leader in nontraditional uses of fiber and has lifted fiber from the world of crafts to provocative fine arts pieces. As a young girl Abakanowicz was faced with the horrors of World War II in Poland, and later had to support herself in a poor country. Much of her work reflects a deep-felt sense of humanity and often a sense of suffering. Originally trained as a weaver, Abakanowicz has since the early sixties concentrated on large, nonfunctional organic forms made of burlap,

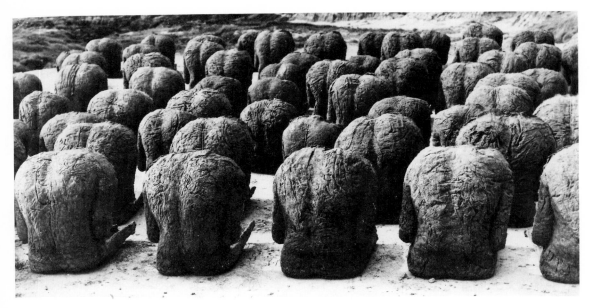

2.57. Magdalena Abakanowicz, *Backs*, 1976–80. Courtesy Marlborough Gallery, New York.

rope, and thread in pieces shown on the gallery floor. She usually shapes the pieces by hand. While many of her works are abstract, some are oriented to the human figure, such as her series *Backs*, 1976–80 [2.57]. The figures are both individual and universal, and speak to the contemporary world in a haunting and primeval voice, asking the viewer to enter a world deep within the earthy textured and colored forms. The artist says of her work, "I like the surface of threads that I make, every square inch differs from the others, as in the creations of nature. I want the viewer to penetrate the inside of my forms. For I want him to have the most intimate contact with them, the same contact one can have with clothes, animal skins, or grass."[30]

Experiments in sculpture during the sixties thus extended in diverse directions, which were to serve as catalysts and points of departure for explorations in subsequent decades.

NOTES: SCULPTURE, 1960S

1. Roy Lichtenstein, address at the College Art Association annual meeting, Philadelphia, January 1964, reprinted in Ellen Johnson, ed., *American Artists on Art, from 1940 to 1980* (New York: Harper & Row, 1982), p. 103.
2. Claes Oldenburg, "I am for an art . . . ," from *Store Days, Documents from The Store* (1961) and *Ray Gun Theater* (1962), selected by Claes Oldenburg and Emmett Williams, New York, 1967, copyright Claes Oldenburg, reprinted in Johnson, ed., *American Artists*, pp. 98–102.
3. Donald Kuspit, "Material as Sculptural Metaphor," in *Individuals: A Selected History of Contemporary Art 1946–1986* (New York: Abbeville Press, 1986), pp. 110–11.
4. Andrew Forge, "Forces against Object-Based Art," *Studio International*, January 1971, p. 33.
5. Claes Oldenburg, "The Poetry of Scale," interview with Paul Carroll, taped in 1968 for *Proposals for Monuments and Buildings, 1965–69*, Chicago, 1969, copyright Claes Oldenburg.
6. Carter Ratcliff, *Red Grooms* (New York: Abbeville Press, 1984), p. 97.
7. Duane Hanson, quoted in Ellen Edwards, "Duane Hanson's Blue Collar Society," *Artnews*, April 1978, p. 60.

8. Quoted in Steven Henry Madoff, "Richard Artschwager's Sleight of Mind," *Artnews,* January 1988, pp. 117–20.
9. Robert Morris, "Notes on Sculpture, Part I," *Artforum,* February 1966, in Gregory Battcock, *Minimal Art: A Critical Anthology* (New York: E. P. Dutton, 1968), p. 228.
10. Quoted by David Bourdon, "The Razed Sites of Carl Andre," *Artforum,* October 1966, in ibid., p. 104.
11. Phyllis Tuchman, "An Interview with Carl Andre," *Artforum,* June 1970, p. 57.
12. Ibid.
13. Michael Brenson, "Donald Judd's Boxes Are Enclosed by the 60's," *New York Times,* November 19, 1988, p. 37.
14. Rosalind Krauss, "Sculpture in the Expanded Field," in *The Originality of the Avant-Garde and Other Modernist Myths* (Cambridge, Mass.: MIT Press, 1985), pp. 276–90.
15. Quoted in Brenson, "Donald Judd's Boxes," p. 37.
16. Quoted in Barbara Rose, "ABC Art," *Art in America,* October–November 1965, p. 63.
17. Robert Morris, "Anti-form," *Artforum,* April 1968, reprinted in Johnson, ed., *American Artists on Art,* p. 186.
18. Robert Smithson, "The Spiral Jetty," in Gyorgy Kepes, ed., *Arts of the Environment* (New York, 1972), reprinted in Johnson, ed., *American Artists on Art,* p. 174.
19. Michael Heizer, in brochure of a show at Galerie H, Graz, 1977, n.p.
20. Quoted in Barbaralee Diamonstein, interview with Christo and Jeanne-Claude, *Inside New York's Art World* (New York: Rizzoli, 1979), p. 94.
21. Anthony Caro, "Interview with Andrew Forge," *Studio International* (London) 171, no. 873 (January 1966).
22. Lucy Lippard, "Eccentric Abstraction," *Art International,* November 1966, p. 28.
23. Eva Hesse, *Art in Process IV,* exhibition catalog (New York: Finch College, 1969).
24. Quoted in Kim Levin, *Lucas Samaras* (New York: Harry N. Abrams, 1975), pp. 45–46.
25. Philip Leider, "Kinetic Sculpture at Berkeley," *Artforum,* May 1966, pp. 40–41.
26. Edward Lucie Smith, *Sculpture Since 1945* (New York: Universe Books, 1987), p. 57.
27. Eduardo Chillida, quoted in Nicholas Shrady, "Affirmations in Iron and Steel," *Architectural Digest,* January 1988, p. 46.
28. Donald Kuspit, "Alive in the Alchemical Emptiness: Jannis Kounellis's Art," in *The New Subjectivism: Art in the 1980's* (Ann Arbor, Mich.: UMI Research Press, 1988), p. 174. Kuspit also points to other challenges to the exhibit space, such as Duchamp's exhibiting his ready-mades; and Beuys's exhibiting and communicating with a dead hare (1965), as well as his living for a week in a New York gallery space with a coyote (1974). But, Kuspit notes, "There is a special threat to the exhibition space in Kounellis's repeated violation of it with living creatures and other material informed with life, suffused with nostalgic associations to it" (p. 174).
29. Quoted in Edward Lucie Smith, *Sculpture Since 1945,* p. 129.
30. Quoted in *Abakanowicz,* by Magdalena Abakanowicz and Jasia Reichardt (New York: Abbeville Press, 1982), p. 127.

ARCHITECTURE, 1960S

THE diversity of experiments in sculpture during the sixties extended also to three-dimensional experiments in architecture. Modern architecture since about 1960, according to Charles Jencks,

> has evolved into a new style, "Late," a version of its former self, and, at the same time, has undergone a mutation to become a new species—"Post"-Modern. . . . Late-Modern architecture takes the ideas and forms of the Modern Movement to an extreme, exaggerating the nature and technological image of a building in an attempt to provide amusement or aesthetic pleasure. It tries to breathe new life into the Modern language of architecture, a language which many people find monotonous and alienating.
>
> Post-Modernists also react against the visual dullness of Modernism, but their solution involves combining the Modern language with another one. Thus a Post-Modern building is doubly coded, one-half modern and one-half something else (often traditional building), in an attempt to communicate with both the public and a concerned minority, usually architects.[1]

It was not until the seventies that Post-Modernism seemed to come into full bloom. (See later discussion, pages 258–68.) Many Late Modern buildings, with their extensions of Modernism and emphasis on glass skin, harmony, and reductive forms, were monumental in scale. As in sculpture, a monumentalist spirit seemed to engage a number of architects. Walter Gropius, who had been closely allied with the Bauhaus for years, in 1963 designed the sixty-story Pan-Am Building, which towered over Grand Central Station, a Beaux-Arts landmark, and blocked a view up Park Avenue. Skidmore, Owings & Merrill moved from smaller structures such as Lever House, in 1951–52, the first postwar corporate image [2.58], to heavy, powerful towers such as its Union Carbide Building of 1963, the Chicago Civic Center, and the ninety-five-story John Hancock Center in Chicago [2.59]. The Hancock Building takes the Miesian dictum of "less is more" to an extreme, but then subverts it with a series of X-like braces that break up the continuous smooth line of the vertical facade. The building was designed for offices, apartments, shops, and entertainment. An elevator could be taken from home to work.

In New York the Miesian credo perhaps reached its height, literally and figuratively, in the World Trade Center Towers, designed by Minoru Yamasaki and Emery Roth and Sons. The building of 110 stories is the second tallest in the world, of lighter color than the Hancock Building, and has thin window strips. These towers, although taller, appear lighter and less aggressive than the Hancock Building.

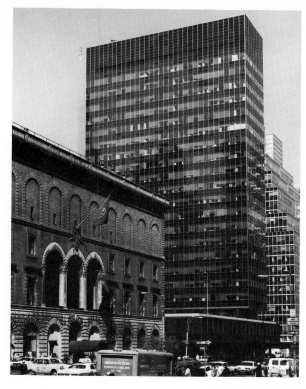

During the sixties Mies van der Rohe completed one of his best-known buildings, the New National Gallery in Berlin, one of his last works. An abstract "universal" interior space is enclosed by a minimal but eloquent cage of black steel and glass. The interior is subdivided by supports and flexible planar partitions for hanging two-dimensional works of art.

In general, the sixties was a time of the building of a number of cultural institutions, marking a flowering of the visual and performing arts. Lincoln Center, although not spectacular in its Neoclassic design, recalling in some ways the layout of the Roman Campidoglio, revitalized the upper West Side of Manhattan. The various buildings, housing the Metropolitan Opera, the New York Philharmonic, and the Vivian Beaumont Theater, were designed by architects Max Abramovitz, Wallace K. Harrison, Philip Johnson, and Eero Saarinen. In addition to Lincoln Center's New York State The-

2.58 *(above)*. Skidmore, Owings & Merrill, Lever House, New York, 1951–52.

2.59 *(right)*. Skidmore, Owings & Merrill, John Hancock Center, Chicago, 1965–70.

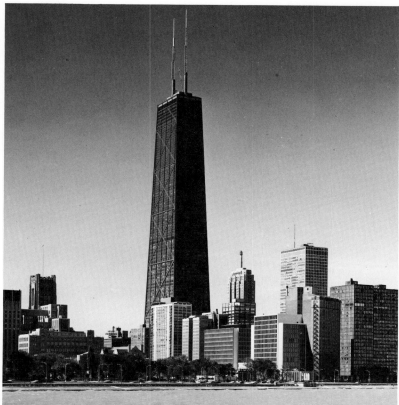

ater, Johnson designed a number of art museums, including those in Fort Worth, Texas; Lincoln, Nebraska; Corpus Christi, Texas; and Utica, New York. The Munson-Williams-Proctor Museum in Utica was a strong marble block with skylit interior.

In Berlin, Hans Scharoun completed his Philharmonic Hall, reminiscent of earlier German Expressionist architecture. Seating in the interior was arranged in a variety of shapes to allow the audience to focus on the orchestra [2.60]. In Paris, José Luís Sert was commissioned to design a building for the art collection of Aimé Maeght, a Paris art dealer and collector. The result, the Fondation Maeght (1954–64), was a combination of sophisticated forms and local materials—local stones and brilliant white stucco.

Le Corbusier completed his only American building, the Carpenter Center for the Visual Arts at Harvard University, in 1963. Although not as dramatic as his Ronchamp church, the building was a good example of Le Corbusier's late style with his use of rough concrete masses and monumental shapes. The building, with its large interior, uninterrupted spaces, and intermittent walls of primary colors, was perfect for the studio activities and exhibition spaces it housed.

Beyond the increased number of cultural institutions, a pervasive theme in some architectural circles was the concept of a "megastructure." A megastructure was usually a complex urban structure or group of structures that would serve a variety of purposes and be adaptable to change. One architect noted for his

2.60. Hans Scharoun, Berlin Philharmonie, 1956–63.

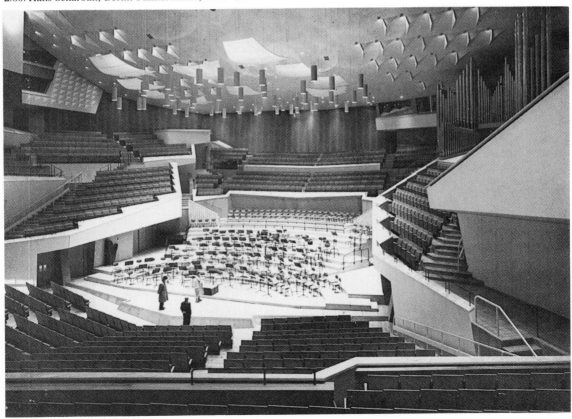

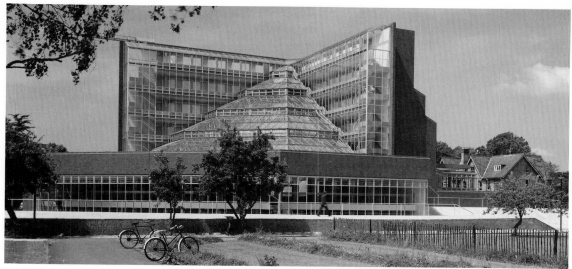

2.61. James Stirling, building for the History Faculty, Cambridge University, 1965–68.

work on megastructures was the British Peter Cook, who worked with a group known as Archigram, which was seen as a branch of the English architectural avant-garde of the sixties. The group included Cook, Warren Chalk, Ron Herron, Dennis Crompton, Michael Webb, and David Greene. In 1961 the group had put together a pamphlet, *Archigram I,* which stated the group's belief in things such as "clip-on" technology, throwaway materials, space capsules, and imagery for and of the mass consumer. A loose affinity with Pop art can be seen. Warren Chalk stated the architects' concern with creating structures symbolic of a new reality:

> We are in pursuit of an idea, a new vernacular, something to stand alongside the space capsules, computers, and throwaway packages of an atomic electric age. . . . We are not trying to make houses like cars, cities like oil refineries, . . . this analogous imagery will eventually be digested into a creative system. . . . It has become necessary to extend ourselves in such disciplines in order to discover our appropriate language to the present day situation.[2]

In 1964 Peter Cook put forth his concept for a huge, changeable megastructure, "Plug-in-

City." There were to be no buildings in the traditional sense, but frameworks into which mechanical and electronic services could be plugged. Some looked upon Cook's scheme as comic and futuristic, but there was an underlying seriousness attempting to deal with a need for the architect's sensitivity to change and with human concerns.

The most completely realized megastructure in Britain was a town center in Cumberland, Scotland, designed by Hugh Wilson, Dudley Leaker, and Geoffrey Copcutt. Densely concentrated in the center structure are government, social, and commercial facilities as well as some housing. Part of the building was left unfinished as if to allow for future needs.

Also emerging in Britain at this time, although not specifically involved with megastructures, was the architect James Stirling. Stirling's vocabulary was mechanistic, and he had a great ability to combine a variety of materials such as glass, metal, and masonry in new contexts. Some of his work in the sixties had a Brutalist vein, reminiscent of Le Corbusier. Other works from the decade, such as his History Faculty building at Cambridge University, England [2.61], present an exciting execution of dynamic and integrated spaces through the

use of glass. Stirling placed the reading room in a quadrant under a glass tent, which was set against an L-shaped block that housed seminar rooms, lounges, and so forth. On the lower levels were spaces for larger, more public functions. At the peak of the reading room were brightly colored fans.

> With its canted interior windows and its glazed galleries, the whole space was a bizarre avocation which seemed to oscillate between twentieth century science fiction, the actualities of aircraft design, and nostalgia for the era of the "grands constructeurs" in steel and glass of the nineteenth century. As before the imagery seemed suffused with Futurist poetry: but there was a once removed quality about this heroic stance—as if Stirling wanted to employ the icons of the machine age polemic without embracing the moral and Utopian commitments.[3]

During the sixties Japanese architecture emerged clearly as an independent entity. An economic miracle had occurred in Japan, and there was an interest in celebrating new industrial techniques. In 1960 an international architectural congress was held in Tokyo that marked the debut of a new postwar Japanese architecture. Out of the conference evolved a loosely formed group, the Metabolists, which included the architects Fumihiko Maki, Kiyonori Kikutake, Arata Isozaki, Kisho Kurokawa, and the critic Noboru Kawazoe, with the architect Kenzo Tange as a kind of mentor figure. Like the Archigram group in England, the Metabolists were concerned with change, mechanism, and a spaceship imagery. The term "Metabolist" arose from the belief that the construction of a building should somehow echo the metabolic processes of life. Kikutake noted the importance of applying the concept of change to a building structure:

> Unlike architecture of the past, contemporary architecture must be changeable, movable, and comprehensible architecture capable of meeting the changing requirements of the contemporary age. In order to reflect dynamic reality, what is needed is not a fixed, static function, but rather one which is capable of undergoing metabolic changes. . . . We must stop thinking in terms of function and form, and think instead in terms of space and changeable function.[4]

Although none of the dreams and visions of the Metabolists actually materialized, their ideas influenced projects of a smaller scale such as Kurokawa's Yamagata Hawaii Dreamland, 1968, where a curved belt of buildings surrounded a pool with monstrous concrete vertical cylinders; or Isozaki's buildings such as the Iwata Girls' High School, 1963–64 [2.62], or the Oita bank, 1966–68. In 1964 Isozaki wrote an essay, "Yami no Leukan," "Space of Darkness," which formulated his and others' concerns for the next decade. His "Space of Darkness" was to operate between two polarities: the shiny new industrial megalopolis and the spirit of Japanese traditional architecture such as the pagoda and Japanese house. For him Japanese architecture was not to be solely Western influenced: "With the four Fukuoka Sogo Home Bank branches designed between 1968 and 1971, Isozaki began to evolve his strategy for creating an illusory 'twilight gloom' as a kind of latter day Japanese Suprematism".[5]

Kenzo Tange also emerged as a major architect during the sixties. Tange, like Cook, dealt with the megastructure with his large-scale proposals for "floating" cities for Boston Harbor and Tokyo Bay, and his Yamanashi Press and Radio Center of 1967. The sixteen towers of the center provided elevators and other services, and in combination with the horizontal levels seemed to provide a limitless and brutal strength, combining forces of traditionalism and futurism [2.63].

An expressionist tendency was seen in Tange's pair of gymnasiums he designed for the Olympic games held in Tokyo in 1964. Both roofs are suspended from giant cables and appear like spiral seashells. The buildings themselves, with rough surface textures, are Brutalistic. But there is a lyricism and grace to the

2.62. Isozaki, Iwata Girls' High School, Iwata, Japan, 1963–64.

2.63. Kenzo Tange, Yamanashi Press and Radio Center, Kofu, Japan, 1967.

curve of the rooflines that counterbalance the otherwise massive forms, giving a continuing sense of drama and visual movement to the complex. The complex "epitomized the transformation from defeated nation to a newfound materialist ebullience," and "demonstrated Japan's mastery of technology and design to an international audience."[6]

Other significant Japanese architects who reached prominence during the decade were Takeo Sato, whose City Hall, 1959, in Iwakuni, was like a modern Japanese pagoda, and Sachio Otani. Otani's International Conference Building in Kyoto, with its trapezoidal and triangular shapes, which housed meeting and exhibit rooms, restaurants, offices, and recreational areas, was a monument to the possibilities of integrating ancient Japanese forms with modern structures.

The visionary qualities of the British Archigram group and Japanese Metabolists was also seen in the work of Paolo Soleri in the United States. Soleri's megastructural schemes for his "Arcologies" (derived from the words architecture and ecology) called for visionary structures in remote areas that housed all the activities of a city. His proposals called for eliminating the automobile from the city and developing solar systems of energy. Soleri called for people to give up single detached homes.

Most of his ideas exist in the form of drawings or models, but perhaps his best-known work, Arcosanti, has been in the process of being built since 1970 near Scottsdale, Arizona [2.64]. There students and disciples of Soleri, who became almost a cult figure, have worked over the years, often paying for the privilege of working on the project. This, as most of his other proposals, is a utopian scheme offering a solution to the ecological, economic, spatial, and energy problems of today's city. Soleri has also developed plans for large floating cities to be set in the ocean.

Another alternative to the detached house,

2.64. Paolo Soleri, Arcosanti (near Scottsdale, Ariz.), 1970 on.

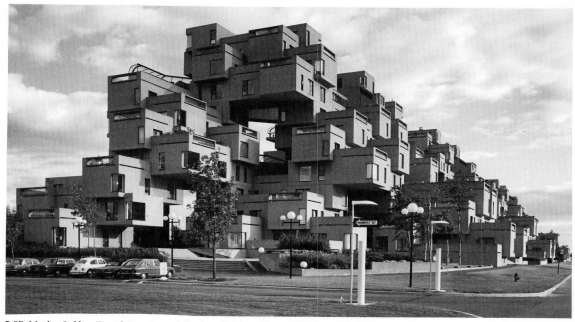

2.65. Moshe Safdie, David Barott, and Boulva, Habitat, Expo '67, Montreal, 1964–67.

as well as the apartment skyscraper, was seen in the work of Moshe Safdie and his design for Habitat at Expo '67 in Montreal [2.65]. His design concept involved stacking prefabricated concrete boxes in an unordered but aesthetic fashion, much the way a child might randomly stack building blocks, to form a coherent whole. Unfortunately, Safdie's ideas were not easily transferable to numerous sites, as initially envisioned, due to difficulties in prefabrication and cost overruns.

One of the most controversial figures in American architecture, whose work was to have a large impact on future architectural innovations, was Robert Venturi, who had been a student of Louis Kahn's. Venturi's book *Complexity and Contradiction in Architecture,* 1966, pointed toward a new vernacular, a more personal architecture that countered a growing boredom with "orthodox" modern architecture. As Venturi wrote in his book, "I like complexity and contradiction in architecture . . . based on the richness and ambiguity of modern experience, including that experience which is

inherent in art. . . . Architects can no longer afford to be intimidated by the puritanically moral language of orthodox modern architecture."[7] Venturi took the adage of Mies van der Rohe, that "less is more," parodied it, and said "less is a bore." Venturi believed that architects should attempt to show perceptual ambiguities, with contradictions and tensions inherent in the work. The vernacular he urged architects to look toward consisted of the commercial strip and "crackerbox" houses. He articulated this concept further in a 1972 book, *Learning from Las Vegas,* which he wrote with his wife, Denise Scott Brown, a specialist in popular culture and urban planning, and partner in their firm, Venturi, Rauch, and Scott Brown. For them a study of American vernacular architecture was to be as important as a study of ancient Greece and Rome had been for earlier generations of architects. Most of Venturi's ideas at the time were not well received, although today he is considered by some to be a father of Post-Modernism. One of his typical projects of the sixties was a house for his wid-

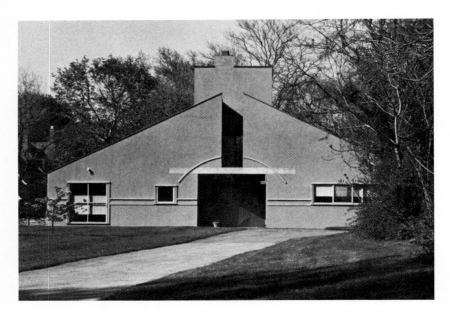

2.66. Robert Venturi, Venturi house, Chestnut Hill, Philadelphia, 1962.

owed mother built in 1962 in Chestnut Hill, Philadelphia [2.66]. Here Venturi parodied the suburban crackerbox and at the same time made the ordinary look unusual. He used elements such as broken arches, irregularly placed and sized windows, stretched lintels, and an expanded facade, all of which may be seen as humorous quotations from architects as diverse as Le Corbusier and Palladio. The interior is complex, with irregularly shaped rooms and crooked staircase. Venturi sometimes provided texts with his buildings, such as the following for his mother's house:

This building recognizes complexities and contradictions; it is both complex and simple, open and closed, big and little; some of its elements are good on one level and bad on another; its order accommodates the generic elements of the house in general, and the circumstantial elements of a house in particular. It achieves the difficult unity of a medium number of diverse parts rather than the easy unity of few or many motival parts.[8]

In his Guild House, in Philadelphia, Venturi extended his ideas further, in the ninety-one-apartment block [2.67]. There is a tension between the common utilitarian look of the building and the more sophisticated classical elements. "In Guild House Venturi deliberately mixed the ordinary with the sophisticated, so that he and the cognoscenti might 'have their tricks,' at the same time that 'the people's wishes, not the architects' ultimately dominate.' Here the 'people's plastic flowers don't look silly in the windows.' "[9]

Besides Venturi, there were other American architects who reacted against the clichés of modern architecture that had come to be during the fifties. On the West Coast there was Charles Moore, and on the East Coast chiefly five, who were briefly called the "New York Five": Peter Eisenman, Richard Meier, Charles Gwathmey, John Hejduk, and Michael Graves. In the late sixties these architects were mainly in their mid-thirties. They became interested in formal issues (versus form and function), and were also influenced by the work of Colin Rowe, who had taught in America from the sixties onward.

Rowe was to later emphasize the significance of applying extended collage and assemblage principles to architecture in a postmodern era:

It is suggested that a collage approach, an approach in which objects are conscripted or se-

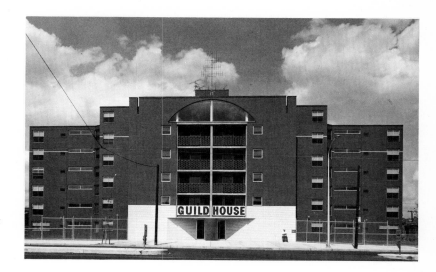

2.67. Venturi & Rauch, Cope &
Lippincott, associated
architects, Guild House,
Philadelphia, 1960–65.

duced from out of their context, is—at the present day—the only way of dealing with the ultimate problems of, either or both, utopia and tradition; and the provenance of the architectural objects introduced into the social collage need not be of great consequence. . . . Societies and persons assemble themselves according to their

own interpretations of absolute reference and traditional value; and up to a point, collage accommodates both hybrid display and the requirements of self-determination.[10]

These young rebels were to mature more fully in the seventies and eighties.

NOTES: ARCHITECTURE, 1960S

1. Charles Jencks, *Architecture Today* (New York: Harry N. Abrams, 1982), p. 12.
2. Warren Chalk, "Architecture as Consumer Product," *The Japan Architect* 165, 1976, p. 37.
3. William Curtis, *Modern Architecture Since 1900,* 2d ed. (Englewood Cliffs, N.J.: Prentice-Hall, 1987), p. 323.
4. Quoted in J. Donat, ed., *World Architecture 2* (London, 1965), p. 13.
5. Kenneth Frampton, "Twilight Gloom to Self-Enclosed Modernity: Five Japanese Architects," in Mildred Friedman, ed., *Tokyo: Form and Spirit* (Minneapolis and New York: Walker Art Center and Harry N. Abrams, 1988), p. 223.
6. Friedman, ed., *Tokyo: Form and Spirit,* pp. 70–71.
7. Robert Venturi, *Complexity and Contradiction in Architecture* (New York: Museum of Modern Art, 1966), p. 16.
8. Ibid., pp. 43–44.
9. H. H. Arnason, *History of Modern Art: Painting, Sculpture, Architecture* (New York and Englewood Cliffs, N.J.: Harry N. Abrams and Prentice-Hall, 1968), p. 693.
10. Colin Rowe and Fred Koetter, *Collage City* (Cambridge, Mass.: MIT Press, 1978), pp. 144–45.

MULTIMEDIA AND INTERMEDIA, 1960S

_DURING the sixties there was increased interest in the possibilities of a liaison between art and technology. In the United States there were several groups that fostered this collaboration. USCO, the "Us Company," formed in 1962 in Garnersville, New York, used film, tapes, slides, and light in creating audiovisual performances and environments that were set up in museums, galleries, schools, and churches throughout the United States. They saw technology as a means of bringing people together in a modern "tribalism." As they wrote in the *Kunst Licht Kunst* catalog, "We are all one, beating the tribal drum of our new electronic environment."[1]

In 1963 Robert Rauschenberg and Billy Klüver, a Swedish physicist in laser research at Bell Labs, and assistant to Jean Tinguely during the construction of *Homage to New York*, worked together to create pieces that incorporated common technological objects such as radios and fans. In October 1966, to celebrate the potential for artist-engineer collaborations, Klüver and Rauschenberg together produced a series of "performances," nine evenings at the New York Sixty-ninth Regiment (the same place that had housed the famed 1913 Armory Show that brought modern art to the United States). *The Nine Evenings: Theater and Engineering* involved the collaboration of forty engineers and ten avant-garde artists to create the elaborate theater, dance, and musical performances. The engineering time required more than three thousand hours' work for the events. Important was the collaborative process where artist and engineer were on equal footing. One significant piece was David Tudor's *Bandoneon!*, which incorporated programmed audio circuits, moving loudspeakers, television images, and lights. As Tudor noted in the *Nine Evenings* program, the machine participated in the composing that was usually left to the composer-artist.

> *Bandoneon* . . . is a combine. . . . [It] will create signals which are simultaneously used as materials for differentiated audio spectrums (achieved through modulation means, and special loudspeaker construction), for the activation of programming devices controlling the audio visual environment. . . . *Bandoneon* uses no composing means; when activated it composes itself out of its composite instrumental nature.[2]

The performances were followed by the founding of Experiments in Art and Technology (EAT) by Klüver and Rauschenberg in an effort to promote collaborative work between artists and engineers. The opening meeting, held early in 1967 at Rauschenberg's loft in Manhattan, was attended by a variety of artists

and scientists, including representatives from AT and T and IBM. The group was endorsed by Senator Jacob Javits. In the early years there were two major EAT projects: an exhibition entitled "Some More Beginnings," an open competition of artist-engineering projects at the Brooklyn Museum in 1968; and the Pepsi-Cola Pavilion at the 1970 World's Fair in Osaka, Japan. At Expo '70 a team of artists and engineers, including Klüver, David Tudor, Robert Breer, and Fred Waldhauer, created a programmed environment of sound and visual imagery in which performances took place. EAT also collaborated in 1967 with K. G. Pontus Hulten, then director of the Moderna Museet in Stockholm, on a section of an exhibit, "The Machine as Seen at the End of the Mechanical Age," for the Museum of Modern Art in New York. The exhibit's aim was to document artists' relationships with technology from the time of Leonardo da Vinci to the present day. Further, EAT organized a lecture-demonstration series for its members given by experts in various technological fields, including computer technology. By the early seventies there were approximately six thousand members of EAT. Membership extended throughout the United States.

Founded on somewhat similar principles as EAT was the Center for Advanced Visual Studies at MIT in 1967 by Gyorgy Kepes, with the support of MIT and several industrial firms in Cambridge. The center provided an environment in which artists could work on collaborative projects with the assistance of scientists and engineers.

Another opportunity to pursue the marriage of art and technology was the Art and Technology program conceived in 1966 by Maurice Tuchman, curator of modern art at the Los Angeles County Museum of Art, and implemented in 1968. The program involved placing approximately twenty artists in residencies of up to twelve weeks at major industries and corporations. Approximately seventy-six artists, including Rockne Krebs, Andy Warhol, Tony Smith, John Chamberlain, and Robert Rauschenberg, participated in the project.

In 1970 the exhibition "Software, Information Technology: Its New Meaning for Art," organized by Jack Burnham at the Jewish Museum in New York, sought to demonstrate the use of electronic and communications technology by artists. There were no traditional art works in the show, only machines. Unfortunately, there were mechanical difficulties with a number of the machines, which alienated viewers who were already skeptical about the use of technology.

The use of technology was extended further to create large-scale environments by a collaborative group in New Haven, Connecticut, called Pulsa. The group, founded by seven artists and architects teaching at Yale, worked with a number of spaces—public, private, rural, urban—using a controlled electronic system to create new environments. Usually a "piece" lasted four to ten hours for a series of evenings from several weeks to several months. In one event at the Boston Public Gardens the audience was surrounded by fifty-five underwater strobe lights and fifty-five amplifiers, which were programmed by computers to emit streams of light and sound through the garden at high speed. Michael Cain, one of the members of the group, spoke of their concerns: "Our environment is totally dominated by electronic phenomena. Our total environment, at least at night, is electric. . . . In such an environment, it seems critical to the Pulsa group that a public art form be developed to deal . . . specifically with the experiences people have today, in terms of time and also of space in the world."[3]

Beyond the various groups that encouraged artistic and technological collaboration, the decade of the sixties also brought the rise of computer and video art. It is somewhat difficult to ascertain the very first time the computer was used to make art. But by 1960 the term "computer graphics" was coined by William

Fetter, a researcher at the Boeing Company in Renton, Washington, to describe his computer-generated plotter drawings of an airplane cockpit. In 1959 the introduction of a Calcomp digital plotter, a computer-driven mechanical drawing machine, made possible the display of linear configurations.

In 1962 Ivan Sutherland completed a doctoral thesis for MIT in which he defined his sketchpad system for interactive computer graphics. With this one could draw directly on the cathode-ray tube (CRT) with a light pen, and there was a memory to hold the forms created.

In 1965 the first exhibition of computer-generated art was organized by mathematicians Friedrich Nake, A. Michael Noll, and George Nees at the Technische Hochschule in Stuttgart, West Germany. In the same year the Howard Wise Gallery in New York, noted for its allegiance to technologically oriented art, held the first exhibition of digital graphics in the United States. The exhibitors of the Wise Gallery were scientists, not artists, and the works were drawn by a plotter, not by hand. Among the works exhibited was the *Guassian Quadratic* series by A. Michael Noll. One of the series was based on the structure of Picasso's cubist

Ma Jolie and explored concepts of programmed randomness. Noll went on to produce a semirandom composition based on a 1917 Mondrian composition and found in a survey that many preferred the computer work and felt it closer to human creativity. Meyer Schapiro, a well-known art historian, pointed to the significance of randomness in our times. "Randomness as a new mode of composition, whether of simple geometric units or of sketchy brush strokes, has become an accepted sign of modernity, a token of freedom and on-going bustling activity."[4]

In 1966 what may be considered the first "computer nude" was created by Kenneth Knowlton and Leon Harmon for the EAT *Some More Beginnings* show. The piece was made by scanning a photograph with a special camera that converted the electronic signals into numerical symbols on magnetic tape, which a computer read and printed on a microfilm output plotter. See also Figure 2.68.

One of the few traditionally trained artists to be working with computers in the mid-sixties was Charles Csuri, an artist on the Ohio State University faculty and founder of the Computer Graphics Research Group at Ohio State. Csuri's computer drawings, such as *Sine-Curve*

2.68. Kenneth Knowlton, computer-processed photograph, consisting of 112 × 45 cells.

Man, 1966, originated as a pencil drawing by the artist. The drawing was then scanned, digitized, and transformed with sine-curve functions and output with a plotter. It was later transferred to silk screen.

At MIT the computer was used by the architect Nicholas Negroponte to grapple with design and construction problems during the late sixties. Negroponte saw the computer and technology as a tool for dealing with some of the complex social problems that existed, to reach an "environmental humanism." In his book *The Architecture Machine,* he declared, "An environmental humanism might only be attainable in cooperation with machines that have been thought to be inhuman devices but in fact are devices that can respond intelligently to the tiny, individual, constantly changing bits of information that reflect the identity of each urbanite as well as the coherence of the city."[5] The blossoming of computer art in the sixties also gave rise to myriad questions concerning the relationship of technology and the artist, the creative process, and the very nature of art that continue to exist today. Where does the creative process begin and end with the use of the machine? Who is the artist? How should the work be evaluated?

An important innovation arising from the marriage of art and technology was in the use of lasers in art. (Laser is an acronym for light amplification by stimulated emission of radiation.) Discovered in 1960, the laser is a man-made light that can be projected across vast spaces without losing its purity and intensity. One of the best-known laser artists during the sixties was Rockne Krebs. Krebs worked as part of the Los Angeles County Museum project mentioned above with the Hewlett-Packard Corporation and was able by virtue of a programming system to make the laser light disappear and reappear, and could reposition the light in a series of varying configurations. "The visual presence of the laser light," said Krebs, "can be sufficiently convincing that one forgets with his eyes and ultimately with his mind the reality of what he sees. The idea of reconfiguration is then a self-conscious attempt to tickle both his mind and his eyes. . . . My mind was stimulated in a way it had never been before, and probably never would again."[6]

Other artists using lasers included Robert Whitman, James Turrell, Mike Campbell, and Barron Krody. The first substantial laser art exhibition was held at the Cincinnati Art Museum in 1969. The show, entitled "Laser Art: A New Visual Art," included entire "environmental" rooms, such as Barron Krody's *Search,* where laser beams reflected against mirrors [2.69].

An expanded use of the laser was seen in the creation of three-dimensional images or holograms, made by splitting the light beam in half, directing one shaft toward an object, the other toward a photosensitive glass plate. The two beams eventually converge on the plate, imprinting an interference pattern there, leaving three-dimensional information that can be reproduced by shining another laser beam or strong light through it. Holographic representations have all of the physical qualities of the real object or form, except they consist of light points that have been focused in space. Holograms can be viewed from different angles and change their relationships to each other when viewed from different positions. A hologram can also be viewed inside out and can create a perspective that makes one feel as though one is inside an image looking out. Bruce Nauman exhibited some of his early holograms at the Leo Castelli Gallery in 1968 [2.70]. Other artists working with holograms have included Jerry Petluck, Carl Frederick Reutersward, and Margaret Benyon. A museum of holography opened in New York in 1976.

It is helpful and important to consider holography in more general terms—as the "means whereby patterns or messages generated by events in a particular area of space and time, interact to generate new patterns, which represent the way in which the separate events

2.69. Barron Krody, *Search*, 1969.

interrelate. . . . If a new esthetic is emerging today, part of it may be a finer sensitivity to interference patterning."[7]

Perhaps the most all-pervasive and far-reaching use of technology was in the rise of video art. For a generation nurtured by television, artists' work in video was perhaps particularly significant, for with the capacity to reach a widespread audience, video had and still has the potential to involve a variety of viewers in an aesthetic experience. In some ways video serves as a tool for democratization. "Unlike the other arts . . . it approaches the pace and predictability of life and is seen in a perceptual system grounded in the home and in the self."[8]

As video art emerged, there was the potential for deep contemplation and exposure to an enriched and multilayered aesthetic experience (in opposition to the sometimes mindless, hypnotic effect that commercial television had, and has, been associated with). There was the

opportunity too for the general public to become more visually perceptive and aware, with increased access to video pieces.

For some, beyond the actual making of video art, video could also "serve as the core of all museum planning and thinking in the next century,"[9] as works of art are transmitted and experienced by the video process. Douglas Davis has suggested the potential of video: "The museum can communicate through television on a private, mind to mind level. It can focus and deepen the experience of art, rather than promote the superficial 'now I have seen it all in ten minutes' experience indoctrinated by the bravura Hoving method. Television restores context and content to the work of art— anybody's work of art."[10]

The first United States environmental installation using a television set was by the German artist Wolf Vostell at the Smolin Gallery in New York in 1963, in an exhibition entitled

"TV-Décollage." There Vostell presented TV sets out of focus, smeared with paint or covered with bullet holes. One of the first attempts at experimental television was in 1964 by Boston's WGBH, where producer Fred Barzyk presented five short visualizations of music.

One of the most well-known video artists has been the Korean-born Nam June Paik, who revolutionized the medium. A comic performance artist originally associated with the Fluxus group in Germany (see discussion on page 198), Paik switched from electronic music composition when he realized the expressive potential in the medium of video. Paik had come to Germany to earn a Ph.D. in philosophy and to study contemporary music. He had met John Cage in Germany in 1958, and, like Cage, incorporated Zen and Dada elements in his work. Paik proclaimed the importance of the video medium, stating that "as collage technique replaced oil paint, the cathode ray tube

2.70. Bruce Nauman, *Holograms (Making Faces)*, 1968. Leo Castelli Gallery, New York.

will replace the canvas,"[11] and, "My experimental TV is not always interesting, but not always uninteresting like nature which is beautiful/not because it changes beautifully/but simply because it changes."[12] In 1963 Paik had his first solo exhibit (nonconcert performance), "Expositions of Music—Electronic Music," at the Galerie Parnass in Wuppertal, West Germany, where he presented thirteen television sets with altered images, and at the doorway to the gallery suspended a slaughtered ox. Although the ox may have attracted more attention than the video, the show was a first—anywhere—of electronic visual music. In 1964 Paik moved to New York, becoming part of the American Fluxus avant-garde performance group, and in 1965 had his first U.S. exhibition at the Galeria Bonino. He also in 1965 acquired one of the first SONY home video recorders, made one of the first personal video tapes, of a cab ride, and displayed it in a café that night. The portopack made the video medium even more accessible to artists and the general public.

In New York Paik met the cellist Charlotte Moorman and collaborated with her on a number of performance pieces, introducing erotic, irreverent, and often humorous qualities into the work. For one of their pieces, *Opera Sextronique*, 1967, Moorman was arrested for indecent exposure, convicted, and given a suspended sentence. In one of their best-known pieces, *T.V. Bra for Living Sculpture*, 1969, Moorman wore a bra of two three-inch television sets and played cello compositions by Paik and other composers. As the audio tones changed, so did the visual images on the "boob-tubes." Mechanical and human attributes were juxtaposed and exchanged as the viewers' perceptions of realities were altered. What was perhaps once considered intimate and private—the bra—suddenly became exposed and public.

Working with the Japanese engineer Shuye Abe, whom he had persuaded to come to New

York, Paik with Abe's assistance perfected a video synthesizer, which enabled them to combine images from a number of television cameras. The possibilities for layering, synthesizing, fragmenting, coloring, and so on became limitless on this new electronic canvas. In 1970 Paik used the synthesizer to produce a four-hour live show at Boston's WGBH. The show, entitled *Video Commune,* used the compositions of the Beatles as soundtrack.

Other important video-performance events in the late sixties included: the use of video projections in *Nine Evenings;* the 1967 WGBH show "What's Happening, Mr. Silver?" an experimental collage and information series in which several dozen inputs were mixed live and at random; and the 1969 exhibit "T.V. as a Creative Medium" at the Harvard Wise Gallery. This was the first American exhibit devoted entirely to video art. It included works by Paik (with Charlotte Moorman), Serge Boutourline, Frank Gillette and Ira Schneider, Earl Reiback, Paul Ryan, Eric Siegel, and Joe Weintraub.

Orientation in Europe toward technological innovations had already been seen in groups such as Group ZERO and Groupe de Recherche d'Art Visuel. In Britain too this tendency surfaced in the mid-sixties with the founding of the Center for Advanced Creative Study in London in 1964 by a group of artists calling for fusions of art and industry. The center named its bulletin and gallery after the artist Takis's *Signals,* his tall blinking-light pieces. These artists declared themselves to be interested in all-encompassing phenomena, "heat, sound, optical illusion, magnetism, contraction and expansion of materials, water, the movement of sand and foam, fire, wind, smoke, and many other natural and technological phenomena,"[13] and felt that art should be an integral part of city planning and architecture. This group eventually dissolved, but its spirit was continued in the opening of a new Center for the Studies of Science in Art in 1967. There artists,

engineers, and scientists came together to work on aesthetic and environmental design problems.

Using technology but moving beyond in its theories and practice was a small but influential international group, "Fluxus," meaning the "flowing," and taking its name from the ancient Greek philosopher Heraclitus, who wrote that "All existence flows in the stream of creation." The group officially established itself in 1962 under the sponsorship of George Maciunas, who ran the AG Gallery in New York, at the "Festspiele neuester Musik" (Festival of the Most Recent Music), in Wiesbaden, Germany. Maciunas was working for the American armed forces in Germany at the time and invited Wolf Vostell, Nam June Paik, and a number of other artists to participate in a month-long Fluxfestival. The Fluxus artists and their friends believed that all modes of thinking and experiencing were related, that distinctions between art and life and between theater, poetry, music, visual art, and dance should be abolished and a new aesthetic model connecting everyday life and art should be derived. Most of the original artists were musicians, and they called their works "compositions," and directions for the works "scores." But in truth their work had little affinity with traditional musical compositions. Among the goals articulated by the little group was an elimination of the fine arts as traditionally understood and a call for the critique of current social conditions. A Fluxus event, unlike a Happening, was usually based on a simple visual or acoustic process, such as the drinking of a glass of beer. But Fluxus theories were not to be profusely or widely articulated by the artists, for as artist Robert Watts wrote, "The most important aspect of Fluxus is that nobody knows what it is. . . . There should be at least one thing not understood by the experts. I see Fluxus wherever I go."[14] And Ken Friedman wrote, "We are trying, in any way possible, to transfer to art the entire range of forms of human communication and experiences."[15]

From 1962 to 1964 there were a number of Fluxus "concerts" and events in major cities, including Paris, Copenhagen, Amsterdam, Nice, and Düsseldorf. There was also an American Fluxus group, consisting primarily of students of John Cage, who had taught at the New School for Social Research in New York from 1956 to 1958. Two elaborate concerts were held at Carnegie Hall in 1964, but there was little positive response and the group began to fall apart. Although the cohesiveness of the group was short-lived, the iconoclastic spirit and goals of the artists remained.

An example of one of the Fluxus pieces may be seen in *Eurasia Thirty-fourth Section of the Siberian Symphony,* 1966, by the German Joseph Beuys, who had joined the group after meeting Nam June Paik in 1962. The piece dealt with the different political ideologies of East and West since the days of ancient Rome. A metal plate represented a large land mass that had been crossed over the years by migrating animals and people and was meant to unify diversity. Seeing himself as a shaman/chief, Beuys drew a cross on a blackboard and erased part of it to write in "Eurasia." The piece was performed in a number of art galleries. Beuys ended his ties with Fluxus by 1965, though, since he felt that "they held a mirror up to people without indicating how to change anything."[16]

The impact of Beuys's work as an artist/activist/teacher was far-reaching. Born in a small town, Cleves, in 1921, Beuys spent much time alone in solitary play, and did not have a close relationship with his parents. During World War II Beuys was drafted by the German airforce and was first trained as an aircraft radio operator. He was later trained as a pilot and assigned to Crimea. He was wounded five times on various missions and then hit by Russian anti-aircraft fire. He crash-landed in a blizzard on barren plains. He was finally rescued by a group of nomads, who wrapped him in fat and felt to warm him. That experience and the images that were a part of it penetrated his consciousness. Beuys later was to use felt and fat in a number of his pieces as metaphors for powerful life experiences.

After the war he studied zoology and in 1947 enrolled to study art at the Düsseldorf Academy of Art. There Beuys was attracted to the work of the sculptor Ewald Matare, who believed in the unity of art and life. Animals have often played a key role in his work, for Beuys believed in the elemental inner strength of animals and that they should be elevated to the same status as humans. In a sixties piece, *How to Explain Pictures to a Dead Hare,* 1965, Beuys, in a bare Düsseldorf Gallery, sat surrounded by felt, fat, wire, and wood, his face covered with a layer of honey and gold leaf. He cuddled a dead hare in his arms and murmured continually to it. With the gold mask Beuys became a shaman/healer transforming the earthly form of the rabbit to a higher spiritual plane. Beuys explained the role of the honey. "In putting honey on my head, I am clearly doing something that has to do with thinking. Human ability is not to produce honey, but to think, to produce ideas. In this way the deathlike character of thinking becomes lifelike again. For honey is undoubtedly a living substance."[17]

Beuys's work was always activist, pushing for changes in the audience's understanding of art or in the status quo. He was often active in the political arena, pressing for political awareness and freedoms. In 1967 he founded his own political party, the Organization for Direct Democracy. He claimed that the party also included all animals in the world. But beyond that the goal of the party was to create a more participatory form of government for his country's citizens. In 1972 Beuys was dismissed from his teaching position at Düsseldorf Art Academy for incorporating activist politics in his teaching, but in 1978 the German Supreme Court ruled the dismissal illegal. A celebrative piece following the 1978 ruling, *Crossing the*

Rhine, involved the rowing of Beuys in a long, sleek wooden boat by five of his students across the Rhine to the academy. In 1976 he had actually run for a seat in the West German Parliament but was defeated.

In 1974 Beuys agreed to come to the United States and saw the visit as one possible way to deal with the trauma of the Vietnam War from which U.S. troops had recently withdrawn. Beuys's visit was a three-day nonstop performance piece, *I Like America and America Likes Me* [2.71], where Beuys, wrapped in felt and carrying a shepherd's crook, and a live coyote shared the same enclosed space. The space also included fifty copies of the *Wall Street Journal* (which were changed daily), two felt blankets, a pile of hay, a water dish, and the searing light of a flashlight, which gradually wore down, shone forth from the blankets.

Beuys had chosen the coyote, a native North American animal, because of its affinity with the plight of the exploited American Indian. The Indians' situation and treatment in America could be seen as analogous to American imposition and interference in Vietnam.

Beuys's work always raised questions but did not propagandize or moralize. His insistence was on transformation and change, and pushing our thinking in new directions. He believed that everyone in some ways could be an artist. "The key to changing things is to unlock the creativity in every man. When each man is creative, beyond right and left political parties, he can revolutionize time."[18]

In another part of the globe during the sixties, experiments in transformation and the creation of new environments was to be found in Brazil in the work of Hélio Oiticica, whose

2.71. Joseph Beuys, *I Like America and America Likes Me,* 1974.

boxes, capes, and environments were provocative and seductive. Oiticica created what he called "energy centers"—boxes, bags, bottles, basins, cabins, capes, beds, and so forth—that were full of substances, such as colored pigments or earth. Larger pieces awaited the entry of a spectator. According to one writer, Oiticica "contributed what must be described as new inventions to modern art. Among them are the bólide, the penetrable, and the parangolé. . . . These inventions of Oiticica's are devices for ordering the chaos of reality, not as formal relationships, but as 'energy centers' to which the psyche and body of the human being immediately feel attracted—'like a fire,' as Hélio once remarked."[19] *Bólide* means "fireball," "nucleus," or "flaming meteor" in Portuguese. *Parangolé,* difficult to translate directly, refers to interior feelings and the expressive, intense experience possible when putting something such as one of Oiticica's "Capes," made from combinations of words, colors, and substances, on the body. The visual was to become integrated with the body as a whole. Another series, *Nucleus,* 1960–63, called for the viewer to walk through floating geometric panels and experience color as a moving environment.

Oiticica was fascinated with the spirit of the Rio carnival, and participated in its dances as well as samba sessions throughout the year. These dance sessions revealed to him "that myth is indispensable in life, something more important than intellectual activity or rational thought when these become exaggerated and distorted."[20] Oiticica developed a notion of Creleisure, where, like the carnival, there was renewal and a true recreation in leisure involving all the senses, not just sterile holidays and recreation. Oiticica organized fiestalike events with other artists, within the art world, emphasizing lived experiences.

Oiticica's influence was not limited to Brazil. In 1969 he had a large retrospective at the Whitechapel Gallery in London. He also lived in New York for six years during the seventies (he died in Brazil in 1980) and his work appeared in the 1970 Information Show at the Museum of Modern Art. There he presented a model for a "non-repressive leisure place" and communal dwelling. His lyrical sensitivity to physical and participatory experience seems particularly daring in a time when consumer and viewer response was often fleeting.

Close to Oiticica's philosophy and sense of aesthetics was Lygia Clark, who also emphasized the whole body in her work in Brazil. By the early sixties she too had abandoned traditional sculpture and painting. She began to work directly with her own body and those of others, as her organic pieces made of materials such as rubber bands, polythene, and air were intended to be handled or passed from one person to another.

Thus the sixties spawned a great diversity of experiments and movements in the visual arts. Although some of these were short-lived, they were to have an impact on subsequent generations of artists. The sixties opened up whole new ways of thinking and new realities on all levels of society. As one cultural historian wrote, "The outcome and meaning of the movements of the sixties are not treasures to be unearthed with an exultant Aha!, but sand paintings, something provisional, both created and revised in historical time. Why assume history has a single direction, posing clear answers to the question of where it is tending?"[21]

NOTES: MULTIMEDIA AND INTERMEDIA, 1960S

1. Frank Popper, "De Groep Usco," *Kunst Licht Kunst,* exhibition catalog (Eindhoven, Holland: Stedelijk-van Abbermuseum, 1968), n.p.
2. David Tudor, quoted in Douglas Davis, *Art and the Future: A History/Prophecy of the Collaboration between Science, Technology and Art* (New York: Praeger Publishers, 1973), p. 70.
3. Quoted in Lucy Lippard, ed., "Time: A Panel Dis-

cussion," *Art International,* November 1969, p. 20.

4. Meyer Schapiro, *Modern Art, Nineteenth and Twentieth Centuries: Selected Papers* (New York: George Braziller, 1978), pp. 253–54.

5. Nicholas Negroponte, *The Architecture Machine: Toward a More Human Environment* (Cambridge, Mass.: MIT Press, 1970), p. 5.

6. Quoted in Maurice Tuchman, ed., *A Report on the Art and Technology Program of the Los Angeles County Museum of Art, 1967–1971* (Los Angeles: Los Angeles County Museum of Art, 1971), p. 174.

7. Jonathan Benthall, *Science and Technology in Art Today* (New York: Praeger Publishers, 1972), pp. 94–95.

8. Douglas Davis, *Artculture: Essays on the Post-Modern* (New York: Harper & Row, 1977), p. 84.

9. Ibid., p. 120.

10. Ibid.

11. Cited in Corinne Robins, *The Pluralist Era: American Art, 1968–81* (New York: Harper & Row, 1984), p. 225.

12. Ibid., p. 224.

13. Quoted in Douglas Davis, *Art and the Future,* p. 62.

14. Quoted in Jürgen Schilling, "Fluxus: Ceci n'est pas un mouvement," *Contemporanea* 1, 3 (September-October 1988): 70.

15. Ibid.

16. Joseph Beuys, quoted in H. H. Arnason, *History of Modern Art: Painting, Sculpture, Architecture* (New York and Englewood Cliffs, N.J.: Harry N. Abrams and Prentice-Hall, 1968), p. 567.

17. Quoted in Howard Smagula, *Currents: Contemporary Directions in Visual Arts* (Englewood Cliffs, N.J.: Prentice-Hall, 1983), p. 231.

18. Ibid., p. 238.

19. Guy Brett, "Hélio Oiticica: Reverie and Revolt," *Art in America,* January 1989, p. 112.

20. Hélio Oiticica, "Apocalipopotesis," unpublished text (1969), cited in ibid., p. 120.

21. Todd Gitlin, *The Sixties: Years of Hope, Days of Rage* (New York: Bantam Books, 1987), p. 433.

III

INDIVIDUALS AND ECLECTICISM: THE 1970S

VIOLENCE did not end in the sixties. The decade of the seventies dawned with the United States' invasion of Cambodia, antiwar demonstrations, and the tragic killing of four students at Kent State University by the Ohio National Guard, all in 1970. Hannah Arendt wrote *On Violence* in the same year. Terror continued into the decade with the death of Israeli athletes at the 1972 Munich Olympics. In 1973 war broke out between Israel and Arab countries, and in another part of the globe, President Salvador Allende of Chile was murdered by right-wing forces. In Germany industrialists were killed by secret revolutionary organizations. In Italy Red Brigade terrorists kidnapped and killed former Prime Minister Aldo Moro in 1978.

Beside global unrest was a diminishing faith in U.S. government policies and officials. In 1971 the *New York Times* published the Pentagon Papers, which pointed to deception of the public. This was followed by the Watergate burglary in Washington, D.C., in 1972, and the ensuing scandal involving cover-ups led to the threat of impeachment of U.S. President Richard Nixon in 1974. Nixon became the first president of the United States to resign when he left office in 1974, to be succeeded by Gerald Ford. Jimmy Carter was elected two years later, bringing with him older fundamentalist beliefs in religion, the family, and progress through the mind and technology. Evangelical Christianity began to sweep through the United States, with more than fifty million devotees by the end of the decade. Attempts to deal with the complexity and uncertainty in the world surfaced in other religious and meditative groups as well. Many turned to Eastern religions and studied Zen Buddhism. Small groups of chanting and dancing members of the Hindu Hare Krishna sect were often seen on street corners, with their shaved heads and flowing gowns. Many turned to Transcendental Meditation, or TM, which was based on Indian religious beliefs. Sensitivity or therapeutic, "T," groups became fashionable in many circles. In the Middle East there was a Muslim revival, a revolution in Iran, and the establishment of an Islamic government by the Ayatollah Khomeini in 1979. The tragic extreme for faithful believers was seen in 1978 when the Reverend Jim Jones and nine hundred of his followers from the People's Temple killed themselves and their children in a mass suicide in the Guyana jungle. In that same year the Polish Karol Wojtyla became Pope John Paul II, the first non-Italian pontiff in four hundred years. A search for spiritual meaning was also reflected in the writings of one of the most prominent writers of the decade, Aleksandr Solzhenitsyn,

who was awarded the Nobel Prize for literature in 1970 and had his *Gulag Archipelago* published in 1974.

It was a decade of feminist politics and solidarity. Kate Millett wrote *Sexual Politics* (1970); Germaine Greer wrote *The Female Eunuch* (1971). In 1973 the U.S. Supreme Court ruled abortion to be legal. International Women's Year was declared in 1975 and a world conference was held in Mexico City. The first U.S. National Women's Conference was held in Houston, Texas, in 1977. More American women joined the work force and pressed for equal pay and job opportunities.

Blacks pressed for equal opportunities as well, and some of the ideals of the civil rights movement became realities. More blacks entered public office, from Carl Stokes of Cleveland to Thomas Bradley in Los Angeles. Alex Haley's *Roots,* tracing his black heritage, and its television dramatization were best-sellers.

There was a demand for tolerance of sexual preference, as the Gay Liberation Movement was formed, asking that the law not impinge upon private life.

Scientific exploration continued. The People's Republic of China launched its first satellite in 1970. The U.S. launched Skylab, the first orbiting space laboratory in 1973. American and Soviet astronauts met in space in 1975 with the Apollo/Soyuz docking. The U.S. Viking 1 and 2 landed on Mars and sent back photographs in 1976, while the U.S. Pioneer II photographed Saturn's moons, rings, and satellites in 1979.

It has been called the "Me Decade," accentuating the need for instant gratification and a sense of well-being. It was a time of pluralism and eclecticism, where individuals and individual groups emerged outside a mainstream. Its books included Jerzy Kosinski's *Being There* (1970), Frances Fitzgerald's *Fire in the Lake* (1972), Erica Jong's *Fear of Flying* (1973), and William Styron's *Sophie's Choice* (1979). Its films included Peter Bogdanovich's *The Last Picture Show* (1971), Francis Ford Coppola's *The Godfather* (1972), Robert Altman's *Nashville* (1975), George Lucas's *Star Wars* (1977), and Michael Cimino's *The Deer Hunter* (1978).

The Me generation also turned to museums and investing in art. Auction house prices soared. Blockbuster shows, such as "The Treasures of Tutankhamen," attracted many as the shows toured the United States. Most of these shows were focused on art from the past, such as artifacts and treasures from Pompeii, ancient China, or Celtic Ireland. Contemporary artists of the decade reflected the pluralistic spirit of the decade, as a great variety of materials, forms, and contents were explored, further breaking down traditional barriers and definitions of art.

PAINTING, 1970S

APPROACHES to painting during the seventies were eclectic and often quite individual. There did emerge some "groupings," such as Decorative and Pattern painting or New Image painting in the United States. But there was not the fervor and rate of change that existed in the sixties. Instead there was a plurality of coexisting styles and experiments. Minimalism continued into the seventies in the work of a number of artists. Brice Marden, for example, "managed to make a new and seemingly final, end-all Minimalist type of painting"[1] [3.1]. In 1975 Marden was given a ten-year retrospective by the Guggenheim Museum, confirming the significance of his work. Superrealist painting also thrived during the decade. Richard Estes represented the United States in the Thirty-sixth Venice Biennale, and his work was also included in Documenta 5, in Kassel, Germany, in 1972.

Yet there was a coldness and starkness in both Minimalism and Superrealism that came to be challenged. In the same year that Brice Marden had his retrospective, the September *Artforum* devoted the entire issue to "the crisis in painting."[2] Was painting coming to an end in the stillness and voids of Minimalism? To fill "the void" there were signs of new interests in pattern, ornament, and image, in personal visions beyond the pure, hard, clean, and geometric forms of Minimalism. This new movement, which came to be called "Pattern and Decoration," or "P&D," or "The New Decorativeness," had a variety of historical roots. There were the "decorative," brilliantly colored cutouts of Matisse. There was renewed interest in the patterns and arabesques of Islamic art when a newly reinstalled Islamic wing reopened at the Metropolitan Museum of Art in 1976. Native American art inspired some artists. Perhaps most important was the recognition of and attention to "craft" forms, such as quilting, embroidery, and needlepoint as "art," as a result of the rising power of women and the Third World. The seeds of this decorative movement had perhaps been sown in particular during 1970–71 when the critic Amy Goldin was teaching at the University of California. At the time, Goldin was concerned with both Oriental and Islamic art and urged her students toward inquiries in both areas. Two of her students there were Robert Kushner and Kim MacConnel, who were to become closely allied with pattern painting. Also connected with the department at the time was Miriam Schapiro, who began exploring both feminist and decorative imagery there in 1970. Schapiro also participated in a conference that Joyce Kozloff attended, pushing for the establishment of a new visual vocabulary that would allow decorative

3.1. Brice Marden, *Grove Group III*, 1973–80. The Pace Gallery, New York.

and "feminine" materials. The spirit of the pattern and decorative approach to painting grew, and in 1975 Schapiro, with the painter Robert Zakanitch, held the first official meeting of the Pattern and Decorative Artists group. The group, which included Joyce Kozloff, Tony Robbin, Miriam Schapiro, and Zakanitch, met regularly along with Amy Goldin. The term *Pattern* painting was said to have been coined by the painter Mario Yrisarry. Pattern painting made use of a great variety of surfaces, forms, and even cartoonlike imagery. Rebelling against the pure Minimalist aesthetic, these artists sought materials and images from diverse sources—from primitive arts to scavenged materials from New York's Canal Street—a postmodern appropriationist sensibility.

Carrie Rickey described the potential richness of this new painting:

This is an art defiant in its dialectic and diversity. Pattern can be, at the same time, an assertion of a system and an intimation of chaos. Patterning could be seen as an opulent response to the austerity and sterility of minimal and reductive art, as an extension of the "all-over" sensibility that characterizes both Abstract Expressionism and environmental art, or as geometric abstraction with exponential variables. It could be read as a positive brand of cultural imperialism that heralds rather than anonymously appropriates the designs of other (mostly Third World) cultures. . . . Patterning's energy source is its refusal to eliminate any possibilities.[3]

Critic John Perreault further defined Pattern painting as "non-Minimalist, non-sexist, historically conscious, sensuous, romantic, rational, decorative. . . . As a new painting style, pattern painting, like patterning itself, is two dimensional, non-hierarchical, all-over, a-centric, and aniconic. It has its roots in modernist art but contradicts some of the basic tenets of the faith, attempting to assimilate aspects of Western and non-Western culture not previously allowed into the realms of high art."[4]

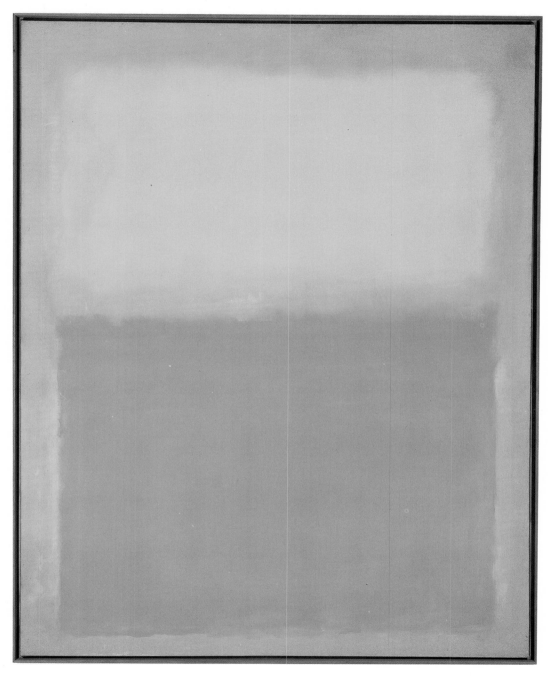

Plate 1. Mark Rothko, *Orange and Yellow*, 1956. Albright-Knox Art Gallery, Buffalo, New York.

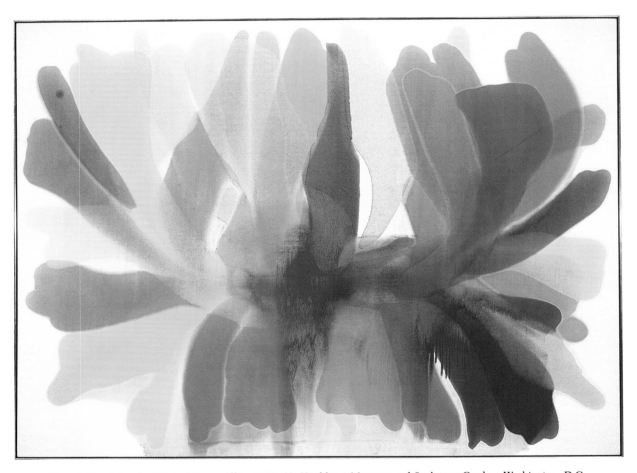

Plate 2. Morris Louis, *Point of Tranquillity*, 1959–60. Hirshhorn Museum and Sculpture Garden, Washington, D.C.

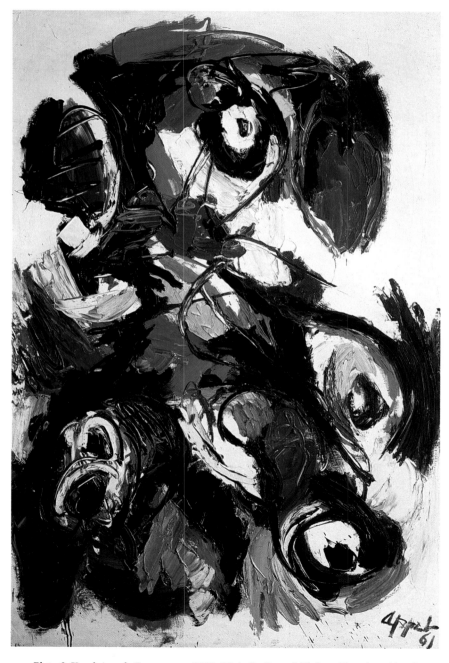

Plate 3. Karel Appel, *Personnage,* 1961. Michelle Rosenfeld, Inc., Fine Arts, New Jersey.

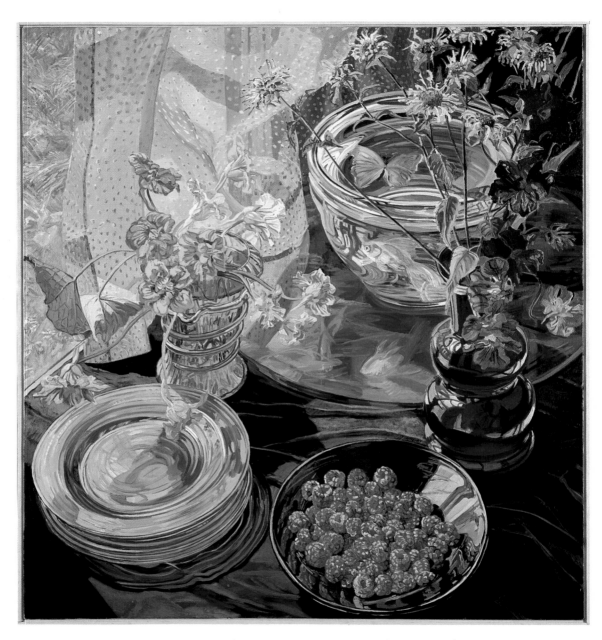

Plate 4. Janet I. Fish, *Raspberries and Goldfish*, 1981. Metropolitan Museum of Art, New York.

Plate 5. Frank Stella, *Shāma (#10, 5.5x)*, 1979. M. Knoedler & Co., Inc., New York.

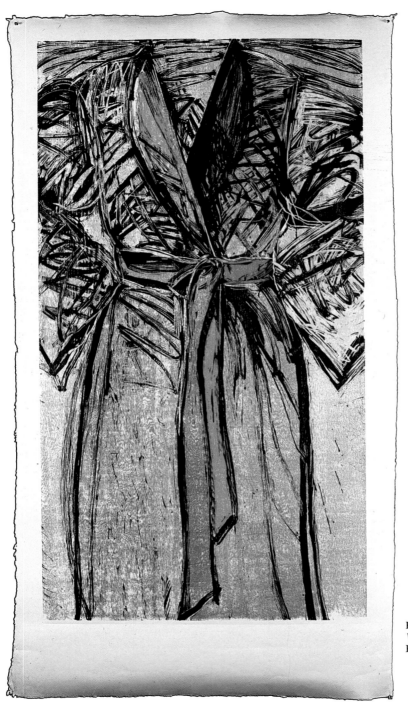

Plate 6. Jim Dine, *Fourteen Color
Woodcut Bathrobe,* 1982. The
Pace Gallery, New York.

Plate 7 *(below).* William Eggleston, *Memphis Tennessee,* 1972.

Plate 8 *(right).* Nancy Graves, *Acordia,* 1982. M. Knoedler & Co., Inc., New York.

Plate 9. Michael Graves, The Portland Building, 1980. Portland, Oregon.

A 1976 exhibit at the Alessandra Gallery in Soho helped clearly establish the work in collectors' and dealers' eyes. Artists included in the show were Joyce Kozloff, Valerie Jaudon, Tony Robbin, Miriam Schapiro, Arlene Slavin, George Sugarman, John Torreano, Robert Zakanitch, and Barbara Zucker.

An exemplary figure of this group was Miriam Schapiro. Schapiro had begun painting in an abstract expressionist style then later turned to Hard-Edge painting, using computers to calculate design ideas. Schapiro was and is a vocal figure in the women's movement, and with artist Judy Chicago sponsored Womanhouse at the California Institute of the Arts in Los Angeles in 1970. Through women's experiences Schapiro searched for a collective past and present that would preserve and honor women's contributions to society. Womanhouse, created with students, was the transformation of an abandoned building into a "female" environment based on women's dreams and fantasies. Schapiro in her own work began to use imagery, as well as actual materials from "women's" history and art—such as scraps of material, yarns, and buttons. She created what she came to call "Femmages," a type of feminist collage, a contraction of the words "feminine" and "image" [3.2]. Her work not only employed fabric in a beautiful and significantly decorative way, but also in many instances connected women around the country. Schapiro wrote of her work in 1976:

> Often when they [other women] were in an audience when I was talking about my work and explaining my idea of "connection" to them, I asked for a "souvenir"—a handkerchief, a bit of lace, an apron, a tea towel—some object from their past which would be "recycled" in my paintings. I saw this as a way to preserve the history of embroidered (often anonymous) works which are our "connection" to the history of a woman's past.[5]

Schapiro was to later write about her continuing immersion in the concept of femmage.

Femmage is many things. It is work by women of history who saved, pieced, hooked, cut, appliquéd, quilted, tatted, wrote, painted and combined materials using traditional women's techniques to achieve their art activities "also engaged in by men but assigned in history to women." Femmage is also practiced by contemporary women, who like their ancestors, are clear about their womanly life and how it shapes their view of the world. Such artists, like Betye Saar, Mimi Smith, Harmony Hammond, Faith Ringgold, Marybeth Edelson, and I were to reshape artifacts from women's culture and give them new voice. As we move into the nineties, Femmage is also coming to mean any deep concerns with women's issues, values, and any ideas relating to gender, language, and media as they illuminate who women are and how they can redeem themselves in the light of deconstructing old mores, customs, style and patriarchal meaning.[6]

A major femmage of the seventies was her 1976 *Cabinet for All Seasons*, a monumental piece composed of four seventy-by-forty-inch panels which were doorlike shapes with trompe l'oeil windows representing each season. One has a sense of the cyclical role of the seasons and of life itself through her shapes and forms and the overlaid gridwork of embroidered handkerchiefs from all over the world. In the same year Schapiro also created her large-scale ten-panel piece *Anatomy of a Kimono*. She spoke of her conceiving and making the piece.

> As always since my conversion to Feminism in 1970, I wanted to speak directly to women. I chose the kimono as a ceremonial robe for the new woman. I wanted her to be dressed with the power of her own office, her inner strength. I wanted the robes to be rich, dignified; it meant that I imagined I would use a lot of gold and silver. I wanted the robes to be clear but also I wanted them to be a surrogate for me—for others. Later I remembered that men also wore kimonos and so the piece eventually had an androgynous quality.[7]

3.2. Miriam Schapiro, *Pandora's Box*, 1973. Collection Zora's, California.

Schapiro's work is decorative and intimate. But it is also political and public and clearly shows Schapiro's unique abilities to balance formal and experimental concerns, as well as personal and social commitments. With her work and that of other Pattern and Decorative painters, the word *decorative* could no longer be seen in pejorative terms nor be assigned to a craft or "low" art status.

Joyce Kozloff, too, turned personal iconography into strong public statements as she created patterns inspired by trips to Mexico and

Morocco, and attempted to break down distinctions between "high" and "low" art and to support the woman's movement. She was first attracted to Churrigueresque architecture in Mexico, and later to the intricate Islamic patterns and designs she encountered in Morocco. In 1978, while she was artist-in-residence at the University of New Mexico, Kozloff began making and painting ceramic tiles for large installations [3.3]. For the exhibition of her *Cincinnati Tile Wall* in a show entitled "Arabesque," Kozloff wrote in the catalog,

> Last year I finished the paintings, at least for now. The abstract and the metaphorical no longer satisfy me. Now I want to make my architectural fantasies concrete, even literal. I am making a room which will have patterns everywhere, on the floor, the walls, the ceiling, and they will be made of tile, fabric, glass, and other materials. Perhaps through this process I can answer the questions about decoration and my work that have begun to obsess me.[8]

Combining Islamic and Celtic pattern influences was the Mississippi-born artist Valerie

Jaudon. Jaudon's overall mazelike compositions have both a simplicity and a complexity in the clean-edged intertwining lines and forms. The monochromatic copper tones of the unprimed canvas of *Jackson,* 1976 [3.4], is about elements such as flatness, rhythm, movement, and symmetry. It is also about centrality, infinity, intimacy, and interpenetration. Jaudon's later work of the early eighties often consisted of more thickly painted three-color pieces with allusions to architectural forms—domes, steeples, arches—and a deeper sense of space. Strongly feminist in orientation, Jaudon has said of her work, "As far back as I can remember, everyone called my work decorative and they were trying to put me down by saying it. Attitudes are changing now, but this is just the beginning. If we can only get over the strict modernist doctrines about purity of form, line, and color, then everything will open-up."[9]

Robert Kushner pushed concepts of pattern and decoration further in his paintings and performance "dresses" for his performances at the Holly Solomon Gallery, which were like mock

3.3. Joyce Kozloff, *Tent-Roof-Floor-Carpet/Zemmour,* 1975. Collection Dr. Peretz; Collection Morganelli, Heumann and Associates.

3.4. Valerie Jaudon, *Jackson,* 1976. Holly Solomon Gallery, New York.

fashion shows where he might don as many as fifty different costumes in sequence. As a student Kushner was drawn immediately to the ideas of the critic Amy Goldin. He was further inspired upon accompanying her on a trip to Iran and Afghanistan. He has recalled, "On this trip, seeing those incredible works of genius, really master works which exist in almost any city, I really became aware of how intelligent and uplifting decoration can be."[10] A number of his paintings in the mid-seventies were made in the shape of *chadors,* the traditional cape and veil garments of Moslem women. He often used floral and kimono dragon imagery. In 1976 Kushner began using animal and human forms in flat overall pattern forms, reminiscent

of Matisse, such as his giant *Slavic Dancers* mural of 1978 [3.5].

Oklahoma-born Kim MacConnel, a fellow student of Kushner's, used all types of sources for his work, from primitive hieroglyphics to American Indian and Oriental rug designs. He also made use of inexpensive machine-printed textiles with garish colors, which he combined with images from older cultures. He often made tapestrylike pieces in softly hanging panels, such as *Parrot Talk,* 1980, where he combined images in unlikely juxtapositions.

Robert Zakanitch took his concepts of patterning from books of linoleum patterns of the fifties and from woodcuts, prints, and pattern samples. Zakanitch had initially worked as a

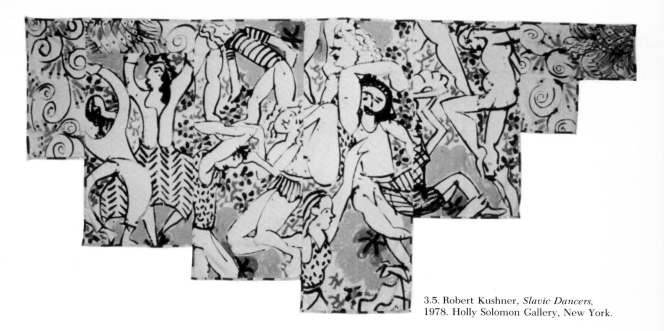

3.5. Robert Kushner, *Slavic Dancers,* 1978. Holly Solomon Gallery, New York.

color field abstractionist using a grid as part of the structure of his compositions. He carried the grid into a number of lushly colored works, such as his large-scale trellis paintings, which transform our perceptions of both the trellis and the wallpaper sample and make a powerful painterly statement of environmental scale.

Creating complete environments was Cynthia Carlson's specialty. Her installations of painted grid marks in an architectural space raised questions about the nature of wallpaper, ornamentation, and the use of wall space. In her *Homage to the Academy,* 1979, at the Pennsylvania Academy of Fine Arts, Carlson repeated the architectural elements already there, the diamond and the rosette, in her own painted wall grid. She also hung some of her own small paintings on the walls. In a statement prepared for the exhibit, Carlson commented on the significance of context:

> Things come to have their meaning for us because of context. Normally decoration depends for its effect on whatever space attention we can find for it. It is peripheral to our "more important" visual goals. I would change the context of decoration by altering the circumstances of traditional placement (location) and means, to bring it

to the center of interest.

> I am using architectural detail, and decoration itself, as the subject. The details of our surroundings *are* our surroundings. The "wallpaper" metaphor brings with it its own instant history.[11]

Also working in architectural scale was Ned Smyth, who was more concerned with sculpture but is mentioned here because of his close affinity with the pattern and decorative painters. He became known particularly for his large-scale cement palm trees with their ornate and decorative surfaces, often done in sparkling mosaics.

Not directly connected with the Pattern painters but carrying their aesthetic to a deeper and perhaps more powerful level were the *Reconstructions* of Lucas Samaras. The paintings or tapestries were made from multicolored scraps of materials and suggested the shimmering power of Byzantine mosaics and Islamic tile patterns. Samaras's patterns were strong and pulsating, penetrating space with sophisticated and colorful forms, as in *Reconstruction No. 52,* 1979 [3.6].

In viewing the Decorative or Pattern movement, it is important to consider some of the artists connected with this style, such as Miriam

3.6. Lucas Samaras, *Reconstruction #52*, 1979. The Pace Gallery, New York.

Schapiro and Joyce Kozloff, in a larger context related to the rise of women artists and their art. Bolstered by the whole feminist movement, women artists banded together and began to demand, and to be given, increased recognition. Women in the Arts was organized in 1971 for the purpose of ending discrimination against women in the art world. The group staged large demonstrations in front of the Museum of Modern Art and the Whitney Museum in 1972. In the same year the Women's Caucus became an official component of the College Art Association, the major U.S. association for higher education and the visual arts. The year 1972 also brought the opening of A.I.R. (Artist in Residence), a cooperative women's gallery in New York. Among the early members of the gallery were Dottie Attie, with her burned and stained copies of Ingres drawings; Judith Bernstein, with her large charcoal drawings of a hairy screw; Sylvia Sleigh, with her portraits of male nudes; Hannah Wilke, with her vaginal sculptures; and Nancy Spero, with her word and image gouache sculptures. Spero's series, *Codex Artaud*, based on the poems of the French Surrealist Antonin Artaud, was exem-

plary of the hard-hitting and erotic content of works by a number of women artists of the time. Through Spero's juxtaposition of text and images, one sees the violation of women, the withdrawal of woman from man. Spero went on to do even more explicitly political and feminist pieces, such as her 1976 *Torture of Women*, which contained quotations from Amnesty International's reports of the torture of women in Uruguay and Chile, and from an ancient Sumerian creation myth.

Following the example of A.I.R., a number of women's galleries had opened by 1975. In New York there was Soho 20, the Women's Interart Gallery at the Women's Interart Center, and the Atlantic Gallery of Brooklyn. In Chicago there was A.R.C. and the Artemsia galleries, and in Rhode Island there was the Hera Women's Cooperative.

Carrying the torch for the black woman artist, and fighting against racism and sexism, was Faith Ringgold, born and raised in Harlem. Ringgold received her master's degree from City College in New York. In 1970 she began to work on political landscape paintings and established the Women Students and Artists for Black Art Liberation (WSABAL). In 1973 she began creating soft doll-like sculptures, and in 1976 turned to masks commemorating her black heritage. Her art, she says,

has always been involved with where I was politically at the time. I must make sure that I'm doing it my way, that I'm not allowing any male domination to direct the way I'm doing things. And that I'm doing all I can do, that I'm not holding myself back. . . . I know who I am now. I am an African American woman. I love using African forms. My classical form does not come from Greece, it comes from Africa. I learned that on my own because I was taught with Greek busts, at City College . . . and I'm very grateful, because I think you should know everything. And I don't feel bad about America.[12]

In general, there was increasing recognition of black or Afro-American artists during the seventies. In 1970 the Museum of the National Center of Afro-American Artists and the Boston Museum of Fine Arts sponsored the largest Afro-American art exhibit held up to that time. In the same year the La Jolla Museum mounted a large group show, "Dimensions of Black Art," and Romare Bearden and Richard Hunt were given retrospectives in 1971 by the Museum of Modern Art. During the first half of the decade the Whitney Museum gave small one-person shows to a number of black artists, including Alvin Loring, Melvin Edwards, Frederick Eversley, Marvin Hardin, James Hampton, and Betye Saar. The Studio Museum in Harlem, founded in 1968, was also a primary exhibition space in a location accessible to a large part of the black population. But despite this increased recognition for both black and women artists, the work was shown in a "separatist" fashion, and the barriers to acceptance in the predominantly white and male mainstreams of contemporary art persisted.

Another impulse in painting different from the Decorative and feminist movements was a return to a more explicit content imagery combining strands of Expressionism and Surrealism in both form and content. The label "New Image" painting was used to band together the work of somewhat disparate artists working with recognizable imagery although not necessarily in a realistic context. Two exhibitions in 1978 attempted to bring together these disparate and idiosyncratic artists into a type of movement. One was "Bad Painting" at the New Museum and the other was the "New Image Painting" at the Whitney Museum. The Whitney show of ten artists included Joe Zucker, Neil Jenney, Nicholas Africano, Susan Rothenberg, and Jennifer Bartlett. The New Museum show included Neil Jenney, Joan Brown, and Charles Garabedian. The term *New Image* was nebulous, but it was difficult to characterize or categorize the deliberately unsophisticated content and form that appeared in a variety of guises.

"Mentors" of this New Image painting may be seen in the work of the Hairy Who group in Chicago, the California Funk artists, and the late work of Philip Guston, who by 1970 had abandoned his abstract expressionist style. The Hairy Who artists, who included Gladys Nilsson, James Nutt, and Karl Wirsum, took their imagery from a variety of "sub-Pop" sources, such as tattoos, comic books, *Mad* magazine, and wrestling magazines, using a primitive kind of style and content image. The Funk artists, who worked in California and included Bruce Nauman, William Wiley, H. C. Westermann, William Allen, and Robert Hudson, were concerned with using funky, humorous elements that poked fun at things such as sex, religion, patriotism, art, and politics. In 1966 Guston had begun painting images of things such as a cup, light bulbs, shoes, and then moved to painting Ku Klux Klan figures smoking cigars, making paintings of themselves, and jumping

out of bottles. The paintings were done with a heavy impasto [3.7].

The "New Imagists" were important not so much for their original style but for their revitalization of figuration. This revitalization occurred in quite individual ways of presentation, appropriation, combination, and narration. Richard Marshall wrote in the Whitney catalog that the artist "felt free to manipulate the image on canvas so that it can be experienced as a physical object, an abstract configuration, a psychological associative, a receptacle for applied paint, an analytically systematized exercise, an ambiguous quasi-narrative, a specifically non-specific experience, a vehicle for formalist explorations or combinations of any of these."[13]

A powerful approach to the New Imagery was to be seen in the work of Susan Rothenberg. In 1973 she started doing her horse paintings, large, heavy impasto pieces that are often

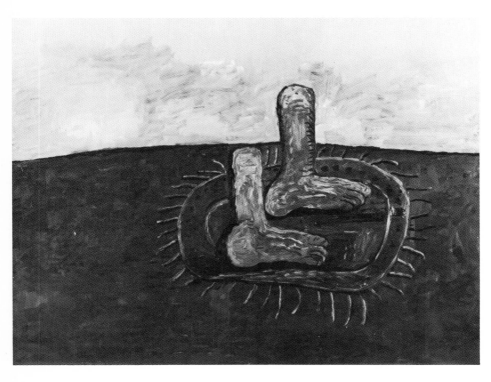

3.7. Philip Guston, *Feet on Rug,* 1978. David McKee Gallery, New York.

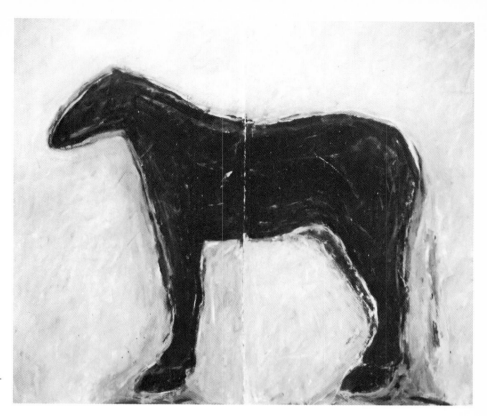

3.8. Susan Rothenberg, *Nonmobilizer*, 1974. Willard Gallery, New York.

bisected, such as *Nonmobilizer* [3.8]. In these paintings she explored both formal and emotive qualities. She was not interested in a realistic portrayal of the horse. She has spoken of her coming to these images while doodling: "I drew a line down the middle, and before I knew it there was half a horse on either side. The horse held the space and the line kept the picture flat. . . . It was great, I was able to stick to the philosophy of the day—of keeping the painting flat and anti-illusionistic, but I also got to use this big, soft, heavy, strong, powerful form to make those ideas visible."[14] Rothenberg painted horses for about six years and then turned to images of the human head and hand. Her distilled images radiated a personal, poetic power that made the viewer reconsider normal modes of perception as well as the mythic power inherent in the image.

Quite different from Rothenberg's large images covering much of the canvas were the small human figures that appeared in Nicholas Africano's work. His work focused on the role of narrative. Africano had been a writer of short, nondiscursive prose and turned to substituting small drawings for words. He wrote about his work:

> It is important for me to work from the specific to the general, to focus on a highly specific moment of an experience—and allow that to become more generalized through another person's response.
>
> I want my paintings to be about something, as opposed to being about nothing or being about themselves. Their reference is human experience so they are figurative and narrative. I don't assume a rhetorical posture as a painter.[15]

Africano's small figures, which often appear as if they were on an empty stage set, were made in partial relief out of wax or magna before being placed in the vast monochromatic spatial voids that Africano often used. In *The Cruel Discussion*, 1977 [3.9], the space may be

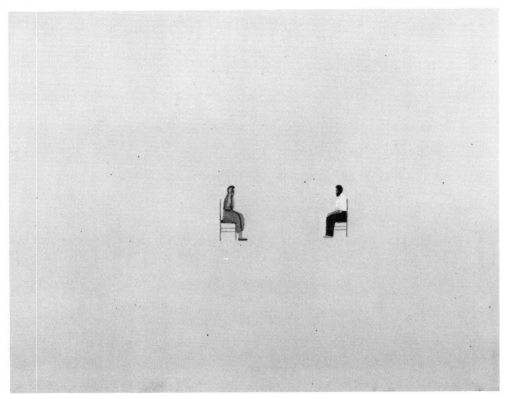

3.9. Nicholas Africano, *The Cruel Discussion*, 1977. Holly Solomon Gallery, New York.

seen as a metaphor for a psychological and spiritual emptiness in a world where it is often difficult to communicate truly with others. The placement of the two figures, slightly off center, close but not too close for any real communication, sets off a wave of discomfort within the viewer, who may confront her or his own loneliness or sense of alienation.

Neil Jenney was less interested in narrative than Africano. His concerns revolved around relationships of objects and figures.

> I was more concerned with approaching the viewer with relationships—for instance a crying girl and a broken vase, birds and jets, or trees and lumber. I'm not interested in a narrative; I'm interested in showing objects existing with and relating to other objects because I think that is what realism deals with. . . . I am interested in using imagery that is universal and transcultural—and an imagery that is profound. I wanted

the objects to be stated emphatically with no psychological implications.[16]

In *Cat and Dog*, 1970 [3.10], one sees a predator-victim relationship, where Jenney has taken the liquid brushstrokes of Action painting and turned them into "Bad" painting. He plays with visual and verbal interactions by introducing the smooth frame and block lettered title as part of the piece, thereby emphasizing the objectness of the work. He thus combines discordant and discrepant elements to make the viewer question his or her perceptions.

In another series (1971–76) Jenney further emphasized the frame and reversed its role with the image. In *Meltdown Morning*, 1975, the heavy black frame with its large green letters, in its coffinlike configuration, dwarfs the idyllic view of a paradise lost. The image is only a slit, a lost allusion and illusion, in the face of

3.10. Neil Jenney, *Cat and Dog*, 1970. Private collection, New York.

the "morning after." (The brushstrokes in a work such as this are more precise and traditionally modeled, and works like this were not included in the "New Image" or "Bad" painting exhibitions.)

Joe Zucker made paint-soaked cotton-ball paintings that often told stories. He constructed his paintings piece by piece, using acrylic, cotton, and Roplex on canvas, emphasizing the process of the work. The materials sometimes mirrored the image, as in his paintings depicting plantations and plantation life. His *Paying off Old Debts*, 1975, portrays a man pushing a wheelbarrow full of cotton, and one finds that the painting is about not only the image but the materials, and all that lies dormant in the history of the all-pervasive cotton materials.

Other painters who came to be associated with the freedom and anarchistic spirit of the New Image painting were Jennifer Bartlett, Pat Steir, Donald Sultan, and Robert Moskowitz. Bartlett, a former cheerleader at Long

Beach High School in southern California, somewhat shocked the art world with her large-scale, multi-imaged piece *Rhapsody*, at the Paula Cooper Gallery in 1976 [3.11]. Receiving her M.F.A. from Yale in 1965, Bartlett had evolved from working in an abstract expressionist style to Process and Conceptual art, and then turned to painting again, simplifying her surface to one-foot-square steel plates. *Rhapsody*, painted in Tester's enamel (the type used for model airplanes) on 988 12-inch-square steel plates fastened to the wall, consisted of four stylized archetypal images: houses, trees, mountains, and the ocean. In the 7-foot-high, 154-foot-long piece, Bartlett examined basic elements of figurations as she wove and intertwined themes and forms in a manner somewhat analogous to a rhapsody. John Russell, the *New York Times* art critic, heralded and applauded the piece as "the most ambitious single work of new art that has come my way since I started to live in New York."[17] The

3.11. Jennifer Bartlett, *Rhapsody*, 1975–76. Paula Cooper Gallery, New York.

somewhat unusual, instant success of Bartlett's work allowed her to continue experimenting freely. At one point she retaught herself techniques of oil painting, which allowed her to explore styles such as impressionism and realism, and the work of Mondrian and Pollock. In 1979 she traded her Soho loft for a villa in Nice for the winter. Although she was not content in Nice, the villa's small garden and cracked swimming pool became the inspiration for hundreds of new drawings, paintings, and other works. She painted the view at all times of day, from a great diversity of perspectives.

A continued interest in gardens led her to collaborate on an actual garden project with architect Alexander Cooper and Partners for the Manhattan Battery Park City Authority in the late eighties. The project involved designing a three-and-a-half-acre garden at the southern tip of Manhattan, and was to consist of a series of twenty-four different gardens, as well

as a variety of structures, which would be an integral part of the garden. Elements of her personal iconography—the house, the tree, and so forth—harking back to her *Rhapsody*, were to become three dimensional and quite public.

Pat Steir turned to art history and analysis, feeling that the making of art involved aspects of research, selection, thought, and intuition, as well as the physical act of making a painting. "The subject of my work *is* point of view, our way of seeing," she says. "I try to see through the eyes of many others."[18] Born Iris Patricia Sukoneck, the eldest of four children, the artist was later to write across a drawing, "I am Pat Steir." Her father had had dreams of being an artist but spent his life designing signs with neon lettering and feared that his daughter would fail as an artist as well. Steir caused a break with her family when she turned down a scholarship to Smith College and enrolled instead at the Pratt Institute in Brooklyn to study

220

graphic art and painting. In 1970 she began painting images of a bird, which was for her a life symbol, usually painting it within a grid, against different shades of blue. (A bird had flown into the studio of a friend, who later gave the bird to Steir.) In the late seventies Steir explored historical elements such as Rembrandt's colors, as well as the brushwork of de Kooning and Pollock. One example and a culmination of Steir's research was her *Brueghel series (A Vanitas of Style)*, an eighty-four-panel work that measured twenty by sixteen feet [3.12]. The piece was based on a sixteenth-century still life of a vase of flowers by Jan Brueghel the Elder. Steir divided the image into grid pieces. In each panel she attempted to capture the essence of other important artists' styles,

which were wide ranging—Matisse, Picasso, LeWitt, Van Gogh, Malevich, Watteau, Chardin, Basquiat, Botticelli. For her the uses of such styles were quotations, not appropriations, which were, according to Steir, simply copies or reproductions of old or modern masters. For her the other artists she looked toward served "as nudes, as if they were sitting for me in my studio. The 'quotation' lets me have a living relationship with art history, not a dead one."[19]

Donald Sultan also turned to art historical precedents as he broke with Minimalism. Sultan also began to explore new materials and was particularly drawn to tar and vinyl, which he had used while working as a handyman at the Denise René Gallery in New York to retile the gallery floor with vinyl. Thereafter Sultan

3.12. Pat Steir, from the *Brueghel* series. Michael Klein, Inc.

began drawing and painting with tar on vinyl surfaces. One of Sultan's most well-known motifs was a large yellow lemon, the source of which lay in a small Manet painting. Sultan carved the shape out of layered tar, filled the shape with plaster, and then overpainted in a deep, majestic yellow, transforming both the Manet image and the viewer's concepts of an ordinary lemon.

A related development of New Image art was a "trans-avant-garde," which the Italian critic Achille Bonito Oliva saw emerging and had designated as a new international movement. In one of his essays Oliva referred to this new trans-avant-garde that had superseded the historical avant-garde and

> placed the figure between turbulence and serenity, letting it move freely and unquestioned as to its provenance or direction. The trans-avant-garde has recognized a sense of pleasure in art, reinstating the work's supremacy, its power over technique. . . . In the neomannerist art of the trans-avant-garde, styles mix eclectically, melding figure and fragments of various and diverse provenances. Removed from their original context and placed in a new figurative reality, old linguistic elements become a kind of ready-made. And myth and allegory become the vehicles for the stylistic resurgence of an image that no longer has the ideological arrogance to claim totality as its field, but reverts instead to a smaller sphere, a dimension open to the expression of individual mythologies.[20]

Oliva referred to European and American artists such as Charles Garabedian, Susan Rothenberg, Julian Schnabel, Anselm Kiefer, David Salle, Francesco Clemente, and Tony Berlant as part of this emerging trans-avant-garde. (See later discussion of some of these artists, whose works matured more fully in the eighties.) Oliva pointed to the abandonment of a "linguistic internationalism, . . . in favor of genius loci, the inspiration that comes from that aspect of an artist's personality that privileges diversity. . . . The term 'genius loci' reestab-lishes the possibility of a composition fragmented by diverse artistic forms."[21] Further, Oliva pointed to differences between American and European art of this trans-avant-garde aesthetic:

> European art leans toward the rediscovery of narcissistic or mythical subjectivity, while American work tends toward the retrieval from the past of an emotional, less stylized kind of art that follows the demands of a vital cultural nomadism marked by stylistic eclecticism. The proverbial Anglo-Saxon pragmatism allows the American trans-avant-garde to adopt the linguistic innovations of an earlier avant-garde, flexibly melding them like patchwork. The proverbial need of European art to adhere to formal qualities determines a compositional level less inclined to contain references to popular; the popular has a style of its own.[22]

A premiere of this trans-avant-garde emphasizing Italian artists occurred in the summer of 1979 in the Sicilian seaside town of Acireale, when Bonito Oliva presented Mimmo Paladino, Nicola De Maria, Francesco Clemente, Enzo Cucchi, and Sandro Chia at the Palazzo di Città.

During the seventies there was also a resurgence of mural painting as public art became further emphasized. A number of artists rejected the museums, galleries, and dealers' "systems" oriented toward consumerism. Some artists were compelled to communicate to a different public, on a larger scale, in the community at large. In New York, City Walls, Inc., sponsored designs to transform the exteriors of ghetto buildings or abandoned sites. In 1974 the former printmaker Richard Haas moved outside to paint a trompe l'oeil version of a cast-iron building on the blank side wall of a cast-iron building at 112 Prince Street in SoHo. Thereafter he transformed a number of city walls into classical views and forms.

In Los Angeles groups such as the Los Angeles Fine Arts Squad painted Superrealist images on buildings. Their 1971 *Isle of California*

depicts the collapse of freeways into the ocean. In San Francisco the all-women's group Mujeres Muralistas created *Latinoamérica* in 1974 in San Francisco's Mission District. The mural, which celebrated the solidarity of a variety of Latin American groups, recalled the tradition of the earlier Mexican muralists.

And in Mexico itself a new generation of muralists had arisen. José Hernández Delgadillo became particularly noted. His 1973 mural at the College of Science and Humanities in the Atzcapotzalco district in Mexico City, painted in a flat, stylized format, referred to the brutality at Tlaltelolco, where more than three hundred students were shot by the police and army shortly before the 1968 Olympic games.

In West Berlin Eduardo Paolozzi was commissioned to paint a large mural of machine components on a blank wall on Kurfurstenstrasse.

There was also support for murals by community members (who were not professional artists) in city neighborhoods in places such as Chicago and Los Angeles. These often contained political or educational themes.

Moving beyond the wall and flat surface as the foundation for painting, a number of artists during the seventies challenged the boundaries between painting and sculpture. Frank Stella's work in the seventies was a radical departure from his Minimalist striped paintings or his Protractor paintings. Although the works became three dimensional, he continually referred to them as paintings. His work of the decade, following his 1970 retrospective at the Museum of Modern Art in New York, consisted of several series, which became progressively more playful and dynamic. His *Polish Village* series, 1971–73, reliefs made in the tradition of Constructivism, were named after wooden synagogues destroyed in Poland during the thirties and forties. They primarily consisted of paint and collage on wood and TriWall cardboard. The Brazilian series, 1974–75, was done on honeycombed aluminum. Stella found he could

employ techniques from printmaking on the metal surface. It was with this series that Stella made his most radical break from the traditional materials of a painter. His *Exotic Bird* and *Indian Bird* series of the late seventies (Plate 5), which juxtaposed curvilinear forms derived from the French curve and rectangular elements, had a Baroque quality and heroic power, with glittering, multileveled forms [3.13]. With these, some of which extended more than three feet from the wall, Stella moved far from the flatness of his earliest paintings. Stella recalled "a sort of mid-life crisis," concerning the radical change in his work:

> Nothing much had changed in the externals of my life. But while I was painting the Protractor pictures, I felt I was coming to the end of something in my work. I really did want a change, and wanted to do things that went beyond the methods and system that underlay my painting until then. I just had to start all over again. That the new work could be contradictory and good is what makes the life of an artist exciting. Anyway, by the early seventies I had more or less "had it" with the art world, and with my relation to other artists. I had paid my dues and earned the right to do whatever I wanted, to just let it happen. I felt loose—sort of beyond the point of criticism. As long as I myself felt confident about the new work, why not just do as I pleased? And the new things really were different. There's a power in the stripe paintings that the newer ones will never have; on the other hand, there is an energy—and a kind of florid excitement—in the newer work that the stripe paintings didn't have. I don't think you can do it all at once. That's why you're lucky to have a lifetime.[23]

As he worked on these painting series, Stella worked on corresponding prints, and ultimately confined his two-dimensional explorations to his prints.

The growing trend toward three-dimensional painting resulted in two large-scale exhibitions at the end of the decade: "Three Dimensional Painting" at the Museum of Contemporary Art in Chicago, and "Planar

3.13. Frank Stella, *Shāma*, 1979. M. Knoedler & Co., Inc., New York.

Painting: Constructs 1975–1980" at the Alternative Museum in New York. One artist included in the Planar painting show was Sam Gilliam, whose paint-soaked, suspended canvases, such as *Autumn Surf*, 1973 [3.14], emphasized an immediacy and physicality that was difficult to achieve on the wall. Gilliam described his work, which often took on landscape characteristics:

> There is an attempt in my own work of continuing the dialogue with what was happening with Pollock and Louis working on the floor, but I am taking that dialogue to the wall. I establish as much facticity as possible, but keep certain elements of illusion. The illusion has been most important in taking these shapes on the wall, in isolating shape against shape. It is a painter's illusion, but I am also carrying on a dialogue with sculpture.[24]

Although there has been some pressure on Gilliam, as a black, to make paintings more directly related to black culture, he has remained an abstract painter.

Another approach to three-dimensional painting may be seen in the work of Alan Shields. Born in Kansas, Shields was primarily a self-taught artist. Using sewing, dyeing, and flocking techniques, Shields's work had a primitive, folk quality, as if he were excavating an interior primitive landscape. His irregular geometric forms, such as his two-sided suspended grids and his multicolored pyramids, were a radical rejection of the cool and formalist doctrines of Minimalism.

Although there were important innovations in paintings during the seventies, some thought painting was dying a slow death during the decade, as explorations in other areas were em-

3.14. Sam Gilliam, *Autumn Surf*, 1973. San Francisco Museum of Modern Art.

phasized. The following excerpts from an essay in a 1978 *Artforum* echo this concern.

> The options open to painting in the recent past appeared to be extremely limited. It was not that everything had been done, but rather that the impulses to create which had functioned in the past were no longer urgent or even meaningful. Tracing magic images, storytelling, reporting, representing in a one-to-one relationship, a scene or figure in paint—none of these acts was credible in the way it once had been. Abstraction appeared to be used up. . . . We no longer believed in the transcendency of paint and saw little reason to use the medium of painting for making art.

> . . . The enterprise of painting *was* in question, *was* "under erasure" [Derrida's term]. . . .

> It was necessary to turn inward, to the means of art, the materials and techniques with which art is made. Artists still interested in painting began an analysis—or deconstruction—of painting, turning to the basic question of *what painting is*, not so much for the purpose of defining it as to actually be able to verify it by beginning all over again.[25]

These new beginnings were to become more evident during the eighties, when synthesis and appropriation were to become dominant.

NOTES: PAINTING, 1970S

1. Corinne Robins, *The Pluralist Era: American Art, 1968–81* (New York: Harper & Row, 1984), p. 183.
2. Ibid., p. 131.
3. Carrie Rickey, "Pattern Painting," *Arts Magazine*, January 1978, p. 17.
4. John Perreault, "Issues in Pattern Painting," *Artforum*, November 1977, p. 33.
5. Miriam Schapiro, written statement, September 18, 1976, cited in Katherine Hoffman, "Toward a New Humanism." *Womenart*, Winter 1977, p. 24.
6. Miriam Schapiro, "Femmage," Katherine Hoffman, ed., *Collage: Critical Views* (Ann Arbor, Mich.: UMI Research Press, 1989), p. 296.
7. Miriam Schapiro, "How Did I Happen to Make the Painting 'Anatomy of a Kimino'?" statement prepared for the exhibition of the painting at Reed College, Portland, Oregon, 1978, copyright Miriam Schapiro 1978. Reprinted in Thalia Gouma-Peterson, *Miriam Schapiro: A Retrospective, 1953–1980* (Wooster, Ohio: College of Wooster, 1980).
8. Quoted in Ruth K. Meyer, *Arabesque*, exhibition catalog (Cincinnati: Contemporary Arts Center, 1978), p. 8.
9. Quoted in H. H. Arnason, *History of Modern Art: Painting, Sculpture, Architecture* (New York and Englewood Cliffs, N.J.: Harry N. Abrams and Prentice-Hall, 1968), p. 620.
10. Quoted in Robin White, "Robert Kushner—Interview," *View*, February–March 1980.
11. Cynthia Carlson, statement prepared for exhibition "Homage to the Academy Building" at the Morris Gallery, Pennsylvania Academy of Fine Arts, Philadelphia, 1979, cited in Ellen Johnson, *American Artists on Art, 1940–1980*, p. 250.
12. Personal interview with author, New York City, July 1977.
13. Richard Marshall, *New Image Painting*, exhibition catalog (New York: Whitney Museum of American Art, 1978).
14. Quoted in Lisbet Nilson, "Susan Rothenberg—'Every Brushstroke Is a Surprise?'" *Artnews*, February 1984, p. 51.
15. In Richard Marshall, *New Image Painting*.
16. Cited in ibid.
17. John Russell, "Gallery Review," *New York Times*, May 16, 1976, Arts and Leisure section, p. 1.
18. Cited in Paul Gardner, "Pat Steir, Seeing Through the Eyes of Others," *Artnews*, November 1985, p. 84.
19. Ibid., p. 88.
20. Achille Bonito Oliva, "Figure, Myth, and Allegory," in Howard Singerman, ed., *Individuals: A Selected History of Contemporary Art* (New York: Abbeville Press, 1986), pp. 242–43.
21. Ibid., p. 247.
22. Ibid.
23. Quoted in William Rubin, *Frank Stella, 1970–1981* (New York: Museum of Modern Art, 1988), p. 14.
24. Quoted in Corinne Robins, *Planar Painting: Constructs 1975–1980*, exhibition catalog (New York: Alternative Museum, 1980), n.p.
25. Marcia Hafif, "Beginning Again," *Artforum*, September 1978, reprinted in Richard Hertz, ed., *Theories of Contemporary Art* (Englewood Cliffs, N.J.: Prentice-Hall, 1985), p. 11.

PRINTMAKING, 1970S

DURING the seventies there continued to be a widening appreciation for prints and printmaking. The great variety of artistic ideas and works inherent in the pluralist spirit of the decade was able to be more widely viewed through the medium of printmaking. Joyce Kozloff continued her pattern art in printmaking. Louise Nevelson made a series of intaglio prints, issued by Pace Graphics, that used net and lace intertwined with geometric elements. Christo sold drawings and prints of his wrapped projects to finance them. In 1971 he produced a print portfolio of unrealized projects, including a wrapped, and thus ineffective, Museum of Modern Art and Whitney Museum of American Art. Vito Acconci translated his autoerotic performances to the print medium in his prints of pistols and penises. Hans Haacke used the print medium as a continuation of his conceptual projects exploring the misuse of personal and corporate power. Robert Rauschenberg celebrated space exploration and probed social events and issues in his prints.

One artist who reached a high point in her print work during the seventies was Helen Frankenthaler, who brought to the medium of woodcutting a magnificent and magical lyricism that usually, due to the stiff nature of woodcutting, was difficult to achieve. Pieces such as *Savage Breeze* of 1974 and *Essence Mul-*

berry of 1977 stand as examples. *Savage Breeze* [3.15] with its sensuous colored shapes and delicate white bisecting lines that flow over the subtle, speckled grains of mahogany plywood on handmade Nepalese paper, is a profound and lyrical statement of intimacy and introspection. In *Essence Mulberry* there is a sense of a gentle Oriental space with calligraphic strokes reminiscent of some of the gestures of her earlier paintings. For the print Frankenthaler used various grains of wood—louan, birch, oak, and walnut—and a variety of opaque and transparent inks—reds, blues, pinks, oranges. The large unprinted area on the antique yellow, handmade Gampi paper is another Oriental aspect of the work—a silent, but richly pregnant void.

Inspiration for *Essence Mulberry* came following Frankenthaler's viewing of an exhibition of fifteenth-century woodcuts at the Metropolitan Museum of Art in New York. She hoped to achieve some of those delicate shadings and forms in her own woodcuts. At Ken Tyler's Bedford Village workshop in New York State, she had at the same time been captivated by the deep crimson of some mulberries in Tyler's backyard and had playfully made a few drawings from the deep red juice of the berries. As she recalled, "It was all very sweet. We had this mulberry juice; I laughed; we fooled

3.15. Helen Frankenthaler, *Savage Breeze*, 1974. Universal Limited Art Editions, West Islip, N.Y.

around a bit. I used it and I didn't use it. The whole print, the notion, the title, the method, and the feel of it was from the heart and the core. I mean it was the juice of the metaphor and the meaning and aesthetic of the print."[1]

One other artist whose work flourished within the medium of printmaking was Jim Dine, who had stopped painting entirely from 1966 to 1969. Printmaking became the path for his return to the making of art. Dine made a number of series of prints during the seventies and early eighties, including his lithographic heart series [3.16], his bathrobes, and a series of etchings that narrate the life of Arthur Rimbaud entitled *Rimbaud, Alchemy,* 1973. The six-print series shows Rimbaud in a number of transformations, both dead and alive. In the series Dine actually incorporated the idea of change and transformation into the printmaking process as he reworked the original plate for the successive images.

Dine's image of his bathrobe became increasingly more mysterious during the seven-ties, particularly in his prints. The robe, for Dine, had been an autobiographical symbol, and as he noted in an interview with John Green in *Artnews,* "The robes have become much more mysterious than they used to be, and that's because I understand them more."[2] Dine's *Fourteen Color Woodcut Bathrobe* (Plate 6) is a lush but mysterious frontal statement, as the strong colors and the somber deeply etched black lines of the robe and the background interact. Dine was not alone in evoking a sense of mystery in his work by the late seventies. Indeed, as one writer noted, "It is perhaps the return of mystery as a motivating element that altered the face of art in the late 1970s."[3]

This interest in the mysterious and the subjective had also led to a renewed interest in the monotype, or unique single print, rather than a unified edition. The tradition of the monotype was not new: it had been made famous by Degas in the nineteenth century. Painters in particular became interested in enlarged forms

of the monotype. Adolph Gottlieb, who had suffered from a stroke, produced a large number of monotypes using an etching press in his studio in 1973–74. Michael Mazur, who had worked as a figurative artist during the sixties, produced a number of powerful, painterly new monoprints.

In 1980 the Metropolitan Museum in New York marked the significance of this printmaking form by mounting an exhibition, "The Painterly Print," which was a historical overview of the monotype.

The exploration of more subjective and intuitive themes by a number of artists led also to

a revival of the ancient craft of papermaking and interests in working with wet, unformed paper pulp. Pursuit of the papermaking process allowed artists to indulge in both a deeply tactile hands-on process and a more intellectual technical and design process.

Garner Tullis was one of the first to make artworks from handmade paper. Opening his California workshop in 1973, he made it possible for artists such as Louise Nevelson, Sam Francis, and Kenneth Noland to combine printing and embossing with papermaking.

In 1973 Ken Tyler began working with Robert Rauschenberg at the French mill Moulin à

3.16. Jim Dine, *Six Hearts*, 1970. Petersburg Press, London.

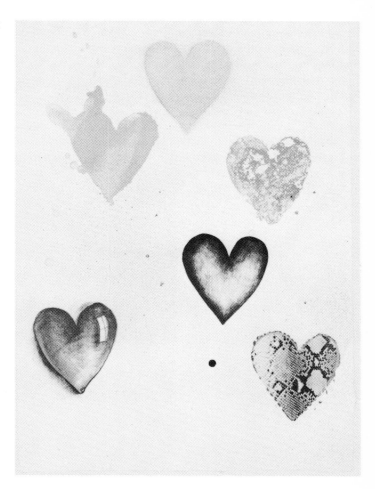

Papier Richard de Bas in Ambert, which Gemini had rented for a week, creating Rauschenberg's *Pages* and *Fuses,* which sparked increased interest in the use of paper pulp. One of the *Six Fuses, Link,* 1974, is exemplary of the vivid shapes, colors, and textures that Rauschenberg achieved.

Tyler had initially been attracted to handmade papers while serving as a guest artist at Cranbrook Academy in Michigan in 1969 and observing a paper mill that Lawrence Barker had set up. In 1970, while in Japan at the Osaka World's Fair, Tyler had been particularly impressed by the beauty of some brilliantly dyed papers hanging out to dry in Kyoto. Tyler's work on *Papers* and *Fuses* was one of his last projects at Gemini, but a first of future collaborations on paper projects. In 1978 he finally set up his own paper mill with Tyler Graphics Ltd. Prior to that he worked with John and Kathleen Koller at their HMP mill in Connecticut with such artists as Ronald Davis, Frank Stella, and Ellsworth Kelly.

At HMP Frank Stella worked on a series of richly textured and colored paper reliefs. His *Olyka (III),* part of a group stemming from Stella's *Polish Village* series, consisted of individual collage layers of handmade paper. When color was applied, underlayers of the edges of previous layers showed through, creating a complex spatial depth.

Once establishing his own mill, Tyler worked with artists such as Kenneth Noland, David Hockney, Anthony Caro, Robert Zakanitch, and British painter Hugh O'Donnell, helping each artist to use paper in new ways to fit their aesthetic needs. David Hockney, for example, continued his exploration of the swimming pool images through a series of paper pools. One of the most spectacular was *A Large Diver, Paper Pool 27,* 1978, which was composed on twelve sheets of paper, measuring in total 72 by 171 inches. The figure has just dived into the pool, leaving the splash and tones of blue and green behind him. "According to Hockney, 'it took a thousand gallons of water to make one of these, which seems to me an awful lot; in a watercolor you use a cupful.' "[4]

Through the use of handmade papers and molded paper pulp, artists were able to further expand their imagery in a medium that could be more easily and widely distributed than painting, drawing, or sculpture.

NOTES: PRINTMAKING, 1970S

1. Quoted in Howard Smagula, *Currents: Contemporary Directions in Visual Arts* (Englewood Cliffs, N.J.: Prentice-Hall, 1983), p. 132.
2. Cited in ibid., p. 109.
3. Riva Castleman, *American Impressions: Prints Since Pollock* (New York: Alfred A. Knopf, 1985), p. 155.
4. Cited in Ruth E. Fine, "Paperworks at Tyler Graphics," in *Tyler Graphics: The Extended Image* (Minneapolis: Walker Art Center, 1987), p. 220.

PHOTOGRAPHY, 1970S

DURING the seventies photography came of age as an art form. There was increased activity on a variety of levels in photography and growing institutional and critical support of photography as a major modern art form. During the decade a number of institutions came into being, particularly in higher education, that had a profound impact on the growth and acceptance of photography by increased numbers in the mainstream. During the seventies more colleges and universities began to offer programs in photography at both the graduate and undergraduate levels. Princeton endowed a chair in the history of photography and Yale endowed a chair in the practice of photography. One of the most prominent photographic programs in the United States came to exist at the University of New Mexico.

The National Endowment for the Arts, with Renato Danese as program director for photography, despite the conservatism of the Nixon administration, funded a number of photography programs, particularly in museums. Smaller, regional museums were thus able to show photographs, which were relatively inexpensive to exhibit, ship, and also acquire. The two major American museums responsible for continuing support of photography were the Museum of Modern Art in New York and George Eastman House in Rochester. Two men

from these institutions—John Szarkowski at the Modern and Van Deren Coke at the Eastman House—were key figures in the flowering of photography. Both were themselves photographers. Van Deren Coke was at Eastman House from 1970 to 1973, then at the University Art Museum, University of New Mexico, Albuquerque, 1973–79, and then moved to the San Francisco Museum of Art in 1979.

The National Endowment also helped fund a number of photographers' books, as photographers became increasingly interested in serial and sequential images, finding the single image too limiting. Some of the most interesting such publications during the seventies done by small presses such as Lustrum included Robert Adams's *The New West, Denver,* Larry Clark's *Tulsa,* Robert Cummings's *Picture Fictions,* and Lee Friedlander's *Self-Portrait.* In 1976 Eve Sonneman published her book *Real Time: 1968–1974,* which consisted of forty-six sets of double images adjacent to each other. Through the double image Sonneman constructed subtle shifts in time, space, and gesture that one would not ordinarily discern. Sonneman explained her aims:

> I did not present a set theory. I did a series of images in which I combined simultaneous images of people in motion in both black and white and

color. . . . The audience was given a multiplicity of choices in the final works to observe meaning in gestures, motion, perpetual changes from black and white to color, in invented time sequences between the frames. The audience could build its own syntax of esthetic pleasure or intellectual work. It was open.[1]

A number of galleries also opened devoted primarily to photography, thereby stimulating the commercial market for photographs. Lee Witkin had opened the first commercially viable New York art gallery devoted exclusively to photography in 1969, and in 1971 the Light Gallery opened in New York. Other such galleries opened soon thereafter in areas outside New York, including Washington, D.C., Los Angeles, Chicago, Boston, Houston, San Francisco, and Seattle. Other important commercial galleries began to incorporate photography into their exhibition programs—Leo Castelli in 1971; Ileana Sonnabend, 1972; Pace Editions, 1973; John Weber, 1974; Marlborough Gallery, 1975; and Robert Miller Gallery, 1977. Other galleries quickly followed suit.

Art journals also devoted more space to photography. The September 1976 issue of *Artforum* dealt exclusively with photography. Photography came to be used as a single medium and as a tool in combining a variety of media, particularly as painting was perceived by many as a dead end. The rise of photography was also seen as a reaction to both Abstract Expressionism and Minimalism. Some "artists of the day were commingling photography, language, performance, painting, video, and other mediums, and collapsing the distance between art and life, high and low culture, the fine and popular arts. There were, in other words, not one but two currents propelling photography to prominence, and to a large extent they were at cross purposes."[2] But these approaches produced a plurality of styles and contents that was able to coexist in the larger pluralistic art world.

Continuing the "straight" use of the me-
dium were photographers connected with the depiction of the "social landscape" and the New Topographics was the seventies work of photographers such as Mark Cohen, Bill Dane, William Eggleston, Ralph Gibson, Joel Meyerowitz, and Tod Papageorge. Topographic photographers such as Robert Adams, Lewis Baltz, and Joe Deal continued their cool and detached visions of the world around them. As Joe Deal stated in the catalog for the 1975 "New Topographics Show," "The most extraordinary images might be the most prosaic, with a minimum of interference (i.e. personal preference, moral judgment) by the photographer."[3]

Robert Mapplethorpe approached not the social landscape but a world of fashion, money, power, drugs, and sexuality and reached toward an inner landscape of flesh and spirit. Carrying the spirit of the New Image painter into photography, Mapplethorpe became noted for his majestic, classical human forms—clear, precise, sensuous—that made him one of the most collected photographers of his generation. Many of his images were homoerotic but he photographed the female nude and still lifes with equal splendor. His self-portraits show him trying on various guises, or portraying aspects of himself. He appears tough, with a leather jacket and cigarette hanging from his mouth; or like an innocent young cupid with powder, lipstick, and mascara; or an upper-class socialite with formal black tie.

Born into a middle-class Catholic family in Queens, New York, Mapplethorpe did not intend to be a photographer. He studied painting and sculpture at the Pratt Institute in Brooklyn from 1963 to 1970. He lived for a period of seven years with the punk poet and rocker Patti Smith, then in the early seventies became a close friend and protégé of John McKendry, curator of prints and photographs at the Metropolitan Museum of Art. McKendry bought him his first camera. Basically, Mapplethorpe was a self-taught photographer. In the seventies he was a staff photographer for Andy Warhol's *In-*

terview magazine, for which he photographed celebrities such as Philip Johnson, Louise Nevelson, Richard Gere, Norman Mailer, Lisa Lyon, Arnold Schwarzenegger, and Warhol himself.

He also inspired Sam Wagstaff, well-known art collector and curator, who became Mapplethorpe's companion in the seventies, to begin collecting photography. (Wagstaff eventually sold his collection of several thousand images to the J. Paul Getty Museum in 1984.)

In a photograph such as *Ajitto, Right,* 1980 [3.17], one quickly sees Mapplethorpe's remarkable abilities to use light, shadow, texture, and form, to produce an image that is both of the flesh and the spirit. Declared one writer of Mapplethorpe's work, as he looked back from the vantage point of the late eighties:

He is the visual poet of our shadow side. In bringing these images up from the darkness and transmuting them into the realms of art, he is performing the ancient role of the artist—but he compels us to face fears and anxieties rarely experienced in the Temple of Art.

Still if he has been the prince of darkness, he has also been the angel of light. . . . The recent work seems ethereal, perhaps even spiritual in its expression of the platonic world of pure form and beauty. The light emanates from within rather than enveloping objects from without.[4]

3.17. Robert Mapplethorpe, *Ajitto, Right,* 1980. Robert Miller Gallery, New York.

Mapplethorpe's tragic death from AIDS in 1989 left a gap in the world of photography and the art world at large, and one wonders what he might have produced had he lived past the age of forty-two.

Shortly after his death, Mapplethorpe's work sparked considerable controversy when the Corcoran Gallery in Washington canceled a scheduled exhibit of his work that contained images of homo- and heterosexual erotic acts and poses. The show was to be financed in part by the National Endowment for the Arts, and the gallery feared congressional disfavor in future allotments of funds. The act of cancellation raised serious questions about artistic freedom and censorship in relation to public funding of the arts.

Moving beyond the deep sensibilities of Mapplethorpe, one finds in the seventies increasing use of photographs by artists not usually considered photographers. Photographs were used as documentation of body art pieces, earth works, and performance pieces. But further, they came to be an integral part of some works. In particular, a number of Conceptual artists during the seventies found that their pieces could only be executed using photographs. For these artists the photograph functioned as a sign of an organizing idea, not as a unique art object to be valued for its formal or expressive qualities. Photography served the function of langauge, as a communicator of cultural information, and was not to be specially valued. A number of Conceptual artists, such as Joseph Kosuth, Robert Barry, Eleanor Antin, Jan Dibbets, and Lawrence Weiner, were involved with concepts of repetition, process, the nature of perception, incompleteness, and how one looks at art. Photography appeared to be the most effective medium to explore such problems. One curator described a characteristic sameness to some of the conceptual work of the time:

There is a prevailing "look" to much of the work; both photography (which was just being ac-

cepted into the realm of fine art during this period) and language play a predominant role; there is a relative lack of color; most presentations are physically unpretentious and require close scrutiny in order to be read. These characteristics are quite unlike those which might be used to describe the immediately preceding movements of abstract expressionism, pop art, and even minimalism.[5]

A primary figure among those Conceptual artists using photography was John Baldessari. In 1970 Baldessari took thirteen years' worth of paintings to a mortuary and had them cremated. The ashes, in a book-shaped urn, were buried behind a bronze plaque that read, "John Anthony Baldessari, May 1953–March 1966." He thus established himself as a Conceptual artist. Baldessari explored perception during the seventies in pieces such as *A Different Kind of Order (The Thelonius Monk Story)*, 1973; *Throwing 4 Balls in the Air to Get a Straight Line (Best of 36 Tries)*, 1973; and *Concerning Diachronic/Synchronic Time: Above/On/Under (with Mermaid)*, 1976 [3.18]. The latter is composed of six movie stills. At the top are an airplane and bird; in the middle are two shots of a motorboat; and on the bottom are a one-man submarine and mermaid. Baldessari, explaining the work, said:

I wanted the work to be so layered and rich that you would have trouble synthesizing it. I wanted all the intellectual things going, and at the same time I am asking you to believe the airplane has turned into a seagull and the sub into a mermaid during the time the motorboat is crossing. I am constantly playing the game of changing this or that, visually or verbally. As soon as I see a word, I spell it backward in my mind. I break it up and put the parts back together to make a new word.[6]

He continued his use of composite photographs and media images into the eighties.

Besides his art work, Baldessari is noted for being an inspiring teacher, particularly for his

3.18. John Baldessari, *Concerning Diachronic/Synchronic Time: Above/On/Under (with Mermaid)*, 1976.

work at Cal Arts, as he introduced students to what the critic Harold Rosenberg called the "de-definition" of art in a course called Post-Studio Art. His fellow Conceptualist and friend Lawrence Weiner has called Baldessari

one of the few humanistic and intellectual artists in the United States. John is most pure because he understands that art is based on the relationship between human beings and that we, as Americans, understand our relationship to the world through various media. We think of any unknown situation in terms of something we've seen at the movies. That is the basis of our normal mass consciousness and how we see the world. John is dealing with the archetypal consciousness of what media represent, using the material that affects daily life.[7]

Like a number of Americans, Europeans were also concerned with conceptual problems and turned to photography to help execute their ideas. Bernhard and Hilla Becher, a German couple trained in painting, explored sets containing congruences and differences as they explored water towers, blast furnaces, and half-timbered houses, which they photographed in both the United States and Europe for more than twenty-five years. (They actually began documentation of these structures in the late fifties.) The couple worked primarily in a grid format, usually from three to eight photographs, and often on a large scale of up to six feet. In a piece such as *Winding Towers*, 1976–82 [3.19], the towers become large anonymous sculptures, with the camera providing details that the human eye on its initial view could not.

Hans Haacke used photographs in his confrontation with political and economic systems. His *Manhattan Gallery Goers' Residence Profile*, 1969–70, and his *Manhattan Real Estate Holdings: A Real Time Social System*, 1971, caused his exhibition at the Guggenheim Museum to be canceled. (See later discussion of Haacke's conceptual work in the seventies under Multi- and Intermedia.)

Related to conceptual art was an interest in story or narrative art that combined storytell-

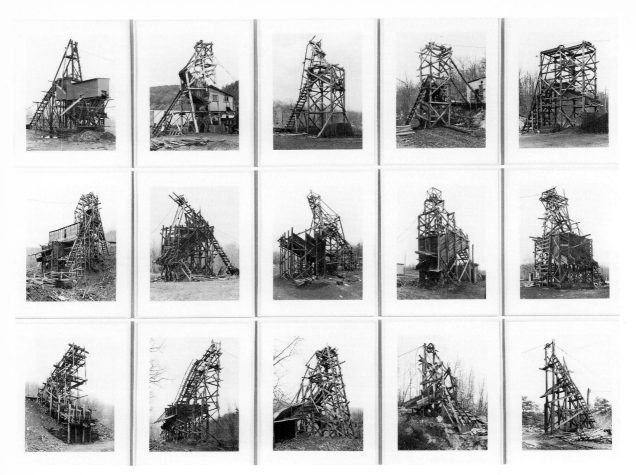

3.19. Bernhard and Hilla Becher, *Winding Towers*, 1976–82. Courtesy Sonnabend Gallery, New York.

ing with the inquiry of conceptual art. Photography, again, was a major tool for artists such as Mac Adams, Bill Beckeley, Peter Hutchinson, Jean LeGac, and Roger Welch. Many of the pieces were personal narratives with the artist as protagonist. Roger Welch's *Family Photo Pieces,* 1972, for example, probed into his family's past, while *The Roger Woodward Niagara Falls Project,* 1975, presented the memories of a boy who survived being swept over the falls.

A number of artists also became interested in constructing environments to be photographed rather than relying on finding suitable situations. One of the first to use constructed subject matter was Robert Cumming, who had studied painting and worked in sculpture before turning to photography. Cumming cre-

ated set-like realities that were akin to elementary science experiments, such as that "of eight balls dropped from the peak of the roof, two fell to the north, six fell to the south" (1974).

Barbara Kasten, who had initially worked in fiber, made photographs beginning in the late seventies based on details from room-sized constructions or installations of paper, wire, and various industrial materials. Her lushly colored polaroids and cibachromes had their origins in a Constructivist tradition but spoke out in a contemporary voice combining formal concerns with everyday subject matter. In the eighties she turned to the use of discolike hues of turquoise, orange, and pink. She sometimes exhibited the sculptural construction along with the photographs to show comparisons be-

tween illusion and "reality."

JoAnn Callis set up arrangements to be photographed to suggest fragments of memory, using images produced by the media. In setting up these tableaux, she became a director as well as artist.

Sandy Skoglund pushed the directional mode further in creating full-scale fantasy environments. Her exhibits too often included the actual installation with large-scale cibachrome prints of the scene. Her *Radioactive Cats*, 1980, showed a tenement filled with green cats, while her *Revenge of the Goldfish*, 1981 [3.20], included ceramic orange-red goldfish swimming

through a bedroom. The photographs in their shiny two-dimensional artificiality are perhaps more haunting than the installations themselves, as the viewer is asked to question what is reality and what is not.

Joel-Peter Witkin's disturbing tableaux and ensuing photographs explored questions about sex, violence, and death. Using actual models, often with physical abnormalities, or employing carnival freaks, Witkin created eerie Surrealist scenes of subjects and themes that one would not dare to stare at for long in actuality. For instance, his *Testicle Stretch with the Possibility of a Crushed Face*, 1982, is like a medie-

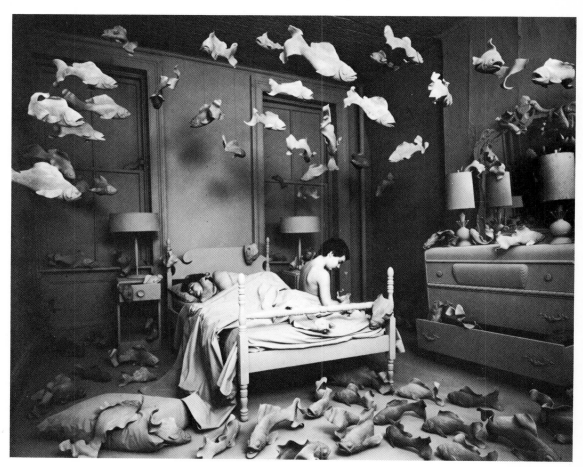

3.20. Sandy Skoglund, *Revenge of the Goldfish*, 1981. Installation, Castelli Graphics, New York.

val torture chamber as a nude, bound figure awaits punishment. Working with his models, Witkin usually exposed no more than one roll of film in the studio and then employed a variety of printing techniques, often scratching the negative extensively. Witkin often explored polarities and paradoxes in his work, as evidenced in a piece such as *The Wife of Cain, New Mexico*, 1981 [3.21], where elements of beauty and ugliness, life and death, human and inhuman, born and unborn are juxtaposed. As Witkin has noted, "I want to live in an age which sees similar beauty in a flower and in the severed limb of a human being."[8] One critic likened Witkin to Edgar Allan Poe, who "used perversity as the motif and motor of his stories," and described his techniques as those of an "alchemist"—"To watch things that both attract and repel one is an ambivalent affair, in which the interaction between emotions and reason is not only unstable, and therefore re-

mains undecided, but besides it also brings about a paralyzing indecision. . . . With the pictures he presents to us he undermines the opinions held in Western civilization about human dignity, individuality and death."[9]

In a quite different vein, William Wegman used the studio format to create humorous and Dadalike images. He became particularly noted for his images of his dog, Man Ray, named after the Surrealist photographer. For approximately ten years Wegman photographed his Weimaraner, who became a celebrity, in front of both a polaroid and large-format camera. The dog was costumed and portrayed in a variety of farcical and humorous situations, and often took on human qualities. Wegman was invited by Polaroid to use its large-format camera in 1978 and found that such a format enhanced the "star image" of the dog. As the dog became older, Wegman dressed him more frequently in zany clothes, hiding his aging

3.21. Joel-Peter Witkin, *The Wife of Cain*, 1981. Courtesy Pace/MacGill Gallery, New York, and Fraenkel Gallery, San Francisco.

body, just as humans tend to do. The dog appeared in outfits such as Brooke Shields jeans, or as an elephant, or as a Man Ray "Ray Bat." Wegman's beloved Weimaraner died in 1982. In the same year Wegman published a collection of his Man Ray photographs, *Man's Best Friend,* dedicating the book to the two Man Rays: "To Man Ray: 1890–1976 and 1970–1982."

Rather than using tableaux environments or constructions, Cindy Sherman turned to the self—herself—to direct and fashion for the purpose of photography. From 1977 to 1980 Sherman photographed herself in a series of *Untitled Film Stills* [3.22], as she played different Hollywood types by dressing up in a variety of guises. Sherman, like a number of other photographers in the seventies, was interested not in the traditional concerns of photography—such as f-stops, print tones, whether the photograph was art or documentary, social injustices, or abstract formal qualities—but in conditions of representation and the nature of theatricality. There is a dramatic ambivalence in much of her work. Are her "masks" serious or a parody? Many of the figures she re-presents in her movie stills are stereotypic images of women established by males and the media—the housewife, the runaway, the provincial small-town girl arriving in the big city. But Sherman does not necessarily pass judgment on the figures she portrays, nor are they part of her own character, but they are drawn from within and the media. She has commented:

> Part of it could be that I want to see what I look like as a certain character—even though I know that person isn't me. There is also me making fun—making fun of these role models of women from my childhood. And part of it maybe is to show that these women who are playing these characters . . . maybe these actresses know what they're doing, know they are playing stereotypes . . . but what can they do?
>
> Sometimes, though, I would think up a character with one sort of feeling in mind, then have

3.22. Cindy Sherman, *Untitled Film Still,* 1979. Metro Pictures, New York.

a completely different feeling when I was actually taking the picture. I don't think a lot of people understand that when you make something, it's not always a completely thought-out thing.[10]

In 1981 Sherman moved to large-scale color close-ups of herself portraying more emotional states. In 1985 she turned to more violent, shocking images, where in six-foot prints she portrays monsterlike images, such as a wart-chinned witch, a cannibalistic, long-tongued giant, or an Eastern sorceress with fake bare breasts. Yet in all her work she has raised questions, in varying degrees, about the way cultures and the media may project negative images of women or the roles they are asked to play.

Using the self in another fashion was Lucas

Samaras in his "photo-transformations." In two polaroid series, from 1970–71 and 1973–74, Samaras photographed himself naked, dancing, posing, crouching, often creating erotic poses. In the 1973–74 series, done after the Polaroid SX-70 instant camera was introduced, he altered the polaroid development process as he scratched, drew, and painted on the wet photo-emulsion. In some of these, the body becomes secondary to the burst of manipulated color as Samaras transforms himself to realms of dreams and animals. In 1978 Samaras explored arrangements of objects in his apartment-studio in a series of polaroid still lifes. And in the same year he invited friends to pose nude next to him, dressed, for his eight-by-ten-inch camera. "I was giving them an art context," Samaras noted, "I promised to exhibit the photos—and they were showing me their bodies. It was a mysterious human event."[11] For Samaras narcissism was "not an isolated, neurotic thing, but positive, outer-directed. . . . It's a process of sharing intelligent delight with others."[12]

Other photographers who created complete fantasy settings included M. Richard Kirstel, Les Krims, and Arthur Tress in the United States. Such fabrications were not limited to the United States, though. In Europe there were De Nooijer, Bernard Faucon, Fontenberto, and Merlo. In Brazil there was Boris Kossoy. The roots of this concern with fabrications to be photographed or a "directional mode" (term used by the critic A. D. Coleman in 1976) may be seen in the words of Arthur Tress, whose surreal fantasies evoked both awe and terror:

> So much of today's photography . . . fails to touch upon the hidden life of the imagination and fantasy which is hungry for stimulation. The documentary photograph supplies us with facts or drowns in humanity, while the pictorialist, avant-garde or conservative, pleases us with aesthetically correct composition—but where are the photographs we can pray to, that will make us well again, or scare the hell out of us? Most of mankind's art for the past 5,000 years was cre-

ated for just those purposes. It seems absurd to stop now.[13]

During the second half of the seventies there was increased interest in emphasizing color in photographic work. The Museum of Modern Art in New York seemed to encourage this trend in 1976 with its mounting of an exhibition of seventy-five dye-transfer color prints by a young Memphis photographer, William Eggleston, with its first completely color monograph on the artist; and a second one-person show of color photography by Stephen Shore. John Szarkowski, of the Museum of Modern Art, referred to Eggleston as the one responsible for "inventing color photography."[14] Eggleston used color as a vehicle to add vividness, both formally and thematically, to his images, which were usually of America's South—deserted streets, abandoned cars, and so forth (Plate 7). Stephen Shore transformed places such as California gas stations into cool, classical objects through the use of color. Joel Meyerowitz moved from black and white street photography in 1973 to capture, through the use of color and a large-format eight-by-ten-inch camera, a splendid elegance in Cape Cod vistas, both delicate and dramatic, as evidenced in his *Porch, Provincetown,* 1977 [3.23]. Meyerowitz also photographed intercity scenes and was commissioned in the late seventies to document contemporary life in St. Louis. Through color, photographers such as Meyerowitz, Shore, and Eggleston were able to lift ordinary objects into the realm of poetry.

Color was also used to enhance manipulated photographic pieces, such as the personal montages of Olivia Parker and Rosamond Purcell. Other photographers revived historic processes using color. Hand tinting was used by photographers such as Canadian-born Nina Raginsky and Alice Steinhardt. Fresson printing, achieving a subtle, grainy surface, was used by the French photographer Bernard Plossu and the American Sheila Metzner. Metzner's por-

3.23. Joel Meyerowitz, *Porch, Provincetown,* 1977.

traits and still lifes take on a painterly, Pre-Raphaelite quality.

Color was also used in the seventies by "street" photographers such as Bruce Davidson, Helen Levitt, and Danny Lyon. Photojournalists too used color to express a variety of perceptions of events and places throughout the globe.

In another arena electronically produced images from processes such as xerography, kwikprinting, and verifaxing came to be used more and more by artists during the seventies. Copy machines had been used by artists in the sixties, particularly by those interested in collage imagery and the possibilities that lay with composing directly on the copy machine glass. One of the first artists to gain recognition for his photocopied collages made with a verifax machine was Wallace Berman of Los Angeles in the mid-sixties. At George Eastman House in Rochester, Thomas Barrow became known for two books he produced with the verifax machine, *Trivia* and *Trivia 2.* Barrow found this process effective in achieving his goal of connecting "the encyclopedic aspects of photography with the overwhelming materialism of our times."[15] The verifax prints had a graininess and imprecision that seemed to fit Barrow's focus on informality, commercial products, and common subject matter, and played down the

craft of the traditional straight photograph.

Sonia Sheridan was also attracted to the cameraless image and immediacy of the copy machine. Her VQC telecopier prints were of her hands, face, and other body parts. Sheridan became founder of the Generative Systems Department at the School of the Art Institute in Chicago, and worked in close association with the 3M Company using its Color-in-Color machine. Ellen Land-Weber of California also used the 3M Color-in-Color machine to produce large color prints very similar to lithographs. Through interaction with technological means, artists such as these moved far beyond the traditional limits of photography.

There were thus many strands of photography during the seventies. In general, the decade was a time of great expansion for photography in form and content and in its integration with other media.

NOTES: PHOTOGRAPHY, 1970S

1. Quoted in Nancy Foote, "Situation Esthetics: Impermanent Art and the Seventies Audience," *Artforum,* January 1980, p. 29.
2. Andy Grundberg and Kathleen McCarthy Gauss, *Photography and Art: Interactions Since 1946* (New York: Abbeville Press, 1987), p. 143.
3. Cited in William Jenkins, ed., *New Topographics: Photographs of a Man-altered Landscape* (Rochester: International Museum of Photography at George Eastman House, 1975).
4. Susan Weiley, "Prince of Darkness, Angel of Light," *Artnews,* December 1988, p. 111.
5. Andrea Miller-Keller, *From the Collection of Sol LeWitt* (New York and Hartford, Conn.: Independent Curators Incorporated in Association with the Wadsworth Atheneum, 1984).
6. Cited in Hunter Drohojowska, "No More Boring Art," *Artnews,* January 1986, pp. 63–64.
7. Cited in ibid., p. 64.
8. Joel-Peter Witkin, "The Grotesque as the Elevation of the Self," *Repulsion: Aesthetics of the Grotesque* (New York: Alternative Museum, 1987), p. 14.
9. Els Barents, cited in Peter Turner, ed., *American Images: Photography 1945–1980* (New York: Viking Press, 1985), p. 205.
10. Cited in Gerald Marzorati, "Imitation of Life," *Artnews,* September 1983, p. 86.
11. Cited in Anne B. Hoy, *Fabrications—Staged, Altered, and Appropriated Photographs* (New York: Abbeville Press, 1987), p. 79.
12. Ibid.
13. Statement in Michael Held, ed., *Contemporary Photographers* (New York: St. Martin's Press, 1982), p. 763.
14. Cited in Douglas Davis, "A Call to the Colors," *Newsweek,* November 23, 1981, p. 115.
15. Thomas Barrow, cited in "Thomas Barrow," *Contemporary Photographers* (New York: 1982), p. 45.

SCULPTURE, 1970S

THERE was a pluralist tendency in sculpture as well during the seventies. Superrealist work and land or earth art continued from the sixties. Artists such as Christo or George Sugarman made larger and bolder pieces. Christo's *Running Fence*, as previously discussed, was probably one of the most controversial pieces of the decade.

Related to the Earthworks was a growing emphasis on large-scale site-specific sculpture and architectural sculpture. The land art differed to some extent from site-specific works in its use of the land or earth as primary sculptural material and the frequent use of an aerial perspective in considering the finished work. Site-specific sculpture frequently consisted of common construction materials and was oriented toward a ground perspective. One artist described site sculpture in the following terms: "Site sculpture expresses a strong consciousness of time. Its materials and structure are either temporary and tentative looking, geared toward the present, the transient and ephemeral, or they suggest reference to timeless building rituals and materials."[1]

Two artists who became noted for their large-scale site works during the seventies were Alice Aycock and Mary Miss. Both began working with primitive architectural constructions built from lumber in the early seventies. Born in Harrisburg, Pennsylvania, in 1946, Aycock developed an early interest in building from her father, who owned a construction company and had studied architecture and engineering. Her father had built Aycock's home and even given her a model of it. She received a B.A. from Douglass College, and an M.F.A. from Hunter College, where she studied with Robert Morris. Aycock was first drawn to Minimalism, but quickly began to pursue a broader path of form and content. One of her early pieces, *Maze*, 1972, consisted of five six-foot-high concentric rings made of wood planking constructed at Gibney Farm near New Kingston, Pennsylvania. The thirty-two-foot diameter outer ring had three random openings, where the spectator could enter. To understand the piece, the spectator had to enter the maze and wander the corridors, thereby experiencing some sense of anxiety, disorientation, or frustration to find a way out. The maze from the outside looked like a fortress of solidity and strength, but the interior, paradoxically, created quite the opposite effect. Aycock referred to a variety of influences for *Maze* [3.24]: the American Indian stockade, the Zulu Kraal, the beehive tombs at Mycenae, the legendary Labyrinth of Crete (she visited Greece in 1970), the writings of Jorge Luis Borges and Italo Calvino, Bruce Nauman's "Corridor Pieces" of 1970,

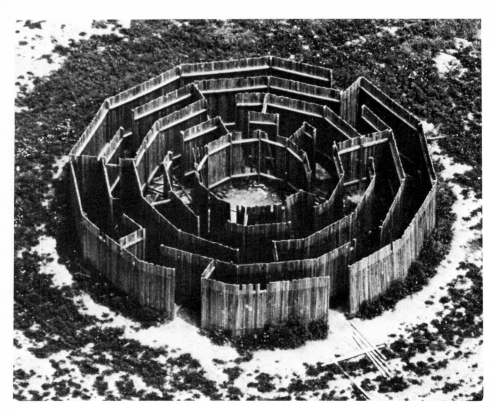

3.24. Alice Aycock,
Maze, 1972.
Gibney Farm,
New Kingston, Pa.

which generated a feeling of entrapment, and her own childhood fears of death and falling into a black void. By creating situations of a possible danger, Aycock felt she could reconstruct those early fears, control them, and thus lay them aside. During the seventies Aycock created a number of pieces that provoked a sense of panic within the viewer, often asking the viewer to crawl through small openings or walk in precarious places. In *Law Building with Dirt Roof (for Mary)*, 1973, created as a memorial for a twelve-year-old niece who died suddenly, the viewer must crouch to enter the thirty-inch opening and is immediately confined and faced with the possibility of the roof, with seven tons of dirt on it, caving in. In *Project for a Circular Building with Narrow Ledges for Walking*, 1976, the spectator has to climb down two sets of steep stairs without railings to reach the lowest edge of the piece.

Aycock wrote of her early work:

In general the work included here reflects the notion that an organism both selects and is selected by the environment. The structures, i.e. spaces and materials of construction, act upon the perceiver at the same time as the perceiver acts on or with the structures. The spaces are psychophysical spaces. The works are set up as exploratory situations for the perceiver. They can be known only by moving one's body through them. They involve experiential time and memory. The works are sited in terms of a preexisting landscape feature and are visible from a distance like a Greek temple. They are goal-directed situations, involving what Peckham refers to as "signs of orientative transition." The actual physical structures are impermanent since I do a minimum of maintenance.[2]

In 1977 Aycock's work began to resemble fantastic stage sets, and she expanded the materials she used to include steel, aluminum, glass, and items such as motors and spinning spools. Her 1979 theatrical *How to Catch and Manu-*

facture Ghosts attempted to deal with the ghostlike nature of memory and functions of the mind. The piece included cranks, wheels, batteries, a live bird in a glass jar, and at various times a gallery attendant blowing bubbles on the large cylindrical base that was like a stage. According to Aycock, the title of the piece came from an eighteenth-century book exploring static electricity and the use of magnetism to resurrect the dead. Other sources for the piece were the hallucinations of a schizophrenic, called N. N., described in Géza Róheim's study *Magic and Schizophrenia*. Part of the piece was a statement by N. N. on the gallery wall, dealing with the notion of psychic translocation. "This is how I go home sometimes; somebody at home—my mother—dreams of me and then I am at home with a broom in my hand helping her. . . . Once I was putting on my shoes at home, my shoes and feet began to lift themselves up in the air and I thought I would be lifted off the ground." Aycock found the schizophrenic hallucinations to be a kind of model for opening up one's vision to transform spaces and ideas. By 1979 Aycock had expanded her vision and imagery further in her "blade machines," which included scimitarlike metal blades and were intended to link modern technology to a historical past. Her research led her to the Middle Ages, and the use of blades to till the soil linked to the blades of a Cuisinart. Her blade machines also appeared at a time of personal crisis. In 1979 she had met Dennis Oppenheim, was married in 1982, but separated by the end of the same year and was later divorced. During the eighties Aycock continued her architectural explorations in pieces such as the *Tower of Babel*, 1986, in Houston.

Mary Miss's architectural sculptures explored time and environmental space, and some works had a fragility that Aycock's did not have. Mary Miss, born in 1944, was the child of an army couple who moved frequently. She graduated from the University of California in 1966 and then attended the Rinehart School of Sculpture at the Maryland Institute from 1966 to 1968. Miss often referred to concepts of layering in her work and allusions to buildings, bridges, theater sets, legends, and literature, and her work often contained actual physical levels. For instance, her 1974 *Sunken Pool* [3.25] consisted of a ten-foot-high latticelike wood structure built around a twenty-foot hole dug three feet in the ground and filled with a foot of water. The viewer could participate directly in the piece by either stepping down into the water or by climbing up the exterior.

One of Miss's most extensive pieces in the seventies was *Perimeters/Pavilions/Decoys*, commissioned by the Nassau County Museum in Roslyn, New York, in 1978 and situated in a large open field. The piece had free parts—an earth mound, three towers, and an underground atrium area of excavation which contained a ladder reaching up to the ground level. The open wood and mesh towers invited the viewer to stand within and behold the sky. The inner recesses of the underground area, which could be entered but not seen well, echoed the shapes of the towers' wooden poles. Within the piece there is the opportunity for the viewer to interact with and confront both the expansive landscape and a personal, intimate experience of the self.

Related to the work of Mary Miss were the constructed forms of Iranian-born Siah Armajani, who attended Macalester College and settled in Minnesota. Much of his work has been inspired by an American vernacular, such as frame houses, barns, and covered bridges, as seen in his *Bridge over a Nice Triangle Tree*, 1970. The multiple dimensions of Armajani's work were described by Janet Kardon in an introductory essay to his 1978 exhibit, "Red School House for Thomas Paine," at the Pennsylvania College of Art.

Armajani shifts among diverse identities in his investigations. As sculptor he uses architectural forms as paradigms for philosophical enquiries.

3.25. Mary Miss,
Sunken Pool, 1974.
Connecticut.

As architect, his program requires that he build models for art spaces, with foundations based upon philosophical tenets. As philosopher, he constructs three dimensional enquiries, which dissect architecture. As teacher, he draws from the vocabulary of architecture, sculpture, philosophy, linguistics, social concern and perception. His discourse subtly organizes and disorganizes American pragmatism.[3]

Michael Singer pointed to the importance of ritual in pieces such as *First Gate Ritual Series,* 1976. A sense of ritual existed in the viewing of a piece as well as in the pieces' being an integral part of the environment in which they were made, usually in the quiet of a woods or marsh. One sees the influence of Oriental thinking in his striving for a sense of wholeness, of integration. Singer's work has usually been made of bamboo poles, marsh grass, and wooden dowels, some of the materials coming from the site of the sculpture. Singer also sought to probe more deeply into himself through his pieces and their relationship to the landscape. He spoke about his *Lily Pond Ritual*

Series, where one was to look through the bamboo openings, as "building an apparatus to see more of what I am, where I am."[4]

Other site sculptors, such as Charles Simonds, Gordon Matta-Clark, and Anne Healy, turned to more urban settings. Matta-Clark transformed already existing architecture into sculpture by cutting holes in it and through it. The son of the Surrealist painter Matta, Matta-Clark had studied architecture at Cornell University and the Sorbonne. In his 1974 *Splitting* he bisected an entire house, revealing layers of materials, structural spaces, and techniques and processes of construction. In another project, *Pier 52,* at an abandoned Hudson River pier, the artist tore away parts of the pier to create new vistas, including a view of the river below the pier. Matta-Clark's work was iconoclastic, both in content and format, causing the spectator to completely reorient his or her thinking concerning objects in the everyday environment and concerning the very nature of sculpture and architecture. As Matta-Clark once noted, "By undoing a building, there are

many aspects of the social conditions against which I am gesturing."[5] Matta-Clark unfortunately died of cancer in 1978 at the age of thirty-five.

Charles Simonds created imaginary dwellings reminiscent of Pueblo Indian architecture for his "Little People," on ledges, abandoned buildings, and the like for nearly ten years throughout the streets of New York. The miniature dwellings of clay bricks and twigs startled many passersby and caused people to rethink their own civilization and immediate environment. These little communities, there were over 250, could be calmly reassuring, nestled securely on a corner or ledge. But beyond that there was the ominous reality that they probably would be reduced to ruins, often within a few days of construction [3.26].

Simonds's work of the early seventies, following graduation from the University of California at Berkeley in the late sixties, was preoccupied with a return to humanity's origins by the use of the body in primitive and ritualistic fashions. In 1970 he made a film, *Birth*, showing himself emerging from the earth, as part man, part earth, and sought to establish a per-

sonal mythological vocabulary. In a subsequent film, *Landscape/Body/Dwelling*, Simonds buried himself in the earth and constructed a group of tiny buildings on his body, which merged into the earth. These films served as foundations for his Little People. Simonds has explained the concepts he tried to express in the films and subsequent sculpture:

> "Landscape/Body/Dwelling" is a process of transformation of land into the body, body into land. I can feel myself located between the earth beneath me (which bears the imprint of my body contour) and the clay landscape on top of me (the underside of which bears the other contour of my body). Both "Birth" and "Landscape/Body/ Dwelling" are rituals the Little People would engage in. Their dwellings in the streets are part of that sequence. It's the origin myth—the origin of the world of man and of the people.[6]

The tiny cities Simonds created were bridges between a mythical past and harsh urban present. Children would often help him make the pieces, fetching materials, and helping him with tools, their innocence and sincerity becoming a part of the piece. Over the years

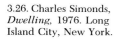

3.26. Charles Simonds, *Dwelling*, 1976. Long Island City, New York.

3.27. Beverly Pepper, *Perazim II*, 1975. Courtesy André Emmerich Gallery, New York.

Simonds developed three distinct groups of Little People, with different philosophies and rituals: the circular people, the spiral people, and the linear people. In his 1975 book *Three Peoples*, Simonds described the Little People's customs and beliefs. For example, he wrote,

> Their dwellings make a pattern on the earth, as of a great tree laid flat, branching and forking according to their loves and hates, forming an ancestral record of life lived as an odyssey, its roots in a dark and distant past. . . .
>
> . . . An old woman came back from her journey into the past with a vision; what everyone had believed to be a life following an endless line was really part of a great unperceived arc that would eventually meet itself. At that point everyone would join their ancestors in a great joyous dance.[7]

Simonds found the interaction with people on the street while he was working to be stimulating, and a part of his process. Once a man "was on his way to kill someone with a knife,

saw Simonds on the street working on one of his 'dwellings,' became fascinated with the story of the Little People, watched him work for quite a while, and consequently never completed his mission."[8]

Beyond the site-specific pieces for private purposes there were also more commissions for public sculpture, particularly under National Endowment for the Arts and General Services Administration funding and corporate funding. Artists such as Claes Oldenburg, Mark di Suvero, Richard Serra, and Beverly Pepper were but a few in the United States to receive commissions. Pepper's large-scale, often brightly painted steel structures, such as *Perazim II* [3.27], called for the passerby to momentarily suspend the demands of contemporary life to interact on an emotional-perceptual basis with the sculptural forms. In a speech given in 1977 at Dartmouth College, Pepper suggested the potential for the significance of public art:

Monumental sculpture is directed to man and his perception, not to function. There is no need to adapt. No need to use the work. The only inescapable need is to relate and to create an interaction between man and aesthetic experience which here becomes a social act. Perhaps this explains a great deal of my belief in the positive value of public large scale works, where the spectator is forced into a confrontation with the materials—hopefully facing them without preconceived ideas. In that instant, the work is potentially an extended human experience, as well as my isolated human expression.[9]

Public sculpture also thrived outside the United States, particularly in Latin America. One of the most noted figures in public sculpture there was the Mexican Helen Escobedo, who was also director of the Museum of Modern Art in Mexico City. She has described her approach as involving "an attempt to fuse hard-edge geometric forms with nature's organic manifestations."[10] Her painted steel *Snake* well illustrates this concern, with its complex intertwining of rectilinear forms. Escobedo has also been involved with nonpermanent environ-

mental sculptures and has pointed to the significance of the temporary and temporal quality of such pieces. When asked if she felt frustrated when her nonpermanent pieces were demolished, she responded, "My considered reply is 'no,' in view of the fact that so much change occurs in present-day life—buildings are razed almost as often as new ones are constructed, urban environments change from day to day, as do many natural ones . . . so much in life is ephemeral, leaving only memories; travel experiences, friendships, sounds and smells, stories told."[11]

While site sculptors worked mainly outdoors, a number of other sculptors were concerned with indoor transformations of spaces as they began to use entire rooms in indoor installations. Sculpture had most definitely forsaken its traditional pedestal and niche! In New York from 1974 to 1979, a huge space called Sculpture Now was used specifically for installations. One artist who used the space in 1976 was Robert Stackhouse with his installation entitled *Running Animals/Reindeer Way* [3.28]. The

3.28. Robert Stackhouse, *Running Animals/Reindeer Way*, 1976. Max Hutchinson Gallery, New York.

piece consisted of a curved corridor of wooden laths, decorated with a pair of reindeer antlers at each end, representing the migratory path of reindeer. Viewers could walk through the corridor and see into the gallery while in turn their shadows could be viewed from the outside. For one critic, *Running Animals* "recalled something made by a hunting tribe, a religious edifice dedicated to the movement of game itself."[12] Stackhouse also used references to archaeological sources, such as Norse ship burials, as in his *Mountain Climber.* His 1979 installation *Sailors,* in two parts, a large wood lath *Ship's Hull,* suspended from the ceiling, and a curved structure, *Ship's Deck,* which could be walked upon spoke to the viewer of quests, of passage, and primitive rituals.

Bernard Kirschenbaum's installations involved the walls, floors, and ceilings of the room being used. His 1977 installation at Sculpture Now, *298 Circles,* transformed the space into a sea of cascading circles. The thirty-inch diameter plywood discs, each painted one of twelve shades of off-white, were suspended from the ceiling, falling thirty inches from the floor. Viewers could circulate through the forms, but only by pushing them aside and dealing with a sense of both inner and outer obstacles while making their way across the room. Kirschenbaum's 1979 installation, *Blue Steel for Gordon,* an eighty-five-foot curtain of blue spring steel stripping that gently swayed, suspended from the center of the Sculpture Now gallery, forced the viewer to confront the architecture of the room and his or her relationship with the given space. It is perhaps no surprise that Kirschenbaum had majored in theater arts and architecture at Cornell University, as one sees his insistence on an active involvement by the viewer in relation to a particular space.

Working with movement and reflection was Salvatore Romano, whose water-site interior installations featured shallow pools, which one usually expected to find outside. His 1977 *Green Street Oracle* consisted of two black vinyl-lined pools with slender black columns arising from them and squares and discs of black polystyrene plastic floating mysteriously in the spotlighted water. His pieces were both dynamic and tranquil as the water served to evoke rational and irrational connotations in the mind and spirit.

Exploring the world of the spirit and the imagination in a more forceful manner were the installations of Jonathan Borofsky. To enter a Borofsky installation was to enter a world of dreams and nightmares. Three-dimensional figures, drawings, doodles, numbers, were all part of the artist's vocabulary, which stressed psychological states of both impermanence and archetypal dreams. His 1980 installation at the Paula Cooper Gallery [3.29] included, besides his usual drawings on the wall, small paintings on the floor and floor sculptures, a motorized silhouetted figure, and a half-black, half-white Ping-Pong table. In a letter to Ellen Johnson, Borofsky wrote about his work:

> The images I create refer to my personal, spiritual, and psychological self. They come from two sources: an inner world of dreams and other subconscious "scribbles" such as doodles done while on the telephone, and an outer world of newspaper photographs and intense visual moments remembered. All of these images are recorded on various small scraps of paper and later some are enlarged onto walls by projection, or made into three dimensional objects.
>
> To balance this attraction to the mystical-spiritual and often emotional visual imagery of my personal unconscious, I have been writing numbers in a linear rational manner since 1968. I began this conceptual exercise by writing the number 1, and I'm now on the number 2,686,-886. These written numbers have been crowded onto approximately 14,000 sheets of paper which are stacked vertically as one continuously growing unit. Whenever I record an image or a dream, I affix a number to it—the number I have reached at that particular moment in my counting.
>
> Most of my work is an attempt to reconcile opposite tendencies—to wed the Western rational mind with that of the Eastern mystic.[13]

3.29. Jon Borofsky, installation, 1980. Paula Cooper Gallery, New York.

Borofsky also had barbs for the art market when in the seventies to purchase a Borofsky painting was to have one made directly by the artist on your wall. It could thus not be resold for commercial profit.

The London-born, American-trained Judy Pfaff created playful Abstract Expressionist-like site-specific installations where she transformed museum and gallery spaces with brilliantly colored forms and materials that included scrounged non-art materials—plaster, barbed wire, neon, contact paper, to name a few. A sense of chaos often confounded the viewer upon initial exposure to the installation. But chaos became engagement, of intensity and force, as one became immersed in the space.

A number of her installations, such as *Kabuki (Formula Atlantic)* [3.30], 1981, were based on swimming experiences in the Caribbean and Pfaff's subsequent exploration of free-flowing and fluid forms. In a statement related to the installation of *Formula Atlantic*, Pfaff noted,

I am pursuing a deeper and denser space, an intensified feeling of vertigo, and something of the terror of that sensation of placelessness. *Formula Atlantic* should be about maximum speed. I want to exhaust the possibilities and push the parameters of dislocation and immersion as far as I can. My threshold increases with each piece. I want to be a kind of synchromesh between my thinking and the making of the work, to free the gesture with the thought.[14]

In Europe, the enigmatic Belgian Marcel Broodthaers, who did not consider becoming an artist until he was forty, became noted for

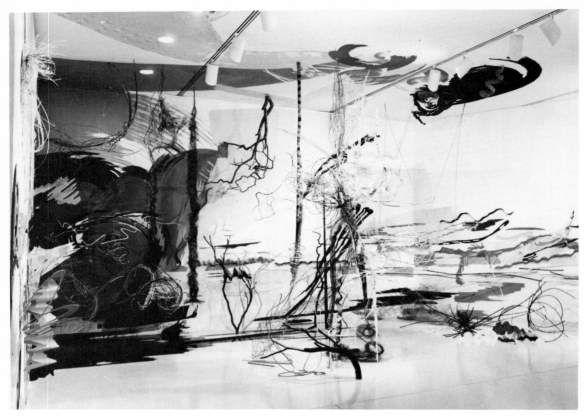

3.30. Judy Pfaff, *Kabuki (Formula Atlantic)*, detail, February 12–May 3, 1981. Hirshhorn Museum and Sculpture Garden, Washington, D.C.

his series of simulated museums, which were room-sized installations begun in 1968. They explored the very essence of what a museum and what art was meant to be. His search for a definition of art may be seen in his 1975 installation, *The White Room*. In the empty white space the artist's tools and other aspects of an art work—the brush, canvas, color, oil—usually expressed in physical terms, were reduced to words written on the walls. The very nature of visual art forms and objects was being questioned. Broodthaers barely eked out an existence as a bookseller, poet, photographer, and night porter. He died in 1976 of liver disease, a pauper, his legs broken so he could fit into a poor man's casket.

In general, a number of the installations being done provided a point of departure for an excavation of different levels of the mind and interior landscape that was easier to do through this mode than through traditional painting or sculpture.

Although she did not create installations, Nancy Graves excavated an archaeological and symbolic past in her work of the period. Born in 1940 in Massachusetts, Graves was the daughter of the assistant director of the Berkshire Museum, which featured exhibits dealing in art, history, and science. She attended Vassar and Yale's School of Art and Architecture, where she earned her B.F.A. and M.F.A. degrees. Among her classmates at Yale were Brice Marden, Chuck Close, Janet Fish, Robert Mangold, and Richard Serra. Her teachers included Alex Katz, William Bailey, and Neil Welliver. She and Richard Serra were married in 1965 but divorced in 1970. Although she was trained in painting, Graves turned to sculpture in her

series of camels, made from materials such as polyurethane, latex, wood, plaster, and painted skins that produced a natural look, in the late sixties. She found herself involved in paleontology, anthropology, archaeology, and osteology. In 1970 she made a trip to Morocco to study the structure, habits, and movements of the camels and made three short films. "They [the camels] had a scale and dimension that permitted what I call drawing," she said. "By 'drawing' I mean the way an artist moves his hand, the way one defines space and form and articulates a structure and I saw that the shape could be a vehicle for sculpture. I was trying to open doors to areas not considered for art."[15]

As she continued her study of the camel, Graves began to use only parts of the camel's body. Her *Variability of Similar Forms*, 1970, is like a primitive dance of thirty-six vertically posed camel leg bones. She went on to fabricate other bone pieces from materials such as steel, wax, and marble dust, and did a series of free-standing abstract multiple-part pieces related to the rituals of tribal societies, in particular the Northwestern American Indians. All of her pieces evoke a sense of mystery, exploration, and excavation, calling the viewer to reach deep within to recall the lost but still meaningful rituals and mysteries of a primitive time. In 1971 Graves also returned to painting, continuing her explorations through the use of maps as departure points for the paintings. In 1976 she was commissioned to make a bronze version of one of her bone sculptures, and has continued to work in both media, her paintings often taking on relief forms. During the eighties she became particularly noted for her highly inventive organic, brightly colored cast bronze sculptures made from a vast range of collected objects, from flowers to pods to dead frogs to potato chips. Pieces such as *Fenced*, 1985 [3.31], have both Baroque and contemporary qualities in them (Plate 8).

The spirit of excavation also existed in the work of Deborah Butterfield, who during the

seventies constructed large- and small-scale horses similar to some primitive tribal sculpture, out of twigs, earth, papier mâché, and even tin cans. Butterfield herself referred to them as "metamorphic self-portraits."[16]

Across the Atlantic there was also interest in the language of archaeology and ethnography that could be incorporated into sculptural expression. The French couple Anne and Patrick Poirier made archaeological models of real and imaginary sites, and often employed genuine excavated fragments in their pieces. They reconstructed Ostia Antica, the ancient Roman port city. In a piece entitled *A Circular Utopia* they created an imaginary temple complex, using patterns of coffering from the dome of the Pantheon in Rome. Through the work they hoped to have the viewer experience time and space in a manner different from the realities of

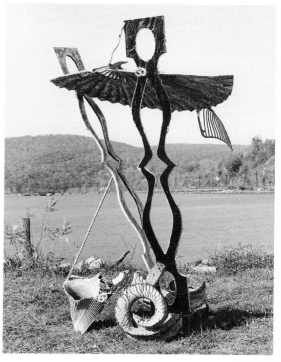

3.31. Nancy Graves, *Fenced*, 9/1985. M. Knoedler & Co., Inc., New York.

everyday life. "Our work," they have stated, "consists of investigating architectural places, often in ruins. Our fascination for ruined towns and buildings is not a morbid fascination for the past but a fascination for the architectural place itself, where time, crumbling the walls, the vaults, the ceilings, allows an immediate understanding of the architectural principle of construction."[17]

And Anne Poirier has stated further:

> We always try to lead the spectator to a sort of "poetic" space, not in the sense of poetry but of unreality. By that we mean spaces of a different nature than that of everyday life. But we also put the spectator on a stage, and scale plays an important part here, whether it be in the miniature models of sites where the spectator must mentally shrink in order to walk through it as though in a town, or in the gigantic works which he must walk around.[18]

In England Tony Cragg turned to the fragments and rubbish of a more current industrialized civilization as he collected broken and discarded objects. He piled layers of found materials, such as bricks, planks, corrugated paper, and plastic, to create geometric shapes or, in a piece such as *Black and White Stack*, 1980 [3.32], painted the pieces in a ground relief form. He went on in the eighties to make shapes, such as a palette or crescent from plastic shards, on the wall. He commented on his use of these discarded fragments: "I am not interested in romanticizing an epoch in the distant past when technology permitted men to make only a few objects, tools, etc. But in contrast to today I assume a materialistically simpler situation and a deeper understanding for the making processes, function and even metaphysical qualities of the objects they produced."[19]

The use of "primitive" materials and concerns with archaeological motifs may be seen as responses to Minimalism and as a way to probe beneath the layered surfaces of an increasingly complex society.

Another response to the cool and smooth forms of Minimalism was seen in the elevation

3.32. Tony Cragg, *Black and White Stack*, 1980. Courtesy Lisson Gallery, London.

of craft forms and materials to the realm of fine art. The California-based ceramic sculptor Robert Arneson became noted for his series of large-scale ceramic self-portraits begun during the seventies. In *California Artist* [3.33], 1982, Arneson portrayed himself as an aging hippie with huge holes instead of eyes, and placed himself on a traditional sculpture pedestal that he mocked and that also served as the lower section of his body. "I like art that has humor," explained Arneson. "I want to make 'high' art that is outrageous, while revealing the human condition which is not always high."[20] During the eighties he became an antinuclear proponent and produced horrifying images of both the makers and victims of a nuclear holocaust.

Marylin Levine made clay reconstructions

3.34. Jackie Winsor, *Four Corners*, 1972. Allen Memorial Art Museum, Oberlin College.

3.33. Robert Arneson, *California Artist*, 1982. San Francisco Museum of Modern Art.

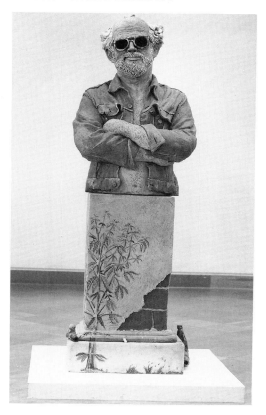

of worn leather objects that were so deceptive one often had to touch them to ascertain the material used.

Canadian-born Jackie Winsor took fibrous materials to transform geometric shapes into enigmatic forms suggesting a hidden life within the form. The process of binding and wrapping was also important for Winsor. For the *Four Corners*, 1972 [3.34], a fifteen-hundred-pound wood and hemp sculpture, Winsor worked four full days a week for six months. In the mid-seventies Winsor turned to using plywood, creating both latticelike and solid boxes that alluded to a hidden core.

Using wood in a trompe l'oeil, figurative, and illusionistic fashion was the craftsman and furniture maker Wendell Castle. His meticulously crafted, completely wooden pieces, such as *Hat and Scarf on a Chest*, 1978, convey both humor and seriousness concerning problems of perception, as the viewer contemplates the

replica and considers its original source.

Integrating craft materials and forms with feminism was Judy Chicago's large-scale *Dinner Party* [3.35]. (She was born Judith Cohen, Chicago was her birthplace.) The piece, completed in 1979, was a five-year project commemorating women's achievements throughout history. The piece integrated in an innovative way traditional women's crafts such as weaving, sewing, embroidery, and china painting and was worked on by hundreds of women throughout the country. The piece consisted of a large triangular table with handmade ceramic place settings for each of thirty-nine women, who included Caroline Herschel, Mary

Wollstonecraft, Georgia O'Keeffe, Natalie Barney, Emily Dickinson, and Margaret Sanger. The equilateral triangular shape was chosen for the table as one of the earliest symbols of the feminine and to symbolize one of the goals of feminism, that of an equalized world. On the floor another 999 women's names were inscribed on porcelain tiles. The shared responsibilities of those working on the project was also an integral part of the process, that an environment of freedom be created that was emblematic of what was sought in the larger world.

As Judy Chicago noted at the end of her written documentation to the project, "We

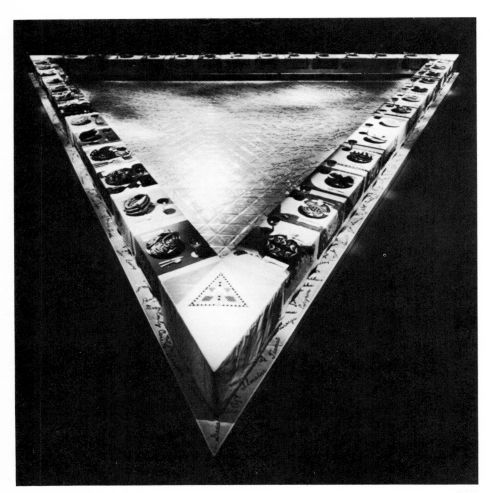

3.35. Judy Chicago, *The Dinner Party*, 1979.

need to be able to be difficult, to be moody, to be preoccupied, to be upset—to be, in fact, human, with all that that means—in order to realize our dreams. I am grateful to the people who have come here, not only to work on *The Dinner Party,* but to help build an environment where women as well as men can be free."[21]

Chicago later directed The Birth Project (1982–83), a collaborative piece involving textiles, interpreting the experience of childbirth.

Carrying the spirit of feminism forth in a different manner was the work of Lynda Benglis. In the late sixties and early seventies she poured liquid substances on the floor (with no mold) gently guiding them into organic shapes. She later moved to making wall reliefs such as *Heraklion,* 1978, often of graceful bow or fan

shapes made from materials such as chicken wire, cotton, plastic, gesso, and gold leaf. More controversial than the sculpture were the advertisements promoting them in the early seventies in *Artforum* and other art magazines. One ad, for example, featured Benglis as a contemporary pin-up figure, while another showed her nude, in full color, atop a large artificial phallus. The series of ads quickly called attention to the media's portrayal of women and common stereotypes.

Sculpture in the seventies, though developing in a variety of directions, was perhaps most notable for its emphasis on large-scale and site-specific works, which completely challenged and changed notions of traditional sculpture and put sculptural forms much more before the public eye.

NOTES: SCULPTURE, 1970S

1. Diana Shaffer, "Drawings for Site Sculpture," in Sam Hunter, ed., *New Directions: Contemporary American Art* (Princeton, N.J.: Commodities Corporation, 1981), p. 72.
2. Alice Aycock, "Work, 1972–74," cited in Alan Sondheim, ed., *Individuals: Post-Movement Art in America* (New York: E. P. Dutton, 1977).
3. Janet Kardon, *Red School House for Thomas Paine* (Philadelphia: Philadelphia College of Art, 1978), cited in Edward Lucie-Smith, *Sculpture Since 1945* (New York: Universe Books, 1987), p. 136.
4. Cited in Kate Linker, "Michael Singer: A Position in and on Nature," *Arts Magazine,* November 1977, p. 104.
5. Joan Simon, "Gordon Matta-Clark 1943–1978," *Art in America,* November–December 1978, p. 13.
6. Cited in Lucy Lippard, "Charles Simonds," *Artforum,* February 1974, p. 36.
7. Cited in Alan Sondheim, ed., *Individuals: Post-Movement Art,* p. 300.
8. Howard Smagula, *Currents: Contemporary Directions in Visual Arts* (Englewood Cliffs, N.J.: Prentice-Hall, 1983), p. 304.
9. Beverly Pepper, "Space, Time, and Nature in Monumental Sculpture," *Art Journal,* Spring 1978, p. 251.
10. Cited in Lucie-Smith, *Sculpture Since 1945,* pp. 134–35.
11. Ibid., p. 135.
12. Phil Patton, "Review," *Artforum,* December 1976.
13. Jonathan Borofsky to Ellen Johnson, August 28, 1980, cited in Ellen Johnson, ed., *American Artists on Art, from 1940 to 1980* (New York: Harper & Row, 1982), pp. 262–64.
14. In Miranda McClintic, *Directions 1981* (Washington, D.C.: Hirshhorn Museum and Sculpture Garden, 1981).
15. Cited in Avis Berman, "Nancy Graves's New Age of Bronze," *Artnews,* February 1986, p. 58.
16. Cited in Harold Rosenberg, "Reality Again," *The New Yorker,* February 5, 1972, p. 138.
17. Cited in Edward Lucie-Smith, *Art in the Seventies* (Ithaca, N.Y.: Cornell University Press, 1980), p. 106.
18. Cited in Lucie-Smith, *Sculpture Since 1945,* p. 142.
19. Ibid., p. 130.
20. Cited in Henry Hopkins, *Fifty West Coast Artists* (San Francisco: Chronicle Books, 1981), p. 25.
21. Judy Chicago, *The Dinner Party, A Symbol of Our Heritage* (Garden City, N.Y.: Anchor Press/Doubleday, 1979), p. 249.

ARCHITECTURE, 1970S

THE nature of architecture, like sculpture, was also to change radically during the seventies as Post-Modernist concepts came to the fore. For architecture it was a decade of eclecticism and plurality as well. The skyscraper mentality with added sculptural adaptations continued, perhaps best symbolized by the completion of the Sears Tower in Chicago in 1974. The building, designed by Skidmore, Owings & Merrill, with its grouping of "modular tubes" of black anodized aluminum and bronze tinted glass, was the tallest in the world. The Citicorp Center in New York, 1973–78, by Hugh Stubbins and Associates, with its sleek white aluminum, ribboned window sides instead of a completely glass skin, and top sliced off at forty-five degrees soared upward with grace and power [3.36]. Unlike some other skyscrapers, the building answered civic needs with its shops, restaurants, church, and subway entrance gathered around a beautiful atrium. The building was not simply an architectural and sculptural monument to corporate power and patronage, but attempted to respond to the larger public. A somewhat unusual feature of the building was its elevation on enormous piers at the center of each side.

I. M. Pei's John Hancock Building in Boston,

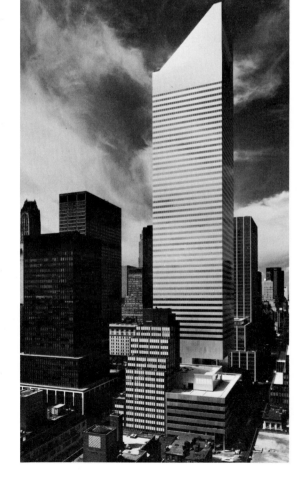

3.36. Hugh Stubbins and Associates, Citicorp Center, New York, 1973–78.

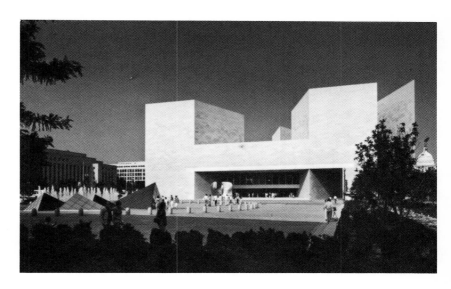

3.37. I. M. Pei & Partners, East Building, addition to the National Gallery, Washington, D.C., 1968–78.

completed in 1977, with its mirror glass and V-grooves in the short sides, also exhibited a sculptural quality. The Pei building suffered initially from problems with the glass falling out, but once the problem was rectified, the building stood as a magnificent, reflective parallelogram.

I. M. Pei exhibited further concern with sculptural forms in the solid geometry of his East Building addition to the National Gallery in Washington, D.C., 1968–78 [3.37]. The addition consists of two separate buildings joined by a glass-roofed court. The rectilinear and triangular forms are clean and pure and carry the spirit of the art inside to the exterior. The coffered skylights allow for the magnificent interplay of light and shadow. The addition appeared to reflect an observation made by Muthesius earlier in the century: "Far higher than the material is the spiritual; far higher than function, material and technique stands Form. These three material aspects might be impeccably handled but—if Form were not— we would still be living in a merely brutish world."[1]

On the other side of the Washington Mall, the Hirshhorn Museum and Sculpture Garden,

designed by Skidmore, Owings & Merrill, arose in 1974. Its round doughnutlike form and walls of concrete constitute another lesson in a classical, "solid" geometry, although it does not have the soaring, expansive quality of the Pei addition. Enhancing the Hirshhorn, though, is its large sculpture garden around the base of the building.

Across the Atlantic Ocean another museum arose, an exoskeletal structure that looked like a high-tech piece sculpture or a child's Tinkertoy construction. With its brightly colored high-tech and factorylike forms, the Centre National d'Art et de Culture Georges Pompidou in Paris, by Renzo Piano and Richard Rogers, was one of the few realized buildings of the English Archigram group [3.38]. Besides serving as a conventional museum, the building also houses libraries of books, music, and film, facilities for video and multimedia works, and a design center. There is also a large open plaza that can accommodate traveling performers, "street art," and large crowds. A five-story outside escalator provides magnificent views of Paris. But for many the design was initially controversial, not fitting for a museum. However, the place became a popular success, illustrating the potential for

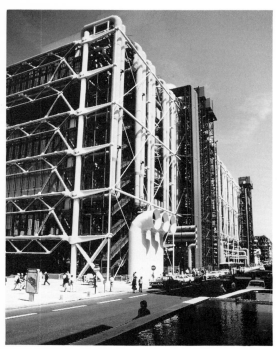

3.38. Renzo Piano and Richard Rogers, Centre National d'Art et de Culture Georges Pompidou, Paris.

3.39. John Burgee, Architects, American Telephone and Telegraph Corporate Headquarters (two views), New York, 1978–83.

vernacular and high-tech forms as a component of a contemporary architectural vocabulary.

In 1975 the architect/author Charles Jencks began using the term *Post-Modern* to describe the evolution from Modernist forms and tenets to a more broadly based architectural language that included historical quotations, complexity, ornament, collage, a concern for context, metaphor and symbol, and at times a sense of humor. The allusions to other periods, including Modernism, were not necessarily faithful or sincere, but tending instead to be ironic or to evince "double coding" (Jencks's term). Tendencies toward this Post-Modernist aesthetic existed internationally.

In the United States Philip Johnson used historic quotations to reject the glass box formula for the skyscraper in his American Telephone and Telegraph building in New York, 1978–83 [3.39]. His historicism was based on diverse

3.40. Charles Moore, Piazza d'Italia, New Orleans, 1975–80.

sources. The multistoried arch that emphasized the entranceway alluded to Brunelleschi's Pazzi Chapel. The lobby, with its grand columns, was supposedly a reference to a Greek or Roman hypostyle, while the broken pediment on the top of the building alluded to Chippendale furniture. Many referred to the highboy-like building as "Chippendale Modern."

Charles Moore, a student of Louis Kahn's, was more radically eclectic in his Piazza d'Italia in New Orleans, built in 1975–80 (in collaboration with the Los Angeles group U.I.G. and a local firm, Perez Associates) [3.40]. Moore, concerned with establishing a "sense of place," sought in the Piazza d'Italia to provide for the Italian-American population in New Orleans a place where the annual Feast of St. Joseph could be celebrated. Moore's sources for his spectacular circular piazza included the circular Place des Victoires in Paris, Hadrian's Mari-

time Theater at his villa near Tivoli, Karl Schinkel's triumphant gateways, and Nicola Salvi's Trevi Fountain in Rome. An "earth sculpture" of a map of Italy was built up diagonally from the circle's center to its circumference, with Sicily placed at the center of the circle, since most of New Orleans's Italians were of Sicilian heritage. Moore took not only from the past but also from the present, and alluded to the future. His use of neon, concrete, and stainless steel juxtaposed modern technologies and marble and brick.

The American Michael Graves turned to a plethora of historic sources in his work. The antecedents he drew from included Roman, Renaissance, and Baroque architecture, and particular figures, such as Claude-Nicolas Ledoux, Edwin Lutyens, Gunnar Asplund, and Le Corbusier. Through multiple references Graves sought multiple levels of meaning in his buildings. His Fargo-Moorhead Cultural Center, 1977–78 in North Dakota and Moorhead, Minnesota, serves as a good example. The center was to serve as a bridge to unite the two cities, which were divided by a river and state line. To symbolize the possible uniting of a duality Graves used a number of devices. A broken arch in the center of the bridge pulls forces from both sides. The separate buildings on each shore, while not identical, have a similar architectural language.

Other formal repetitions underline the oxymoronic figure of two in one: the red masonry and the blue glazing which interweave throughout the whole scheme. The anthropomorphism implicitly coded in the central bridge reiterates this same message: two legs, one head, two eyes, one chin. The image of some crawling animal is suggested just enough to work on our subconscious. Indeed the historicist references are kept at a level of abstraction to give them a kind of halo effect—the penumbra we have mentioned. . . . References to the Ponte Vecchio in Florence, the pyramid at Sir John Vanbrugh's Castle Howard (1699–1712), Ledoux's cylindrical buildings, a

3.41. Michael Graves, Public Services Building, Portland, Oregon, 1978–82.

Serliana pergola, and a Borrominian lantern are more obscure; their point is not so much to be perceived and understood as to be suggested and to suggest.[2]

Graves became particularly known for his Portland Public Services Building, 1978–82 [3.41], which is somewhat like a child's construction with its blocklike elements and cream-colored facade festooned with green stylized garlands and its bisected maroon-colored classical vocabulary. There Graves combined a few modern elements, such as large plate-glass windows, with classical elements, such as a colonnade, swag, sconce, and keystone. But he lifts these historical allusions to a contemporary time, presenting them in slightly distorted or somewhat unusual fashion—a three-story keystone, for example. Graves is also interested in the building, ensuring that as a public building it truly serves the

public and that it is an integral part of its context. He has referred to his years in Rome, 1960–62, after winning the Prix de Rome, as deeply affecting his architectural sensibilities:

It was in Rome that I came to understand architecture as a fully flowered idea; it was there that I became aware of varied architectural intentions living together. Prior to the disruption of modernism—which required a clean slate—the continuum of architectural language and ideas had been striking. The continuity comes from a classical understanding, in which the relationships must be three parts: man, the building and the landscape.[3]

One writer described Graves's Portland building as a "truly civic building," embodying what Graves envisioned: architecture as a "fully flowered idea" involving man, nature, and the landscape (Plate 9).

The Portland Building is a truly civic building, permeated with dignity, scale, color, vitality, referential layers of ancient civic archetypes of Greek temple and Roman arch, and even with an explicit image of humanity itself. The Atlas figure and giant face embody all the people of Portland, Oregon, who have symbolically taken the reins of the future in hand with this very building. The double image alludes to their deepest past as well, to the totemic communal art of the Northwestern Indians, the oldest inhabitants of the Portland area.[4]

Graves later cautioned against the wholesale use of historical quotations and allusions, and the resulting emptiness:

If the current commercial, cosmetic postmodernism—with its pilasters pasted onto the pizza shop and its pediments—mounted to the fronts of industrial parks and shopping centers—is dead, it should be. However, we should be reminded that those ideas are no thinner than the glass-box banks of commercial modernism, which we have been seeing for the past thirty or forty years.

What interests me in designing a building, particularly in an urban context, is using the context of the street and surroundings in my compo-

sition. I do not mean only fitting into the height and scale of the surroundings in my composition, as city planners and landmarks commissions would have us do. Rather I attempt to create buildings—such as my scheme for the expansion of the Whitney Museum in New York—in which the architecture says something about the surroundings in a fresh and original way. We are all used to good literature, which can take familiar subjects such as love and death and deal with them in new and illuminating ways. I think architecture can shed new light on existing contexts as well.[5]

Robert Stern, a New York architect, also used historical quotations in domestic designs in the mid-seventies. In his "House for an Academic Couple," in Connecticut, 1974–76, he applied thin classical moldings and colored

3.42. Richard Meier, Douglas House, Harbor Springs, Mich., 1971–73.

paint to flat-roofed modern box shapes. The ambiguities created between seriousness and parody in the building evoke a type of intellectual wit that seems fitting for the owners.

Richard Meier took modernist forms as his historical vocabulary as he elaborated and/or exploited architectural elements often associated with Modernism, such as the ribbon window and Le Corbusier's "piloti." His glistening white structures with complex spatial treatment often emphasized three dimensionality, as seen in his Douglas House in Harbor Springs, Michigan (1971–73) [3.42]. In this house there is a great sense of freeness and openness. In this and Meier's buildings simple geometric modernist forms become intricate and complex in their interaction with one another. There is a lyrical serenity in his work; but there is also a contagious energy that results from the interplay of the forms with light and shadow. The sense of openness that is created appears to go beyond the formal boundaries of the building. In 1988 Meier won the Gold Medal of the Royal Institute of British Architects, one of the few Americans ever to do so.

In Europe one of the best-known architects using the language of Post-Modernism was the Spanish architect Ricardo Bofill, who did a large amount of work in France. He and his firm, Taller de Arquitectura, were particularly concerned with large-scale housing projects, such as his Les Arcades du Lac, at Saint-Quentin-en-Yvelines, France, 1975–81, and his Spaces of Abraxas, Marne-la-Vallée, France, 1978–82 [3.43]. In Les Arcades du Lac he created a Versailles for the common people, with quotations from the original Versailles and ceramic tiles in four shades of earth colors on the facade and straightforward arched and rectilinear forms. The lake enhances the sweep of the classical forms. But unlike the historical Versailles, there is no ostentation and pretension.

The Spaces of Abraxas, named after the Mesopotamian symbol for both good and bad, consists of 584 apartments fit into monumental

3.43. Ricardo Bofill, Spaces of Abraxas, Marne-la-Vallée, France, 1978–82.

forms that clearly allude to a Roman theater, with nine stories, a triumphal arch of ten stories, and a nineteen-story palace. The classical forms were realized with materials of modernism, such as precast concrete, glass, and steel. There are colossal glass columns, massive, exaggerated entablatures, and in the central square freestanding columns create what Bofill called an "urban window. Its role is to frame the urban landscape, to unite or divide two exterior spaces."[6] Set on an elevation looking toward Paris, the complex is like a classically designed garden of buildings, as the formal shapes embrace and interact with one another. Peter Hodgkinson, once part of Britain's Archigram and later an associate of Bofill's, described the Spaces of Abraxas, as "the Cape Canaveral of the classical space age, the return of a people's ritual, a group of buildings that communicate space, telling the fable of an ancient epic rediscovered to serve man anew."[7]

In Italy the language of Post-Modernism was articulated in a somewhat different fashion by the Milanese architect Aldo Rossi, who was the leader of a group called the Neo-Rationalists or *Tendenza* (Tendency). The group saw itself as being part of a new order coming to Italy. Rossi believed in the power of simple, reductive forms, some of which had surreal or dreamlike qualities to them, such as his well-known Teatro del Mondo, which was a brightly colored wooden construction set afloat on a barge in a central area of Venice for the 1980 Venice Biennale. The building was a re-creation of the Theatrum Mundi, a sixteenth-century floating festival theater, on one level, but it was more than that, for in its floating state it also brought fleeting and floating images to the mind—a silo, a lighthouse, a Romanesque fortress, a medieval castle, an Italian campanile. The structure at first appeared to be foreign and antithetical to its Venetian setting, but upon contemplation, one realized that both the physical and conceptual levels of "floating" were indeed an integral part of the total setting, which Rossi gave a new meaning to through his new construction.

The Austrian-born Hans Hollein found in-

spiration in Venturi and Las Vegas as he re-
belled against his Bauhaus-Modernist training
at the Illinois Institute of Technology, where he
had enrolled in 1958. Returning to Europe,
Hollein worked mainly on smaller spaces, such
as his 1978 Austrian Travel Bureau in Vienna
[3.44]. The space glistened like a complex, mul-
tifaceted jewel, with its brass palm trees, highly
polished ship's railing, Oriental pavilion, partial
Greek columns, and pyramid shapes. There
was also a model of the Wright Brothers' bi-
plane and a chessboard seating area. The space
was clearly a collage of allusions from various
levels of society and history.

The British architect James Stirling also
used a collagelike method in some of his work.
His addition for the Neue Staatsgalerie in Stutt-
gart, Germany, 1977–83, which he worked on
with Michael Wilford, was perhaps one of his

most exciting works. With its wide range of his-
torical and contemporary references, including
Egypt, Rome, Greece, Romanesque and Ren-
aissance Italy, Neoclassicism, and high tech, the
building provides a rich and wide range of vi-
sual experiences for the museum visitor. The
addition complements the original Renaissance
Revival museum, as it repeats the U-shaped
plan of the old in the new part and allows a
continuous flow between the two spaces. There
is also the irony of traditional shapes presented
in a paradoxical manner, such as the "dome-
less" dome shape. Stirling's historical collage
testifies to the potential richness inherent in
the collage format. In its multiple levels of
physical and conceptual experience, the build-
ing serves as signpost to past and present as
well as the entryway to new possibilities.

In Japan Arata Isozaki used the language of

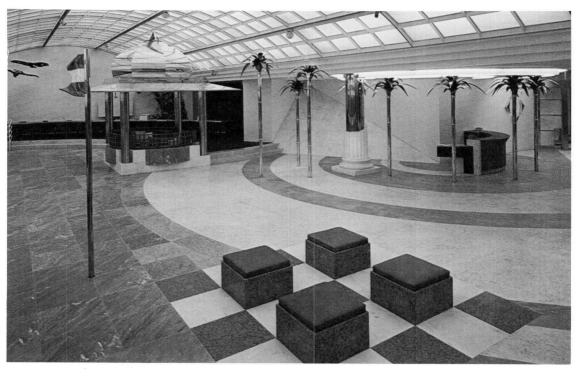

3.44. Hans Hollein, Austrian Travel Bureau, Vienna.

Post-Modernism to synthesize Eastern and Western ideas and techniques. As part of the metaphysical school of Japanese Post-Modernism, Isozaki often posed questions, literally and figuratively, in his work. His design for the Fujimi Country Club near Oita, Japan, 1972–74 [3.45], with its long, black barrel vault in the shape of a question mark and Palladian references is enigmatic for many. Isozaki has responded to "Why the question mark?": "It is only natural that pursuing a fluid form on a flat surface should resemble the traces of movement of the hand or pen. But when asked why, in this particular case, those traces became a question mark, I have no answer. Probably the form approached the question mark without my being aware of it."[8] Isozaki's response is somewhat enigmatic, but the key perhaps lies in the reference to the pen and hand—to the art of Japanese calligraphy and its evocation of a lyrical spontaneity. The dominating black roof of the country club is like a large calligraphic gesture in the open landscape.

Also connected with the metaphysical school in Japan was Monta Mozuna, whose architecture related to a variety of literary metaphysical sources as diverse as Incan myths, Isaac Asimov's science fiction, Carl Jung's archetypes, Shintoism, and Chinese yin and yang symbols. His Heaven Phase House is "based on seven columns positioned on the basis of a projection of the stars in the Great Bear. The architectural spaces are delineated by lines drawn to connect these columns; Demi-forms, based on the Yin/Yang duality, generate the living and private areas, the skylights, the half-arched bridge and half-sunburst. Half a five-pointed star creates the staircase."[9]

Beyond postmodern forms there were also more alternative building structures and designs that were quite different from traditional building forms. The American myth of the open road and mobility resulted in nomadic designs such as Chris Roberts's *Houseboat,* 1970, with its soaring wooden sail-like forms and large circular portholelike windows that

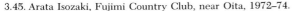

3.45. Arata Isozaki, Fujimi Country Club, near Oita, 1972–74.

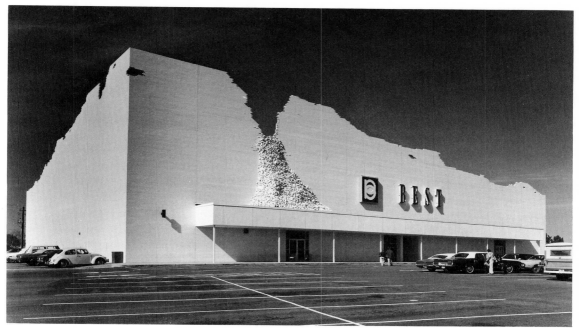

3.46. Maples-Jones Associates, SITE Projects, Inc., Indeterminate Facade Showroom, Almeda-Genoa Shopping Center, Houston, 1975.

extended to the roof. The call of the road and the rise of transient communes in the late sixties and early seventies increased the popularity of the van. There developed subsequently a *truckitecture,* a term used to describe individually designed homes on wheels by West Coast photographers from Environmental Communications. The painted and "sculpted" vans and recycled school buses became brightly colored icons of the vernacular along highways and at trailerparks.

There was also an increased interest in inflatable, pneumatic structures and a "soft" architecture. For some this soft or air architecture was "an art of absence. . . . Inflatable structures correspond to the void in reality . . . an alternative to absoluteness, inflexibility, and materiality."[10] The U.S. Pavilion at the Osaka World's Fair in 1970 was an inflatable dome. The design team Chrysalis made large-scale inflatable toys and created an inflatable living pod. The American group Ant Farm made fanciful large-scale play spaces, with names such as Dreamland, Flagbag, and the

World's Largest Snake. The art of inflatables was also seen in Europe in the work of such groups as the Hans-Rucker Company of Düsseldorf, Coop Himmelblau of Vienna, Evenstructures of Amsterdam, and a French student group, Utopie.

Taking the wit and irony of Post-Modernism in a direction that came to be called "Dearchitecturalization" was the design collaborative SITE (Sculpture in the Environment). Formed in 1970, the main figures in the group were James Wines, Alison Sky, and Michelle Stone. They became particularly noted for their works for the Best Products Company, a catalog-showroom merchandiser, whose standard building was a two-story brick-walled, box-like structure 203 feet wide, 190 feet deep, and 30 feet high. The interiors were like giant warehouses, but the exteriors were radically transformed by SITE and a number of other architects. The 1975 Best Products showroom at the Almeda-Genoa Shopping Center, Houston, Texas [3.46], may serve as one example. The facade of spilling bricks and jagged edges,

as if the building were being razed or were a ruin, is shocking to initial perceptions. Ambiguities concerning traditional ideas of architectural construction and structure arise immediately. Motifs of collapse and decay suddenly become motifs of commercial newness. The building also added a new dimension to the Texan landscape, as the illusion of a classical ruin burst forth on the horizon. In this project architecture was regarded by SITE "as a matrix for art ideas and as a 'found object'—or the 'subject matter' of art, rather than the objective of design. The building also uses architecture as a means of social and psychological commentary, as opposed to an exploration of form, space, and structure."[11]

It is interesting to note that ruin and decay were dealt with literally in other arenas with a push toward restoration and refurbishing of older buildings. A good example may be seen in Boston, where the city's eighteenth-century Faneuil Hall and nineteenth-century Quincy Market were transformed into open and vibrant spaces for the public while retaining the integrity of the older buildings and market area.

Of all the routes explored during the seventies in architecture, it is the Post-Modernist experiments that were perhaps the most significant, as the architects and their buildings began to establish new territories and new maps for architectural explorations.

NOTES: ARCHITECTURE, 1970S

1. Muthesius, "Wo Stehen Wir?" 1911, cited in William J. R. Curtis, *Modern Architecture Since 1900,* 2d ed. (Englewood Cliffs, N.J.: Prentice-Hall, 1987), p. 388.
2. Charles Jencks and William Chaitkin, *Architecture Today* (New York: Harry N. Abrams, 1982), p. 140.
3. Michael Graves, "Has Post Modernism Reached Its Limit?" *Architectural Digest Supplement,* April 1988, p. 10.
4. Marvin Trachtenberg, "Second Modernism (Post-Modernism)," in Marvin Trachtenberg and Isabelle Hyman, *Architecture from Prehistory to Post Modernism/The Western Tradition* (Englewood Cliffs, N.J. and New York: Prentice-Hall and Harry N. Abrams, 1986), p. 573.
5. Graves, "Has Post Modernism Reached Its Limit?" pp. 7–8.
6. Cited in Vincent Scully, "Ricardo Bofill," *Architectural Digest Supplement,* April 1988, p. 60.
7. Cited in H. H. Arnason, *History of Modern Art: Painting, Sculpture, Architecture* (New York and Englewood Cliffs, N.J.: Harry N. Abrams and Prentice Hall, 1968), p. 698.
8. Cited in Trachtenberg, "Second Modernism (Post Modernism)," p. 578.
9. Jencks and Chaitkin, *Architecture Today,* p. 196.
10. Willoughby Sharp, *Air Art* (New York: Kineticism Press, 1968), p. 7.
11. James Wines, cited in Arthur Drexler, Introduction, *Buildings for Best Products* (New York: Museum of Modern Art, 1979), p. 10.

MULTIMEDIA AND INTERMEDIA, 1970S

DURING the seventies the boundaries between the visual arts and other art forms, and other disciplines, continued to be broken down. With roots in Dada and Futurist performances, sixties Happenings, and Conceptual art, there emerged a full flowering of performance art during the seventies, as artists found the art object and even the written word too confining. A number of artists turned toward the use of theatrical elements to assure a direct and immediate confrontation with the audience and society at large. Through the medium of performance, artists could choose their own subject, materials, and site without the intervention of critics or the gallery system. Performance demanded action, not passivity, and was intended to evoke a strong and immediate response from the viewer.

Closely associated with performance art during the decade was Vito Acconci. Born in the Bronx in 1940, Acconci was initially a writer and poet, having graduated from Holy Cross College in Worcester, Massachusetts, and having attended the Writers' Workshop at the University of Iowa. Upon moving to New York, Acconci moved from standard fiction formats to poetry events, where his readings began to involve the use of audio tapes and props. By the late sixties he found the printed page too constricting and turned to the visual arts. Influenced initially by Richard Serra's prop pieces, Donald Judd, and Fluxus performance artists, Acconci became concerned with the notion that art is about the "targeting" of attention. In one of his early performances, *Trademarks*, 1970 [3.47], although executed without an audience, Acconci used his own body as target as he bit into as much of his own nude body as he could reach. This piece, like a number of Acconci's pieces, was made public through the use of photographs and video tape. In another piece executed in the same year, *Applications*, Acconci sought to change a space through the introduction of human components. Kathy Dillon, Acconci's girlfriend at the time, covered his body with lipsticked kisses. Acconci then transferred the marks to his friend and sculptor Dennis Oppenheim by rubbing their bodies together. On one level the piece was body art, with people as the tools and support surfaces. But there were other levels. Acconci recalled, "Dennis was pretty shaken up. There was something else going on, and we hardly knew what. We tried to avoid the implications at the time, but the fact was, once there was more than one person, those implications were unavoidable. *Applications* was about dominance, submission and control."[1] Pieces such as this raised questions too about levels of metaphor, the use of the human body in art, and sexual politics.

One of Acconci's most well-known and no-

3.47. Vito Acconci, *Trademarks*, 1970. Photograph courtesy Sonnabend Gallery, New York.

torious pieces was his 1971 *Seedbed*. For this piece, in the Sonnabend Gallery in New York, he built a low ramp under which he lay unseen twice a week for two weeks for six hours at a time. As visitors entered the gallery Acconci would masturbate and utter sexual fantasies about the viewer. "I'm doing this with you now . . . you're in front of me . . . you're turning around . . . I'm moving toward you, leaning toward you . . ."[2] Acconci's piece asked the viewer to relate the sexual and creative act to each other, and greatly stretched the idea of what was acceptable as art.

After 1973 Acconci abandoned live pieces and began to do installations that usually involved recordings of Acconci's voice. His pieces began also to take on sociological ramifications, going beyond the personal, psychological orientation of some of his earlier pieces. In his 1977 piece for the Whitney Biennial, *Tonight We Escape from New York*, a ladder symbolizing class mobility extended into a stairwell of four flights. An audio tape identified the symbol and at the same time spouted offensive statements directed at women and blacks. Acconci, in retrospect, commented about the piece, "Did a white male even have the right to utter these words? I am uncertain where questioning

leaves off and further oppression begins. What I want is for both levels to exist at once. Then again, perhaps it's all a parody."[3]

Using the body in an extreme fashion in a conceptual and performance piece was Chris Burden. In Los Angeles in 1971 he achieved international notoriety by having a friend shoot him in the arm. The performance was made permanent by photographic documentation. Two years later, Burden used his body in another piece, *Doorway to Heaven*, where he stood in the doorway of his studio and pushed two electric wires into his chest, as viewers stared. The wires crossed and exploded, burning Burden somewhat but saving him from

3.48. Gilbert and George, *The Singing Sculpture*, 1971. Courtesy Sonnabend Gallery, New York.

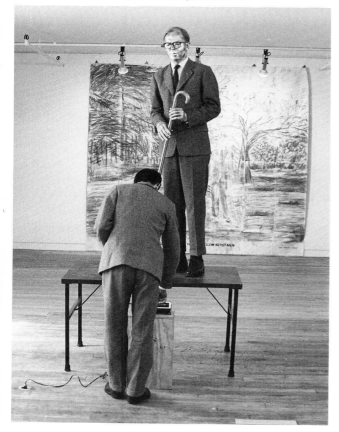

electrocution. These pieces were violent and extreme, but they also spoke of the artist's ability to rise above the physical and endure.

In Europe a more brutal and less controlled manifestation of body and performance art appeared in the work of a group of Viennese artists living in Germany—Hermann Nitsch, Rudolph Schwarzkogler, Günter Brus, and Otto Mühl. Their harsh and brutal ceremonies involved more literal violence and horror as participants, for example, had their bodies smeared with the blood of dismembered animals. Schwarzkogler actually died from a series of self-mutilations performed in the name of art.

The human body was used in a more "positive" fashion by the London-based artists Gilbert and George, who transformed their bodies into a living and assembled sculpture and brought a sense of humor to body and performance art. In one of their best-known pieces, *The Singing Sculpture*, 1971 [3.48], they covered themselves with metallic paint, wore "proper" English suits, stood on a table and appeared as marionettes mouthing words to a pre-war song that is the title of the piece. In later work, extending into the eighties, the pair presented themselves through documentation in large-scale photomontages and photograms.

Approaching performance and body art in a somewhat different manner was Carolee Schneeman, whose work in the sixties and seventies was concerned with a sexual and a personal freedom. In various performances her nude body was collaged with elements such as paper, plastic, pigment, snakes, sausages, chicken carcasses, light projections, and other human bodies. To her the body was an important expressive vehicle, as it evoked kinesthetic and factual responses, and forced the public to confront its perceptions of the human body. Her pieces called for a feminine mythology, emphasizing elements such as intimacy, tactility, empathy, or physicality, which would replace cultural stereotypes and taboos concern-

ing the body, in particular the female body. In *Eye Body*, for example, Schneeman appeared nude with live snakes crawling on her torso, and surrounded herself with plastic sheeting and other found materials emphasizing the physicality of her body. The identification of her body with the serpent alluded to early snake goddesses and allusions to the serpent's association with rebirth, fertility, and new life in many ancient myths.

> For Schneeman, "the life of the body is more variously expressive than a sex-negative society can admit. I didn't stand naked in front of 300 people because I wanted to be fucked, but because my sex and work were harmoniously experienced [so] I could have the audacity, or courage, to show the body as a source of varying emotive power (1968). . . . I use my nude body in *Up to and Including Her Limits* [a recent mixed media performance in which Schneeman reads from a long scroll removed from her vagina] as the stripped down, undecorated human object (1975). . . . In some sense I made a gift of my body to other women: giving our bodies back to ourselves."[4]

Schneeman's art was looked upon by many as repulsive and vulgar, and was criticized by some as narcissistic. But as Lucy Lippard noted,

> Men can use beautiful, sexy women as neutral objects or surfaces, but when women use their own faces and bodies they are immediately accused of narcissism. There is an element of exhibitionism in all body art, perhaps a legitimate result of the choice between exploiting oneself or someone else. Yet the degree to which narcissism informs and affects the work varies immensely. Because women are considered sex objects, it is taken for granted that any woman who presents her nude body in public is doing so because she is beautiful. She is a narcissist, and Acconci, with his less romantic image and pimply back, is an artist.[5]

Body art, whether male or female, did point to concepts of role and questions about female and male imagery, as well as androgynous urges. The Viennese Urs Lüthi, for example, created transvestite photo dramas of himself. Katharina Sieverding of Düsseldorf did a series of photographs *Aspects of Transvestism*. She saw these

> not as a pathological phenomenon but as "communications-material," exposing roles, repression, ambiguity, possibility, and self-extension; "The conquest of another gender takes place in oneself" (*Heute Kunst*, April 1974). Such a positive approach has more in common with traditional (Platonic, Gnostic, etc.) myth of the androgyne as two in one, "the outside as the inside and the male with the female neither male nor female," than with contemporary art's emphasis on separation over union of the two sexes.[6]

Performance art was not, of course, devoted exclusively to presentation of the human body or parts thereof. One of the most dynamic figures connected with performance art was Laurie Anderson, who emerged in the seventies as a kind of cult figure. One critic described her elaborate multimedia performance pieces "as the biggest, most ambitious and most successful example to date of the avant-garde hybrid known as performance art."[7] Raised in the Chicago suburb of Glen Ellyn, the daughter of a well-to-do paint manufacturer, Anderson seriously studied violin until age fifteen. As a student at Barnard College, though, she majored in art history and trained as an Egyptologist. In New York she was influenced by Minimalists such as Sol LeWitt, and experimented with sculpture herself. She also heard composers such as Philip Glass featured at a number of New York galleries and gradually became involved in performance art. The spirit of exploration has always been a part of Anderson's way of life. One summer she attempted to get to the North Pole by hitching rides from bush pilots in the Alaskan tundra. She got within several hundred miles of the Pole.

Anderson's first performance was in 1972 at

the Town Green in Rochester, Vermont, where she wrote and conducted a piece for automobile horns. By 1974 she was performing more pieces on urban streets, such as *Duets on Ice* [3.49], where she froze the blades of a pair of skates into huge ice blocks and played her violin until the ice melted. She then walked awkwardly away in her skates on the bare street. Her appearances were like a ghostly troubadour, as the music stopped when the ice melted, leaving puzzled faces in the crowd gathered to watch her.

Anderson moved on to more complex, large-

scale, sometimes operalike pieces, often involving both fear and humor. One of her most ambitious pieces was her epic performance series *United States (Transportation, Politics, Money, and Love)*, begun in 1979. Identified with new wave punk, the piece included film and slide projections; a voice-activated synthesizer (Vocoder), allowing her to speak and act in chords; her "talking" violin with prerecorded tape; and her backup band, which included saxophones, drums, synthesizer, and jazz bagpiper. She spoke about her use of filters to change her voice:

3.49. Laurie Anderson, *Duets on Ice* (two views), 1975. Courtesy Institute of Contemporary Art, University of Pennsylvania, Philadelphia.

> One of the reasons I use filters to change my voice is I'm interested in a kind of corporate voice that might be compared to the writing in *Newsweek* or *Time*, in which someone starts an article and then it's edited and re-edited and re-edited and the article finally comes out in Timese or Newsweekese and it's a corporate voice. It has someone's name signed on it, but it's in the style of that particular magazine. This corporate voice is a spooky voice, because it's a highly stylized voice. One of the things I'm trying to get at through these filters is to look at those kinds of—particularly American—voices that try to convince you there's a person behind it and there isn't. There's a corporation behind it. I like that technology can trick you and to call attention to the way it can trick you.[8]

Anderson's piece had no story line, but through wordplays and a series of vignettes Anderson pointed to important concerns of modern life, such as the terrors of war or the spoiling of the environment or dehumanization:

> Anderson's theme is nothing less than the dehumanizing crackup of modern society, and she treats it with an elaborate structure of symbols and images. Airplanes are a metaphor for physical risk (she was in a plane crash once), weightlessness, and enforced camaraderie; dogs become a symbol of nature in harmonious, trusting alliance with humanity; the telephone is used both as an instrument of impersonal communication and the conveyor of whispered intimacies.[9]

In using elements of popular culture, and "serious" "high" art, Anderson reached out to and embraced a much wider audience than the art world normally did.

German-born Hans Haacke, involved with process art in the sixties, geared his work to a much larger world as he switched to sociopolitical systems and their connections with the art system in the seventies. He explained his notion of the role of the artist:

> The artist's business requires his involvement in practically everything. . . . It would be bypassing the issue to say that the artist's business is how to work with this and that material or manipulate the findings of perceptual psychology, and that the rest should be left to other professions. . . . The total scope of information he receives day after day is of concern. An artist is not an isolated system. In order to survive he has to continually interact with the world around him. . . . Theoretically there are no limits to his involvement.[10]

One of Haacke's pieces, *Shapolsky et al. Manhattan Real Estate Holdings, Real Time Social System as of May 1, 1971,* 1971, documented through photographs the slum real estate of some of the Guggenheim Museum's trustees. The piece, slated to be shown at a Haacke exhibition at the Guggenheim Museum, provoked the cancellation of the exhibit by Thomas Messer, director of the Guggenheim, and the subsequent resignation, in protest, of the curator of the exhibit, Edward Fry. In another piece dealing with larger "systems," *Gallery Goers' Residence Profile,* September 1972, Haacke attempted to document where viewers of one of his exhibits came from and if they were an isolated segment of the population, which they proved to be.

In 1974 the artist, at the invitation of the Wallraf-Richartz Museum in Cologne, prepared the *Manet Project,* which was to display Manet's painting *Bunch of Asparagus* on an easel surrounded by panels indicating the social and economic status of those who had owned the picture from 1880 up until its purchase by

the museum with funds from the Friends of the Museum (whose status was to be listed as well). The proposal was rejected, but artist Daniel Buren in a concurrent show at the Wallraf-Richartz Museum, in support of Haacke, pasted versions of the *Manet Project* on his stripe paintings. These were pasted over by the museum, which prompted other artists to withdraw their works from exhibition at the museum in protest. Haacke's piece was finally installed in a commercial gallery in Cologne and received all the more attention because of the incident at the Wallraf-Richartz. Although not widely accepted, Haacke's work of the seventies served to raise questions concerning the complicated interrelationships of various systems of contemporary society.

In England the Artist Placement Group, founded by John Latham and Barbara Steveni, went further than Haacke in its emphasis on a socially relevant and catalytic role for the artist. The group paid artists retainers and placed them in communities to serve as catalysts for change in social, political, and economic systems. In Germany the Free International University of Creative and Interdisciplinary Research, based on Joseph Beuys's concept of a "Social Sculpture," pushed for the acceptance of the concept that everyone has the creative potential to be an artist of some type and thus help transform life into a continuing and positive creative experience. In France the Collectif d'Art Sociologique was formed in 1974 by Hervé Fischer, Fred Forest, and Jean-Paul Theriot, which attempted to activate people within a particular social milieu. One of Fischer's projects for the Jordaan district in Amsterdam, in 1978, involved giving citizens the opportunity to write and edit an entire page in the daily newspaper, *Het Parool,* thereby empowering citizens somewhat and promoting a shared communication rather than a one-way communication delivered downward from the newspaper to the general population.

As already indicated, a number of perfor-

mance artists used video as a method of documentation. During the seventies video as an art form unto itself also became more fully realized with technological innovations and wider public acceptance. More galleries and critics began to espouse video art. *Expanded Cinema* by Gene Youngblood, published in 1970 by E. P. Dutton, was the first publication to cover video art. That same year the first issue of *Radical Software,* founded by Beryl Korot and Phyllis Gershuny, appeared and became a voice of the video movement until 1974. On the inside cover of the first 1970 issue appeared the following words:

> Power is no longer expressed in land, labor, and capital, but by access to information and the means to disseminate it. As long as the most powerful tools (not weapons) remain in the hands of those who would hoard them, no alternative cultural vision can succeed. Unless we design and implement alternate information structures which transcend and reconfigure the existing ones, other alternative systems and life styles will be no more than products of the existing processes. . . . Our species will survive neither by totally rejecting nor unconditionally embracing technology—but by humanizing it; by allowing people access to the informational tools they need to shape and reassert control over their lives.[11]

In 1971 the National Endowment for the Humanities initiated the Public Media program, which became the Media Arts program in 1977. In 1971 video artists Woody Vasulka and his wife, Steina, founded The Kitchen, which became an important interdisciplinary art center in New York, where new video work was shown. By 1976 *Video Art: An Anthology,* edited by Beryl Korot and Ira Schneider (New York: Harcourt Brace Jovanovich), the first anthology of video criticism and statements by video artists, was published. In the same year the Rockefeller Foundation published *Video: State of the Art* by Joanna Gill.

In general, there was a growing change in video art during the seventies from "a first gen-

eration involved with Neo-dada, formalism, conceptualism, feminism, performance, installation, documentary, experimental, and abstract work," to "a second generation pursuing the postmodern concerns of language, new narrative, media, culture, poetry, and perception."[12]

Continuing to be in the forefront of video experimentation and innovation was Nam June Paik. In 1971, using the video synthesizer he had developed with Shuya Abe, Paik began work on his *Global Groove* for the television laboratory at WNET in New York. The work was a multilayered, electronically collaged piece that included performances by John Cage, Allen Ginsberg, Charlotte Moorman playing Paik's *TV Cello* sculpture, go-go dancers, and Japanese commercials. With its unusual colors and altered images, the piece was a radical departure from traditional television and demonstrated well the possibilities inherent within the video medium.

Also working at WNET in the early seventies was Ed Emshwiller, who had originally been an abstract expressionist painter and worked professionally as an illustrator for science fiction publications. His interest in both representational and abstract visual images led him to experimental film work combining live performance with abstract animation. In his 1972 video piece *Scape-mates* he combined images of live dancers from the Alwin Nikolais Dance Company with abstract synthesized video imagery to produce a visually beautiful but haunting look at man and technology.

In 1974 computer technology was combined with video technology, which allowed complicated and sophisticated editing as well as new programming and collaging through the use of computers and new digital special effects. With the use of digital processing, the video image itself could be translated into digital information. Video artists Ed Emshwiller and Woody and Steina Vasulka were among the first to work with the combined technologies and collaborated with engineers to design some

of the first programs and systems that could digitally process the video signal.

In 1978 Woody Vasulka and Jeffrey Schier developed the Digital Image Articulator, which stored different shapes, forms, and colors and could layer different video images. One critic noted, Vasulka had "long argued for the possibility of producing an 'electronic' reality that would be more convincing than camera reality, reflecting a Modernist faith in science and the transformative powers of technology."[13]

One of the first combined video-computer works was Ed Emshwiller's *Sunstone*, produced at the New York Institute of Technology in 1979 [3.50]. Emshwiller worked with computer scientists for eight months to produce the intricate, multidimensional work that used two-dimensional computer paint imagery and three-dimensional computer animation. Emshwiller has commented about his explorations:

> I'm fascinated by the character of the mark that one is capable of using with different instruments. In my early training, I studied graphics and used engraving and etching tools, then water colors, crayons, movie cameras, video cameras—

every one makes a different kind of mark and can combine things in different ways. That sort of thing has always fascinated me because the character of the mark has such an impact emotionally and stimulates thought relationships just as imaginative content does.[14]

Ed Emshwiller has further noted the great significance of the multilayered medium of video for our multilayered world: "We live in a multilayered world and in a world that is so self-aware of various perspectives, ideologies and of the meaning of signs and images—it [video collage] is something that enables one to reflect on the complexity of life and relish its mystery."[15]

Besides its marriage with video technology, the computer continued its growth as a tool for artists in both the United States and Europe as they increasingly created digitally produced images. The British artist Harold Cohen, who explored the potential of artificial intelligence for the visual arts at Stanford University's Artificial Intelligence Laboratory, devised his own system for creating drawings with computers that would simulate freehand drawing resembling his own work. He developed a program call AARON (a reference to the artist's Hebrew

3.50. Ed Emshwiller, *Sunstone*, 1979.

3.51 *(opposite)*. Richard Voss, *Fractal Planetrise*. Richard F. Voss/IBM Research.

name) based on aspects of human perceptual behavior, from which black and white drawings could be made and then hand colored if so desired. At the first exhibit of his computer-generated art works, at the Los Angeles County Museum in 1972, Cohen also exhibited a computer-controlled drawing machine, which made a series of drawings during the show. Cohen continued to modify his program, working toward an AARON with color capabilities. In the mid-eighties he summarized the program's growth: "The AARON of 1972 [compared to the program today is] analogous to that of an adult to a small child . . . where the earlier AARON had been limited to knowledge of image-making strategies, the new AARON is more explicitly concerned with knowledge of the external world and the function of that knowledge in image-making."[16]

With advanced technology came the ability to create three-dimensional solid images with the computer. Work in the late sixties, simultaneously at MAGI SynthaVision in Elmsford, New York, and at the University of Utah, enabled artists by the seventies to create fantastic three-dimensional images, such as David Em's 1979 *Transjovian Pipeline.* MAGI's system was "based on primitive mathematical shapes such as spheres, cubes, and cones that could be rendered directly in the system. Their approach had the benefit of allowing for modeling with constructive solid geometry in which a complex solid is built out of simpler solid primitives."[17] At Utah there was a different solution, "where the evolution from wire frame models on a vector display to shaded surfaces with an impression of solidity on a raster screen was accomplished by using shading algorithms. Solids modeled in this manner were mathematically described as a series of connected polygonally bounded planar surfaces. This development in turn required algorithms to remove hidden surfaces."[18]

In 1975 Bui-Tuong Phong, a Utah scientist, created a lighting model that allowed for the

representation of highlights. And in 1976 James Blinn, a doctoral candidate at Utah, defined a set of algorithms for what was called "bump mapping," a way to create textures on three-dimensional images. Although Blinn's work was developed for scientific purposes and was used specifically by the Jet Propulsion Laboratory in 1979 to simulate the Voyager I spacecraft as it passed Jupiter, artists such as David Em have had access to the computers and software developed by Blinn.

The simulation of nature imagery by computer was enhanced by developments in fractal geometry that were conceived and executed from 1975 to 1980 by Benoit Mandelbrot, a mathematician at the IBM Thomas J. Watson Research Center. The magnificent mountain imagery in Richard Voss's *Fractal Planetrise,* 1989, illustrates the different effects that are possible by changing the fractal dimension of the program [3.51]. "The central principle on which fractals are modeled is that of 'self-

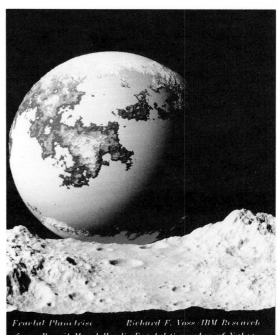

Fractal Planetrise Richard F. Voss /IBM Research from Benoit Mandelbrot's Fractal Geometry of Nature

similarity': every large form is composed of smaller, virtually identical units, themselves comprised of progressively smaller replications. . . . The geometry of fractals, with its seemingly magical capacity to recreate our world as a mathematical construction, has caught the imagination of artists as no other

A further computer technique, allowing for the creation of three-dimensional complexities, was "ray tracing." First worked on by the nuclear physicist Phillip Mittelman at MAGI in the late sixties, in experiments to develop nuclear radiation shielding, the technique was further developed in the seventies, but, unfortunately, was expensive because it necessitated intensive computer time. This technique "not only takes into account hidden surfaces, highlights, shading and shadows, but also copes magnificently with reflections, refractions, transparency, and textures."[20]

Beyond generating three-dimensional imagery, the computer was also incorporated in actual three-dimensional pieces. In 1970 James Seawright, in *Network III*, an installation at the Walker Art Center, incorporated a digital minicomputer. The piece was the first sculpture to contain such. When visitors to the exhibit walked across a carpet concealing pressure-sensitive plates, the programmed computer gave each person an individual pattern. The movements of each spectator were then flashed on a grid of lights suspended above the carpet. Seawright pushed the concept of interactive participation between art work and viewer in his *Network IV*, 1970–73, installed at the Seattle airport. Participants pushed buttons to create patterns on the wall-sized grid of lights. Seawright also worked with computerized lighting systems coordinated with electronic music for performances of the Mimi Garrard Dance Company from 1973 to 1978, and worked with Garrard, his wife, on a number of interdisciplinary pieces, such as *Night Blooming (Serious)*, a piece activated at night in the couple's garden, where sparkling rows and patterns of red LED (light emitting diode) lights in a dome-shaped cover that opened and closed were controlled by a computer inside the house. The program used was sensitive to the weather and instructed the dome to close when it rained.

One other artist who like Seawright was among the first to explore interactive sculpture was Wen-Ying Tsai, who came to the United States in 1950 and earned a degree in mechanical engineering from the University of Michigan. After receiving a John Hay Whitney Opportunity Fellowship for painting in 1963, Tsai worked in the field of art. While a fellow at MIT's Center for Advanced Visual Studies, beginning in 1969, he devoted himself to the use of modern technology in the visual arts, believing strongly that "the only hope to harness the immense power of modern tools for the real benefit of mankind lies in the direction of artists working to reunite art and contemporary science and technology."[21] He has created elegant cybernetic sculptures that incorporate vibrating steel or fiberglass rods and high-frequency electronic flashes whose movements are controlled by computer programs that interact with the viewer. In his *Cybernetic Sculptures A and B*, the graceful and lyrical movements of the fiberglass rods are controlled by audio input, such as voices or hand clapping, and by a preprogrammed pattern so that two different sources of movement are possible.

As is evident in the above examples, the marriage of art and technology and the combined efforts of artists and scientists continued significantly as the seventies progressed. Emphasis on the use of technology was not only a response to a yearning for "the new" but also a response to a rapidly changing world. As Herbert Shore, director of the UNESCO-related Consortium on Technology, the Arts and Cultural Transformation (TACT), noted, "The older-classical-art impulses are dying, not because the technological world no longer is sensitive to the skill of the painter's hand, but because the artist senses the need for something more, escape from old structures and strictures, an attempt to become an integral part of life

itself, the seeking of new harmonies of relationship with nature and the universe."[22]

The great diversity of experiments and optimistic pluralism of the seventies was a change from the disillusionment of much of the larger culture in the sixties. Abandoning the starkness and coldness of Minimalism, artists became more concerned with narratives, contexts, systems, and social concerns. There was some danger by the end of the decade, though, that pluralism might become an institution rather than a celebration of individual works and theories. In 1980 the critic Kim Levin, looking back at the decade, found some significant common concerns:

The schizophrenia of the recent art world resulted from a double bind: modern art, on which

contemporary artists had been weaned—the only art they really knew—no longer had anything to do with reality. Whatever it said to them of form and style was meaningless once it had been revealed that style was only an empty shell. . . . There may be a variety of personal styles instead of one style, but they were all talking about the same thing: a desire for content, a search for meaning. If we begin to realize that the unity is iconographic rather than stylistic, the confusions dissolve.[23]

In this quest for meaning, the visual arts in the seventies were not any easier to grasp than the art of the previous two decades. If anything, much of the work confronted the viewer more directly, raised questions, and did not give absolute responses but demanded that the viewer think and interact with the work.

NOTES: MULTIMEDIA AND INTERMEDIA, 1970S

1. Cited in Ellen Schwartz, "I Want to Put the Viewer on Shaky Ground," *Artnews,* June 1981, p. 96.
2. Ibid., p. 97.
3. Ibid., p. 98.
4. Carolee Schneeman, cited in Lucy Lippard, *From the Center: Feminist Essays on Women's Art* (New York: E. P. Dutton, 1976), p. 126. Lippard notes in a footnote, "The 1968 quotations are taken from Schneeman's book, *Cézanne She Was a Great Painter* (1975); the 1975 quotation was from another self-published book, *Up to and Including Her Limits* (1975)."
5. Lippard, *From the Center,* p. 125.
6. Ibid., p. 128.
7. Michael Walsh, "Post-Punk Apocalypse," *Time,* February 21, 1983, p. 68.
8. "Interview with Laurie Anderson," *Impressions,* Spring 1981, pp. 14–15.
9. Walsh, "Post-Punk Apocalypse," p. 68.
10. Cited in Jack Burnham, *Great Western Salt Works: Essays on the Meaning of Post-Formalist Art* (New York: George Braziller, 1974), p. 30.
11. *Radical Software,* first issue, 1970, inside cover.
12. Max Almy, "Video: Electronic Collage," in *Collage: Critical Views,* ed. Katherine Hoffman (Ann Arbor, Mich.: UMI Research Press, 1989), p. 355. This essay

clearly discusses some of the technological aspects of innovations in video art since its inception.
13. Charles Hagen, "Breaking the Box: The Electronic Operas of Robert Ashley and Woody Vasulka," *Artforum,* March 1985, p. 57.
14. Cited in Almy, "Video: Electronic Collage," p. 360.
15. Ibid., p. 371.
16. Harold Cohen, "Off the Shelf," *Visual Computer,* July 1986, p. 193.
17. Cynthia Goodman, *Digital Visions: Computers and Art* (New York: Harry N. Abrams, 1987), pp. 102–3.
18. Ibid., p. 103.
19. Ibid., p. 114.
20. John Lewell, "Ray Tracing Goes 'Full Length,'" *Computer Pictures Magazine,* May–June 1986, p. 1.
21. Wen-Ying Tsai, quoted in *Electra* (Paris: Musée d'Art Moderne, 1984), p. 166.
22. Herbert Shore, "No Future Wrapped in Darkness— Observations on Art, Culture, and Technology in a Changing World," *The Structurist,* Number 21/22, 1981/1982, p. 111.
23. Kim Levin, "The State of the Art," *Art Journal,* Fall–Winter 1980, reprinted in Kim Levin, *Beyond Modernism* (New York: Harper & Row, 1988), pp. 31–33.

IV

SEARCHING FOR HEROES:
THE 1980S

WHEREAS the journalist and novelist Tom Wolfe called the seventies "the Me decade," he called the eighties the decade of money fever. In the United States in particular there was an emphasis on making money, on commodities, on entrepreneurial projects. Donald Trump and Trump Tower were for many at the top of the ladder to be climbed. Works of art became an integral part of the emphasis on commodities and big business. By the end of the eighties the art world was becoming a complex web of big money, the politics of exhibition, dealer-gallery relationships, and conflicts between the artist's studio and the marketplace. In 1988 Picasso's 1905 work *Acrobat and Young Harlequin* from his Rose Period was sold at auction in three and a half minutes for $38.46 million. Sold to an unidentified Japanese businessman, the painting commanded the highest price paid at auction for a twentieth-century work of art. Earlier, Van Gogh's nineteenth-century *Irises* was sold for $53.9 million. The total amount spent the evening of the Van Gogh sale was $110.22 million, a new auction record for a single sale. In May of 1988 Jasper Johns's 1962 oil painting titled *Diver* sold at auction to Philadelphia Eagles owner Norman Braman for $4.18 million, the highest price then fetched for a work by a living artist. Shortly thereafter the record was topped for Johns when his *White Flag*, depicting an American flag with newsprint and white encaustic paint, sold at auction to a Swedish realtor, Hans Thulin, for a record $7.04 million. The painting had originally been purchased in 1958 for $1,200. The multi-million-dollar sales to corporate and business figures began to worry curators and museum directors, who feared soaring prices would prohibit many museums, particularly smaller ones, from buying and exhibiting good works of art for the general population. Perhaps the only museum truly able to compete was the enormously wealthy J. Paul Getty Museum, but it too was hesitant. As John Walsh, director of the Getty commented,

These buyers are getting some risky status symbols. The resale value on a $53 million Van Gogh is not a fixed thing like that of a Rolls Royce. There is an ocean of money out there from corporate acquisitions and mergers. There is a willingness to make a relatively small investment in interesting and exciting property like art. Some of these investments are solid, but there is a lunatic fringe out there. We will have to pay more, too, but we have set limits. Within them, we'll continue to seek out the rarest and finest. . . . I suppose the good news is that all these works being sold have not reached their final destination. They are still circulating in private hands and could still conceivably come to museums.[1]

Art was becoming a type of status symbol in certain affluent circles. As Tom Wolfe noted in an interview, "status is an influence at every level. You can't escape it. It's all part of what I call plutography: depicting the acts of the rich."[2] There was a sad irony, though, that this increased private spending was not matched by increased government and corporate support of the arts. By the end of the decade state arts councils in the United States and the National Endowments were targets for budget cutting. And "according to one study, contributions to the arts by corporations throughout the United States fell from a high of $547 million in 1986 to $496 million in 1987."[3]

While some thirsted for economic power and status, others thirsted for spiritual fulfillment. For some baby boomers entering midlife (in the United States there were over sixty million) the fixation on money, power, and materialism caused a spiritual void and the quest for something more. It was also "a season of remembrance, assimilating decades of war, antiwar protests, the women's, environmental and civil rights movements, and the ferment caused by Mikhail S. Gorbachev and leaders in Europe, Japan, the Middle East, and Latin America."[4] Joseph Campbell, a scholar and specialist in comparative mythology, became somewhat of a new cult figure as his 1949 book *The Hero with a Thousand Faces,* a comparative study of Eastern and Western myths, was on the *New York Times* best-seller list for sixteen weeks in 1988. A second book, *The Power of Myth,* based on Campbell's conversations with Bill Moyers, was on the list for over twenty-five weeks, and more than thirty-five thousand tapes of the Moyers-Campbell conversations were sold. The search for a new spiritual energy led to a religious emphasis, in a turning toward a variety of Christian, Jewish, Islamic, and Buddhist beliefs, as well as to individualized prayer outside any specific religious orientation.

The quest for renewed spiritual meanings

may also be seen as a response to events in the world at large. The decade opened with the eruption of Mount St. Helens in Washington in 1980. There was a botched U.S.-Iran hostage rescue, and Ronald Reagan was elected in 1980. In the same year the Iran-Iraq War began. In 1981 both President Reagan and Pope John Paul II were victims of assassination attempts, and Egyptian President Anwar Sadat was murdered. In the same year France elected its first Socialist president, François Mitterrand, while martial law was declared in Poland. The year 1982 brought the Falklands War, the United States' backing of the Nicaraguan Contras versus the Sandinistas and the death of Soviet President Brezhnev. In 1983 Lech Walesa, leader of the Solidarity movement in Poland, was awarded the Nobel Prize for Peace. In 1984 India's prime minister, Indira Gandhi, was assassinated, and Ronald Reagan was reelected. Mikhail Gorbachev became leader of the Soviet Union in 1985, bringing with him his policies of glasnost and perestroika, which created a new openness in the Soviet Union and increased contact and cultural exchanges with the West. In 1989 the opening of the Congress of People's Deputies marked the first national assembly in seven decades in the Soviet Union in which most members were chosen through competitive elections. In late 1989, the Berlin Wall was torn down, bringing promises of a more open Europe and hopes for a united Germany.

A push toward openness was also felt in China, where in early 1989 massive student demonstrations called for Prime Minister Li Peng's ouster and democratic reforms. A group of art students constructed and erected a twenty-seven-foot sculpture of plaster and plastic foam modeled after the Statue of Liberty in Tiananmen Square, in the heart of Beijing. Called the Goddess of Democracy and Freedom, the statue symbolized the students' common hopes for democracy. But the "Freedom Spring" was short-lived and ended in violence

and suppression as hundreds were injured and killed by government troops.

If there was increased tolerance in Soviet-Western relations, there was decreased tolerance of apartheid policies in South Africa. By mid-decade there were frequent anti-apartheid protests in both the United States and Europe. There were more terrorist attacks too by mid-decade—in particular the 1985 Palestinian attacks on the Rome and Vienna airports. In 1988 a terrorist bomb smuggled onto a Pan Am plane exploded over Scotland, killing most of its innocent passengers.

A 1986 nuclear accident in Chernobyl in the U.S.S.R. brought home the perils of nuclear power, and further inspired antinuclear movements and demonstrations. That same year also brought the tragic explosion of the Challenger Space Shuttle seconds after its take-off. A nation watched the television in horror as the crew of seven, including a New Hampshire schoolteacher, was killed before its very eyes. The U.S. Iran-Contra scandal was also exposed that year.

"Black Monday" came in 1987 as world stock markets plunged downward and many feared a severe depression similar to that following the 1929 crash. But the market rallied and revived, leaving the fever for money still very much a part of the decade. Another positive sign in 1987 was the Reagan-Gorbachev Washington Summit and the signing of the INF (Intermediate-range Nuclear Forces) treaty aimed at reducing missile arsenals in Europe. In 1988 a Reagan-Gorbachev Moscow Summit was held, and the U.S.S.R.'s withdrawal from its war in Afghanistan began. In 1988 the Republican George Bush was elected president of the United States, after a campaign that marked the immense power of the media, particularly television.

Outside the political arena, the world of science brought forth the first artificial heart transplant at the Utah Medical Center. Beyond the 1986 Challenger disaster, the space program had launched the first woman, Sally K. Ride, into space in 1983; brought back photographs of Saturn's rings with Voyager II; and sent up Giotto, a mission to Halley's Comet in 1986. What the world of science could not conquer was the scourge of AIDS, which in the eighties brought death to growing numbers of both the homosexual and heterosexual population. The disease inspired a number of artists to help raise money for research for its cure.

In popular music the decade saw Boy George, Michael Jackson, Bruce Springsteen, Prince, and Madonna rise to fame. Andrew Lloyd Webber captivated audiences with his musical extravaganza productions of *Cats* and *Phantom of the Opera.* The experimental compositions of Philip Glass and Steve Reich became more widely accepted. John Cage served as Charles Eliot Norton Lecturer at Harvard University. His composition *101* was created from 487 quotations from political, literary, and philosophical sources, chopped up by a computer using a program based on I Ching. There was an independent part for every member of the orchestra and it was performed without a conductor. One critic described the work as a "texture piece. It does not imitate the sounds of nature, instead by operating the way nature works, it *extends* nature. The origins of many of the sounds in the piece are not apparent, and silences are as important as sounds. But collectively they create a shimmer one could imagine as the sound the Earth makes as it journeys through space."[5]

Literary achievements included William Golding's *Rites of Passage* (1980), Gabriel García Márquez's *Chronicle of a Death Foretold* (1982), Keri Hulmes's *The Bone People* (1986), and Garrison Keillor's *Lake Wobegon Days* (1986). In 1989 Salman Rushdie's novel *The Satanic Verses* provoked a death contract from Iran's fanatical Ayatollah Khomeini, accusing the book of blaspheming Islam, the Koran, Moslems, and the prophet Mohammed. The book's controversy raised questions about

relationships between art, politics, and religion. (In June 1989 Khomeini died and was mourned by thousands in Iran.)

The film industry portrayed heroes and heroines from the common folk to the political to the extraterrestrial in a variety of guises. For example, there was Richard Attenborough's *Gandhi* (1982), Steven Spielberg's *E.T.* (1982), Sydney Pollack's *Out of Africa* (1985), Spielberg's *The Color Purple* (1985), and Bernardo Bertolucci's *The Last Emperor* (1987).

This search for heroes and with it a search for meaning was seen on a variety of levels, including the visual arts, during the decade. Both the goal and the process of the journey were important. As one young woman, after suffering a crushed hand in a sculpture foundry, wrote when she first regained the ability to type, using the words of Joseph Campbell, "A hero ventures forth from the world of common day into a region of supernatural wonder: fabulous forces are there encountered and a decisive victory is won: the hero comes back from this mysterious adventure with the power to bestow boons on his fellow man."[6]

NOTES: OVERVIEW, 1980S

1. Quoted in William Wilson, "Soaring Prices Have Museum Curators Worried," *Boston Sunday Globe*, November 20, 1988, p. 105.
2. Tom Wolfe, "Master of His Universe—An Interview," *Time*, February 13, 1989, p. 92.
3. William Honan, "Arts Dollars: Pinched as Never Before," *New York Times*, May 28, 1989, p. 20.
4. John Wheeler, "Theme for the 90's: A Rebirth of Faith," *Boston Globe*, November 10, 1988, p. 21.
5. Richard Dyer, "Cage: No Maestro, please!" *Boston Sunday Globe*, April 2, 1989, p. B2.
6. Quoted in Joseph Berger, "By Telling Legends, He Became One Himself," *New York Times*, December 10, 1988, p. 31.

PAINTING, 1980S

THE journey in search of new meanings and heroes and the emergence of passionate, imaginative, tactile, and often figurative imagery in painting gave a new birth to the medium of painting, which had been considered dead by some as events in the larger world of the sixties and seventies seemed to dwarf painting. As the seventies turned into the eighties, many artists looked for new heroes beyond the world of Modernism. The search for new heroic forms and content brought new and aggressive explorations of allegory and myth, both individual and collective.

The critic Barbara Rose wrote of this new birth in painting in the early eighties:

> Today, the essence of painting is being redefined not as a narrow and reductive anti-illusionism, but as a rich, varied capacity to birth new images into an old world. . . . Today, it is not the literal material properties of painting as pigment on cloth, but its capacity to materialize an image, not behind the picture plane, which self-awareness proclaims inviolate, but behind the proverbial looking-glass of consciousness, where the depth of the imagination knows no limits. . . .
>
> The idea that painting is somehow a visionary and not a material art, and that the loves of its inspiration is in the artist's subjective unconscious was the crucial idea that Surrealism passed on to Abstract Expressionism. After two decades of the rejection of imaginative poetic fantasy for

the purportedly greater reality of an objective art based exclusively on verifiable fact, the current rehabilitation of the metaphorical and metaphysical implications of imagery is a validation of a basic Surrealist insight. The liberating potential of art is not as literal reportage, but as a catharsis of the imagination.[1]

Neo-Expressionism was born and it struck a nerve that longed for passionate experience and imagination. With its multiple layers and colors, it rejected the cold purity of Minimalism. The roots of Neo-Expressionism lay in the German Expressionists of the early part of the century, the Surrealists, and the Abstract Expressionists. It also filled a void that, as Hilton Kramer noted, had existed for two decades.

> For nearly two decades, all the styles approved by "advanced" opinion had prohibited large areas of experience from playing any role whatever, in the creation of new art. More specifically, the experience of the sixties—not the art styles of the sixties but the social and spiritual experience—had been programatically denied entry into the pictorial imagination. Toward this realm of experience the visual arts adopted an amnesiac stance. Art seemed to have lost its capacity to pay attention to the world it occupied. The experience of the sixties and the changes it effected—in family life, in the relation of the sexes, in clothes, and work and education and religion—were declared off limits as far as painting was concerned.

An intolerable tension was created between art and life. It was in the attempt to relieve and resolve this tension that the Neo Expressionist movement was born. Its first task was to encompass the kind of poetry and fantasy that had long been denied to it. . . . Their paintings swamped the eye with vivid images and tactile effects, relying more on instinct and imagination than on careful design. The mystical, the erotic, and the hallucinatory were once again made welcome in paintings which were made to shun the immaculate and the austere in favor of energy, physicality, and surfeit.[2]

Neo-Expressionism or the "New Painting," as some termed it, was seen as an international tendency but there was no attempt by the artist to make art that was homogeneous or anonymous. Instead, individual artists and their native roots, in particular the Germans, the Italians, and the Americans, were able to shine forth, both consciously and unconsciously, as metaphor, myth, dreams, symbols, and mystery came to dominate the world of painting.

The emergence of Neo-Expressionism brought to European art a flowering and authority that had not existed since the advent of Abstract Expressionism, when the United States began to dominate the world of aesthetics and the visual arts. And as Carter Ratcliff noted in 1981,

Some of the New York art world are upset by much of the best painting and sculpture of the Eighties for the simple (and not very admirable) reason that it is European. . . . Manhattan is undergoing an invasion of extremely promising young painters from Europe. The MOMA citadel is being breached, and the New York art community has begun to pay close attention. They have no choice. Several leading New York galleries have become showcases for the invaders, American collectors are responding, and the idea of European dependence is becoming obsolete. In short, the American hegemony is at an end.[3]

Turning to Germany first, one found a group of painters trying to come to grips not only with personal mythologies but also with their troubled history and their heritage of Holocaust and a divided country. Among those first turning to a form of Expressionism was Georg Baselitz, born George Kern in 1938 in Deutschbaselitz, a town now in East Germany. Baselitz adopted the name of his birth place after moving to West Berlin in 1957 following expulsion from the art academy in East Berlin for "political immaturity." From 1960 to 1963 Baselitz published a number of manifestos and painted a *Pandemonium* series portraying non-mainstream and alienated figures such as Artaud and Lautréamont. During the height of the influence of Pop art in the mid-sixties, Baselitz painted a number of large heroic men hovering over a desecrated landscape. During the eighties he became particularly noted for his heavily impastoed, colorful canvases of upside-down figures, symptomatic of a world turned upside down and topsy-turvy. His 1983 *The Brücke Choir* [4.1] conveys anxiety as well as dignity. It also alludes to the earlier German Expressionist group Die Brücke, which fought against the growing materialism and dehumanization it felt existed in German society at the time. (Die Brücke was founded in 1905 by a group of young artists in Berlin.) Like the earlier group, Baselitz saw the bridge motif as a mode to pass from old conventions to a new, transformed world. There is a further historical allusion in Baselitz's work, for the original Bridge group took its name from a well-known passage in the prologue of Nietzsche's *Thus Spoke Zarathustra* (1883): "What is great in man is that he is a bridge and not an end; what can be loved in man is that he is an *overture* and a *going under.* I love those who do not know how to live, except going under, for they are those who cross over."[4]

Baselitz's figures appear to be literally "going under," perhaps to be transformed by the power of the music they sing or by art in general, if "music" is extended to represent the realm of art.

4.1. Georg Baselitz, *The Brücke Choir* (Brückechor), 1983. Emily and Jerry Spiegel Collection.

Markus Lüpertz illustrated a world of absurdity and anxiety inherent in a divided Germany in a seventies series based on German military motifs combined with artist's tools, such as a palette, and in the eighties with a forty-eight painting suite with eight related mixed-media sculptures based on themes from *Alice in Wonderland*. Themes of transformation, dominance, and a subtle sense of violence, which are part of the children's story, were apparent in pieces such as *March Hare (Märzhase)*, 1981.

Jorg Immendorff depicted German society as analogous to bizarre scenes in a nightclub or bar in his *Café Deutschland* series, where history, myth, and autobiography become intertwined. Immendorff had been a political activist and follower of Joseph Beuys, and tended to make more direct visual comments on German society than some of the other German artists of the time.

Beginning with my earliest ventures at the academy my work was affected by political activity. Initially, this involvement was more emotional. . . . Today my artistic expression is built upon and nourished by real experience which conveys authentic optical information, since I am no more isolated than my neighbor. We are all related as in a great network; only in this manner can man make contact and communicate.[5]

In Immendorff's *Nachtwache (Night-Watch)*, 1982, one sees the complex intertwining of political, personal, and mythical imagery, as man and beast become interchangeable. Evident too are numerous references to divided, seared, or torn images, which can only refer at least on one level to a divided Germany.

A. R. Penck's work tended to be more mysterious, suggesting a primitive coding. His mixing of stick figures, hieroglyphic, and graffitilike signs speak of personal and collective concerns. Until 1980 Penck lived in East Germany and

was forbidden to show his work there. He was forced to do his work in the West under an assumed name. (His real name is Ralf Wingler. The name Penck was borrowed from a nineteenth-century Ice Age geologist.) He eventually emigrated to the West. The brief text accompanying his 1982 painting *Dis(D#)*, points to some of his deep-seated concerns.

I'd almost like to keep quiet when I think of you,
 but then I'm startled and think: you've
 made language pointless.
You'd almost have choked me, throttled me,
 turned me to stone.
Now out of the distance and after I have lost all
 the chess games in the café, I can see more
 clearly: just what are your criteria?
What do you chieftains think, crouching like a
 minotaur at the heart of the labyrinth?
What haven't you considered?
Schizophrenia was pretty bad. The ballet mouse in
 the cat-suit died with electronic discipline.
What's your model? What's your picture?
Still I'm here and your generals dream about it.
 It's the bitter experience plus formal logic
 which still force me to think of you, and
 speak to you.
What is a picture, what is realism, what is
 dialectics?
I see your television tower signalling over the wall
 and still don't know whether your
 informers are paid or not.
Has your ideology won? . . .[6]

Penck's free-flowing distorted and disjointed symbols, which often looked like a combination of graffiti and hieroglyphics, as seen in *Am Fluss*, 1982 [4.2], illustrated Penck's perceptions of a world where traditions were shattered and transition and change were necessary.

Another exile from East Germany, Sigmar Polke, often used a mechanically patterned background on cheap fabric or grid on which he would paint or collage imagery often relating to contemporary society. In his *Hochstand*, 1984, one finds the eerie juxtaposition of a bed of brightly painted flowers and a watch or guard tower enshrouded in a blue and white lightning field, behind a partial screen of a mechanically produced gridlike fabric. The two "worlds" are joined by delicate swirls of dripped paint. In the late eighties Polke continued his somewhat irreverent approaches to painting by working on both sides of medium-sized canvases and displaying them on stands throughout a gallery space. Polke scattered various powdered materials across the resin-cov-

4.2. A. R. Penck, *Am Fluss (Hypothèse 3)*, 1982. Private collection.

ered canvases, and then created hybrid images with references to sources as diverse as the Neoclassical and Mayan periods. The translucent two-sided images were ambiguous visual puzzles.

Of all the German painters who received increased recognition during the eighties, perhaps Anselm Kiefer stood out most strongly. In 1988 a survey of his work at the Museum of Modern Art in New York, the Chicago Art Institute, and the Philadelphia Museum of Art gave Americans an opportunity to experience the full range and power of his monumental paintings, as well as his prints and books. Kiefer's paintings are more than paintings: the viewer is lured into a physical and instinctual world of myth, religion, and history, with Kiefer's extraordinary combination of materials, such as acrylic, emulsion, and oil paints entangled with straw, sand, shellac, or molten lead. Born in Bavaria in 1945, two months before the end of World War II, Kiefer was raised Roman Catholic and denied "access" to the whole Nazi era and subsequent division of Germany. In his paintings he often attempts to come to grips with those elements of German society which had been repressed.

In art school he was influenced by the teachings of Joseph Beuys and Beuys's belief in alchemy and the transformative powers of the artist. One of his important early paintings, *Nero Paints,* which he showed in 1975, depicted a field with blood dripping from its deep furrows, on which was superimposed the outline of a large, burning painter's palette. The title refers to the ancient Roman emperor Nero's watching the destruction as well as "cleansing" of Rome, and at the same time believing in the cleansing power of fire attributed to alchemists. Elements of scorching and burning have occurred frequently in Kiefer's work. "Scorched earth is a technical term used in the army," Kiefer has explained. "Retreating troops set fire to the area they are leaving so that the enemy won't be able to grow crops there anymore. . . . I don't want to illustrate an

ordinary military operation, but to depict the problem of the contemporary art of painting. If you like, you might view it as a new start that every painting has to make. Each work of art destroys the one before it."[7]

Kiefer draws often on apocalyptic or elegiac themes from mythical and historical events and persons, such as Brunhilde and Siegfried, the Meistersinger of Nuremburg, the blue-eyed, blond-haired Margarethe from Goethe's *Faust,* and the young Jewish Shulamuth from the Song of Solomon. The expansive and expressive qualities of the work also recall the inner mythologies of a Jackson Pollock. In his vast and grandiose *Osiris und Isis,* 1985–87 [4.3], Kiefer presents both hope and despair. The heavily textured surface that contains paint, mud, earth, rock, tar, and bits of ceramic and metal carries allusions to creative and destructive forces. According to one version of the Egyptian myth, the god Osiris, who was slain and cut into pieces by his brother, Set, was brought back to life by his wife and sister, Isis. In Kiefer's work, Isis becomes linked with a television circuit board atop a pyramid, with wires extended to parts of Osiris's dismembered body, intimating possibilities of regeneration through both technological and spiritual forces. The themes of creation and destruction, hope and despair, seperation and regeneration or unification can also be seen as being closely allied to German history. Some have called Kiefer a history painter, but he really goes beyond history as he lifts his allusions to deeply rooted inner realms of the mind that are often locked or hidden by social conventions and tradition.

In 1984 Kiefer became the first contemporary German artist to be given a retrospective at the Israel Museum in Jerusalem. The *Jerusalem Post Magazine* wrote, "Mourning might be the key to the psyche of Kiefer. It is not a mourning of the Jews of our times. Kiefer seems to be mourning the indigestibility of his heritage by battling it with an ongoing series of waking dreams."[8]

4.3. Anselm Kiefer, *Osiris und Isis*, 1985–87. San Francisco Museum of Modern Art.

The presence of the past was also evident in the work of a number of Italian artists, who also came to be associated with Neo-Expressionism or the New Painting. As indicated earlier, the term *trans-avant-garde* was also applied to a number of these artists, particularly the Italian artists. The three *C*'s—Francesco Clemente, Enzo Cucchi, and Sandro Chia—of the Italian trans-avant-garde were noticed in particular at the 1980 Venice Biennale.

Born in Naples in 1952, growing up in the shadow of Mount Vesuvius, Francesco Clemente was the only child of affluent parents (his father was a judge). He began writing poetry at about age six and turned to painting by the time he was an adolescent. "Painting became a way of realizing my sexual identity at an age when we are very conscious of sex, but I had always been exposed to art. Titian, Raphael, Goya, Caravaggio, Botticelli—they were all around me. And the frescoes of Luca Giordano."[9] Clemente never attended art school, but when he was eighteen he moved to Rome

and began making what he called his "signature" images—such as gargoylelike heads and nude goddesses with gaping eyes and sensuous mouths.

Clemente found inspiration in a great variety of sources from the past—the Egyptians, the Greeks, the Romans, the Renaissance, the Baroque period, William Blake—and has been fascinated with both Eastern and Western religions. He first went to India in the early seventies and later began to divide his time among residences in Madras, where he studied Buddhism and Sanskrit, New York, and Rome. He has been inspired by contemporary painters such as Cy Twombly, Julian Schnabel, and Brice Marden.

A major work of Clemente's in the eighties was his cycle of twelve large paintings (with two companion paintings), *The Fourteen Stations* [4.4], which combines the suffering of Christ on the road to Calvary with Clemente's private fantasies and dreamlike, often erotic, imagery. In number eight of the series one sees

292

4.4. Francesco Clemente, *The Fourteen Stations, No. VII*, 1981–82. Gagosian Gallery, New York.

a helpless nude strewn with women's shoes as rats scurry below. In this, as in a number of Clemente's works, there is an underlying sense of violence that pervades the otherwise transformative qualities of the work.

The slightly older Florentine Sandro Chia, born in 1946, has been considered one of the most important artists to come from Florence since Bronzino in the early sixteenth century. In his turn to richly colored expressionist paintings, after having been involved with Minimalism and Conceptualism, he too was to emphasize the transformative quality of painting, with an almost religious fervor.

> I've been through conceptualism, minimalism, everything. There is a new richness to our perception because we went through all that. Now that it's possible to look at paintings again, we see it not only as paint on canvas, but as something else. . . . A painting is not just an object: it has an aura again. There is a light around the work. It is a miracle in a way. A total concrete, physical miracle. Painting is made with heavy things—stretchers, canvas, paint. Heavy duty things. But they become light.[10]

Chia often uses mythic imagery, but with wit and sense of parody. His 1981 *The Idleness of Sisyphus* [4.5] uses the myth of the Corinthian king condemned to the repetition and frustration of eternally pushing a giant boulder up the side of the mountain only to have it roll back down as the gods watch, laughing. Chia's portrayal of Sisyphus in a business suit points to a bankruptcy in modern life. Chia's portrayal is sympathetic not to the victim, though, but to the laughing of the gods. His work raises questions about the nature of the hero in modern society.

Enzo Cucchi, of Ancona, Italy, used richly impastoed surfaces and often used pottery, rocks, and hunks of wood or metal in his apocalyptic and often doom-filled images. His *Vitebsk-Harar*, 1984 [4.6], evokes a sense of the "day-after," with a hint of the redemptive power of art as the grand piano remains standing, alone, upright, in the wash of what appears to be a wave of destruction.

Also associated with the trans-avant-garde in Italy were Mimmo Paladino and Nicola de Maria. Death looms large in Paladino's paint-

4.5. Sandro Chia, *The Idleness of Sisyphus*, 1981. The Museum of Modern Art, New York.

ings, as he uses skeletons and animals often in mythical imagery to delve into an eerie life and death of the spirit. His 1982 *Presepe (Crèche)* with its circle of a dozen dogs on a blood-red background, eating and playing about a dog asleep or dead in a crèche, has been likened to a parody of the Last Supper, where the black dog is Judas and the dog in the crèche is a Christlike figure. A human torso looks on from the back of the circle while red enshrouded figures as well as a vulturelike form loom menacingly in the background. Several crosses are placed randomly near the dogs on the right. Whether the painting is a parody of the Last Supper or not, the piece forces the viewer to explore deep, instinctual levels of the human psyche that have a kinship to Paladino's skeletal animal forms. Paladino has referred to his interest in penetrating to such levels:

> I paint, draw animals spontaneously, because they please me and because I am interested in

nature. Nature possesses something mysterious: its impossibility of communication with people. Nature is original, wild, always fascinating, always new to discover. I am interested not only in the context of art, but in the mysterious, the inexplicable, the forgotten. When I create a work I want to penetrate these areas.[11]

Nicola de Maria delighted in the color and light that is often associated with the Italian landscape that has inspired artists for centuries. He became known for his completely colored rooms of abstract shapes and colors, such as the one at the Villa Celle, painted between 1975 and 1982 with its orange crescents and green panel floating on a brilliant blue, with a painted red and green suitcase on the floor, which spoke of a transcendent journey to a world of colored music. His later more conventional-sized paintings employed images of germination and fertility as in his *Reign of Flowers*, 1983–84.

Although the European return to an emphasis on painting and expressionist tendencies was probably strongest in Germany and Italy, these countries did not stand alone. In France, arising from the provinces, was a young group of artists associated with the term *figuration libre* (free figuration) led by Robert Combas, who came from a working class family on the southern coast of France. The young artists rebelled against the reductive abstractions of the Support/Surfaces group in Paris. Combas's work, like others in the group, was filled with imagery from cartoons and vulgar jokes, with graffitilike forms. Another member, Jean-Charles Blais, born in 1956 in Nantes, was less dependent on cartoons and turned to painting on posters torn from the subway which had been repasted and covered up, thereby dealing with multiple layers of contemporary society from the very beginning of each work.

In Spain, newly awakened from the isolation of the Franco era, the works of the Barcelona painters Ferrán Garcià Sevilla and Miguel Barceló were both vibrant and provocative.

Although expressionist tendencies were not as strong in Great Britain, there were several artists whose work appeared to be a part of this spirit of the times, and were included in the 1982 international "Zeitgeist" exhibit in Berlin. Bruce McLean, originally trained as a sculptor, and then working in performance arts, produced a series of exuberant linear, figurative pieces containing scattered words on black grounds that resembled blackboards and chalk drawings. His *Contained (Historically, Politically, Physically)*, 1982, with its concentric circles of intertwined human forms, speaks to the viewer more intellectually than intuitively or emotionally, quite different from a Clemente or Kiefer.

More of the mythic and intuitive was to be seen in the work of Christopher LeBrun, whose Pegasuslike images are highly poetic and even romantic, as seen in *Dream, Think, Speak,* 1982, as the mythic horse emerges from darkness into light. Even these somewhat expres-

4.6. Enzo Cucchi, *Vitebsk-Harar*, 1984. Courtesy Sperone Westwater Gallery, New York.

sionist pieces have a sense of calm and order about them that is quite different from the Germans or Italians mentioned above. In general, the British art of the time did not tend to emphasize the unconscious and all the emotive, intuitive, and even irrational elements that went with it. Indeed, the artist Malcolm Morley was to state, "One of the problems that you never hear talked about in Britain—nobody really talks about it anywhere—is the role of the unconscious in art and the discovery of the unconscious through the medium of art. I don't think I could have done anything if I'd stayed in England; I would have become a drunk!"[12]

In the United States the spirit of Neo-Expressionism was to be found in the work of such artists as Julian Schnabel, David Salle, Robert Longo, and Eric Frischl. The Brooklyn-born (1951), Texas-educated Julian Schnabel at the age of thirty began to receive international acclaim with his epically scaled, aggressive paintings on velvet, and paintings made with broken crockery and other found materials. Schnabel

dealt with mythical and religious themes, but reworked them, often in vulgar and harsh representations that spoke of a world turned upside down, and one searching for new myths. *Geography Lesson,* 1980 (one of four paintings from *Huge Wall Symbolizing the Fate's Inaccessibility*), a painting on velvet, creates a curious tension suggested by allusions to contemporary and classical worlds with the classical column, mighty red buck, and sketchy young schoolchildren surrounding a partially rendered globe. The use of velvet provides a further ambiguity as one thinks of the royalty and richness associated with velvet, as well as the cheap and tawdry velvet paintings often found in discount- and dimestores, a "low" art.

But it was his powerful and dramatic "plate" paintings that contained electrifying surfaces of color and texture, that appealed to many who were starved by the smooth, clean geometric surfaces of Minimalism. The colored shards of pottery in a piece such as *King of the Wood* [4.7], 1984, heighten its drama (the piece

4.7. Julian Schnabel, *King of the Wood,* 1984. Courtesy The Pace Gallery, New York.

also includes spruce roots). The rough, raw materials and their kinship to archaeological digging tend to evoke the rawness of human emotions that are often hidden or suppressed by social conventions. *King of the Wood,* whose imagery is said to relate to a passage from James George Frazer's *Golden Bough,* is also about the hero, caught between life and death, that Schnabel raised to the contemporary eye. The figure in the painting depicts the priest-king of the wood at Nemi, a sanctuary for the goddess Diana. The golden bough taken by Aeneas for protection to the nether world supposedly came from the sacred tree. The legend further indicates that if a runaway slave broke a branch from the tree, he could challenge the king to combat and take his place if successful. Issues of power, mastery, and territory are thus inherent in the piece—all issues in the contemporary world, at all levels of society. Perhaps more important than specific imagery or iconography in Schnabel's work is the emotive power in the grandiose gestures and surfaces of the work. "My painting," Schnabel said,

is more about what I think the world is like than what I think I'm like. I'm aiming at an emotional state, a state that people can literally walk into and let themselves be engulfed by. . . . Maybe I make paintings larger than I am so that I can step into them and they can massage me into a state of unspeakableness. The paintings in my last show are the view from the bridge, the bridge between life and death. I think about death all the time.[13]

For some, however, Schnabel's ego was as large as his paintings, and he was merely an example of an aggressive entrepreneur working with the gallery system, successfully marketing his work and rising quickly and deliberately to the status of celebrity. By the age of thirty-five he had also written a memoir, *CVJ: Nicknames of Maitre D's and Other Excerpts from Life,* published by Random House. The critic Robert Hughes was to write in a piece entitled "The Artist as Entrepreneur,"

There was a more than accidental correspondence between Schnabel's success in meeting the nostalgia for big macho art in the early 80's and Sylvester Stallone's restoration of American virtue in the character of Rambo. . . . But the American art world, despite its recent fixation on "irony," does not have much sense of humor; too much is at stake to entertain the thought that a hero might be a buffoon. Like the political analysts who insisted that Ronald Reagan's "image" would never succumb to the truth of his dim-wittedness, some art critics persist in treating Schnabel as though his fame were a given fact of culture which no perception of the ineptitude of his work can alter. "No one expected him," Thomas McEvilley pants in his essay in the catalog of the Schnabel retrospective. . . . "No one knew they wanted him. Yet somehow the age demanded him. . . . There is nothing anyone can do about it." The notion that this man is an emanation of the zeitgeist matches his fantasies about himself.[14]

Despite the controversial criticism of Schnabel and his paintings, the strong impact of his work and persona cannot be discounted.

No less dramatic than Schnabel's work were the drawings, paintings, and assembled pieces of Robert Longo. Born in Brooklyn in 1953, a first-generation American, Longo grew up in an accountant family striving to rise into the middle class. Longo did poorly in school and was finally diagnosed as dyslexic as a senior in high school. He went to North Texas State near Dallas to study music but switched to art since he could not read the music. He did not stay in Texas, and finally graduated from the State University at Buffalo in 1975, where he met Cindy Sherman at the art school. He moved to New York with Sherman in 1977 and first became noticed by the art world for his large-scale black and white charcoal drawings, such as his *Men in the Cities* series, 1979–82, and the *White Riot* series. The *Men in the Cities* series was made from photographing his friends

dressed in business clothes in contorted poses achieved when Longo tossed balls at his friends or jerked them with ropes. The contorted poses seem to speak of the underlying pressures and tensions of corporate and urban life. Longo also created large assembled pieces that often contained sculpture (wood carving, stone, intaglio, or bronze casting), painting (acrylic, spray paint, and gold leaf), drawing, silk screen, and photography. Works such as *Ornamental Love,* 1983, and *All You Zombies (Truth Before God),* 1986 [4.8], often contained taut contradictions in imagery and format, creating a rising tension based on ambiguity. In *Ornamental Love* a collapsed highway (linoleum and metal) is juxtaposed next to a tightly cropped red-filtered

image of a couple kissing (painted panel) as gold-leaf flowers (cast bronze) appear to emanate from the man's ear. Themes of love, death, destruction, and power are thus intertwined. In *All You Zombies* one sees references to classical and futuristic images as well as an exploration of power. "Artists are like guardians of culture," Longo declared. "I'm totally obsessed with the idea of human value. I feel that I'm contributing to my culture, posing certain questions about living and the pressures of living today."[15]

Eric Fischl used heroic scale and a rich painterly technique to explore middle-class taboos, which became linked with Freudian interpretations and narrative structure. Fischl's

4.8. Robert Longo, *All You Zombies (Truth Before God),* 1986. Metro Pictures, New York.

4.9. Eric Fischl, *Bad Boy*, 1981. Saatchi Collection, London.

suburban figures, often naked, frequently hint at an underlying alcoholism, voyeurism, or homosexuality. But more important than these specific taboos is the pervasive state of vulnerability and psychological nakedness and self-consciousness seen in his subjects. In one of his best-known paintings of the early eighties, *Bad Boy* [4.9], Fischl depicts a young adolescent's discovery of sexuality as a nude older woman exposes herself to a clothed young boy who at the same time appears to be pilfering the woman's purse. The bowl of fruit, in particular the bananas and apples, carries further themes of masculine and feminine sexuality as well as temptation. Beyond the sexual themes, it is the moment of self-consciousness and awkwardness for the subjects of the painting, as well as for the viewer, that is an important component of the piece. One must further ask, Why is the boy bad? Is it because he stands observing the woman or because he is going through her purse? Money and sexuality become subtly intertwined. In other works Fischl becomes more of a social critic. In *A Brief History of North Africa*, 1985, he depicts cultural confrontation in an eerie beach scene.

Although not directly associated with the young Neo-Expressionists quickly rising to public recognition, the older Leon Golub (born in 1922), with his large-scale expressionist, socially critical paintings, usually depicting mercenary, tortuous, and violent situations, was very much a part of the rising expressionistic aesthetic. In 1982 Golub had a one-person show of his *Mercenary* series at the Susan Caldwell Gallery—his first in nearly twenty years. In the sixties and seventies he painted his *Gigantomachies*, expressionist images of warring classical nudes. He also did a number of paintings in the seventies related to the horrors and tragedies of the Vietnam War, but destroyed many of them, and considered giving up painting. His *Riot* se-

ries of the mid-eighties was based on photographs he had saved of 1976 riots at Thammassat University in Bangkok, where forty-one students were killed by the violence of the police, army troops, and other students calling themselves the Red Gauns. As early as 1959 Golub had written, "Man is seen as having undergone a holocaust or facing annihilation or mutation. The ambiguities of these huge forms indicate the stress of their vulnerability versus their capacities for endurance."[16] By the eighties his work was less ambiguous and more explicit. In his *Interrogation II* [4.10], for instance, one clearly sees the potential for man's inhumanity to man. The blood-red monochromatic background further emphasizes the violence of the image. The cultural violence

depicted by Golub as well as a number of other artists reflected too the growing violence in society at large, which was portrayed somewhat differently than the art of earlier decades dealing with cultural violence. "Today's images are not simply representative, as in the sympathetic style of social realism or in the ambiguous fashion of Warhol's electric chairs. Rather, artists today critically confront the complex, interactive role of art in a culture that is dominated by fragmentation and dislocation, and is fraught throughout with violence."[17]

David Salle, a native of Oklahoma, united both public and "private" images by working mainly with appropriated images. His assembling of disconnected images illustrated to the viewer where he or she might stand in contem-

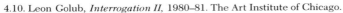

4.10. Leon Golub, *Interrogation II*, 1980–81. The Art Institute of Chicago.

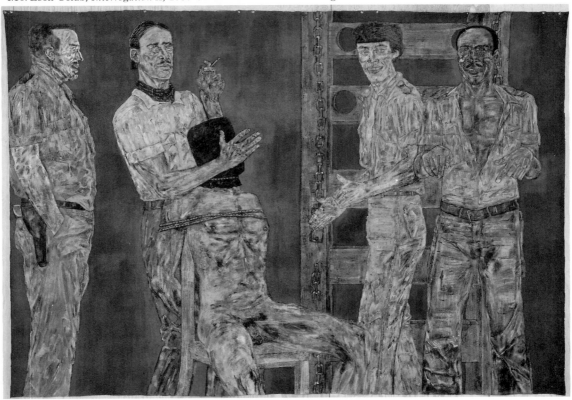

porary society—often overloaded with media, mythical imagery, information systems, and sometimes feeling schizophrenic, torn between realities. Salle borrowed from Minimalism's smooth surfaces, Jasper Johns's juxtaposition of contrasting imagery, and other periods in art history, as well as comic books and popular illustrations. Salle has spoken about his appropriation of various images: "It is the way things appear in reproduction, the way things appear through various forms of presentation, that's what's interesting to me. The original source is never really very interesting to me. . . . Basically I'm attracted to images which are either self-effacing or self-conscious or both. The way I used to experience it was: images which seem to understand us . . ."[18] His juxtaposition of imagery and the play on words in *Intact Feeling* [4.11], 1984, provokes several questions: What is the meaning of intact or tacked in? Is the body intact or subverted or distorted, or serving as background for an overlay of a wooden fence and landscape forms? Where does feeling emanate from? What are the sexual connotations in the piece? Is the piece sexist? The format itself is reminiscent of film frames.

Like Salle, the somewhat older Ida Applebroog borrowed everyday events from television, film, magazines, commercials, cartoons, and art history, and recycled them. Much of her work raised questions about gender, politics, and violence, but offered no solutions. In a piece such as *Two Women III*, 1985, the viewer is forced to wrestle with questions of gender, male and female roles, and stereotypic images of the feminine or female. One sees a panel with men in beauty pageant sashes imprinted with Mr. Utah, Mr. Idaho, and so forth juxtaposed beside a painting of a garish green, corseted, open-mouthed woman. Beside her is a de Kooning-style woman and another nude woman, urinating. The piece is both humorous and deadly serious when one considers its connotations and implications.

The appropriationist vocabulary used by a

4.11. David Salle, *Intact Feeling*, 1984. Private collection.

number of artists, including Salle and Applebroog, was termed *cultural cannibalism*[19] by one artist, Thomas Lawson, who also used such vocabulary in his work. In his essay *A Fatal Attraction: Art and the Media*, Lawson elaborated further his perceptions of the appropriationist and pastiche aesthetic, and the influence of the mass media:

This work is conditioned by an understanding that the insistent penetration of the mass media into every facet of our daily lives has made the possibility of authentic experience difficult, if not impossible. Our daily encounters with one another, and with nature, our gestures, our speech, are so thoroughly impregnated with a rhetoric absorbed through the airwaves, that we can have no certain claim to the originality of any of our

actions. Every cigarette, every drink, every love affair echoes down a never-ending passageway of references—to advertisements, to television shows, to movies, to the point where we no longer know if we mimic or are mimicked.[20]

Salle's and Lawson's work was a part of the larger Post-Modernist aesthetic that pervaded the eighties, as the absolute status of representation was challenged. As Fredric Jameson wrote, "Modernism's formulation of the problem of representation [was] borrowed from a religious terminology which defines a representation as 'figuration,' a dialectic of the letter and the spirit, a 'picture language' (Vorstellung) that embodies, expresses, and transmits otherwise inexpressible truths."[21] Post-modernism was characterized by its "resolution to use representation against itself to destroy the binding or absolute status of any representation."[22] "Post-modern artists demonstrate that 'reality,' whether concrete or abstract, is a fiction, produced and sustained only by its cultural representation."[23] Further, Jean Baudrillard's concept of the "precession of the simulacra" well described what appeared to be the nature of simulation and reality for a number of artists and critics:

> Simulation is no longer that of a territory, a referential being, or a substance. It is the generation by models of a real without origin or reality; a hyperreal. The territory no longer precedes the map, nor survives it. Henceforth, it is the map that precedes the territory—PRECESSION OF SIMULACRA—it is the map that engenders the territory. . . . [O]f the same order as the impossibility of rediscovering an absolute level of the real is the impossibility of staging an illusion. Illusion is no longer possible, because the real is no longer possible.[24]

Post-Modernism for some also contained elements of schizophrenia. In his essay "Post-Modernism and Consumer Society," Fredric Jameson described the schizophrenic experience (derived largely from the work of French psy-

choanalyst Jacques Lacan) as a basic feature of Post-Modernism. He saw schizophrenic experience as "an experience of isolated, disconnected, discontinuous material signifiers which fail to link up into a coherent sequence."[25] As "others among others,"[26] individuals, according to some theorists, had lost their identities and were afloat in space and time, grappling with concepts of and relationships to a variety of realities. In confronting the world and grappling with changing concepts of reality/realities artists turned to methods such as appropriation, deconstructive processes, layered images, and more expressionist formats in search of some type of grounding and meaning in the contemporary world. It is perhaps important to note that neither Neo-Expressionism nor the use of appropriation were terms to be applied to a cohesive movement or group of artists such as the Abstract Expressionists. Rather, the terms are perhaps better used as evidence of a particular Zeitgeist, as artists emerged from their particular cultural heritages. It was perhaps only in Germany, where a number of artists responded to their unique history, that some sense of cohesiveness may be seen.

Neo-Expressionism, with its large, heroic canvases, was also the kind of style that appealed to a new generation of art collectors who had made money quickly at an early age on Wall Street and in the corporate world. For many art became another investment, as the young collectors looked at artists' track records and often sought the macho-like paintings. And to be noted is the fact that there was a kind of backlash for the acceptance of women artists in the early eighties. One collector noted, "I'd never buy a woman artist. They quit in mid-career to have babies."[27] In general, "the period from 1980 to 1985 was a discouraging one for many women artists. Although they made up nearly 40% of the professional artist population in the United States (according to U.S. Census figures), they were still very far behind their male counterparts in gallery representation, in

museum showings and in the permanent collections of major museums, and in earning capacity."[28] In 1984 a feminist group, donning guerilla masks and calling themselves the Guerilla Girls, arose to make public appearances protesting the curatorial selection at the Museum of Modern Art's 1984 "International Survey of Painting and Sculpture," which included only 14 women among the 165 artists represented, and other instances of discrimination against women in the art world.

Neo-Expressionism and the postmodern era opened the door to the exploration of other expressive formats. Of particular interest for a number of younger American artists was the use of graffiti and cartoons. The East Village in New York, with places such as Club 57, a church basement converted into a nightspot for the neighborhood's youth, served as a meeting ground for young art students, particularly those from the School of Visual Arts, and untrained "graffiti" artists. The Fun Gallery was also opened in the East Village to sponsor graffiti-oriented art. And in the South Bronx a storefront gallery, Fashion Moda, sponsored by the National Endowment for the Arts, also encouraged works on canvas by graffiti artists who had used subways and city walls as their surfaces. In 1980 the unorthodox Times Square Show, sponsored by Fashion Moda and CoLab (Collaborative Projects, Inc., an organization founded in 1977 by about thirty artists who felt they were locked out of the commercial system), celebrated graffiti-oriented art in a nontraditional setting. Held in a run-down midtown Manhattan building formerly occupied by a massage parlor, the exhibit was also a showcase for artists who had no gallery affiliation. The dilapidated building was transformed into a total environment of living street art. Walls, closets, stairwells, toilets, and the like were so covered with art works that it was sometimes difficult to tell where each piece ended. In 1983 graffiti art was recognized internationally with the first museum exhibition of graffiti art by Rotter-

dam's Boymans-Van Beuningen Museum. In 1989 the Museum of American Graffiti, the brainchild of the East Village painter Martin Wong, opened on Bond Street in downtown Manhattan. The building was owned by Japanese investors who planned to underwrite the cost of the museum with the income from shops and restaurants in the building.

Three figures to emerge as major influences in the graffiti celebration were Keith Haring, Kenny Scharf, and Jean-Michel Basquiat. Trained at the School of Visual Arts, Haring, beginning in 1980, made his mark in public spaces by making graffiti drawings on temporary black poster blanks throughout New York's subway system. He expanded on his black and white drawings to make large colorful canvases, often containing Azteclike patterns and cartoonlike forms, which came to be sought after in the commercial gallery world [4.12]. One of his best-known works was a three-hundred-foot mural he painted on the Berlin Wall in 1986. The mural contained a row of black and red human figures on a yellow background—using the colors of the East and West German flags. Haring died at the age of thirty-one, of AIDS, in February 1990.

A classmate and companion of Haring's at Club 57 was Kenny Scharf, whose boldly colored, dazzling canvases drew inspiration from the Hollywood world he grew up in—color T.V., cartoon characters such as the Jetsons and Flintstones, and the promise of a "space age" existence that permeated his childhood. Scharf recalled his fascination with color television: "I used to sit down and hallucinate in front of the T.V. . . . It didn't matter what you watched if you were that close to it, it was just color. I remember watching the Kennedy assassination and my mother screaming all of a sudden. I remember thinking, why is she so upset? I see people getting murdered all the time. We always watched people getting shot on T.V., and she never did anything."[29] His large ten-by-seventeen-foot canvas *When the Worlds Col-*

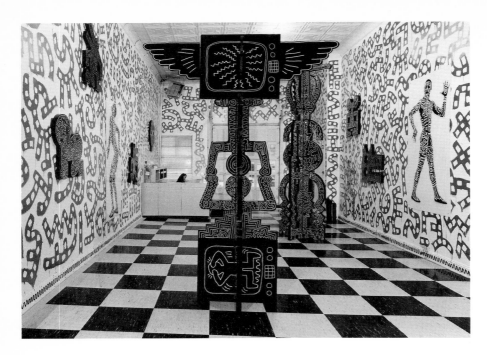

4.12 *(left)*. Keith Haring, one-man show, December 1983–January 1984. Tony Shafrazi Gallery, New York.

4.13 *(opposite, top)*. Kenny Scharf, *When the Worlds Collide*, 1984. Tony Shafrazi Gallery, New York.

4.14 *(opposite, bottom)*. Jean-Michel Basquiat, *Untitled*, 1981.

lide [4.13] is a combination of surreal, psychedelic, science fiction, and cartoon worlds that collide and frolic together. There is no sense of anxiety or dread, of worlds unknown, but a sense of fun and exuberance.

The young Jean-Michel Basquiat, born in Brooklyn of Haitian-Hispanic descent, initially signed himself with a friend Al Diaz, SAMO© in their felt marker messages and spontaneous graffiti throughout New York. Dropping out of school at seventeen, Basquiat was basically untrained as an artist, although his art revealed influences of Picasso, African masks, and graffiti and hieroglyphiclike forms, as seen in his 1981 *Untitled* [4.14]. He rose quickly, though, to a certain stardom, which some felt may have been his undoing. He died tragically at age twenty-seven from a drug overdose. At age nineteen he did not have a place to live. By age twenty-four his paintings were selling from ten thousand to twenty-five thousand dollars. His friend Keith Haring spoke of the art world and Basquiat shortly after his death:

Achieving success was not a problem for Jean-Michel, . . . success itself was the problem. The art world is always eager to add some flavor to its increasingly tired, market-oriented establishment. However, in their haste to find new blood, honesty is sometimes replaced by superficiality. The hype of the art world of the early eighties became a constant blur. . . .

The ease with which Jean-Michel achieved profundity convinced me of his genius. A seemingly effortless stream of new ideas and images proved the potency of his vision. His life and philosophy, which taught by example and bold gestures, elevated him to the role of a teacher. But perhaps it was his simple honesty that has made him a true hero.[30]

In Chicago there was continued interest in cartoonlike and Neo-Pop imagery in the work of the Chicago Imagists, which had its beginnings in groups such as the Hairy Who of the sixties. Using intense color, often in unmodulated blocks, and intricate, refined techniques of painting rather than large gestural strokes, the Chicago Imagists, such as Roger Brown, Art Green, Gladys Nilsson, Ed Paschke, and Karl Wirsum, drew on influences from both high and popular art. These sources were wide ranging—from Persian miniature painting and de Chirico and Magritte to comic books, amusement parks, and children's cheap toys. In Jim

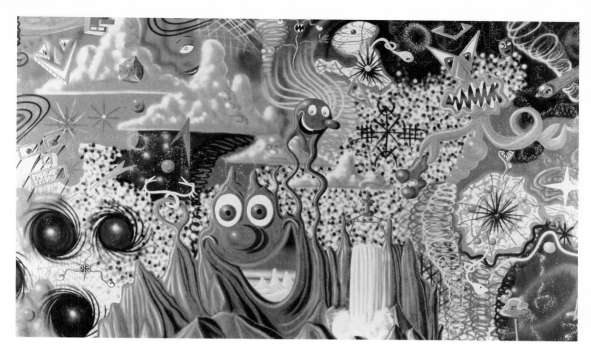

Nutt's *Another Mistake,* 1983, one sees an amalgam of surreal, Pop, cubist, and hard-edge abstract painting, which points to the rapidity of image absorption and technique in contemporary society. For, as artist Ed Paschke noted,

> Our view of the world is changing as the global environment expands through media-accessibility and the information reservoir gets deeper. My belief is that these elements (good or bad) have woven their way into the fabric of our lives. I also believe that an artist always works within the context or conditions that are indigenous to his or her own time and in doing so, reflects the energy, temperament, and attitudes of that time.[31]

As the decade progressed, "appropriation" appeared in a variety of guises in both American and European painting. The "old master" Jasper Johns, who represented the United States at the Venice Biennale in 1988, packed his paintings of the decade with a great variety of appropriated images. One of his most significant pieces was his series of four large paintings, *The Seasons—Spring, Summer, Fall, and Winter,* made in 1985 and 1986. Johns used the classical theme of the equation of the cycle of

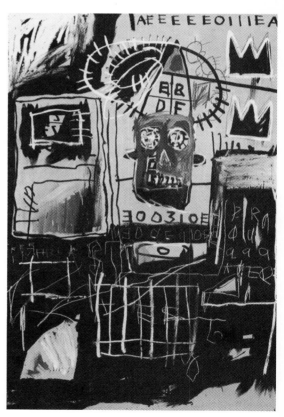

life with the cycle of the seasons to portray his progress from childhood to old age. One finds the allusion to Johns's own persona in the shadow figure that dominates each painting. In each painting there are allusions to Johns's own work—the flags, his crosshatch paintings—and to art history—to the *Mona Lisa* or to Grünewald's sixteenth-century Isenheim altarpiece. In *Summer*, 1985 [4.15], the layered, fragmented imagery, part of which is "taped" and "tied" visually, is filled with the ambivalence and ambiguity that has been evident in much of Johns's work throughout his career. For example, the Mona Lisa is clearly from da Vinci, but its taped presentation suggests both the Duchampian deconstruction of the image (in

the application of the mustache) and a Baudrillardian emphasis on the simulacrum, where "the real" is known only through its reproduction or representation. The sea horse next to the Mona Lisa suggests the artist's studio on the island of St. Martin, but may also have been included for its sexual connotation, the sea horse being a rare example of a male bearing offspring. The sea horse and its shadow image that is a part of the piece that appears to be a quotation from Johns's own work, and gently nudges the gray human figure, may allude to the rise of a bisexual or androgynous culture, as well as to the fertile and creative powers of the artist and art.

Black artist Robert Colescott appropriated entire compositions from art history as he replaced traditional white figures with black figures, calling the viewer's attention to racial differences through a type of parody that quickly became deadly serious. The bride in Jan van Eyck's *Wedding Portrait*, the female nude in Manet's *Déjeuner sur l'herbe*, and George Washington in Emanuel Leutze's *Washington Crossing the Delaware* all became black in Colescott's newly rendered compositions.

The Russian émigrés Vitaly Komar and Alexander Melamid, who had lived in New York since 1978, had become known for their imitations of Pop art, fake Lichtensteins that they "decomposed" to appear as if they had been discovered after centuries of burial and decay; as well as their mockeries of academic realism, where, for instance, President Reagan was depicted as a centaur. After 1978 their paintings included many appropriations from artists such as Cézanne, David, Balthus, and Malevich, and Komar and Melamid themselves. In 1986 they redecorated New York's largest discotheque for May Day and included a model of Lenin's tomb and copies of *Pravda*, which were handed out at kiosks. In the late eighties, to escape the New York art world, the couple moved out to Bayonne, New Jersey, a quiet, middle-class town that had not become

4.15. Jasper Johns, *Summer*, 1985.

4.16. Komar and Melamid, *Evening at Bayonne,* 1988. Private collection.

"chic" or "yuppified," and sketched and painted Bayonne's people and landscapes [4.16], particularly those connected with the Bergen Point Brass Foundry. There was no Post-Modernism there. The artists' heroes were the small man, the worker in particular, the local place, perhaps a nostalgia for their Russian roots.

Masami Teraoka, a native of Japan living in Hawaii, took images and symbols from ukiyo-e prints and the kabuki stage to use in his powerful watercolors, which served as warnings about AIDS. On first impression the paintings look like elegant traditional Japanese prints. Another look, as in *Geisha and Fox* [4.17] from

his *AIDS* series, reveals the "dark" side of traditional symbols. In this painting the fox, typically portrayed by the Japanese as a ghost or joker, becomes a cruel seducer and representative of the virus, as it pulls a nude woman, trying to rip open a condom package, into a fiery sea of lava. Teraoka's elegant and refined techniques enabled him to carry across his important messages in a manner perhaps more effective than other, more didactic, methods used to educate the population about AIDS.

Painters such as Philip Taaffe and Ross Bleckner turned to stylistic appropriation: raiding some of the aesthetics of Op art to give new dimensions to their paintings. Bleckner's 1987

4.17. Masami Teraoka, *Geisha and Fox,* AIDS series, 1988.

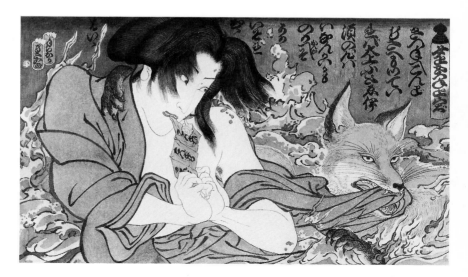

series *Architecture of the Sky, Always Saying Goodbye* uses circular frameworks of resin dots that shine forth from beneath the painting's surface. In *Always Saying Goodbye* [4.18] one finds a domelike configuration that emerges protectively from the white light radiating from above. There is a celestial and heavenly quality to these works, which takes on a double-edged significance and sad irony upon learning that Bleckner's dots were inspired by the patterns that Kaposi's sarcoma lesions (frequently the most visible symptoms of AIDS) form on the body. His works are thus both abstract and representational and attempt to deal with aspects of death and dying that might otherwise be denied.

Confronting social issues in a different manner was the collaborative work of Tim Rollins and K.O.S. (Kids of Survival). Rollins, an artist and teacher, and a group of South Bronx teen-

4.18. Ross Bleckner, *Always Saying Goodbye*, 1987. Collection Jewel Garlick, New York.

agers from broken and poor homes working together created a group of powerful drawings and collage paintings. Their works became a collaboration of members of a group as well as a collaboration between the artists and the world around them. The group literally and figuratively appropriated texts from literature they had read, discussed, and interpreted visually. A book such as Kafka's *Amerika*, for *Amerika X*, 1986–88 [4.19], was taken apart and its pages were glued onto Belgian linen, which was used as a ground for some of the painting. Some of the text was left open to the viewer. The final visual pieces were inspired by the connections between the actual reading of the book, the teenagers' own lives, and additional imagery such as that of Picasso. The work of Rollins and K.O.S. demonstrated a powerful interplay between text and visual elements. A piece such as *Amerika X* gives the viewer a new context in which to consider the nature of language, literature, and the tension between visual and verbal statements. Important were not only the products, which came to be owned by major museums and collectors, but also the process. The collective problem solving that was necessary and the life-giving force that lifted the kids beyond the web of an impoverished future were significant aspects of the work. Their works were in many ways more "activist" than actual political or social images, when one considers Rollins's long-term goal to raise enough money to found an accredited high school in the Bronx that would use art as the basis of the entire curriculum.

Meyer Vaisman used appropriated imagery in the manner of a prankster. Born and raised in Caracas, Venezuela, Vaisman came to New York to study art. In 1982 he opened a gallery, International with Monument, in the East Village. The gallery helped launch the careers of artists such as Peter Halley and Jeff Koons, and was successful enough for Vaisman to turn to the making of art full time. Vaisman poked fun at history's heroes in a painting such as *In the*

4.19. Tim Rollins and K.O.S. (Kids of Survival), *Amerika X*, 1986–88. South Bronx.

Vicinity of History [4.20], as he combined classical and European coin faces as well as caricatures upon a grid of cameo-oval shapes (often used for traditional portraiture). Some ovals were empty frames. Some of these and the background upon which these were placed were textured with the printed photographic enlargement of the canvas weave. This textural reproduction, along with the reproduction of the reproductions of some of history's heroes, casts a tawdry look at traditional notions of the hero. Vaisman's laugh at aspects of history and his refusal to accept historical myths of the individual hero reflects a poststructuralist position that "adds: not only is the bourgeois individual subject a thing of the past, it is also a myth; it never really existed in the first place; there have never been autonomous subjects of that type. Rather this construct is merely a philosophical and cultural mystification which sought to persuade people that they 'had' individual subjects and possessed this unique personal identity."[32] In his work Vaisman appears to demythologize a cult of personality and the art that glorified it. Through Vaisman's techniques the "hero," ironically, is that of mechanical reproduction.

In Italy there was a group of artists, includ-

4.20. Meyer Vaisman, *In the Vicinity of History*, 1988. Sonnabend Gallery, New York.

ing Alberto Abate, Ubaldo Bartolini, and Carlo Maria Mariani, known as the Anachronistici, who actually copied or "pastiched" classical and academic techniques and compositions. The stiff poses, empty forms, and dead colors seem to point to a need to look again at old mythologies and techniques, as they often appear empty and meaningless in current society. Mariani's *The Left-Handed Painter*, 1983, mimics the tradition of an Ingres or David, but also contains a witty irony as the "artist" paints the cherub into existence. The sterility of the painting hints at an emptiness and void in the art of today, which artists seek to fill. Explorations of this genre were also shared by the English Stephen McKenna and the French Gérard Garouste. Garouste's work, though, tended to be more sensual and expressive.

One may ask why appropriation became so much a part of the making of art during the eighties. Part of the explanation would seem to lie in the state and dilemma of a postmodern world—that many live in a culture of quotations and fragments, which come to us on many levels, but particularly through the media. One writer has noted that "our sense of wholeness is as fragmented by the media we use as it is by the media hurled at us. By now, in a society so suffused with images, the tricks and gestures of the surface have become easily detachable from whatever substance they once signified."[33] And further, the enshrouding by fragments and quotations has led to a kind of layered and "collaged vision fostered by the rapidly escalating demands on our attention, so we have collage personalities made up of fragments of public people who are, in turn, made from fragments themselves—polished, denatured, simplified."[34] Fragments rather than wholes seem to characterize the times. There was no recognizable self-image or an avant-garde art to look up to.

Dealing with fragmentation in a more physical and literal way was Elizabeth Murray, who along with a number of other artists, such as

Gerhard Richter, Howard Hodgkin, David Reed, and Ron Janowich, turned to organic or geometric abstraction to articulate a presence and quest for meaning in a postmodern world. Some called the return to abstraction "Neo-Abstraction," but the abstraction of the mid-eighties was not necessarily retrospective or a renewal of a previous style.

Elizabeth Murray came to New York in 1967 after graduating from the Art Institute in Chicago and Mills College. It was not until 1979–80, though, that she made the radical change in her paintings that was to bring her increased recognition. Drawing upon Cubist fragmentation and the biomorphic qualities inherent in Surrealism, Murray shattered her canvases into electrifying shards and fragments charged with vibrant colors and forms. In *Cracked Question*, 1987 [4.21], a giant multifaceted piece, a compelling and overflowing sense of energy exudes from the work. There is a momentum that halts one's gaze and causes one to question what the cracked question is, and what the nature of our world is. Murray has encouraged some contextural reading of her work, although does not use a specific symbolism. "I want my work to reflect my feelings about the society we live in; it's political in that sense."[35]

The British Howard Hodgkin by the eighties had developed a full abstract vocabulary of dots, swirls, waves, stripes, and zigzags that were employed in painted collagelike pieces of buoyant and colorful forms. Some of his most vibrant and alluring pieces were part of his *Neapolitan* series, which recalled a stay in Naples. In his *Bay of Naples*, 1980–82, one finds brilliant hues, particularly the turquoise and rose tones, that carry forth the brilliance of the Mediterranean light and water.

The East German–born Gerhard Richter rebelled against his Social Realist training and his East German heritage by moving to West Berlin in 1961, shortly before the Berlin Wall was built. During the sixties the artist did a large

4.21. Elizabeth Murray, *Cracked Question*, November 1987. Paula Cooper Gallery, New York.

number of "photo-paintings," by hand painting camera-made images—landscapes, portraits, interiors. But by the beginning of the eighties Richter came to concentrate on Expressionist abstractions. His work, as in *Vase*, 1984, is somewhat different from a de Kooning, for Richter layers and fragments his colors in a manner different from the integrative gestures of the Action painters, a manner that suggests unknown realities. As he notes,

> Accustomed to recognizing real things in paintings we refuse, justifiably, to consider color alone (in all its variation) as what the painting reveals, and instead allow ourselves to see the unseeable, that which has never before been seen, and indeed is not visible. This is not an artful game, it is a necessity; and since everything unknown frightens us and fills us with hope at the same time, we take these images as a possible explanation of the inexplicable or at least as a way of dealing with it.[36]

Richter has also referred to his relationship to reality in words that partially fit what his paintings attempt to deal with—"haziness, inse-

curity, fragmentary performance . . ."[37]

The Danish Per Kirkeby created abstract layered painted surfaces that at times resembled geological strata (an area in which he worked during his career as a scientist up until the early sixties). Kirkeby has worked in a variety of media—painting, drawing, brick sculpture, film, and written texts. His paintings such as *Nature Morte I*, 1987, evoke a dark poetic quality that invites viewers to contemplate a variety of layers both within the painting and within the viewers themselves.

The Irish-born Sean Scully, who moved to New York in 1973, saw abstraction as a freeing technique, a way to get away from oppressive references. Scully turned to geometric forms as he created rich surfaces from striped and grid configurations. In contrast to earlier geometric and Hard-Edge paintings, Scully's paintings have a rich, velvety surface that is both mysterious and evocative. In *To Want*, 1985, the bands of blacks, browns, sienas, and creamy white are made by sensuous brushstrokes and untaped edges. There is a human presence to the work rather than merely a hard geometry.

Ron Janowich used abstract forms with figurative archlike spaces in some of his pieces, such as *Aureal II,* 1985, which suggest a quest for a deeper, inner space, both metaphorically and physically. The atmospheric light of *Aureal II* suggests a vastness and infiniteness far beyond the everyday world. His arch-shaped pieces are like Byzantine icons in their direct, glowing power to suggest a beyond.

Peter Halley used abstraction to mock some aspects of Minimalism and sixties art by his use of materials such as Day-Glo colors and artificial stucco, while superficially employing the "official" shapes of Minimalism and geometric abstraction. But at a closer look, Halley's shapes were like rectangular and square cells, closing us in, as in *Red Cell,* 1988 [4.22], or like the frame of a television set or film strip, reminding us of the spaces we inhabit and what we often put in them. Halley, like a number of other younger artists, such as Vaisman and Koons, in the latter part of the decade attempted to force another look at the role of "high" and modern art in contemporary society. He created works that, as one writer noted,

provide a new theoretical framework for the role of "high" art within a general sociological context. Halley fabricates his paintings with an idiosyncratic mélange of science fiction, Robert Smithson, French post-structuralist philosophy, and a nostalgia for, and resentment of the 1960's. The most explicit rupture which takes place in Halley's art is his refusal to grant iconic status to that most persistent of geometric forms, the square.[38]

Halley's and other artists' "footnotes" to Minimal art and Duchampian ready-mades were labeled by some as "Neo-Geo."

The late eighties also brought a renewed interest in landscape painting. It was not, however, the panoramic, expansive landscape painting of the nineteenth century. It was another view of the fragmentation of the times, or a look at nature as a symbol of loss, to the world of media and technology. Many of the paintings were small, like shards of a vulnerable or shattered world. Chuck Connelly's pieces, such as *Mailman,* 1987, contained an underlying sense of vulnerability and agitation. Michael Zwack based his paintings, such as *Purple Heart,* 1987,

4.22. Peter Halley, *Red Cell,* 1988. Sonnabend Gallery, New York.

4.23. April Gornik, *Flood at Twilight*, 1990. Edward Thorp Gallery, New York.

which looked like faded snapshots, on photographs he clipped from magazines. Once again the simulacrum pervaded. Nature experienced directly was gone. Zwack's paintings were not living worlds, but faded memories. Mark Dean, in a painting such as *Search for Strange Formations: Our Journey to Elephant Rocks,* 1984, created a small, dreamlike world with its roots in Surrealism. Odd-shaped boulders, some in animallike shapes, lie in a parched barren orange desert against a stark blue, gray-clouded sky, with no hint of human presence. One may ask if it is a prehistoric world or a futuristic world where human beings have destroyed themselves. The stark juxtaposition of the complementary blue and orange tones, with none of the verdant greens of traditional landscape paintings, gives the painting an ominous quality.

April Gornik painted landscapes that captured a significant stillness often difficult to find in the contemporary world. Some of her work has been compared to nineteenth-century American Luminist painting. Her landscapes were not necessarily based on exact scenes outside but were more concerned with the sensation of *experiencing* a landscape. To enter the quiet stillness of a painting such as *Flood at Twilight,* 1990 [4.23] may be seen as analogous to entering a private space within the human psyche. The painting is a part of a series done based on a trip to France and her seeing the allées of neatly planted trees dividing the flood plains into abstract patterns, representing the cultivation of nature by humanity. Gornik came to painting particularly through the urging of her instructor Eric Fischl, who was a young faculty member at the Nova Scotia College of Art and Design in Halifax, where for many of the students and faculty at the time painting was considered dead. By the time of Gornik's graduation in 1974, at which Joseph Beuys spoke, Gornik and Fischl had become a couple, and remained so.

This renewed interest in landscape painting, which for many was traditionally as-

sociated with picturesque and "Sunday" paint-
ing, expanded perceptions of and approaches
to the landscape through the medium of paint-
ing, indicating that landscape painting was not
necessarily an observable reality.

The eighties also brought increased recogni-
tion of the art of cultures outside the European
and American traditions. From "down under"
came Australian artists of four generations,
from the "Angry Penguins" art movement of
the late thirties and forties to the New Wave art
scene of the eighties, who were recognized at
the Australian Biennale, which coincided with
Australia's bicentennial celebration. One of the
artists receiving increased international atten-
tion was Juan Davila, a native of Chile, who fled
to Australia after the 1973 coup in Chile.
Davila's paintings were often political and ho-
moerotic parodies, and pointed at both the Aus-
tralian culture and the international art mar-
ket. The art of aboriginal Australia also
pervaded the international art scene, particu-
larly after a major exhibition, "Dreamings: The
Art of Aboriginal Australia," opened at the Asia
Society in New York in 1988. Contemporary
artists, sometimes in collaboration with tribal
artists, used acrylic paints to bring new life to
the ancient art and rituals of the desert.

> To the aborigines, dreaming refers to a time
> when a succession of hero-ancestors with human,
> animal, elemental and plant characteristics trav-
> eled on the empty earth, making of it what they
> could.
> An individual dreaming represents the origi-
> nal journey and adventure, and the continuing
> presence of one such ancestor. The dreaming is
> the reality behind the esthetics of the work; it's
> a proof-through-design of the artist's ownership
> of a section of the world.[39]

For the contemporary world, these dream-
scapes could serve as another route to explore
in a search of heroes and roots in a fragmented
world.

Out of Africa came a resurrection of African
Christian art, as tribal motives and Christian
themes were combined in two- and three-di-
mensional forms. This art was created, though,
for the community, not for museums. But it
began to receive increased outside interest.
Originally fostered by Roman Catholic mission-
aries, the artistic resurgence and incorporation
of local culture into Christian themes was en-
couraged by political independence and the in-
crease of black clergy in Africa. Noted one re-
porter,

> Not since Europe's Renaissance has such a large
> and varied body of living Christian art been pro-
> duced. In inaccessible rural workshops, thatched-
> roof villages and teeming urban slums, a firma-
> ment of fine artists inspired by Christian themes
> is emerging from within a much larger commu-
> nity of folk artisans. . . . There is no question that
> African Christian art, serene and savage, florid
> and austere, stands virtually alone in the vigor
> and authenticity with which its practitioners seek
> to express the inexpressible.[40]

The collision of two cultures, Latin and
Anglo, was also seen in the increased recogni-
tion of Hispanic art during the eighties. Two
1987 exhibitions, "Art of the Fantastic: Latin
America, 1920–1987," and "Hispanic Art in the
United States," in particular, made it possible
for the power and fantasy of much Hispanic art
to be more fully perceived. In the catalog to
"Art of the Fantastic," the curators wrote of the
eighties generation of Latin American artists:

> Their mission is less a search for ideals or for an
> understanding of their existence and more an
> exploration of ways to cope with the traumas of
> modern urban life. Humor, irony, and theatrical
> exaggeration frequently blunt the pain of trag-
> edy. . . .
> The positive and negative effects of the
> United States consumer culture on Latin Ameri-
> can countries became a topic for some art-
> ists. . . .
> Urban loneliness and violence, the second-
> class role of women, and the plight of the refugee
> are other aspects of contemporary existence ad-
> dressed by this generation. . . .
> This generation has adopted and reshaped

contemporary styles of painting to fit its understanding of contemporary life. Installations, graffiti art, neo-expressionist painting, and work that appropriates motifs from Kitsch culture exemplify some of the types of art being made today in Latin America. While fantasy is not unique to the art of the Southern Hemisphere, it has a special edge in their paintings. It provides not only a bridge to their own cultural and political past, but also a means to tame the uncontrollable reality of life in the 1980's.[41]

Alex Vallauri, Waldemar Zaidler, and Germán Venegas explored the positive influence of U.S. culture on Latin America, while Siron Franco saw it as a destructive force. The Argentinians Armando Rearte and Guillermo Kuitca expressed isolation in their work, and Luis Azaceta and Arnaldo Roche sometimes expressed the sense of dislocation felt by refugees. Rocío Maldonado represented a feminist perspective.

The work of Paul Sierra and Patricia Gonzalez may serve as two examples of the collision as well as integration of two worlds. Sierra, born in 1944 in Havana, Cuba, was the son of a lawyer and was chided as a child for filling his notebooks with drawings instead of homework. When he was sixteen his family left Cuba and moved to Chicago, where in 1963 Sierra began studying painting at the School of the Art Institute of Chicago. There he became close friends with his painting teacher, the Puerto Rican artist Rufino Silva. In 1966, though, disillusioned with his schooling, Sierra dropped out and entered the world of advertising as a layout artist. He did little painting until after his second marriage following a honeymoon in Puerto Rico, which revived the colors and sounds of his childhood in the Caribbean. Thereafter he delved further into researching his heritage, although he did not return to Cuba, for his painting. Other influences included the painters Francis Bacon, Goya, Jackson Pollock, and Willem de Kooning. In paintings such as *Cuatro Santos* and *Three Days and Three Nights* [4.24], one finds a refreshing energy, in the

4.24. Paul Sierra, *Three Days and Three Nights,* 1985. Collection the artist.

sometimes "naive" but powerful forms. The emphasis on the diagonal placement of forms jars the viewer's expectation of a vertical/horizontal orientation to pull him or her into another world of powerful fantasies.

Patricia Gonzalez, born in 1958 in Cartagena, Colombia, was the daughter of an architect. Her parents separated when she was eleven and she lived with her paternal grandmother until moving to London with her mother at age eleven. She received a B.F.A. from the Wimbledon School of Art and in 1980 moved back to Cartagena. But she found it difficult to find an artistic community and returned to London temporarily, then on to Texas to join one of her former painting teachers, Derek Boshier. Her paintings, such as *Fountain View*, relate to landscape imagery of South America but go beyond in their dreamlike evocation of layers deep within the human psyche. Gonzalez has referred to Van Gogh, Nolde, and Frida Kahlo as painters she particularly admires. One can see a little of each in *Fountain View*. The small figure that lurks behind the leaflike form in the painting is both primitive and modern in its vulnerability and sense of unknowing.

The significance of the meeting of Latin and Anglo cultures, and resulting new expressions and insights, was voiced by the critic Mark Stevens: "The meeting of Latin and Anglo America in the South has an almost geological character, as of great cultural and historical masses slowly colliding. Out of this comes displacement and paradox, not purity; one can hope for the sizzle of crossed connections and shock of insight. 'Their culture is ancient,' writes Octavio Paz of Hispanic Americans, 'but they are new.' "[42]

The policies of glasnost and perestroika in the Soviet Union brought about a liberalization in the visual arts there and increased contact and exchange with the West in the arts. In the November 1988 issue of *Art in America*, Jamey Gambrell noted, "There's been a virtual explosion of museum and gallery exhibitions (ex-

tremely uneven in quality) of Russian artists in the West; Sotheby's organized a multi-million-dollar auction of Russian and Soviet art last summer; and journalists and art critics have probably written more copy on Russian art in the last year than in the preceding two decades combined."[43] There was a rehabilitation of the Russian avant-garde of the early twentieth century as artists such as Malevich and Kandinsky were shown, and the status of "unofficial" artists was elevated from the underground to above ground. Only a decade before, in 1974, these unofficial artists, whose work and ideas did not conform to Soviet doctrines, had received international attention at the "Bulldozer" exhibition in September, when they attempted to show their work in an open field in Beliaevo, a neighborhood just outside Moscow. When the authorities grew nervous at the crowds attending, the crowds were dispersed and bulldozers sent in to "bury" the show. Many works were damaged or destroyed, and a number of persons were hurt or arrested. Following worldwide censure Moscow officials allowed a one-day show to be held two weeks later. Ten thousand people attended. Up until Mikhail Gorbachev's deepening policies of glasnost in 1987, unofficial artists during the seventies and early eighties developed their work privately, in a variety of styles, showing in apartments and publishing their own Samizdat magazines and manifestos. One young Russian critic, Viktor Misiano, noted, "It didn't really matter what a person's artistic creed was . . . —i.e. whether he was a conceptual artist, a neo-abstractionist, a Neo-Expressionist or whatever—the important thing was . . . the common idea of opposition to official dogmatism."[44] With the new status, "unofficial" artists born in the thirties, such as Ilya Kabakov, Erik Bulatov, Ivan Chuikov, and Eduard Shteinberg, were recognized. Kabakov, in paintings, albums, and installations, documented

the uneventful lives and deaths of a new sort of anti-hero. . . . Kabakov explores and articulates

the pathos of everyday Soviet reality through the drab esthetics of its post war mass culture. . . . Kabakov's characters—all simultaneously Soviet everyman and modern artist—are people who have retreated into worlds of humble fantasy defined by the four walls of their small rooms in Moscow's communal apartments. . . . Kabakov's canvases and drawings are overflowing with names, patronymics and surnames, but among the myriad voices that haunt his work, no hierarchy, no wholeness, no organizing individuality— no author—is to be found.[45]

Chuikov's paintings exuded a postmodern concern with fragmentation as he experimented with shifts in perspective and scale. In pieces such as *Vermeer* and *Random Choice*, Chuikov juxtaposed a variety of styles and images through the use of reproductions of old master paintings, graphics from Soviet posters, picture postcards, and so on. In a number of

series titled *Fragments*, images were enlarged in a progressive sequence until appearing abstract.

Eric Bulatov worked within official Soviet art structures as an illustrator of children's books while simultaneously pursuing his own private visions in paintings initially considered unacceptable to the establishment. In the late eighties he was allowed to travel to the West and spent several months working in New York in 1989. A number of Bulatov's paintings, such as his *Sky-Sea*, 1984 [4.25], suggest barriers and blockage through the use of large letters or other flat devices that obscure or prevent access to the underlying image. Bulatov spoke of his paintings, pointing to the possible political connotations in them:

> In a sense this political interpretation is correct. The closed space does represent a lack of free-

4.25. Eric Bulatov, *Sky-Sea*, 1984. Photograph courtesy Phyllis Kind Gallery, New York.

dom, and art is the way to freedom. At the same time, there is another aspect to the treatment of space in my works. I try to achieve an effect of openness through a sort of blurred line between the reality in the painting and the reality outside the painting. I am for a very direct communication between the viewer and the painting, and in fact, when I put human figures in the paintings they are always right on the edge, as they had just stepped over that line from reality into the painting. The block letters sometimes define that line.[46]

A younger generation of unofficial artists included Nikolai Filatov, Sergei Volkov, Sergei Shutov, Irina Nakhova, and Vadim Zakharov. There was no one "style" or imagery for these artists either. Filatov painted in a Neo-Expressionist mode. Volkov created dark, heavy impastoed canvases with symbols such as a laurel wreath or a twinging serpent. Nakhova used architectural elements, portraying what was once solid as unstable in her experiments with light, space, and perspective. A number of these artists traveled to Europe and the United States for the first time beginning in the late eighties. In the Soviet Union there was a new kind of competition among artists as they began exhibiting and selling their works more openly and frequently. A cooperative gallery, Moscow's first "gallery," was scheduled to open in the fall of 1988. Ironically, though, this spirit of openness brought about rifts and jealousies in a once cohesive and small art community. Some artists spoke of a "nostalgia for the good old days when they were limited to showing in each other's apartments, and were harassed for contact with foreigners. Artists who used to get together regularly to discuss new work or just hang out and talk about art, life, death and religion, now meet only at art events, and the talk usually turns to—money."[47]

Since the death of Mao Zedong and end of the repressive Cultural Revolution, China also experienced, under the leadership of Deng Xiaping, a reopening of cultural contacts with the rest of the world. Blatant political and protest art was still banned, but there was more tolerance of diverse styles until Tiananmen Square. Some artists turned to experimentation with Western styles, taking their influences from a wide range of painters, such as Goya, Van Gogh, Dali, and Picasso. Others sought to synthesize their own artistic heritage with Western influences. In general, there seemed to be an emphasis on realism, with a number of artists emulating the style of the American Andrew Wyeth. One sees, for example, *Waking,* 1988, by Di Lefeng, painted in a meticulously realistic manner. The painting is of a young girl in modern dress but alludes to an ancient legend concerning the "waking of insects," one of the twenty-four solar terms of the Chinese calendar, marking the beginning of spring. In his painting Di Lefeng attempts to link his ancient and modern worlds, as well as nature and art, in alluding to a spirit of renewal in both. Di Lefeng was born in Jin County in the province of Lianoning in 1958. He graduated from Lianoning Educational College in 1987, majoring in art, and became an artist with the Jinzhan Painting Institute.

Synthesizing technical aspects of European and Chinese painting was Wu Guanzhong. In *Houses in the Mountain,* 1988, one sees the integration of lyrical abstraction and calligraphic gestural brushstrokes to depict a traditional Chinese subject. Of a different generation than Di Lefeng, Guanzhong was born in 1919 and graduated from the National Art College in 1942. He studied further in Paris at the Ecole National Superiere des Beaux-Arts. He later became a professor at the Central Institute of Applied Arts in China.

Artists such as Yongping Huang and Gu Dexing departed more radically from Chinese traditions. Huang used newspaper pulp pulverized in washing machines to sculpt burial mounds, while Gu Dexing created Judy Pfaff-like environments and wall pieces from pieces of brightly colored, burned and melted plastic.

Interaction between China and the West

has provided a variety of alternatives for artistic expression and has pointed to commonalities inherent in Chinese art and modern Western art. As a professor in Shanghai stated,

> Throughout history there have been alternating cultural flows between China and the West—at one time emanating from China and more recently, emanating from the West. But synthesis is something different and more important. And, I believe, very possible. For there is more in common between Chinese art and modern Western art than many people understand. The free-floating spaces in Abstract Expressionism for example, have a long history in Chinese painting. And the economy of means and empty spaces in Minimalism are like-wise very familiar to Oriental art.[48]

There has also arisen a conflict for young artists as they are torn between their traditional heritage and modern and postmodern Western influences. But there has also been an insistence on continuing channels of openness. The statement of a young Shanghai artist is perhaps typical: "We have a great tradition, in China, but we must not let it stagnate by isolation from other cultures. We must learn about other countries not only to enrich our own art and civilization but also to introduce our work to the rest of the world. We want to understand others and we want them to understand us. All young painters feel this way today."[49]

The decade thus witnessed a great international chorus of diverse voices in painting. In this diversity there seems to appear frequently the common search for meaning or heroes in a seemingly dislocated and fragmented, secularized world.

NOTES: PAINTING, 1980S

1. Barbara Rose, *American Painting: The Eighties, A Critical Interpretation* (New York: VISTA Press, 1987), n.p.
2. Hilton Kramer, "Signs of Passion," in *Zeitgeist*, ed. Christos M. Joachimides and Norman Rosenthal (New York: George Braziller, 1983), p. 17. (The original version of the catalog for the 1982 "Zeitgeist" International Art Exhibition in Berlin was published jointly by Verlag Albert Hentrich and Kunstbuch Berlin Verlagsgesellschaft, Berlin.)
3. Carter Ratcliff, "The End of the American Era," *Saturday Review*, September 1981, p. 42.
4. Nietzsche, *Thus Spoke Zarathustra*, tr. Walter Kaufmann (New York, 1980), pp. 14–15.
5. Jörg Immendorff, cited in Jörg Huber, "Situation-Position: Ein Gesprach mit Jörg Immendorff über seine politische Malerei," translated by Annegreth Nill and reprinted in *Carnegie International Catalogue*, 1985, p. 144.
6. A. R. Penck, "Dis," adapted from the German by Jeremy Adler, cited in Joachimides and Rosenthal, ed., *Zeitgeist*, p. 62.
7. Cited in Paul Taylor, "Painter of the Apocalypse," *New York Times Magazine*, October 16, 1988, p. 103.
8. Cited in ibid.
9. Cited in Paul Gardner, "Gargoyles, Goddesses, and Faces in the Crowd," *Artnews*, March 1985, p. 58.
10. Sandro Chia, quoted in Tony Godfrey, *The New Image Painting in the 1980's* (New York: Abbeville Press, 1986), p. 69.
11. Ibid., p. 72.
12. Ibid., p. 89
13. Interview with Hayden Herrera, "Expressionism Today: An Artist's Symposium," *Art in America*, December 1982, pp. 58–75.
14. Robert Hughes, "The Artist as Entrepreneur," *The New Republic*, December 14, 1987, p. 28.
15. Quoted in Howard N. Fox, *Avant-Garde in the Eighties* (Los Angeles: Los Angeles County Museum of Art, 1987), p. 22.
16. Cited in Peter Selz, ed., *New Images of Man*, exhibition catalog (New York: Museum of Modern Art, 1959).
17. Karen Koehler, "The Art of Cultural Violence," in *An American Renaissance: Painting and Sculpture Since 1940*, Sam Hunter, ed. (New York: Abbeville Press, 1986), p. 179.
18. Cited in John Roberts, "An Interview with David Salle," *Art Monthly*, March 1983, pp. 3–7.
19. Thomas Lawson, "Last Exit: Painting," *Artforum*, October 1981, p. 42.
20. Thomas Lawson, *A Fatal Attraction: Art and the Media* (Chicago: The Renaissance Society of the University of Chicago, 1982).
21. Fredric Jameson, "In the Destructive Element Im-

merse," *October 17,* Summer 1981.

22. Ibid.

23. Craig Owens, "Representation, Appropriation and Power," *Art in America,* May 1982, p. 21.

24. Jean Baudrillard, "The Precession of the Simulacra," in *Art after Modernism: Rethinking Representation,* ed. Brian Wallis (New York and Boston: The New Museum of Contemporary Art, in association with David Godine Publishers, 1984), p. 253.

25. Fredric Jameson, "Post-Modernism and Consumer Society," in *The Anti-Aesthetic: Essays on Postmodern Culture,* ed. Hal Foster (Port Townsend, Wash.: Bay Press, 1983), p. 115.

26. Hal Foster, "The Problem of Pluralism," *Art in America,* January 1982, p. 14.

27. Statement quoted in Calvin Tomkins, "Righting the Balance," in *Making Their Mark—Women Artists Move into the Mainstream, 1970–1985,* ed. Randy Rosen and Catherine C. Brawer (New York: Abbeville Press, 1989), p. 47.

28. Ibid.

29. Cited in Godfrey, *The New Image Painting,* pp. 148–49.

30. Keith Haring, "Remembering Basquiat," *Vogue,* November 1988, p. 234.

31. Cited in Edward Lucie-Smith, *American Art Now* (New York: William Morrow, 1985), pp. 124–25.

32. Jameson, "Post-Modernism and Consumer Society," p. 115.

33. Leo Braudy, *The Frenzy of Renown: Fame and Its History* (New York: Oxford University Press, 1986), p. 4.

34. Ibid., p. 5.

35. Elizabeth Murray, cited in Robert Starr, "Shape Shifter," *Art in America,* April 1989, p. 214.

36. Cited in *Carnegie International,* 1985, p. 200.

37. Cited in I. Michael Danoff and Roald Nasgaard, "An Introduction to the Work of Gerhard Richter," *Gerhard Richter: Paintings* (New York: Thames and Hudson, 1988).

38. Dan Cameron, "Peter Halley," *Carnegie International, 1988,* p. 76.

39. Thomas Keneally, "Dreamscapes," *New York Times Magazine,* November 13, 1988, p. 52.

40. Richard N. Ostling, "Africa's Artistic Resurrection," *Time,* March 27, 1989, pp. 76–79.

41. Holliday T. Day and Hollister Sturges, *Art of the Fantastic: Latin America, 1920–1987* (Indianapolis, Ind.: Indianapolis Museum of Art, 1987), p. 175.

42. Mark Stevens, "Devotees of the Fantastic," *Newsweek,* September 7, 1987, p. 68.

43. Jamey Gambrell, "Notes on the Underground," *Art in America,* November 1988, p. 128.

44. Viktor Misiano, cited in ibid., p. 132.

45. Jamey Gambrell, "Perestroika Shock," *Art in America,* February 1989, p. 134.

46. Cited in Katy Kline, "Revealing Realities," *Art New England,* June 1989, p. 17.

47. Jamey Gambrell, "Perestroika Shock," p. 180.

48. Cited in Waldemar A. Nielson, "New Art from the New China," *Beyond the Open Door: Contemporary Paintings from the People's Republic in China* (Pasadena, Calif.: Pacific Asia Museum, 1987), p. 22.

49. Ibid., pp. 22–23.

PRINTMAKING, 1980S

ARTISTS during the eighties continued to use the medium of printmaking as a way to explore ideas and styles that were not as easily permitted in other media. The monotype or the unique print, rather than an edition of identical prints, also continued to be important. The jumbo print and prints in multiple sections came to have increased significance. The following examples are but a few of the works done in printmaking in the eighties.

In Germany a number of artists turned to the block print, already important in the German tradition, as a direct and vigorous medium capable of expressing some of the heroic and mythic concerns of artists such as Anselm Kiefer and Matthias Mansen. Kiefer, who did not print editions, used woodcuts or fragments of woodcuts in his books, collage drawings, and canvases. The woodcuts were cut and printed by hand in his studio. In his large, sixty-five-by-sixty-two-inch woodcut *Grane,* 1982, one sees the brutal and powerful directness of the medium. The image of the large horse, rising like a phoenix out of the flames, is taken from Grane, the name of Brunhilde's horse, with whom she leaps into the flames at the end of Wagner's *Der Ring des Nibelungen.* The horse, with all its mythic dimensions and connotations, stands as a bridge between the contemporary world and the world of myth and the subconscious.

The young German Matthias Mansen also used the large-scale woodcut frequently. In his six-part woodcut sequence in six states, *Sitzende (Sitting),* 1986, one sees the graphic transformation of an unidentified figure from a dark silhouette to an almost transparent cellular figure. The fracturing and fragmentation of the figure appears particularly direct and effective because of the medium. The block used was a found object, a door or piece of furniture. The artist printed the sequence by hand, using Ivory Black oil color, which when pushed around resembled applications of paint with a palette knife. Mansen rarely printed editions, instead producing variations on blocks or combinations of blocks.

The Russian artist Oleg Kudryashov, who emigrated from Moscow to London in 1974, also preferred the unique print, as he explored drypoint on zinc plates. Rebelling against Social Realism, Kudryashov turned for inspiration to Russian Constructivism, as seen in his *Composition* (triptych), 1982. For this piece he printed the same plate three times. Once, he heavily inked the plate. Then he printed it uninked but covered with brown and gray watercolor. Finally, he printed the plate less heavily inked, again with brown and gray watercolor applied before painting. The result was a subtle polyphony of shapes and forms.

Sandro Chia saw printmaking, and in partic-

ular etching, as a type of alchemy. "The print shop," he said, "is a little mysterious with all those machines and devices. It's like an alchemist's laboratory, a place where transformations occur. And art and alchemy are the same, and unlike science, because they're both looking for something that's impossible to find. . . . Printmaking is a way to try new things. It's like a crucible—you can throw everything in."[1] Chia used etching to further explore figure-ground relationships, and to appropriate various devices of marking and hatching used in historical prints. In the series "Gardens and Villas of Italy" Chia reproduced photographic elements from an old illustrated architectural guidebook, which he transferred to the plate through photo-etching, and then reworked and worked over the images.

Enzo Cucchi's interest in recovering the mythic dimensions of life led him to pursue large-scale prints as well as his paintings. "It's obvious," he said, "that a crisis stricken world has to cling to something, to a solid image bearer. In this incredible state of weakness, the image is the last hope for the world."[2] One of Cucchi's large-scale projects was his trio of prints *La Lupa di Roma* (*The She-Wolf of Rome*). One of the trio measured 77 by 37¾ inches. Cucchi used a variety of printing techniques—etching, drypoint, embossing, and silk screen, and also used watercolor to create his expansive and color-saturated image, where golden yellows and fiery oranges envelop the viewer. The colossal prints together illustrate a symbolic history of Rome. In the first print an egg stands in a gashed and fiery landscape. The center image shows a Marmatine prison with a towering brick shaft. The sense of dismalness is relieved by a suggestion of golden light at one of the upper windows. The last print is an empty winter plain, occupied only by scattered skulls and mysterious black chasms.

In the United States Robert Cumming used the monoprint to explore relationships between the written word and visual elements.

One of his monotypes, a triptych, dealt with the comma, which, elevated to the level of a visual icon, confronted the viewer head on. Printed in blueprint blue, the inanimate comma takes on the qualities of a spinning object in two parts of the triptych—*Cut Out Comma/Apostrophe* and *Cool Comma*.

Frank Stella pushed his exploration of printmaking further during the decade as he explored serialized imagery and unconventional approaches to relief and intaglio printing in his *Circuits* prints [4.26] and *Swan Engravings*.

> The etched plates, which for *Pergusa Three* in the *Circuits* series were embedded in the blocks, did not resemble or produce traditional etchings. Stella drew and painted directly on a magnesium plate with a stop-out tusche or had his designs photographically transferred. The designs were raised in relief, not incised, after the plate was immersed in an acid bath—the identical method for the embossing of designs on the magnesium surfaces of the paintings.[3]

Critical, too, for Stella's prints were the unorthodox inking and wiping of the plates. A variety of techniques were employed, using Q-tips, sanding blocks, newsprint, and rags, to achieve complicated nuances of color and texture.

> The visual strength of the Circuits prints and Swan Engravings is practically unequaled in the history of printmaking. Robert Hughes aptly described the Circuits prints as taking on a "stiff, congested richness like mosaic or imbossed hide, invoking a Byzantine degree of ceremonial excess." It is, indeed, the dense materiality of these prints that most dramatically established their technical significance for the recent course of contemporary printmaking. The patent difference between Stella's prints and traditional ones is *surface*. The tactile appearance of the Bedford prints was achieved through multiple interactions of paper, mixed media, and the changing of paper until it was ink saturated. Traditional prints are flat; Stella's adamantly are not.[4]

4.26. Frank Stella, *Pergusa Three*, from the *Circuits* series, 1982. Walker Art Center, Minneapolis/Tyler Graphics Archive.

A number of artists also turned more frequently to multiple-section prints printed on more than one sheet of paper. Crown Point Press, in Oakland, California, founded by Kathan Brown in 1962, became noted for some of its large multiple-section prints. In an installation shot at Crown Point Gallery one can see several large pieces of Vito Acconci's. Prints, for Acconci, were "a way to deal with wall space," and "to start to clarify images more."[5] His *2 Wings for Wall and Person,* 1981, was a twelve-part photo-etching based on a photograph of small model-airplane wings that Ac-

conci built from a kit. The total print, measuring fifty-two inches by twenty-two feet, was displayed in two sections—two horizontal rows of three panels. The space in between allowed the viewers to stand in such a way that they could "try on" the wings. Acconci's *3 Flags for 1 Space and 6 Regions,* a six-part colored print, seventy-two by sixty-four inches, was made from overlapping the American, Russian, and Chinese flags.

Printmaking has thus allowed artists to reach out to greater numbers and to experiment in new ways. Increased sophistication in

printmaking and in distribution of materials through electronic media may make printmaking an even more significant medium in the future when and if prints may be transmitted electronically and reconstructed in physical form, thereby allowing the visual arts to touch more and more lives.

NOTES: PRINTMAKING, 1980S

1. Cited in Don Hawthorne, "Prints from the Alchemist's Laboratory," *Artnews,* February 1986, p. 90.
2. Ibid., p. 95.
3. Richard H. Axsom, "Frank Stella at Bedford," in *Tyler Graphics: The Extended Image* (Minneapolis: Walter Art Center and New York: Abbeville Press, 1987), p. 173.
4. Ibid., p. 174. Quotation by Robert Hughes is from *Frank Stella: The Swan Engravings,* exhibition catalog (Fort Worth, Tex.: Fort Worth Art Museum, 1984), p. 7.
5. Vito Acconci, cited in Ronny Cohen, "Jumbo Prints," *Artnews,* October 1984, p. 87.

PHOTOGRAPHY, 1980S

By the eighties photography appeared to have truly come of age. Photographs were exhibited and collected perhaps more widely than ever before. Artists used photography as a vehicle of rich experimentation in diverse and unique ways. In general, though, there continued to be two paths, established in the past: (1) purist, "straight" photography, and (2) a fabricated image constructed by the artist rather than discovered in the world around the artist. More artists not trained as photographers came to use photography to express their ideas and concerns. What some called "neo-conceptual" photography used slogans, symbols, and stereotypic imagery to pose questions about society at large and the way in which words and visual images can manipulate behavior.

One museum curator called photography *"the* art form of the eighties."[1] Another commented, "Postmodern work is a radical kind of photography that was picked up outside the photography community by people who weren't tied to formalist esthetics and so were willing to entertain photography in a different way. . . . It then became the darling of the decade."[2]

New York Times photography critic Andy Grundberg further noted the role of photography in a postmodern world:

The self-conscious awareness that we live in a camera-based and camera-bound culture is an essential feature of the photography that came to prominence in the art world of the early 1980's and has come to be called postmodernist. Generally speaking, postmodernist art accepts the world as an endless hall of mirrors, as a place where all we *are* is images and where all we *know* are images. There is little room in the postmodern world for a belief in the originality of one's experience, in the sanctity of the individual artist's vision. What postmodernist art implies is that things have been used up, that we are all prisoners of what we see. Clearly these are disconcerting and radical ideas and it takes no great imagination to see that photography, as a nearly indiscriminate producer of images, is in part responsible for them.[3]

Artists concerned with appropriation found photography particularly important, for images could be photographed and rephotographed, and arranged to give new contexts and meanings to the visual images that shape society.

One of the most radical of the photographers emphasizing appropriation was Sherrie Levine, who in 1981 began to photograph poster and book reproductions of "master" photographs and paintings, and then signed them. Many people were outraged as she exhibited reproductions of art historical icons such as

a Walker Evans photograph [4.27]. Yet her conceptual pieces raised serious questions about originality, uniqueness, the collecting of "unique" works, the art work as commodity, and artistic individuality. Her replicas suggest that authenticity may be impossible. But there is also a suggestion of the constant need for art to present the viewer with a sense of meaning and transcendence. There is an ambiguity of conceptual irony and a nostalgic reverence for the "master" images inherent in a number of her photographs. As she commented, "I choose pictures that manifest the desire that nature and culture provide us with a sense of order and meaning. I appropriate these images to express my simultaneous longing for the passion of engagement and the sublimity of aloofness."[4]

Later Levine rephotographed comic strips and cartoons, isolating them in a frame and presenting them as her own work. In particular she took images from *Krazy Kat* that finally appeared as a type of abstraction after passing through various stages of reproduction from newsprint to photograph. Some of her Krazy Kat reproductions hinted at feminist themes when Ms. Kat, as a target of Mr. Mouse's bricks, suggested the image of a battered woman. It is perhaps significant that in general, much of the "fun" of the original cartoons had disappeared in Levine's and other artists' appropriation of the image.

Richard Prince reshot images from the *Jetsons* and cartoons from the *New Yorker,* as well as magazine and existing images [4.28]. "He implies through his art the exhaustion of the image universe; it suggests that a photographer can find more than enough images already existing in the world without the bother of making new ones. Pressed on this point, Prince will

4.27 *(opposite)*. Sherrie Levine, *Untitled (After Walker Evans: 2)*, 1981. The Menil Collection, Houston.

4.28. Richard Prince, *Tell Me Everything*, 1986. Courtesy Barbara Gladstone Gallery, New York.

I've been married for thirty-four years and I'm still in love with the same woman. If my wife ever finds out, she'll kill me.

admit that he has no desire to create images from the raw material of the physical world; he is perfectly content to glean his material from photographic reproductions."[5]

Prince was also a writer. In his book *Why I Go to the Movies Alone,* he further states his attitudes toward a postmodern world:

> Magazines, movies, T.V. and records, it wasn't everybody's condition to him, but it sometimes seemed like it was, and if it really wasn't, that was alright. . . . His own desire had very little to do with what came from himself because what he put out (at least in part) had already been out. His way to make it new was *make it again,* and making it again was enough for him and certainly, personally speaking, *almost* him. . . .
>
> They hung the photographs of Pollock right next to these new "personality" posters they just bought. . . . The photographs were what they thought Pollock was about. And this kind of take wasn't as much a position as an attitude, a feeling that an abstract expressionist, a T.V. star, a Hollywood celebrity, a president of a country, a baseball great, could easily mix and associate together . . . and what measurements or speculations that used to separate their value could now be done away with.[6]

Prince combined text and photographic reproductive techniques in his acrylic and silk-

screened images on canvas of the late eighties, where he used jokes as his subject matter. Upon being asked how he came to use jokes, a number of which have to do with human relationships, he replied, "I live here. I live in New York. I live in America. I live in the world. I live in 1988. It comes from doing cartoons. It comes from wanting to put out a fact. There's nothing to interpret. There's nothing to appreciate. There's nothing to speculate about. I wanted to point to it and say what it was. It's a joke."[7]

Barbara Kruger, who had been an art director with Condé Nast publications for eleven years, used appropriated photographs and added texts of exhortation to address issues concerning the individual and society, often with feminist emphasis. However, hers was not a dogmatic or didactic feminism. Rather, she hoped for shifts in meaning according to what the spectator brought to the piece. "I hope for the idea that there are *feminisms,* that there are a multiplicity of readings of what constitutes feminism," she said. "When I talk about the work, I never say, this is what it means. When I show my work people ask questions. Whenever they ask what a work means, I say the construction of meaning shifts. And it shifts according to each spectator."[8]

Kruger's billboardlike images, and a num-

ber were actual billboards, sought to affect power and social relations by raising questions. Through the use of montage techniques, such as juxtaposition, superimposition, and intertwining of text and image, as seen in *You Are Not Yourself* [4.29], 1983, she sought to explore and expose stereotypes and clichés concerning the individual self and society. Much of her work was concerned with gestures and signs.

> In Kruger's work, the strategic value Lacan attributes to pose is doubled and redoubled. . . . She stages for the viewer the techniques whereby the stereotype produces subjection, interpolates him/her as subject. . . . [I]n Kruger's

4.29. Barbara Kruger, *You Are Not Yourself,* 1983. Courtesy Mary Boone Gallery, New York.

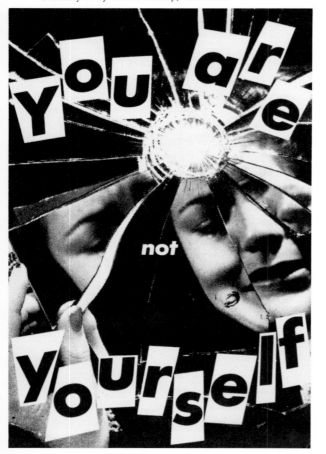

double inversion, the viewer is led ultimately to reject the work's address, this double postulation, this contradictory construction. There is risk, of course, that this will take the form of yet another gesture—a gesture of refusal. It can, however, be an active renunciation. Against the immobility of the pose, Kruger proposes the mobilization of the spectator.[9]

The British artist Victor Burgin used photographs and text to emphasize political issues, often pointing to social and/or sexual inequities, as seen in *The Bridge,* 1984. Some of his works, like Kruger's, are similar to billboards with strong visual tableaux. In *The Bridge* are juxtaposed images dealing with sexual differences and scenes from an Alfred Hitchcock film.

The directorial mode and staging of tableaux that was seen earlier in the work of Cindy Sherman was carried out in a variety of ways during the eighties. Jan Groover created still-life tableaux that combined reality and artificiality. Her combination of fragments of classical architecture, sculpture, and painting with harsh lighting and slashing background forms jars the viewer's sense of what is real and not real. Her work, like that of a number of other photographers of the decade, called for a reconsideration of the notion that photography could represent reality and the truth.

Eileen Cowin staged domestic docudramas, loosely based on soap opera scenes or film stills, where she often used herself, her twin sister, and members of her family, defying a tradition of family portraits that were to represent harmony and wholeness, at least on the surface. Cowin's scenes often contained elements of discord and anxiety. In later works such as a 1988 *Untitled* cibachrome, which draws heavily on a Magritte painting, one finds allusions to alienation and voyeurism.

Ellen Brooks and Laurie Simmons used dolls in fabricated tableaux to create miniature environments that were microcosms of a larger world. Simmons used the dolls as representa-

tives of herself, her family, and acquaintances who were a part of her growing up in the suburbs in the sixties. She was concerned not only with exploring these past relationships, but with exposing conventional representations of particular cultural models and behavior that were part of her childhood. In a piece such as *Tourism: St. Basil at Night,* one sees the glitz of night lights attract undiscerning tourists (the dolls), who are portrayed, with their different single colors of yellow, blue, green, and red, as very one-dimensional and similar to one another.

Brooks's later work in the decade involved taking black and white photographs of landscape scenes that had been manipulated by humans, such as a golf course, from magazines and other printed sources and overpainting them. She then rephotographed the "found" and painted image through a mesh filter device, producing a pseudo-pointillist style seen through various layers of reproduction. The work involved appropriation of both style and content, but also illuminated a type of layered vision that one may often experience where either the "original" object or image is so obscured by layers of meaning imposed from without that it is difficult to discern what is authentic, or the viewers come enshrouded with their own layers of perceptual baggage, making it difficult to view a work on its own terms. Brooks's work also points to the subjugation of the natural by the cultural and postindustrial as the "natural" landscape becomes obliterated by humankind and then by layers of reproduction imagery.

James Welling appropriated a classic photographic style and an institutional presentation, often using beautiful frames, to subvert traditional ways of looking at photographs. In the early eighties he made "straight" photographs of crumpled aluminum foil, Jell-O, or flakes of dough spilled on a velvet drape, which could be seen as both representational and abstract visual metaphors that play against each other

[4.30]. For some they may be analogous to Stieglitz's *Equivalents,* a series of sky and cloud abstractions that were "equivalents" for human experience and emotion. But for others the works may evoke a state of nothingness.

> In expressive terms they seem to be "about" something specific, yet they are "about" everything and nothing. To the artist they embody tensions between seeing and blindness; they offer the viewer the promise of insight but at the same time reveal nothing but the inconsequence of the materials with which they were made. They are in one sense landscapes, in another abstractions; in still another sense they are dramatizations of the postmodern condition of representation.[10]

Welling himself noted the importance of ambiguity in his work: "Ambiguity is an important stage in understanding my work, but I don't want the viewer to be perceptually baffled by these photos. . . . What interests me is this primitive desire to look at shiny, glittering objects of incoherent beauty. I'm trying to locate a place outside of the dominating power of language where these sensual landscapes can exist. It's an ambiguous site because the photographs are antagonistic to language."[11]

Welling continued his concerns with ambiguity in his photographs of the late eighties, of sumptuous, cascading drapes in rich mahogany frames. There is a brooding, elegiac sense to the pieces, but there is also a free-flowing buoyancy in the work. Photographed with a four-by-five camera in his studio, the photographs, part romantic and part ironic, evoke many associations, which Welling intended:

> What I'm really interested in is this ever-widening set of associations in the work. With the photographs of drapes I'm involved in the numerous things draped fabric evokes: flags, drapes, curtains, bunting, sails, interiors, etc. I wanted to make a complicated photograph which connected on a number of subjective and cultural overlaps. . . . The drapery photographs in this show are a personal cenotaph to the nineteenth century. I think my work is close to what

4.30. James Welling, *Untitled*, 1980. Jay Gorney Modern Art, New York.

4.31 *(opposite)*. Starn Twins, *Double Mona Lisa with Self-Portrait*, 1985–88.

has traditionally been defined as poetry. The world is a complex of coded activities which are often difficult to access. I don't see how the artist's vision can be less complex.[12]

The Starn Twins subverted and deconstructed photographic traditions and the very process of making photographic pieces. The twins often took photographs of existing images, such as the Mona Lisa in *Double Mona Lisa with Self-Portrait* [4.31], 1985–88. They then collaged crumpled, torn, or marred fragments, often using cellophane tape, into large constructions which had both painterly, photographic, and sometimes sculptural qualities. These pieces shatter traditional images of historic heroes and historic icons, as in *Double Mona Lisa* and *Christ Stretched*, 1985–86, where a seventeenth-century painting by Philippe de Champaigne of the dead Christ is

mounted horizontally in a black wooden case; or *Crucifixion*, 1985–88, a fragmented wall installation of wire, tape, and wood with photographs of a painting of Christ. In *Double Mona Lisa* the Starn Twins photographed their own reflections on the Plexiglas box that surrounds the painting, making themselves an integral part of the reproduction and re-presentation of the famous icon. The physical and conceptual layers of this piece exemplify concerns with a postmodern, fragmented and collaged vision. The double or twin image of the Mona Lisa in association with the twins themselves alludes also to their roles as artists in a contemporary world—artists who are refabricating and reconstituting existing images, and in the process perhaps continually redefining themselves. For, as Terry Eagleton suggests in *Literary Theory: An Introduction*, all meaning may be transitory and provisional in our times.

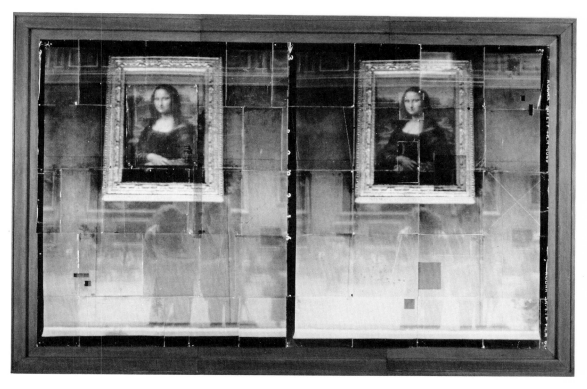

Nothing is ever fully present in signs: it is an allusion for me to believe that I can ever be fully present to you in what I say or write, because to use signs at all entails that my meaning is always somehow dispersed, divided and never quite at one with itself. Not only my meaning, indeed, but me: language is something I am made out of, rather than merely a convenient tool I use, the whole idea that I am a stable unified entity must also be a fiction. . . . It is not that I can have a pure, unblemished meaning, intention or experience which then gets distorted and refracted by the flawed medium of language: because language is the very air I breathe. I can never have a pure, unblemished meaning or experience at all.[13]

This premise of never being able to have a "pure, unblemished meaning or experience" appears to be a crucial postmodern concern, and one that artists such as the Starn Twins using photography could very directly address.

In an attempt to deal with changes in meaning and human relationships, a number of art-ists turned to multiple images, finding the single image incomplete. Nan Goldin's series of friends and lovers, resulting in a slide and sound show, *The Ballad of Sexual Dependency,* 1983, contained documents of feeling and expression in an almost photojournalist fashion.

Lorna Simpson, with her texts and sense of photographs, often explored gender and social issues. In *Gestures/Reenactments,* 1985, a series on black men, Simpson shot various parts of one man, but juxtaposed these with a text that suggested different people by using different names and suggesting different points of view, thereby interweaving multiple narratives and meanings. The first line of her text in *Gestures/ Reenactments,* "So who's your hero," is a question that appeared to be asked in a variety of contexts in postmodernist inquiry.

More direct exploration and documentation of human emotion appeared in the photojournalist portraits by Mary Ellen Mark in India or

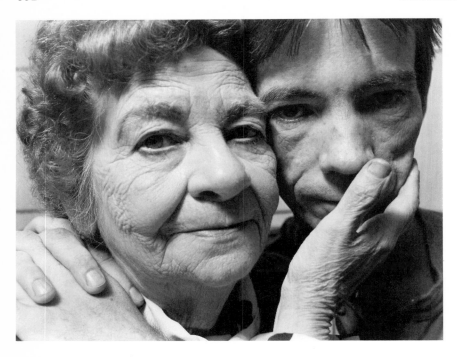

4.32. Nicholas Nixon, *Tom Moran and His Mother, Catherine,* August 1987. Courtesy Zabriskie Gallery, New York.

in the series by Nicholas Nixon of those afflicted with AIDS, of the aged, and the Brown sisters. Nixon's portraits of AIDS sufferers following the ravages of the dreaded disease are so compelling that they are at times difficult to look at for an extended period of time. Yet the dignity of the subject is maintained. The viewer may be both sympathetic and outraged at the devastation of the incurable disease, which Nixon poignantly captures. His series of the Brown sisters, one of whom was his wife, is a journey through time as the sisters age and change over time. The group portraits are simple and direct, but speak eloquently about relationships through gesture and pose, and about human interactions with time that cannot be erased or turned back. Taken singularly they might be little more than sensitive family portraits lifted from an album. But as a group, they stand as a provocative and universal reflection of the implications of growing older [4.32].

Other photographers also dealt with issues of aging and mortality. John Coplans made large-scale studies of his own aging physical form. His *A Body of Work*, a series of self-portraits [4.33], showed his body in a variety of poses, ranging from the Edward Weston bell-pepper shape to a strong muscular Michelangelo torso to a Warhol-like androgeny. What one does not see is specific facial features. Rather, Coplans's body, nearing seventy, becomes a variety of landscapes of contours and skin tones and blemishes. Coplans's photographs were part of a varied and rich career of a man who had multiple roles in an evolving art world: from painter to founding editor of *Artforum* to senior curator at the Pasadena Art Museum to winner of the Frank Jewett Mather College Art Association Award for his own criticism to director of the Akron Art Museum.

Issues of authenticity and the ability or inability to experience "pure" meaning were further complicated by the use of digitized electronic photography, which records an image digitally, an image that can be stored in a computer to edit, montage, and alter. Nancy Bur-

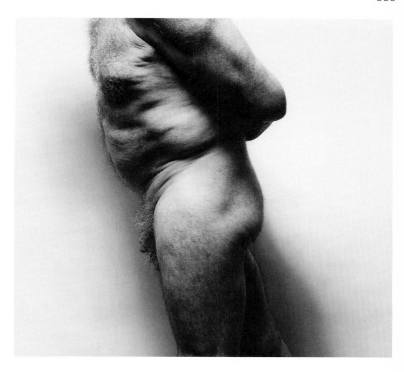

4.33. John Coplans, *Self-Portrait (Side Torso Bent with Large Upper Arm)*, 1985. Galerie Lelong, New York.

son, a conceptual artist, used the computer and technology to create composite faces. In her *Untitled*, 1988 [4.34], facial image Burson used a computer's bank of so-called normal facial types to create a somewhat abnormal one.

Howard Sochurek, a former *Life* magazine staff photographer, used the computer to transform forms of energy from medical machinery used to examine the body, such as sound and X-rays, to visual color print forms. Joni Carter, using electronic photography and computers, made "paintings" from freeze-frame broadcast images.

In Europe the eighties also brought a continued blossoming of photography, but not on the same level as in the United States. Uta Eskedson, curator of photographs at the Folkwang Museum in Essen, West Germany, noted in 1989,

> Photography is very lively in Europe at the moment and not just in Germany. . . . In Europe there is a division between so-called high art and trivial or low art, with photography associated with low art. This no longer makes sense. We should talk about the work, not where it comes from. Photography is learned in trade schools, not in the academy. In Germany the conflict has been that art galleries have no space for traditional photography. In the U.S. photography has been integrated into the college system for a long time. Photography is part of daily life, and that has resulted in a very different history of the medium.[14]

A sampling of approaches to the use of photography by Europeans may be seen in the work of Arnulf Rainer, Jean-François Lecourt, Christian Boltanski, Patrick Faigenbaum, Thomas Ruff, and the collaborative teams of Anna and Bernhard Blume, and Vera Lehndorff and Holger Trülzsch.

The Austrian Arnulf Rainer was trained as a painter, and painted in surrealist and art informal styles. As early as 1953–54 he made photographs of himself that he expressionistically overpainted, and continued to do so into the

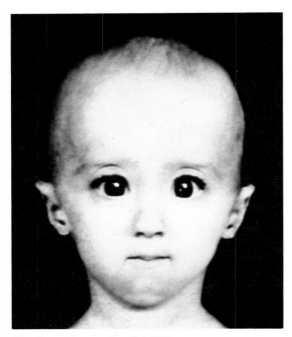

4.34. Nancy Burson, *Untitled*, 1988.

eighties. It is this synthesis of painting and pho-
tography that makes the work powerful, as the
strong gestured brushstrokes combine with the
often contorted and distorted facial features to
begin a journey inward to subconscious and
perhaps uncivilized levels of the psyche. There
is a frenzy to many of the almost primal images
that recalls in spirit the frenzy of some of Emil
Nolde's paintings of candle dancers. Beyond
the use of photographs of himself, Rainer also
used mummies, corpses' faces, death masks,
and images of crucifixions from 1970 to 1983.
More than many of the painters, Rainer, in his
overpainted photographs, extends the spirit of
Neo-Expressionism to a darker, more primal
realm. And his pictures are perhaps all the
more shocking as it is realized that the images
are not individuals but Everyman in an ex-
panded, emotional, and physical state, which
may be difficult to come to terms with if it is
admitted that such a state may in some part
exist in each of us.

Jean-François Lecourt also explored the
self, with his photographic self-portraits that in-
volved elements of performance art. Having
skills as a marksman and karate master, Le-
court took his self-portraits by simultaneously
tripping his camera shutter and firing a rifle
through the apparatus into the negative,
thereby portraying himself as the artist flirting
with death.

The Paris-born Christian Boltanski, born on
Liberation Day in 1944, with the middle name
of Liberté, rephotographed images of children
to deal with issues of memory, youth, and
death. In his *Monument* series Boltanski sur-
rounded photographs of photographs of chil-
dren with small lights like candles and framed
them with tin. Works such as these are best
understood in the context of the Holocaust,
where the faded photographs and flickering
lights are but dark and dim memories not spe-
cific figures. In other candle pieces Boltanski
added small copper figurines, whose shadows
danced in both deathly and playful silhouettes
on the walls behind.

Patrick Faigenbaum, a Frenchman, used
portraiture to capture a sense of decay in his
portrayal of the Italian aristocracy at home. In
his portraits the ornate decor of regal interiors
appears to stifle and dwarf the individuals who
live there. The dark tones of his prints and his
placement of his subjects at a distance from the
camera accentuate the feeling of unhappiness
and subtle crumbling of an aristocratic world.

The young German Thomas Ruff turned to
large-scale color prints taken with his four-by-
five Technika camera. The sharply detailed
portraits show every blemish and facial detail—
freckles, blemishes, birthmarks—and are en-
larged to five times life size. They are then
melded to Plexiglas and encased by a frame.
The powerful frontal images are sometimes
named but often are listed only as *Portrait*
[4.35] and appear to be people the viewer
might know rather than celebrities or heroes
who would traditionally be aggrandized in the

blown-up imagery that Ruff uses. Ruff gives his subjects no instructions concerning dress or pose, instead letting them select how they would like to be seen, or how they view themselves. But the enlargement of what otherwise could be a photograph taken for a passport goes beyond the reality of the subject and the studio. One West German asserted that Ruff's work is "visual proof of the impossibility of realistic representation of appearance."[15] And Ruff himself has stated that "photography lies, and it has done so virtually since its invention, but it has taken people a hundred and fifty years to realize this. It lies because it purports to represent reality. But a photograph remains a picture, and photography is merely a technique for the creation of pictures—just like painting."[16]

Anna and Bernhard Blume, collaborators since 1986, created large-scale photo sequences that often explored domestic scenes and gender roles. The scenes often show objects and humans who are out of control. Bernhard brought to photography his work in conceptual art and his participation in Fluxus and other performances, while Anna brought her concerns with a female sensibility, seen in her large drawings of 1975–82. In *Trautes Heim* (*Cozy Home*) one finds food and dishes overpowering a woman (Anna), who is ejected from her kitchen chair, as traditional perceptions of home and kitchen as stable and ordered are shattered and turned upside down. The Blumes used a variety of photographic techniques— time lapse, selective focus, blurred images, multiple exposures, and mirrors—to portray space, time, and dreamlike forms in unusual ways. There is a directness to the work that draws the viewer into these psycho-social dramatic sequences. Anna Blume has called the work "photodocuments" and "phototherapy."

The German team Vera Lehndorff and Holger Trülzsch brought a background of fashion modeling (Lehndorff was once known as Veruschka) and painting to their collaborative

photographic pieces. Drawing upon conceptual and performance art, Lehndorff posed in front of abandoned warehouses and various landscapes, while her naked body was painted by Trülzsch as "camouflage" to fit into the surroundings. The strong color photographs made from the "set" were often disturbing, with the tension created between abstraction and figuration.

In general, it is perhaps fabrication and construction of imagery, as well as appropriation, that dominated much of the experiments in photography during the decade. The conflation of "high" and popular culture in many works seemed to bring a new kind of energy and vitality to photography. In looking toward the future it is difficult to pinpoint what the journey down the road of construction and fabrication

4.35. Thomas Ruff, *Portrait*, 1988. Courtesy Museum of Fine Arts, Boston.

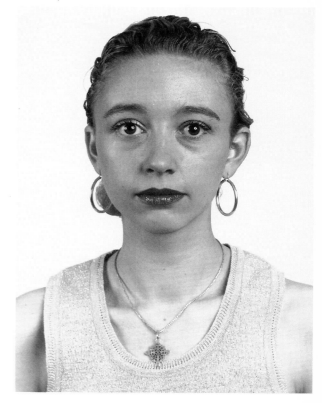

of images will bring. The role of technology in photography, though, cannot be avoided. As computers and digitalized imagery become more widely used in photography, the darkroom and its chemicals may become archaic or obsolete.

NOTES: PHOTOGRAPHY, 1980S

1. Cited in Susan Weiley, "The Darling of the Decade," *Artnews,* April 1989, p. 143.
2. Kathleen McCarthy Gauss, curator, Los Angeles County Museum of Art, cited in ibid., p. 145.
3. Andy Grundberg and Kathleen McCarthy Gauss, *Photography and Art: Interactions Since 1946* (New York: Abbeville Press, 1987), p. 207.
4. Cited in Benjamin H. D. Buchloh, "Allegorical Procedures: Appropriation and Montage in Contemporary Art," *Artforum,* September 1982, p. 52.
5. Grundberg and Gauss, *Photography and Art,* p. 209.
6. Richard Prince, *Why I Go to the Movies Alone* (New York: Tantam Press, 1983), pp. 63, 69–70.
7. Richard Prince, "Interview with Elisabeth Sussman and David Ross," *The BiNational: American Art of the Late 80's* (Boston and Cologne: Museum of Fine Arts and the Institute of Contemporary Art and Dumont Buchverlag, 1988), p. 164.
8. Barbara Kruger, cited in Carol Squiers, "Diversionary (Syn) Tactics," *Artnews,* February 1987, p. 79.
9. Craig Owens, "The Medusa Effect, or The Specular Ruse," *Art in America,* January 1984, pp. 97–105.
10. Grundberg and Gauss, *Photography and Art,* p. 211.
11. James Welling, "Interview with Trevor Fairbrother," *The BiNational: American Art in the Late 80's,* p. 221.
12. Ibid., pp. 221–22.
13. Terry Eagleton, *Literary Theory: An Introduction* (Minneapolis: University of Minnesota Press, 1983), p. 96.
14. Cited in Weiley, "The Darling of the Decade," pp. 148–49.
15. Cited in John Dornberg, "Thomas Ruff," *Artnews,* April 1989, p. 165.
16. Ibid., p. 165.

SCULPTURE, 1980S

SCULPTURE of the eighties is difficult to categorize according to any one style or theme. Important was the diversity of approaches and the increased exhibitions and attention given to sculpture by the middle and end of the decade. There appeared to be limitless stylistic approaches, techniques, and materials. In some cases there was a revival of traditional materials and forms, with the use of wood, stone, and bronze. In other instances technology or Post-Modernist concerns dominated the work. Neo-Expressionist painting seemed to open up new possibilities for sculpture as painters such as Schnabel and Kiefer emphasized the physicality and potential power and beauty of rawness in their work. The purity and cleanliness of Minimalism was finally set aside, although there was a continued interest in simple abstract forms that came partially from Minimalism's legacy.

Although no one style or theme can be said to have dominated the decade, Martin Friedman, in his introduction to the catalog for an exhibition, "Sculpture Inside Outside," featuring seventeen young American sculptors who came of age artistically in the eighties, pointed to four tendencies that appeared to be prevalent in much of the sculpture of the decade: figuration, transformed objects, organic abstraction, and architectural abstraction.[1] In many instances artists' works exhibited qualities of several "categories." The artists selected for discussion below illustrate some of these emphases, as well as other concerns representative of the time. Those selected for discussion are but a few examples of the diversity of both form and content found in the large number of works being made.

A major figure to emerge was Martin Puryear, born in 1941 in Washington, D.C. Puryear took some of the simple reductive forms of Minimalism and invested them with human and primitive qualities, often using wood, which tended to evoke warmer sensations than a cool metal or glass. Growing up in Washington, D.C., Puryear developed interests in history, ethnology, and biology as well as art. Following his graduation from Catholic University in 1963, he joined the Peace Corps and spent two years teaching secondary school in Sierra Leone. As he studied traditions in West African carpentry and building, where work was primarily done by hand, Puryear became increasingly interested in pursuing sculpture via a craft tradition. Following his tour with the Peace Corps, he studied at the Swedish Royal Academy of Art in Stockholm for two years and there became involved with Scandinavian craft. He then went on to Yale to receive his M.F.A. degree in sculpture in 1971. Much of

Puryear's sculpture suggests an intimate meeting of modern and primitive spirits. Some of his works, such as *For Beckwourth,* 1980, suggest solid, primitive, architectural, or sculptural forms. *For Beckwourth,* consisting of a square wood base on which is mounted an earthen dome, was based on the dome of Tibetan stupas. The piece was named after a black American frontiersman and also alludes to the use of wood and earth by American pioneers to construct shelters. In other pieces, such as *The Spell,* 1985, there is a more open linear and lyrical quality [4.36]. *The Spell,* combining "natural" and man-made materials with the use of pine, cedar, and steel, bridges modern and primitive worlds in both form and content, as it plays with images of cornucopia, vortex, and totem, which become intertwined. The light, smoothly rounded rim and the darker woven cedar resonate together, rooted in a handmade

crafts tradition, while the straight steel ribs further define the otherwise curvilinear structure. A new conelike hollow embraces and supports the wooden shapes. The ambiguous interplays of line and shape, of curvilinear and straight edge, or organic and geometric, of primitive and modern, draws the viewer quickly into the piece.

Meg Webster's work incorporated primitive and modern qualities as she synthesized aspects of Minimalism and Earthworks pieces. Beginning in 1980, she began using "natural" materials such as sand, earth, and gravel. The reductive and elemental shapes—the circle, triangle, square—used by the Minimalists began to take on more sensuous and primal qualities through Webster's choice of materials. Her 1988 *Moss Bed* is illustrative of the living, animate quality that much of her work has. Webster also did site-specific pieces as well as pieces that actu-

4.36. Martin Puryear, *The Spell,* 1985. Photograph courtesy Donald Young Gallery, Chicago.

ally grew and changed. One such piece, *Two Hills for Passage,* 1983, exhibited as part of her M.F.A. thesis at Yale in 1983, consisted of two mounds of earth on which grass was planted and grew, inside, under fluorescent lights, illustrating a natural process in an unnatural way. This paradoxical presentation was inherent in a number of Webster's pieces.

Tom Butter also transformed simple geometric shapes and forms, but employed different materials. Butter's use of fiberglass and resin enabled him to create translucent pieces that have both transcendent and earthy qualities. Born in Amityville, New York, in 1952 he first became familiar with fiberglass while sailing as a boy off Long Island and repairing and modifying boats. He received a B.F.A. from the Philadelphia College of Art in 1975, concentrating in printmaking. It was during his graduate work at Washington University in St. Louis that he turned increasingly to sculpture. Intrigued by the work of both Eva Hesse and Brancusi, Butter began to use fiberglass in his work in 1977 when he moved to New York. In a piece such as *Orbit,* 1986, one sees Butter's organic and more formal geometric shapes. The vaselike shape is almost a straight cylinder until the top, where its beautifully rhythmic rim serves as a collar for the orange figurative or podlike shape that rises boldly from the enclosure. The pod shape suggests growth and change, as it rises from an enclosed inner world to pierce the outer space. In works after 1986 Butter began to incorporate wood, wire, sheet metal, and aluminum as well as fiberglass in his pieces.

Working with blown glass as well as steel or bronze, Christopher Wilmarth transformed Minimalist shapes and forms into eloquent interplays of light, color, and shadow. In 1978 Wilmarth was invited by the poet Frederick Morgan to illustrate his translation of a group of poems by the nineteenth-century French Symbolist Stéphane Mallarmé. As Wilmarth considered taking on the project, he realized that some of his concerns were the same as Mallarmé's. "Mallarmé's work is about the anguish and longing of experience not fully realized, and I found something of myself in it."[2] Wilmarth illustrated the poems through drawing, etchings, and wall sculptures. The common denominator was an ovoid form suggestive of an egg, a seed, a head, a womb—a growing, organic entity. For the sculpture Wilmarth turned to blown glass and found an intimacy in the process and product not obtained in previous work. One of the most powerful pieces of the project was *Insert Myself within Your Story,* 1979–80 (title taken from the first line of one of the erotic poems), consisting of two steel plates open like an upright book, with one plate partially inserted into a glass oval. The glass was etched to allow for partial glimpses of the generating steel. Male and female are invoked both separately and in union.

Following the Mallarmé project, Wilmarth continued to use blown glass. Of particular note were his three versions of *Baptiste (Longing),* 1983–84. The pieces were inspired by the figure Baptiste Debureau, a nineteenth-century mime, wrenched between fantasy and reality, who appeared in Marcel Carné's film *The Children of Paradise,* which was Wilmarth's favorite film. The ovoid blown glass appears again in the three pieces as a human head. The third version incorporated blown and flat glass, as well as bronze. The combination of straight edge and ovoid forms and subtleties of light, color, and texture provoke sensations of intimacy and seduction.

Joel Shapiro took Minimalist geometric shapes and created stick figures that are rhythmic and energetic, reaching out into space, often suggesting the movements of a dancer. Many of his figures were built of square-cut posts and cast in iron or a rich reddish-gold bronze—with wood grain, knot holes, and the like. There was a smooth economy of form. But often inherent in the assembled forms was a sense of a fragmented, struggling figure reach-

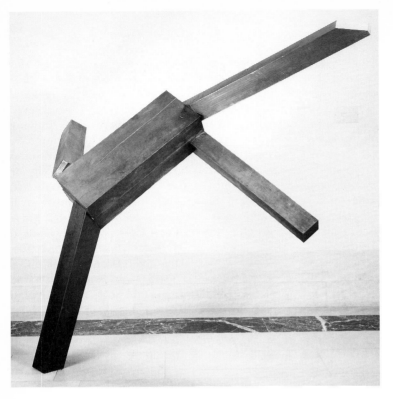

4.37. Joel Shapiro, *Untitled,* 1984. The Saint Louis Art Museum.

4.38 *(opposite).* Bryan Hunt, *Prodigal Son, Barcelona* series, 1985. Blum Helman Gallery, Inc., New York.

ing out and groping in a spatial void [4.37].

By the eighties Bryan Hunt had broken almost completely with Minimalist influences. Born in Terre Haute in 1947, Hunt moved to Tampa, Florida, with his family when he was ten and grew up in the shadow of the lift-offs of Cape Canaveral. He initially entered the University of South Florida to study architecture, but became more concerned with design and drawing and ultimately left the school. He made his first journey to Europe in 1968 and spent much of his visit drawing the "classics," such as the white cliffs of Dover, Chartres Cathedral, the Medici tombs, and the caryatids of the Erechtheum. Thereafter he continued to study the classics, primarily through travel. Hunt has made sculptures from a variety of themes, including streamlined airships, the Hoover Dam, the Empire State Building, and the Great Wall of China, and waterfalls. During the eighties Hunt also began to make a series of armature-like works, such as *Prodigal Son,*

1985, which are both figurative and abstract [4.38]. "The armatures and the linearity of the subject matter," Hunt explains, "become the most refined kind of drawing in space. A painter can make the illusion of a line in space but sculptures truly have the ability to make a line in space."[3] Some of Hunt's work alludes to classical and heroic forms and themes, as indicated in his titles such as *Seated Caryatid,* 1984, and *Icarus,* 1984. The richly textured white plasters done for his *Barcelona* series can be read both as fragments of Greek goddesses and as elegant abstract forms emphasizing line and texture. Combined with the plaster were wood and steel elements, as Hunt combined the processes of modeling, carving, and welding. The "Barcelona Project," which was commissioned by that city to celebrate in 1992 the five hundredth anniversary of Columbus's voyage, was to consist of a single large sculpture placed under a skylight in the center of a restored Catalonian ruin. Hunt's spatial "drawings"

have strong gestural and textural elements that invite the viewer to become involved in both the process and product.

Judith Shea used figurative fragments often based on classical and historic forms to reach toward what she termed the "essence of [a] human presence or human energy without the extraneous parts. The center of the torso, or some portion [of it] seemed to contain the presence. You didn't need arms, legs, or a head to represent the human presence."[4] Her background as a clothing designer led her to use clothes as a type of primary structure. Her large-scale outdoor piece, *Without Words,* 1988, incorporates historical "fragments" to address some contemporary concerns of fragmentation, presence, gaze, and gesture. The piece consists of two bronze "figures"—an empty seated coat with no figure and a Hera-like head-

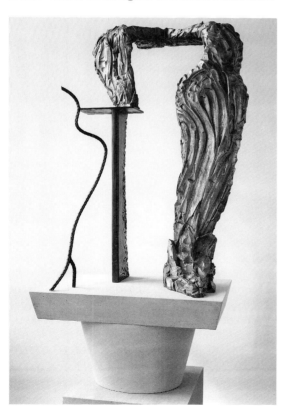

less female figure—and a central marble head fragment of an ancient Egyptian head, based on an Eighteenth Dynasty sculpture of Queen Tiye. Psychological and emotional undertones seem to pervade the work as the coat "gazes" at the melancholy but sensuous fragmented head, while the female torso stands cold, unimpassioned.

The human figure was treated in a much different fashion by artists influenced by the grit and graffiti of urban living and by the media. The young Rodney Alan Greenblat, growing up in southern California, a child of the television age, was selected for inclusion in the Whitney Biennial when he was only twenty-four. His figures and assembled pieces are from a world of cartoons and childhood fantasies and games. He graduated from New York's School of the Visual Arts in 1982 and settled in the East Village, showing with Gracie Mansion's Gallery when it opened. Like Kenny Scharf's paintings, Greenblat's work is filled with good humor and fun, as he creates imaginary figures and little universes. In his *Guardian,* a gaudy colored angel-winged figure decorated with Eskimo drawings and a gilded television set showing a science fiction comic, the worlds of electronic media and primitive ritual seem to coexist peacefully [4.39]. "I like the idea of making happy decorative art," Greenblat said. "I like opening art to a kind of craziness, an upbeat feeling. As for the element of fantasy, it's important in our life. If we took everything seriously, without humor, we wouldn't be able to function. The world is so full of trouble, we have to laugh in order to live."[5]

Predominant in the 1980 Times Square Show were Tom Otterness and John Ahearn. (The Times Square show took place in Times Square in a run-down four-story abandoned massage parlor that was filled with the energy and work of approximately one hundred artists. Every possible space, including toilets and closets, was filled, and loud carnival music blared

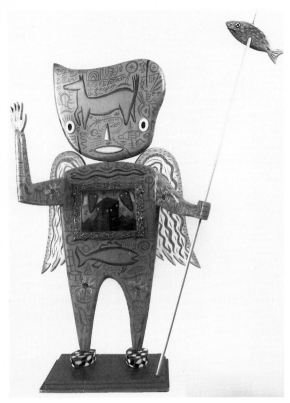

4.39. Rodney Alan Greenblat, *The Guardian*, 1984. Gracie Mansion Gallery, New York.

from loudspeakers.) Otterness, a chief activist in CoLab, which cosponsored the show, poked fun at archetypal figures such as Jack and Jill and Adam and Eve. His *Jack and Jill*, 1985, are automatons who jar our childhood memories of innocent nursery rhyme figures. A naked Jill holds Jack's pants as a trophy while the partially clothed Jack holds a banana in his hand. Inside the pail is a globe, suggesting a worldliness and universality of the figures as well as an ironic acquisition of knowledge, both sexual and social. Yet the expressions on the figures' faces are not those of pleasure or fun, but a certain grimness of acceptance. Other Otterness figures, still small, were less specific or were like "dough boy" figures, often arranged in frieze form, parodying archaic and classical forms.

John Ahearn, also involved with CoLab, chose to live and work in the South Bronx with its urban ghetto problems of poverty and disor-

ganization. Ahearn with his associate Rigoberto Torres took for his subjects the citizens of this destitute area, making lifecasts and creating bust pieces, relief murals, and large-size full body pieces. Unlike the work of Duane Hanson or John De Andrea, Ahearn's pieces, such as *Louis and Virginia Arrojo*, 1980, have a strong emotive and expressive power. Ahearn also saw his work as a gift to the community, to further a sense of cohesiveness. "Our sculpture work has been nourished by its constant interaction with people. Our lifecasts are 'tokens of our affection,' made to underscore cohesion and continuity. The community portraits were created and displayed in the South Bronx. The 'bust' pieces are made primarily to initiate or cement friendships; the larger figures are used for permanent sculpture murals in the area."[6]

The rubble and kitsch of the urban scene became for some artists a source for scavenging for parts for assembled pieces. The layered and collage/assembled aesthetic had not disappeared, and artists such as Donald Lipski raided junkyards, dumpsters, and dimestores. His work was filled with a bursting energy, often both literally and figuratively, as his collected fragments appeared ready to burst forth from a "container," as seen in his *Building Steam No. 317*, 1985. This piece was part of a series whose title was in partial homage to the eighteenth-century inventor James Watt, who invented the steam engine, which was to become a crucial tool for the Industrial Revolution. The compressed sense of energy inherent in the pieces in this series is analogous to trapped steam. From the refuse and fragments of a technological age, Lipski created new energies.

Jin Soo Kim used the debris of the urban landscape—bedsprings, plastic pipes, floor tiles, radiators, broken chairs—to create installations and environmental sculpture that explore the polarities of life and death. A native of South Korea, Kim grew up as the daughter of a midwife, witnessing both the sorrows and joys that could accompany birth. Due to economic and

social constrictions Kim was unable to study art in Korea as she would have liked, but instead studied to be a nurse. She came to the United States in 1974 and ultimately received her M.F.A. from the School of the Art Institute of Chicago. In the early eighties she worked primarily in painting and collage, but became haunted by what she saw and found in parts of Chicago. A number of her installations have included skeins of brown paper wrapped around wood, which she has related to her duties as a nurse that involved wrapping dead bodies in plastic before they left the hospital. Some of the elements of her pieces suggest the human figure, decayed or disposable. As she has said, "I see traces of people in the scattered and forgotten objects I pick up in the margins of the city."[7] Although her work is filled with fantasy and feels at times as if one were floating in an underwater grotto, there are disturbing questions that arise from the work about life, death, and the ease of discarding materials in our society.

More direct in the questions he posed through his installations was the work of Lothar Baumgarten. Baumgarten raised questions concerning the tolerance of other cultures and the destruction and exploitation of third world and minority groups. His 1988 *Terra Incognita,* an assembled floor installation, consisted of thin fragments of shattered redwood trees, lengths of electric wiring, yellow and blue electric lamps, and heavy white dinner plates containing runic drawings. The piece was a portrait of an area on the frontier between Brazil and Venezuela that the artist had visited on six different occasions, with a minimum stay of four months, between 1977 and 1986. The splintered wood pieces allude to the destruction of a forest and Indian culture by outsiders. The curved configurations of the electric wiring may allude to the meandering rivers of the area, but the wiring and plates are also representative of an industrialized culture. The blue lights stand for a type of glow the jungle vegeta-

tion may take on at twilight, which Baumgarten witnessed, while the yellow lights refer to the Indian practice of painting yellow any lamps they might have to ward off malaria-carrying mosquitoes. John Russell said the piece was about "a manifold collapse—of the environment, of civil rights, of a complex system of signs that give life—from which we should not avert our eyes. When we drive home on a winter's evening and see the neighbor's lights, the polluted waters and quite possibly the ravaged trees, we should realize that *Terra Incognita* is not only about a forgotten people in a far country."[8]

Baumgarten's piece for the 1988 Carnegie International was a ceiling installation of approximately 110 feet by 40 feet that celebrates the Cherokee alphabet, which was devised between 1809 and 1821 by an Indian named Sequoyah. The piece, *The Tongue of the Cherokee,* consisted of painted, laminated, and sandblasted glass panels that eloquently presented the characters of the alphabet, which made it possible for a Cherokee newspaper to be published and read and elevated the status of the tribe. Baumgarten's piece is about the beauty of an "other" and an unknown language, but it also reminds us about the obliteration of many aspects of American Indian cultures due to white oppression.

While Baumgarten's work provokes the viewer about social concerns, Harold Tovish's assembled constructions of the eighties speak about existential concerns, of alienation, isolation, and fragmentation. Tovish's use of dark spaces, mirrors, and disembodied heads, embedded in fractured egglike shapes, result in haunting and eerie sensations as the viewer confronts his pieces, and confront one must, either by looking down, into, or across, at eye level. Tovish's *Region of Ice,* 1984, with its spiral of glass shards and melancholy face—it too a shard peering from within the fractured oval—conveys the sense of endless fragmentation [4.40].

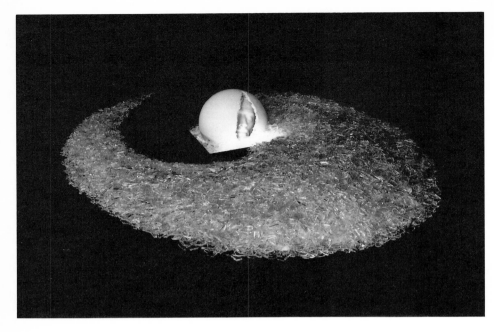

4.40 *(left)*. Harold Tovish, *Region of Ice*, 1984.

4.41 *(below)*. Haim Steinbach, *Generic Black and White #2*, 1987. Jay Gorney Modern Art, New York.

A younger generation of artists appropriated a variety of objects and forms, and represented or reassembled them. Haim Steinbach collected objects of kitsch and cultural artifacts from past decades and placed them on formica shelves that mocked Minimalism. In his *Generic Black and White #2*, 1987, Steinbach plays on Pop, Minimal, and kitsch references [4.41]. The juxtaposition of the cornflakes cereal boxes and the mass-produced ceramic ghost figures on the black and white shelves produces a conflation of Pop and Minimal art that can be read as both serious and parodic. Steinbach spoke of his presentation of objects as aspects of a culture or cultures: "archaeologists dig up the culture of others. They apply scholarly, scientific methods as they try to retrieve a picture of extinct civilizations. I am also a digger, but I

assemble material from my everyday environment. I want to capture the picture of the history of the present. I'd like to understand the process by which humanity fabricates fictions of the past or present."[9] Steinbach's pieces often appeared like commodities on a shelf in a store window, thereby questioning the growing emphasis in many circles of the art work as commodity.

Jeff Koons's polished stainless steel, porcelain, and wood pieces of appropriated Pop, kitsch, and heroic icons—from Louis XIV to Michael Jackson to Bob Hope to children's stuffed animals—were somewhat analogous to the business concept of "adding value" to a commodity for marketing and sales purposes. And for Koons the business world was no stranger. By the age of thirty-three he had been a publicist for the Museum of Modern Art and had spent more than five years selling mutual bonds and commodities on Wall Street. His brash transformation of the Baroque bust of Louis XIV to stainless steel (1986) was, according to

him, a symbol "of what has happened to art since it has been given freedom. It is a symbol of how artists have exploited art. I wanted to give it a fake luxury. That's why it's in polished stainless steel. The piece tries to be as seductive as possible, to use anything it can to seduce a viewer. I think the work is about the difficulty of telling the difference, in today's society, between who is a victim and who is a victimizer."[10] His larger-than-life white and gold porcelain *Michael Jackson and Bubbles* [4.42] is seductive as well in its reclining odalisquelike pose of endearment, and the glitter and glitz of the white and gold. The black singer is portrayed as white. He is artificial, frozen, but glamorous. For Koons this concern with artificiality relates to death. "I am interested in certain supreme forms of artificiality, of closed systems, of perfection, of death. I suppose that is what death is, a completion. Therefore it must be perfect. Since I consider my recent pieces to be as perfect as it is technically possible to render them, then it follows that they are about

4.42. Jeff Koons, *Michael Jackson and Bubbles*, 1988. Sonnabend Gallery, New York.

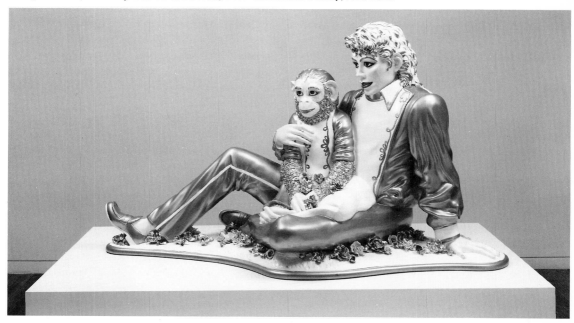

death, or at least stasis, as much as anything else."[11] If Koons's pieces were ever aimed at raising questions about artwork seen primarily as commodity, and the death of a modernist spirit of transcendence, they quickly became convincing examples of this commodification, as their prices rapidly soared upward.

Robert Gober appropriated domestic objects such as cribs, sinks, and chairs and re-created them in new formats that were often disjunctive and jarring. One recalls Marcel Duchamp's ready-mades in some of his pieces, but Gober's work tended to go beyond Duchamp's conceptual emphasis, which claimed that any object could be a work of art if the artist declared it so. Gober's *Slanted Playpen,* 1987, for instance, is a play upon the security and protection that a child's crib usually suggests, bringing intimations of insecurity, anxiety, and fear of the unknown in the distorted sides of the otherwise well-crafted crib. Gober's series of crafted sinks were not found objects, like Duchamp's urinal, but were made from wood, wire, and plaster, with no plumbing but open holes where pipes would fit. Some of the sinks were representational; others were flattened and abstracted. Although there appeared to be a Minimalist influence in the simplified, glistening white forms, there was a dreamlike and emotional quality hidden beneath the surface.

Artists such as Gober, Koons, and Steinbach, "questioning the ideas of authenticity and any presentation of the artistic self, . . . quote from a variety of styles and appropriate the behaviors of shopkeepers as well as consumers."[12]

Beyond art done for a museum or gallery, public art in three-dimensional formats continued to flourish during the decade. With a greater number of projects came increasingly varied approaches. Some pieces had ecological connotations, such as Lowry Burgess's *Boundless Cubic Lunar Aperture* (the fourth component of an ongoing work, *The Quiet Axis,* 1968–88), a piece involving a petrified sycamore, water from the mouths of the world's major

rivers, and the singing of whales. Part of this project, *Boundless Aperture,* was chosen as the first official art object to travel into outer space, aboard the shuttle Discovery in early 1989. Other pieces sought public participation, such as Paul Matisse's *Kendall Band,* 1987, fourteen teak hammers swinging between sixteen aluminum tubes in a fifty-foot row, set in motion by a wall handle, in a Cambridge, Massachusetts, subway station. Public art also consisted of straightforward sculptures or two-dimensional pieces placed indoors or outdoors in public spaces.

In 1988 an exhibition organized by real estate developers Olympia and York, entitled "The New Urban Landscape," organized to inaugurate the World Financial Center, was intended to celebrate the potential of public art. The exhibition was seen as an opportunity to blend art with the ebb and flow of daily activities, to change perceptions concerning the relationship of architecture and public space, and shed a positive light on urban life. The new urban landscape that the show was to celebrate was the planned residential and commercial community of Battery Park City, built on a landfill on the Hudson River in lower Manhattan. Unfortunately, most of the works commissioned for the show were displayed inside and appeared simply as large-scale sculptural pieces. However, the intent of the exhibition and the success of some of the pieces emphasized the growing significance of public art in American life. One of the most directly confrontational pieces for the public was Dennis Adams and Andrea Blum's *Land Fill: Bus Station,* 1988. The piece, a backlit photograph of a defiant funeral scene in Soweto, pierced by a concrete beam where one could sit, stood like an advertisement, but invited contemplation about racial issues and the nature of power. "It's a piece about the loss of power," said Blum, "but it's also a piece about fighting back."[13]

Another piece in the show, Mierle Lader-

man Ukeles' *Ceremonial Arch Honoring Service Workers in the New Service Economy,* was as important for the process as well as the product. The piece was made from a steel arch along with materials donated from city agencies. Gloves, bags, tools, and so forth, worn with usage, paid honor to the service systems of New York City. For approximately ten years beginning in 1979, Ukeles worked as an unsalaried artist-in-residence, attempting to document the city's maintenance system and show the significance of garbage disposal through a series of projects involving the sanitation workers, the actual garbage, and the collection process. One of her proposed projects late in the decade, *Flow City,* was to be a series of sequential participatory environments and observation points to increase public awareness of the maintenance system. Ukeles' work challenged traditional notions of public art that were more static and oriented toward the status quo. As one writer noted, "By studying the municipal department engaged in this entropic cycle of waste disposal, Ukeles has developed a forum for creative intervention and a way to increase the public's awareness of the connectedness of all urban and natural systems. Within the banal and the maligned, she recovers significant ideas about cities, circulation and public perception."[14]

One of the most controversial public art projects of the decade was Richard Serra's *Tilted Arc* [4.43]. The piece, commissioned by the General Services Administration (GSA) in 1979 (completed 1981), was located in a plaza at the corner of Broadway and Lafayette Street in New York City. It quickly provoked controversy and served as an example of the difficulties surrounding the placement of art in a public space. It also raised questions about policies for public art and public involvement. *Tilted Arc,* a site-specific work, was a slightly curved wall weighing 73 tons, measuring 120 feet long by 12 feet high. Some complained that it blocked a view up Broadway and of a park and

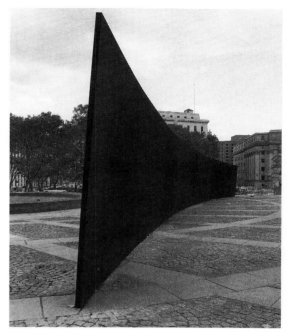

4.43. Richard Serra, *Tilted Arc,* 1981.

turned its back on a centrally located fountain. The piece met with outrage from people who worked in buildings facing the plaza. Thirteen hundred government employees signed a petition asking for the removal of the piece. After lengthy discussions involving artists, critics, government administrators, the general public, and a U.S. District Court, a GSA panel recommended relocating the piece at a cost of $500,-000. Serra filed a lawsuit against the GSA in 1986, demanding $30 million in damages, claiming the work was site-specific and that its integrity would be destroyed when relocated. But after eight years of controversy and various court rulings and appeals, *Tilted Arc* was disassembled—destroyed in the eyes of some—on March 15, 1989, under the surveillance of William Diamond, regional administrator of the GSA, in the middle of the night. It was carried off and packaged behind barbed wire in a yard in Brooklyn. "'Good riddance' was the headline of the editorial in the *Wall Street Journal.*

The world is finally safe from the evil thing."[15] Serra presented his description of and reactions to the case in the May 1989 issue of *Art in America*. Among his comments were the following:

> The governmental decree to remove and thereby destroy *Tilted Arc* is the direct outcome of a cynical Republican cultural policy that only sees art as a commodity. . . .

> If I had known that the government would claim *Tilted Arc* as its own speech and would claim the right to alter and destroy it, I never would have accepted the deal. . . .

> Publishers can continue to crop photos, magazine and book publishers can continue to mutilate manuscripts, black-and-white films will continue to be colorized, and the federal government can continue to destroy art.

> The new rule that I am urging is moral rights legislation, such a law would acknowledge a link between an artist and his work, even after the work has been sold.[16]

Also provoking controversy was the Vietnam Veterans Memorial, 1980–82 [4.44], located on the Mall in Washington, D.C. Designed by the then twenty-one-year-old Maya Ying Lin of Athens, Ohio, who was a student at Yale University, the 250-foot-long, V-shaped granite wall bears the names of nearly sixty thousand American men and women who died or are missing in Southeast Asia. Although the design was selected from a competition organized by the nonprofit Vietnam Veterans Memorial Fund (VVMF) formed in 1979, some veterans considered it "unheroic" and "death-oriented." Lin's intentions were to create a reflective and contemplative piece that would also be an integral part of the land. "I had an impulse to cut open the earth . . . an initial violence that in time would heal. The grass would grow back, but the cut would remain, a pure, flat surface, like a geode when you cut it open and polish the edge. . . . I chose black

granite to make a surface reflective and peaceful."[17] Due to some veterans' protests the project was temporarily halted in January 1982 by Secretary of the Interior James Watt. A compromise was reached in the commissioning of a naturalistic bronze sculpture of three life-sized soldiers by the artist Frederick Hart, which was also placed on the Mall, and dedicated in 1984.

Cases such as these have renewed debate about the complex issues surrounding public art and the rights and roles of artists, the general public, and funding agencies.

As Americans worked diversely in three-dimensional formats, so too did European sculp-

4.44. Vietnam Veterans Memorial, 1980–82. Washington, D.C.

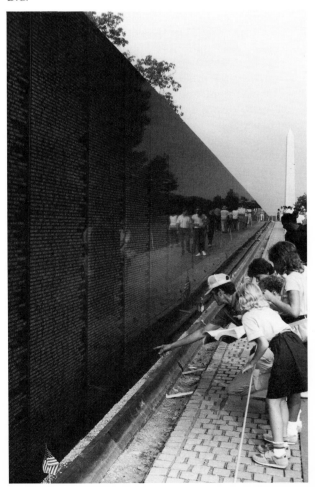

tors. In Great Britain Tony Cragg continued to stand out internationally. His work of the late eighties featured monumental casts of laboratory equipment such as flasks and test tubes, which were expanded or distorted and cast in heavy rusting steel. Cragg sought other languages in ordinary forms and saw these forms as "metaphors for bodies or parts of bodies. A body after all is a container, and so is, say, a stomach, like a retort, it contains a chemical reaction, all that acid pumping away to break down food."[18] Cragg also registered his concerns about genetic engineering, in particular super hybrid sugar beets that make up much of the European Economic Community's sugar supply, as seen in his grim piece *Inverted Sugar Crop,* 1987, with its pile of ugly jack o'lantern–faced sugar beets cast in bronze. But rather than have his work appear didactic, Cragg has said, "I'm more concerned with the fact that we've changed so much already that there isn't a way back. That old idea of a return to nature just isn't an option anymore. I think what you can do is put in a plea for a higher degree of sensitivity to the world we are living in, the world we have done so much to make."[19]

Richard Deacon used metaphor in a more lyrical, linear fashion, "drawing in space" with materials such as laminated wood and galvanized steel. In 1978–79 Deacon had read the German writer Rainer Maria Rilke's *Sonnets to Orpheus* and was greatly drawn to the subtly ambiguous and sometimes elusive poetry. A number of his sculptures of the eighties that refer to ears, horns, or mouths allude to Rilke's metaphor of Orpheus's head. Like the allusion to an ear in some of his pieces, there is an echo that resonates for the viewer in many of his pieces. In his *For Those Who Have Ears,* 1983, there is a sense of the familiar that reverberates and bounces off into a territory of the strange and the unknown.

Anish Kapoor, born in India, but living and working in England since he was seventeen, sought to come to grips with the intangible un-

knowns of his Indian heritage—Hindu mythology, art and architecture, and so on. He made a trip to India in 1979 and much of his work of the next decade was inspired by that trip. He was particularly interested in the mounds of colored powder frequently found outside temples. He began creating various forms—some like fruit or seashells, some geometric, some suggesting parts of the body or landscape—of chalk or plaster dusted with powdered pigment in the bright hues associated with Indian crafts. For some pieces he sprinkled powder around the bases, creating a halo effect. The arrangement of the forms in *Six Secret Places* suggests the equivalent of an Indian tantric diagram, a focus for meditation. Kapoor viewed his work and its process as tools for transformation. "Working is something to do with contemplation, which is itself an act of prayer," he said. "The most important thing one is doing is making a transformation. That act of transformation is the same as an act of prayer, consecrating a particular time which is separated from one's ordinary life. The same is true of the transformative character of the place in which work is made or shown."[20] Kapoor gradually abandoned geometric forms for biomorphic ones and began to use wood, fiberglass, limestone, and polystyrene often covered with mud and cement.

The sense of spiritual power found in Kapoor's work was also seen in Antony Gormley's work. Beginning in 1981 Gormley began working with life-size figures, often using his own body to cast his images, often of lead. Frequently the figures were without any features or details, and sexless. Some appeared as if they had stepped out of a science fiction or futuristic movie. Violence and intimacy could pervade a work such as *Landing II,* 1988–89, where two figures lay face to face on top of one another as if they were about to be shot from a cannon. Gormley also used smaller figures, as seen in his *Field,* 1988–89, featuring a crowd of about 150 terra-cotta figures each about a foot tall. Their

only features were their two eyes, and they stood at attention in a careful configuration, waiting, waiting, for a Godot or some unknown orders. One critic noted that

> Gormley's work involves stringing together beginnings and ends, insides and outsides, spiritual and sexual desire. It involves containing in one chord both absolute futility and absolute hope. The sound is desperate and ecstatic, and it helps define the tone of this time. . . . For Gormley everything is interrelated. In these withdrawn and exhibitionistic, meditative and confessional sculptures, there is a great deal of connection between what happens in the bedroom, what happens on the playing fields, what happens in prayer and what happens in war.[21]

Instead of probing spiritual interiors, Bill Woodrow chose to excavate and explore elements relating to technology and the machine age, such as machine and car parts. There is a violent and deconstructive aspect to a piece such as *Car Door, Armchair and Incident,* 1981. Here Woodrow cut out a shotgun shape from a car door and placed the gun on a tattered and broken armchair. The chair appeared to also have had one corner shot off by the gun, and the chair "guts" were splashed on the wall behind.

In Spain sculpture in particular blossomed in the second half of the eighties. The opening of the Centro de Arte Reina Sofía, Madrid's contemporary art museum, in 1987 and more international exhibitions fostered a growing recognition of Spanish artists. Below are but a few examples of work that began to emerge from Spain.

Born in 1946 in Barcelona, Susana Solano began making sculpture in the late seventies and had her first solo exhibition at the Fondació Miró in Barcelona. Solano's cagelike structures, usually fabricated from iron sheeting, connoted enclosure and imprisonment, but the open and meshed areas that provided a sense of elegance and light spoke of openness and hope. *Dos*

Nones, 1988, with its solid and open areas, well illustrated this powerful ambiguity. Other pieces, such as *Fa El 8* [4.45], expanded further concepts of containment.

Pello Irazu explored enclosures in a different manner. He took Minimalist geometric forms and added a warmth and protective quality to the enclosed spaces through the use of painted wood. Irazu's *Daimiel,* 1988, oil on maple wood, with its cantileverlike levels and warm yellow "floor," was much akin to an architectural structure.

Ricardo Cotanda approached sculpture in a more metaphorical fashion. His *Ampla (pieza no. 2)* (*Ampla* [*Timid Piece No. 2*]), consisted of an enormous canvas bag whose opening was obstructed by a piece of iron, alluding to the penetration of enclosures through the juxtaposition of the soft and hard, warm and cold materials of canvas and iron. His *A Veces Miento* (*Sometimes I Lie*), 1988, a blue cloth floor piece folded in the shape of a paper cup, with a metal pool ladder extending out from the opening, alluded to a children's game, but also again to metaphorical enclosures and entryways.

Pedro Romero, born in Aracena in 1964, dealt with semantic and critical issues. With his inscriptions on tablets or plaques propped up on books, Romero explored the meaning of the book as an object as seen in *Mueble I (Furniture*

4.45. Susana Solano, *Fa El 8,* 1989. Photograph courtesy Donald Young Gallery, Chicago.

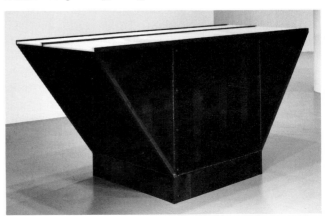

I), 1988, where words became embedded in materials and colors, rather than standing forth with their usual verbal connotation.

Victoria Gil, born in 1968, studied at the school of Fine Arts in Seville. She explored feminist concerns through the use of materials such as rubber gloves made into ringed and necklace forms. She became particularly "interested in the feminine aspects of labor. She simultaneously breaks down the conception of woman as object of labor, a social commodity, and through the example of her work, lays new emphasis on woman as maker, a cultural worker in her own right."[22]

In Italy too sculpture emerged with a diversity of approaches. There was Antonio Catelani, whose architectonic forms contained elements of disruption and disturbance in an otherwise closed system, whose roots lay in Minimalism. In *Tipologia*, 1988, the placement of marble slabs cut at irregular angles in wooden scaffolding evoked subtle emotional responses and a feeling of disorder.

Gilberto Zorio's work suggested alchemy as he explored the nature and energy of the materials he used. Born in Andorno Micca in 1944, he studied at the Accademia di Belle Arti in Turin, receiving a degree in 1970, and went on to teach at the Liceo Artistico in Turin. He has stated about his work:

> I am trying to join the components of potentiality, of experiences, of energies, of desires, of expectations, which are reflected in queries. . . .
>
> Energy is the possibility of filling emptiness, the possibility of planning past, present and future, the possibility of letting the known and the unknown function of language become operative. . . .
>
> . . . Energy is neither an abstract note nor something completely physical, but it implies a total human dimension, an anthropomorphic dimension.[23]

Zorio often used fragile materials, such as crystal, terra-cotta, and light, in precarious arrangements. He also sometimes used cobalt chloride, which causes a sculpture's surface to change color in response to atmospheric humidity, which can also be influenced by the presence of a viewer. A recurring motif has been the star, which can be seen astronomically as an energy system itself, and as a symbol of aspiration. One such piece was his *Stella (per purificare le parole)* (*Star to Purify Words*), 1980, a terra-cotta and metal floor piece, where the brilliance and energy of the star image has been shattered and dismembered [4.46]. The star, with its deep fissures and broken tip, whose rupture was made more violent with the addition of a piercing metal rod, stood as a broken but transformed image, for there was a raw beauty inherent in the cracked terra-cotta. Beginning in the late sixties Zorio also made systems, *For Purifying Words,* that emphasize communication processes.

> In these works the viewer speaks into a funnel-shaped mouth piece attached to a vessel containing alcohol; the words are filtered through the alcohol and emerge "metaphorically purified," cleansed of any ideological residue, to enter a free state. The dual nature of alcohol parallels the symbolic meaning of the works themselves: both purify and both are essences of spirits obtained by distillation.[24]

The somewhat older Luciano Fabro, born in 1936 in Turin, had been involved with sculpture and installations since the sixties. But it was not until the eighties, as his work became more widely exhibited in both solo and group exhibitions, that the power of his work was more widely seen. Often Fabro attempted to jar or expand the viewer's perceptual powers. In 1986, to address the crisis in nature following the Chernobyl nuclear disaster, Fabro made *Prometo* (*Prometheus*), a piece in which broken, unstable geometric forms linked small columns of marble, and the failing of external structures was explored. Fabro frequently used marble, a strong element in his artistic heri-

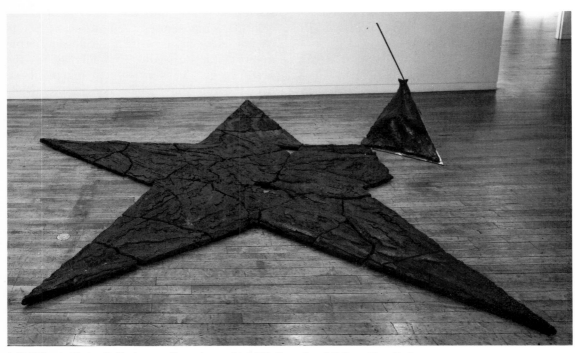

4.46. Gilberto Zorio, *Stella (per purificare le parole)*, 1980. Sonnabend Gallery, New York.

tage, exploring its classical qualities, but presented it with modern concerns. In his *Ovarius,* 1988, done for the Carnegie International, he encased marble ovals in industrial steel cables, which stretched in serpentine fashion along the floor. The serpentine shapes alluded to the snake as symbol of both the forbidden and the fertile or creative. In the juxtaposition of the classical marble and industrial steel, Fabro linked two worlds, in form and content, and surprisingly there was little tension in such a juxtaposition. The ovals appeared to lie comfortably, protected in the strong steel cables.

Quite different from these sculptors were those Italian artists who came to be associated with Geo-Romanticism, which may be seen as both an offshoot and reaction to Minimalism and somewhat different from the American "Neo-Geo." As one writer noted: "The Geo-Romanticism developing in Italy today, though formally as astute as Minimalism, is more hu-

manizing. This romanticizing tendency is typical of Italian art—even the most rigidly conceived art is softened by Italian artists; there is an ethnologic impatience with art that does not relate to the human condition. Italian Geo-Romantic art puts the romance back into geometric art."[25]

Satprakash[3] took geometric forms such as the obelisk and, using soft, couchlike material, added a touch of lightness, of whimsy and frivolity to what could be heavy and ponderous.

Piera Legnaghi's enormous organic iron sculptures communicated an embracing warmth and a litheness. For Legnaghi iron "represents the archaic element of material, which according to mythology, originated between heaven and earth. In this way, the loftiness of the stars and the deep womb are held together by a binding thread."[26] Her large pieces, such as *Grande Madre,* 1988, exploring elliptical and rounded shapes and configura-

tions, suggested a unity between human 'and planetary forms.

Carlo Marzuttini used micro-scrap metals and reassembled them into harmonious and subtly colored pieces that forced the viewer to rethink the role and impact of technology. Marzuttini noted,

> I use rejected pieces of technology because in this way I have thousands of forms and an infinite number of combinations. I use perspex, plastic, metals, colors. If I wanted, I could use virtually anything. Every small piece of metal or wood, every blade—be it grass or steel—has its complementary opposite. There is harmony and beauty in everything, big or small. The task involves making all this visible. My "machines" are not imitations of high technology—to some extent they are demystifications of it, a "different" side to technology if you like.[27]

His *I Love You,* 1986, has both hard and soft, warm and cold qualities, with its subtle blue-green to transparent color modulation and harder edge, metallic machine parts. It could be viewed as a type of phallic symbol, but the whimsical curvilinear elements, including the subtle curve at the bottom, suggest more androgynous qualities.

While a number of Italian sculptures tended to harmonize and soften sculptural forms, a number of German artists involved in sculpture turned to more aggressive and powerful forms—sometimes harsh, sometimes piercing, sometimes dealing directly or indirectly with the painful memories of German history.

Ulrich Horndash's interest in history and architecture was seen in his flag pieces and protruding wall panels. *Baufahne Rot (Construction Flag Red)*, 1985, although not referring to any specific historic event, recalled the memories of the massive assemblies and flag installations of Hitler. The red "bricks" reminded one of the crumbling of bricks and the shedding of blood during war's devastation. But the architectonic, ordered structure of the brick formation presented with a sense of personal protec-

tiveness in the soft draperies also alluded to a reconstruction and rebuilding. The flag could then be a banner of celebration, and it was this type of ambiguity that drew the viewer into a more intimate discourse with this and other draped works. Some of Horndash's pieces referred more to the French Revolution and the Enlightenment period, as representative of the beginnings of a new order where foundations were laid for the modern world. Horndash spoke of his active dialogue with history:

> Our relationship towards the present and towards the past is always changing. At the moment the change is revolutionary for me, the past is now the present, it's what it's all about, history, in other words, history is becoming my own present, my spiritual reality. Both are happening alongside each other: history, and the everyday production of thoughts. . . . In art today one must stand out on the basis of a strengthened sense of history. I cannot be satisfied if I'm swimming around like an amoeba in a test-tube. I need a fixed point, from which I lift the world off its hinges. Metaphorically, you understand, pre-Socratically.[28]

Bruno K.'s work was concerned with power, domination, heroes, and ancestral remembrances and remnants seen as trophies and medals. "My work," said Bruno K. in 1988,

> in the last few years can be divided into groups: carriages and objects on wheels, put together from objects trouvés, and used for public auctions; posed action photographs—trophies, ancestral portraits, made of semi-finished metal products and velvet materials, in some cases place related items; and then ship superstructures in plate steel construction, room-related items. In a purely formal sense the pieces are very different, but as far as their content is concerned, they are not. The carriages and ship superstructures are vehicles for campaigns of exploration and conquest, including those in the field of art. The room-related pieces are part of a siege and occupation strategy, while the ancestral pictures are tokens of victories won.[29]

In his *Parkdeck für Eroberer 2/Badewan-nenkapitän* (*Parking Lot for Conquerors 2/Bathtub Captain*), 1987–88, there was both power and pain in the apparatus. But there was also a strange humor as one began to contemplate the notion of a parking lot for conquerors, and the notion of a bathtub captain. The heroes were static, reduced to commanding a bathtub. "Who, then, are today's heroes and what do they stand for?" Bruno K. appeared to ask.

Wolfgang Laib indirectly explored elements of history through his interests in Hindu, Buddhist, and Zen thought, and his use of ancient and natural materials—milk, marble, pollen, rice, and wax—in his sculptural vocabulary. His 1988 *Passageway* resembled an Egyptian tomb in structure, and contained elements of life and death. The bare lightbulbs and constricting, enclosed space suggested an interrogation room. But the beeswax from which the walls and ceiling were constructed emitted an intoxicating fragrance that was sensuously alluring and life-giving. Earlier pieces had also contained "life-giving materials"—such as his *Milkstones* series of the mid-seventies, in which Laib poured milk into impressions in rectangular slabs of marble; his exhibition in jars or colored piles of his actual collection of pollen begun in 1977; or his small reliquary structures of metal and marble around which he scattered rice. As one sensed the nurturing and meditative qualities in Laib's work, it was perhaps no surprise to learn that he studied medicine at the University of Tübingen and received a degree in 1974. He subsequently chose not to practice and began to devote his full time to art.

Katharina Fritsch explored death as well as religious and social themes through her use of mass-produced imagery. Her yellow, painted madonna, first appearing in 1981, questioned the role of the sacred image, as a hallowed and revered image became a commodity detached from Christian ideas. Her 1988 *Tischgesellschaft* at the Basel Kunsthalle featured thirty-two identical polyester men, painted black and white and seated around a long table covered with a continuous red and white patterned cloth. The ghostly figures were hardly human, appearing like automatons submitting to a larger authority. The madonna appeared again in a 1988 installation for the Carnegie International. A plastic white madonna, her head enshrouded, stood silently tall. Before her was a pool of blood. Undertones of violence emerged as religious and social questions became intertwined in the relationship between the virginal white figure and the deep red blood. The fact that Fritsch's madonna was plastic and could be mechanically and mass reproduced raised further questions concerning the uniqueness of sacred images. Here the sacred and the profane seemed to be complexly interlocked.

Rebecca Horn's work also functioned at a variety of levels as she explored aspects of power, seduction, and alienation. Born in 1944 in Odenwald, Germany, Horn was a war baby and had a disrupted childhood as she moved from boarding school to boarding school. Forced by her parents to pursue something practical, she studied economics for a year at the university in Hamburg, but took art classes on the side. She later enrolled full time at the Hamburger Kunstverein, where the program was unacademic and open-ended, to study painting and sculpture. In 1968 Horn suffered from a serious case of tuberculosis, which was to affect her work. She began to explore the balance of life and death and the very sense of being alive. In the seventies she began to make prosthesislike attachments for the body, designed for physical and sensory awareness. The body sculpture *Cornucopia*, 1970, resembled black lungs connecting the mouth to the breast, suggesting an autoeroticism. The lunglike shapes also looked like a horn, a motif relating to the horn of plenty, and to Horn's own name, which appeared frequently in her work. Horn later made motorized sculptures, sometimes using feathers, which seemed to relate to ritual-

istic or mating dances. Horn also made narrative surrealistic films in which she included some of the motorized sculptures. In 1988 Horn won the prestigious Carnegie Prize for her installation *The Hydra-Forest: Performing Oscar Wilde 1988*. The title and piece combined two literary references: a short story "Hercules 2 or the Hydra" by East German writer Heiner Müller, and Oscar Wilde. In Müller's story the main character was terrified that a forest was closing in on him. He became more and more frightened when he realized the forest was an animal, a hydra. He fought back, but ultimately realized he was fighting against himself. Wilde, usually characterized as a dandy, suffered from his condemnation as a homosexual, receiving a sentence of two years of hard labor and, later, alienation from his friends. Beyond the title, Wilde is further identified in the piece with ribboned patent-leather shoes. Horn's piece became an environment, producing frightening feelings of anxiety and despair, as 460,000-volt electric arcs hissed and sparked in the dimly lit, all white, enclosed chamber. Seven electric devices appearing like hanging snakes hung from the ceiling, each emitting different pitches at syncopated intervals. On the floor were six inverted glass cones and a pair of men's shoes overflowing with crushed coal, whose black marred the white floor. Sensations of a paralyzing fear of death arose readily within the viewer. Yet Horn described the room as a "womb in a metal cage,"[30] suggesting the suffering that may go with birth and new creations. Horn's use of the number seven in the seven items on the floor and ceiling could have reference to the apocalyptic Day of Judgment in the Book of Revelation and its multiple levels of meaning. One writer referred to alchemy and its redemptive qualities to sustain and give life:

> The simultaneous symbolism of death, and rebirth, and other clues—the union of opposite sexes; mercury in inverted glass cones; sulphur in coal, whose black color represents "nigredo"; the whiteness of the room, which symbolizes "albedo," an egg, or a furnace—point to alchemy. In *Hydra Forest*, Horn synthesizes the Hercules myth, which symbolizes for the alchemists the spiritual struggle that leads to immortality, with the important alchemical concept of destruction and regression to the womb, "regressus ad uterum," and Wilde's tortured last years, to state that the existential struggle is part of the purification process toward a higher consciousness.[31]

Rosemarie Trockel, in some of her pieces, dealt with sexual issues and power in a more explicit fashion. An untitled piece for the 1988 German/American Bi-National exhibit consisted of a wax pair of legs sawed off from the rest of the body, resting on a wooden slab (reminiscent of the sawed lady trick at carnivals). In back of the feet was reproduced on glass a large black and white negative of Georges de la Tour's painting *The Cheater with Ace of Diamonds*. The juxtaposition of the cheating image with the woman's legs linked perceptions of women as sexual objects and as mystery with concepts of cheating. Trockel spoke of the relation of the image and the wax figure:

> I've stripped the "cheater" of his attractiveness, which lies in the artificial coloring and lighting of the original painting. I reproduced the negative in black and white on a glass plate so that it would become translucent and transparent. To the same extent, the apparently dull, pale wax of the figure—as a finished work it looks almost as if it's lying on the cardplayer's table—is transformed into a body of light, an illuminated sign, so to speak, of what lies in the dark. The original effects undergo an inversion. I contrast Georges de la Tour's artificial picture of reality with the artificiality of the fun-fair figure. Through this inversion, the entire work is a work about the interplay between perception, realism, and artificiality. . . . The black area on the floor . . . is an allusion to the tendencies of simulation and appropriation. Woman, inconsistency, reaction to fashionable trends—those are constant, ever-recurring elements of my work.[32]

Trockel also made knitted pieces in which she attempted to deconstruct well-known philosophical and cultural givens. By knitting (which is usually associated with domesticity) a statement such as "Cogito, ergo sum" (I think, therefore I am) and stretching the wool over canvas, Trockel questioned the fundamental meanings of such a given. The statement, symbol, or words that Trockel used could, in knitted form, be easily reproduced as a commodity, and therefore quickly lost the cultural meaning

and power ordinarily associated with them.

By the end of the decade the richness and diversity of sculptural explorations in form, content, and materials were far-reaching. One writer wrote of "its unfocused expansiveness. The new sculpture has become suddenly unbound, proliferating its amazing variety of styles in confidence, supported by a marketplace that has turned its gaze, at least for the instant—on three dimensional art."[33]

NOTES: SCULPTURE, 1980S

1. Martin Friedman, "Seventeen Americans," in *Sculpture Inside Outside,* ed. Friedman (Minneapolis and New York: Walker Art Center and Rizzoli, 1988), p. 11.
2. Christopher Wilmarth, cited in Maurice Poirier, "Christopher Wilmarth: 'The Medium Is Light,'" *Artnews,* December 1985, p. 74.
3. Cited in Phyllis Tuchman, "Bryan Hunt's Balancing Act," *Artnews,* October 1985, p. 72.
4. Cited in Donna Harkavy, "Judith Shea," in *Sculpture Inside Outside,* ed. Friedman, p. 213.
5. Cited in Paul Gardner, "Rodney Alan Greenblat's Candy-Colored Cartooniverse," *Artnews,* January 1986, p. 107.
6. Cited in *Carnegie International,* 1985, p. 88.
7. Cited in *Options 24: Jin Soo Kim,* exhibition brochure (Chicago: Museum of Contemporary Art, 1985).
8. John Russell, "Lothar Baumgarten's Discreet Provocations," *New York Times,* November 6, 1988, p. 36.
9. Cited in Elisabeth Sussman, "Interview with Haim Steinbach," in *The BiNational: American Art of the Late 80's* (Boston and Cologne: Museum of Fine Arts and Dumont Buchverlag, 1988), p. 192.
10. Cited in Elisabeth Sussman and David Joselit, "Interview with Jeff Koons," ibid., p. 121.
11. Cited in Peter Carlsen, "Jeff Koons," *Contemporanea,* September–October 1988, p. 41.
12. Joan Simon, "Figurative Imagings," *Sculpture Inside Outside,* ed. Friedman, p. 31.
13. Cited in Allan Schwartzman, "Corporate Trophies," *Art in America,* February 1989, pp. 39–40.
14. Patricia Phillips, "Waste Not," *Art in America,* February 1989, p. 47.
15. Michael Brenson, "The Messy Saga of 'Tilted Arc' Is Far from Over," *New York Times,* April 2, 1989, p. 33.

16. Richard Serra, " 'Tilted Arc' Destroyed," *Art in America,* May 1989, pp. 34–47.
17. Maya Lin, cited in Joel L. Swerdlow, "To Heal a Nation," *National Geographic,* May 1985, p. 557.
18. Tony Cragg, cited in Andrew Graham-Dixon, "Cragg's Way," *Artnews,* March 1989, p. 137.
19. Ibid., p. 136.
20. Cited in Edward Lucie-Smith, *Sculpture Since 1945* (New York: Universe Books, 1987), p. 140.
21. Michael Brenson, "A Sculptor Who Really Gets into His Work," *New York Times,* May 7, 1989, p. 34.
22. Mar Villaespesa, "Seville," *Contemporanea,* January–February 1989, p. 71.
23. Cited in Diane Waldman, *Italian Art Now: An American Perspective, 1982 Exxon International Exhibition* (New York: Solomon R. Guggenheim Museum, 1982), p. 128.
24. Ibid., p. 129.
25. Robert A. Whyte, "Forewords," in Maria Grazia Torri, curator, *Grand Tour, Italian Geo-Romantic* (Milan: Fabbri Editori, 1988), p. 8.
26. Piera Legnaghi, ibid., p. 66.
27. Carlo Marzuttini, ibid., p. 72.
28. Cited in Rainer Crone, Jürgen Harten, Ulrich Luckhardt, and Jiri Svestka, *BiNational: German Art of the Late 80's* (Cologne: Dumont Buchverlag, 1988), p. 148.
29. Cited in ibid., pp. 190–91.
30. Rebecca Horn, cited in Mina Roustayi, "Getting Under the Skin," *Arts.*
31. Ibid., pp. 67–68.
32. Cited in Crone et al., *BiNational,* pp. 282–83.
33. Steven Henry Madoff, "Sculpture Unbound," *Artnews,* November 1986, p. 109.

ARCHITECTURE, 1980S

THE historicism and quotations of Post-Modernism continued in architecture into the eighties. Luxury, affluence, and opulence seemed to pervade the revival and use of historic forms, which perhaps reflected the conservatism of the Reagan era. A number of large-scale buildings were built. Along with the AT and T Building, Philip Johnson and John Burgee completed towers in Boston, Chicago, Houston, and Dallas. The firm of Kohn Pederson Fox completed Procter and Gamble's headquarters in Cincinnati, and for an office tower on New York's Madison Avenue the firm employed quotations from the Acropolis, the Vatican courtyard, the Campidoglio in Rome, and the Chrysler Building in New York. Post-Modernism had begun with concerns about connections to a broader culture that the tenets of modern architecture seemed to disallow. But by the mid-eighties quotationism appeared to have become for some a comfortable and easy vocabulary that gave almost no credence to Modernist contributions and revered and quoted the past for the sake of the past in sometimes undiscerning ways, without critically distinguishing between epochs and styles. A sentimentality appeared to ring forth. The denial of the significance of Modernist contributions was further seen in a 1986 PBS television series, hosted and written by the architect Robert Stern, "Pride of Place: Building the American Dream." Stern's emphasis was mainly on reinterpreting and reshaping the past.

By the latter part of the decade questions began to arise concerning the widespread and sometimes rapid and empty use of quotation and revivalist forms. In 1987 the critic Douglas Davis noted,

> Meanwhile, out in the landscape, a vulgate postmodernism is spreading like a preindustrial plague, far from the pages of the svelte architecture magazines which normally display only the erudite Stern and Co. variety. Spurred by the end of the Carter-Reagan recession early in this decade, our suburbs, industrial parks, "energy parks," shopping malls and fast-growing cities have transformed themselves into grade school lessons in tepid historicism. We are unsuspecting heirs to a generation of granite-and-glass office buildings masquerading as Roman pantheons, discount department stores tarted up as pagodas, and drugstores embellished with Doric and Corinthian columns.[1]

Davis went on to cite "revivalist horrors" by both unknown and well-known architects such as Helmut Jahn and Kevin Roche.

> Kevin Roche, who once reared constrained glass-paned marvels like the Ford Foundation Building, and the Metropolitan Museum's Lehman

Wing, now lets barely a fortnight pass without dumping another grandiose "quotation" on the landscape, whether it be the white metal Taj Mahal (where it functions as the headquarters of General Foods); the densely colonnaded E. F. Hutton Building that dares to rise in Manhattan beside the stark CBS "black rock" constructed by Roche's late partner, Eero Saarinen; or the 46-story hybrid now sprouting at 35 West Wacker in Chicago.[2]

Davis's comments may appear cynical and extreme, but they did not stand alone. Paul Goldberger, architecture critic for the *New York Times,* was to write,

But the climate created by Venturi's ideas soon shifted toward an easier, more indulgent way of viewing the past; by the 1980's the past began to seem not like a source for modern government but more like a warm bath in which we could wallow. The thinkers who began post-modernism were gradually supplanted by the wallowers in it, as the monument became more and more a victim of its own commercial success.[3]

Some architects turned to architecture with social concerns, such as shelters for the homeless or affordable housing, which had not been priorities in the previous decade. There appeared to be a renewed commitment beyond the erection of corporate "monuments." And there was renewed interest in the forms and tenets of modern architecture where architecture "was not a servant of established social patterns but a master of them."[4]

In particular there was a growing interest in the deconstructivist movement in architecture, celebrated by the 1988 "Deconstructivist Architecture" exhibit at the Museum of Modern Art, curated by the architect Philip Johnson. The show called attention to the slashing forms and harsh lines of an architecture that sought to redefine conventional use of mass and space. In his introductory essay for the catalog of the exhibit, Johnson linked these deconstructivist tendencies with formal emphasis on the diago-

nal overlapping of rectangular or trapezoidal bars, with the early Modernist experiments of the Russian Constructivists. Seven architects from throughout the world were selected and included: Frank Gehry (born in Canada, based in California), Peter Eisenman (born in New Jersey, based in New York), Bernard Tschumi (born in Switzerland, based in New York), Avid Libeskind (born in Poland, based in Italy), Rem Koolhaas (born and based in Holland), Zaha M. Hadid (born in Iraq, based in England), and Coop Himmelblau (born and based in Austria).

Deconstructivist architecture was described by Mark Wigley, associate curator of the exhibit, as posing

problems to both the center and margins, both the conservative mainstreams and the radical fringe of the architectural profession. . . . The work in this exhibition is neither a projection into the future nor simply a historicist remembrance of the past. Rather it attempts to get under the skin of the living tradition, irritating it from within. Deconstructivist architecture locates the frontiers, the limits of architecture, coiled up within everyday forms. It finds new territory within old objects. . . . The interrogation of pure form pushes structure to its limits, but not beyond. The structure is shaken but does not collapse; it is just pushed to where it becomes unsettling.[5]

Deconstructivist architecture was not hailed as a new style but as a way of questioning the assumptions of architecture and the filling of space. "What the architects share is the fact that each constructs an unsettling building by exploiting the hidden potential of modernism, . . . they produce a devious architecture, a slippery architecture that slides uncontrollably from the familiar into the unfamiliar, toward an uncanny realization of its own alien nature: an architecture, finally, in which form distorts itself in order to reveal itself anew."[6]

Frank Gehry, with his unorthodox, deconstructivist approach to architecture, in 1989 won the prestigious Pritzker Prize, the highest

international award in architecture, awarded for life achievement. Upon the occasion of the award, one critic wrote of "the growing consensus that Frank O. Gehry is the most influential architect in the world."[7] Gehry was born Frank Goldberg in 1929 in Toronto, and changed his name, which he was later to regret, in his twenties. As a young child Gehry would often play with his grandmother, building model towns with scraps from his father's hardware store. His family moved to Los Angeles when he was eighteen. He studied architecture at the University of Southern California. His buildings often look like random piles of children's blocks and improvised play materials. Sometimes his work incorporates surreal objects, such as a giant fish outside a Japanese restaurant or a forty-five-foot-tall pair of binoculars serving as

the entrance to a California office building. Gehry's designs tend to pierce the unconscious rather than revive the past as some of his post-modern contemporaries did. His view of the world around him is often reflected in the unsettling and often perturbing qualities of his architecture, which sometimes appears half-built. "We're in a culture made up of fast food and advertising and throwaways and running for airplanes and catching cabs—frenetic. So I think there's a possibility that those ideas about buildings are more expressive of our culture than something finished is," observed Gehry.[8]

There is a sense of continuous vitality and power in Gehry's buildings, such as his 1983 Norton House in Venice, California [4.47]. This home for a screen writer who was once a life-guard looks like a lifeguard station, with an as-

4.47. Frank Gehry, Norton House, Venice, Calif., 1983.

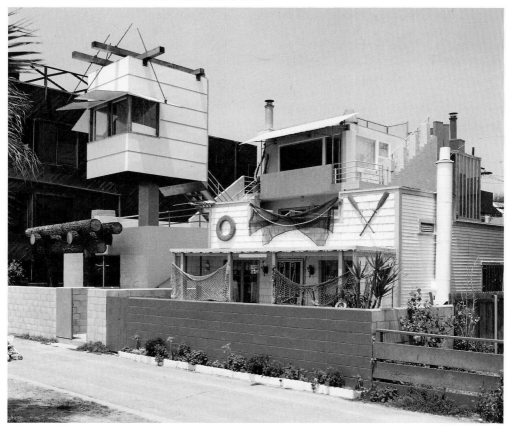

semblage of cheap materials and odd forms that are typical of Gehry's work. But the rawness and pull-apart quality of many of his buildings, which may include materials such as sheet metal, wire mesh, chain-link fencing, rough timber, and abandoned plywood, exudes a life and compelling presence. Among his most noteworthy buildings are his Aerospace Museum (1983–84), the Loyola Law School (1981–84), and the Temporary Contemporary Museum (1983), all in Los Angeles. The cantilevered, seven-sided polygon that is the Aerospace Museum is covered with riveted sheet metal. A white stucco wing houses aircraft suspended below a skylight monitor while a Lockheed F104 points skyward ready for a diagonal take-off above the service entrance.

Gehry's own house in Santa Monica, California, begun in 1978, and using what were then considered forbidden materials, was one of his first buildings to draw public acclaim. Gehry had bought a small pink stucco home on an ordinary street, and wrapped it with a layer of new rooms constructed from "junk" materials such as corrugated metal and raw wood.

Beyond running his architectural firm, Gehry also collaborated with his friends Claes Oldenburg (an Oldenburg sculpture of a tea bag was scheduled to fit in a niche of Gehry's Tower Records building in Boston) and Richard Serra. He also designed a stage set for the choreographer Lucinda Childs and designed museum installations for the work of other artists.

Peter Eisenman also turned to deconstructivist forms. In the seventies his houses, such as House VI, The Frank House, in Cornwall, Connecticut, represented an art-for-art's-sake approach to architecture, where Modernist forms were broken up and deconstructed, and the house appeared like a piece of contemporary sculpture.

In his 1989 Wexner Center for the Visual Arts at Ohio University [4.48], Eisenman presents a playful collage of disparate forms and materials. In a single glance, one may view brick, tinted glass, clear glass, white glass, white steel, white stone, concrete, and red stone. An airy jungle gym–like white steel scaffold is juxtaposed with massive forms of dark brick that allude to the past, to an old armory building that

4.48. Peter Eisenman, Wexner Center for the Visual Arts, Ohio University, 1989.

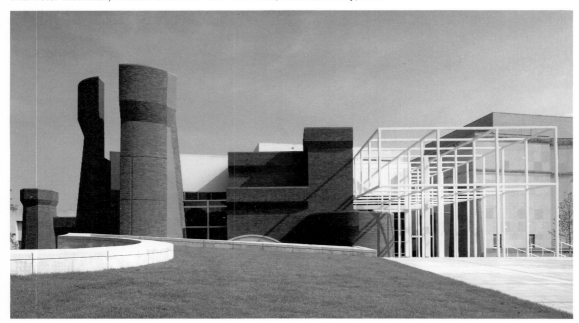

once occupied the site. Eisenman plays with the grid form seen in the scaffolding on the inside as well, as he deconstructs and departs from traditional "rules" of classical architecture. Inside, as one enters, a fake beam shoots past at eye level and stops in midair, while a fake column stops ten feet from the floor, like a giant stalactite. His eclectic juxtapositioning of forms and materials sets up a wide range of relationships, some conflicting, some complementary, but all dynamic—intertwining past, present, and future. Eisenman's vision has been called "fresh, because there is one architectural tradition Eisenman has fortunately not abandoned: the projection of art's creative drive into the midst of urban life."[9]

One further example of this deconstructivist approach may be seen in the rooftop remodeling of forty-three hundred feet of attic space in a traditional apartment building in Vienna by Coop Himmelblau. Outward- and upward-thrusting skeletal winged forms transform the roof. The metallic construction may be seen as chaotic, but it also gives new life to the rigidity of the apartment block.

Outside of deconstructive explorations, other architects continued to work within the tenets of Modernism. Some buildings, such as Norman Foster's aluminum and steel Hong Kong and Shanghai Bank, 1979–84, raised questions about the emergence of a "neo-Modernism" [4.49]. Here the curtain walls are recessed and covered with metal *brises-soleil*. The piers are set at the corners and the building is viewed in part as a ladder of floors and forms. A large public space exists at ground level, while numerous atria are on the upper levels. A flight of imagination and fantasy is possible for users and viewers of this building that goes beyond the stricter "form follows function" and utilitarian emphasis of early Modernism.

Moshe Safdie used Modernist forms to create a monumental and elegant space for the collections of the National Gallery of Canada in

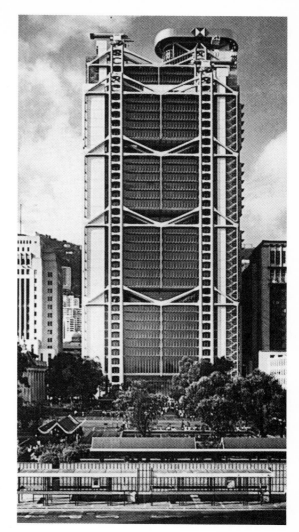

4.49. Norman Foster and Associates, Hong Kong and Shanghai Bank, 1979–84.

Ottawa (1988). Safdie's assemblage of faceted glass is alluring in both night and day. Impressive is the Great Hall, which is enclosed in a cage of concrete and glass. The upper part is filled with automatic counterbalanced "sails" that modulate and filter light by day and look like giant blooming flowers by night. The galleries are grouped into three main blocks. Almost all the views outward are toward two internal, glass-covered courtyards, one for a garden, the other a water court, with a glass floor as well as ceiling. Inside and outside

become intertwined throughout much of the building.

One of the most talked-about structures of the decade was I. M. Pei's addition to the Louvre, opened in 1989 [4.50]. The seven-story seventy-one-foot-high glass and steel pyramid, with its pristine Modernist lines, incited controversy concerning its incongruity with its Baroque surroundings. But upon completion the project met with widespread approval and even enthusiasm. The pyramid, with its tensile structure, is an elegant object surrounded by reflecting pools and fountains, through which the original buildings of the Louvre are visible. And there are links to Paris's architectural heritage. Like the Eiffel Tower, the pyramid is a delicate monument to technology. Like other monuments, such as the obelisk at the Place de la Concorde and the Arc de Triomphe, the pyramid is a simple and basic geometric form. Other French architects too, such as Boullée

and Ledoux, used such forms, including the pyramid, in their work.

Beneath the glistening glass is the Louvre's central courtyard and more than 650,000 square feet of new space that houses shops, cafeterias, auditorium, education, and information facilities, and storage and work areas. Entry to the museum is through the pyramid, updating very quickly perceptions of a beautiful but antiquated museum space. The large pyramid is surrounded by three smaller ones, which are intended to light three underground passages that connect the Hall of Napoleon to the three main wings of the Louvre. The pyramids stand glistening and powerful, illuminating and extending the forms of the famous museum. Pei's own words seem to echo forth from his project, which attempts to link many years of French history with a contemporary world: "Continuity and change, continuity and change—that's the key to the whole thing. You have to respect

4.50. I. M. Pei, addition to the Louvre, Paris, 1989.

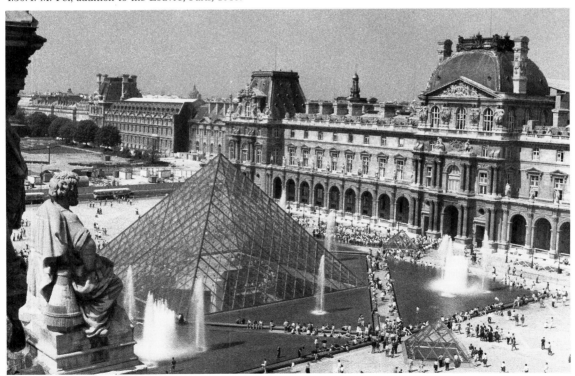

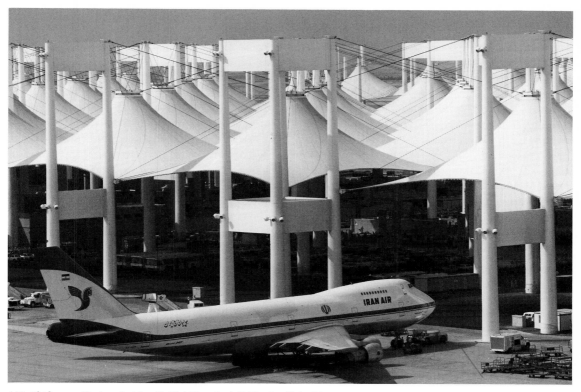

4.51. Skidmore, Owings & Merrill, Haj Terminal, Jidda, Saudi Arabia.

the continuity of history, but you cannot not change."[10]

The younger Stephen Holl used Modernist forms in a more ascetic manner, emphasizing a meticulous craftsmanship. His materials were related to the earth—stucco, concrete, sandblasted glass, and stone. In general, he worked on a small or human scale. When possible, Holl designed not only a building but also its fixtures, rugs, and furniture. His "signature" would often consist of geometric figures imprinted onto various surfaces, ranging from windows to tableware. In Holl's Hybrid Building, a retail-office-residential complex in Seaside, Florida, one can see Holl's subtle manipulation of modern forms. Details such as the changes in the angling of the lower balconies and the uneven placement of the upper windows speak to Holl's subtle sense of design. In one apartment the walls tilt at four degrees. For Holl awareness of a physical presence of shapes and spaces

is important. "He holds an existentialist belief in a building as something that's not a figment of thought or imagination but is actually physically there. For Holl, the world is experienced rather than understood, and its form should manifest its making."[11]

During the decade there was also renewed interest in "regionalism," and attempts to incorporate "local" and folk architectural elements of a given country or region into large-scale industrial or public projects. For example, the Haj Terminal in Jidda, Saudi Arabia [4.51], a gateway to the Holy Places for air travelers, designed by Skidmore, Owings & Merrill in the early eighties, used fabric construction relating to Islamic constructions and designs. The terminal was designed in the form of a repeating series of Teflon tents on steel poles. The Ministry of Foreign Affairs (1979–83) in Riyadh, Saudi Arabia, designed by the Danish architect Henning Larsen, also combined modern and

Islamic vocabularies. The brown stone exterior with its small windows alludes to local mud fortresses. Inside are pristine white walls. But there are also fountains and allusions to the Alhambra, as well as abstract patterns on the floors that relate to Islamic design.

In Mexico Teodoro Gonzalez de Leon, who had worked with Le Corbusier in the forties, added to his vocabulary of rough and bold concrete forms elements of ancient Mexico and pre-Columbian cultures. In particular, he was concerned with the protected courtyard or patio, as an important part of Mexican tradition and culture. His

> Collegio de Mexico (1979–1982) combines stratified concrete terraces (reminiscent of the platforms and contours of pre-Columbian architecture) with an amplified atrium that follows the slope of the land and is covered by a trellis of plants. Gonzalez de Leon has spoken of the need to touch on the "constants" in tradition: in his case those spatial archetypes which are found in the vernacular and which recur in both pre-Hispanic and Hispanic examples.[12]

And in India Raj Rewal's concerns with public space led him to draw upon the structure of desert towns rather than a free-standing housing block. In his Asian Games Housing (1982) he designed courtyard houses with tall rooms and interlocking terraces. The washed terrazzo, amber-colored finish is similar to the honey-color stones of ancient desert towns.

The Sri Lankan architect Geoffrey Bawa attempted to create structures that incorporated the craft and architectural traditions of the island, and that were in harmony with the tropical climate and vegetation. His own studio (1981) in Columbo, which emphasized openness and the craft tradition of the area, gracefully combines ancient and modern vocabularies.

By the end of the eighties it appeared that some aspects of Modernism had been renewed, and that Post-Modernism was not the only definitive style. A variety of choices appeared to be allowed. As Douglas Davis noted, "Postmodernism must content itself with a place, surely transitory, in the rhythm of styles. It is simply a choice, not an echo of divinity. The renewal of modernity returns us to a metaphysic that claims neither certainty nor finality."[13]

NOTES: ARCHITECTURE, 1980S

1. Douglas Davis, "Late Postmodern: The End of Style," *Art in America,* June 1987, p. 16.
2. Ibid., pp. 16–17.
3. Paul Goldberger, "80's Design: Wallowing in Opulence and Luxury," *New York Times,* November 13, 1988, p. 32.
4. Ibid.
5. Mark Wigley, "Deconstructivist Architecture," in Philip Johnson and Mark Wigley, *Deconstructivist Architecture* (New York: Museum of Modern Art, 1988), pp. 18–19.
6. Ibid., pp. 19–20.
7. Robert Taylor, "Far Out Work Honored," *Boston Sunday Globe,* p. B41.
8. Cited in Martin Filler, "Maverick Master," *House and Garden,* November 1986, pp. 211–12.
9. Herbert Muschamp, "Art," *Vogue,* October 1989, p. 273.
10. Cited in "Pei's Peak," *House and Garden,* July 1988, p. 102.
11. Robert Campbell, "Two Visionary Architects in New York Show," *Boston Globe,* February 21, 1989, p. 34.
12. William J. R. Curtis, *Modern Architecture Since 1900,* 2d ed. (Englewood Cliffs, N.J.: Prentice-Hall, 1987), p. 396.
13. Douglas Davis, "Late Postmodern: The End of Style," p. 23.

MULTIMEDIA AND INTERMEDIA, 1980S

B Y THE eighties it was evident that many boundaries had been broken that had previously existed between the visual arts and the performing arts and within the visual arts themselves. Advancements in technology, in particular the computer, excited the imaginations of many visual artists.

In 1986 Andy Warhol, for example, began using an inexpensive Amiga computer, working with image-processing effects, in particular the video palette and the pixel-based imagery. By colorizing a picture-processed photograph, which was then recorded on film, Warhol could produce a finished piece in minutes, rather than the weeks it had taken him to complete his earlier silk-screen pieces. By using colorized video-digitized images and by changing hues electronically, Warhol could create studies for portrait commissions and other pieces. The computer offered the potential for endless serial images.

Kenneth Knowlton developed computer programming that could map out the placement of dominoes to produce portraits of both intellectual and perceptual interest, as seen in his 1983 *Charlie Chaplin* [4.52]. The computer was programmed to make use of the black-and-white combinations that were an inherent part of cathode-ray reproduction.

Joseph Nechvatal used the scanamural pro-cess to execute his more conventional drawings on a large mural scale. His first paintings in his scanamural series were executed at 3M and then hand tinted. He later submitted color transparencies for what he called his computer/robotic paintings [4.53]. Nechvatal wrote about the significance of the computer for his work and for society at large:

> The computer is the social organizer in the 80's— it frees us from the psychic condition of the nineteenth century factory—which has been the universal condition of the twentieth century. The computer's work is free from sweaty compromise, self-doubt, and human flexibility. The computer/robotic paintings address this faith in the infallibility of the computer technology which is rapidly changing all of society. Through the theme of control and release, they confront the potentially totalitarian technology of the digital society which symbolizes and appeals to both external order (efficiency, hierarchy, security) and internal (tidy compartmentalization, strict logic). Informative technology is meant to make all of society run on time through control under the guise of benevolent connectedness.[1]

Using digitalized imagery in a somewhat different manner was Jennifer Holzer, whose language-based art reflected the depth and diversity of concerns in contemporary society. Chosen to represent the United States at the

Venice Biennale in 1990, Holzer first became noted for her writings on flashing electronic ribbons of LED (light emitting diode) display signs such as the one at One Times Square shortly after the 1980 Times Square show. Holzer was invited by the Public Art Fund to put her texts onto the giant color electronic signboard. Texts such as "Torture is barbaric," "Fathers often use too much force," "Money creates taste," flashed before the public eye. Her programs for LED machines appeared at galleries and public spaces internationally. Her texts tended to be open-ended and accessible to a diverse public, unlike some of the earlier language-based conceptual artists, whose works were more esoteric and directed the viewer to a "conclusion." Her *Survival* series included texts such as "What urge will save us

now that sex won't?" "Savor kindness because cruelty is always possible later," "Laugh hard at the absurdly evil."

Born in middle America, in Gallipolis, Ohio, Holzer, from a very early age, wanted to be an artist. She attended Duke University, the University of Chicago, and finished at Ohio University. She attended graduate school at the Rhode Island School of Design, which she disliked because of its traditional orientations. It was not until she moved to New York City in 1976 and was accepted into the Whitney Museum's Independent Study Program that she turned to public art texts, as a result of the readings in the Whitney program, some of which she wanted to make more accessible to a larger public. At first she used posters pasted to city walls and then turned to contexts such as T-shirts, bill-

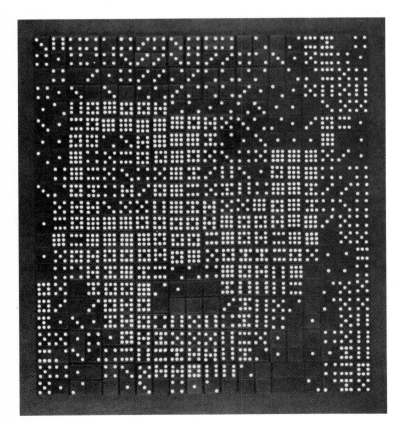

4.52. Kenneth Knowlton, *Charlie Chaplin*, 1983.

4.53 *(opposite)*. Joseph Nechvatal, *The Informed Man*, 1986. Collection The Dannheiser Foundation.

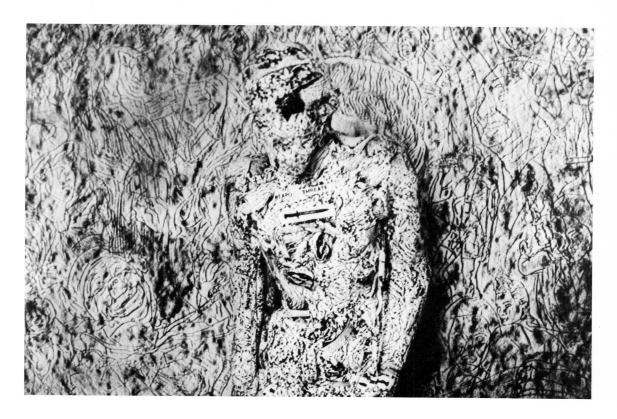

boards, and small books. In the early eighties she discovered the power of electronic imagery.

In a major installation at the Dia Art Foundation in 1989 entitled "Laments," Holzer's texts appeared in columns of moving colored digitalized lights, and at the same time were carved into the granite and marble tops of thirteen stone sarcophagi [4.54]. The sarcophagi, of three different sizes, suggesting the burial places of adult, child, and infant, evoked an ancient world and the rituals of death and burial, while the moving signs were icons of a fragmented postmodern world. The thirteen texts focused on both current and age-old concerns with sorrow, struggle, violence, and death. Some were specific, dealing with issues such as AIDS, nuclear holocaust, and the environment. Others dealt with universals—"I see space and it looks like nothing and I want it around me." "If the process starts, I will kill this baby a good way." Although the content of the

texts were harsh reminders of the complexity and cruelness existing in our world, they were softened by the visual changes in color, typeface, and patterns, programmed into cycles in the columns containing the texts. Between each cycle the screens were dark, and the transition from dark to light brought a ray of hope to the provoking issues and questions Holzer's texts raised.

Video artists also used the computer increasingly to manipulate and perfect their images.

In the 1980's, the pioneering technical work that was done by artists and engineers has been further developed by the video and television industry. Digital processing has been perfected to the degree that each pixel can be manipulated with precise control. . . . A new generation of artists have chosen video as an appropriate medium to reflect the dynamics of the postmodern world. In a milieu characterized by crossovers between art forms—painting, sculpture, video, film, media,

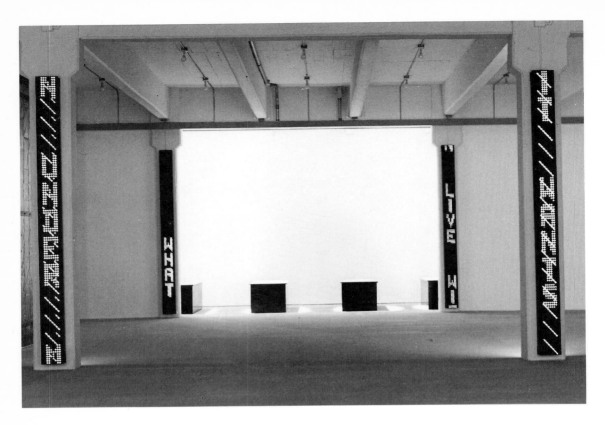

music, theater, and design—where appropriation, collaboration, and eclecticism are the norm, video provides an expansive and articulate medium of expression.[2]

Through the use of the computer and other technological advances in the television industry, video artists were able to create works of increasing complexity, moving far beyond the linear and narrative emphasis of traditional filmmaking.

John Sanborn, originally interested in film, was just one artist who turned to video to create new contexts and layers of meaning. In 1981 he collaborated with the composer Robert Ashley on a seven-part opera, *Perfect Lives,* depicting the mythology of small-town America in a postmodern world. Sanborn also worked with dance choreographers such as David Gordon and Charles Moulton. In his 1986 *Luminaire,* dancers interacted within an environment where space and movement of the camera were articulated by computer animations and digitally moved video elements [4.55]. In one sequence the viewer was guided through a computer-generated art museum, whose galleries represented different periods in the history of art. In a futuristic "gallery," there was a three-dimensional computer abstract into which the viewer was pulled, suggesting the impact of the computer for the future of the visual arts.

Larry Kaufman used a new digital recording device to create his 1988 *The Whole Truth,* an analysis of the act of telling lies. A visual and verbal collage of lies, their structures and contagiousness was created through multiple layering of images and statements. With the new digital recording device, "each performer was recorded separately as a moving cut out until the entire sequence was complete. Digital recording allows each new image to be added to the frame as new data; there is never any generational loss of picture quality as in multiply recorded layers of analogue video. The video collage can now be digitally composed with an

almost endless number of layers and elements."[3]

Teri Yarbrow, originally trained as a painter, turned to video and computer-generated images to communicate statements of personal and social concern. Her 1987 *Atomic Dreams* portrayed the terrors of impending nuclear doom through a series of horrifying dreams, which consisted of a collage of old war footage, the dreamer, and computer-generated images [4.56]. One sequence consisted of a digitally constructed, formidable tunnel of war,

made from twenty-seven separate moving video panels.

Max Almy used the computer in both the process and content of the 1983 *Perfect Leader,* a short satire about the making and marketing of a political candidate by a computer [4.57]. The entire work was structured to simulate interaction with a computer program.

Dara Birnbaum, with degrees in painting and architecture, came to video in 1978 to express a feminist perspective. Using appropriation strategies, Birnbaum often used Pop and Dada art in her work. In a large installation *PM Magazine,* 1982, Birnbaum set a video monitor in a large photographic image of a woman at a computer keyboard. The footage on the moni-

tor tape included a television commercial for Wang computers, baton twirlers, a man and a woman swinging a small child, and a young girl eating an ice cream cone—images conveying the "good life" in America. The figures were intercut with a slow-motion shot of a woman at the computer keyboard producing rainbows, perhaps a symbol of woman as archetypal creator. But all these images were fragmented, "dissolved," "wiped" with the method of presentation possible with the video format. The images were transitory, suggesting the fleeting impact, and possible resulting alienation, of women in particular, but of men as well, in a world dominated by fragmentation.

Bill Viola used video to explore the layers of

4.57. Max Almy, from *Perfect Leader,* 1983.

the human psyche. His *Sleep of Reason* installation for the 1988 Carnegie International, jumping off from Goya's work, delves into the subconscious and conscious aspects of the human mind. His installation was spare, with a traditional piece of living/bedroom furniture on top of which were placed a lamp, digital clock, a vase of white flowers, and a television set. Projections of images, such as a swooping white owl, filled the walls and swept the viewer into a metaphorical world of dreams. His installations have been called

> symbolic, emotional arenas with components drawn from the everyday world. In them elusive video/sound images seem to assume palpable existence; and tangible objects take on strong mental and emotional associations. Evocative of the deeper, nonverbal areas of consciousness, generally associated with sleep and dreams, the installations function as gateways to areas as profound and as challenging as the viewer's receptiveness permits.[4]

Adrian Piper used video to stress the connections between art and contemporary political and social issues. Piper first studied sculpture at the New York School of Visual Arts, and later went on to receive a Ph.D. in philosophy from Harvard University. Her interest in human relations and large global questions stemmed from this philosophical background. In her performances and videotape of *Funk Lessons I–IV* (1983–85) Piper attempted, as she described it, "to restructure people's social identities, by making accessible to them a common medium of communication—Funk music and dance—that has been largely inaccessible to white culture, and has consequently exacerbated the xenophobic fear, hostility and incomprehension that generally characterizes the reaction of White to Black popular culture in this society."[5]

Piper's performances were run as a series of dance lessons involving black music and dances, in which the audience repeated and practiced the dance steps. Through the participatory nature of the performances, Piper hoped to expose and then diminish the sense of distance and alienation that existed in many lives and break down some racial barriers.

Terry Allen attempted to probe into the heart of human experience through the use of multimedia. With a background as a country-rock singer and songwriter, Allen used drawing, painting, sculpture, collage and assemblage, poetry and narrative, video, film, installations, performances, songs, and sound tracks to explore the depths of human experience. One of his series, *Youth in Asia,* begun in 1983, explored self-sacrifice and self-destruction using a variety of media. The title pun on euthanasia was intended, and there were numerous references to Vietnam veterans. In one of the pieces of the series, the image of Buddha was covered with already chewed bubble gum.

The worlds Allen created were raw, some reminiscent of his childhood days in Amarillo and Lubbock, Texas. There were allusions to sleazy bars, arid deserts, barbed wire enclosures, and the grit and grime of the dirt of daily life—the chewed bubble gum, spotted formica, torn vinyl, and swatches of human hair. In much of Allen's work there was a constant reminder of decay and death in the world. His 1985 *China Night* installation alluded to the precarious plight of the American Indian and to Vietnam. The piece consisted of an almost life-size stucco building, whose walls were painted with Hopi Kachina images and which was surrounded by barbed wire. In the window frame was etched Saigon, and an American flag served as glass in a symbolic dominant position. The neon sign blinked alternately "China" and "Kachina" night. On the dirty sand surrounding the building there were references to soldiers' careless disposal of trash—cigarette butts and packages, twisted beer cans and cups—all overseen by a plastic blue madonna whose foot rested on a green plastic snake. Behind the window lay a tableau of Snow White and the Seven

Dwarfs, standing sadly around a half-buried neon sign that read "There it is." There was a sense of nothingness and finality in the scene, of death in the "houses" of both East and West.

Alfredo Jaar, with the use of photographs, mirrors, and light boxes, combining architecture and film, probed more directly than Allen into current political and social issues, particularly inequities caused by world politics. A native of Chile, born in 1956, Jaar moved with his family at age ten to Martinique. He later returned to Chile to study architecture and film, in time for the political coup that ended the rule of Salvador Allende. In 1982 he left Chile for New York, and became concerned with the invisibility of Latin American culture for most United States citizens. In 1985 he received a grant from the Guggenheim Foundation to travel to Brazil to photograph a gold mining operation along the Amazon. His photographs depicted a kind of living hell, as itinerant workers scrambled to find the elusive gold and its promises of a better life. Jaar used these photographs in several installations. In one, *Gold in the Morning,* created for the 1986 Venice Biennale, Jaar chose a rough and remote brick surfaced corner area, in which he placed the photographs in marginal locations, alluding, of course, to the status of the workers. In the center of the room lay a gilded frame on a bed of nails. The nails in the center of the frame were sprayed gold, suggesting both the lure and corruption and pain possible in the search for and use of the gold. Jaar also used the images of the gold miners in *Rushes,* a temporary installation in New York's Spring Street subway station, where he replaced the ads with his images. The work was not identified as art, and viewers were forced to confront the miners on direct and human terms, not as art or as photographs of a far away and unknown place.

Jaar later made a trip to Nigeria to document the impact of the toxic waste dumped by American and European freighters along the coast of Africa. His photographs emphasized the poverty of small towns, where people rifled through the garbage despite its potentially lethal effects; these photographs too were used in a series of installations. His piece for the 1989 exhibit "Les Magiens de la terre," at the Centre Georges Pompidou in Paris, was an elaborate dark labyrinth, leading to an open interior space. Along the labyrinth path were placed illuminated color photographs that contained figures confronting the camera as well as scavenging in the garbage. A statement by Jaar, accompanying the piece, included the following: "La Géographie ça sert, d'abord, a faire la guerre (Geography = War). . . . This project deals neither with Africa nor with waste. Rather it tries to discuss and confront the *Void,* the extraordinary widening gap between Us and Them, that striking distance that is, after all, only a mental one. This project deals with Us and Them at the very same time because no other alternative seems real enough."[6]

Jaar's work was not didactic or polemic, though, nor did it offer a closed position or opinion. Jaar's frequent use of mirrors also made it possible to reverse images, and for the viewer to be one of the "Others," be it from an underdeveloped country or culture or in a small group in midtown Manhattan. Jaar himself, although committed to a larger social view, stated, "I'm pessimistic, I don't think we can change the world with art. My hope is to make people rethink certain preconceived notions they may have about underdeveloped countries."[7]

> Jaar's approach to art and society links him to a new breed of politically aware artists for whom the task is to encourage thought rather than to stake out "politically correct" positions. . . . Jaar shares . . . with other artists a desire to reconstitute a set of public values within our extremely privatized society by making citizens recognize the nature of their relationship to the social whole. At the same time he appreciates the deep resistance to change of the problems before us.[8]

Like Jaar, Krzysztof Wodiczko encouraged the public to rethink political and social con-

ceptions through his art. The Polish-born, New York–based artist projected large photographic images of objects and body parts onto public buildings and monuments that changed the nature and public aura of the specific site. Through his large-scale spectacles, executed in the United States, Canada, and Europe throughout much of the decade, Wodiczko raised questions about the function of art and architecture in public spaces, and created a sense of disruption and dissonance at his various sites. A 1984 projection of a hand positioned as if pledging allegiance to the flag on New York's AT and T Building, shortly before the 1984 presidential election, asked the public to consider relationships between corporate business and patriotism, particularly in an election year. Other Wodiczko pieces included the projection of chains and padlocks on the New Museum of Contemporary Art in New York, 1985, and a swastika projected on South Africa House in Trafalgar Square, 1985. In Wodiczko's work heroic and antiheroic attributes became complexly intertwined.

Artists' use of technology and multi- and intermedia formats demonstrated clearly that space could no longer truly be perceived or understood from a single viewpoint, and that time need no longer be linear and chronological. "The recognition of movement and change is the essence of 20th century time. Becoming is no longer being changed but changing. To exist is to change; to mature is to create oneself endlessly."[9]

By the end of the decade, technology stood firmly established as a tool for some artists to probe deeply into the meaning of time, as past, present, and future were easily and quickly intertwined. Questions arose as to whether technology would help preserve the status quo or whether it would help create new cultural forms and systems. And there were underlying fears about advancements in technology—fears that involve alienation, fragmentation, dehumanization, and spiritual death. But it appeared to be within the grasp of the artist to master and use technological processes for human-oriented ends. A number of artists working during the eighties using technology and multimedia formats clearly demonstrated the potential for discovering a deeper sense of humanity, where man and woman may discover that

> on the one hand, the same man experiences so many different unconnected and irreconcilable things in one and the same moment, and that, on the other, different men in different places often experience the same things, that the same things are happening at the same time in places completely isolated from each other. This universalism of which modern technics have made contemporary man conscious, is perhaps the real source of the new conception of time and the whole abruptness with which modern art describes life.[10]

"As the artist confronts the unknown, the partially known, the dimly known, new symbols emerge, new visions of life, external images of internal things. The crises of our times are not simply personal sorrow or tragedy, but are human situations to which we feel compelled to respond creatively, and about which we feel compelled to communicate. . . . The artist, committed to understanding the promise and potential of the technological age, helps to unwrap the darkness from [the] future."[11]

Looking back over the decade at the visual arts in general, the search for heroes to look up to led to varieties of "places" and modes of expression that were in many ways as pluralistic as the seventies. There was an exploration of mythic spaces and figures, of sacred inner realms. There was, as television celebrated its fiftieth anniversary, appropriation and amplification of mass media imagery and forms. There was a rush toward stardom, a push toward the artist and art work as celebrity and commodity. By the end of the eighties money, above many factors, seemed to define the success or failure of any given work of art or artist.

The marketplace had superseded, in many ways, the artist, the artist's materials and studio. And as one critic, Robert Taylor, noted,

> During the 80's the want of a viable aesthetic to take the place of modernism is more keenly felt than ever, and its principal casualty is the artist who believes art transcends consumption. Will there be a place for him in the 1990's? Approach-

ing the last decade of the 20th century, art seems poised to experiment with 90's technologies. The public for art is expanding, its increase assured by concepts of universal education, and in the auction houses, scarcity is destined to drive up 90's prices. Museums will be booming. In all this, however, at the hinge of the decade is the need to radically redefine that role and determine if the artist can relate to a culture in which the world is interpreted by bankers.[12]

NOTES: MULTIMEDIA AND INTERMEDIA, 1980S

1. Joseph Nechvatal, "Theoretical Statement Concerning Computer/Robotic Paintings," typescript (New York: Brooke Alexander Gallery), p. 12.
2. Max Almy, "Video: Electronic Collage," in *Collage: Critical Views*, ed. Katherine Hoffman (Ann Arbor, Mich.: UMI Research Press, 1989), pp. 362–64.
3. Ibid., p. 365.
4. Barbara London, "Bill Viola," *Carnegie International*, 1988, catalog, p. 146.
5. Adrian Piper, unpublished manuscript, "Notes on Funk I–IV," p. 7.
6. Alfredo Jaar, *Contemporanea*, June 1989, back of cover page.
7. Cited in Eleanor Heartney, "Mirror Vision," *Contemporanea*, June 1989, p. 54.
8. Ibid.
9. Herbert Shore, "No Future Wrapped in Darkness," p. 110. "Observations on Art, Culture, and Technology in a Changing World," *The Structurist*, no. 21/22, 1981/82, Eli Bornstein, ed. (Saskatoon, Canada).
10. Arnold Hauser, *The Social History of Art*, vol. 4 (New York: Vintage Books, 1969), p. 244.
11. Shore, "No Future Wrapped in Darkness," pp. 112–13.
12. Robert Taylor, "An Era When Cash Superseded Canvas," *Boston Globe*, January 1, 1989, p. 86.

LOOKING BACKWARD AND FORWARD

DESPITE the cynicism of some concerning the commodification of art and the role of the marketplace in assessing artists and artworks at the end of the eighties, there is a larger view possible, upon looking back at the entire picture and context of the visual arts since 1945. In 1945 with the detonation of the atomic bomb the world was catapulted into an age where total destruction was possible at any given moment. But it was a world too where advances in science and technology promised untold and unforeseen improvements in the quality of human life. The modern and post-modern world has been faced with an unending stream of paradoxes, as exemplified in the creative and destructive forces inherent in technology. The modern experience has consisted, in the words of Marshall Berman, of finding

> ourselves in an environment that promises us adventure, power, joy, growth, transformation of ourselves and the world—and at the same time, that threatens to destroy everything we have, everything we know, everything we are. . . . To be modern is to be part of a universe in which as Marx said, "all that is solid melts into air!" . . . To be modern is to live a life of paradox and contradiction. It is to be overpowered by the immense bureaucratic organizations that have the power to control and often to destroy all communities, values, lives; and yet to be undeterred in our determination to face these forces, to fight to change the world and make it our own. It is to be both revolutionary and alive to new possibilities.[1]

Compounding this has been the postmodern experience of increased fragmentation and simulation, of impurity and recycling.

A primary figure in helping the public "see," in an all-incompassing manner, the impact of modernity and postmodernity, and new possibilities, has been the visual artist. As a barometer and challenger of contemporary culture, as well as a harbinger of new visions, visual artists, particularly since 1945, have brought to the public forum a continuing stream of explorations and experiments that have both entertained and provoked serious questions.

Since Marcel Duchamp brought forth for exhibition his first ready-made (a urinal that he signed with the pseudonym R. Mutt), the definition of art has remained in flux. And since 1945 there have been ever-increasing approaches to the notion of what art is or can be. Works such as Jackson Pollock's targets, Donald Judd's boxes, or Roy Lichtenstein's comics were once considered alien, from a foreign aesthetic. But, like the Impressionists, who were once considered radical and alien, changes in time,

temperament, and taste have made these once unacceptable avant-garde works an integral part of an artistic "establishment." It remains to be seen what will become of the works of more recent years, particularly those that have reached out to different levels of culture, as boundaries between popular and "high" culture, between studio and marketplace, have become less defined. Nor can we really visualize what the art of the twenty-first century will be about, except that the possibilities are endless.

What is important, though, is perhaps not the definitions of art nor the diverse realms into which art has and may expand but the fact that a wide range of artistic voices does exist. These voices are and will be important for the future in a world that promises to grow more complex. Given the popularity of the art marketplace,

museums, and galleries, there is the potential for art and artists, if not subsumed and exploited by economics, to wield cultural power. It is hoped that the exploratory and experimental spirit that has characterized the visual arts since 1945 will continue to triumph. The visual artist is not and will not be simply "rearranging the deck chairs on the *Titanic*" in aesthetic formations, but can provide ways of seeing that open the door to the complex and rich meanings inherent in human life and its mysteries. For, in the words of Joseph Campbell, the artist "is the true seer and prophet of his century, the justifier of life and as such, of course, a revolutionary far more fundamental in his penetration of the social mask of his day than any fanatic idealist spilling blood over the pavement in the name simply of another unnatural mask."[2]

NOTES: LOOKING BACKWARD AND FORWARD

1. Marshall Berman, *All That Is Solid Melts into Air: The Experience of Modernity* (New York: Simon & Schuster, 1982), pp. 13, 15.

2. Joseph Campbell, *The Inner Reaches of Outer Space* (New York: Harper & Row, 1986), p. 132.

SELECTED BIBLIOGRAPHY:
BOOKS AND EXHIBITION CATALOGS

Abbott, Berenice. *Lisette Model* (preface). Millerton, N.Y.: Aperture, 1979.

Ackley, Clifford S. *Private Realities: Recent American Photography.* Boston: Museum of Fine Arts, 1974.

Adams, Ansel. *Ansel Adams: Images 1923–1974.* Boston: New York Graphic Society, 1974.

————. *Photographs of the Southwest.* Boston: New York Graphic Society, 1976.

Adrian, Dennis. *Sight out of Mind: Essays and Criticism on Art.* Ann Arbor, Mich.: UMI Research Press, 1985.

Alinder, Jim. *Altered Landscapes.* Palatka, Fla.: Fine Arts Gallery, Florida School of Arts, 1978.

Alloway, Lawrence. *The Venice Biennale, 1895–1968.* Greenwich, Conn.: New York Graphic Society, 1968.

————. *Christo.* New York: Harry N. Abrams, 1969.

————. *American Pop Art.* New York: Collier Books, Macmillan Co., 1974.

————. *Topics in American Art Since 1945.* New York: W. W. Norton, 1975.

————. *Robert Rauschenberg.* Washington, D.C.: National Collection of Fine Arts, 1976.

————. *Network: Art and the Complex Present.* Ann Arbor, Mich.: UMI Research Press, 1984.

————, ed. *Roy Lichtenstein.* New York: Abbeville Press, 1983.

Amaya, Mario. *Pop Art . . . and After.* New York: Viking Press, 1965.

Ambasz, Emilio. *The Architecture of Luis Barragan.* New York: Museum of Modern Art, 1976.

————. *Emilio Ambasz: Designs.* New York: Rizzoli International, 1988.

American Photography: The Sixties. Lincoln: University of Nebraska, Sheldon Memorial Art Gallery, 1966.

American Prints in the Collection of the Museum of Modern Art, New York. New York: Museum of Modern Art, 1987.

Anderson, Laurie. *United States.* New York: Harper & Row, 1984.

Arbus, Diane. *Diane Arbus.* Millerton, N.Y.: Aperture, 1972.

Arendt, H., ed. *Illuminations.* New York: Schocken Books, 1969. (Contains Benjamin, Walter, "The Work of Art in the Age of Mechanical Reproduction.")

Armstrong, Richard, John G. Hanhardt, Richard Marshall, and Lisa Phillips. *1989 Biennial Exhibition.* Whitney Museum of American Art and W. W. Norton, 1989.

Armstrong, Tom, Wayne Craven, Norman Reder, Barbara Haskell, Rosalind E. Krauss, Daniel Robbins, and Marcia Tucker. *Two Hundred Years of American Sculpture.* New York: Whitney Museum of American Art, 1976.

Arnason, H. H. *History of Modern Art: Painting, Sculpture, Architecture.* New York and Englewood Cliffs, N.J.: Harry N. Abrams and Prentice-Hall, 1986.

————. *Calder.* New York: Viking Press, 1971.

Arnheim, Rudolph. *Art and Visual Perception.* London: Faber, 1969.

Art of the Sixties and Seventies—The Panza Collection. New York: Rizzoli, 1984.

Art Since Mid-Century, Figurative Art. With contributions by Hodin, Marchion, Langui, Alloway, Restany, etc. Greenwich, Conn.: New York Graphic Society, 1971.

Art Since 1945. With contributions by Hunter, Grohmann, Read, Hodin, etc. New York: Harry N. Abrams, 1959.

Ashton, Dore. *The Unknown Shore: A View of Contemporary Art.* Boston, Mass., and Toronto, Ont.: Little, Brown & Co., 1962.

————. *Modern American Sculpture.* New York: Harry N. Abrams, 1968.

————. *Pol Bury.* Paris: Maeght Editerer, 1970.

————. *The New York School: A Cultural Reckoning.* New York: Viking Press, 1973.

————, ed. *Twentieth Century Artists on Art.* New York: Pantheon Books, 1985.

————. *Out of the Whirlwind: Three Decades of Arts Commentary.* Ann Arbor, Mich.: UMI Research Press, 1987.

Ashton, Dore, and Agnes Martin. *Agnes Martin: Paintings and Drawings, 1957–1975.* London: Hayward Gallery, 1977.

Attitudes: Photography in the 1970's. Santa Barbara: Santa Barbara Museum of Art, 1980.

Axsom, Richard. *The Prints of Frank Stella: A Catalogue Raisonné, 1967–1982.* New York: Hudson Hills Press, 1983.

Baigell, Matthew. *A Concise History of American Painting and Sculpture.* New York: Harper & Row, 1984.

Baker, Joan Stanley. *Japanese Art.* London: Thames and Hudson, 1984.

Baker, Kenneth. *Minimalism.* New York: Abbeville Press, 1988.

Ballerini, Luigi. *Spelt from Sibyl's Leaves: Explorations in Italian Art.* Milan: Electa International, 1982.

Banfield, Edward C. *The Democratic Muse: Visual Arts and the Public Interest.* New York: Basic Books, 1984.

Bann, Stephen, ed. *The Tradition of Constructivism.* London: Thames and Hudson, 1974.

Bann, Stephen, et al. *Four Essays on Kinetic Art.* London: Motion Books, 1966.

Bardi, P. M. *Profile of the New Brazilian Art.* Rio de Janeiro: Livraria Kosmos Editôra, 1970.

Barnitz, Jacqueline. *Latin American Artists in the U.S. before 1950.* Flushing, N.Y.: Godwin-Ternbach Museum at Queens College, 1983.

Baro, Gene. *Nevelson: The Prints.* New York: Pace Editions, 1974.

Barr, Alfred H., Jr. *Painting and Sculpture in the Museum of Modern Art, 1929–1967.* New York: Museum of Modern Art, 1977.

————. *School of Paris: Paintings from the Florene May Schoenborn and Samuel A. Marx Collection.* New York: Museum of Modern Art, 1979. (Reprinted from a 1965 exhibition of a private collection.)

Barrett, Cyril. *Op Art.* London: Studio Vista, 1970.

Barrette, Bill. *Eva Hesse: Sculpture.* Timken Press, 1988.

Bartlett, Jennifer. *Jennifer Bartlett: Rhapsody.* New York: Harry N. Abrams, 1985.

Barzel, Amnon, Henry Geldzahler, Joseph Kosuth, Donald Kuspit, Thomas M. Messer, et al. *Europe Now: Contemporary Creation in Western Europe,* catalog for inaugural exhibition of the Museum of Contemporary Art, Prato, Italy: Centro D-Electra, 1988.

Leonard Baskin: The Graphic Work, 1950–70. New York: FAR Gallery, 1970.

Battcock, Gregory. *Why Art.* New York: E. P. Dutton, 1977.

————, ed. *Minimal Art: A Critical Anthology.* New York: E. P. Dutton, 1968.

————, ed. *The New Art: A Critical Anthology.* New York: E. P. Dutton, 1969.

————, ed. *Idea Art: A Critical Anthology.* New York: E. P. Dutton, 1973.

————, ed. *The New Art.* New York: E. P. Dutton, 1973.

————, ed. *Super Realism: A Critical Anthology.* New York: E. P. Dutton, 1975.

————, ed. *New Artists Video: A Critical Anthology.* New York: E. P. Dutton, 1978.

Battcock, Gregory, and Robert Nickas, eds. *The Art of Performance: A Critical Anthology.* New York: E. P. Dutton, 1984.

Beal, Graham. *Jim Dine: Five Themes.* New York and Minneapolis: Abbeville Press and Walker Art Center, 1981.

Beardsley, John. *Earthworks and Beyond.* New York: Abbeville Press, 1984.

Beaton, Cecil, and Gail Buckland. *The Magic Image: The Genius of Photography from 1839 to the Present Day.* Boston: Little, Brown & Co., 1975.

Becker, Jürgen von, and Wolf Vostell, eds. *Happenings: Fluxus: Pop Art: Nouveau Realisme.* Reinbek near Hamburg: Rowohet, 1965.

Beckett, Wendy. *Contemporary Women Artists.* New York: Universe Books, 1988.

Benthall, Jonathan. *Science and Technology in Art Today.* New York: Praeger Publishers, 1972.

Berman, Marshall. *The Experience of Modernity—All That's Solid Melts into Air.* New York: Simon & Schuster, 1982.

Bernstein, Roberta. *Jasper Johns' Paintings and Sculptures, 1954–1974: "The Changing Focus of the Eye."* Ann Arbor, Mich.: UMI Research Press, 1985.

Beyond the Open Door—Contemporary Paintings from the People's Republic of China. Pasadena, California: Pacific Asia Museum, 1987.

Billeter, Erica, ed. *Images of Mexico.* Dallas: Dallas Art Museum, 1989.

Blake, Peter. *Form Follows Fiasco—Why Modern Architecture Hasn't Worked.* Boston: Little, Brown and Co., 1974.

Blesh, Rudi. *Modern Art USA: Men, Rebellion, Conquest, 1900–1956.* New York: Alfred A. Knopf, 1956.

Bloch, E. Maurice. *Tamarind: A Renaissance of Lithography.* Washington, D.C.: International Exhibitions Foundation, 1971.

————. *Words and Images: Universal Limited Art Editions.* Los Angeles: UCLA Art Council, 1978.

Bois, Yve-Alain, et al. *Endgame: Reference and Simulation in Recent Painting and Sculpture.* Cambridge, Mass.: MIT Press, 1987.

Bosworth, Patricia. *Diane Arbus: A Biography.* New York: Alfred A. Knopf, 1984.

Bourdon, David. *Christo.* New York: Harry N. Abrams, 1971.

Bowman, Russell. *Philip Pearlstein: The Complete Paintings.* New York: Alpine Fine Arts Collection, 1983.

Bowman, Russell, Philip Pearlstein, and Irving Sandler. *Philip Pearlstein: A Retrospective.* Milwaukee: Milwaukee Art Museum, 1983.

Braun, Emily, ed. *Italian Art in the Twentieth Century.* Munich: Prestel Art Books, 1989.

Brett, Guy. *Kinetic Art: The Language of Movement.* London: Studio Vista, 1968.

Brolin, Brent. *The Failure of Modern Architecture.* New York: Van Nostrand Reinhold, 1976.

Brooks, H. Allen, and Alexander Tzonis, eds. *Chandigarh: City and Musée.* New York: Garland Publishing, 1983.

Brown, David, and Ian Barker. *Aspects of British Art Today.* Tokyo: Asahi Shimbun, 1982.

Buchloh, Benjamin H. D. *Formalism and Historicity—Changing Concepts in American and European Art Since 1945.* Chicago, 1977.

Buettner, Stewart. *American Art Theory, 1945–1970.* Ann Arbor, Mich.: University Microfilms International Research Press, 1981.

Bunnell, Peter. *Jerry N. Uelsmann.* Millerton, N.Y.: Aperture, 1970.

Bürger, Peter. *Theory of the Avant-Garde.* Translated by Michael Shaw. Minneapolis: University of Minnesota Press, 1984.

Burnham, Jack. *Beyond Modern Sculpture: The Effects of Science and Technology on the Sculpture of This Century.* New York: George Braziller, 1968.

————. *Great Western Salt Works: Essays on the Meaning of Post-Formalist Art.* New York: George Braziller, 1974.

Burnham, James. *Software: Information Technology: Its New Meaning for Art.* New York: Jewish Museum, 1970.

Butler, Christopher. *After the Wake: An Essay on the Con-*

temporary Avant-Garde. Oxford, England: Clarendon, 1980.

Cage, John. *Silence.* Middletown, Conn.: Wesleyan University Press, 1961.
———. *Silence: Lectures and Writings.* Cambridge, Mass.: MIT Press, 1967.
———. *Notations.* New York: Something Else Press, 1969.
Cage, John, and Russell Conner. *Paik-Abe Video Synthesizer with Charlotte Moorman: Electronic Art III.* New York: Galeria Bonino, 1971.
Calas, Elena and Nicolas. *Icons and Images of the Sixties.* New York: E. P. Dutton, 1971.
Calas, Nicolas. *Art in the Age of Risk and Other Essays.* New York: E. P. Dutton, 1968.
———. *Transfigurations: Art—Critical Essays on the Modern Period.* Ann Arbor, Mich.: UMI Research Press, 1985.
Caldwell, John, curator. *Carnegie International, 1988.* Pittsburgh: Carnegie Museum, 1988, distributed by Prestel Art Books, Cologne.
Callahan, Harry. *Photographs: Harry Callahan.* Santa Barbara: El Mochuelo Gallery, 1964.
Campbell, Joseph. *The Inner Reaches of Outer Space.* New York: Harper & Row, 1986.
Canaday, John. *Embattled Critic.* New York: Noonday Press, 1962.
———. *Culture Gulch.* New York: Farrar, Straus and Giroux, 1969.
Canter, Norman. *Twentieth Century Culture—Modernism to Deconstruction.* New York: Peter Lang, 1988.
Carmean, E. A., Jr. *The Great Decade of American Abstraction: Modernist Art, 1960 to 1970.* Houston, Tex.: Museum of Fine Arts, 1974.
Carmean, E. A., Jr. *Helen Frankenthaler: A Painting Retrospective.* New York: Museum of Modern Art and Harry N. Abrams, 1989.
Castedo, Leopoldo. *A History of Latin American Art and Architecture.* Translated by Phyllis Freeman. New York: Praeger Publishers, 1969.
Castleman, Riva. *Technics and Creativity: Gemini G.E.L.* New York: Museum of Modern Art, 1971.
———. *Modern Art in Prints.* New York: Museum of Modern Art, 1973.
———. *Printed Art: A View of Two Decades.* New York: Museum of Modern Art, 1980.
———. *American Impressions: Prints Since Pollock.* New York: Alfred A. Knopf, 1985, 1st edition.
———. *Jasper Johns: A Print Retrospective.* New York: Museum of Modern Art, 1986.
———. *Prints of the Twentieth Century: A History.* N.Y.: Thames and Hudson, 1988.
Catalano, Gary. *The Years of Hope: Australian Art and Criticism, 1959–1968.* New York: Oxford University Press, 1981.
Celant, Germano. *Arte Povera.* New York: Praeger Publishers, 1969.
———. *Piero Manzoni.* New York: Sonnabend Press, 1972.
———. *The European Iceberg.* New York: Rizzoli, 1985.
———. *Unexpressionism—Art beyond the Contemporary.* New York: Rizzoli, 1988.
Chang, Arnold. *Painting in the People's Republic of China: The Politics of Style.* Boulder: Westview Press, 1980.

Chase, Gilbert. *Contemporary Art in Latin America: Painting, Graphics, Sculpture, Architecture.* New York: The Free Press, 1970.
Chase, Linda. *Hyperrealism.* New York: Rizzoli, 1975.
Chiarenza, Carl. *Aaron Siskind: Pleasures and Terrors.* Boston: New York Graphic Society, 1982.
Chipp, Herschel B., ed. *Theories of Modern Art.* Berkeley: University of California Press, 1969.
Cobb, Henry. *The Architecture of Frank Gehry.* New York: Rizzoli International, 1986.
Cockcroft, E., J. Weber, and J. Cockcroft. *Toward a People's Art: The Contemporary Mural Movement.* New York: E. P. Dutton, 1977.
Coe, Brian, and Paul Gates. *The Snapshot Photograph.* London: Ash and Grant, 1977.
Coke, Van Deren. *The Painter and the Photograph.* Albuquerque: University of New Mexico Press, 1964.
———. *Fabricated to Be Photographed.* San Francisco: San Francisco Museum of Modern Art, 1979.
Coleman, A. D. *Light Readings: A Photography Critic's Writings 1968–1978.* New York: Oxford University Press, 1979.
Colpitt, Frances. *Minimal Art: The Critical Perspective.* Ann Arbor, Mich.: UMI Research Press, 1989.
Compton, Michael. *Optical and Kinetic Art.* London: Tate Gallery, 1967.
———. *New Art at the Tate Gallery.* London: Tate Gallery, 1983
Compton, Susan, ed. *British Art in the Twentieth Century, The Modern Movement.* Munich: Prestel Art Books, 1989.
Concerned Photographer, The. New York: Grossman Publishers in cooperation with the International Fund for Concerned Photography, vol. 1, 1968, vol. 2, 1972.
Constantine, Mildred. *Tina Modotti: A Fragile Life.* New York and London: Paddington Press, 1975.
Cook, Christopher, curator. *Harold Tovish: A Retrospective Exhibition, 1948–1988.* Andover, Mass.: Addison Gallery, 1988.
Cook, John W., and Heinrich Klotz, eds. *Conversations with Architects.* New York: Praeger Publishers, 1973.
Cooper, O. C., Olle Granath, Pontus Hulten, Cecilia Lindqvist, Lars Nittve, Mario Perniola, and Ingrid Rein. *Walter De Maria: Two Very Large Presentations.* Stockholm: Moderna Museet, 1988.
Coplans, John. *Serial Imagery.* Pasadena: Pasadena Art Museum, 1968.
———. *Andy Warhol.* Greenwich, Conn.: New York Graphic Society, 1971.
———. *Ellsworth Kelly.* New York: Harry N. Abrams, 1973.
———, ed. *Roy Lichtenstein.* New York: Praeger Publishers, 1972.
Coplans, John, and Philip Leider. *Assemblage in California: Works from the Late 50's and Early 60's.* Irvine, Calif.: Art Gallery, University of California, Irvine, 1968.
Cowart, Jack. *Lichtenstein—Roy Lichtenstein 1970–1980.* New York: Hudson Hills Press, 1981.
Cox, Annette. *Art-as-Politics: The Abstract Expressionist Avant-Garde and Society.* Ann Arbor, Mich.: University Microfilms International Research Press, 1982.
Crane, Diane. *The Transformation of the Avant-Garde. The New York Art World, 1940–1985.* Chicago and London: University of Chicago Press, 1987.

Crichton, Michael. *Jasper Johns*. New York: Harry N. Abrams, 1977.

Crone, Rainer. *Andy Warhol*. New York: Praeger Publishers, 1970.

Crone, Rainer, Jürgen Harten, Ulrich Luckhardt, and Jiri Svestka. *BiNational: German Art of the Late 80's*. Düsseldorf and Cologne: Städtische Kunsthalle and Kunstsammlung Nordrhein-Westfalen and Kunstverein für die Rheinland und Westfalen, and Dumont Buchverlag, 1988.

Cumming, Robert. *Robert Cumming Photographs*. Carmel, Calif.: Friends of Photography, 1979.

Cummings, Paul. *Artists in Their Own Words*. New York: St. Martin's Press, 1979.

Curtis, William. *Le Corbusier, Ideas and Forms*. New York: Rizzoli, 1986.

Curtis, William J. R. *Modern Architecture Since 1900*. 2d ed. Englewood Cliffs, N.J.: Prentice-Hall, 1987.

Dabrowski, Magdalena. *Contrasts of Form: Geometric Abstract Art, 1910–1980*. New York: Museum of Modern Art, 1985.

———. *The Drawings of Philip Guston*. New York: Museum of Modern Art, 1988.

Dal Co, Francesco, ed. *Kevin Roche*. New York: Rizzoli International, 1985.

———. *Mario Botta*. New York: Rizzoli, 1988.

Danoff, I. Michael, and Roald Nasgaard. *Gerhard Richter: Paintings*. New York: Thames and Hudson, 1988.

Danto, Arthur. *The Philosophical Disenfranchisement of Art*. New York: Columbia University Press, 1986.

Davies, Colin. *High Tech Architecture*. New York: Rizzoli, 1988.

Davies, Hugh, and Riva Castleman. *The Prints of Barnett Newman*. New York: Barnett Newman Foundation, 1983.

Davis, Douglas. *Art and the Future: A History/Prophecy of the Collaboration between Science, Technology and Art*. New York: Praeger Publishers, 1973.

———. *Artculture: Essays on the Post-Modern*. New York: Harper & Row, 1977.

Davis, Douglas, and Allison Simmons. *The New Television*. Cambridge, Mass.: MIT Press, 1978.

Day, Holliday T., and Hollister Sturges. *Art of the Fantastic: Latin America, 1920–1987*. Indianapolis: Indianapolis Museum of Art, 1988.

Decorative Impulse, The. Philadelphia, Pa.: Institute of Contemporary Art, 1979.

Delahoyd, Mary. *Alternatives in Retrospect: An Historical Overview, 1969–1975*. New York: New Museum, 1981.

Dennison, Lisa. *Angles of French Art Today. 1986 Exxon International Exhibition*. New York: Solomon R. Guggenheim Museum, 1986.

———. *New Horizons in American Art*. New York: Solomon R. Guggenheim Museum, 1985.

Derrida, Jacques. *The Truth on Painting*. Translated by Geoffrey Bennington and Ian McLeod. Chicago: University of Chicago Press, 1987.

de Sausmarez, Maurice. *Bridget Riley*. Greenwich, Conn.: New York Graphic Society, 1970.

de Wilde and Petersen. *Attitudes/Concepts/Images*. Amsterdam: Van Gennep, 1982.

Diamondstein, Barbaralee. *Inside New York's Art World*. New York: Rizzoli, 1979.

———. *Visions and Images: American Photographers on Photography*. New York: Rizzoli International, 1981.

———. *American Architecture Now*. New York: Rizzoli International, 1985.

Jim Dine: Complete Graphics. Berlin: Galerie Mikro, 1970.

Dower, John, intro. *A Century of Japanese Photography*. New York: Pantheon Press, 1980.

Drew, Philip. *The Architecture of Arata Isozaki*. New York: Harper & Row, 1982.

Drexler, Arthur. *Buildings for Best Products*. New York: Museum of Modern Art, 1979.

———. *Transformations in Modern Architecture*. New York and Boston: Museum of Modern Art and New York Graphic Society, 1979.

Duberman, Martin. *Black Mountain: An Exploration in Community*. New York: E. P. Dutton, 1972.

Euclaire, Sally. *The New Color Photography*. New York: Abbeville Press, 1981.

Eisenman, et al. *Five Architects: Eisenman, Graves, Gwathmey, Hejduk, Meiser*. 2d ed. New York: Oxford University Press, 1975.

Elderfield, John. *Morris Louis*. New York: Museum of Modern Art, 1986.

———. *Frankenthaler*. New York: Museum of Modern Art and Harry N. Abrams, 1989.

Eureka: Artists from Australia. Australia: Institute of Contemporary Art, 1982.

Ferguson, Bruce, Joan Simon, and Roberta Smith. *Abstraction in Question*. Sarasota, Fla.: John and Mabel Ringling Museum of Art, 1988.

Field, Richard S. *Jasper Johns: Prints 1960–1970*. New York: Praeger Publishers, 1970.

———. *Jasper Johns: Prints, 1970–1977*. Middletown, Conn.: Wesleyan University Press, 1978.

Finch, Christopher. *Pop Art: Object and Image*. London and New York: Studio Vista and E. P. Dutton, 1968.

Fine, Elsa Honig. *The Afro-American Artist*. Holt, Rinehart and Winston, 1973.

Flack, Audrey. *Audrey Flack on Painting*. New York: Harry N. Abrams, 1981.

———. *Art and Soul: Notes on Creating*. New York: E. P. Dutton, 1986.

Foley, Suzanne. *Time-Sound Conceptual Art in the San Francisco Bay Area: The 1970's*. Seattle: University of Washington Press.

Forge, Andrew. *Robert Rauschenberg*. New York: Harry N. Abrams, 1969.

Forty Years of Modern Art 1945–1985. London: Tate Gallery, Salem House Publishers, 1986.

Foster, E. A. *Robert Rauschenberg: Prints, 1948–1970*. Minneapolis: Institute of Arts, 1970.

Foster, Hal. *Recodings: Art, Spectacle, Cultural Politics*. Port Townsend, Wash.: Bay Press, 1985.

———, ed. *The Anti-Aesthetic: Essays on Postmodern Culture*. Port Townsend, Wash.: Bay Press, 1983.

Foster, Stephen C. *The Critics of Abstract Expressionism*. Ann Arbor, Mich.: UMI Research Press, 1980.

———, ed. *"Event" Arts and Art Events*. Ann Arbor, Mich.: UMI Research Press, 1988.

Fox, Howard N. *Avant-Garde in the Eighties*. Los Angeles: Los Angeles County Museum of Art, 1987.

Fox, Howard N., Miranda McClintic, and Phyllis Rosen-

zweig. *Content: A Contemporary Focus, 1974–1984.* Washington, D.C.: Hirshhorn Museum and Sculpture Garden, 1984.

Frampton, Kenneth. *Modern Architecture: A Critical History.* New York and Toronto: Oxford University Press, 1980.

Francis, Richard. *Jasper Johns.* New York: Abbeville Press, 1984.

Francke, H. W. *Computer Graphics/Computer Art.* Translated by Gustav Metzger. London: Phaidon, 1971.

Franco, Jean. *The Modern Culture of Latin America: Society and the Artist.* Hammondsworth, England: Penguin Books, 1970.

Frank, Elizabeth. *Pollock.* New York: Abbeville Press, 1983.

Frank, Robert. *Les Américains.* Paris: Delpire, 1958. Published in English as *The Americans.* Introduction by Jack Kerouac. New York: Grove Press, 1959.

Frankenstein, Alfred. *Karel Appel.* New York: Harry N. Abrams, 1980.

Franzke, Andreas. *Georg Baselitz.* Munich: Prestel Art Books, 1989.

Fried, Michael. *Morris Louis.* New York: Harry N. Abrams, 1970.

Friedman, Joseph S. *The History of Colour Photography.* London and New York: Focal Press, 1968.

Friedman, Martin. *Oldenburg: Six Themes.* Minneapolis: Walker Art Center, 1975.

———. *Tyler Graphics: The Extended Image.* New York: Abbeville Press, 1988.

Friedman, Martin, Peter Gay, and Robert Pincus-Witten. *A View of a Decade: 1966–1976/Ten Years.* Chicago: Museum of Contemporary Art, 1977.

Friedman, Martin, R. H. Fuchs, and M. M. M. Vos. *Jan Dibbets.* New York: Rizzoli, 1987.

Friedman, Mildred. *The Architecture of Frank Gehry.* Minneapolis: Walker Art Center, 1988.

———, ed. *Tokyo: Form and Spirit.* Minneapolis and New York: Walker Art Center and Harry N. Abrams, 1988.

Fry, Edward, and Miranda McClintic. *David Smith: Painter, Sculptor, Draftsman.* New York: George Braziller, 1983.

Fuller, Buckminster. *Operating Manual for Spaceship Earth.* Carbondale: Southern Illinois University Press, 1969.

Futagawa, Yukio, ed. *Ricardo Bofill.* New York: Rizzoli, 1985.

Gablik, Suzi. *Progress in Art.* New York: Rizzoli, 1977.

Galassi, Peter, intro. *Nicholas Nixon, Pictures of People.* New York: Museum of Modern Art, 1988.

Gans, Herbert. *Popular Culture and High Culture.* New York: Basic Books, 1974.

Gauss, Kathleen McCarthy. *Studio Work: Photographs by Ten Los Angeles Artists.* Los Angeles: Los Angeles County Museum of Art, 1982.

———. *New American Photography.* Los Angeles: Los Angeles County Museum of Art, 1985.

Gee, Helen. *Photography of the Fifties: An American Perspective.* Tucson: Center for Creative Photography, 1980.

Gehry, Frank. *Cross Currents of American Architecture.* New York: St. Martin's Press, 1985.

Geldzahler, Henry. *American Painting in the Twentieth Century.* New York: Metropolitan Museum of Art, 1965.

———. *New York Painting and Sculpture, 1940–70.* New York: E. P. Dutton, 1969.

Georges, Rip, and Jim Heimann. *California Crazy: Roadside Vernacular Architecture.* San Francisco: Chronicle Books, 1980.

Gibson, Ralph. *The Somnambulist.* New York: Lustrum, 1970.

Glusberg, Jorge. *Art in Argentina.* Milan: Giancarlo Politi Editore, 1986.

Godfrey, Tony. *The New Image Painting in the 1980's.* New York: Abbeville Press, 1986.

Gohr, Siegfried, ed. *Georg Baselitz 1963–1983.* Munich: Prestel Art Books, 1989.

Goldberg, RoseLee. *Performance: Live Art 1909 to the Present.* New York: Harry N. Abrams, 1979.

Goldberger, Paul. *On the Rise—Architecture and Design in a Post-Modern Age.* New York: Times Books, 1983.

Goldman, Judith. *James Rosenquist.* New York: Viking Penguin, 1985.

Goldman, Shifra M. *Contemporary Mexican Painting in a Time of Change.* Austin: University of Texas Press, 1981.

Goldwater, Marge, intro. *Marcel Broodthaers.* New York: Rizzoli, 1988.

Goodman, Cynthia. *Art and the Question of Meaning.* New York: Crossroads Publications, 1981.

Goodyear, Frank H., Jr. *Contemporary American Realism Since 1960.* Boston: New York Graphic Society, 1981.

———. *Neil Welliver.* New York: Rizzoli, 1985.

Gottlieb, Carla. *Beyond Modern Art.* New York: E. P. Dutton, 1976.

Gotz, A., Winfried Konnertz, and Karin Thomas. *Joseph Beuys: Life and Works.* Cologne: M. DuMont Schauberg, 1973.

Grayson, Sue. *Eureka: Artists from Australia.* London: Institute of Contemporary Arts and Arts Council of Britain, 1982.

Green, Jonathan. *American Photography: A Critical History 1945 to the Present.* New York: Harry N. Abrams, 1984.

Greenberg, Clement. *Art and Culture: Critical Essays.* Boston: Beacon Press, 1961.

———. *Post-Painterly Abstraction.* Los Angeles: Los Angeles County Museum of Art, 1964.

Greenough, Sarah, Joel Snyder, David Travis, and Colin Westerbeck. *On the Art of Fixing a Shadow: 150 Years of Photography.* Washington, D.C.: National Gallery of Art; Art Institute of Chicago; Boston: Little, Brown and Co., 1988.

Grinten, Franz Joseph van der, and Hans van der Grinten. *Joseph Beuys: Olfarben-Oilcolors 1936–1965.* Munich: Prestel Art Books, 1989.

Gruen, John. *The New Bohemia: The Combine Generation.* New York: Grosset & Dunlap, 1967.

Grundberg, Andy, and Kathleen McCarthy Gauss. *Photography and Art: Interactions Since 1946.* New York: Abbeville Press, 1987.

Guilbaut, Serge. *How New York Stole the Idea of Modern Art: Abstract Expressionism, Freedom, and the Cold War.* Chicago: University of Chicago Press, 1983.

Guse, Ernst-Gerhard. *Richard Serra.* New York: Rizzoli, 1988.

Haacke, Hans. *Framing and Being Framed: Seven Works, 1970–75.* New York: New York University Press, 1976.

Halbreich, Kathy. *Affinities: Myron Stout, Bill Jensen, Brice Marden and Terry Winters.* Cambridge, Mass.: MIT List

Visual Arts Center, 1983.

Hall, James Baker. *Minor White: Rites and Passages*. Millerton, N.Y.: Aperture, 1978.

Hanhardt, John G., Michael Nyman, Dieter Ronte, and David A. Ross. *Nam June Paik*. New York: Whitney Museum of American Art, 1982.

———, ed. *Video Culture: A Critical Investigation*. Layton, Utah: Peregrine Smith Books, 1986.

Hansen, Al. *A Primer of Happenings and Time/Space Art*. New York: Something Else Press, 1965.

Haskell, Barbara. *H. C. Westermann*. New York: Whitney Museum of American Art, 1978.

———. *Blam! The Explosion of Pop, Minimalism, and Performance, 1958–1964*. New York: Whitney Museum of American Art in association with W. W. Norton, 1984.

Hayter, S. W. *New Ways of Gravure*. New York: Pantheon, 1949.

———. *About Prints*. New York and London: Oxford University Press, 1962.

Heller, Ben, Dore Ashton, Herman Cherry, Michael Fried, Henry Geldzahler, Robert Rosenblum, Irving Sandler, Alan R. Solomon, Leo Steinberg, and Ulfert Wilke. *Toward a New Abstraction*. New York: Jewish Museum, 1963.

Heller, Jules. *Printmaking Today*. New York: Holt, Rinehart and Winston, 1972.

Heller, Nancy. *Women Artists: An Illustrated History*. New York: Abbeville Press, 1987.

Hendricks, Jon. *Fluxus Codex*. New York: Harry N. Abrams, 1988.

Henri, Adrian. *Total Art: Environments, Happenings, and Performance*. New York: Praeger Publishers, 1974.

Herbert, Robert L., ed. *Modern Artists on Art*. Englewood Cliffs, N.J.: Prentice-Hall, 1964.

Hertz, Richard, ed. *Theories of Contemporary Art*. Englewood Cliffs, N.J.: Prentice-Hall, 1985.

Hess, Thomas B. *Abstract Painting: Background and American Phase*. New York: Viking Press, 1951.

———. *Barnett Newman*. New York: Walker and Co., 1969.

Hickey, Dave, and Peter Plagens. *The Works of Edward Ruscha*. New York: Hudson Hills Press, 1982.

Higgins, Dick. *The Computer and the Arts*. New York: Abyss Publications, 1970.

Highwater, Jamake. *The Sweet Grass Lives On—Fifty Contemporary North American Indian Artists*. New York: Lippincott and Crowell, 1980.

Hitchcock, Henry Russell. *Latin American Architecture Since 1945*. New York: Museum of Modern Art, 1955.

Hobbs, Robert. *Robert Smithson: Sculpture*. Ithaca, N.Y.: Cornell University Press, 1981.

Hockney, David. *David Hockney Photographs*. New York: Petersburg Press, 1982.

———. *Cameraworks*. New York: Alfred A. Knopf, 1984.

Hodin, J. P. *Barbara Hepworth*. Neuchâtel: Editions du Griffon, 1961.

Hodin, J. P., et al. *Figurative Art Since 1945*. London: Thames and Hudson, 1971.

Hoffman, Katherine, ed. *Collage: Critical Views*. Ann Arbor, Mich.: UMI Research Press, 1989.

Hofmann, Hans, and Sara T. Weeks, eds. *Search for the Real and Other Essays*. Cambridge, Mass.: MIT Press, 1967.

Hofmann, Werner (text). *Neue Realisten und Pop Art*. Berlin: Akademie der Kunst, 1964.

Holt, Nancy, ed. *The Writings of Robert Smithson*. New York: New York University Press, 1979.

Honnef, Klaus, and Johannes Cladders. *Hanne Darboven*. Münster: Westfälischer Kunstverein Landesmuseum, 1971.

Hoy, Anne H. *Fabrications—Staged, Altered, and Appropriated Photographs*. New York: Abbeville Press, 1987.

Hughes, Robert. *The Shock of the New*. New York: Alfred A. Knopf, 1981.

Hulten, K. G. Pontus. *The Machine As Seen at the End of the Mechanical Age*. New York: Museum of Modern Art, 1968.

Hunter, J. *New Directions: Contemporary American Art*. Princeton, N.J.: University Art Museum, 1981.

Hunter, Sam. *"USA" in Art Since 1945*. New York: Harry N. Abrams, 1958.

———. *Modern American Painting and Sculpture*. New York: Dell, Laurel edition, 1959.

———. *Larry Rivers*. New York: Harry N. Abrams, 1969.

———, ed. *An American Renaissance: Painting and Sculpture Since 1940*. New York: Abbeville Press, 1986.

Hunter, Sam, and John Jacobus. *American Art of the Twentieth Century: Painting, Sculpture, Architecture*. New York: Harry N. Abrams, 1974.

Irving, Fiona. *David Salle*. Philadelphia: University of Pennsylvania Museum of Contemporary Art, 1986.

Ito, N. *Art in Japan Today II, 1970–1983*. Tokyo: 1984.

Janis, Harriet, and Rudi Blesh. *Collage: Personalities*. Philadelphia: Chilton, 1962.

Janis, Sidney. *Abstract and Surrealist Art in America*. New York: Reynal & Hitchcock, 1944.

Japanese Photography Today and Its Origin. Bologna: Gratis Edizioni D'Arte, 1979.

Jeffrey, Ian. *Photography: A Concise History*. New York and Toronto: Oxford University Press, 1981.

Jeffri, Joan. *The Emerging Arts*. New York: Praeger Publishers, 1980.

Jencks, Charles. *Architecture 2000*. New York: Praeger Publishers, 1971.

———. *Le Corbusier and the Tragic View of Architecture*. Cambridge: Harvard University Press, 1973.

———. *The Language of Post-Modern Architecture*. 5th ed. New York: Rizzoli, 1984.

———. *Post-Modernism: The New Classicism in Art and Architecture*. New York: Rizzoli, 1987.

Jencks, Charles, and William Chaitkin. *Architecture Today*. New York: Harry N. Abrams, 1982.

Jenkins, William, ed. *New Topographics: Photographs of a Man-altered Landscape*. Rochester: International Museum of Photography at George Eastman House, 1975.

Jeppson, Gabriella. *Richard Long*. Cambridge, Mass.: Fogg Art Museum, Harvard University, 1980.

Joachimides, Christos M., and Norman Rosenthal, eds. *Zeitgeist*. New York: George Braziller, 1983.

Joachimides, Christos M., Norman Rosenthal, and Wieland Schmied. *German Art in the Twentieth Century*. Munich: Prestel Art Books, 1988.

Johnson, Ellen H. *Claes Oldenburg*. Baltimore: Penguin Books, 1971.

———. *Modern Art and the Object: A Century of Changing Attitudes*. New York: Harper & Row, 1976.

———, ed. *American Artists on Art, from 1940 to 1980*. New York: Harper & Row, 1982.

Johnson, Philip. *Writings.* New York: Oxford University Press, 1979.

———. *Deconstructivist Architecture.* New York: Museum of Modern Art, 1988.

Johnson, Una E. *American Prints and Printmakers.* Garden City, N.Y.: Doubleday, 1980.

Judd, Donald. *Donald Judd: Complete Writings 1959–1975.* New York: New York University Press, 1975.

Kallard, Thomas. *Laser Art and Optical Transforms.* New York: Optosonic, 1979.

Kammansky, David, ed. *One Hundred Years of Philippine Painting.* Pasadena, California: Pacific Asia Museum, 1984.

Kaprow, Allan. *Assemblages, Environments and Happenings.* New York: Harry N. Abrams, 1966.

———. *Some Recent Happenings.* New York: Something Else Press, 1966.

Kardon, Janet. *The East Village Scene.* Philadelphia: University of Pennsylvania Institute of Contemporary Art, 1984.

Kariel, Henry S. *The Desperate Politics of Postmodernism.* Amherst: University of Massachusetts Press, 1989.

Katz, William. *Robert Indiana: The Prints and Posters, 1961–1971.* Stuttgart and New York: Edition Domberger, 1971.

Katzman, Louise. *Photography in California, 1945–1980.* New York: Hudson Hills Press in association with the San Francisco Museum of Modern Art, 1984.

Kelker, Nancy, and Teresa del Conde. *Mexico: The New Generations.* San Antonio: San Antonio Museum of Art, 1985.

Kepes, Gyorgy. *The Visual Arts Today.* Middletown, Conn.: Wesleyan University Press, 1960.

———, ed. *The Nature and Art of Motion.* New York: George Braziller, 1965.

———, ed. *Arts of the Environment.* New York: George Braziller, 1972.

Kirby, Michael. *Happenings: An Illustrated Anthology.* New York: E. P. Dutton, 1965.

———. *The Art of Time: Essays on the Avant-Garde.* New York: E. P. Dutton, 1969.

Kismaric, Susan. *California Photography: Remaking Make-Believe.* New York: Museum of Modern Art, 1989.

R. B. Kitaj: Complete Graphics, 1964–69. Berlin: Galerie Mikro, 1969.

Klüver, Billy. *Nine Evenings: Theatre and Engineering.* New York: Foundation for Contemporary Performance Arts in cooperation with Experiments in Art and Technology, 1966.

Klüver, Billy, Julie Martin, and Barbara Rose, eds. *Pavilion by Experiments in Art and Technology.* New York: E. P. Dutton, 1972.

Kostelanetz, Richard, ed. *The New American Arts.* New York: Collier Books, 1967.

———, ed. *John Cage.* New York: Praeger Publishers, 1970.

———, ed. *Esthetics Contemporary.* 2d ed. New York: Prometheus Books, 1988.

Kosuth, Joseph. *The Making of Meaning: Selected Writings and Documentation of Investigations on Art Since 1965.* Stuttgart: Staatsgalerie, 1981.

Kozloff, Max. *Jasper Johns.* New York: Harry N. Abrams, 1967.

———. *Renderings: Critical Essays on a Century of Modern Art.* New York: Simon & Schuster, 1968.

———. *Photography and Fascination.* Danbury, N.H.: Addison House, 1979.

Kramer, Hilton. *The Age of the Avant Garde: An Art Chronicle of 1956–1972.* New York: Farrar, Straus and Giroux, 1973.

———. *The Revenge of the Philistines: Art and Culture 1972–84.* New York: The Free Press, 1984.

Kranz, Stewart. *Science and Technology in the Arts: A Tour Through the Realm of Science/Art.* New York: Van Nostrand Reinhold, 1974.

Krauss, Rosalind E. *The Sculpture of David Smith.* Cambridge, Mass.: MIT Press, 1971.

———. *Grids: Format and Image in Twentieth Century Art.* New York: Pace Publications, 1980.

———. *The Originality of the Avant-Garde and Other Modernist Myths.* Cambridge, Mass.: MIT Press, 1985.

Krauss, Rosalind E., Laura Rosenstock, and Douglas Crimp. *Richard Serra: Sculpture.* New York: Museum of Modern Art, 1986.

Krauthammer, C. *Cutting Edges: Making Sense of the Eighties.* New York: Random House, 1985.

Krens, Thomas. *Helen Frankenthaler: Prints, 1961–1979.* New York: Harper & Row, 1979.

Krens, Thomas, Michael Govan, and Joseph Thompson. *Refigured Painting: The German Image 1960–88.* Munich: Prestel Art Books, 1988.

Krinsky, Carol H. *Gordon Bunshaft of Skidmore, Owings and Merrill.* Architectural History Foundation American Monograph. Cambridge, Mass.: MIT Press, 1988.

Kudielka, Robert. *Bridget Riley: Works, 1959–78.* Buffalo: Albright-Knox Art Gallery, 1978.

Kuh, Katherine. *The Artist's Voice: Talks with Seventeen Artists.* New York and Evanston: Harper & Row, 1962.

Kultermann, Udo. *The New Sculpture, Environments and Assemblages.* New York: Praeger Publishers, 1969.

———. *Art and Life.* New York: Praeger Publishers, 1971.

———. *New Realism.* Greenwich, Conn.: New York Graphic Society, 1972.

Küng, Hans. *Art and the Question of Meaning.* New York: Crossroads Publications, 1981.

Kuspit, Donald. *The Critic Is Artist: The Intentionality of Art.* Ann Arbor, Mich.: UMI Research Press, 1984.

———. *The New Subjectivism: Art in the 1980's.* Ann Arbor, Mich.: UMI Research Press, 1988.

Lane, John, and John Caldwell. *Carnegie International, 1985.* Pittsburgh: Museum of Art, Carnegie Institute, 1985.

Leavens, Ileana B. *No! Contemporary American Dada.* Seattle, Wash.: Henry Art Gallery, 1985.

Leavitt, Ruth. *Artist and Computer.* New York: Harmony Books, 1976.

Legg, Alicia, ed., with Mary Beth Smalley. *Painting and Sculpture in the Museum of Modern Art: Catalog of the Collection, 1987.* New York: Museum of Modern Art, 1989.

Levin, Kim. *Lucas Samaras.* New York: Harry N. Abrams, 1975.

———. *Beyond Modernism.* New York: Harper & Row, 1988.

Leymarie, J. *Art Since Mid-Century: The New Internationalism.* Greenwich, Conn.: New York Graphic Society, 1971.

Liberman, Alexander. *The Artist in His Studio*. New York: Random House, 1988.

Lindey, Christine. *Superrealist Painting and Sculpture*. New York: William Morrow, 1980.

Lipman, Jean. *Calder's Universe*. New York: Viking Press, 1976.

Lipman, Jean, and Richard Marshall. *Art about Art*. New York: E. P. Dutton and Whitney Museum of American Art, 1978.

Lippard, Lucy R. *Pop Art*. New York: Praeger Publishers, 1966.

———. *Eccentric Abstraction*. New York: Fischbach Gallery, 1966.

———. *Changing: Essays in Art Criticism*. New York: E. P. Dutton, 1971.

———. *Grids*. Philadelphia: University of Pennsylvania, Institute of Contemporary Art, 1972.

———. *Tony Smith*. London: Thames and Hudson, 1972.

———. *Six Years: The De-Materialization of the Art Object*. New York: Praeger Publishers, 1973.

———. *Eva Hesse*. New York: New York University Press, 1976.

———. *Overlay: Contemporary Art and the Art of Prehistory*. New York: Pantheon Books, 1983.

———. *Get the Message? Activist Essays on Art and Politics*. New York: E. P. Dutton, 1984.

Lippard, Lucy R., Bernice Rose, and Robert Rosenblum. *Sol LeWitt*. New York: Museum of Modern Art, 1978.

Lipsey, Roger. *An Art of Our Own: The Spiritual in Twentieth Century Art*. Boston and Shaftsbury: Shambhala, 1988.

Littlejohn, David. *Architect: The Life and Work of Charles W. Moore*. New York: Holt, Rinehart & Winston, 1984.

Livet, Anne, Dave Hickey, and Peter Plagens. *The Works of Edward Ruscha*. San Francisco: San Francisco Museum of Modern Art, 1982.

Livingston, Jane. *M. Alvarez Bravo*. Boston and Washington, D.C.: David R. Godine, publisher, and The Corcoran Gallery, 1978.

Livingston, Jane, and John Beardsley. *Hispanic Art in the United States*. New York: Abbeville Press, 1988.

Livingstone, Marco. *David Hockney*. New York: Holt, Rinehart and Winston, 1981.

Lobell, John. *Between Silence and Light—Spirit in the Architecture of Louis Kahn*. Boulder: Shambhala, 1979.

Loeb, Judy. *Feminist Collage: Educating Women in the Visual Arts*. New York: Teachers College Press, 1979.

London, Barbara, ed. *Bill Viola: Installations and Videotapes*. New York: Museum of Modern Art, 1987.

Long, Richard. *Richard Long*. New York: Solomon R. Guggenheim Museum, 1986.

Lovejoy, Margot. *Postmodern Currents: Art and Artists in the Age of Electronic Media*. Ann Arbor, Mich.: UMI Research Press, 1988.

Lucie-Smith, Edward. *Late Modern: The Visual Arts Since 1945*. New York: Thames and Hudson, 1969 and 1975.

———. *Art Now: From Abstract Expressionism to Superrealism*. New York: William Morrow, 1970.

———. *Super Realism*. Oxford: Phaidon, 1979.

———. *Art in the Seventies*. Ithaca, N.Y.: Cornell University Press, 1980.

———. *American Art Now*. New York: William Morrow, 1985.

———. *Movements in Art Since 1945*. New York: Thames and Hudson, 1985.

———. *Sculpture Since 1945*. New York: Universe Books, 1987.

Lyon, Danny. *Conversations with the Dead*. New York: Rinehart and Winston, 1971.

Lyons, Lisa, and Kim Levin. *Wegman's World*. Minneapolis: Walker Art Center, 1983.

Lyons, Lisa, and Robert Storr. *Chuck Close*. New York: Rizzoli, 1987.

Lyons, Nathan, ed. *Aaron Siskind Photographer*. Rochester, N.Y.: George Eastman House, 1965.

———, ed. *Contemporary Photographers: Toward a Social Landscape*. Rochester: Horizon Press in collaboration with George Eastman House, 1966.

———, ed. *Photographers on Photography: A Critical Anthology*. Englewood Cliffs, N.J., and Rochester, N.Y.: Prentice-Hall and George Eastman House, 1966.

———, ed. *The Persistence of Vision*. New York: Horizon Press in collaboration with George Eastman House, 1967.

Maenz, Paul, and Gerd De Vries. *Anselm Kiefer*. Cologne: Paul Maenz Gallery, 1986.

Mahsun, Carol Anne, ed. *Pop Art and the Critics*. Ann Arbor, Mich.: UMI Research Press, 1988.

———, ed. *Pop Art: The Critical Dialogue*. Ann Arbor. Mich.: UMI Research Press, 1988.

Mann, Margery. *Imogen Cunningham: Photographs*. Seattle: University of Washington Press, 1970.

Mann, Margery, and Anne Noggle. *Women of Photography: An Historical Survey*. San Francisco: San Francisco Museum of Modern Art, 1975.

Marano, Lizbeth. *Parasol and Simca: Two Presses/Two Processes*. Lewisburg, Pa., and Wilkes-Barre, Pa.: Bucknell University Press and Wilkes College Press, 1984.

Marcus, Greil. *Lipstick Traces: A Secret History of the Twentieth Century*. Cambridge, Mass.: Harvard University Press, 1988.

Marincola, Paula, and Douglas Crimp. *Image Scavengers: Photography*. Philadelphia: University of Pennsylvania Institute of Contemporary Art, 1982.

Masheck, Joseph. *Historical Present: Essays of the 1970's*. Ann Arbor, Mich.: UMI Research Press, 1984.

Mattison, Robert Saltonstall. *Robert Motherwell: The Formative Years*. Ann Arbor, Mich.: UMI Research Press, 1987.

McLuhan, Marshall. *Understanding Media: The Extensions of Man*. New York: McGraw-Hill, 1964.

McLuhan, Marshall, and Quentin Fiore. *The Medium Is the Message*. New York: Bantam Books, 1967.

McMullen, Roy. *Art, Affluence, and Alienation*. New York and Toronto: New American Library, 1968.

McShine, Kynaston. *An International Survey of Recent Painting and Sculpture*. New York: Museum of Modern Art, 1984.

———. *Berlinart 1961–1987*. Munich: Prestel Art Books, 1987.

———, ed. *Joseph Cornell*. New York: Museum of Modern Art, 1980.

———, intro. *Andy Warhol: A Retrospective*. New York: Museum of Modern Art and New York Graphic Society, 1989.

Mead, Christopher, ed. *The Architecture of Robert Venturi*. Albuquerque: University of New Mexico Press, 1989.

Meisel, Louis K. *Photorealism.* New York: Harry N. Abrams, 1981.

——. *Richard Estes: The Complete Paintings, 1966–1985.* New York: Harry N. Abrams, 1986.

Merkert, Jörn. *David Smith.* Munich: Prestel Art Books, 1989.

Messer, Thomas. *The Emergent Decade.* New York: Solomon R. Guggenheim Museum, 1966.

Meyer, Ursula. *Conceptual Art.* New York: E. P. Dutton, 1972.

Meyer, Ursula, and Al Brunelle. *Art-Anti-Art.* New York: E. P. Dutton, 1970.

Michals, Duane. *Sequences.* Garden City, N.Y.: Doubleday, 1970.

——. *Real Dreams.* Danbury, N.H.: Addison House, 1976.

——. *Photographs/Sequences/Texts: 1958–1984.* Oxford: Museum of Modern Art, 1984.

Miller, Dorothy C., ed. *Americans 1942 to 1963: Six Group Exhibitions.* New York: Museum of Modern Art, 1972.

Miller, Jo. *Josef Albers: Prints, 1915–1976.* Brooklyn: Brooklyn Museum, 1973.

Moffett, Kenworth. *Kenneth Noland.* New York: Harry N. Abrams, 1977.

——. *Jules Olitski.* New York: Harry N. Abrams, 1981.

——. *Larry Poons Paintings, 1971–1981.* Boston, Mass.: Museum of Fine Arts, 1981.

Monaco, James. *Media Culture.* New York: Delta, 1978.

Moore, Ethel, ed. *Contemporary Art 1942–72: Collection of the Albright-Knox Art Gallery.* New York: Praeger Publishers, 1973.

Moore, Henry, and John Hedgecoe. *Henry Moore: My Ideas, Inspiration and Life as an Artist.* San Francisco: Chronicle Books, 1986.

Morgan, Ann L., ed. *Contemporary Architects.* 2d ed. Chicago: St. James Press, 1987.

Moser, Joann, Michael Danoff, and Jan K. Muhlert. *Mauricio Lasansky.* Iowa City: University of Iowa Press, 1976.

Motherwell, Robert, and Ad Reinhardt, eds. *Modern Artists in America.* New York: Wittenborn, Schultz, 1952.

Müller, Gregoire. *The New Avant-Garde: Issues of the Seventies.* New York: Praeger Publishers, 1972.

Naef, Weston J. *Intimate Landscapes: Photographs by Eliot Porter.* New York: Metropolitan Museum of Art and E. P. Dutton, 1979.

Nakamura, Tanio. *Contemporary Japanese Style Painting.* New York: Tudor Publishing, 1969.

Neff, John Hallmark. *Contemporary Art from the Netherlands.* Amsterdam: Visual Arts Office for Abroad at the Netherlands Ministry for Cultural Affairs and Social Welfare, 1982.

Negroponte, Nicholas. *The Architecture Machine: Toward a More Human Environment.* Cambridge, Mass.: MIT Press, 1970.

——. *Soft Architecture Machines.* Cambridge, Mass.: MIT Press, 1974.

Nemser, Cindy. *Art Talk: Conversations with Twelve Women Artists.* New York: Charles Scribner's Sons, 1975.

Nervi, Pier L. *Aesthetics and Technology in Building (Charles Eliot Norton Lectures, 1961–62).* Cambridge, Mass.: Harvard University Press, 1965.

Nevelson, Louise, and Diana MacKown. *Dawns and Dusks.* New York: Charles Scribner's Sons, 1976.

New Figuration in America. Milwaukee Art Museum, 1983.

Newhall, Beaumont. *The History of Photography from 1839 to the Present Day.* 5th rev. ed. New York: Museum of Modern Art, 1982.

——, ed. *Photography: Essays and Images.* New York: Museum of Modern Art, 1980.

Newhall, Nancy. *Ansel Adams: The Eloquent Light.* San Francisco: Sierra Club, 1963.

Newton, Charles. *Photography in Printmaking.* London: Victoria and Albert Museum, 1979.

Nichols, Karen, and Patrick Burke. *Michael Graves, Buildings and Projects, 1982–1986.* N.Y.: Princeton Architectural Press, 1989.

O'Connor, Francis V., and Eugene V. Thaw. *Jackson Pollock: A Catalogue Raisonné of Prints, Drawings and Other Works.* New Haven: Yale University Press, 1978.

O'Doherty, Brian. *Object and Idea: An Art Critic's Journal, 1961–67.* New York: Simon & Schuster, 1967.

——. *American Masters: The Voice and the Myth in Modern Art.* New York: E. P. Dutton, 1982.

——. *Inside the White Cube: The Ideology of the Gallery Space.* Venice, California: Lapis Press, 1986.

O'Hara, Frank. *Art Chronicles: 1954–1966.* New York: George Braziller, 1975.

O'Neill, John, ed. *Clyfford Still.* New York: Metropolitan Museum of Art, 1979.

Olander, William, and Abigail Solomon Godeau. *The Art of Memory/The Loss of History.* New York: New Museum, 1985.

Oldenburg, Claes. *Store Days.* New York: Something Else Press, 1967.

——. *Proposals for Monuments and Buildings, 1965–1969.* Chicago: Big Table, 1969.

Owens, Craig, et al. *Philip Johnson: Processes—The Glass House, 1949, and the AT and T Corporate Headquarters.* Cambridge, Mass.: MIT Press, 1979.

Paik, Nam June. *Nam June Paik: Video 'n' Videology, 1959–1973.* Syracuse, N.Y.: Everson Museum of Art, 1974.

Parker, Fred. *Attitudes: Photography in the 1970's.* Santa Barbara, Calif.: Santa Barbara Museum of Art, 1979.

——. *Sequence Photography.* Santa Barbara, Calif.: Santa Barbara Museum of Art, 1980.

Pellegrini, Aldo. *New Tendencies in Art.* New York: Crown Publishers, 1966.

Perreault, John, and Graham W. J. Beal. *Wiley Territory.* Minneapolis: Walker Art Center, 1979.

Peterson, Dale. *Genesis-Creation and Recreation with Computers.* Reston, Va.: Reston Publishing, 1983.

Petruck, Peninah. *The Camera Viewed: Photography after World War II.* New York: E. P. Dutton, 1979.

Phillips, Lisa. *Frederick Kiesler.* New York: Whitney Museum of American Art and W. W. Norton, 1988.

Phillpot, Clive, and Jon Hendricks. *Fluxus: Selections from the Gilbert and Lila Silverman Collection.* New York: Museum of Modern Art, 1989.

Pincus-Witten, Robert. *Postminimalism.* London Press, 1977.

——. *Eye to Eye: Twenty Years of Art Criticism.* Ann Arbor, Mich.: UMI Research Press, 1984.

——. *Postminimalism into Maximalism: American Art,*

1966–1986. Ann Arbor, Mich.: UMI Research Press, 1986.

Plagens, Peter. *Sunshine Muse: Contemporary Art on the West Coast.* New York: Praeger Publishers, 1974.

———. *Moonlight Blues: An Artist's Art Criticism.* Ann Arbor, Mich.: UMI Research Press, 1986.

Plottel, Jeanine Parisier, ed. *Collage.* New York: New York Literary Forum, 1983.

Plous, Phyllis. *Scapes.* Santa Barbara: University Art Museum, 1985.

Plous, Phyllis, and Mary Looker. *Neo-York: Report on a Phenomenon.* Santa Barbara: University Art Museum, 1984.

Poggioli, Renato. *The Theory of the Avant-Garde.* Translated by Gerald Fitzgerald. Cambridge and London: Belknap Press of Harvard University Press, 1968.

Ponente, Nello. *Modern Painting: Contemporary Trends.* Lausanne: Albert Skira, 1960.

Popov, Genrikh P., et al. *Ten Plus Ten: Contemporary Soviet and American Painters.* Fort Worth: Fort Worth Art Museum, 1989.

Popper, Frank. *Origins and Development of Kinetic Art.* Greenwich, Conn.: New York Graphic Society, 1968.

Portoghesi, Paolo. *After Modern Architecture.* New York: Rizzoli, 1980.

———. *Postmodern.* New York: Rizzoli, 1983.

Post-Avant-Garde Painting in the Eighties. Art and Design Profiles series. New York: St. Martin's Press, 1988.

Price, Jonathan. *Video Visions—A Medium Discovers Itself.* New York: New American Library, 1977.

Primary Structures: Younger American and British Sculptors. New York: The Jewish Museum, 1966.

Doug Prince: Photo Sculpture. New York: Witkin Gallery, 1979.

Printz, Neil, and Remo Guidieri. *Andy Warhol: Death and Disasters.* Houston: The Menil Collection and Houston Fine Art Press, 1988.

Ratcliff, Carter. *Andy Warhol.* New York: Abbeville Press, 1983.

———. *Red Grooms.* New York: Abbeville Press, 1984.

———. *Gilbert and George: The Complete Pictures, 1971–1985.* New York: Rizzoli, 1986.

———. *Komar and Melamid.* New York: Abbeville Press, 1988.

Rathbone, Belinda. *One of a Kind: Recent Polaroid Color Photography.* Boston: David R. Godine, 1979.

Raven, Arlene. *Crossing Over: Feminism and Art of Social Concern.* Ann Arbor, Mich.: UMI Research Press, 1988.

———, ed. *Art in the Public Interest.* Ann Arbor, Mich.: UMI Research Press, 1989.

Raven, Arlene, Cassandra L. Langer, and Joanna Frueh, eds. *Feminist Art Criticism: An Anthology.* Ann Arbor, Mich.: UMI Research Press, 1988.

Redstone, Louis. *Public Art: New Directions.* New York: McGraw-Hill, 1981.

Reichardt, Jasia. *The Computer and Art.* New York: Von Nostrand Reinhold, 1971.

Rice, Shelley. *Deconstruction, Reconstruction: The Transformation of Photographic Information into Metaphor.* New York: New Museum, 1980.

Richard, Paul. *Red Grooms: A Catalogue Raisonné of His Graphic Work, 1957–1981.* Nashville: Fine Arts Center, 1981.

Richardson, Brenda. *Gilbert and George.* Baltimore: Baltimore Museum of Art, 1984.

Robins, Corinne. *The Pluralist Era: American Art, 1968–81.* New York: Harper & Row, 1984.

Rohn, Matthew L. *Visual Dynamics in Jackson Pollock's Abstractions.* Ann Arbor, Mich.: UMI Research Press, 1987.

Rose, Barbara. *A New Aesthetic.* Washington, D.C.: Corcoran Gallery of Art, 1967.

———. *Helen Frankenthaler.* New York: Harry N. Abrams, 1971.

———. *Claes Oldenburg.* New York: Little, Brown and Co., 1977.

———. *Lee Krasner.* New York: Museum of Modern Art, 1983.

———. *American Painting: The Eighties, A Critical Interpretation.* New York: VISTA Press, 1987.

———. *Autocritique Essays on Art and Anti-Art 1969–1987.* New York: Weidenfeld and Nicolson, 1988.

———, ed. *Readings in American Art Since 1900: A Documentary Survey.* New York: Frederick A. Praeger, 1968.

Rose, Bernice. *Drawing Now.* New York: Museum of Modern Art, 1975.

———. *The Drawings of Roy Lichtenstein.* New York: Museum of Modern Art, 1987.

Rosen, Randy, and Catherine Brawer. *Making Their Mark: Women Artists Move into the Mainstream.* New York: Abbeville Press, 1988.

Rosenberg, Harold. *The Tradition of the New.* New York: McGraw-Hill, 1965.

———. *The Anxious Object: Art Today and Its Audience.* New York: Horizon Press, 1966.

———. *Art Works and Packages.* New York: Horizon Press, 1969.

———. *The De-Definition of Art: Action Art to Pop to Earthworks.* New York: Horizon Press, 1972.

———. *Discovering the Present: Three Decades in Art, Culture, and Politics.* Chicago: University of Chicago Press, 1973.

———. *Art on the Edge.* New York: Macmillan Co., 1975.

———. *Art and Other Serious Matters.* Chicago: University of Chicago Press, 1985.

Rosenblum, Naomi. *A World History of Photography.* New York: Abbeville Press, 1984.

Rosenblum, Robert. *Frank Stella.* Harmondsworth, England: Penguin Books, 1971.

———. *Modern Painting and the Northern Romantic Tradition, Friedrich to Rothko.* New York: Harper & Row, 1975.

Rosenstock, Laura. *Christopher Wilmarth.* New York: Museum of Modern Art, 1989.

Rosenthal, Mark. *Jasper Johns: Work Since 1974.* Philadelphia: Philadelphia Museum of Art, 1988.

———. *Anselm Kiefer.* Philadelphia: Philadelphia Museum of Art, 1987.

———. *Anselm Kiefer.* Munich: Prestel Art Books, 1989.

Rosenthal, Mark, and Richard Marshall. *Jonathan Borofsky.* Philadelphia: Philadelphia Museum of Art, 1984.

Rowe, Colin, and Fred Koetter. *Collage City.* Cambridge, Mass.: MIT Press, 1978.

Rowell, Margit. *New Images from Spain.* New York: Guggenheim Foundation, 1980.

Rubin, David. *The Computer in Contemporary Art*. Reading, Pa.: Albright College, 1987.

Rubin, William S. *Frank Stella*. New York: Museum of Modern Art, 1970.

———. *Anthony Caro*. New York: Museum of Modern Art, 1975.

———. *Frank Stella 1970–1987*. New York: Museum of Modern Art, 1988.

———, ed. *"Primitivism" in Twentieth Century Art: Affinity of the Tribal and the Modern*. New York: Museum of Modern Art, 1984.

Rubinstein, Charlotte Streifer. *American Women Artists from Early Indian Times to the Present*. New York: Avon Books, 1982.

Ruscha, Edward. Series of twelve books, including: *Twenty-Six Gasoline Stations*, 1967; *Nine Swimming Pools*, 1968; *Every Building on the Sunset Strip*, 1968; *A Few Palm Trees*, 1971; *Colored People*, 1971.

Russell, John, and Suzi Gablik. *Pop Art Redefined*. New York: Praeger Publishers, 1969.

Saff, Donald, and Sacilotto. *Printmaking: History and Process*. New York: Holt, Rinehart and Winston, 1978.

Samaras, Lucas. *Lucas Samaras: Photo-Transformations*. Long Beach: The Art Galleries, California State University, 1975.

Sandback, Amy Baker, ed. *Looking Critically: Twenty-one Years of Artforum Magazine*. Ann Arbor, Mich.: UMI Research Press, 1984.

Sandler, Irving. *The Triumph of American Painting: A History of Abstract Expressionism*. New York: Harper & Row, 1976.

———. *The New York School: The Painters and Sculptors of the Fifties*. New York: Harper & Row, 1978.

———. *Alex Katz*. New York: Harry N. Abrams, 1979.

———. *Al Held*. New York: Hudson Hills Press, 1984.

———. *American Art of the 1960s*. New York: Harper & Row, 1988.

Sanmartin, Antonio, ed. *Venturi, Rauch and Scott Brown*. New York: St. Martin's Press, 1987.

Sayres, Sohnya. *Sixties without Apology*. Minnesota: University of Minnesota Press, 1984.

Schiff, Nancy R. *A Celebration of the Eighties*. New York: Harry N. Abrams, 1983.

Schjeldahl, Peter, intro. *Cindy Sherman*. New York: Pantheon Books, 1984.

Schon, Donald A. *Technology and Change: The New Heraclitus*. New York: Delacorte Press, 1967.

Schultze, Franz. *Fantastic Images: Chicago Art Since 1945*. Chicago: Follett Publishing, 1972.

———. *Mies Van der Rohe: A Critical Biography*. Chicago: University of Chicago Press, 1985.

Schwartz, Barry. *The New Humanism: Art in a Time of Change*. New York: Praeger Publishers, 1974.

Schwartz, Sanford. *The Art Presence*. New York: Horizon Press, 1982.

Scully, Vincent, and David Dunster. *Robert Stern*. New York: St. Martin's Press, 1987.

Seitz, William C. *The Art of Assemblage*. New York: Museum of Modern Art, 1961.

———. *The Responsive Eye*. New York: Museum of Modern Art, 1965.

———. *São Paulo Biennale 9: USA Environment USA, 1957–1967*. Philadelphia: University of Pennsylvania, Institute of Contemporary Art, 1967.

———. *George Segal*. New York: Harry N. Abrams, 1972.

———, intro. *Art Criticism in the Sixties*. New York: October House, 1967.

Seldes, Lee. *The Legacy of Mark Rothko*. New York: Holt, Rinehart and Winston, 1978.

Selz, Peter. *Art in Our Times, A Pictorial History, 1890–1980*. New York: Harry N. Abrams, 1981.

———. *Art in a Turbulent Era*. Ann Arbor, Mich.: UMI Research Press, 1985.

Serota, Nicholas, ed. *Fernand Léger*. Munich: Prestel Art Books, 1988.

Serota, Nicholas, Stephen Bann, and Roberta Smith. *Brice Marden: Paintings, Drawings and Prints, 1975–80*. London: Whitechapel Art Gallery, 1981.

Shapiro, David. *Jim Dine—Painting What One Is*. New York: Harry N. Abrams, 1981.

Shearer, Linda. *Brice Marden*. New York: Solomon R. Guggenheim Museum, 1975.

———. *Vito Acconci: Public Places*. New York: Museum of Modern Art, 1988.

Siegel, Jeanne. *Artwords: Discourse on the 60's and 70's*. Ann Arbor, Mich.: UMI Research Press, 1985.

———. *Artwords 2: Discourse on the Early 80's*. Ann Arbor, Mich.: UMI Research Press, 1988.

Simon, Joan, and Jean-Christophe Ammann. *Bruce Nauman*. London: Whitechapel Art Gallery, 1986.

Simon, Joan, and Sarah McFadden, eds. *Carnegie International, 1988*. Munich: Prestel Art Books, 1989.

Simpson, Charles R. *SoHo: The Artist in the City*. Chicago: University of Chicago Press, 1981.

Singerman, Howard. *Individuals: A Selected History of Contemporary Art 1945–1986*. New York: Abbeville Press, 1986.

Siskind, Aaron. *Aaron Siskind: Photographs, 1966–1975*. New York: Farrar, Straus and Giroux, 1976.

———. *Places: Aaron Siskind Photographs*. New York: Light Gallery and Farrar, Straus and Giroux, 1976.

Siu, Wai-fong Anita. *The Modern Spirit in Chinese Painting: Selections from the Jeanette Shambaugh Elliott Collection*. Phoenix: Phoenix Art Museum, 1985.

Slivka, Rose. *Peter Voulkos*. Boston: New York Graphic Society and Little, Brown and Co., 1978.

Smagula, Howard. *Currents: Contemporary Directions in Visual Arts*. Englewood Cliffs, N.J.: Prentice-Hall, 1983.

Smith, David. *David Smith*. New York: Holt, Rinehart and Winston, 1968.

Smith, G. E. Kidder. *Italy Builds*. New York: Reinhold, 1955.

Smith, Joshua P. *The Photography of Invention: American Pictures of the 1980's*. Cambridge, Mass.: MIT Press, 1989.

Smith, Patrick S. *Andy Warhol's Art and Films*. Ann Arbor, Mich.: UMI Research Press, 1986.

———. *Warhol: Conversations about the Artist*. Ann Arbor, Mich.: UMI Research Press, 1988.

Smith, Roberta. *Body Language: Figurative Aspects of Recent Art*. Cambridge, Mass.: (MIT) Committee on the Visual Arts, 1981.

Sohm, Hans, ed. *Happenings and Fluxus*. Cologne: Kölnischen Kunstverein, 1970.

Sommer, Frederick. *Frederick Sommer at Seventy-Five: A*

Retrospective. Long Beach: California State University, 1980.

Sonfist, Alan, ed. *Art of the Land: A Critical Anthology.* New York: E. P. Dutton, 1983.

Sontag, Susan. *Against Interpretations.* New York: Delta/Dell, 1967.

———. *On Photography.* New York: Farrar, Straus and Giroux, 1973.

Spade, Rupert. *Eero Saarinen.* New York: Simon & Schuster, 1971.

Spaeth, David. *Mies van der Rohe.* New York: Rizzoli International, 1985.

Stegner, Wallace. *Ansel Adams. Images 1923–1974.* Boston: New York Graphic Society, 1971.

Steichen, Edward, ed. *The Family of Man.* New York: Simon & Schuster, 1986. (Thirtieth anniversary edition of 1955 catalog.)

Steinberg, Leo. *Jasper Johns.* New York: Wittenborn, 1963.

———. *Other Criteria: Confrontations with Twentieth Century Art.* New York: Oxford University Press, 1972.

Stella, Frank. *Working Space.* Cambridge, Mass.: Harvard University Press, 1986.

Stern, Robert. *Robert A. M. Stern 1965–1980: Buildings and Projects.* New York: Rizzoli International, 1982.

Stich, Sidra. *Made in U.S.A.: An Americanization of Modern Art in the 50's and 60's.* Berkeley, Ca.: University of California Press, n.d.

Stirling, James. *James Stirling.* New York: St. Martin's Press, 1983.

Strand, Mark. *The Art of the Real: Nine American Figurative Painters.* New York: Crown Publishers, 1983.

Systemic Painting. New York: Solomon R. Guggenheim Museum, 1966.

Szarkowski, John. *The Photographer's Eye.* New York: Museum of Modern Art and Doubleday, 1966.

———. *Harry Callahan.* New York: Museum of Modern Art, 1967.

———. *New Japanese Photography.* New York: Museum of Modern Art, 1974.

———. *William Eggleston's Guide.* New York: Museum of Modern Art, 1976.

———. *Mirrors and Windows: American Photography since 1960.* New York: Museum of Modern Art, 1978.

———. *Winogrand: Fragments from the Real World.* New York: Museum of Modern Art, 1988.

———, ed. *Callahan.* New York and Millerton, N.Y.: Museum of Modern Art and Aperture, 1976.

Szeemann, Harald. *Cy Twombly.* Munich: Prestel Art Books, 1989.

Tafuri, Manfredo. *The Sphere and the Labyrinth: Avant Gardes and Architecture from Piranesi to the 1970's.* Cambridge, Mass.: MIT Press, 1987.

———. *History of Italian Architecture, 1944–1985.* Cambridge, Mass.: MIT Press, 1989.

Takashina, S., Y. Tono, and Y. Nakahara, eds. *Art in Japan Today.* Tokyo: 1974.

Tausk, Peter. *Photography in the Twentieth Century.* London: Focal Press, 1980.

Taylor, Paul. *Post-Pop Art.* Cambridge, Mass.: MIT Press, 1988.

Terenzio, Stephanie. *The Painter and the Printer: Robert Motherwell's Graphics, 1943–1980.* New York: Ameri-

can Federation of Arts, 1980.

Tisdall, Caroline. *Joseph Beuys.* New York: Solomon R. Guggenheim Museum, 1979.

Tomkins, Calvin. *The Bride and the Bachelors: The Heretical Courtship in Modern Art.* New York: Viking Press, 1965.

———. *Off the Wall: Robert Rauschenberg and the Art World of Our Time.* Garden City, N.Y.: Doubleday, 1980.

———. *Post to Neo: The Art World of the Eighties.* New York: Holt, Rinehart & Winston, 1988.

Torri, Maria Grazia. *Grand Tour: Italian Geo-Romantic.* Milan: Fabri Editori, 1988.

Tousley, Nancy. *Prints: Bochner, Le Witt, Mangold, Marden, Martin, Renouf, Rockburne, Ryman.* Toronto: Art Gallery of Ontario, 1975.

Toward a New Abstraction. New York: Jewish Museum, 1963.

Trachtenberg, Alan, ed. *Classic Essays on Photography.* New Haven, Conn.: Leete's Island Books, 1980.

Trachtenberg, Marvin, and Isabelle Hyman. *Architecture: From Pre-History to Post Modernism.* New York and Englewood Cliffs, N.J.: Harry N. Abrams and Prentice-Hall, 1986.

Trevor, Fairbrother, David Joselit, and Elisabeth Sussman. *The BiNational: American Art of the Late 80's.* Boston and Cologne: Institute of Contemporary Art and Museum of Fine Arts, and Dumont Buchverlag.

Tuchman, Maurice. *Edward Kienholz.* Los Angeles: Los Angeles County Museum of Art, 1966.

———. *New York School: The First Generation.* Greenwich, Conn.: New York Graphic Society, 1970.

———. *Art and Technology: A Report on the Art and Technology Program at the Los Angeles County Museum of Art 1967–71.* New York: Viking Press, 1976.

———, ed. *New York School: The First Generation Painting of the 1940's and 1950's.* Los Angeles: Los Angeles County Museum of Art, 1965.

———, ed. *American Sculpture of the Sixties.* Los Angeles: Los Angeles County Museum of Art, 1967.

Tuchman, Maurice, et al. *The Spiritual in Art: Abstract Painting 1890–1985.* New York: Abbeville Press, 1986.

Tuchman, Maurice, and Stephanie Barron. *David Hockney: A Retrospective.* New York: Harry N. Abrams, 1988.

Tucker, Ann, ed. *The Woman's Eye.* New York: Alfred A. Knopf, 1973.

Tucker, Marcia. *Joan Mitchell.* New York: Whitney Museum of American Art, 1974.

———. *John Baldessari.* New York: New Museum, 1982.

Tucker, Marcia, and Robert Pincus-Witten. *John Baldessari.* New York: New Museum, 1981.

Turner, Peter, ed. *American Images: Photography 1945–1980.* New York and London: Viking Press and Barbican Gallery, 1985.

Tyng, Alexandra. *Beginnings: Louis I. Kahn's Philosophy of Architecture.* Somerset, N.J.: Wiley Interscience, 1984.

Uelsmann, Jerry N. *Jerry N. Uelsmann: Silver Meditations.* Dobbs Ferry, N.Y.: Morgan & Morgan, 1975.

———. *Jerry N. Uelsmann: Twenty-five Years, A Retrospective.* Boston: New York Graphic Society, 1982.

Upright, Diane. *Morris Louis: The Complete Paintings.* New York: Harry N. Abrams, 1987.

Utopia/Post Utopia: Configurations of Nature and Culture in Recent Sculpture and Photography. Boston and Cambridge: Institute of Contemporary Art and MIT Press, 1988.

Van der Marck, Jan. *George Segal.* New York: Harry N. Abrams, 1975.

Varnedoe, Kirk. *Duane Hanson.* New York: Harry N. Abrams, 1985.

———, ed. *Modern Portraits: The Self and Others.* New York: Wildenstein Gallery, 1975.

Venturi, Robert. *Complexity and Contradiction in Architecture.* New York: Museum of Modern Art, 1966.

Venturi, Robert, Denise Scott Brown, and Steven Izenour. *Learning from Las Vegas.* Cambridge, Mass.: MIT Press, 1972, 1977.

Venturi, Robert, and Denise Scott Brown. *The View from the Campidoglio: Selected Essays, 1953–84.* New York: Harper & Row, 1984.

Von Moos, Stanislaus. *Venturi, Rauch and Scott Brown.* New York: Rizzoli, 1987.

Vostell, Wolf. *Happening und Leben.* Berlin: Werk, 1970.

Waldman, Diane. *Ellsworth Kelly: Drawings, Collages and Prints.* Greenwich, Conn.: New York Graphic Society, 1971.

———. *John Chamberlain.* New York: Solomon R. Guggenheim Museum, 1971.

———. *Roy Lichtenstein: Drawings and Prints.* New York: Chelsea House, 1972.

———. *Robert Ryman.* New York: Solomon R. Guggenheim Museum, 1972.

———. *Joseph Cornell.* New York: George Braziller, 1977.

———. *British Art Now: An American Perspective. 1980 Exxon International Exhibition.* New York: Solomon R. Guggenheim Museum, 1980.

———. *Italian Art Now: An American Perspective. 1982 Exxon International Exhibition.* New York: Solomon R. Guggenheim Museum, 1982.

———. *New Perspectives in American Art. Exxon National Exhibition.* New York: Solomon R. Guggenheim Museum, 1983.

———. *Australian Visions: 1984 Exxon International Exhibition.* New York: Solomon R. Guggenheim Museum, 1984.

———. *Enzo Cucchi.* New York: Rizzoli International, 1986.

———. *Willem de Kooning.* New York: Harry N. Abrams, 1988.

Walker, John A. *Art in the Age of the Mass Media.* London: Pluto Press, 1983.

Wallis, Brian, ed. *Art after Modernism: Rethinking Representation.* New York: New Museum, 1984.

———, ed. *Hans Haacke.* Cambridge, Mass.: MIT Press, 1987.

Wallis, Brian, et al., eds. *Modern Dreams.* Cambridge, Mass.: MIT Press, 1988.

Ward, John L. *American Realist Painting, 1945–1980.* Ann Arbor, Mich.: UMI Research Press, 1988.

Warhol, Andy. *The Philosophy of Andy Warhol (From A to B and Back Again).* New York: Harcourt Brace Jovanovich, 1975.

Warhol, Andy, and Pat Hackett. *POPism: The Warhol Sixties.* New York: Harcourt Brace Jovanovich, 1980.

Watrous, James. *A Century of American Printmaking, 1880–1980.* Madison: University of Wisconsin Press, 1984.

Weaver, Mike, ed. *The Art of Photography 1839–1989.* New Haven: Yale University Press, 1989.

Weiner, Lawrence. *Statements.* New York: Louis Kellner Foundation, Seth Siegelaub, 1968.

Weiss, John, ed. *Venus, Jupiter and Mars: Frederick Sommer.* Wilmington: Delaware Art Museum, 1980.

Wescher, Herta. *Collage.* Translated by Robert E. Wolf. New York: Harry N. Abrams, 1968.

Tom Wesselmann: Graphics, 1964–1977. Boston: Institute of Contemporary Art, 1978.

Wheeler, Karen, and Peter Arnell, eds. *Michael Graves: Buildings and Projects, 1966–1981.* New York: Rizzoli International, 1983.

White, Minor. *Minor White: Rites and Passages. His Photographs Accompanied by Excerpts from His Diaries and Letters.* Millerton, N.Y.: Aperture, 1978.

Whitford, Frank. *Eduardo Paolozzi.* London: Tate Gallery, 1971.

Wines, James. *De-Architecture.* New York: Rizzoli, 1987.

Wines, James, foreword. *SITE.* New York: Rizzoli, 1989.

Winogrand, Garry. *Women Are Beautiful.* New York: Farrar, Straus and Giroux, 1975.

Wise, Kelly, ed. *The Photographer's Choice: A Book of Portfolios and Critical Opinion.* Danbury, N.H.: Addison House, 1975.

———, ed. *Lotte Jacobi.* Danbury, N.H.: Addison House, 1978.

Witkin, Joel-Peter. *Joel-Peter Witkin: Photographs.* Pasadena, Calif.: Twelvetrees Press, 1985.

Wolfe, Thomas. *The Painted Word.* New York: Farrar, Straus and Giroux, 1975.

Wolfram, Eddie. *History of Collage.* New York: Macmillan Co., 1978.

Women of Photography: An Historical Survey. San Francisco, Calif.: San Francisco Museum of Art, 1975.

Woods, Gerald, Philip Thompson, and John Williams, eds. *Art without Boundaries.* New York: Praeger Publishers, 1974.

Woodward, Christopher. *Skidmore, Owings and Merrill.* New York: Simon & Schuster, 1970.

Wrede, Stuart. *Mario Botta.* New York: Museum of Modern Art, 1986.

———, intro. *Emilio Ambasz/Steven Holl: Architecture.* New York: Museum of Modern Art, 1989.

Wright, F. L. *The Future of Architecture.* New York: Horizon Press, 1953.

Wye, Deborah. *Louise Bourgeois.* New York: Museum of Modern Art, 1982.

———. *Committed to Print: Social and Political Themes in Recent American Printed Art.* New York: Museum of Modern Art, 1988.

INDEX

Abakanowicz, Magdalena, 179, *180*
Abate, Alberto, 310
ABC art, 132
Abe, Shuye, 197–98, 275
Abraham (Newman), 22
Abramovitz, Max, 183
Abstract Expressionism, 8–37, 41, 47, 48, 50, 58, 65, 70, 78, 81–82, 84, 85, 98, 107–9, 115, 118, 120, 124, 130, 136, 141, 163, 164, 208, 209, 216, 219, 232, 251, 287, 288, 302, 319
Abstraction-Création group, 41
Academicism, 28
Accardi, Carla, 48
Accident (Rauschenberg), 57, *58*
Acconci, Vito, 137, 227, 269–71, 270, 323
Achromatics (Manzoni), 101
Acoustical Ceiling (Calder), 75
Action painting, 11, 19, 28, 57, 311
Adams, Ansel, 59–60, *61*
Adams, Dennis, 346
Adams, Mac, 236
Adams, Robert, 148, 231, 232
Adelman, Bob, 150
Aerospace Museum (Los Angeles), 360
Africano, Nicholas, 215, 217, *218*
Agam, Yaacov, 130, 131
Agbatana I (Stella), *131*
AG Gallery (New York), 198
Agricola series (Smith), 82
Ahearn, John, 341, 342
A.I.R. Gallery (New York), 214–15
Ajitto, Right (Mapplethorpe), *233*
Akron Art Museum, 332
Albers, Josef, 31, 37, 41, 55, 129, 130, 142, 143, 146
Ale Cans (Johns), 141, *142*
Alechinsky, Pierre, 45
Alessandra Gallery (New York), 209
Allen, Terry, 371

Allen, William, 216
Alloway, Lawrence, 35, 107, 135
All You Zombies (Truth Before God) (Longo), *298*
Almeda-Genoa Shopping Center (Houston), *267*
Almy, Max, *370*
Alpha (Louis), 32, *33*
Alternative Museum (New York), 224
Alvarez Bravo, Manuel, 155
Alvermann, H. P., 120
Always Saying Goodbye (Bleckner), *309*
Amaral, Antonio Henrique, 120
Amarillo Ramp (Smithson), 169
Ambulance Disaster (Warhol), 110
American Abstract Artists, 16, 82
American Dream I (Indiana), 114
Americans, The (Frank), 68, 153
American Scene painting, 9, 14
American Telephone and Telegraph Building (New York), *260*, 357, 373
Amerka X (Rollins and K.O.S.), 308, *309*
Am Fluss (Penck), *290*
Ampla (Cotanda), 350
Anatomy of a Kimono (Schapiro), 209
Anderson, Laurie, 272–74, *273*
Andre, Carl, 163, *164*, 169
Andrews, Michael, 128
Andujar, Claudia, 155
Angry Penguins, 314
Another Mistake (Nutt), 305
Ant Farm, 267
Anthropometrics (Klein), 100
Antin, Eleanor, 234
Anuszkiewicz, Richard, 130, 146
Aperture, 62, 68, 155
Appel, Karel, 45, *46*
Applebroog, Ida, 301
Applications (Acconci), 269

Appropriation, 305–10, 326, 344
Arbus, Diane, 151–52
Arcades du Lac, Les (Saint-Quentin-en-Yvelines), 263
A.R.C. Gallery (Chicago), 215
Arches (Metzker), 154
Archigram, 185, 186, 259, 264
Architectural sculpture, 243–46
Architecture of the Sky series (Bleckner), 308
Arcosanti (Scottsdale, Ariz.), *188*
Are Years What? (di Suvero), 173
Arikha, Avigdor, 129
Armajani, Siah, 245–46
Armitage, Kenneth, 73
Arneson, Robert, *255*
Arp, Jean, 69, 75, 76
Art and Language, 137
Art As Idea As Idea (Kosuth), 137
Art in America, 126, 316, 348
Artaud, Antonin, 98, 214
Art Brut, 43, 74
Art Deco, 144
Artemsia Gallery (Chicago), 215
Arte Povera, 138–39, 179
Art = Language, 139
Artforum, 136, 166, 207, 225, 232, 257, 332
Art Informel, L', 42
Art Institute of Chicago, 16, 26, 242, 291, 310, 315
Artist Placement Group, 274
Artists Union, 16
Artnews, 17, 40, 107, 228
Art of This Century Gallery (New York), 10
Artschwager, Richard, 162, 163
Arts Magazine, 40, 121
Ashbery, John, 13
Ashley, Robert, 368
Asian Games Housing, 364
Asia Society (New York), 314
Asparagus and Lemon (Hamaguchi), 54, *55*
Aspects of Transvestism (Sieverding), 272

Asplund, Gunnar, 261
Associated Press building (New York), 76
Atelier 17, 53, 64
Atlantic Gallery (Brooklyn), 215
Atomic Dreams (Yarbrow), *369*
Attie, Dottie, 214
Auerback, Frank, 128
Aula Magna (Caracas), 75
Aureal II (Janowich), *312*
Australian Biennale, 314
Austrian Travel Bureau (Vienna), 265
Automatism, 9, 16, 41
Autumn Rhythm (Pollock), *15*, 36
Autumn Surf (Gilliam), 224, *225*
A Veces Miento (Cotando), 350
Aycock, Alice, 243–45, *244*
Azaceta, Luis, 315

Baboon with Young (Picasso), *69*
Backs (Abakanowicz), *180*
Bacon, Francis, *5*, *6*, 50, 57, 73, 128, 315
Bad Boy (Fischl), *299*
Badger, George, 62
Bailey, William, 122, *123*, 124–25, 252
Bainbridge, Terry, 138
Baldaccini, César, 118, 177
Baldessari, John, 234, *235*
Baldwin, Michael, 138
Balthus, 8, *9*
Baltz, Lewis, 148, 232
Bandoneon! (Tudor), 192
Banfi, Gianluigi, 95
Baptismal Scene (Rothko), 12, *21*
Baptiste (Longing) (Wilmarth), *339*
Barboza, Anthony, 151
Barceló, Miguel, 295
Barcelona series (Hunt), 340
Barker, Lawrence, 230
Barr, Alfred, 36
Barragan, Luis, 75
Barrow, Thomas, 241
Barry, Robert, 138, 176, 234

Bartlett, Jennifer, 215, 219, 220
Bartolini, Ubaldo, 310
Barzyk, Fred, 196
Baselitz, George, 288, *289*
Baskin, Leonard, 55, *56*
Basquiat, Jean-Michel, 221, 303, 304, *305*
Bathtub Collage (Wesselmann), 113, *114*
Batman (Richier), 70, *71*
Battery Park City (New York), 220, 346
Baudrillard, Jean, 302
Baufahne Rot (Horndash), 353
Bauhaus, 37, 41, 61, 63, 64, 87, 89, 124, 135, 182, 265
Baumgarten, Lothar, 343
Bawa, Geoffrey, 364
Bayer, Herbert, 63
Bay of Naples (Hodgkin), 310
Bazaine, Jean, 41
Baziotes, William, 9, 10, 12–13, 53
Beal, Jack, 122
Bearden, Romare, 120, *121*, 215
Becher, Bernhard, 235, *236*
Becher, Hilla, 235, *236*
Bechtle, Robert, 125
Beckmann, Max, 5, 55
Bed (Rauschenberg), 37
Belgioioso, Lodovico, 95
Bell, Larry, 168
Bend Sinister (Noland), *129*
Benglis, Lynda, 257
Bengston, Billy Al, 115
Benjamin, Walter, 117
Benton, Thomas Hart, 14
Benyon, Margaret, 195
Berengo, Gianni, 155
Berkshire Museum, 252
Berlant, Tony, 222
Berlin Philharmonie, *184*
Berman, Wallace, 241
Bernstein, Judith, 214
Beuys, Joseph, 179, 199, *200*, 274, 289, 291, 313
Big Splash (Hockney), *117*
Bikeriders, The (Lyon), 150
Bill, Max, 41
Birds (Wols), 42, 43
Birnbaum, Dara, 370
Birolli, Renato, 48
Birth (Simonds), 247
Bischof, Werner, 150
Bisilliat, Maureen, 155
Bissière, Roger, 41
Black and White Stack (Cragg), *254*
Black Bulerias (Voulkos), 85
Black in White America (Freed), 150
Black Triangle (Bladen), 165
Black Vase with Daffodils (Fish), 124, *125*
Black Venus (Saint-Phalle), 177
Black Widow (Calder), *76*
Bladen, Ronald, 165–66
Blais, Jean-Charles, 295
Blake, Peter, 50, 116

Blake, William, 146
Bleckner, Ross, 308, *309*
Blind Home, St. Paul Minnesota (Liebling), 149
Blind Leading the Blind, The (Bourgeois), 80, *81*
Blinn, James, 277
Blue Girl in Front of Black Door (Segal), 160
Blue Package (Bravo), 128
Blue Rhythm (Hofmann), 10, *11*
Blue Steel for Gordon (Kirschenbaum), 250
Blum, Andrea, 346
Blume, Anna, 333, 335
Blume, Bernhard, 333, 335
Body art, 269–72
Body of Work, A (Coplans), 332, *333*
Boetti, Alighiero, 139
Bofill, Ricardo, 263, *264*
Bolotowsky, Ilya, 31
Boltanski, Christian, 333, 334
Bolt of Lightning (Noguchi), 77
Bontecou, Lee, 141, 174
Borduas, Paul Emile, 41
Borglum, Gutzon, 76
Borofsky, Jonathan, 250, *251*
Borromini Square II (Pomodoro), 179
Boshier, Derek, 316
Boston Institute of Modern Art, 13
Boston Museum of Fine Arts, 215
Botero, Fernando, 120
Botticelli, Sandro, 221
Boullée and Ledoux, 362
Bourgeois, Louise, 80, *81*, 175
Boutourline, Serge, 198
Box 4 (Dante's Inferno) (Samaras), 176
Boymans-Van Beuningen Museum (Rotterdam), 303
Brancusi, Constantin, 76, 164, 179, 339
Brandt, Bill, 63–64
Braques, Georges, 111, 118
Bravo, Claudio, 128
Bread (Johns), 143
Bread Works (Manzoni), 101
Brecht, George, 98
Breer, Robert, 193
Breton, André, 9, 48, 80
Breuer, Marcel, 77, 89
Breughel series (Steir), 221
Bridge, The (Burgin), 328
Bridge, The (Kline), *19*
Bridge over a Nice Triangle Tree (Armajani), 245
Brief History of North Africa, A (Fischl), 299
Brihat, Denis, 155
Brillo (Warhol), 157
Broken Obelisk (Newman), 82, 168, *169*
Broodthaers, Marcel, 251–52
Brooklyn Bridge, Nov. 28, 1982, The (Hockney), 118

Brooklyn Museum, 55, 193
Brooks, Ellen, 328, 329
Brooks, James, 10, 20
Brown, Denise Scott, 189
Brown, Joan, 215
Brown, Kathan, 146, 323
Brown, Roger, 304
Brücke, Die, 288
Brücke Choir, The (Baselitz), 288, 289
Brus, Günter, 271
Brutalism, 94
Bryen, Camille, 42
Building Steam No. 317 (Lipski), 342
Bulatov, Eric, 316–18, *317*
Burden, Chris, 271
Buren, Daniel, 138, 274
Burgee, John, 357
Burgess, Lowry, 346
Burgin, Victor, 328
Burn, Ian, 138
Burnham, Jack, 193
Burri, Alberto, 44, *45*, 48
Burson, Nancy, 332–33, *334*
Bury, Pol, 146, 176
Bus Riders (Segal), *160*
Butler, Reg, 73, 74
Butter, Tom, 339
Butterfield, Deborah, 253

Cabinet for All Seasons (Schapiro), 209
Café Deutschland series (Immendorff), 289
Cage, John, 13, 29, 31, 37, 39, 57, 80, 98, 199, 275
Cain, Michael, 193
Calder, Alexander, 54, 75, 76, 81
Caldwell, Susan, Gallery, 299
California Artist (Arneson), *255*
Callahan, Harry, 61, *62*, 68, 154, 155
Callis, JoAnn, 237
Calzolari, Pierpalo, 139
Cambridge University, History Faculty, *185*
Campbell, Joseph, 376
Campbell, Mike, 195
Campbell, Roy, 7
Canyon (Rauschenberg), 37, *38*
Capa, Cornell, 150
Capa, Robert, 65, 150
Capogrossi, Afro, 48
Capogrossi, Giuseppe, 48
Caponigro, Paul, 64
Car Door, Armchair and Incident (Woodrow), 350
Carlson, Cynthia, 213
Carnegie International, 343, 352, 354, 371
Caro, Anthony, *173*, 174, 177, 230
Carter, Joni, 333
Cartier-Bresson, Henri, 65
Castelli, Leo, 39, 166, 176
Castelli Gallery (New York), 112, 160, 195, 232

Castle, Wendell, 255
Cat and Dog (Jenny), 218, *219*
Catelani, Antonio, 351
Celant, Germano, 139
Cenodoxus Isenheim Altarpiece (Tinguely), 99
Center for Advanced Creative Study (London), 198
Center for the Studies of Science in Art (London), 198
Centro de Arte Reina Sofia (Madrid), 350
Ceremonial Arch Honoring Service Workers in the New Service Economy (Ukeles), 347
Chadwick, Lynn, 73–74
Chagall, Marc, 53, 54, 64
Chalk, Warren, 185
Chamberlain, John, 82, 84, 85, 177, 193
Chance Meeting (Michals), 152
Chanel (Flack), 125, *126*
Chant G (Courtin), 54
Chardin, 221
Charlie Chaplin (Knowlton), 365, *366*
Charnel House (Picasso), 5
Chase Manhattan Bank (New York), 77
Chia, Sandro, 222, 292, 293, *294*, 321–22
Chicago, Judy, 209, *256*, 257
Chicago Civic Center, 182
Chicago Imagists, 304
Chicago 10 or 16 (Siskind), 63, *64*
Childs, Lucinda, 360
Child with Toy Hand Grenade (Arbus), 151
Chillida, Eduardo, 177, *178*
Chim, 65
China Night (Allen), 371
Chinese Landscape (Summers), 56
Christina's World (Wyeth), 6
Christo, 118, 144, 171–73, *172*, 227, 243
Christ on the Cross (Sutherland), 6
Christ Stretched (Starn Twins), 330
Chrysalis, 267
Chuikov, Ivan, 316, 317
Cigarette (Smith), 165
Cincinnati Art Museum, 195
Cincinnati Tile Wall (Kozloff), 211
Circuits series (Stella), 322, *323*
Circular (Gottlieb), 24, *25*
Circular Utopia, A (Poirier), 253
Circumnavigation of the Blood (Sommer), 65, *66*
Circus (Calder), 75
Cirrus Editions, 142

Citicorp Center (New York), 258
City Square (Giacometti), 69, *70*
City Walls, Inc., 222
Clark, Larry, 231
Clark, Lygia, 201
Clarke, David, 29
Clemente, Francesco, 222, 292, *293*, 295
Cleopatra Flesh (Olitski), 32
Clerque, Lucien, 155
Close, Chuck, 125, 126, *127*, 252
Coat, Pierre Tal, 41
CoBra, 45–46, 55, 98
Codex Artaud (Spero), 214
Cohen, Harold, 276–77
Cohen, Lynn, 155
Cohen, Mark, 148, 232
Coke, Van Deren, 231
Coleman, A. D., 240
Colescott, Robert, 306
Collaborative Projects, Inc. (CoLab), 303, 342
Collectif d'Art Sociologique, 274
College Art Association, 157, 214
College of Sciences and Humanities (Mexico City), 223
Color Field painting, 21–23, 25, 31, 107, 131
Colville, Alex, 6–8, *7*
Combas, Robert, 295
Comb of the Wind (Chillida), *178*
Complex One (Heizer), 170
Composition (Burri), *45*
Computer art, 193–95, 275–78, 333, 365–70
Conceptual art, 35, 101, 136–39, 147, 219, 227, 234–35, 269, 293, 326, 333, 335, 366
Concerned photographers, 150, 151
Concerning Diachronic/ Synchronic Time (Baldessari), 234, *235*
Concord (Sugarman), 274
Concrete art, 41
Concrete Group, 98
Condensation Cube (Haacke), 176
Conjectures to Identify (Paolozzi), 144
Connelly, Chuck, 312
Constant, Georges, 45, 46
Constructivism, 50, 64, 72, 75, 78, 83–84, 129, 132, 135, 163, 223, 236, 321, 358
Contained (Historically, Politically, Physically) (McLean), 295
Conversations with the Dead (Lyon), 150
Cook, Peter, 184–86
Cooper, Alexander, 220
Cooper, Paula, Gallery (New York), 135, 136, 219, 250
Copcott, Geoffrey, 185

Coplans, John, 332, *333*
Corcoran Gallery (Washington, D.C.), 234
Corneille, Cornelius, 45–46
Cornell, Joseph, *78*, 81, 86
Cornucopia (Horn), 354
Corpron, Carlotta, 64
Corrente group, 48
Cosmic Terror (Tamayo), 48
Cosmogonies (Klein), 100
Costa, Lucio, 95
Cotanda, Ricardo, 350
Courtin, Pierre, 54
Covenant (Newman), 21, *22*
Cowin, Eileen, 328
Cox, Orville, 60
Cracked Question (Murray), 310, *311*
Cragg, Tony, *254*, 349
Creeley, Robert, 13
Crimp, Douglas, 37
Critic Smiles, The (Johns), 143
Crocus (Rauschenberg), 37
Crompton, Dennis, 185
Crossing the Rhine (Beuys), 199–200
Crown Point Press, 146, 323
Crucifixion (Starn Twins), 330
Cruel Discussion, The (Africano), 217, *218*
Cruz-Diez, Carlos, 146
Csuri, Charles, 194
Cuarto Santos (Sierra), 315
Cubi (Smith), 82, *83*
Cubic Lunar Aperture (Burgess), 346
Cubism, 10, 16, 30–32, 41, 78, 80, 107, 112, 116, 118, 310
Cucchi, Enzo, 222, 292, 293, *295*, 322
Cultural cannibalism, 301
Cumming, Robert, 231, 236, 322
Cunningham, Imogen, 60
Cunningham, Merce, 13, 31, 37, 39, 98
Current (Riley), *130*
Cut Out Comma/Apostrophe and Cool Comma (Cumming), 322
Cuyahoga Justice Center (Cleveland), 77
Cybernetic Sculptures A and B (Tsai), 278
Cybernetic Tower (Schöffer), 100

Dada, 37, 39, 69, 74, 85, 98, 118, 269, 370
Daimiel (Irazu), 350
Dalet Tet (Louis), 31
Dali, Salvador, 9, 54, 318
Dane, Bill, 232
Danese, Renato, 231
Darboven, Hanne, 138
Dark Star Park (Holt), 170
Da Silva, Maria Elena Vieira, 41, 42, 70
Davidson, Bruce, 147, *150*, 241

Davila, Juan, 314
Davis, Douglas, 196, 357–58, 364
Davis, Ronald, 230
Davis, Stuart, 32–33, 48, 107, 113
Day and Night (Tyler), 142
Days at Sea (Gibson), 154
Deacon, Richard, 349
Deal, Joe, 148, 232
Dean, Mark, 313
De Andrea, John, 73, 160, 161, 342
DeCarava, Roy, 149
Décollage, 118–19
Deconstructivist architecture, 358–61
Decorative movement, 174
Degas, Edgar, 74, 228
Dehner, Dorothy, 83
Déjà-Vu (Gibson), 154
De Kooning, Elaine, 9, 17
De Kooning, Willem, 9–11, 15–17, *18*, 19, 26, 36, 37, 54, 57, 80, 81, 84, 115, 124, 221, 311, 315
Del Monte Peach Halves (Warhol), 109
De Maria, Nicola, 222, 293, 294
De Maria, Walter, 170, *171*
Demi-soeur de l'inconnue (Dufrênes), 119
Denny, Robyn, 116
De Nooijer, 240
Derrida, Jacques, 225
Deschamps, Gérard, 118, 119
Deschin, Jacob, 66
De Stijl, 41, 45, 135
Dia Art Foundation, 367
Diaz, Al, 304
Dibbets, Jan, 139, 171, 234
Diebenkorn, Richard, 28, 131, *132*
Dieuzaide, Jean, 65
Different Kind of Order, A (Baldessari), 234
Di Lefeng, 318
Dillon, Kathy, 269
Dine, Jim, 98, 108, *114*, 115, 141, 228, *229*
Dinner Party (Chicago), *256*, 257
Directed Seeding-Canceled Crop (Oppenheim), 171
Dis (D#) (Penck), 290
Di Suvero, Mark, 82, 83, *84*, 86, 173, 174, 248
Documentary photography, 66
Donatello, 74
Doorway to Heaven (Burden), 271
Dorazio, Piero, 48
Dos Nones (Solano), 350
Double Mona Lisa with Self-Portrait (Starn Twins), 330, *331*
Double Negative (Heizer), 170
Douglas House (Harbor Springs, Mich.), *263*
Downes, Bruce, 66

Dream, Think, Speak (LeBrun), 295
Dubuffet, Jean, 43, *44*, 57, 74
Duchamp, Marcel, 10, 37, 39, 48, 58, 75, 78, 80, 101, 107, 163, 346, 375
Duets on Ice (Anderson), 272
Dufrênes, François, 118, 119
Dvizdjene Group, 102
Dwelling (Simonds), *247*
Dymaxion House (Fuller), 92
Dynamite (Kowalski), 179

Eagleton, Terry, 330–31
Early Dynastic (Paolini), 179
Earthworks, 139, 147, 169–72, 243, 338
Eastman, George, House, 59, 147, 231, 241
East 100th Street (Davidson), *150*
Echo, The (museum), 75
Eddy, Don, 125
Edelson, Marybeth, 209
Edwards, Melvin, 215
Eggleston, William, 232, 240
18 Happenings in Six Parts (Kaprow), 98, *99*
Einstein, Albert, 64
Eisenman, Peter, 190, 358, *360*, 361
Eisenwerth, Genannt, 63
Elegy to the Spanish Republic, xxxiv (Motherwell), 27, *28*
Eleta, Sandra, 155
El Greco, 14
Em, David, 277
Emery Roth and Sons, 182
Emmerich, André, Gallery (New York), 168
Emshwiller, Ed, 275, *276*
Endless House (Kiesler), 81
Environmental Communications, 267
Environments, 36, 98, 101, 113
Epstein, Jacob, 69
Equipo 57, 102, 176
Equivalents, 61–62, 329
Ernst, Max, 5, 9, 10, 54, 78
Erwitt, Elliot, 148
Escher, M. C., 55, *56*
Escobedo, Helen, 249
Eskedson, Uta, 333
Essence Mulberry (Frankenthaler), 227
Estes, Richard, 125, 126, *127*, 147, 207
Eurasia Thirty-fourth Section of the Siberian Symphony (Beuys), 199
Europe after the Rain (Ernst), 5
Evans, Walker, 59, 67, 326
Evening at Bayonne (Komar and Melamid), *307*
Evenstructures, 267
Eversley, Frederick, 215
Excavation (de Kooning), 16

Exotic Bird series (Stella), 223
Experimental Group, 45
Experiments in Art and Technology (EAT), 192–94
Expo '67 (Montreal), 92, *189*
Expression Libre, 155
Eye Body (Schneeman), 272

Fabro, Luciano, 351–52
Fa El 8 (Solano), *350*
F-111 (Rosenquist), 112–13, 120
Fagends and Drainpipe Variations (Oldenberg), 158
Faigenbaum, Patrick, 333, 334
Fallen Angel, The (Michals), 152
Falling Warrior (Moore), 71
False Start (Johns), 39
Family Photo Pieces (Welch), 236
Faneuil Hall (Boston), 268
Fargo-Moorhead Cultural Center, 261
Fashion Moda (Bronx), 303
Faucon, Bernard, 240
Faurer, Louis, 149
Fautrier, Jean, 42
Fauvism, 10
Federation of Modern Painters and Sculptors Show (New York), 12
Feeley, Paul, 30
Feet on a Rug (Guston), *216*
Feininger, Andreas, 65
Feldman, Morton, 37
Feldman, Robert, 146
Female Model in Robe Seated on Platform Rocker (Pearlstein), *122*, *123*
Feminist art, 209, 214–15, 256–57, 326, 327
Fenced (Graves), *253*
Ferber, Herbert, 81
Fernandez, Arman, 118, 144
Ferris, Milton, 62
Ferus Gallery (Los Angeles), 109
Fetter, William, 193–94
Field (Gormley), *349*
Figuration libre, 295
Filatov, Nikolai, 318
Fink, Larry, 148
First Gate Ritual Series (Singer), 246
First Pull (Olitski), 32
Fischbach Gallery, 175
Fischer, Hervé, 274
Fischl, Eric, 296, 298, *299*, 313
Fish, Janet, 124, *125*, 252
Five Feet of Colorful Tools (Dine), 114
Flack, Audrey, 125, *126*
Flag (Johns), 39, *40*, 143
Flag on Orange Field (Johns), 39
Flash, L.A. Times (Ruscha), *115*

Flavin, Dan, 134, 163, 168, 169
Flooded Allée (Gornick), 313
Flow City (Ukeles), 347
Fluxus group, 141, 198–99, 269, 335
F.M. Manscapes (Trova), 144
Fogg Museum (Cambridge, Mass.), 24
Folkwangmuseum (Essen), 63, 333
Fondacío Miró (Barcelona), 350
Fontana, Franco, 155
Fontana, Lucio, 48, 49, *50*, 101
Fontana, Roberto, 155
Fontcuberto, 240
For Beckwourth (Puryear), 338
Ford Foundation, 58
Ford Foundation Building (New York), 357
Ford Motor Company, 92
Forest, Fred, 274
Forma group, 48
For Those Who Have Ears (Deacon), 349
Foster, Norman, *361*
Fotoform, 63
Fountain of Peace, The (Noguchi), 77
Fountain View (Gonzalez), 316
Four Corners (Winsor), *255*
Four Darks in Red (Rothko), 23
Fourteen Stations, The (Clemente), 292, *293*
Fractal Planetrise (Voss), 277
Francis, Sam, 26–29, *28*, 107, 229
Franco, Siron, 315
Frank, Robert, *67*, 68, 153, 155
Franke, Herbert, 64
Frankenthaler, Helen, *30*, 31, 107, 141, 143, 227, *228*
Frank House (Cornwall, Conn.), 360
Frasconi, Antonio, 55
Freed, Leonard, 150
Free International University of Creative and Interdisciplinary Research, 274
Freud, Lucian, 128
Fried, Michael, 214
Friedlander, Lee, 68, 147–48, *149*, 231
Friedman, Ken, 198
Friedman, Martin, 337
Fritsch, Katharina, 354
Frost, Robert, 64
Fry, Edward, 274
Fujimi Country Club (Oita, Japan), *266*
Fuller, Buckminster, 92, *93*
Fun Gallery (New York), 303
Funk artists, 216
Funk Lessons I–IV (Piper), 371

Fuses (Rauschenberg), 230
Futurists, 98, 269

Gagnon, Charles, 155
Galaxies (Kiesler), 80
Galerie Vignon (Paris), 75
Gallas Rock (Voulkos), 85, 86
Gallery J (Paris), 118, 177
Gambrell, Jamey, 316
Garabedian, Charles, 215, 222
Garcia-Rossi, Horacio, 102
Garciá Sevilla, Ferrán, 295
Garden Road, The (Porter), 124
Garouste, Gérard, 310
Garrard, Mimi, Dance Company, 278
Garth, Midi, 13
Gaul, Winfred, 120
Gehry, Frank, 81, 358–60, *359*
Geisha and Fox (Teraoka), *307*
Geldzahler, Helen, 108
Gemini G.E.L., 142, 143, 229–31
General Services Administration Art-in-Architecture Program, 168, 248, 347
Generic Black and White (Steinbach), *344*
Genovés, Juan, 120
Geodesic dome, 92, *93*
Geography Lesson (Schnabel), 296
Geo-Romanticism, 352
German/American BiNational, 355
German Expressionists, 10, 44, 55, 89, 287, 288
Germination (Peterdi), *54*
Gershuny, Phyllis, 275
Gesture painting, 19–21, 25, 26, 31, 33, 35–37, 41, 136
Gestures/Reenactments (Simpson), 331
Getty, J. Paul, Museum, 233
Giacomelli, Mario, 155
Giacometti, Alberto, 57, 69
Giacometti, Giovanni, 70
Giant Hamburger (Oldenburg), *158*
Giant Wiper (Oldenburg), 158
Gibson, Ralph, 152–54, *153*, 232
Gigantomachies (Golub), 299
Gikow, Ruth, 58
Gil, Victoria, 351
Gilbert and George, *271*
Gill, Joanna, 275
Gilliam, Sam, 224, *225*
Gillette, Frank, 198
Ginsberg, Allen, 275
Giotto, 5
Girl (Butler), 73
Glass, Philip, 272
Glass House (New Canaan, Conn.), *88*

Global Groove (Paik), 275
Glyndebourne (Ray-Jones), 155
Gober, Robert, 346
Goeritz, Mathias, 74–75
Gohlke, Frank, 148
Goldberger, Paul, 358
Golden Days (Balthus), 8, *9*
Golden Section paintings (Rockburne), 134
Goldin, Amy, 207, 208, 212
Goldin, Nan, 331
Gold in the Morning (Jaar), 372
Goldwater, Robert, 80
Golub, Leon, 28, 299, *300*
González, Julio, 177
Gonzalez, Patricia, 315, 316
Gonzalez de Leon, Teodoro, 364
Goode, Joe, 115
Goodnough, Robert, 141
Gordon, David, 368
Gorky, Arshile, 9, 10, 17
Gormley, Antony, 349–50
Gornik, April, *313*
Gottlieb, Adolph, 9, 10, 12, 24, *25*, 55, 228–29
Goya, Francisco de, 110, 315, 318
Gracie Mansion Gallery (New York), 341
Graeser, Camille, 41
Graffiti art, 303
Graham, John, 14
Graham, Martha, 76, 80
Grand Central Moderns (New York), 79
Grande Madre (Legnaghi), 352
Grande Vitesse, La (Calder), 76
Grane (Kiefer), 321
Grass (Lye), 176
Graves, Michael, 190, 261–63, *262*
Graves, Nancy, 252, *253*
Grave Situation, A (Matta), 48
Great American Nude series (Wesselmann), 113
Great Parade, The (Léger), 7, *8*
Green, Art, 304
Green, John, 228
Greenberg, Clement, 10, 13, 15, 28, 31, 35–36
Greenblat, Rodney Alan, 341, *342*
Greene, David, 185
Green Gallery, 176
Green Street Oracle (Romano), 250
Green Target (Johns), 39
Green White (Kelly), *35*
Griffiths, Philip Jones, 150, 155
Grooms, Red, 98, 115, 128, *159*, 160, 161
Groover, Jan, 328
Gropius, Walter, 89, 182
Gross, Mimi, 159
Grossman, Maurice, 57

Grossman, Tatyana, 57, 58, 141, 142
Grosz, George, 120
Groupe de Recherche d'Art Visuel (GRAV), 102, 198
Group of Four Trees (Dubuffet), 44
Group ZERO, 49, 101–2, 198
Grundberg, Andy, 325
Grünewald, Matthias, 6, 99
Gruppo N, 102, 176
Gruppo T, 102, 176
Grygo, George, 161
Guardian (Greenblat), 341, *342*
Guardians of the Secret (Pollock), *12*
Guassian Quadratic series (Noll), 194
Gu Dexing, 318
Guerilla Girls, 303
Guernica (Picasso), 5
Guest, Barbara, 13
Guggenheim, Peggy, 10
Guggenheim Foundation, 149
Guggenheim Museum (New York), 10, 89–90, *91*, 107, 178, 207, 235, 274
Guild House (Philadelphia), 190, *191*
Guston, Philip, 10, *20, 216*
Gutai, 98
Guttso, Renato, 48
Gwathmey, Charles, 190

Haacke, Hans, 176, 227, 236, 274
Haas, Ernst, 155
Haas, Richard, 222
Hadid, Zaha M., 358
Hains, Raymond, 118
Hair Boxes (Artschwager), *163*
Hairy Who, 216, 304
Haj Terminal (Jeddah), *363*
Halley, Peter, *312*
Hamaguchi, Yozo, 54, *55*
Hamilton, Richard, 50, 107, 115, 143, 144
Hammond, Harmony, 209
Hampton, James, 215
Hancock Building (Boston), 258–59
Hancock Building (Chicago), 182, *183*
Hank Champion (di Suvero), *84*
Hansen, Al, 98
Hanson, Duane, 160, 161, 342
Hans-Rucker Company, 267
Happenings, 36, 97–98, *99*, 115, 157, 159, 175, 269
Hard-Edge painting, 35, 106, 115, 129, 209
Hard Hat Rally (Winogrand), 147, *148*
Hardin, Marvin, 215
Hardy, Bert, 155
Hare, David, 81
Haring, Keith, 303, *304*

Harmon, Leon, 194
Harper's Bazaar, 68
Harrison, Charles, 138
Harrison, Wallace K., 183
Hart, Frederick, 348
Hartigan, Grace, 26
Hartung, Hans, 41, 42, 70
Harvard University Carpenter Center for the Visual Arts, 184
Harvard Wise Gallery (Boston), 198
Hat and Scarf on a Chest (Castle), 255
Hawkins, Erik, 13
Hayter, William Stanley, 53–55
Head Surrounded by Sides of Beef (Bacon), 5, *6*
Healy, Anne, 246
Heihachiro, Fukuda, 29
Heinecken, Robert, 154
Heizer, Michael, 169, 170
Hejduk, John, 190
Held, Al, 20, 129
Hepworth, Barbara, 72, *73*
Heraklion (Benglis), 257
Hera Women's Cooperative, 215
Herbin, Auguste, 41
Here (Newman), 82, 88
Hernández Delgadillo, José, 223
Herron, Ron, 185
Hesse, Eva, 135, 166, *175, 339*
Heyboer, Anton, 55
Higgins, Chester, 151
High School Days (Johns), 143
Himmelblau, Coop, 267, 358, 361
Hine, Lewis, 66, 149
Hinman, Charles, 131
Hirshhorn Museum and Sculpture Garden (Washington, D.C.), 259
Hochstand (Polke), 290
Hockney, David, *117,* 118, 143, 144, 230
Hodgkin, Howard, 310
Hodgkinson, Peter, 264
Hofmann, Hans, 9, 10, *11,* 13, 15, 16, 30, 80, 84, 160
Holl, Stephen, 362–63
Hollander, Irwin, 142
Hollein, Hans, 264, *265*
Holograms, 195
Holt, Nancy, 170
Holzer, Jennifer, 365–67, *368*
Homage to New York (Tinguely), 99, 192
Homage to the Academy (Carlson), 213
Homage to the Square series (Albers), 129
Hon (Saint-Phalle), 177
Honegger, Gottfried, 41
Hong Kong and Shanghai Bank building, *361*
Horizon, 13
Horn, Rebecca, 354–55
Horndash, Ulrich, 353

Horse and Rider (Marini), 74
Horse and Train (Colville), *7*
Hosoe, Eikoh, 156
Hotel Eden (Cornell), *78*
Houseboat (Roberts), 266
House of Goethe (Chillida), 178
Houses in the Mountain (Wu), 318
Houston Chapel, 23, 82, 107
Hoving, Thomas, 151
How to Catch and Manufacture Ghosts (Aycock), 244–45
How to Explain Pictures to a Dead Hare (Beuys), 199
Hudson, Robert, 216
Hudson River Landscape (Smith), *82*
Huebler, Douglas, 138
Huge Wall Symbolizing the Fate's Inaccessibility (Schnabel), 296
Hughes, Robert, 128, 297, 322
Human Condition, The (Michals), 152
Hunt, Bryan, 340, *341*
Hunt, Richard, 215
Huntington Library (San Marino, Calif.), 36
Hurrell, Harold, 138
Hutchison, Peter, 236
Hybrid Building (Seaside, Fla.), 363
Hydra Forest, The (Horn), 355

Icarus (Hunt), 340
Ideal Stone Composition (Marini), 74
Idleness of Sisyphus (Chia), 293, *294*
Ikko, 156
I Like America and America Likes Me (Beuys), *200*
Illegal Operation (Kienholz), 161
Illinois Institute of Technology (Chicago), *87*
I Love You (Marzuttini), 353
Immendorff, Jorg, 289
Independent Group, 74, 116
Indiana, Robert, 107, 108, 113–14
Indian Bird (Stella), 223
Indian Village, New Mexico, U.S.A. (Ikko), 156
Inert Gas Series (Barry), 176
Informed Man, The (Nechvatal), *367*
Insert Myself within Your Story (Wilmarth), 339
Installations, 249–52, 270, 278, 343, 354, 355, 370–72
Institute of Contemporary Art (Boston), 13
Institute of Contemporary Arts (London), 74, 144
Institute of Design (Chicago), 61
Intact Feeling (Salle), *301*
Interactive sculpture, 278

Interior (Bearden), 121
Interior Exterior Figure (Moore), 71
International Center of Photography (New York), 150
International Conference Building (Kyoto), 188
International Museum of Photography (Rochester, N.Y.), 147, *148*
International Style, 87, 93, 96
Interrogation II (Golub), *300*
Interview, 110, 232
In the Vicinity of History (Vaisman), *309*
Inverted Sugar Crop (Cragg), 349
Irazu, Pello, 350
Irwin, Robert, 169
Ishimoto, Yasuhiro, 156
Isle of California (Los Angeles Fine Arts Squad), 222
Isozaki, Arata, 186, *187,* 265, *266*
Israel Museum (Jerusalem), 291
It Is magazine, 33
Iturbide, Graciela, 155
Ives Field (Katz), *122*
Iwakuni City Hall, 188
Iwata Girls' High School, 186, *187*

Jaar, Alfredo, 372
Jack and Jill (Otterness), 342
Jackie III (Warhol), 144
Jackson (Jaudon), 211, *212*
Jackson, Martha, Gallery (New York), 157
Jacobi, Lotte, 64, *65*
Jahn, Helmut, 357
Jameson, Fredric, 302
Janis, Sidney, Gallery (New York), 107, 118, 158
Janowich, Ron, 310, 312
Jaudon, Valerie, 209, 211, *212*
Javits, Jacob, 193
Jefferson Memorial Arch (St. Louis), 89
Jencks, Charles, 182, 260
Jenney, Neil, 215, 218, *219*
Jewell, Edwin Alden, 12
Jewish Giant at Home with His Parents in the Bronx (Arbus), 151
Jewish Museum (New York), 39, 134, 163, 193
Johns, Jasper, 36–39, *40,* 57, 80, 107, 109, 136, 141, *142,* 143, 157, 301, 305, *306*
Johnson, Elaine L., 53
Johnson, Ellen, 250
Johnson, Lester, 28
Johnson, Philip, *88, 89,* 183–84, 260, 357, 358
Jorn, Asger, 45, 46

Judd, Donald, 144, 163, 164, *165,* 269, 375
Judson Gallery (New York), 98
Just What Is It That Makes Today's Homes So Different, So Appealing? (Hamilton), 50–51

K., Bruno, 353–54
Kabakov, Ilya, 316–17
Kabuki (Formula Atlantic) (Pfaff), 251, *252*
Kahlo, Frida, 48, 316
Kahn, Louis, 90–91, *92,* 189, 261
Kanage, Consuelo, 60
Kandinsky, Wassily, 10, 316
Kansas City Art Institute, 36
Kapoor, Anish, 349
Kaprow, Allan, 36, 39, 97–98, *99,* 115, 175
Kardon, Janet, 245
Kasten, Barbara, 236
Katz, Alex, *122,* 252
Katz, Leo, 64
Kaufman, Larry, 368
Kawaga Prefectural Offices, 95
Kawazoe, Noboru, 186
Keetman, Peter, 64
Kelly, Ellsworth, *35,* 129, 230
Kelpra studio, 144
Kendall Band (Matisse), 346
Kennedy Airport (New York), 76, 89, *90*
Kepes, Gyorgy, 61, 193
Kerouac, Jack, 67
Kidner, Michael, 130
Kids of Survival (K.O.S.), 308
Kiefer, Anselm, 222, 291, *292,* 295, 321, 337
Kienholz, Edward, 161, *162*
Kiesler, Frederick, 80–81
Kikutake, Kiyonori, 186
Kim, Jin Soo, 342–43
Kinetic art, 102, 176
King, Philip, 177
King and Queen (Moore), 71, *72*
King of the Wood (Schnabel), *296,* 297
King's Heritage (Truitt), 166
Kirkeby, Per, 311
Kirschenbaum, Bernard, 250
Kirstel, M. Richard, 240
Kistler, Lynton, 58
Kitaj, Ronald B., *116,* 117, 144
Kitchen, The, 275
Klee, Paul, 42, 43, 179
Klein, William, 68
Klein, Yves, 49, 100–101, 118, 144
Kline, Franz, 10, *19,* 20, 26, 54, 62–63, 84
Klüver, Billy, 192, 193
Knowlton, Kenneth, *194,* 365, *366*
Kohn Pederson Fox, 357
Koller, John, 230

Koller, Kathleen, 230
Komar, Vitaly, 306, *307*
Koolhaas, Rem, 358
Koons, Jeff, *345,* 346
Korot, Beryl, 275
Kossoy, Boris, 240
Kosuth, Joseph, *137,* 138, 234
Kounellis, Jannis, 179
Kouros (Noguchi), 76, *77*
Kowalski, Piotr, 179
Kozloff, Joyce, 207–10, *211, 214, 227*
Kozloff, Max, 115
Kramer, Hilton, 287
Krasner, Lee, 9, 16, *17,* 53
Krauss, Rosalind, 165
Krebs, Rockne, 193, 195
Krims, Les, 68, 240
Krody, Barron, 195, *196*
Kruger, Barbara, 327, 328
Kudryashov, Oleg, 321
Kuitca, Guillermo, 315
Kuniyoshi, Yasuo, 48
Kunst Licht Kunst catalog, 192
Kurokawa, Kisho, 186
Kushner, Robert, 207, 211–12, *213*
Kuspit, Donald, 158, 179
Kwannon (Lassaw), 82

Labrot, Syl, 155
Laib, Wolfgang, 354
La Jolla Museum, 215
Lam, Wifredo, 46, *47*
Land, Edwin, 60
Land Art. *See* Earthworks
Landfall Press, 142
Land Fill: Bus Station (Adams and Blum), 346
Landing II (Gormley), 349
Landscape/Body/Dwelling (Simonds), 247
Land-Weber, Ellen, 242
Lange, Dorothea, 62, 153
Langsner, Jules, 35
Large Diver, Paper Pool 27, A (Hockney), 230
Larsen, Henning, 365
Lasansky, Mauricio, 54
Lasers, 195
Lassaw, Ibram, 81, 82
Latham, John, 274
Latinoamérica (Mujeres Muralistas), 223
Latow, Murial, 109
Laughter (Herbin), 41
Laurin, Lou, 46
Lavender Disaster (Warhol), 110
Lavender Mist (Pollock), 15
La Villegle, Jacques de, 118
Law Building with Dirt Roof (Aycock), 244
Lawrence, Jacob, 120
Lawson, Thomas, 301–2
Lead Piece (Andre), *164*
Leaker, Dudley, 185
LeBrun, Christopher, 295
Le Corbusier, 80, *94,* 95, 185, 190, 261, 263, 364

Lecourt, Jean-François, 333, 334
Ledoux, Claude-Nicolas, 261
Left Handed Painter, The (Mariani), 310
LeGac, Jean, 236
Léger, Fernand, 7, *8,* 80, 84, 107
Legnaghi, Piera, 352
Lehndorff, Vera, 333, 335
Le Parc, Julio, 102, 146
Lerner, Nathan, 64
Leslie, Alfred, 122
Lettrists, 98
Leutze, Emanuel, 28
Lever (Andre), 163
Lever House (New York), 182, *183*
Levin, Kim, 279
Levine, Marilyn, 255
Levine, Sherrie, 325, *326*
Levitt, Helen, 149, 241
LeWitt, Sol, 134–37, *135,* 144, 163, 166, *167,* 221, 272
Liberation (Shahn), 5
Liberman, Alexander, 35
Libeskind, Avid, 358
Lichtenstein, Roy, 108, 111, *112,* 143–44, 157, 375
Liebling, Jerome, 149
Life magazine, 13, 65, 67, 108, 153, 155, 333
Light Ballets (Piene), 101–2
Light Bulb (Johns), 143
Light Gallery (New York), 232
Lightning Field (de Maria), 250, *251*
Lily Pond Ritual Series (Singer), 246
Lin, Maya Ying, *348*
Lincoln Center (New York), 183
Lindner, Richard, 50
Lipchitz, Jacques, 54
Lippard, Lucy, 135, 174–76, 272
Lipski, Donald, 342
Lipstick Ascending on Caterpillar Tracks (Oldenburg), 159
Lipton, Seymour, 81
Little Big Horn (Voulkos), 85
Little Girl (Bourgeois), 80
Location Piece, No. 14 (Huebler), 138
Loewensberg, Verena, 41
Loft on 26th St. (Grooms), *159*
Lohse, Richard P., 41
Long, Richard, 171
Longo, Robert, 296, 297, *298*
Look magazine, 65, 153
López-Garcia, Antonio, 128
Loring, Alvin, 215
Lorre, Peter, 64
Los Angeles County Museum of Art, 118, 173, 193, 195, 277
Los Angeles Fine Arts Squad, 222

Lotti, Georgio, 155
Louie, Ernest, 62
Louis, Morris, 31–32, *33,* 107, 224
Louis and Virginai Arrojo (Ahearn), 342
Louvre (Paris), *362*
Loyola Law School (Los Angeles), 360
Luce, Clare Booth, 48
Luminaire (Sanborn), 368, *369*
Lupa di Roma, La (Cucchi), 322
Lüpertz, Markus, 289
Lustrum Press, 153, 231
Lüthi, Urs, 272
Lutyens, Edwin, 261
Lye, Len, 176
Lyon, Danny, 68, 147, 150, 241
Lyons, Nathan, 147
Lyrical Abstractionists, 41

MacConnell, Kim, 207, 212
Maccoy, Guy, 58
McCoubrey, John, 28
McCullin, Donald, 150, 155
McEvilley, Thomas, 297
Maciunas, George, 198
Mack, Heinz, 101
McKendry, John, 232
McKenna, Stephen, 310
McLean, Bruce, 295
McLean, Richard, 125
Magazine of Art, 14
Magdalene (Bacon), 5
Magic Base (Manzoni), 101
Magnum, 65
Mailman (Connelly), 312
Maine (Pratt), 155
Maki, Fumihiko, 186
Making a Work with His Body (Shiraga), 98
Maldonado, Rocío, 315
Male and Female (Pollock), 12
Malecich, 221, 316
Mallarmé, Stéphane, 339
Mandelbrot, Benoit, 277
Manessier, Alfred, 41
Manet, Eduard, 222
Manet Project (Haacke), 274
Mangold, Robert, 134, 144, 252
Manhattan Gallery Goers' Residence Profile (Haacke), 235, 274
Manhattan Real Estate Holdings (Haacke), 235, 274
"Manifesto Against Style" (Klein), 49
Manifesto Bianco (Fontana), 49
Manifesto del Maccinismo (Munari), 101
Mann, Thomas, 64
Man of Peace (Baskin), 56
Mansen, Matthias, 321
Manzoni, Piero, 48–50, 101
Manzù, Giacomo, 48, 74, *75*

Mapplethorpe, Robert, 232–34, *233*
March Hare (Lüpertz), 289
Marden, Brice, 134, 144, 207, *208*, 252, 292
Mariani, Carlo Maria, 310
Marilyn Monroe (Warhol), *145*
Marini, Marino, 74
Marisol, 141, 160
Mark, Mary Ellen, 150, 331
Marlborough Gallery (New York), 24, 232
Marriage of Reason and Squalor, The (Stella), 41, *42*
Marshall, Richard, 216
Martin, Agnes, 35, 132, *133*, 134
Maryan, 57
Marzot, Livio, 179
Marzuttini, Carlo, 353
Masson, André, 9, 54
Matare, Ewald, 199
Mathieu, 42
Matta, 9, 47–48, 54, 246
Matta-Clark, Gordon, 246
Mattiacci, Eliseo, 139
Matisse, Henri, 6, 16, 25, 48, 111, 207, 212, 221
Matisse, Paul, 346
Matisse, Pierre, 70, 76
Mavignier, Almire, 146
Maze (Aycock), 243, *244*
Mazur, Michael, 229
Meadows, Bernard, 73
Megastructures, 185, 186, 188
Meier, Richard, 190, *263*
Melamid, Alexander, 306, *307*
Meltdown Morning (Jenney), 218
Memorial to the Idea of a Man If He Was an Idea (Westermann), 85
Mendelson, Erich, 89
Men in the Cities series (Longo), 297
Mercenary series (Golub), 299
Merlo, 240
Mertin, Roger, 148
Merz, Mario, 139
Merz, Marisa, 139
Messer, Thomas, 274
Metabolists, 186, 188
Metropolitan Museum of Art (New York), 13, 32, 36, 151, 207, 227, 229, 357
Metzker, Ray, 154
Metzner, Sheila, 240–41
Meyerowitz, Joel, 148, 232, 240, *241*
Michael Jackson and Bubbles (Koons), *345*
Michals, Duane, 147, *152*
Midnight and Moon (Tyler), 142
Mies van der Rohe, Ludwig, 80, *87*, 87–88, *89*, 182–83, 189
Milant, Jean, 142

Mile Long Drawing (de Maria), 250
Milkstones (Laib), 354
Miller, Robert, Gallery (New York), 232
Minimalism, 35, 41, 74, 87, 106, 132–39, 144, 154, 162–66, 168–70, 173, 175, 207, 208, 221, 223, 224, 232, 243, 254, 272, 279, 287, 293, 296, 301, 337–40, 344, 346, 350–52
Ministry of Education and Health (Rio de Janeiro), 95
Miró, Joan, 14, 25, 48, 53, 54, 80
Misiano, Viktor, 316
Miss, Mary, 243, 245, *246*
Mitchell, Joan, 26, *27*, 41, 143
Mittelman, Phillip, 278
Miyasake, George, 57
Model, Lisette, *68*
Moderna Museet (Stockholm), 177, 193
Modernism, 28, 82, 94, 182, 260, 263, 265, 287, 302, 357, 358, 360–62, 364
Moholy-Nagy, László, 61, 63
Monde, Le, 128
Mondrian, Piet, 16, 33, 80, 82, 194, 220
Monet, Claude, 15, 27, 111
Monogram (Rauschenberg), 85
Monument series (Boltanski), 334
Moon and Half Dome, Yosemite National Park, California (Adams), 60
Moonrise over Hernandez (Adams), 60
Moore, Charles, 190, *261*
Moore, Henry, 57, 69, 71–73, *72*, 173
Moorman, Charlotte, 197, 198, 275
Morellet, François, 102
Morgan, Barbara, 62, 64
Morgan, Frederick, 339
Morgan, Williard, 66
Morley, Malcolm, 125, 143, 296
Morlotti, Ennio, 48
Morris, Robert, 37, 163, *166*, *167*, 168, 169, 176, 243
Moses (Kahlo), 48
Moskowitz, Robert, 219
Moss Bed (Webster), 338
Motherwell, Robert, 9–12, 25–26, *28*, 30, 47, 53, 83, 115, 141
Moulton, Charles, 368
Mountain Climber (Stackhouse), 250
Mountains and Sea (Frankenthaler), *30*, 31
Mozuna, Monta, 266
Mueble I (Romero), 350–51
Mühl, Otto, 271
Mujeres Muralistas, 223
Multiples, 141

Multiplication of Transformable Art, 144
Munari, Bruno, 101
Munson-Williams-Proctor Institute (Utica, N.Y.), 184
Murray, Elizabeth, 310, *311*
Museum of American Graffiti (New York), 303
Museum of Contemporary Art (Chicago), 158, 223
Museum of Modern Art (Mexico City), 249
Museum of Modern Art (New York), 13, 16, 36, 37, 41, 53, 59, 66–67, 71, 76, 85, 99, 118, 121, 129, 131, 134–35, 139, 143, 150, 156, 193, 201, 214, 215, 223, 227, 231, 240, 291, 303, 345, 358
Museum of Non-objective Painting (New York), 10
Musicalists, 41
Muthesius, 259

"*N*" *(Female Nude)* (Bailey), 122, *123*
Nachtwache (Immendorff), 289
Nake, Friedrich, 194
Nakhova, Irina, 318
Nakian, Reuben, 81
Nanas (Saint-Phalle), 144
Nassau County Museum, 245
Nation, The, 13
National Center of Afro-American Artists, 215
National Endowment for the Arts, 149, 168, 231, 234, 248, 303
National Endowment for the Humanities, 275
National Gallery (Washington, D.C.), 76, *259*
National Gallery of Canada (Ottawa), 361
National Serigraph Society, 58
Nature More I (Kirkeby), 311
Nauman, Bruce, 166, 195, *197*, 216, 243
Naviglio Gallery (Milan), 101
Neapolitan series (Hodgkin), 310
Nechvatal, Joseph, 365, *367*
Neel, Alice, 126, *128*
Negroponte, Nicholas, 195
Neighborhood (Rockburne), 134
Neo-Abstraction, 310
Neo-Dadaists, 141
Neo-Expressionism, 287–303, 318, 334, 337
Neo-Geo, 312, 352
Neo-Pop, 304
Neo-Rationalists, 264
Nero Paints (Kiefer), 291
Nervi, Pier Luigi, *96*
Nesch, Rolf, 54–55
Ness, George, 194

N.E. Thing Company, 138
Networks (Seawright), 278
Neue Staatsgalerie (Stuttgart), 265
Nevelson, Louise, 78–80, *79*, 81, 86, 227, 229
Newark, New Jersey (Friedlander), 147–48, *149*
New Criticism and Formalism, 28
New Decorativeness, 207
New Front of the Arts, 48
Newhall, Beaumont, 59, 62, 66
Newhall, Nancy, 62
New Image painting, 207, 215–22, 232
Newman, Barnett, 9, 12, 21, *22*, 81–82, 88, 107, 168, *169*
New Museum, 215
New Museum of Contemporary Art (New York), 373
New National Gallery (Berlin), 183
New Painting. *See* Neo-Expressionism
New Perceptual Realism, 121, 122
New Realism, 118–20, 144
New Topographics, 148–49, 232
New Wave, 314
New York Five, 190
New York School, 11, 13
New York Times, 66, 113, 128, 219, 325, 358
New York Triangle (Haas), 155
Nicholson, Ben, 50, 72
Niemeyer, Oscar, *95*
Night Blooming (Serious) (Seawright), 278
Nikolais, Alwin, Dance Company, 275
Nilsson, Gladys, 216, 304
Nine Evenings: Theater and Engineering, 192, 198
1954 (Still), *22*
Nitsch, Hermann, 271
Nixon, Nicholas, *332*
Nocturne (Manessier), 41
Noguchi, Isamu, 48, 76, *77*, 81
Nolan, Sidney, 128
Noland, Kenneth, 31, *32*, *129*, 227, 230
Nolde, Emil, 316, 334
Noll, A. Michael, 194
Nomad (Rosenquist), 112, *113*
Nonmobilizer (Rothenberg), 217
Northwest Printmakers Society, 55
Norton House (Venice, Calif.), *359*
Notations in Passing (Lyons), 147
Notre-Dame-du-Haut (Ronchamps), *94*, 95
Nouveaux Réalistes, 118–20, 177

Nouvelle Tendence, 102
Novecento realism, 48
Nowicki, Matthew, 88–89
Nuclears, 49
Nucleus (Oiticica), 201
Nude, East Sussex Coast
(Brandt), 63
Nunc Stans (Dubuffet), 44
Nutcracker (Chamberlain),
85
Nutt, James, 216, 305

0.9 (publication), 137
Ocean Greyness (Pollock),
15
Ocean Park (Diebenkorn),
131, *132*
O'Doherty, Brian, 14, 16–17
O'Donnell, Hugh, 230
Odysseus series (Bearden),
121
O'Hara, Frank, 13, 15, 57
Oiticica, Hélio, 200–201
O'Keeffe, Georgia, 60,
133–34
Oldenburg, Claes, 37, 98,
108, 115, 136, 141, 143,
157–59, *158*, 169, 248,
360
Olitski, Jules, 31, 32
Oliva, Achille Bonito, 222
Oliveira, Nathan, 57
Olson, Charles, 13
Olyka (Stella), 230
Olympia and York, 346
Olympic Stadium (Tokyo),
95
One: Number 31, 1950
(Pollock), 15
One and Three Chairs
(Kosuth), *137*
1¢ Life (Ting and Francis),
141
Onement I (Newman), 21
Op art, 106, 129–30, 144,
146, 176
Opera Sextronique (Paik and
Moorman), 197
Oppenheim, Dennis, 169,
171, 245, 269
Oppenheimer, Joel, 13
Orange and Yellow
(Rothko), 23
Orbit (Butter), 339
Ordeal by Roses No. 29
(Hosoe), 156
Organization for Direct
Democracy, 199
Origine group, 48
Ornamental Love (Longo),
298
Orozco, 14
Osaka World's Fair (1970),
193, 230, 267
Osiris und Isis (Kiefer), 291,
292
Otani, Sachio, 188
Other World (Escher), 55,
56
Otterness, Tom, 341, *342*
Our Lady of All Protections
(Stankiewicz), *84*

Ovarius (Fabro), 351
Ozenfant, Amadée, 80

Pace Graphics, 227, 232
Pages (Rauschenberg), 230
Paik, Nam June, 197–99, 275
Painted Bronze (Johns), 157
Paladino, Mimmo, 222,
293–94
Palazzetto dello Sport
(Rome), *96*
Pan-Am Building (New
York), 182
Pandemonium series
(Baselitz), 288
Pandora's Box (Schapiro),
210
Pani, Mario, 75
Paolini, Giulio, 179
Paolozzi, Eduardo, 50, 73,
74, 115–16, 144, 223
Papageorge, Todd, 148, 232
Parasol Press, 146
Paris Biennale, 85
*Parkdeck für Eroberer
2/Badewannenkapitän*
(K.), 354
Parker, Olivia, 240
Parrot Talk (MacConnell),
212
Parsons, Betty, Gallery (New
York), 35
Partisan Review, 13
Pasadena (Erwitt), 148
Pascali, Pino, 138–39
Paschke, Ed, 304, 305
Passageway (Laib), 354
Past Continuous (Krasner),
16
Pattern and Decoration
(P&D), 207–13
Paying off Old Debts
(Zucker), 219
Paz, Octavio, 316
Pearlstein, Philip, 122, *123*,
124
Pei, I. M., 76, 134, 258, *259*,
362
Penck, H. R., 289, *290*
Penn Center (Metzker), 154
Pennsylvania, University of,
Medical Research
Building, 91, *92*
Penone, Giuseppe, 139
Pepper, Beverly, *248*, 249
Pepsi, New York (DeCarava),
149
Perazim (Pepper), *248*
Peressuti, Enrico, 95
Perfect Leader (Almy), *370*
Perfect Lives (Sanborn and
Ashley), 368
Performance art, 139, 197,
211, 227, 269–75, 335, 371
Pergusa Three (Stella), 322,
323
Perimeters/Pavilions/Decoys
(Miss), 245
Perreault, John, 208
Persephone (Tucker), 177
Personnage (Appel), *46*
Peterdi, Gabor, *54*

Petersburg Press, 143
Petluck, Jerry, 195
Pfaff, Judy, 251, *252*
Phases group, 47
Philadelphia Museum of
Fine Arts, 58, 291
Philadelphia Print Club, 55
Phong, Bui-Tuong, 277
Photogenics, 64
Photojournalism, 65–67,
150–51, 155, 331–32
Photo-League, 62
Photo-Realism, 121, 125–26,
141, 146, 160
Piano, Renzo, 259, *260*
Piazza d'Italia (New
Orleans), *261*
Picasso, Pablo, 5, 14, 16, 17,
25, 46, 48, 53, 57, *69*, 111,
118, 177, 194, 221, 304,
308, 318
Pie Counter (Thiebaud), 115
Piège (Télémaque), 120
Piene, Otto, 101
Pier 52 (Matta-Clark), 246
Pilkington, Phillip, 138
Piper, Adrian, 371
Pistoletto, Michelangelo,
138, 139
Planetary Folklore
(Vasarely), 146
Planets, The (Lassaw), 82
Plossu, Bernard, 155, 240
PM Magazine (Birnbaum),
370
Poirier, Anne, 253–54
Poirier, Patrick, 253–54
Polaroid Corporation, 60
Polish Village series (Stella),
223, 230
Polke, Segmar, 290
Pollock, Jackson, 9–16, *15*,
26, 29, 30, 49, 53, 80, 136,
220, 221, 224, 291, 315,
327, 375
Pomodoro, Arnaldo, 178–79
Pomodoro, Gio, 178–79
Pompidou Centre (Paris),
259, *260*, 372
Pond Hulten, K. G., 193
Poons, Larry, 130
Pop art, 33, 37, 39, 50–51,
74, 106–22, 126, 129, 141,
143–44, 147, 157, 160,
162, 185, 288, 344, 345,
370
Popular Photography, 66
Porch, Provincetown
(Meyerowitz), 240, *241*
Portal (Noguchi), 77
Porter, Eliot, 155
Porter, Fairfield, 122, 124
Porthmeor: Sea Form
(Hepworth), 72, *73*
Portland Public Services
Building, 262
Portrait of Nick Wilder
(Hockney), 117
Portrait of Pope Innocent X
(Velázquez), 5
Possibilities (journal), 12
Post-Modernism, 37, 165,

182, 189, 258, 260–68,
302, 325, 337, 357, 364
Post-Painterly
Abstractionists, 107, 177
Post studio sculpture, 169
Praise for Elohm Adonai (di
Suvero), 173
Prater, Christopher, 144
Pratt, Charles, 155
Pratt Graphic Art Center,
58
Precisionists, 114, 115
Presepe (Paladino), 294
Presidential Palace (Brasilia),
95
Price, Kenneth, 175
Primary Structure art, 132
Prince, Richard, 326, *327*
Printed Matter, 135
Prinzhorn, Hans, 43
Process art, 139, 166, 219,
274
Procter and Gamble
building (Cincinnati), 357
Prodigal Son (Hunt), 340,
341
*Project for a Circular
Building with Narrow
Ledges for Walking*
(Aycock), 244
Prometo (Fabro), 351
Public Art Fund, 366
Pulsa, 193
Purcell, Rosamond, 240
Purple Heart (Zwack), 312
Puryear, Martin, 337, *338*
Putzel, Howard, 10

Quibb art, 120
Quiet Axis, The (Burgess),
346
Quincy Market (Boston), 268

Radical Software
(periodical), 275
Radioactive Cats (Skoglund),
237
Raginsky, Nina, 240
Rainer, Arnulf, 333–34
Rainfall (Caro), *173*
Rajzik, Jaroslaw, 64
Rake's Progress, A
(Hockney), 117
Ramos, Mel, 115
Ramsden, Mel, 138
Rape of Persephone
(Gottlieb), 12
Rapt at Rappaports (Davis),
33
Ratcliff, Carter, 288
Rauschenberg, Robert, 31,
36–40, *38*, 57, 85, 86, 98,
107, 109, 136, 141, *143*,
147, 177, 192, 193, 227,
229–30
Ray, Man, 63, 64
Ray-Jones, Tony, 155
Raysse, Martial, 118
Read, Herbert, 10
Réalités Nouvelles–Nouvelles
Réalités, 41

Rearte, Armando, 315
Rebus (Rauschenberg), 37
Reconstructions (Samaras), 213, *214*
Red and Black #53, The (Motherwell), 26, *27*
Red Cell with Conduit (Halley), 312
Red Cube (Noguchi), 77
Red Painting (Reinhardt), 33, *34*
Red Pines (Shinsen), 29
Reed, David, 310
Regionalism, 363
Region of Ice (Tovish), 343, *344*
Reiback, Earl, 198
Reign of Flowers (de Maria), 294
Reinhardt, Ad, 33, *34*, 35, 80, 129, 163
Reiss, Erich, 64
Rembrandt, 221
René, Denise, Gallery (New York), 221
René, Denise, Gallery (Paris), 99, 146
Renger-Patzsch, Albert, 64
Restany, Pierre, 118, 120
Reuben Gallery (New York), 98
Reutersward, Carl Frederick, 195
Revenge of the Goldfish (Skoglund), 237
Rewal, Raj, 364
Rhapsody (Bartlett), 219, *220*
Riboud, Marc, 150
Richier, Germaine, 70, *71*
Richter, Gerhard, 310–11
Rickey, Carrie, 208
Rickey, George, 176
Riis, Jacob, 66, 149
Riley, Bridget, *130*, 144, 146
Rilke, Rainer Maria, 8
Rimbaud Alchemy (Dine), 228
Ringgold, Faith, 209, 215
Riopelle, Jean-Paul, 41, 42
Riot series (Golub), 299–300
Ritual Branch (White), 62, *63*
Rivera, Diego, 14, 48, 78
Rivers, Larry, 28, *29*, 57, 107, 141
Riverside Museum (New York), 150
Robbin, Tony, 208, 209
Roberts, Chris, 266
Roche, Arnaldo, 315
Roche, Kevin, 357–58
Rockburne, Dorothea, 134, 144, 146
Rockefeller, Nelson, 48
Rockefeller Center (New York), 76
Rodger, George, 65, 155
Rodriguez, José Angel, 155
Rogers, Ernesto, 95
Rogers, Richard, 259, *260*
Roger Woodward Niagara Falls Project (Welch), 236

Roh, Franz, 63
Rollins, Tim, 308
Romano, Salvatore, 250
Romanticism, 173
Romero, Pedro, 350–51
Roosevelt, Franklin, 10
Roosevelt Field Shopping Center (Long Island), 134
Rose, Barbara, 110, 287
Rose, Bernice, 136
Rosenberg, Harold, 11, 13, 19, 28, 139, 234
Rosenblum, Robert, 21, 36, 108
Rosenquist, James, 37, 108
Rossi, Aldo, 264
Rosso, Medardo, 74
Roszak, Theodore, 81
Rotella, Mimmo, 118, 119
Rothenberg, Susan, 215, 216, *217*, 222
Rothko, Mark, 9, 10, 12, 13, 23, 24, 27, 29, 53, 80, 107
Rowe, Colin, 190–91
Royal College of Art, 71, 116, 117, 130
Rubin, William, 36
Ruckus Manhattan (Grooms), 160
Ruff, Thomas, 333, 334, *335*
Running Animals/Reindeer Way (Stackhouse), *249*, 250
Running Fence (Christo), *172*, 243
Ruscha, Edward, *115*, 144
Rushes (Jaar), 372
Rushton, David, 138
Russell, John, 128, 219, 343
Ryan, Paul, 198
Ryder, Albert Pinkham, 14
Ryman, Robert, 134, 144

Saar, Betye, 209, 215
Saarinen, Eero, 89, *90*, 183, 358
Saarinen, Eliel, 89
Sackler, Arthur M., Museum (Cambridge, Mass.), 24
Safdie, Moshe, *189*, 361
Sailors (Stackhouse), 250
St. Louis Botanical Gardens, 92
St. Mark's Church (New York), 135
Saint-Phalle, Niki de, 118, 144, 177
St. Peter's Cathedral (Rome), 74
Salk, Jonas, Institute for Biological Studies (La Jolla, Calif.), 92
Salle, David, 222, 296, 300–302, *301*
Salon des Réalités Nouvelles, 41, 100
Salvi, Nicola, 261
Samaras, Lucas, 175–76, 213, *214*, 239–40
Sanborn, John, 368, *369*
Sandwich and Soda (Lichtenstein), 144

Sandwich Man, Tokyo (Tomatsu), 156
San Francisco Museum of Art, 231
Sans II (Hesse), *175*
Santomaso, Giuseppe, 48
São Paulo Biennale, 71
Saret, Alan, 166
Sartre, Jean-Paul, 69
Sato, Takeo, 188
Satprakash, 352
Saudi Ministry of Foreign Affairs (Riyadh), 365
Saura, Antonio, 57
Savage Breeze (Frankenthaler), 227, *228*
Savogran Company (Norwood, Mass.), 92
Scape-mates (Emshwiller), 275
Schanker, Louis, 55
Schapiro, Meyer, 194
Schapiro, Miriam, 207–9, *210*, 213–14
Scharf, Kenny, 303–4, *305*, 341
Scharoun, Hans, *184*
Schier, Jeffrey, 276
Schinkel, Karl, 261
Schmoll, J. A., 63
Schnabel, Julian, 222, 292, *296*, 297, 337
Schneeman, Carolee, 271–72
Schneider, Ira, 198, 275
Schoenberg, Arnold, 80
Schoener, Allon, 151
Schöffer, Nicolas, 100
School of Paris, 41–42
Schultze, Wolfgang, 42
Schwarz, Arturo, 141
Schwarzkogler, Rudolph, 271
Schwitters, Kurt, 37, 45, 98, 107
Scott, Tim, 177
Scully, Sean, 311
Sculptures in the Environment (SITE), 267, 268
Sculpture Now (New York), 249, 250
Seagram Building (New York), 23, 88, *89*
Search (Krody), 195, *196*
Search for Strange Formations (Dean), 313
Sears Tower (Chicago), 258
Seasons, The (Johns), 305, *306*
Seated Caryatid (Hunt), 340
Seawright, James, 278
Security Guard (Hanson), *161*
Seedbed (Acconci), 270
Segal, George, 159, *160*, 161
Seitz, William, 85, 129
Seligman, Kurt, 53
Sentinel (Smith), 82
Serra, Richard, 166, 168, 176, 248, 252, 269, *347*, 348, 361
Seymour, David, 65, 150
Shahn, Ben, 5, 58

Shāma (Stella), *224*
Shapiro, Joel, 339, *340*
Shea, Judith, 341
Shelter Drawings (Moore), 71
Sheridan, Sonia, 242
Sherman, Cindy, *239*, 297, 328
She-Wolf (Pollock), 12
Shields, Alan, 224
Shikō, Munakata, 55
Shining Back (Francis), *28*
Shinsen, Tukuoka, 29
Shiraga, Karzuo, 98
Shore, Herbert, 278
Shore, Stephen, 148, 240
Shrine of the Book (Jerusalem), 81
Shteinberg, Eduard, 316
Shutov, Sergei, 318
Siegel, Eric, 198
Siegelaub, Seth, 138
Sierra, Paul, *315*
Sierra Club, 60
Sieverding, Katharina, 272
Signals (Takis), 198
Silva, Rufino, 315
Simmons, Laurie, 328–29
Simonds, Charles, 246–48, *247*
Simpson, Lorna, 331
Sine-Curve Man (Csuri), 194–95
Singer, Michael, 246
Singers at Sammy's Bar, New York (Model), *68*
Singier, Gustave, 41
Singing Sculpture, The (Gilbert and George), *271*
Single Form (Hepworth), 72
Siskind, Aaron, 61–63, *64*, 68, 154
Site-specific sculpture, 243–48, 347
Situationniste Internationale (SI), 47, 98
Sitzende (Mansen), 321
Six Hearts (Dine), 228, *229*
Six Secret Places (Kapoor), 349
Skidmore, Owings & Merrill, 182, *183*, 258, 259, *365*
Skoglund, Sandy, *237*
Sky, Alison, 267
Sky above the Clouds (O'Keeffe), 134
Sky Cathedral (Nevelson), *79*
Sky Garden (Rauschenberg), *143*
Sky-Sea (Bulatov), *317*
Slanted Playpen (Gober), 346
Slavic Dancers (Kushner), 212, *213*
Slavin, Arlene, 209
Sleep of Reason (Viola), 371
Sleigh, Sylvia, 214
Slide Mantra (Noguchi), 77
Small Woods Where I Met Myself (Uelsmann), *154*
Smith, Beuford, 151

Smith, David, 13, 17, *82–83*, 86, 173, 177
Smith, Edward, Lucie, 177
Smith, Henry Holmes, 65
Smith, Jack, 50
Smith, Leon Polk, 35
Smith, Mimi, 209
Smith, Richard, 115, 116, 131
Smith, Tony, 163, 165, 166, 193
Smith, W. Eugene, 67, 150
Smithson, Robert, 169, *170*
Smolin Gallery (New York), 196
Smyth, Ned, 213
Snake (Escobedo), 249
Sobre la Represión Politica (Genovés), 120
Sochurek, Howard, 333
Social landscape, 147
Social Realism, 50, 118, 310, 321
Society for Photographic Education, 147
Soft architecture, 267
Soft Pack (Smith), 116
Soho 20 Gallery (New York), 215
Solanis, Valerie, 110
Solano, Susana, *350*
Soleri, Paolo, *188*
Solomon, Holly, Gallery (New York), 211
Sommer, Frederick, 65
Somnambulist (Gibson), *153*
Sonnabend Gallery (New York), 232, 270
Sonneman, Eve, 231–32
Sonnier, Keith, 175
Sontag, Susan, 156
Soto, Jesus Rafael, 146, 176
Soulages, Pierre, 41, 42, 54
Southern States series (Indiana), 114
Spaces of Abraxas (Marne-la-Vallée), 263, *264*
Spatial Concepts (Fontana), 49, *50*
Spell, The (Puryear), *338*
Spero, Nancy, 214–15
Spiral Group, 120
Spiral Jetty (Smithson), 169, *170*
Splitting (Matta-Clark), 246–47
Spoerri, Daniel, 118, 177
Spoleto Festival, 83
Spread (Noland), 31, *32*
Square of the Five Towers, The (Goeritz, Barragan, and Parri), 75
Stackhouse, Robert, *249*, 250
Staël, Nicholaes de, 41
Stain painting, 30–32
Stamos, Theodoros, 13
Standard Station Amarillo (Ruscha), 115, 144
Stankiewicz, Richard, *84*
Starn Twins, 330, *331*
State Hospital (Kienholz), 161

Stations of the Cross (Matisse), 6
Stations of the Cross (Newman), 22, 107
Stedelijk (Eindhoven), 102
Steichen, Edward, 66
Steinbach, Haim, *344*, 345
Steinberg, Leo, 37
Steindecker, Oliver, 24
Steinert, Otto, 63, 64
Steinhardt, Alice, 240
Steir, Pat, 219, 220, *221*
Stella, Frank, 39–41, *42*, *131*, 143, 223, *224*, 230, 322, *323*
Stella (per purificare le parole) (Zorio), 351, *352*
Stern, Robert, 263, 357
Sternberg, Harry, 58
Steveni, Barbara, 274
Stevens, Mark, 125, 316
Stieglitz, Alfred, 59–61, 64, 133, 329
Still, Clyfford, 9, 10, 21–23, *22*, 27
Stirling, James, *185*, 186, 265
Stone, Michelle, 267
Strand, Paul, 59
Stream (Shinsen), 29
Street, The (Bearden), *121*
Stubbins, Hugh, Associates, *258*
Studio Architetti BBPR, 95–96
Studio International, 177
Studio Museum in Harlem, 215
Sudre, Jean Pierre, 65
Sugarman, George, 173, 174, 209, 243
Sultan, Donald, 219, 221–22
Summer (Johns), *306*
Summers, Carol, 56–57
Sunken Pool (Miss), 245, *246*
Sunstone (Emshwiller), *276*
Supermarket Shopper (Hanson), 161
Superrealism, 222
Superrealist art, 160, 243
Support/Surfaces group, 295
Surrealism, 6, 9–12, 16, 31, 46–48, 53, 54, 64, 65, 70, 71, 73, 74, 81, 85, 120, 152, 154, 155, 175, 207, 215, 237, 246, 287, 310, 333
Survival series (Holzer), 366
Sutherland, Graham, 6, 57, 73
Sutherland, Ivan, 194
Swan Engravings (Stella), 322
Swenson, Gene, 107, 108
Sydney Opera House, *93*
Syrian Bell (Rothko), 12
System with Figure (Heyboer), 55
Szarkowski, John, 156, 231, 240
Szilasi, Gabor, 155

Taaffe, Philip, 308
Table with Pink Tablecloth (Artschwager), 162
Tachism, 42–45, 102
Takis, 101, 198
Taller de Arquitectura, 263
Tamarind Lithography Workshop, 58, 142
Tamayo, Rufino, 48, *49*
Tange, Kenzo, 95, 186
Tango-Bolero (Deschamps), *119*
Tanguy, Yves, 9, 54
Tanning, Dorothea, 10
Tapié, Michel, 42
Tàpies, Antoni, 44, 45
Tate Gallery (London), 23
Taxi Cab I (Held), 20
Taylor, Robert, 374
Tea Bag (Oldenburg), 141
Teatro del Mondo (Venice), 264
Télémaque, Hervé, 119–20
Tell Me Everything (Prince), 327
Temporary Contemporary Museum (Los Angeles), 360
Tendenza group, 264
Tent-Roof-Floor-Carpet/ Zemmour (Kozloff), *211*
Teraoka, Masami, *307*
Terra Incognita (Baumgarten), 343
Testicle Stretch with the Possibility of a Crushed Face (Witkin), 237
Tet (Louis), 31
Theriot, Jean-Paul, 274
Thiebaud, Wayne, 115
Things Are Queer (Michals), *152*
Thompson, Virgil, 13
Three Days and Three Nights (Sierra), *315*
3 Flags for 1 Space and 6 Regions (Acconci), 323
Throwing 4 Balls in the Air to Get a Straight Line (Baldessari), 234
Thwaites, John Anthony, 120
Tie (Dine), *114*
Tillim, Sidney, 121
Tilted Arc (Serra), 168, *347*, 348
Time magazine, 60, 128
Time Pocket (Oppenheim), 171
Times Square Show, 303, 341–42, 366
Tinguely, Jean, 37, 99, 100, 118, 144, 177, 192
Tipologia (Catelani), 351
Tischgesellschaft (Fritsch), 354
Tomatsu, Shomei, 156
Tomlin, Bradley Walker, 20
Tom Moran and His Mother, Catherine (Nixon), *332*
Tongue of the Cherokee, The (Baumgarten), 343
Tonight We Escape from New York (Acconci), 270

Torment (Baskin), *56*
Torreano, John, 209
Torres, Rigoberto, 342
Torre Velasca (Milan), 96
Torso Sheaf (Arp), 69
Torture of Women (Spero), 215
Totem Lesson (Pollock), 12
Tourism: St. Basil at Night (Simmons), 329
Tourists (Hanson), 161
Tovish, Harold, 343, *344*
To Want (Scully), 311
Tower of Babel (Aycock), 245
Tower Records building (Boston), 360
Trademarks (Acconci), 269, *270*
Trans-avant-garde, 222, 292–94
Transjovian Pipeline (Em), 277
Transom (Rauschenberg), 37
Trautes Heim (Blume), 335
Tree (Martin), *133*
Tress, Arthur, 240
Triumph and Glory (Dubuffet), 43, *44*
Trockel, Rosemarie, 355–56
Trolley, New Orleans (Frank), *67*
Trotsky, Leon, 48
Trova, Ernest, 144
Truckitecture, 267
Truitt, Anne, 163, 166
Trülzsch, Holger, 333, 335
Tsai, Wen-Ying, 278
Tschumi, Bernard, 358
Tuchman, Maurice, 118
Tucker, William, 177
Tudor, David, 192, 193
Tullis, Garner, 229
Tumbleweed (Rosenquist), 113
Turrell, James, 195
T.V. Bra for Living Sculpture (Paik and Moorman), 197
Two Color Groups with Dark Square Excentrum (Bill), 41
Two Garbage Cans (Ikko), 156
Two Hills for Passage (Webster), 339
298 Circles (Kirschenbaum), 250
Twombly, Cy, 132, 292
2 Wings for Wall and Person (Acconci), 323
Two Women III (Applebroog), 301
Tyler, Ken, 142–43, 227, 229–30

Uecker, Gunther, 101–2
Uelsmann, Jerry N., *154*
Ukeles, Mierle Laderman, 347
UNESCO building (Paris), 71, 77, 178

Unfurleds (Louis), 107
Union Carbide Building (New York), 182
Union Tank Car Company (Baton Rouge), 92
United Nations Plaza (New York), 72
United States (Transportation, Politics, Money, and Love) (Anderson), 273
Universal Limited Art Editions (ULAE), 57, 141
Untitled (to the "innovator" of Wheeling Peachblow) (Flavin), *168*
Untitled Film Stills (Sherman), *239*
Up to and Including Her Limits (Schneeman), 272
Us Company (USCO), 192
Utopie, 267
Utzon, Jørn, 93–94
Uzzle, Burke, 148

Vaccari, Franco, 156
Vaisman, Meyer, 308, *309*
Valensi, Henri, 41
Vallauri, Alex, 315
Valley Curtain (Christo), 172
Val Veeta (Ramos), 115
Vandenberg Center (Grand Rapids), 76
Van Der Zee, James, 151
Van Dyke, Willard, 60
Van Gogh, Vincent, 5, 221, 316, 318
Varèse, Edgar, 13, 80
Variability of Similar Forms (Graves), 253
Vasarely, Victor, 129, 146
Vase (Richter), 311
Vasulka, Steina, 275
Vasulka, Woody, 275, 276
Vedona, Emilio, 48
Velonis, Anthony, 58
Velvet Underground, 110
Venegas, Germán, 315
Venice Biennale, 16, 31, 32, 61, 69, 71, 73, 77, 207, 264, 292, 305, 366, 372
Venturi, Robert, 189, *190, 191,* 358
Vermeer and Random Choice (Chuikov), 317
Video art, 193, 196–97, 275–76, 367–71
Video Commune (Paik), 198
Vietnam, Inc. (Griffiths), 150, 155

Vietnam Veterans Memorial (Washington, D.C.), *348*
Vincent with Hood (Katz), 122
Viola, Bill, 370–71
Virgin Snow (Heihachiro), 29
Vishniac, Roman, 150
Vitebsk-Havar (Cucchi), 293, 295
Volkov, Sergei, 318
Voltri (Smith), 82, 83
Voss, Richard, *277*
Vostell, Wolf, 196–98
Voulkos, Peter, 85, *86*

Wagstaff, Sam, 233
Wait, The (Kienholz), *162*
Waking (Di), 318
Waldhauer, Fred, 193
Walker Art Center (Minneapolis), 278
Wallraf-Richartz Museum (Cologne), 274
Walter Lippmann (Kitaj), *116*
War (Hanson), 161
Warhol, Andy, 80, 106–12, *109, 110, 128,* 144, *145,* 147, 157, 193, 233, 300, 332, 365
Warren, Dody, 62
War Series, No. 6 (Lawrence), 5
Washington Crossing the Delaware (Rivers), 28, *29*
Washington Gallery of Modern Art, 107
Watt, James G., 60
Watteau, Jean-Antoine, 221
Watts, Robert, 198
Wayne, June, 58
Webb, Michael, 185
Weber, John, 232
Webster, Meg, 338–39
Weed against the Sky, Detroit (Callaghan), 61, *62*
Wegman, William, 238–39
Weil, Susan, 37
Weiner, Lawrence, 138, 234, 235
Weintraub, Joe, 198
Weisenthal, Morris, 54
Welch, Roger, 236
Welling, James, 329, *330*
Welliver, Neil, 122, *124,* 252
Wesselmann, Tom, 108, 113, *114*
Westermann, H. C., 85, 175, 216
Weston, Edward, 59, 60, 332

Wexner Center for the Visual Arts (Ohio University), 360
When Worlds Collide (Scharf), 304, *305*
Where Time Has Vanished (Ikko), 156
White, Minor, 61–65, *63,* 68
Whitechapel Gallery (London), 51, 177, 201
White Flag (Johns), 39
White Manifesto (Fontana), 101
White Patio with Red Door (O'Keeffe), 133
White Riot series (Longo), 297
White Room, The (Broodthaers), 252
Whitman, Robert, 98, 115, 195
Whitney Museum of American Art (New York), 128, 214–16, 227, 270, 341, 366
Whole Truth, The (Kaufman), 368
Wife of Cain, The (Witkin), 238
Wigley, Mark, 358
Wiley, William, 216
Wilke, Hannah, 214
Wilmarth, Christopher, 339
Wilson, Hugh, 185
Winding Towers (Becher), 235, *236*
Wines, James, 267
Winged Figure (Chadwick), 73
Winogrand, Garry, 68, 147, *148*
Winsor, Jackie, *255*
Wirsum, Karl, 216, 304
Wise, Howard, Gallery, 194
Without Words (Shea), 341
Witkin, Joel-Peter, 237, *238*
Witkin, Lee, 232
Wodiczko, Krzysztof, 372–73
Wolfe, Tom, 13
Wols, Wolfgang, 42, *43*
Woman and Bicycle (de Kooning), 17, *18*
Womanhouse, 209
Woman in Grey (Tamayo), 48, *49*
Woman Reaching for the Moon (Tamayo), 48
Women and Dog (Marisol), 160
Women in the Arts, 214
Women's Interart Center (New York), 215

Women Students and Artists for Black Liberation, 215
Wong, Martin, 303
Woodrow, Bill, 350
Woodruff, Hale, 120
Woolworth's (Estes), 126, *127*
Work and Play (Dubuffet), 57
Works Progress Administration (WPA), 10, 16, 58
World Financial Center (New York), 346
World Trade Center (New York), 182
Wright, Frank Lloyd, 89–90, *91*
Wu Guanzhong, 318
Wyeth, Andrew, 6, 318

Yale University, Beinecke Library, 77
Yamagata Hawaii Dreamland, 186
Yamanashi Communications Center (Kofu, Japan), 186, *187*
Yamasaki, Minoru, 182
Yarbrow, Teri, *369*
Yavno, Max, 149
Yellow Manifesto (Vasarely), 129
Yongping Huang, 318
Yoshihara, Jiro, 98
You Are Not Yourself (Kruger), *328*
Youngblood, Gene, 275
Young Girl on a Chair (Manzu), 74, *75*
Youth in Asia (Allen), 371
Yrisarry, Mario, 208
Yunkers, Adja, 55
Yvaral, 102

Zadkine, Ossip, 31, 32, 84
Zaidler, Waldemar, 315
Zakanitch, Robert, 208, 209, 212–13, 230
Zakharov, Vadim, 318
Zambezia, Zambezia (Lam), 46, *47*
Zao-Wou-Kij, 41
Zigrosser, Carl, 58
Zone System, 60
Zorio, Gilberto, 351, *352*
Zucker, Barbara, 209
Zucker, Joe, 215, 219
Zwack, Michael, 312–13